Wrapped in Pride

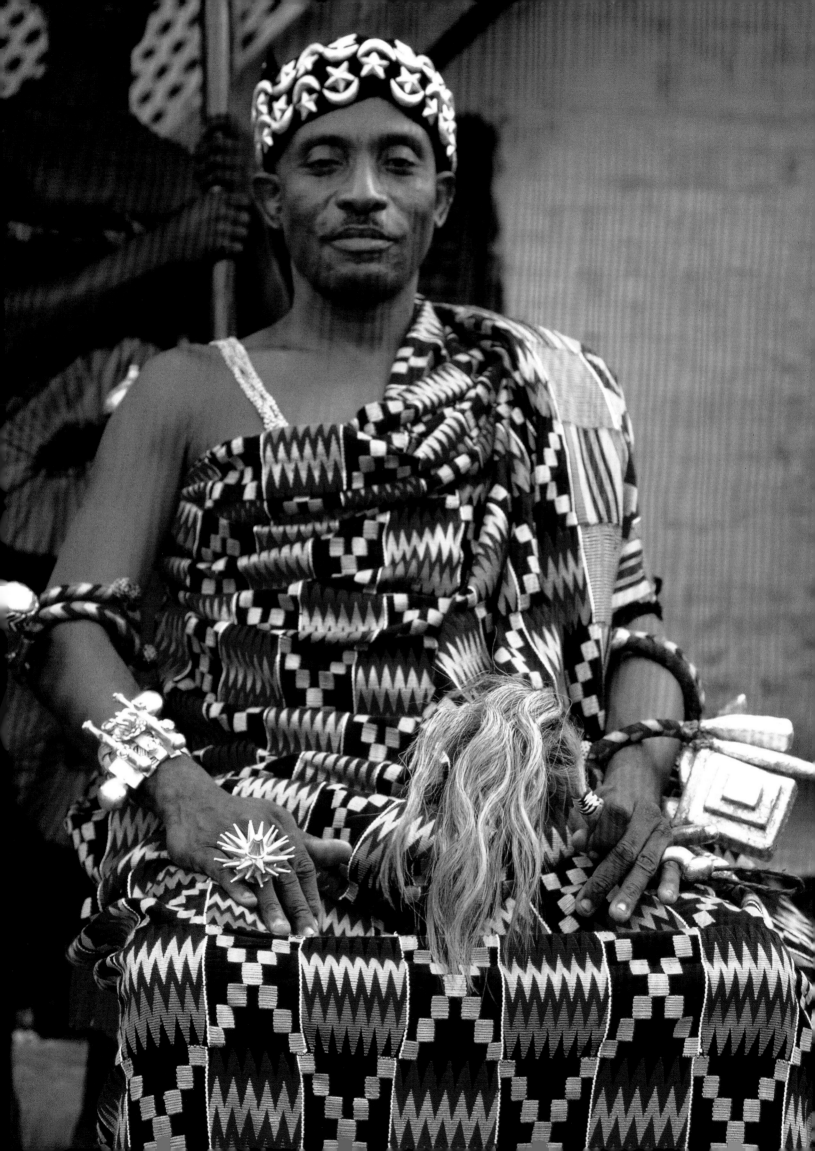

Wrapped in Pride

Ghanaian Kente and African American Identity

Doran H. Ross

With Contributions by
Agbenyega Adedze
Abena P. A. Busia
Nii O. Quarcoopome
Betsy D. Quick
Raymond A. Silverman
Anne Spencer

UCLA Fowler Museum of Cultural History
Los Angeles

Funded in part by
National Endowment for the Humanities
National Endowment for the Arts

UCLA Fowler Museum of Cultural History Textile Series, No.2
Published with the assistance of the Getty Grant Program

Published in conjunction with an exhibition
of the same name organized by the
UCLA Fowler Museum of Cultural History
and the Newark Museum

Cover: Detail of cat. no. 10.

Page 2: Paramount chief Nana Akyanfuo Akowuah Dateh II, both an Asafohene and
 Akwamuhene, in Kumase, Ghana. Asante peoples, Ghana. Photograph by Eliot
 Elisofon, 1970. Eliot Elisofon Photographic Archives. National Museum of
 African Art.

Page 6: Young woman dancing in front of Asantehene Opoku Ware II at the
 celebration of his silver jubilee. Photograph by Carol Beckwith and Angela
 Fisher, Kumase, 1995.

Page 8: Two young women attend an Ewe *durbar* wearing extremely simple kente.
 Photograph by Michelle Gilbert, Anloga, 1977.

Page 10: Ewe kente strip. FMCH X97.11.7.

Page 16: Detail of Ewe cloth with a map of Ghana. Kpetoe, date unknown.
 Photograph courtesy of Nii O. Quarcoopome.

Page 330: Woman lying in state wearing a fante wig and covered in multicolored silk
 cloth. Kente cloth covers the walls of the open room (Odampan) in which she
 is displayed. The deceased was called an Adwoa Amoah. She was an important
 woman in Alabiri *boron*, a ward of Abiriw-Akuapem. Kente is not used like this
 for Christian funerals. Documentation and photograph by Michelle Gilbert,
 Abiriw-Akuapem, 1991.

Back cover: Window with kente curtain. Photograph by Doran H. Ross, Pikine, a
 village outside of Dakar, Senegal, 1996.

Center strip details:
 Chapter 1—FMCH X97.11.7
 Chapter 2—FMCH X96.30.25
 Chapter 3—FMCH X98.17.3
 Chapter 4—FMCH X98.17.4
 Chapter 5—FMCH X70.979
 Chapter 6—FMCH X96.30.29
 Chapter 7—FMCH X98.17.5
 Chapter 8—FMCH X96.30.28
 Chapter 9—FMCH X97.12.10
 Chapter 10—FMCH X98.17.6
 Chapter 11—FMCH X98.17.7
 Chapter 12—FMCH X97.12.8
 Chapter 13—FMCH X97.11.7

Lynne Kostman, Manuscript Editor
Michelle Ghaffari, Editorial Assistant
Patrick Fitzgerald, Designer
Don Cole, Principal Photographer
Daniel R. Brauer, Production Coordinator

UCLA Fowler Museum of Cultural History
Box 951549, Los Angeles, California 90095-1549

The Fowler Museum is part of UCLA's School of the Arts and Architecture

Requests for permission to reproduce material from this catalog should be sent to
the UCLA Fowler Museum Publications Department at the above address.

Printed and bound in Hong Kong by South Sea International Press, Ltd.

Library of Congress Cataloging-in-Publication Data

Ross, Doran H.
 Wrapped in pride : Ghanaian kente and African American identity
/ Doran H. Ross ; with contributions by Raymond A. Silverman ...
[et al.].
 p. cm. — (UCLA Fowler Museum of Cultural History textile
series ; no. 2)
 Catalog accompanying an exhibition of the same name held at the
Newark Museum and the UCLA Fowler Museum of Cultural History.
 Includes bibliographical references
 ISBN 0-93-074168-4 (hard)
 ISBN 0-93-074169-2 (soft)
 1. Kente cloth—Ghana—Exhibitions. 2. West African strip weaving—Ghana—Exhibitions. 3. Ashanti
(African people)—Costume—Exhibitions. 4. Ewe (African people)—Costume—Exhibitions. 5. Costume—
Symbolic aspects—Ghana—Exhibitions. 6. Kente cloth—United States—Exhibitions 7. Afro-Americans—
Costume—Exhibitions. 8. Costume—Symbolic aspects—United States—Exhibitions. I. Silverman, Raymond Aaron.
II. Newark Museum. III. University of California, Los Angeles. Fowler Museum of Cultural History IV. Title. V. Series.
 NK8989.6.G5 R67 1998
 746.1'4'09667—dc21 98-41970
 CIP

Major funding for this publication and the exhibition has been provided by

National Endowment for the Humanities
 dedicated to expanding American understanding of history and culture
National Endowment for the Arts
The Getty Grant Program

The Ahmanson Foundation
AT&T
The Chase Manhattan Bank
Geraldine R. Dodge Foundation, Inc.
Jerome L. Joss Foundation
Manus, the support group of the UCLA Fowler Museum of Cultural History
New Jersey Council for the Humanities, a State Affiliate of the
 National Endowment for the Humanities
New Jersey Network Television
New Jersey State Council on the Arts/Department of State
The Newark Public Schools
The Prudential Foundation
The Times-Mirror Foundation
UCLA James S. Coleman African Studies Center
Victoria Foundation, Inc.

Lenders to the exhibition

Peter Adler
Emma Amos
Sonya Y. S. Clark
Adriene Cruz
Michelle Gilbert
Chester Higgins Jr.
Eli Leon
Museum of International Folk Art, Santa Fe
National Archives—Office of Presidential Libraries, Washington, D. C.
National Museum of African Art, Washington, D. C.
Office of the Governor, New Jersey
Dorothy Taylor

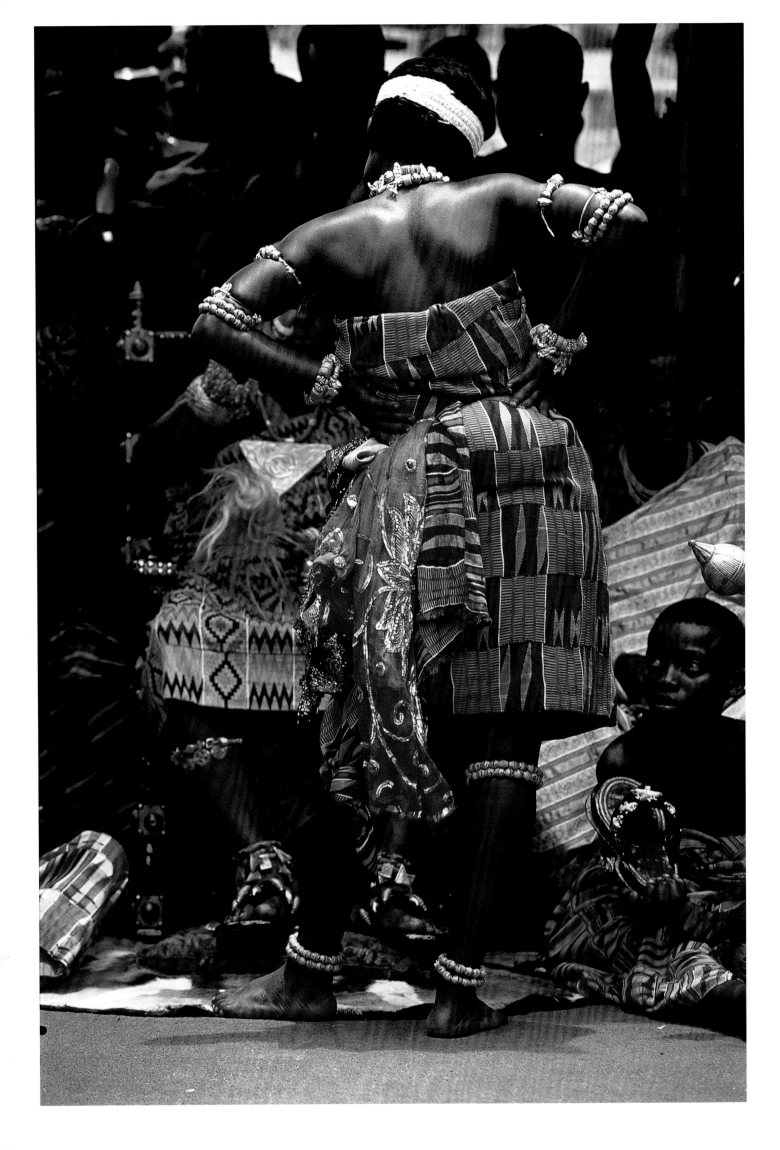

Contents

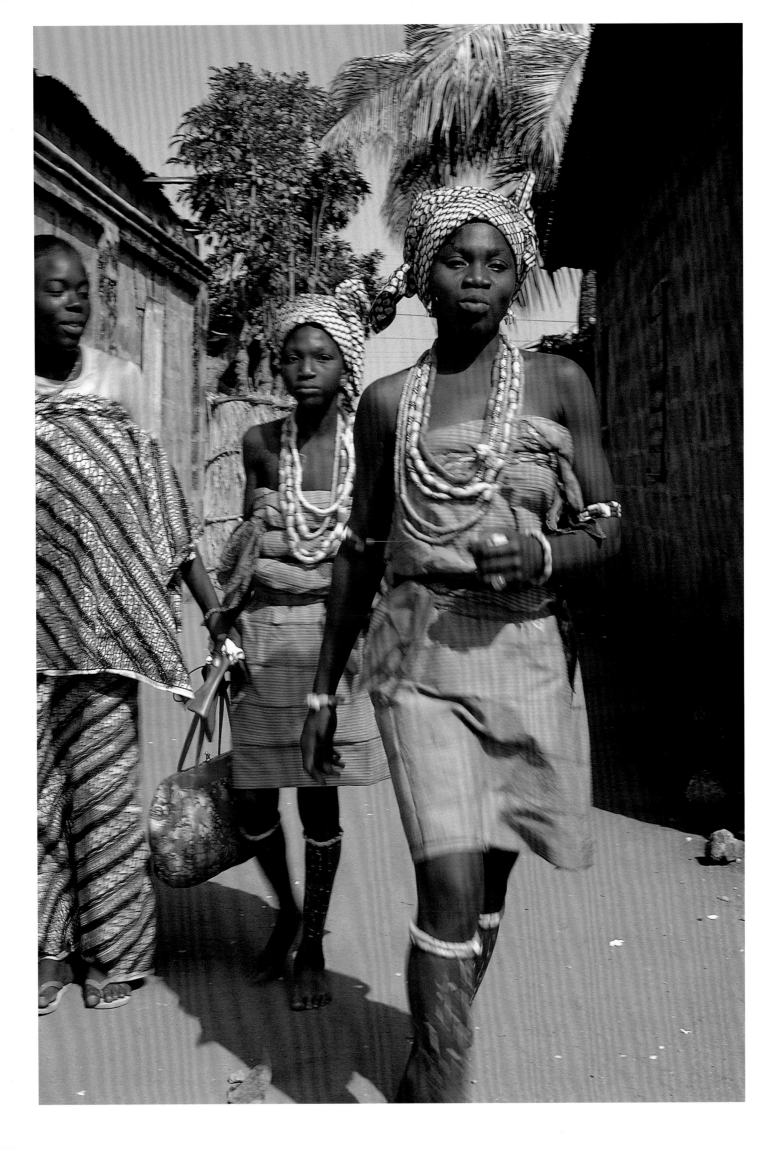

Foreword

I first began thinking about kente in 1973 while attending the exhibition *African Textiles and Decorative Arts* at the Los Angeles County Museum of Art. There were only a few examples of the cloth, mounted on the walls as if they were paintings. Indeed with their electric colors, vibrant geometry, and impressive scale, the weavings worked well (in the early 1970s) as dynamic examples of modern, if not contemporary, art.

My next encounter with kente occurred at the opening of *African Art in Motion* (1974) at the newly expanded Frederick S. Wight Art Gallery on the UCLA campus. My own exaggerated memory of that evening finds all the African attendees wearing stylish dark suits and elegant Western dresses with the rest of us, White and Black, wearing some version of African adornment—ranging from comparatively inconspicuous items of jewelry to complete African ensembles.

This static image of kente changed dramatically with my first visit to Ghana in 1974. At a festival in Cape Coast several Fante chiefs wore and "danced" kente. Images of the cloth as a flat work of art disappeared in favor of something more akin to a kinetic sculpture, part kaleidoscope and part kite. Kente was made for movement, whether in a fast powerful dance or a slow majestic procession.

These first impressions of kente were shaped primarily by visual responses to the cloth. It was only after repeated visits to Ghana that I began to appreciate the variety of contexts that helped define the importance of kente. These events in turn were themselves defined in part by the presence of the cloth. With time I also began to understand some of the complexities of cloth names, which serve as catalysts for the contemporary construction and expansion of meaning, both surrounding and embedded within the cloth. For me, this is the most engaging and telling part of kente's history—how it has come to mean so many things to so many people at the end of the twentieth century. This volume attempts to bring the history and significance of kente up to date. It is my hope that it will eventually serve as a benchmark for subsequent studies that examine the further growth of the tradition.

Doran H. Ross
Director, UCLA Fowler Museum of Cultural History

Daa Daa Kente

J. T. Essuman

Daa daa Kente, Daa daa Kente Daa (repeat)

Mo dɔfo 'dɔfo bɛkyɛ m' Kente, daa

Mo dɔfo 'dɔfo bɛkyɛ m' Kente, daa

Mo dɔfo papa bɛkyɛm Kente dabaa

Kyɛm bi O, Kyɛm bi O!

Daa, Daa, Kente Daa.

Everyday Kente, Everyday Kente, Always (repeat)

My beloved lover will give me a gift of Kente, Always

My beloved lover will give me a gift of Kente, Always

My good lover will give me a gift of Kente, Always

Give me one as a gift, Give me one as a gift

Everyday Kente, Always.

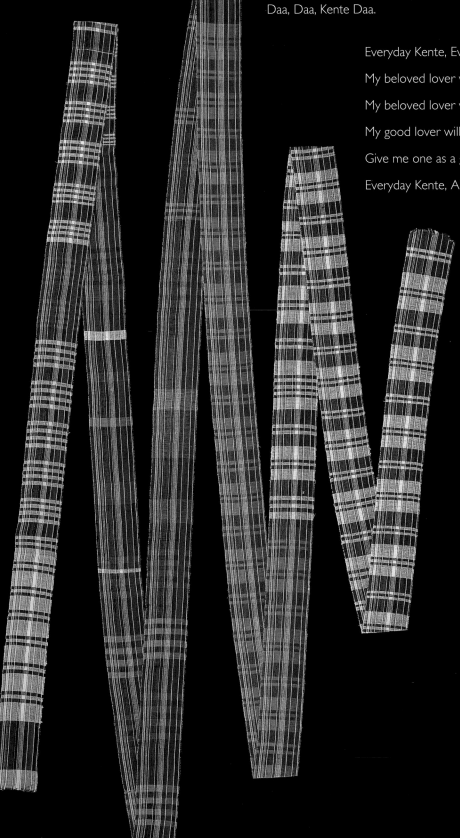

Acknowledgments

This project began with a telephone call from Anne Spencer, Curator of Africa, the Americas and the Pacific at the Newark Museum, inquiring about the possibility of organizing an exhibition on kente cloth that would bring the tradition up to date and consider its history on both sides of the Atlantic. I want to thank Anne for all her efforts on behalf of this project. There are few museum professionals as dedicated and hard working as she is. I would also like to thank Director Mary Sue Sweeney Price, Ward L. E. Mintz, Peggy Dougherty, David Mayhew, Isimeme Omogbai, Lucy Voorhees Brotman, Eathon G. Hall Jr., Gregory Blackburn, Rebecca A. Buck, Vivian James, Alejandro Ramirez, Jane Stein, Catherine Jellinek, and Lorelei Rowars of the Newark Museum for their many contributions to *Wrapped in Pride* and for facilitating the collaboration between our two institutions.

For me, this book and its companion exhibition are the culmination of nearly twenty-five years of involvement with the expressive culture of Ghana. My mentor Herbert M. Cole first led me to West Africa in 1974 to begin preliminary research for the UCLA exhibition and publication *The Arts of Ghana* (1977). As always I want to thank Skip for his faith in my work and for his consistent support through the years. Initial research on *Wrapped in Pride* in Ghana was facilitated by Professor J. H. K. Nketia. His good offices opened many doors and provided the catalyst for even more friendships. At the National Museum of Ghana Joe Nkrumah regularly offered enlightened humor and wise counsel, and Bruce Lohoff and Nick Robertson at the United States Information Service in Accra extended many courtesies. Cornelius Adedze provided considerable research assistance and documented the first Bonwire Kente Festival. Samuel Adams was a driver "pass all." Others who provided important assistance include Joseph Armah Niiattoh, Ablade Glover, Hayford Appiah-Kubi, Jemina Hayfron-Benjamin, Kwame Labi, Kwasi Boady, Isaac Azey, Garbah Ibrahim, Ephraim Agawu, and Osei Kwadwo.

In Bonwire I would like to thank Nana Kwasi Amoah, Acting Bonwirehene; Nana Kofi Nkrumah, Dumakwihene; Nana Osei Kwadwo, Adontehene; Nana Kwasi Agyei, Benkumhene; Nana Kwame Kwaning, Gyasehene; Nana Kwasi Gyamfi, Kentehene; Nana Amofa, Gyidomhene; Nana Kwasi Afrane; and Nana Berhene, Oyokomanhene.

Samuel Cophie, an Ewe weaver who has lived in Bonwire since 1960, provided unique perspectives on many issues. His knowledge and friendship are warmly appreciated. Gratitude is also extended to the following weavers who work with Cophie: Joshua Cophie, Seth Cophie, Akwasi Kwakye, Kojo Awusi, Osei Kwame, Atuahene Kwabena, Kofi Boateng, Solomon Owusu Babeeto, Samuel Bempah, and Samuel Kwaku Appiah.

Other weavers who provided assistance, information, and other courtesies include Philip Boakye Ansa, Okai Neyeh Williams, Samuel Adomako, Richard Gyimah, Thomas Abegya, James Antobreh, Charles Neyeh, Yaw Sarpong, Kings Mawutor Fiador, Kofi Kankam, Kwesi Adai, Yaa Yasmin Minkah, E. Y. Fiagbe, Kobla Dodze, and Emanuel Fusese.

As with so many of our projects, the National Endowment for the Humanities has been not only a source of funding but also an integral part of the exhibition development process. I would particularly like to thank Nancy Rogers and Suzi Jones for their efforts on our behalf. My sincerest thanks, as well, to Mr. Jerome L. Joss for his support of the *Wrapped in Pride* project and for his long-standing patronage of the Fowler Museum. The Getty Grant Program lent its generous support to the publication and made available special funds for three high school internships that continued the work of our Community Research Partnership with Crenshaw High School. I would also like to thank Ed Keller, Director of the James S. Coleman African Studies Center for his support.

The contributors to this volume have brought a wealth of research and ideas to the project. This book has been visually and intellectually enriched by Abena P. A. Busia, Raymond A. Silverman, Anne Spencer, Agbenyega Adedze, Nii O. Quarcoopome, and Betsy D. Quick. Their efforts are greatly appreciated.

Lynne Kostman brought reason, order, and eloquence to the editing process. Her considerable energy and impressive patience were instrumental in bringing the volume to completion. Rebecca Van Dyck-Laumann offered a critical eye and mind in assisting with the Twi orthography. Michelle Ghaffari provided assistance with a variety of editorial tasks including proofreading. This book was designed by Patrick Fitzgerald with imagination and wit. His good humor and creative fortitude sustained a complicated project with dramatic results. The substantial photographic requirements were handled beautifully by Don Cole and his assistant Jonathan Molvik. Danny Brauer masterfully coordinated the production of the book and handled myriad complicated details pertaining to its printing.

Many talented photographers have shared their wonderful images with us. Carol Beckwith, Clayton Everett, Angela Fisher, Frank Fournier, Chester A. Higgins Jr., Cheryl Himmelstein, Brian Lanker, Lester Sloan, James Sudalnik, Cary Wolinsky, and Ira Wyman. Special thanks are extended to Howard L. Bingham for his remarkable photographs of

Muhammad Ali. Michelle Gilbert shared not only photographs but also important documentation. James Sudalnik videotaped the UCLA All African Peoples' Graduation and First A.M.E. services. David Mayo shared responsibility with me for videotaping the weaving process and festivals in Ghana.

Paul Jenkins of the Basel Mission Archive has provided considerable help over the years. The resources of this archive have enriched many studies of Ghanaian history and culture. I would also like to thank Regula Islin and Veit Arlt for their assistance during my most recent visit. Bernard Gardi shared his research and documentation from the Museum der Kulturen, Basel, and provided useful insights on early kente. Christraud M. Geary, Curator of the Eliot Elisofon Photographic Archives at the National Museum of African Art, also supplied important photographs that have enhanced this volume.

Artists who have contributed to the beauty of this catalog include: Emma Amos, Isaac Azey, John Biggers, Larry Poncho Brown, Kofi Obeng, James Phillips, Frank E. Smith, Angela Williams, Adriene Cruz, Dorothy Taylor, and Sonya Y. S. Clark.

In addition to the artists who lent their own work, the generosity of the following lenders has been essential: Peter Adler; Abena P. A. Busia; Michelle Gilbert; Michael D. Harris; Eli Leon; Museum of International Folk Art; National Museum of African Art, Smithsonian Institution; National Archives; the Newark Museum; and those who wish to remain anonymous.

Special attention and research were provided by Joseph C. Akers Jr., Joyce H. Bailey, Dustin Bingham, Bishop Charles E. Blake, Michelle Elliot, Zette Emmons, Deborah Garcia, Twyla Lang-Gordon, Beth Guynn, Julie L. Haifley, Robert A. Hill, Harvey L. Hodge, Reynoir I, Tamara Jardes, Carol D. Kemp, Abraham Lee, George Nichols, Sandra M. Posey, Ekow Quarcoo, Bernice Johnson Reagon, Valencia Roner, Pravina Shukla, Lotus Stack, Rebecca Van Dyck-Laumann, Wendy M. Whitney, Wim de Wit, Alfre Woodard, and Itibari Zulu.

Extra efforts in obtaining copyright permissions and procuring images were made by Margaret Adamic, Aku Sika Akuffo, Lorrain R. Alkire, Julie Allen, Kurt Andrews, Herbert Aptheker, Kim Arrington, Deirdre Biddy, Patricia M. Boulos, Anthony T. Browder, Blanche Brown, Carol Christiansen, Jeanne L. Chvosta, David Cohen, Carolyn Cole, Phyllis Collazo, Guy Cooper, Kevin Corothers, Joannie C. Danielides, Alison Deeprose, David Graham Du Bois, Robert Estall, Pamela Exum, Rose Fennell, Robert Fishbone, Paula Fletcher, Eugene L. Foney, Steve Fox, Bernard Gardi, Nancy Glowinski, Richard L. Green, Roger Greene, Meg Greenfield, Ivy Hamlin, Bill Hammons, Don Hodgdon, Michele Jelley, Paul Jenkins, Bruce Owen Jones, Holly Jones, Deborah Keith, Annette S. Knapstein, Georgina K. Kusi, Lynne Lamb, Heather Lee, Roselynn Lee, Renée K. Cogdell Lewis, Teri E. Long, Theresa L. Mahoney, Maureen McCready-Glassman, Lynn Mervosh, Diane Meuser, Jennifer Minerva-Hinck, Mark Monakey, Mary Morel, Paul Mørk, Kwaku Ofori-Ansa, Rebecca Oliver, Paula Potter, Murray Pottick, Lupe M. Salazar, Seija Schiff, Linda L. Seidman, Judith Sellars, Ted Shaner, Allison Sherer, William Siegmann, Sid Simpson, Eric Smalkin, J. Weldon Smith, Susan Snyder, Keith and Shereen Stafford, Bettye Stanley, Winnie Taylor, Ben Tripp, T. W. Wahlberg, Alvia J. Wardlaw, Jack Weiser, and Bruce M. Wenner.

The exceptional students and staff at Crenshaw High School informed this project in many ways. Thanks are extended to Principal Yvonne Noble, teachers Mary Covington and Susan Curren, and students Ademunyiwa Akinloye, Maureen Barrios, Cesar Bravo, Rolando Cordoba, Aphrodite J. Dielubanza, Carroll Houston, David Humes, Aisha Kennedy, Monique Lane, Taaji Madyun, Maritza Mejia, Ronn Menzies, Alvyna Sanders, Sadikifu Shabazz, Danielle E. Smith, Amy Tariq, Byron Williams, Havonnah Wills, and La Ron Young.

A warm welcome at 92nd Street School in Los Angeles was given by principals Margaret Young and Veronica Morris and teachers Claudia Hernandez, Kandice McLurkin-Hasani, Ethel Tracy, John Estrada, and Gwendalyn V. Newman. Guidance from First A.M.E. in Los Angeles was provided by Reverend J. L. Armstrong, Reverend Jeanne Baherry, Reverend Quanetha Hunt, and Reverend Cecil L. Murray.

The help of C. K. Adom, Misonu Amu, Jacqueline Cogdell DjeDje, and Yvonne Korkoi Nkrumah was instrumental on the interleaf on music.

Notably, Lyn Avins and Delia Cosentino took on much of the research and writing for the Curriculum Resource Unit accompanying the exhibition. Lisa Rosen assisted with bibliographical and production details. A special thanks to Lyn Avins for her many years of service to the Fowler Museum and to the young people and teachers it serves. The unit was admirably designed by Tony Kluck. Stacey Hong assisted with the interpretation of the exhibition for younger audiences. Kristen Quine worked on public programming at UCLA.

David Mayo, Fran Krystock, and Anne Spencer accompanied me on research and collecting trips to Ghana. The demands of preparing the Fowler Museum's textiles for exhibition were met by Jo Hill, Museum Conservator, and Mary Jane Leland methodically

analyzed nearly twenty pieces for the first appendix to this volume. David Mayo, Director of Exhibitions at the Fowler Museum, worked closely with me in developing the installation floor plan and design. The market and store environments for the exhibition were created by Don Simmons and Victor Lozano Jr. Karyn Zarubica coordinated efforts in developing the traveling exhibition schedule.

Grant writing and fundraising at UCLA were successfully led by Kyrin Ealy Hobson and Lynne K. Brodhead. Christine Sellin admirably took charge of Public Relations with assistance from Lisa Rosen.

I would especially like to thank Clarissa Coyoca, Assistant Director at the Fowler, for attending to numerous responsibilities in my absence. Dina Brasso and Kathlene Kolian dealt with the maze of accounting issues. Other staff who lent support include Patricia Anawalt, Jose Garcia, Roy Hamilton, Ray Huang, Sue Kallick, Sarah Kennington, Lori Lavelle, Frank Munoz, Barbara Sloan, David Svenson, Polly Svenson, Emory Thomas, and Nicola Willey.

Jennifer Lees facilitated much of the early research on *Wrapped in Pride*. The success of this project was also driven by the efforts of three extraordinary magicians, Farida Sunada, Linda Lee, and Betsy Escandor. Organizing objects, research, and manuscripts, this triumphant troika kept the project on course and ensured whatever success it has achieved.

The wizard of *Wrapped in Pride* was Betsy Quick, Director of Education at the Fowler Museum of Cultural History. Friend, colleague, and teacher extraordinaire, Betsy propelled a three-year adventure with her enthusiasm and insight. Her unique perspectives on the role of museums in contemporary society and her commitment to community and audience are a constant inspiration. This project would not have happened without her.

Doran H. Ross
Director, UCLA Fowler Museum of Cultural History

Wrapped in Pride: Ghanaian Kente and African American Identity is the result of the collaborative efforts of many individuals, who, in a truly community-based undertaking, joined with us to promote the greater understanding of the transatlantic meaning of this beautiful and complicated cloth, as well as those who make it and those who wear it. I commend Anne Spencer, Curator of Africa, the Americas and the Pacific at the Newark Museum, and Doran H. Ross, Director of the UCLA Fowler Museum of Cultural History in Los Angeles, whose work together on this subject has broadened our horizons immeasurably. Their knowledge of and enthusiasm for this subject have truly enriched us all.

On behalf of the Newark community, I thank those who, over the span of more than four years, have responded to this Museum's request for assistance in identifying the meaning of kente in Ghana, in the African Diaspora in the United States, and particularly in Newark. This idea was first discussed with Clement Alexander Price, Professor of History at Rutgers University, who was pivotal in helping us think through the wider context of a potential museum exhibition on the subject, and with Museum Trustee Gloria Hopkins Buck, who helped frame the educational component of the kente project.

That component, in which Newark and Los Angeles high school students were invited to participate, became integral to the entire fabric of the exhibition. On both coasts, students learned techniques of oral history and documentary photography in order to interview their elders about the subject of kente in African American life. Their contributions will be precious components of the exhibition at both venues.

We are especially grateful to the many Newark teachers and principals who partnered with us so that the student research project could go forward: Sister Gwen Samuels and Brother Reuben Dash at the Chad Science Academy, and Gwen Jackson, W. Gwendelyn Sanford, Walter Kaczka, and Dr. Doris Culver at University High School. We also acknowledge the efforts of the students themselves: at the Chad Science Academy, Latoi Boatwright, Aneesa Chambers, Najah Dupree, Nzinga Green, Tanisha Green, Wendy Jean-Louis, Tonya Johnson, Nadirah Keith, Tracey Marcus, Carline Millevoix, Keisha Murphy, Janel Watts, and Maria Webb; and at University High School, Prunella Booker, Waleeah Brooks, Aja Davis, Qwanna Garrett, Jabez Gatson, Jasmine Hemingway, Shanika Jones, Erica Moore, Ugochuku Nwachukwu, Francina Radford, Danielle Scarborough, Shontae Scott, Brehita Taborn, Christina Vega, and Fatimah Winbush. The kente research project was assisted by Newark Museum Schoonhoven interns Joy Robinson and Georgena McLeod.

We are equally indebted to the many Newark community members who generously gave their time to be interviewed by these students about their involvement with kente: Nana Kyei Ababio II, Arnold Adjepong, Rashid Agwedicham, Nii Akuetteh, Walter Amoah,

Emma Amos, George Asamoah-Duodu, Father John Oppong Baah, Sandra Benson, Reverend Milton Biggham, Dr. Charles Boateng, Dr. Abena P. A. Busia, Rakesh Changur, Christopher Cottle, The Honorable Mildred Crump, former Newark Municipal Councilwoman at Large, New Jersey Assistant Secretary of State Mary Cudjoe, Kabu Okai-Davies, Linda Farrell, Stephanie Hughley, Bernard Jackson, Gloria Imani Jackson, J. Garfield Jackson Sr., The Honorable Sharpe James, Mayor of Newark, Lorna Johnson, Veronica Jones, Maxwell Juma, Barbara King, Grace Kofie, Marate Kristos, Father James McConnell, Marita McEntyre, Darnell McGee, Reginald Miles, Tiplah Mulbah, Mansa Mussa, Father Antonio Nelson, Linwood Oglesby, Atta Owusu, Edmund Phillips, Mary Puryear, Father Paul Schetelick, Margie Shaheed, Nancy Shakir, Teresa Smith, Karen Smith-Phillips, Reverend Richard Spaulding, Stars of Urban Life, Martina Tamakloe, Vanessa Freeland Thomas, Donald Tucker, New Jersey State Assemblyman and Newark Municipal Councilman, Ellen Ugdah-Gningue, Sharon Vann Williams, Carolyn Whitley, Patricia Winckler, Dr. Zachary Yamba, and Captain Fateen Ziyad.

In addition, we appreciate the help given by others who participated in the project: Frederika Bey, Joseph Denchi, Leon Bunion, Lillian Cokley, Leo Gunther, Mary Reid, Bruce Williams, Tammara Jones, Rhonda Allwood, Karen Thomas, Stacey Akwei, Pauline Blount, Lubna Muhammed, Dr. C. Brown, Yolanda Horsley, Katunge Mimy, and Paula Blount.

The planning of such a multifaceted project as *Wrapped in Pride: Ghanaian Kente and African American Identity* would not have been possible without the enthusiasm and dedication of the members of the Newark Museum's Advisory Committee, whose many contributions ranged from helping us identify potential interviewees to generating participation by the large Ghanaian community living in our area. I thank Dr. Obiri Addo, G. Ofori Anor, Sam Asamoah-Duodu, Celeste Bateman, George Bonsu, Gloria Hopkins Buck, Dr. Abena P. A. Busia, Patricia Hall Curvin, Nii Aso Glover, Stephanie Hughley, Chase Jackson, Lorna Johnson, Maxwell Juma, Alex Kennedy, Dr. Julia Miller, Mansa Mussa, Kabu Okai-Davies, Dr. Clement Alexander Price, Mary Puryear, Gwen Samuels, W. Gwendelyn Sanford, Debra Spruill, and Captain Fateen Ziyad.

We are also most grateful to Congressman Donald M. Payne for agreeing to chair our opening celebrations and to the members of the Honorary Gala Committee. We thank New Jersey Network, our partner in creating a documentary on *Wrapped in Pride* that will be broadcast widely.

A project of this complexity necessarily involved many staff members at the Newark Museum. For their particular dedication to *Wrapped in Pride*, I thank Ward L. E. Mintz, Deputy Director for Programs and Collections, Peggy Dougherty, Director of Development, David Mayhew, Deputy Director for Marketing, Isimeme Omogbai, Deputy Director for Finance and Administration, Lucy Voorhees Brotman, Director of Education, Eathon G. Hall Jr., Assistant Director of Education for School Programs, Gregory Blackburn, Exhibit Designer, Rebecca A. Buck, Registrar, Vivian James, Assistant Registrar, Alejandro Ramirez, Community Relations Coordinator, Jane Stein, Program Coordinator, Catherine Jellinek, Public Relations Officer, and Lorelei Rowars, Museum Shop Manager, as well as all of the staff who assisted in supporting their efforts.

Many institutions and individuals have agreed to lend to this exhibition. Without their support, the rich diversity of kente in all its varied aspects could not have been displayed. For the Newark showing, we are particularly grateful to Blessed Sacrament Church, Carolyn Whitley, The Honorable Christine Todd Whitman, Governor of New Jersey, Gwen Samuels, and Christopher Cottle.

This exhibition would not have been possible without the generous and abiding support of public and private funders. On behalf of the Trustees of the Newark Museum Association, I thank the National Endowment for the Humanities, the National Endowment for the Arts, the Getty Grant Program, the Prudential Foundation, AT&T, the Geraldine R. Dodge Foundation, Inc., the Jerome L. Joss Foundation, the Victoria Foundation, Inc., the New Jersey Council for the Humanities, the New Jersey State Council on the Arts/Department of State, the Newark Public Schools, the Chase Manhattan Bank, and also Ghana Airways Limited and New Jersey Network Television. The Newark Museum receives operating support from the City of Newark, the State of New Jersey, and individuals, foundations, and corporations who join us our mission of excellence in the presentation of art, science, and education.

We hope that *Wrapped in Pride* and its focus on an important world artistic tradition will promote further understanding of yet another manifestation of the many-layered relationship of Africa and the Americas.

Mary Sue Sweeney Price
Director, The Newark Museum

Notes to the Reader

Unless otherwise noted, all photographs and cloths are from Ghana and likewise all cloths are strip weaves unless designated as broadloom, machine woven, or roller printed. We have attempted to conform to contemporary orthographic conventions except where popular usage strongly suggests an alternative. For example, we have chosen to use *kente* instead of *kentɛ,* because the word now figures on the world stage and is most commonly spelled in the former manner in both Ghana and the United States. Some inconsistencies in spellings have also been allowed, and they naturally occur in citation of the historic literature. We use the current "Asante," who nevertheless live in the "Ashanti Region" of Ghana; Ashante and Ashantee are also found in older sources. All chiefs, queen mothers, and other officials appearing in photographs are identified by their titles at the time of the photograph; these do not necessarily represent their current status. In the catalog cloths from the workshop of Samuel Cophie have been positioned in the Asante section, although an equally good case could be made for identifying them as Ewe. In addition, since many northern Ewe textiles produced over the past fifty years are indistinguishable from the Asante, one must be cautious of attributions of cloths woven during this period. Finally, all interleaves were written by Doran H. Ross with the exception of "Women Weavers In Bonwire" by Anne Spencer and "Still I Rise" by Betsy D. Quick.

Doran H. Ross

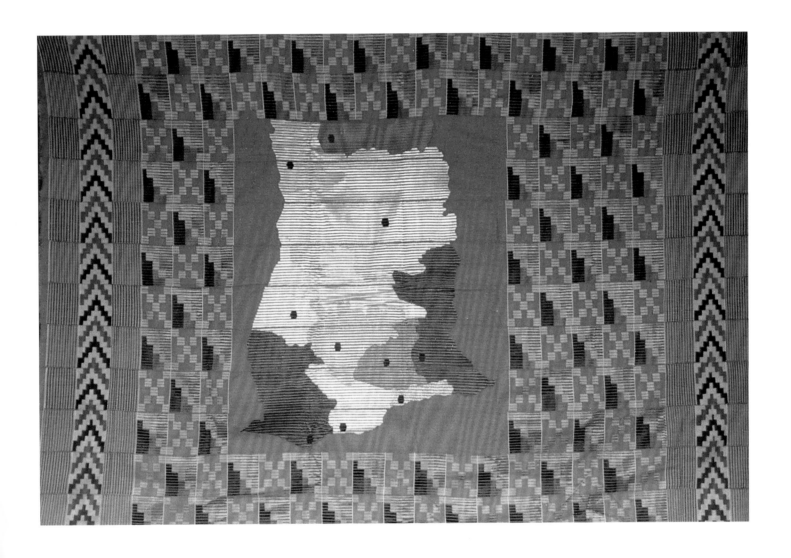

BURKINA FASO

BENIN

BOLGATANGA

TAMALE Yendi

CÔTE
D'IVOIRE TOGO

Salaga

Bondoukou GHANA

Hani

Tanoboase Tuobodom

Berekum

Techiman

Tanoso

Mampon Kpandu

Agona Kumawu

Ntonso Adanwomase Kpalime Notse

Wonoo Bonwire

KUMASE Ejisu Abetifi HO Dokpokope

Kokofu Odumase Kpetoe

Essumeja Akpokope

Kibi Agbozume Popo

Awukugua **LOME**

Abiriw

Akuropon Anyako

Aburi

Ada Anloga

Abeadze Dominase Enyan Abaasa **ACCRA**

Mankesim

Saltpond Lowtown

Elmina Anomabu

CAPE COAST GULF OF GUINEA

ATLANTIC OCEAN

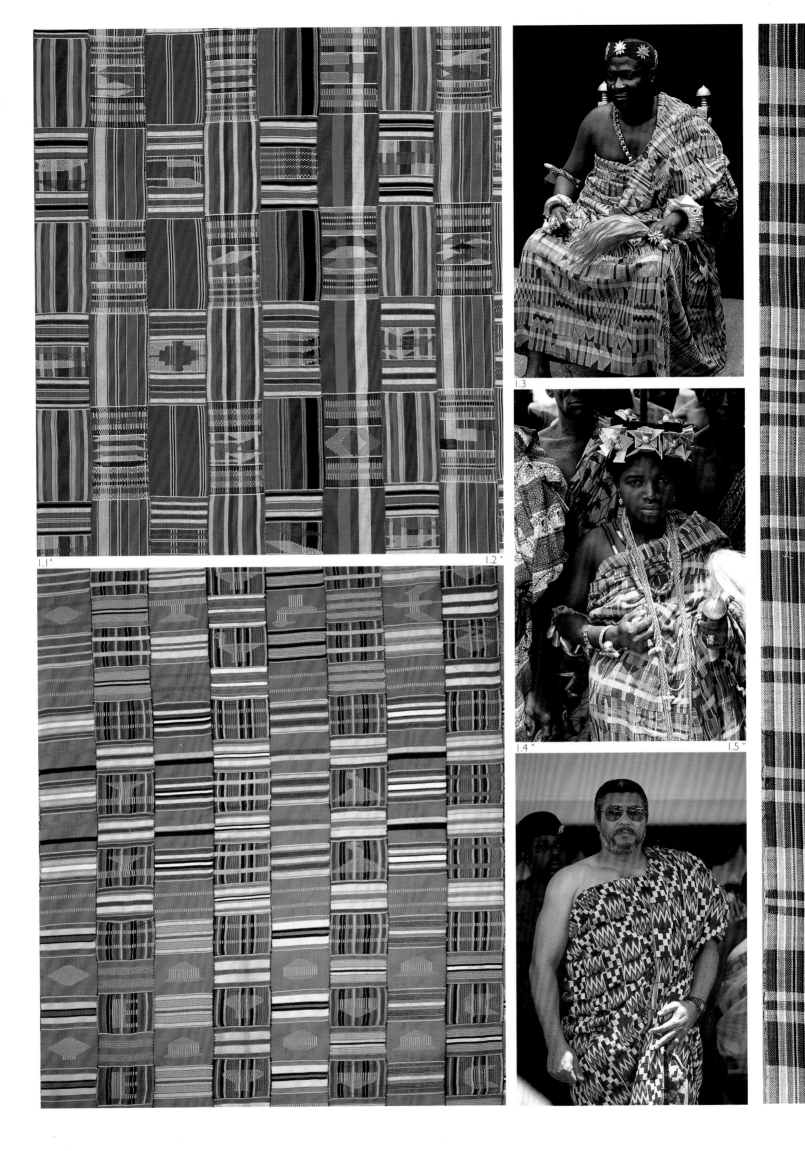

1.1 ^

1.2 ˅

1.3

1.4 ^

1.5 ˅

The strip-woven cloth called kente, made by the Asante peoples of Ghana and the Ewe peoples of Ghana and Togo, is the best known of all African textiles (figs. 1.1, 1.2). Its renown has spread internationally, so that it is now one of the most admired of all fabrics in many parts of the world. Kente has its origins in the former Gold Coast of West Africa as festive dress for special occasions—traditionally worn by men as a kind of toga and by women as an upper and lower wrapper (figs. 1.3–1.7). Its existence as spectacular apparel, however, has obscured its many other roles in Asante and Ewe culture, especially in royal regalia (fig. 1.8). Over the past forty years the cloth has been transformed into hats, ties (fig. 1.9), bags, shoes, and many other accessories, including jewelry, worn and used on both sides of the Atlantic. Individual kente strips have found a permanent home in the United States and are especially popular when worn as a "stole" or applied to academic and liturgical robes (figs. 1.10–1.12). Kente patterns have also developed a life of their own and have been appropriated as surface designs for everything from Band-Aids and balloons to greeting cards and book covers. Appearing in contexts both sacred and profane, kente has come to evoke and to celebrate a shared cultural heritage, bridging two continents.

As we will discuss later, kente has some rivals for attention on the international scene, especially the embroidered raffia cloth of the Kuba peoples of the Democratic Republic of the Congo (formerly Zaire) and the Bamana mud cloth of Mali. While the former had some exposure in the United States well before the advent of kente and the latter has recently made more significant gains in the world of haute couture, kente remains the

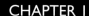

CHAPTER 1

Introduction: Fine Weaves and Tangled Webs

Doran H. Ross

1.1 Detail of Asante man's cloth, circa 1950. Rayon. Width of warp strips 9.1 cm. FMCH X87.380.

1.2 Detail of Ewe man's cloth, circa 1950. Cotton. Width of warp strips 9.7 cm. FMCH X98.16.1.

1.3 Ejisuhene Nana Diko Pim III wearing a rare Asasia, Oyokomon Adweneasa cloth. Photograph by Doran H. Ross, Ejisu, 1976.

1.4 Queen mother from Fante state of Abeadze Dominase wearing Oyokoman Adweneasa. Photograph by Doran H. Ross, 1975.

1.5 His Excellency, Flt. Lt. Jerry John Rawlings, President of the Republic of Ghana, wearing a cloth known as Fathia Fata Nkrumah at a *durbar* honoring the Silver Jubilee of Otumfuo Opoku Ware II, Asantehene. Photograph by Frank Fournier, Kumase, 1995.

1.6 Female members of Fante *asafo* (warrior) group at a *durbar* for President Hilla Liman (?). Photograph by Doran H. Ross, Saltpond, 1980.

1.7 Members of the Singing Band of the Abiriw Presbyterian Church of Ghana celebrating their anniversary. Documentation and photograph by Michelle Gilbert, Abiriw-Akuapem, 1990.

1.6 ˆ 1.7 ˇ

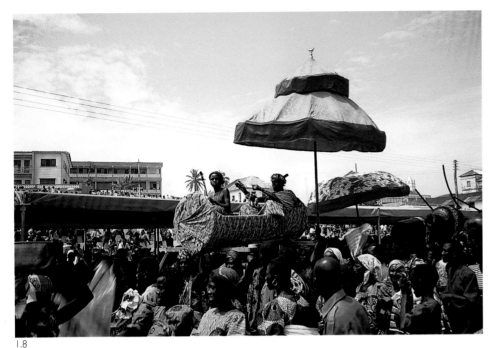

1.8

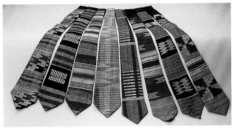

1.9

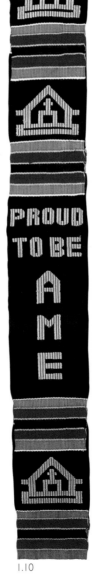

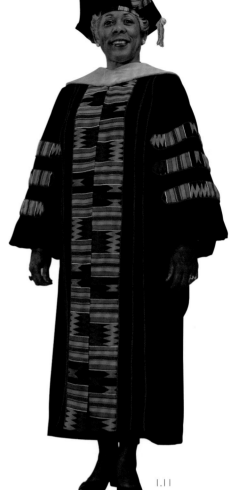

1.11

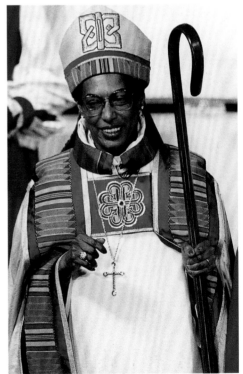

1.8 Fante paramount chief riding in a kente-lined palanquin during a *durbar* celebrating Fetu Afahye. Photograph by Doran H. Ross, Cape Coast, 1997.

1.9 Assortment of ties made from handwoven kente. Rayon. Width of tie on left 9 cm. Private collection.

1.10 Kente stole with the legend "Proud to be AME," woven for the African Methodist Episcopal Church. Rayon. Width 11.5 cm. FMCH X95.51.1.

1.11 Promotional photograph for academic robes available from Prime Heritage Collection, Memphis, Tennessee. Photograph by Prime Heritage Collection.

1.12 Bishop Barbara Harris at her ordination as the first female bishop in the history of the Episcopal Church. AP/Wide World Photos, 1989.

1.13 Asante-style strips woven by Ewe weavers at Agotime Akpokope. Photograph by Doran H. Ross, 1997.

1.10

1.12

textile of choice for African Americans on many occasions that foreground issues of heritage and achievement. Kente with its vivid colors enmeshed in a visually compelling geometry (or, in some cloths, an equally engaging absence of the same) has occupied a prominent role in the worlds of design, fashion, and politics during the second half of the twentieth century. Moreover, it has been a potent symbol in the context of many of the most important African and African American ideologies of the period, as we will see in chapter 10.

The chapters that follow will examine a heritage that benefits to a great extent from a healthy exchange of ideas and entrepreneurial initiatives across the Atlantic. Kente, however, is not exempt from controversy in several interrelated arenas. At the forefront are debates concerning the primacy of Asante versus Ewe weaving. These involve issues of ethnic and cultural pride and reflect as well sizable economic stakes in the form of tourist dollars and export revenues, as well as still-lucrative indigenous markets. While certain clues as to its origin reside in the textile itself (see, for example, Lamb 1975, 91–93, 210–12), the fact is that most of the arguments exist in the easily manipulated realm of oral tradition, thus rendering it impossible to determine definitively who influenced whom. Despite kente's obscure past, two facts remain certain: neither the Asante nor the Ewe invented narrow-strip weaving on the horizontal treadle loom, and at various points along the way, each group influenced the other.

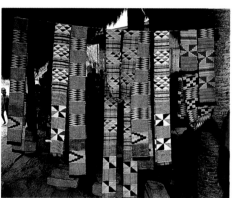
1.13

The arguments for Ewe or Asante primacy and indeed those dealing with subsequent innovations in design are partly a product of false distinctions between the two traditions, if they can even be called that. The similarities between the two, especially in central and northern Ewe areas, are much greater than any discernible differences. And Ewe weavings from this area made during the past fifty years are virtually indistinguishable from those of the Asante (fig. 1.13).

Beyond these issues, it is becoming increasingly problematic to describe cultural phenomena solely in terms of ethnicity, especially if these "ethnic groups" are nearby or contiguous. The phrase "ethnic boundaries" may be one of the most misleading, essentialist, and abusive constructions of all time. When applied to material culture, it creates a plethora of problems. Aside from kente, the Ewe and Asante share a vast array of elite art forms, including stools, swords, umbrellas, linguists' or counselors' staffs, and a wealth of personal adornment. Arguments for the history of any one of these items are undoubtedly related to several of the rest. The fact that these items exist primarily in royal contexts where the Asante and other Akan groups have complicated and well-developed rituals and ideologies pertaining to their use, in contrast to a weaker tradition of chieftancy and royal regalia among the Ewe, suggests that the source for much of this material comes from the Akan direction.

The historical relationship of the two traditions aside, Asante kente has attracted more attention than Ewe kente both within Ghana and without. This is especially true in the United States where patterns typically considered Asante dominate fashion and design. This preeminence, however, is not due to any aesthetic superiority. It is instead attributable, at least in part, to the spectacular and relatively well-documented history of the Asante Empire, particularly its many confrontations with the British in their search for trade access to the interior of the Gold Coast and to Asante gold. War, especially with a major military and media power, attracts considerable attention; this was as true in the nineteenth century as it has proven to be in the twentieth.

The political and social structure of the Asante must also be considered. The elaborate system whereby the Asante king, or Asantehene, heads a series of paramount chiefs who in turn rule over an array of divisional, town, and village chiefs—most with a stunning assortment of court officials—has led to a dynamic tradition of royal patronage for court regalia including textile production. In the present century the exclusive use of Asante cloths by Kwame Nkrumah, the first president of Ghana, over the period from 1948 to 1966 also helped to give these weavings a significant headstart on the international scene.

Compared to the Asante system of chieftancy, that of the Ewe is considerably more modest and lacks an entrenched tradition of royal patronage. Most Ewe were under German hegemony from about 1884 to 1914 and were thereafter divided between the French and the British. This ensured that the Ewe would be a minority group in southern Ghana where Akan, the language group of the Asante, was dominant. It also resulted in the marginalization of the Ewe in the postcolonial cultural development of the country.

Asante textiles were also systematically studied much earlier than those of the Ewe, beginning with Robert Rattray's chapter on "Weaving" in his *Religion and Art in Ashanti* (1927). This bias continued when the National Museum of Ghana opened in 1957 and featured an installation of eight pieces of Asante kente and no Ewe examples; the display remained on view until 1995. It was not until Venice Lamb's important book *West African Weaving* (1975) that Ewe kente received any substantial consideration in an English-language publication. Peter Adler and Nicholas Barnard's *African Majesty* (1992) is the only publication to date that gives more weight to Ewe material than Asante.

Tourism in Ghana during the 1960s and 1970s also promoted Asante weaving at the expense of Ewe. For any visitor to the country at that time, a trip to Kumase was considered mandatory. Due to the Asante village-based craft specialization and the widespread recognition of Bonwire as the home and center of Asante weaving, a pilgrimage to Bonwire became a necessary part of any visit to the Asante capital.[1] This activity was promoted in all the major international travel guides to Ghana, West Africa, and Africa. Bonwire continues to capture considerably more notice than the Ewe centers of Agbozume and Kpetoe, which in many instances are virtually ignored.[2]

The competition between Asante and Ewe interests has escalated over the past five years and has been particularly animated in the print media (see for example Awere 1996 and Apaa 1997). The creation of an annual festival based in the Ewe town of Kpetoe in Agotime traditional area in 1996 and another in the Asante weaving center of Bonwire in 1998 is also rather dramatic evidence of a desire on the part of each group to promote its own weaving industry (fig. 1.14). The Agotime festival program of 1997 was explicit in stating its motives: "Our kente festival is an economic one which aids at promoting the kente industry at both the local and international levels" (1997, 6). The foreword to the Bonwire festival program of 1998 written by Rose Oteng, the Ejisu-Juaben district chief executive, also stresses economic development:

> It is important to note that of all the above tourist attractions, Bonwire as the center and home of kente ranks very high among tourist destinations of international visitors. This is because kente has become the principal tourism marketing trade identification for Ghana. Kente as a single tourist product has played a significant role in the socio-economic and cultural development of the nation in general and the District and for that matter Bonwire in particular. [Oteng 1998, 2]

1.14 Programs for Agotime (1997) and Bonwire (1998) Kente Festivals. Private collection.

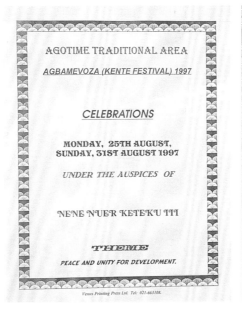

AGOTIME TRADITIONAL AREA

AGBAMEVOZA (KENTE FESTIVAL) 1997

CELEBRATIONS

MONDAY, 25TH AUGUST,
SUNDAY, 31ST AUGUST 1997

UNDER THE AUSPICES OF

NENE NUER KETEKU III

THEME

PEACE AND UNITY FOR DEVELOPMENT.

Venus Printing Press Ltd. Tel: 021-663108.

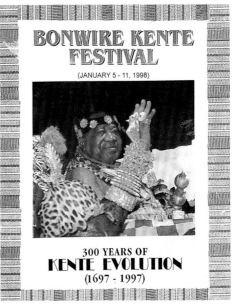

BONWIRE KENTE
FESTIVAL
(JANUARY 5 - 11, 1998)

300 YEARS OF
KENTE EVOLUTION
(1697 - 1997)

The conception of the Bonwire festival began after plans were well under way for the second Agotime festival in 1997. The subtitle of the Asante event, *300 Years of Kente Evolution (1697–1997),* was clearly intended to emphasize the historical depth of Asante weaving. Despite the commercial success of the better known Asante weaving, Ewe textiles are often more widely admired for their inventiveness, their more expansive color range, and their figurative vocabulary—traits that make them more desirable to many collectors.

Bonwire's fame aside, its claim to being "the" Asante weaving center does not go unchallenged even within the Asante heartland. Bonwire is one of forty or more towns and villages where weaving is a substantial occupation for many inhabitants. It is frequently stated that the Asantehene's official weavers reside in Bonwire, but nearby Adanwomase is also recognized as a seat for royal weavers, and considerable animosity arose between the two towns when the latter was excluded from the Bonwire Kente Festival (Owusu-Baah 1998, 13). Wonoo, another town in the vicinity, has been making claims that it "produces much better quality kente fabrics" than Bonwire and has proposed a "museum and craft (kente) production centre" to capture its share of tourist dollars (personal communication, Nana Asante-Frempong, Member of the Ghanaian Parliament, 1997). It remains to be seen whether the market will bear three competing centers and whether the well-established status of Bonwire can seriously be challenged.

For better or worse, this publication admits to and perpetuates a bias for Asante weavings. This bias is rooted in the already stated fact that it is Asante textiles that have captured the fashion and popular imagination of the international community and of the African American populations of the United States. This bias has also been shaped in part by my own research interests, which have focused on the Akan peoples of Ghana in general and the Asante in particular. There is clear need for more extensive research on Ewe weaving traditions, and I am looking forward to the upcoming dissertation of Malika Kraamer of the School of African and Oriental Studies, University of London, to move Ewe weaving to the foreground.

Although the term *kente* is popularly used throughout much of the world, its origins are heavily contested. In written records it dates back to at least 1847 when a man's cloth of twenty-seven strips (fig. 10.6) was accessioned into a Danish collection as a "cotton blanket (kintee) from Popo," an Ewe town in present-day Togo (Cole and Ross 1977, 40). The word, however, is not mentioned once in Rattray's substantial chapter on Asante weaving (1927, 220–63). Significantly *kente* is not the indigenous word for the cloth in either of the two cultures that produce it. The generic word for Asante strip-woven cloth is *ntama* or *ntoma*. This category is subdivided into four basic types: Ahwepan, Topreko, Faprenu, and Asasia. These four types are distinguished by technical considerations (see chapter 6). The Asante also use the term *nsaduaso* for the higher quality cloths produced under the last three headings. Obviously, none of these terms remotely resembles the word kente. The Ewe traditionally call their strip-woven cloth *avɔ* or *ɖo,* and again none of the subtypes suggest a relationship to the word *kente.*

Johann Gottlieb Christaller's *A Dictionary, English, Tshi (Ashante), Akra* identifies *kente* as a Fante trade word equivalent to *ntama* or *otam,* the generic Asante terms for cloth (1874, 51). The second edition of Christaller's *Dictionary of the Asante and Fante Language Called Tshi (Twi)* defines kente as "country cloth, a home-made negro-dress, consisting of a number of narrow strips of cotton-cloth sewed together" (1933, 234). Just when, where, and how this term was applied and exactly to what is not clear. Venice Lamb suggests that the word *kente* is derived from the Fante word for basket, *kenten* (1975, 128). Since the coastal Fante were not weavers, it is plausible that they would use a word taken from a familiar genre (woven baskets) that seemed technologically similar to an unfamiliar one (woven cloth). This explanation is the least politically charged since it assigns the origin of the word as applied to strip-woven cloth to a relatively neutral party in the debate.

Most other explanations favor Asante origins of the word. Asante oral tradition relates that the original cloths were made with raffia "thread," a material also used in larger strips to make mats and baskets, hence the word *kente* (Kyerematen 1964, 76). In support of this, Christaller identifies a mat as *kete* and a basket as *kenten* (1933, 235, 234). Another source suggests that the word was coined to honor Asantehene Oti Akenten, who reigned in the mid-seventeenth century at the time when narrow-strip weaving was supposedly introduced to the Asante heartland (Hale 1970, 26). A third Bonwire tradition identifies the "invention" of kente with the introduction of unraveled European silk (see chapter 10) during the reign of Asantehene Osei Tutu (ca. 1680–1717). At that time, as reported in the program of the first Bonwire Kente Festival: "the chief of Bonwire had a beautiful wife

called Yaa Adoma whose nickname was 'Kenten' because of her huge frame. The general consensus was that the new cloth be named after Adoma Kenten." The same authors state that this began the custom of naming cloths after natural phenomena, people, events, and proverbs (Safo-Kantanka and Awere 1998, 8, 9).

These "Asante-centric" contentions are countered by a recent argument for an Ewe etymology. The Ewe words *ke* and *te,* meaning "open" and "close," are held to refer to the raising and lowering of the warp threads essential to the basic weaving processes (Apaa 1997, 9). Whether these two words actually conflated to form the word *kente* is still open to debate.

Yet another translation has considerable currency in the United States. The earliest reference to it that I can find is in Kofi Antubam's undated booklet, *Ghana Arts and Crafts,* which appeared around 1960. Here Antubam defined *kente* as "that which will not tear under any condition" (n.d., 41). Emmanuel V. Asihene's more widely available and better known *Understanding the Traditional Art of Ghana* states, "The word *kente* is Akan and means *Ke-ente*, that is, 'whatever happens to it, it will not tear'" (1978, 57). I have not been able to independently confirm this translation, but Christaller (1933, 497) defines "*tɛ* " as "imitative of the *sound* of rending, breaking or tearing (in two)." The above translations have circulated widely in the United States where they have become potent metaphors for unity, strength, and shared commitment within the African American community (see for example Lange 1992, 4; Zulu 1992, 7; Douglas 1992, 1, 12).

Whether folk etymologies or linguistic history, these explanations of the word *kente* exist as part of a dynamic oral tradition that only intermittently appears in print. As will become apparent in subsequent chapters, there are few rigidly codified interpretations of the meaning of the term, of the cloth's proper use, or of specific names for various designs and patterns. The contested origins of Ghanaian strip weaving and disputes over the etymology and meaning of the word *kente* and other issues are compounded by debates about what constitutes "authentic" kente. Putting aside for the moment the problems surrounding the notion of "authenticity," it is essential to make clear that there are at least four technologically different fabrics that are regularly called kente by both Ghanaians and those in the Diaspora (fig. 1.15). Only one of these four is unequivocally recognized as the "real thing." That is the cloth composed of three- to four-inch-wide strips woven on a horizontal treadle loom and subsequently sewn together to form textiles of various sizes. Even here, however, conservative voices might rule out those cloths that are merely composed of warp stripes, requiring the presence of weft-faced blocks of designs as a prerequisite for the designation "kente" (see chapter 8).

1.15 **(a)** Strip-woven kente; **(b)** Broadloom kente; **(c)** Machine-woven kente; **(d)** Roller-printed kente. The strip-woven example is rayon; the other examples, cotton. Width of strip on left 12.5 cm. Private collection.

1.16 Broadloom kente with four different warp patterns. Rayon. Length 201 cm. NM 97.25.11.

1.17 A Female participant at the Ga festival called Homowo wears a broadloom kente in the pattern known as Toku Akra Ntoma (Toku's soul cloth). Photograph by Herbert M. Cole, Accra, 1972.

1.18 A young girl representing her matrilineage wears a broadloom kente cloth in the Oyokoman pattern at Fetu Afahye. Photograph by Doran H. Ross, Cape Coast, 1997.

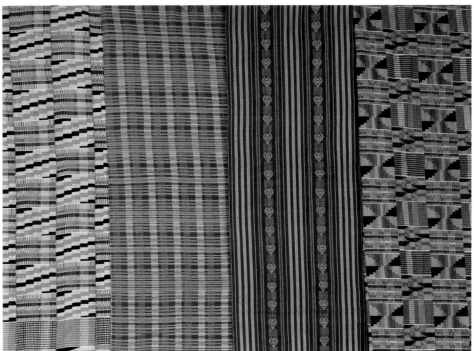

1.15

Complicating the picture somewhat is the introduction in the 1950s of British-made broad looms to both the University of Science and Technology and the National Cultural Centre, Kumase, by Lionel Idan, then a lecturer at the University and deputy director of the Centre. This allowed the hand-loom production of cloth in widths around 114 cm simulating twelve to twenty-four strips in a single cloth (figs. 1.16). Two widths were typically sewn together to form a man's cloth. Immediately upon their introduction and through most of the 1970s, these cloths were considered quite fashionable and were in high demand. They have since fallen somewhat out of favor, and today the broad looms are used more to produce novelty textiles with figurative imagery or weavings drawn from British pattern books. Nevertheless there are a significant number of broadloom kente that are still being worn at festivals (figs. 1.17, 1.18).

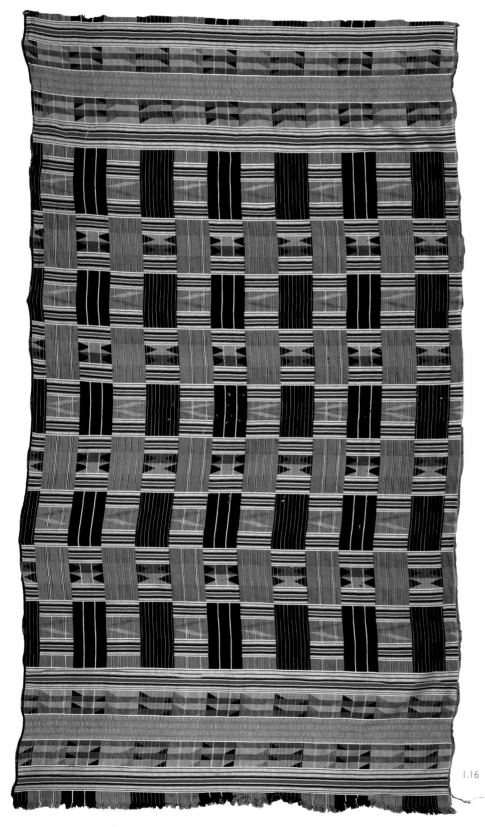

1.16

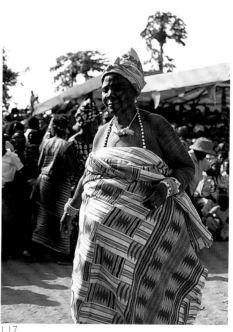

1.17

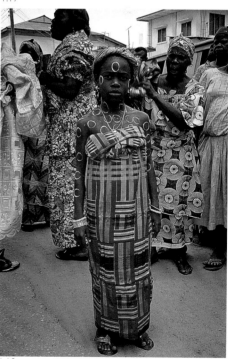

1.18

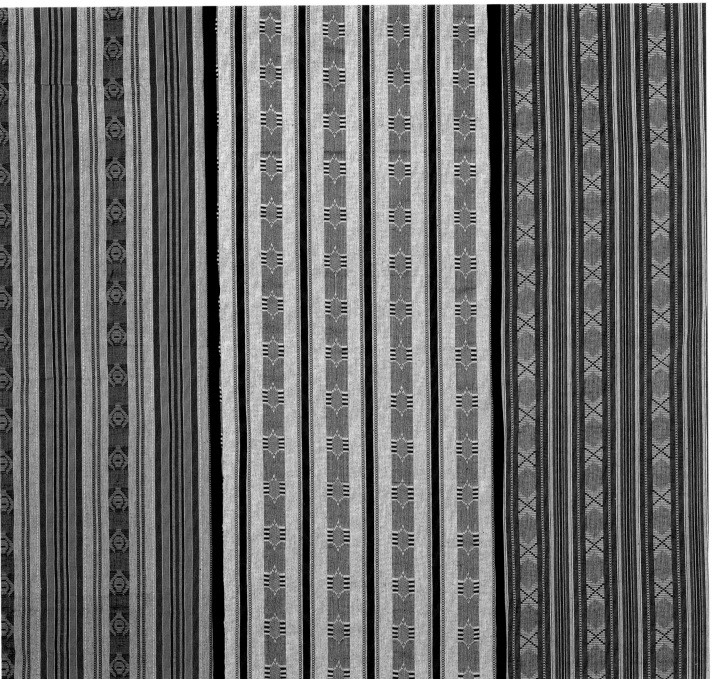

1.19

1.19 Machine-woven cloth inspired by kente patterns and often called kente in the United States. Cotton and rayon. Private collection.

1.20 Crenshaw High School student Shayla Scarlet wearing a machine-woven cloth at her school's annual African Dress Day. Photograph by Sadikifu Shabazz, 1996.

1.21 A painted hanger with a dress made from roller-printed kente shown at the Accra textile market. Photograph by Doran H. Ross, Accra, 1997. FMCH X97.36.16A,B.

1.22 Stall specializing in roller-printed kente at Kumase market. Photograph by Doran H. Ross, Kumase, 1997.

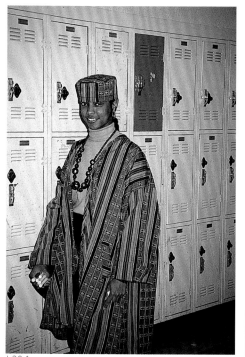

1.20 ˆ

1.21 ˆ

1.22 ˘

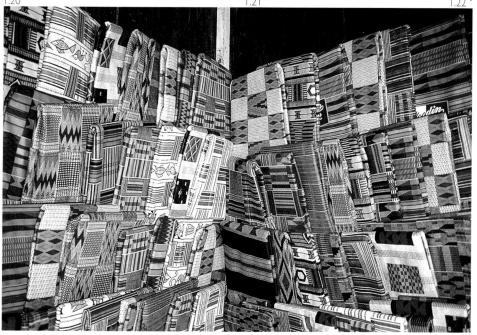

Two other types of cloth, both machine produced beginning in the 1960s, have come to be called kente in popular parlance. One is machine woven from threads of different colors (fig. 1.19, 1.20), while the other is roller printed on a background of machine-woven white cloth (figs. 1.21, 1.22; see Bickford 1997). The former is only loosely based on kente designs while the latter can replicate kente patterns with considerable accuracy. Both Asante and Ewe weavers have serious problems with calling either of these factory-made cloths "kente" and view their industrial appropriation as something of a copyright infringement. It is significant that these cloths are not produced by the textile mills in Ghana but are turned out in large quantities by mills in Benin, Togo, Côte d'Ivoire, and Senegal among other countries (some of which are outside of Africa). Nevertheless, they are imported into Ghana in substantial quantities from all of these sources and sold as inexpensive substitutes for strip-woven textiles. The machine-woven textiles are, of course, seamless and thinner than their strip-woven counterparts. As a result, they are easier to cut, tailor, and sew, as well as lighter and cooler to wear. This permits their use in often dramatic fashion designs incorporating large blousy sleeves, which have achieved popularity on both sides of the Atlantic.

Outside of the Asante and Ewe heartlands, the machine-made products frequently appear in festival contexts with about the same frequency as the handwoven materials (fig. 1.23). They also have a major presence at the Art Centre Textile market in Accra where they are sold as raw cloth or incorporated into hats, vests, backpacks, sandals, and a staggering array of other products (see the interleaf on the "Accra Textile Market"). Even in Kumase, the Asante capital, factory-made kente is widely sold with some stores specializing in the material (see fig. 1.22). Most Ghanaians obviously know the difference and group the roller-printed fabrics in the category called "fancy cloths." Outside of Ghana, however, the word *kente* is regularly applied to all four types of cloth. In the African American communities of the United States, where ideas about the cloth are more important than its means of production, it would be problematic to call the machine-produced fabric anything but kente (see chapter 12), although more knowledgeable individuals will use "kente print" for the roller-printed versions.

It is beyond the scope of this publication to resolve the contested origins of the word *kente* or its appropriate application to a given method of manufacture. For the purposes of the rest of this volume, we will use *kente* to refer to the strip-woven cloth and use the designations "broadloom kente," "machine-woven kente," and "roller-printed kente" where the context does not already make the distinction clear.

We will for the most part avoid referring to any of the latter three types by using value-laden referents such as "fakes," "replicas," or "imitations." This will certainly not please everyone, but as we shall see, it more accurately reflects the complexity of an international phenomenon enmeshed in contexts and meanings that extend well beyond those originally intended. In addition to controversies over the primacy of Asante or Ewe kente, the meaning of the word itself, and what constitutes authentic kente, there is also considerable discussion surrounding the appropriate use of the textile and related issues of appropriation and commodification. These will be dealt with in some detail in subsequent chapters.

In the chapters that follow we attempt to examine some of the key issues that surround our understanding of kente on both sides of the Atlantic. Following the lead of several recent Fowler Museum of Cultural History publications, we will periodically place "interleaves," or two-page photo essays, between chapters to focus on select topics. Chapter 2 will outline the rise of the Asante Empire and introduce the sophisticated panoply of regalia that supports the institution of chieftancy, including an assortment of non-kente textiles produced using different techniques. The wonderful mix of contexts for wearing and using kente will then be explored in chapter 3 with a strong focus on functions that extend beyond the realm of dress. This will be followed by Ghanaian poet Abena Busia's firsthand account of six textiles that have left a lasting impression on her and her family. In chapter 5 Raymond Silverman moves into sacred contexts, examining the practice of dressing Akan gods in kente.

After a visual tour of the Asante weaving center of Bonwire, the basic components of the Asante and Ewe loom will be described in chapter 6 along with the fundamentals of the weaving process. The next interleaf features the lyrics of Ephraim Amu's popular song about kente followed by a photographic essay on the Bonwire Kente Festival. In chapter 7 Anne Spencer profiles weaver Samuel Cophie, an Ewe born in Anyako who has been weaving and selling kente in Bonwire since 1961. Remaining in Bonwire we then look briefly at the increasing presence of women weavers in what, up until the last twenty years, has been an exclusively male art form. Another interleaf presents the Accra Textile Market with its kaleidoscopic colors and maze of objects.

Asante practices for naming warp patterns and weft designs are discussed in chapter 8 accompanied by a presentation of some of the most significant and popular examples of each. Agbenyega Adedze shifts the focus to Ewe traditions in chapter 9 and provides some historical background in addition to an examination of the current situation. A presentation of Howard Bingham's photographs of Muhammad Ali's visit to Ghana of 1964 leads into a discussion of an awareness of kente and its movement into the wider world. Simple Sly's photographs of children dressed as chiefs and queen mothers are then juxtaposed with images of kente-adorned African American dolls raising further questions about kente and identity. In chapter 11 Nii Quarcoopome tackles the use of kente in the advertising agendas of corporate America.

The cornerstone of this whole project is presented by Betsy Quick in chapter 12, "Pride and Dignity." This chapter is based in large part on the research efforts of students from Crenshaw High School in Los Angeles and classes from Chad Science Academy and University High School in Newark. Photographs and excerpts from the students' interviews provide remarkable insights into the use and perception of kente in their own

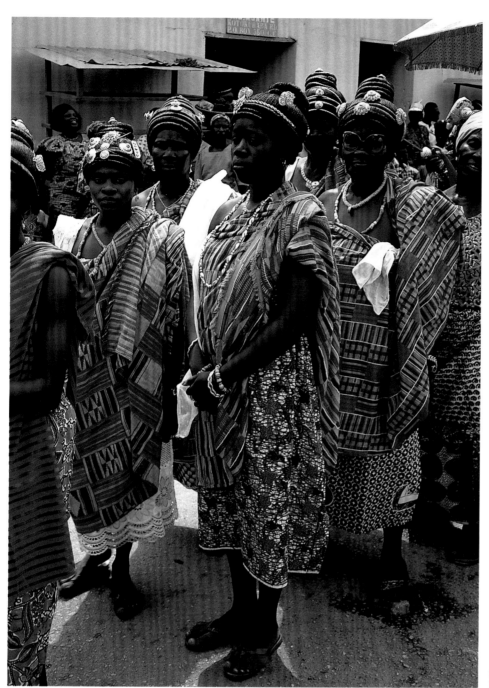

1.23 Fante women wearing a mix of strip-woven and roller-printed cloths at Fetu Afahye. Photograph by Doran H. Ross, Cape Coast, 1997.

neighborhoods, and indeed in the larger context of the two cities. Two interleafs that follow display an array of kente stoles woven for groups ranging from the NAACP, ISIS, and 100 Black Men to more familiar religious and educational institutions and for UCLA graduation.

A final interleaf documents the Ghanaian production of an ever-widening assortment of kente-adorned products observed at the large market that accompanied Panafest 1997 in Cape Coast. The concluding chapter addresses some of the ramifications of the globalizing of once somewhat isolated traditions and what it means to both producers and consumers, as well as to those more directly involved in the marketplace. This is followed by a catalog of the key works drawn from the exhibition accompanying this volume and from the Fowler and Newark Museum collections

This volume is directed at the general reader and is in no way intended to eclipse the previously mentioned works—Rattray (1927); Menzel (1972); Lamb (1975); and Adler and Barnard (1992)—all of which are essential for anyone seriously interested in the topic. We do, however, hope to break new ground in several areas. First we feel it is essential to expand the narrow view of kente as a cloth restricted to use as a garment. As we shall see, there are many traditional uses and contexts that are important to understand when considering comparable practices in the United States. We also want to examine how and why kente gained such a wide audience elsewhere in Africa and in the United States. To fully appreciate kente as both an art form and a commodity, it is essential to examine contemporary kente phenomena on both sides of the Atlantic and to realize that Ghanaians and African Americans are more or less equally involved in finding new genres to develop. And finally we hope that this volume will help articulate what kente means to the people who make, sell, or otherwise use the cloth in daily life and special occasions in the United States.

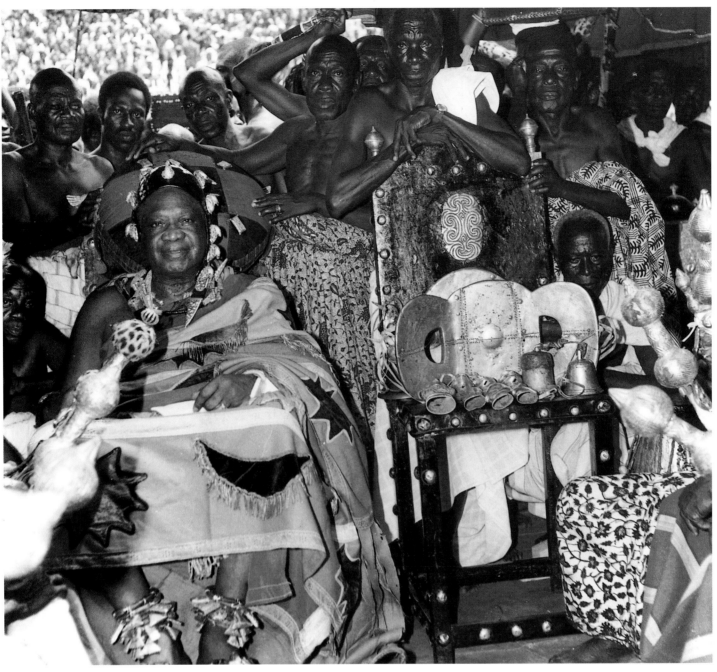

2.1 Asantehene Otumfuo Opoku Ware II wearing an appliqué felt cloth known as Nkrawɔ. The Asantehene is seated in state next to the Sika Dwa Kofi (the Golden Stool born on Friday). Ghana Information Services.

A Brief History of the Asante

The Asante are the most populous and best known of the Akan (Twi-speaking) peoples of Ghana. Other Akan groups include the Akwamu, Fante, Akuapem, Denkyira, Akyem, Nzima, and Bono. The Asante still occupy a significant portion of south central Ghana, an area of once-dense tropical forest. The region has an average annual rainfall of around 150 cm (60 inches), which occurs during two rainy seasons—the first running roughly from May to July, and the second from September to November. These rains feed several important rivers, including the Tano, Offin, Pra, and Volta, all of which figure prominently in Asante history. There is only one substantial natural lake, Bosumtwe, which, according to some traditions, is believed to be near a cave or hole in the ground from which certain Asante groups originated (Rattray 1929, 131, 236). This explanation of local origins undoubtedly evolved as a justification of Asante domination over a large part of the surrounding territory.

Numerous Akan oral traditions—including a few belonging to the Asante—refer to migrations from the north. The naming of the modern state of Ghana—formerly the British colony known as the Gold Coast—after the medieval kingdom of the same name was in part impelled by these traditions. The medieval kingdom of Ghana, however, existed from the eighth to the eleventh century C.E. and was located between the Senegal and Niger Rivers in what is now western Mali and southern Mauritania. It is thus too far removed in time and place to be the actual origin of the Akan. Furthermore, Twi is a branch of the Kwa family of languages, which are spoken more or less continuously along the coast from southeastern Côte d'Ivoire across southern Ghana, Togo, and Benin and on to southwestern Nigeria. The nuclear settlement area of the Akan must certainly lie along this belt. In fact there seems to be some consensus that what was to become the Asante Empire was a consolidation of several related but smaller states moving into their present locations from more southerly areas (Fynn 1971, 28, 29; Wilks 1975, 110, 111).

In the context of the present volume, an examination of the rise of the Asante Empire in the late seventeenth century is an appropriate point of departure and will introduce a number of important issues. The Asante have a fairly conventionalized tradition of chiefly succession. Before the consolidation of the Asante Empire under Osei Tutu, at least five chiefs are recognized: the tandem rulers Twum and Antwi; Kobia Amamfi; Oti Akenten; and Obiri Yeboa, an Oyoko clan leader.[1] The latter was killed in battle in the last third of the seventeenth century, and his successor, Osei Tutu, is considered to be the first Asantehene of the Oyoko Dynasty. The initial impetus for the formation of the Asante Empire may be found in a series of military victories led by Osei Tutu, who utilized European firearms purchased on the coast and received support from the powerful Akan state of Akwamu. The beginning date of Osei Tutu's reign is unclear. Ivor Wilks places the origins of the Asante Empire and the founding of its capital, Kumase, "perhaps about 1680" (1975, 111). The current "official" dates of Osei Tutu's reign are listed as 1680–1717 in the "Programme" of 1995 for the Adae Kɛseɛ festival honoring the silver jubilee of Asantehene Opoku Ware II, the fifteenth Asantehene (see chapter 3).

The defining event of Osei Tutu's reign was the creation of the Golden Stool born on Friday (Sika Dwa Kofi). According to accounts that can still be recited by virtually all Asante youths, the priest (ɔkomfo) Anokye delivered a solid gold stool from the heavens, which landed gently on the knees of Osei Tutu. The stool was said to house the soul and spirit (sunsum) of the Asante nation. It was never to be used as a seat, indeed to this day it rests on its own chair (fig. 2.1).[2] According to tradition, Ɔkomfo Anokye then pulverized nail parings and hair taken from the most important Asante chiefs and queen mothers. He mixed this powder with various medicines to form a potion, some of which was consumed by the royals and some poured onto the Golden Stool to emphasize that the fate of the Asante was inextricably bound with that of this majestic object. To further ensure that there would be no challenges to the state symbol and embodiment of the Asante nation, the royal stools of all other leaders were buried along with other key items of regalia (see Rattray 1927, 289, 290; Kyerematen 1969, 2–5).

The states (aman, sing. ɔman) that were united under the aegis of Osei Tutu and the Golden Stool in Kumase included Mampon, Kokofu, Bekwai, Nsuta, and Dwaben.[3] Each of these was headed by its own paramount chief (ɔmanhene, pl. amanhene), who was subordinate to the Asantehene and considered a divisional chief in the larger political order. The political organization of the Asante Empire was and is quite sophisticated and complex and is perhaps best delineated in Ivor Wilks's landmark publication *Asante in the Nineteenth Century: The Structure and Evolution of a Political Order* (1975).

Of the five states mentioned above, the chiefs of all but Mampon are descended from the Oyoko clan (*abusua*), one of seven recognized by the Asante. Descent, inheritance, and succession among the Akan are matrilineal, meaning that they follow the mother's side of the family rather than the father's. For example, in the selection of a chief, the chief's sons are ineligible to succeed him. The new chief must come from the Oyoko clan, and by rules of marriage the old chief would have married someone from a clan other than his own. The chief's younger brothers or his mother's sister's sons or her daughter's sons could succeed him, however, assuming they met certain other physical and leadership qualifications.

This system of descent provides considerable prestige and power to the queen mother (*ɔhemaa*, see figs. 1.4, 3.28). This woman may literally be the mother of the chief, her sister, her sister's daughter, or even the chief's sister. The queen mother is actively involved in the selection of the chief, and the Asantehemaa, or queen mother of the Asante (fig. 3.6), selects the Asantehene in consultation with the royal elders, various Kumase chiefs, and certain *amanhene*. The queen mother is said to serve as regent until the enstoolment of a new chief (Kyerematen n.d., 12, 13). Like the chief, the queen mother has her own regalia including a royal stool, palanquin, fans (see fig. 3.37), jewelry, and kente.

Asante Regalia

It is generally maintained that the seventeenth-century ancestors of the Asante were under the domination of the kingdom of Adanse and later that of Denkyira (Fynn 1971, 27–29) and that the leadership of Osei Tutu brought about the defeat of the latter in 1701. Much of eighteenth- and nineteenth-century Asante history is concerned with military conquests and political agreements aimed at controlling trade with Europeans on the coast and with Islamic regions to the north. The Asante were particularly interested in acquiring firearms, gunpowder, iron, brassware, cloth, salt, and various luxury goods from the south for which they exchanged gold, ivory, and slaves (until slavery was abolished in the early nineteenth century). From the north, the Asante also received cloth (both cotton and silk) in addition to shea butter (a multipurpose vegetable fat), ivory, and assorted manufactured goods, which were exchanged largely for gold and kola nuts, a popular stimulant and a very lucrative trade item (Wilks 1975, 178, 179).

Whether in trade with the north or south, or even with peoples to the east and west, cloth figures prominently in Asante mercantile interests. In addition to woven fabrics, raw materials—cotton, silk, and dye stuffs—were also important commodities. The introduction of weaving to Asante from the north is addressed in chapter 6. A perusal of Rattray's discussion of Asante weaving makes it clear that a significant percentage of cloth patterns

(that is, warp-strip configurations) were once solely the prerogative of the Asantehene or other designated chiefs. The obvious conclusion here is that the development of Asante fine weaving, now known as kente, was stimulated by and under the control of royal patronage. *Nsaduaso* (as fine Asante kente is indigenously known) is only one component of a spectacular array of royal regalia that buttresses the institution of kingship or chieftaincy.

Stools are the most important and complex of all items of Asante royal regalia. The central supports are carved in many named patterns (some of which coincide with names used for kente), and more important chiefs typically have larger stools, often decorated with silver. Some stools may serve as state symbols and others as the personal seat of the ruler. Asante gods are also frequently placed on stools (see chapter 5). Upon the death of an honored chief or queen mother, his or her personal stool is blackened with soot and sheep's blood and stored in an ancestral stool room where it receives periodic offerings, prayers, and sacrifices (see Kyerematen 1969 and Sarpong 1971).

Kente and other royal textiles are classified as "stool property" and are thought to be owned by the state as a whole. Such heirloom regalia is called *agyapadie*. Rattray explains the etymology of the word as "*adie-pe-agya*, something sought after (by the ancestors) and then put aside (for safekeeping)" (1929, 331). The chief is considered a trustee of the state regalia and is expected to make significant additions to it at his own expense. Rattray goes on to cite traditional law supporting this:

> There was an immemorial law to the effect that everything which became attached to a Stool became the inalienable property of that Stool. "One does not break off leaves, place them in the mouth of an elephant, and then take them out," and, "Something that has fallen into a well does not get taken out again," are two legal maxims bearing on this subject. [Rattray 1929, 331]

The Asantehene has a designated official, the Abenasehene, who is in charge of the storing and maintenance of the king's cloths including their mending. He is also said to select the king's cloth for public appearances. Tradition maintains that the Asantehene does not appear in public wearing the same textile twice. Nevertheless, Opoku Ware II has been photographed in the same cloth on different occasions, so this practice has become somewhat relaxed (Kyerematen n.d., 3; Boaten 1993, 26, 30). According to one account the Asantehene has "300,000" cloths in his treasury (Boaten 1993, 30). This number could be either a fairly significant typographical error or a figure of considerable symbolic significance. Regardless, it is certainly a measure of the importance of cloth as a status symbol and form of wealth.

Kente and the Prempehs

Photographs of Asantehenes date back to Nana Mensa Bonsu (r. 1874–1883; see Wilks 1976, 39, 40). There is an especially rich record for the last three Asantehenes: Nana Agyeman Prempeh I (r. 1888–1931; figs. 2.2, 2.3); Nana Osei Agyeman Prempeh II (r. 1931–1970; figs. 2.4–2.7); and Nana Opoku Ware II (r. 1970 to present; see figs. 2.8, 2.9a–c). A systematic compilation and examination of all extant photographs of Asante kings would undoubtedly reveal a remarkable history of cloth use and could be the subject of a fascinating book in itself.

Details from even the small selection of photographs included here raise interesting questions about the formal development of kente. For example, in figure 2.2, Prempeh I is wearing a cloth that has a half-width strip on the bottom. This serves perhaps as a protective buffer between the main body of the cloth and the ground with which it frequently comes into contact. Examples of a strip of solid-color plain weave used on one or both sides of more complex fine weaves are also seen in two early examples illustrated in figure 10.9 and 10.12, and these probably served the same purpose. Asante weavers in Bonwire are not familiar with either practice, and it probably died out in the first part of this century.

The beginnings of double weave are also open to debate. I know of no examples of hand-picked double weave weft designs (see chapter 6) from the nineteenth century, either in photographs or extant cloths. The photograph of Prempeh II, circa 1960 (fig. 2.6) is remarkably one of the earliest of an Asantehene wearing such a cloth, as seen on the third and fifth strips from the bottom. Bonwire weavers maintain that this tradition dates to the early part of this century, but it seems possible that it postdates Prempeh I's return from exile in 1924.

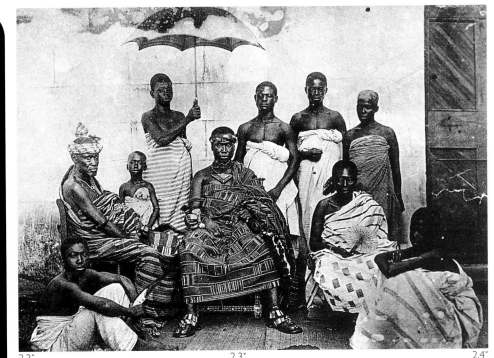

2.2^

2.3ˇ

2.4ˇ

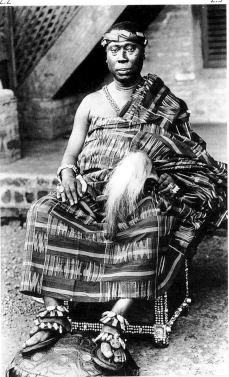

2.2 Asantehene Agyeman Prempeh I at Elmina in 1896, prior to being sent into exile (first to Freetown, Sierra Leone, and then to the Seychelles). He appears to be wearing a cloth known as "*Obi nkye obi kwan mu si*" (Eventually one strays into another's path). Basel Mission Archive D-30.18.068, Elmina 1896.

2.3 Asantehene Agyeman Prempeh I shown wearing an Oyokoman cloth after his return from exile. Basel Mission Archive D-30.6200.3, 1926.

2.4 Asantehene Osei Agyeman Prempeh II wearing an Oyokoman cloth and standing next to the English governor of the Gold Coast. Basel Mission Archive, QD-30.004.0001, 1935.

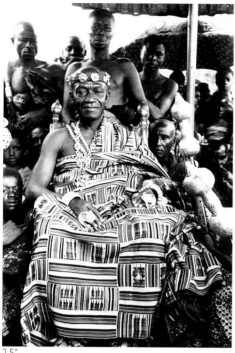

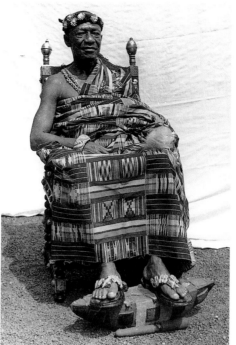

2.5 Asantehene Osei Agyeman Prempeh II wearing a cloth known as Asantehene Besehene or Nana Prempeh Besehene (see Menzel 1972, nos. 683, 684). Basel Mission Archive D-10.62.081.

2.6 Asantehene Osei Agyeman Prempeh II wearing a cloth with alternating strips of Kubi (a man's name) and Oyokoman. This photograph taken circa 1960 is one of the earliest showing a cloth with solid blocks of double weave weft designs (on the third and fifth strips from the bottom). Photograph by Paul Anane, Ghana Information Services.

2.7 Asantehene Osei Agyeman Prempeh II wearing an Oyokoman Adweneasa Asasia cloth (see chapter 8). Ghana Information Services.

2.5^ 2.6^ 2.7ˇ

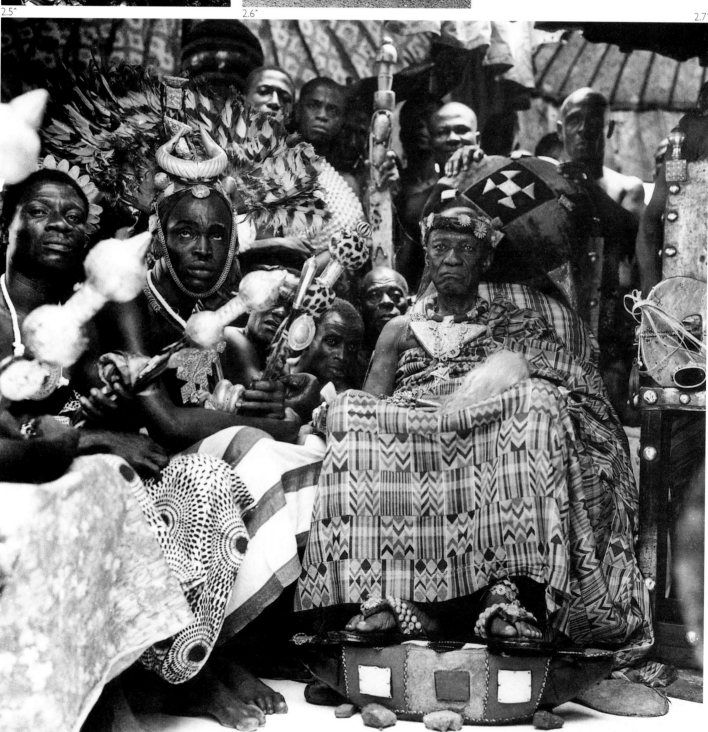

The Asante capital of Kumase is located on a prominent rocky ridge above the Nsuben River. In the nineteenth century the town had a population that varied from about fifteen thousand to forty thousand. The Asantehene's palace covered an area of nearly five acres and like much Asante architecture was built up from units of one or two rooms on each side of a relatively square courtyard. The walls consisted of earth and cane, and roofs were thatched with palm fronds (see Wilks 1975, 374–86). The surface of the palace walls were finished in low relief decoration that included both abstract and representational imagery, some of which was shared with other Akan art forms. Remnants of this style of architecture are still found conserved in a few extant structures scattered around the Asante region (see Swithenbank 1969). The palace and Kumase itself had a few two-story structures, including a stone building called the Aban completed under Asantehene Osei Bonsu in 1822 by masons from the coast. It was intended as a museum or palace of culture inspired in part by accounts of the British Museum. This is where the treasures of the Asantehene were stored. The British removed most of the Aban's valued contents and took them to England before destroying the structure during the sacking of Kumase in 1874 (Wilks 1975, 200, 201).

Art of the Asante: The Visual-Verbal Nexus

At the time of the founding of Kumase, near the end of the seventeenth century, the Asante homelands were rich in animal life—wild boar, an assortment of monkeys, an impressive variety of birds, small antelopes, large land snails, and tortoises provided food. Rivers were filled with fish and freshwater crabs. There were also porcupines, leopards, elephants, and crocodiles, which played and continue to play roles that are more symbolic than subsistence oriented within the context of Asante life.

2.8 Asantehene Opoku Ware II wearing the amulet-laden *batakari kɛsɛɛ* (great war shirt) while being carried in a palanquin at his installation. Ghana Information Services, 1970.

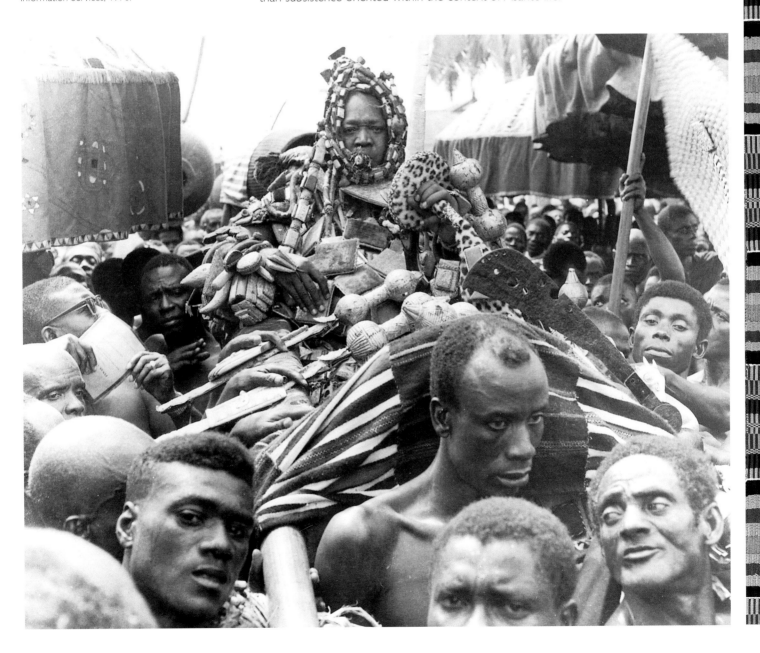

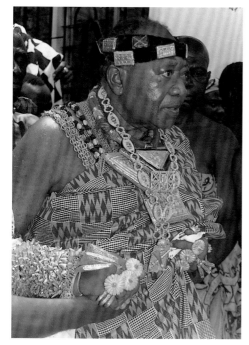
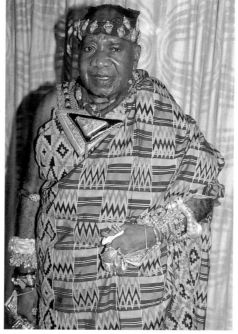
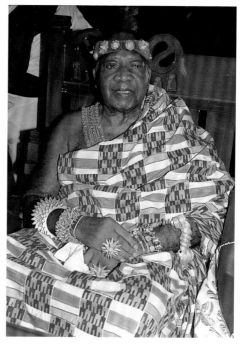

2.9a–c Asantehene Opoku Ware II wearing three different cloths at his silver Jubilee: **(a)** Asam Takara (Guinea fowl feathers); **(b)** Mamponhemaa (Queen mother of Mampon); **(c)** Toku Akra Ntoma (Toku's soul cloth). Photographs by Daniel Oteng, Kumase, 1995. Courtesy Manhyia Palace Museum.

The land also naturally provided oil palms, wild yams, and kola nuts. The Asante practiced a system of slash-and-burn shifting agriculture, and indigenous West African cultigens included white and yellow yams, guinea corn, fonio, and pearl millet. With European contact beginning in the late 1400s, new crops from Asia and the Americas were introduced. From the East came varieties of yam, taro, and sugar cane; and from the Americas, ground nuts, cassava, cocoyam, pineapples, and several varieties of maize. Also from the Americas came tobacco, and locally produced tobacco pipes began to be made around 1600 C.E.

To attempt a systematic description of the flora and fauna of the Asante tropical forest is obviously well beyond the scope of any study of Akan expressive culture. Such a presentation, however, would shed considerable light on how the Asante see much of their immediate environment, which in turn stimulates and informs an artistic tradition whose forms, subjects, and meanings are probably more diverse than that of any other African culture. There are few animals, plants, objects, and human experiences that have not been addressed at one time or another by one of the more than fifty artistic genres that constitute the Akan aesthetic universe (see Cole and Ross 1977 and McLeod 1981).

A description of the Asante environment has as much to do with the intellectual life of the people as it does with such fundamental anthropological concerns as subsistence patterns and local economies. The vast majority of Akan arts draw their imagery from or are named after an enormous corpus of subjects, many of which are shared across object types. In some instances these are simply identified by their name, but more frequently they are associated with a proverb, folktale, boast, insult, riddle, or other verbal form that extends the meaning of a given subject. This visual-verbal nexus of Akan art is one of its defining features.

For example, the rainbow is a motif found on stools (*dwa*), counselor's staffs (*akyeame poma*), ceramics (*kuruwa*), and kente, among other genres. Sometimes it is merely called *nyankontɔn* (God's arch). On one of the staffs of a counselor to the Asantehene it is known as the "circular rainbow" (*kontonkrowe*). The carver of the staff, Osei Bonsu, explained in English "the Asantehene was the rainbow that surrounded all his subjects" (Ross 1984, 38). In another context the same image might prompt the proverb "The rainbow of death encircles every man's neck" (that is, death is inevitable; Sarpong 1974, 21). Some of these proverbial associations are highly conventionalized, and others may be more open-ended with multiple or even conflicting interpretations (see Cole and Ross 1977, 9–12).

There was something of a renaissance in Asante royal arts, including kente, from the time of the return of Agyeman Prempeh I from exile in 1924 through the installation of Prempeh II in 1931 and the restoration of the Asante Confederacy in 1935. During this period the Asantehenes reasserted their political rights, in part through public displays of regalia, and other chiefs similarly competed for attention and power from the colonial administration (see Ross 1977, 25). That cloth, among the most personal and visual of all arts, was part of this renaissance and negotiation for power is not surprising. The present Asantehene, Nana Opoku Ware II (fig. 2.8), has continued a distinguished history of royal patronage, and cloths recently commissioned by him rival the finest of all Asante kente (figs. 2.9a–c).

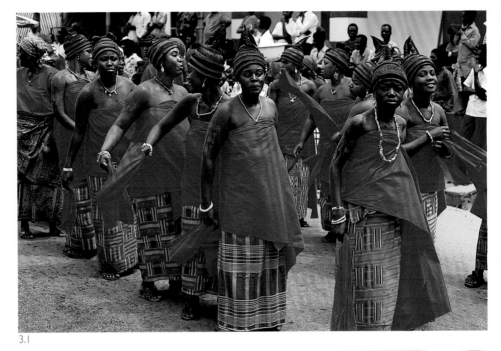

3.1

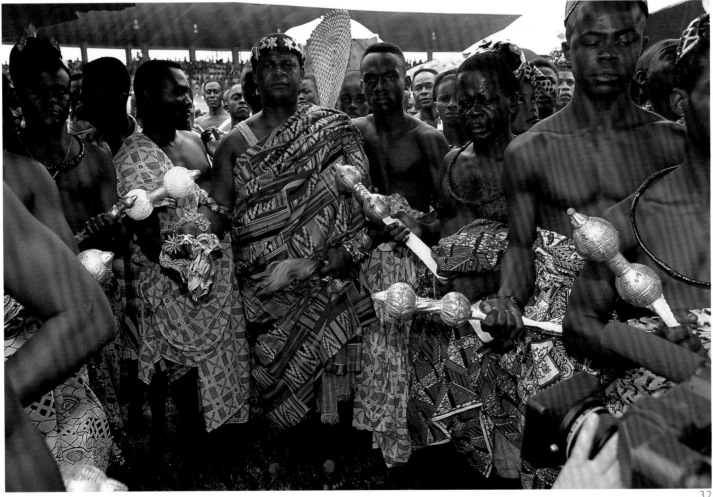

3.2

The popular Ewe proverb from which this chapter takes its title underscores the fact that dress does not exist in isolation from the wearer or, for that matter, from the social and cultural context in which it is worn. Kente is first and foremost a high-status garment worn on special occasions. It is not, however, the sole textile choice for most of these events, nor is it appropriate for all of them. It is also not limited to use as clothing since it may adorn several items of royal regalia and function in other situations as well.

Kente is most frequently seen in public during the spectacular array of festivals that periodically illuminate most of southern Ghana and Togo (figs. 3.1–3.3). Each festival serves a series of slightly different functions but nevertheless shares a number of traits with the rest. Almost all are major annual events; they are times of homecoming and thanksgiving— opportunities to renew ties with family, friends, and birthplace. Many involve elaborate rites of purification to ensure continuity of clan and state. Remembering and honoring the ancestors are key features of most such events. Prayers for children, health, and prosperity are customarily employed in seeking the aid and protection of important deities. Some of these festivals are also linked to firstfruits or the harvest cycle.[1]

For the Asante the Adae Kɛseɛ is the most important and conspicuous ceremonial occasion for the wearing of kente.[2] In principle it is an annual event, but the cost and elaborate planning currently required have limited its occurrence. It has, in fact, been conducted only three times (1985, 1991, and 1995) since the enstoolment in 1970 of Asantehene Opoku Ware II. Rather than being based on the ritual calendar, Adae Kɛseɛ ceremonies are now often timed to coincide with other significant anniversary events. The 1985 festival, for example, also commemorated the fiftieth anniversary of the restoration of the Asante Confederacy, and the 1995 event coincided with the silver jubilee of the reign of the Asantehene.

This complex multifaceted festival takes place over several days and has yet to be fully documented as many of its rituals are conducted privately in secluded areas. The 1991 festival as recorded by Barfuo Akwasi Abayie Boaten I (1993) included the following events:

—The collection of holy water from shrines dedicated to select Asante deities
—An almsgiving ritual for children
—A ceremonial cutting of the Asantehene's hair and nails
—A sharing of drinks with invited guests and with various shrines and stool houses
—A fɔntɔmfrom drumming celebration
—The durbar
—A visit to the royal mausoleums at Breman and Bantama, where the remains of past Asantehenes are maintained
—Rituals at the stool house to feed the ancestors; rites of propitiation and purification
—Court of the queen mother
—Swearing-in ceremony of elevated chiefs

CHAPTER 3

A Beautiful Cloth
Does Not Wear Itself

Doran H. Ross

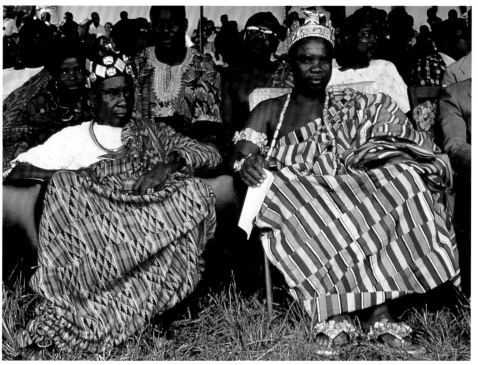

3.3

3.1 Female members of the "No. 1 Asafo Company" wearing kente skirts at the annual Fetu Afahye. Photograph by Doran H. Ross, Cape Coast, 1976.

3.2 Asante chief entering the Kumase Sports Stadium at the Adae Kɛseɛ durbar for the silver jubilee of the reign of Asantehene Opoku Ware II. Photograph by Frank Fournier, Kumase, 1995.

3.3 Ewe chiefs at the festival known as Agbogboza. Photograph by Agbenyega Adedze, Notse, Togo, 1989. Eliot Elisofon Photographic Archives, National Museum of African Art.

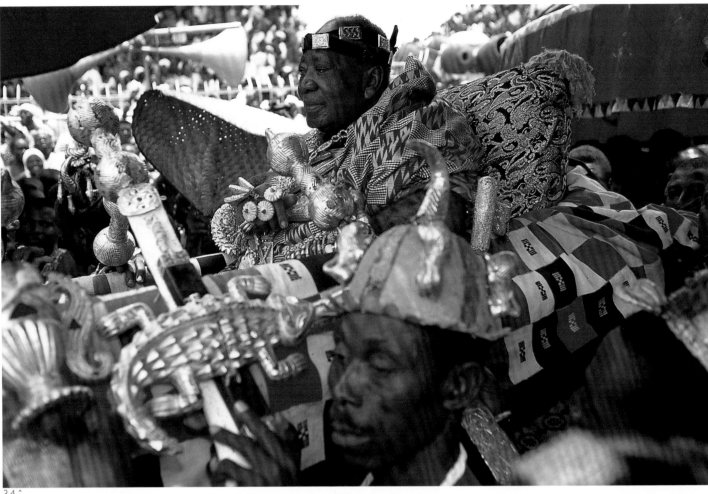

3.4 ^

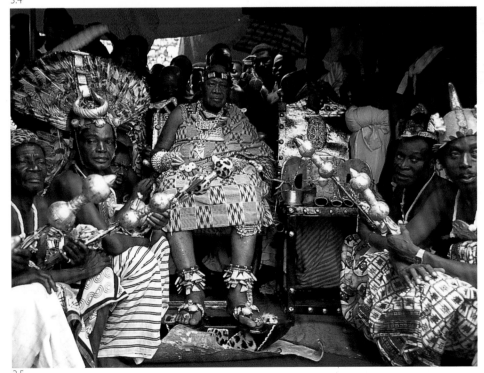

3.5

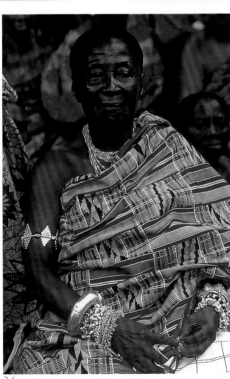

3.6

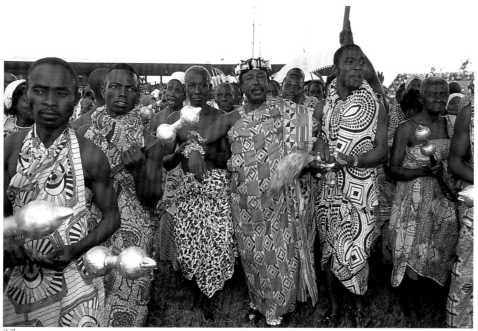

3.7

3.4 Asantehene Opoku Ware II being carried into the Kumase Sports Stadium in a palanquin as part of the celebration of the twenty-fifth anniversary of his reign. Photograph by Frank Fournier, Kumase, 1995.

3.5 Asantehene Opoku Ware II seated in state at the *durbar* commemorating the silver jubilee of his reign. To his left is the Golden Stool that is considered the "soul" of the Asante nation. Photograph by Frank Fournier, Kumase, 1995.

3.6 The queen mother of the Asante, Asantehemaa Nana Afia Kobi Serwaa Ampem II, at the twenty-fifth anniversary of the reign of Asantehene Opoku Ware II. Photograph by Carol Beckwith and Angela Fischer, Kumase, 1995.

3.7, 3.8 Asante chiefs with their entourages entering the Kumase Sports Stadium for the celebration of the silver jubilee of the reign of Asantehene Opoku Ware II. Photograph by Frank Fournier, Kumase, 1995.

3.9 Fante chief at the annual Fetu Afahye accompanied by sword-bearers and a counselor—all wearing kente. The blurred textile in the center of the photograph is a small piece of kente being waved to cool the chief. Photograph by Doran H. Ross, Cape Coast, 1997.

The *durbar*, a public audience at the court of a local ruler, comes in the middle of these rituals and is the crowning celebratory event of the festival. Although the word *durbar* is Indian in origin—part of the shared British colonial legacy—it is used today throughout Ghana to mean a "turning out" of chiefs and their court officials in honor of an important occasion or a visiting dignitary. Among the Asante this may be part of an Adae Kɛseɛ or completely independent of it.

The Adae Kɛseɛ *durbar* typically consists of a public procession by the Asantehene (fig. 3.4) and other paramount and divisional chiefs to the area where the king and the queen mother sit in state to be honored by their subjects and guests (figs. 3.5, 3.6). Sword-bearers, linguists, and other court officials of Asante chiefs generally wear wax prints or factory-produced cloths (figs. 3.7, 3.8) Elsewhere among the Akan it is not unusual to see these same officials draped with kente (fig. 3.9). Contemporary *durbars* in Ghana generally provide opportunities for the presentation of inspirational speeches often on themes of economic development. In recent years the venue for the most important *Asante durbars* —including the visit of Queen Elizabeth II in 1961—has been the Kumase Sports Stadium.

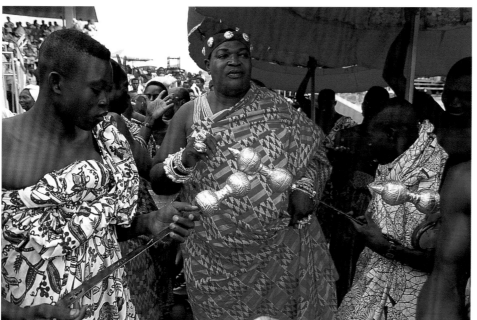

3.8

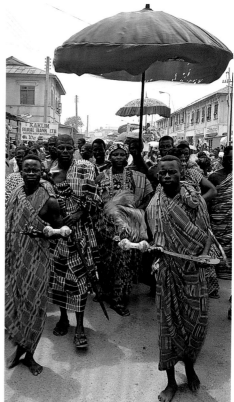

3.9

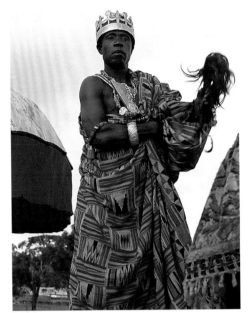

3.10 ^

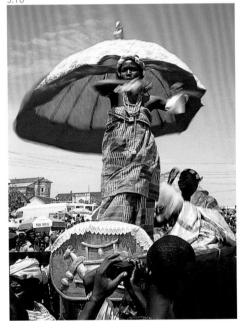

3.11 ^ 3.12 ^

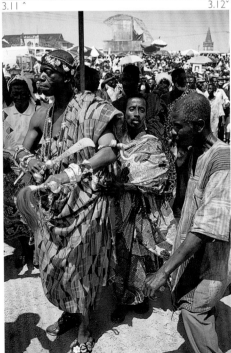

Durbars throughout the Akan area share many of the same characteristics. Although there is considerable dancing and drumming while the king is seated in state, the entering procession provides the greatest spectacle. The most important chiefs are carried in palanquins on the shoulders of four or six men. Overhead a large umbrella, 10 to 12 feet in diameter, "dances." It is twirled or pumped up and down to "cool" the chief. Frequently state sword-bearers walk alongside the palanquin with the hilts of their swords, resplendent in gold leaf, resting on the litter. Behind follows an ensemble of six or more drums along with a group of musicians playing side-blown ivory trumpets. Other attendants carry select items of state regalia in front of the palanquin, while followers of the chief wave a variety of cloths, some of which may be kente, to further cool the royal personage (see fig. 3.9). The chief himself will be richly adorned with gold ornaments, including his crown and sandals, as well as a stunning array of necklaces, armlets, bracelets, anklets, and often a full complement of cast-gold finger rings. During the last Adae Kɛseɛ most chiefs wore kente during the *durbar,* but a variety of locally produced stamped, embroidered, and appliqué cloths were also to be seen in addition to numerous imported brocades, damasks, silks, and velvets (see figs. 3.7, 3.8; see also the interleaf, "In Place of Kente," which follows this chapter).

The British envoy Thomas Bowdich described and illustrated an Adae Kɛseɛ in considerable detail during his visit to Kumasi in 1817. As visitors came into the capital, he noted, "the number, splendor and variety of arrivals, thronging from the different paths, was as astonishing as entertaining" (1819, 274). By the end of the next day, "the umbrellas were crowded even in the distant streets, the town was covered like a large fair, the broken sounds of distant horns and drums filled up the momentary pauses of the firing which encircled us" (1819, 275). Bowdich provided a panoramic drawing of the festival with several hundred figures. His description of the entourage of one chief is especially telling:

> Above is the fanciful standard of a chief who is preceded and followed by numerous attendants; he is supported round the waist by a confidential slave, and one wrist is so heavily laden with gold, that it is supported on the head of a small boy; with the other hand he is saluting a seated *caboceer* [captain], sawing the air by a motion from the wrist. His umbrella is sprung up and down to increase the breeze, and large grass fans are also playing; his handsomest slave girl follows, bearing on her head a small red leather trunk, full of gold ornaments, and rich cloths; behind are soldiers and drummers, who throw their white-washed drums in the air, and catch them again with much agility and grimace, as they walk along. Boys are in the front, bearing elephant tails, fly flappers etc. and his captains with uplifted swords, are hastening forward the musicians and soldiers. [Bowdich 1819, 276]

If one substitutes "voluntary" or "appointed" court officials, which they probably were, for "slaves," then Bowdich's description could describe any of a large number of Akan and Ewe festival scenes even today.

A key part of the display during the parade of chiefs at an Akan or Ewe *durbar* occurs when the individual chiefs periodically stand in their palanquins and dance for their subjects with a sword in one hand and a horsetail fly whisk in the other (figs. 3.10, 3.11).[3] This is where the royal cloths become most animated. The percussion-driven dance of most Akan performance ensembles creates a pattern of loading and unloading of the cloth that amplifies and extends the gestures of the chief. The rising and falling of the textile provides a counterpoint to the polyrhythms of Akan performance. The overall effect is a blaze of color produced by the movement of the kente and accented by bursts of gold as the jewelry catches the light and reflects it. Whether dancing or merely walking, the drape of the cloth requires frequent adjustment. Some men can do this with considerable style and elegance, others are less accomplished. A chief might even have a designated attendant who follows him closely and is assigned solely to assist in keeping the cloth in order (fig. 3.12).

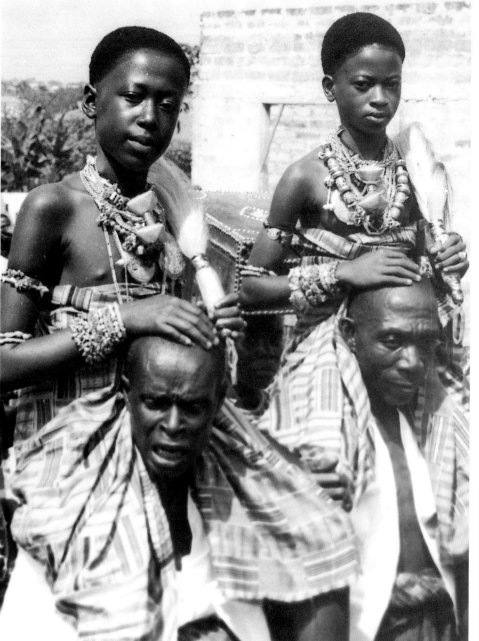

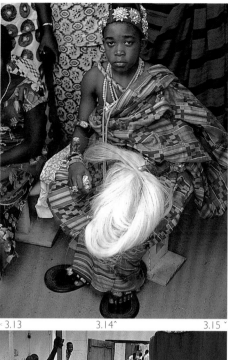

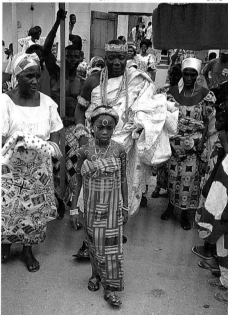

<3.13 3.14^ 3.15˅

Ghanaian festivals and the wearing of kente are not just adult events. Boys and girls can play several key roles in the proceedings. Indeed, it is even possible for a relatively young boy to occupy the position of chief (fig. 3.14). He generally serves with the queen mother as a regent, but he nevertheless may perform highly visible public roles on key occasions. Many Akan chiefs are preceded in a procession by a young girl, usually the chief's niece, who represents the matrilineage and the soul (*kra*) of the chief (fig. 3.15). When the chief is carried in a palanquin, the young girl sits in front of the chief, and like him, she may periodically stand and dance for the onlookers (see fig. 3.11). The Asantehene's entourage includes two young girls called the *mprakyire*, who are gloriously dressed in kente and wear double cast-gold "soul discs" (*akrafokonmu*) suspended from their necks, along with other gold necklaces and bracelets, while holding white horsetail fly whisks (fig. 3.13). In procession they are carried on the shoulders of two men, and when the king is seated in state, they stand behind him with the fly whisks. These girls may be selected from among the daughters of the Asantehene or from the royal matrilineage and are said to represent the wealth of the king (Kyerematen 1961, 15).

3.10 Paramount chief of Enyan Abaasa dancing in his palanquin at the annual Yam festival. Photograph by Doran H. Ross, Enyan Abaasa, 1974.

3.11 A young woman (wearing Ewe kente) who represents the matrilineage of a Fante chief and dances in front of him in a palanquin at the annual Fetu Afahye. Photograph by Doran H. Ross, Cape Coast, 1997.

3.12 Fante chief attending Panafest accompanied by an attendant who assists in maintaining his cloth. Photograph by Doran H. Ross, Cape Coast, 1997.

3.13 These two young girls (*mprakyire*) form part of the entourage of the Asantehene. They hold horsetail fly whisks and are carried on the shoulders of attendants. Photographer unknown, Kumase. Ghana Information Services.

3.14 Boy chief from Anomabu. Photograph by Herbert M. Cole, 1973.

3.15 A young Fante girl, wearing Asante broadloom kente, walks in front of a chief and represents his matrilineage at the annual Fetu Afahye. Photograph by Doran H. Ross, Cape Coast, 1997.

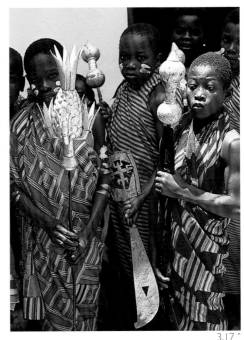

3.16 ^ 3.18 ˅ 3.17 ^

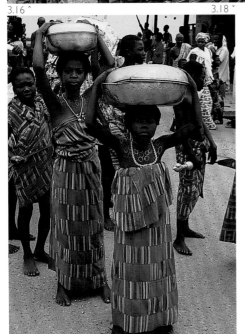

Although the Asantehene's sword-bearers are all adult males, many Akan chiefs employ young men or boys for this purpose and to carry other items of regalia such as sandals and fly whisks (fig. 3.16). At recent festivals among the Fante about one out of four of these supporters wore either handwoven kente or kente prints (fig. 3.17). Young girls may also serve in these supporting roles and in addition to fly whisks may carry stools or ritual vessels (fig. 3.18)

The death, funeral, and burial rites of an Asantehene (or other important Akan chief) and the subsequent installation and enstoolment ceremonies for the successor are also occasions for the selective use of kente. The traditional mourning cloths of the Asante, however, cannot properly be called kente, although the finest and rarest of them are strip woven from dark brown cotton thread and have subtle dark red weft designs (fig. 3.19). More common are the stamped cloths called Adinkra with dark red, dark brown, or black backgrounds, respectively known as Kɔbene, Kuntunkuni, and Birisi. If the mourners are not wearing kente, the deceased may nevertheless lie in state or be buried in kente. In the case of the Asantehene, the corpse is dressed in the full regalia of a living monarch. According to the Asante scholar A. A. Y. Kyerematen, "The walls of Patokromu [a large room in the palace], where the corpse is laid in state, are decorated with a variety of rich kente cloths—described as the erection of a Kente House (si ntoma dan)" (n.d., 8). State swords rest against the sides of the bed, and an umbrella stands over it. The whole scene suggests that of a chief being carried in a palanquin to the resting place of the ancestors.

3.16 Fante chief with sandal-, fly whisk-, and sword-bearers—all wearing machine-printed kente—at the annual Fetu Afahye. Photograph by Doran H. Ross, Cape Coast, 1997.

3.17 Fante boys carrying chiefly regalia and awaiting the enstoolment procession of a chief. Photograph by Doran H. Ross, Saltpond, 1975.

3.18 Young girls bearing ritual containers at an enstoolment procession for a Fante chief. Photograph by Doran H. Ross, Saltpond, 1975.

3.19a,b Details of two Asante funeral cloths **(a)** Kuntunkuni woven by Samuel Kwaku Appiah, 1996. Cotton. Warp-strip widths between 10.5 and 10.8 cm. FMCH X97.11.1. **(b)** Kuntunkuni Kɛseɛ woven by Osei Antobre, 1994. Cotton. Warp-strip widths between 20 and 21.5 cm. FMCH X96.30.16.

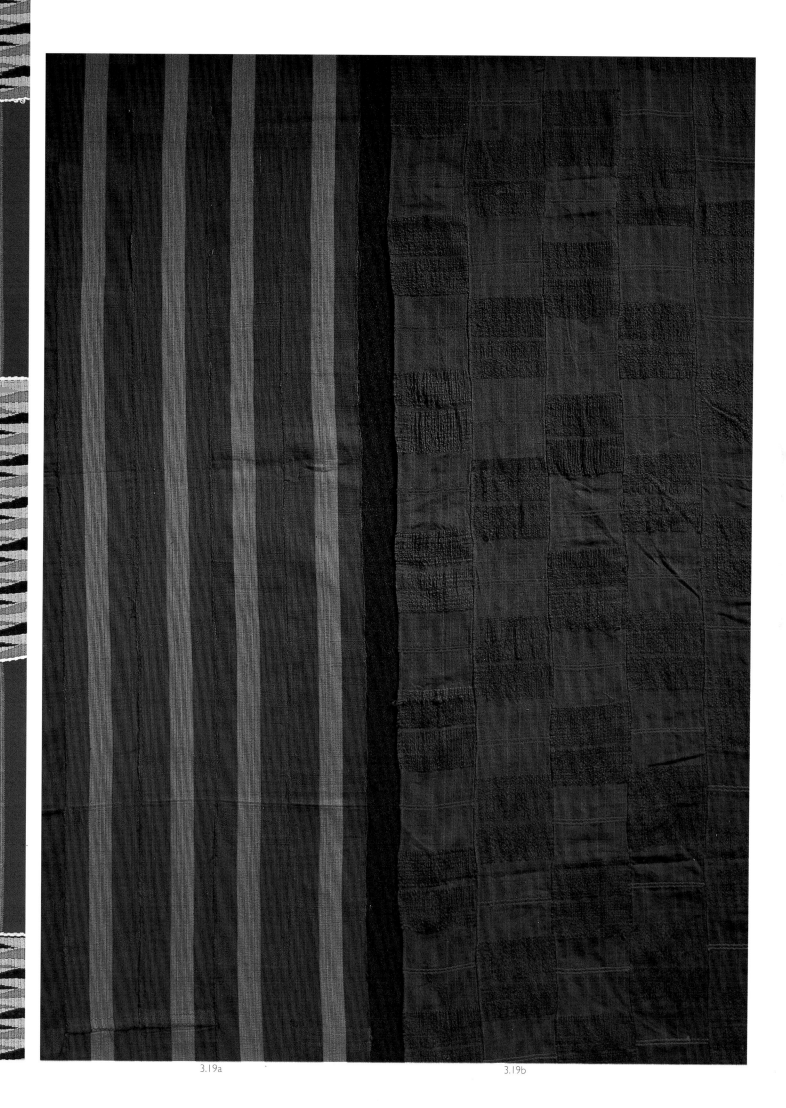

3.19a 3.19b

Funeral practices both royal and non-royal vary considerably among the Akan as well as among other peoples of southern Ghana and Togo (figs. 3.20, 3.21). In some areas kente is draped in the funeral room (fig. 3.22), as is the case with the Asantehene. In addition to the deceased occasionally being dressed in kente, his or her bed may be covered with the cloth or the coffin might have a piece laid over it (fig. 3.23).[4] Gifts of kente made to the deceased for burial in the coffin were also once part of the Asante tradition for important chiefs (Kyerematen n.d., 9).

For most participants, the wearing of mourning cloths during funeral rites is often carried over into the installation and enstoolment rites of a new chief (fig. 3.24). During the installation process the Asantehene will wear a white Adinkra (Adinkra Fufuo) at certain junctions of the ceremony. Before he is lifted onto the Golden Stool three times by major chiefs, he puts on the great war shirt (*batakari kɛseɛ*)—of the type seen here on the former Ejisuhene (fig. 3.25)—which he continues to wear as he is paraded in a palanquin for the first time in public (see fig. 2.8). Installments in other Akan areas typically include a procession and *durbar* where the chief might wear kente or other prestige cloth.

3.20 Second funeral (Ayi Kɛseɛ) for Awukuguahene (Awukugua Chief) Nana Asare Agyeiman (died 1974) of Agyemande ward *(boron)*, Akwukugua-Akuapem. The second funeral is performed a year after the actual burial in a complex celebration that lasts several days. The tent or shelter is made of palm branches covered on the outside with kente cloth. This structure is referred to as *ban mu* (Twi: from *ban*, a structure, enclosure, or fence; and *mu*, inside) or *ba te* (Okere Guan). At the entrance to the shelter is a brass pan *(ayowa)* with water and cleansing herbs for the mourners. Documentation and photograph by Michelle Gilbert, Awukugua-Akuapem, 1976.

3.21 Second funeral for Odede Yaw Odei of Akyemede ward, Awukagua-Akuapem. The shelter or tent of palm branches is covered with kente cloth. The black stool of the clan of the deceased is placed inside the temporary shelter. Documentation and photograph by Michelle Gilbert, Awukugua-Akuapem, 1989.

3.20 ^

3.21 ^

3.22 ˄

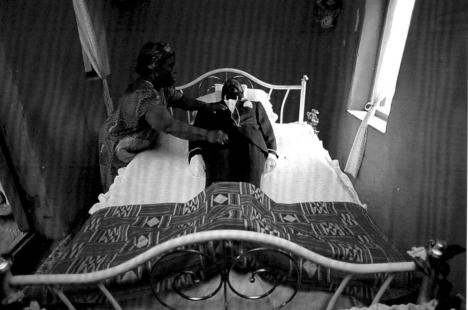

3.22 Deceased, Nana Ekua Dufie, lying in state with strip-woven kente drapes lining the funeral room. Photograph by Cary Wolinsky, Berekum, 1992.

3.23 Funeral bed of taxi driver Nii Sackey Quarcoopome. Photograph by Cary Wolinsky, Accra, 1992.

3.24 Entourage wearing mourning dress for an Asante chief. This group is attending a procession connected with the swearing of allegiance to the Asantehene by newly enstooled chiefs. Photograph by Doran H. Ross, Kumase, 1976.

3.25 The former Ejisuhene, Nana Diko Pim III, wearing a *batakari kɛseɛ*. Photograph by Doran H. Ross, Ejisu, 1976.

3.23 ˄ 3.24 ˅ 3.25 ˅

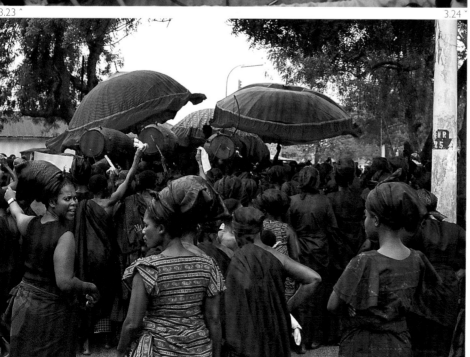

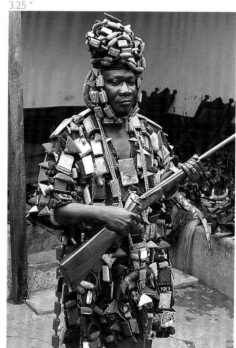

Another arena for the prominent use of cloth among the Akan is the lining of palanquins. The Asante typically drape their litters with heavy wool or cotton cloths imported from present-day Côte d'Ivoire and Mali (see fig. 3.4). Collectively called *nsa* or *kassa*, these textiles came into the heartland from the elaborate trade network that helped feed the kingdom's desire for imported material. Many other Akan areas share the Asante use of foreign textiles in palanquins but also employ handwoven kente (fig. 3.26). At a procession following an enstoolment in the Fante town of Saltpond, both the new chief and the queen mother were carried through the streets in kente-lined palanquins although neither wore kente (figs. 3.27, 3.28). Kente-lined palanquins are especially commonplace at many Fante festivals (fig. 3.29).

Just as chiefs wear kente, so do the principal gods of the Akan. Unlike the practice observed in some areas of Africa, these deities are not represented by figurative wood carvings but rather by assemblages of ritual and medicinal materials gathered in a brass container that is draped with kente or other cloth. The conceptualization of the deity's shrine parallels that of a royal court and contains stools, swords, counselors' staffs, and fly whisks as regalia of the god (fig. 3.30). This context for the use of kente is dealt with in considerably more detail in chapter 5.

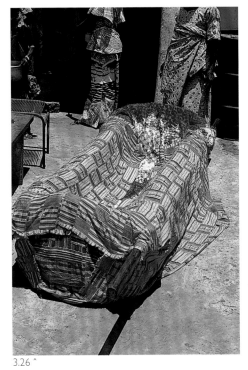

3.26 ˆ

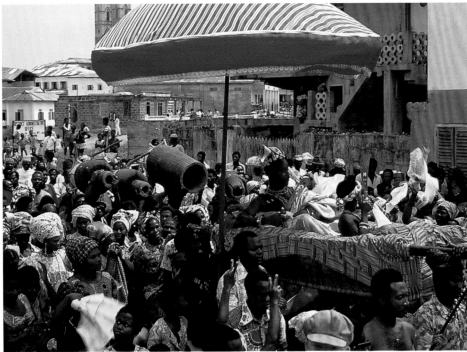

3.27 ˆ 3.28 ˇ

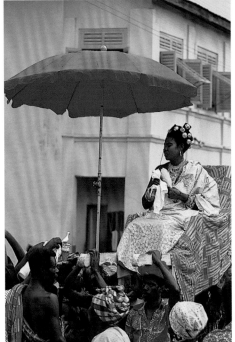

3.26 Kente-lined palanquin at a Fante chief's palace prior to a *durbar*. Photograph by Doran H. Ross, Saltpond, 1975.

3.27 Paramount chief of Saltpond in a procession following his enstoolment. Photograph by Doran H. Ross, Saltpond, 1975.

3.28 Queen mother of Saltpond on kente-lined litter at the enstoolment procession of the chief in figure 3.27. Photograph by Doran H. Ross, Saltpond, 1975.

3.29 Fante chief carried in palanquin at the Nkusukum Ɔdambea festival. Photograph by Doran H. Ross, Lowtown, 1980.

3.30 Asante Tano River shrine. Photograph by Herbert M. Cole, near Kumase, 1976.

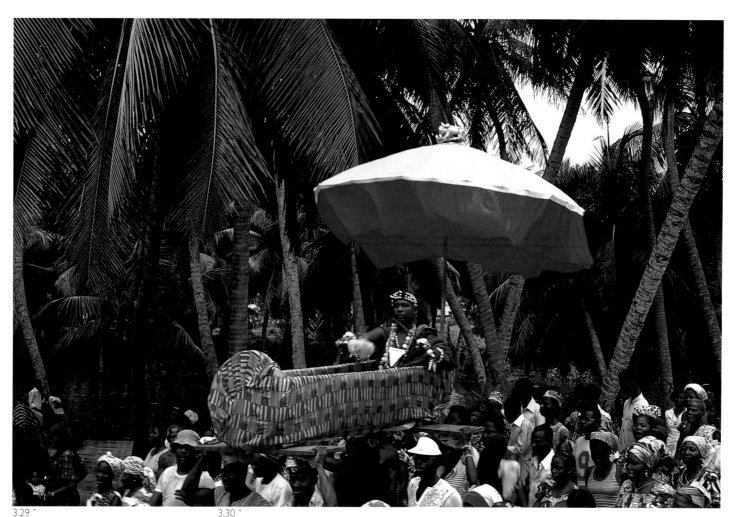

3.29 ^ 3.30 ˅

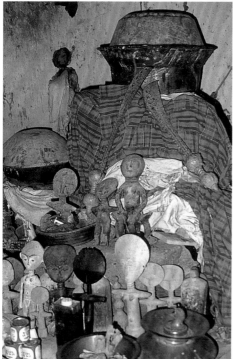

3.31 ^

Just as kente-lined palanquins frame the chief for public display, in more contemporary contexts the textile continues to function as a framing device, centering attention on a designated person or object. Several chiefs have deliberately posed in front of kente for official portraits. As we will see in chapter 10, even the speaker's podium in Ghana's parliament has been centered against large kente wall hangings, one featuring a warp-stripe pattern based on Ghana's national flag (see fig. 10.51).[5] Kyerematen's photographs for his book *Panoply of Ghana* (1964) frequently positioned the royal regalia on a kente backdrop (figs. 3.31, 3.32). Some weavers have even created special cloths incorporating rectangular areas of plain weave designed to accommodate photographs (fig. 3.33). These uses of kente as a backdrop and framing device anticipate similar, but admittedly more commercial, adoptions of the cloth as a border design on book covers, greeting cards, photograph frames, and advertisements in the United States and elsewhere (see the concluding chapter).

Kente's prominent role as a garment has led to its also serving as a prestigious gift item. This may take the form of an outright gift of the textile or a gift of the right to wear particular patterns. For example, Rattray notes that the pattern called Kofi Esono (Kofi the elephant) was named after "an Ashanti celebrity who was presented with this cloth by the King of Ashanti and given permission to wear it" (1927, 236). Rattray also notes that an Adweneasa was "one of the cloths presented by the Ashanti to the Princess Mary on the occasion of her wedding" (1927, 237). Throughout Rattray's discussion of textile patterns, there are numerous references to designs "formerly only worn by the King of Ashanti" or "worn with the permission of the king" (1927, 236–44). More contemporary examples of kente as a high-status political gift are discussed in chapter 10 of this volume, including the presentation of cloths by President Jerry Rawlings of Ghana to President Bill Clinton and his wife, Hillary, in March 1998 (fig. 3.34). The tradition of kente as a meaningful gift has been carried over into the United States, especially during Kwanzaa, where it fulfills Maulana Karenga's stipulation of a culturally significant present, and at the end of the school year when a stole is frequently given as a graduation gift (see chapter 12).

3.32 ^

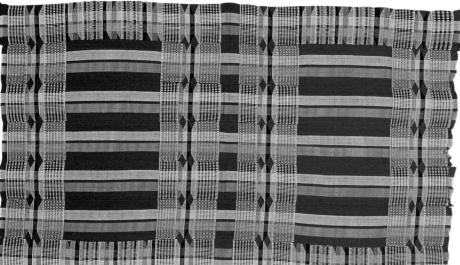

3.33 ^

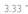

3.31 *Aburukuwa* drum of paramount chief of Akuapem, photographed against a kente cloth as part of the documentation of state regalia by A. A. Y. Kyerematen, Akuropon. Ghana Information Services. Photograph by Bob Okanta, before 1964.

3.32 State swords and gold-leaf stool photographed against Sika Futuro Adweneasa kente and leopard skin as part of the documentation of state regalia by A. A. Y. Kyerematen, Kibi Akyem Abuakwa. Ghana Information Services. Photograph by Bob Okanta, before 1964.

3.33 Oyokoman kente with sections of plain weave. This cloth was woven as a frame for photographs. Samuel Cophie workshop. Rayon. Length 113 cm. FMCH X96.30.5.

3.34 President Bill Clinton and First Lady Hillary Clinton wearing kente cloths presented to them by the people of Ghana, represented here by President Jerry Rawlings and his wife, Nana Konadu Agyeman-Rawlings, Accra. Photograph by Ira Wyman for *Newsweek*, © 1998 *Newsweek* Inc. All rights reserved. Used with permission.

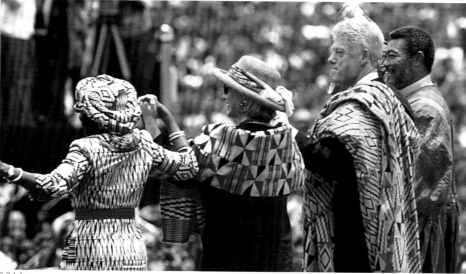

3.34 ^

The role of kente as a gift intersects with another function in two Ewe cloths identified as "hammocks," one in the British Museum (Picton and Mack 1989, cover, 126,127) and the second in the Museum of International Folk Art, Santa Fe (fig. 3.35). Both are most probably by the same weaver as they share a common color scheme, many of the same motifs, a similar style of representation, and unusual fringed edges. The Santa Fe example includes an inscription: "W. J. A. JONES PROVINCIAL COMMISSIONER/ GILLIAN FROM DADOY." There is little published information on W. J. A. Jones, but we do know that he was commissioner of the Central Province in 1928 (Kuklick 1979, 68, 83).

It is unlikely that either of these pieces was intended to function as a hammock since the seams connecting the selvages (a problem area even for cloths intended only to be worn) would be placed under excessive stress by the weight of a human body. The fringe and the weft-faced designs would also not survive repeated use. More likely these works were made specifically as presentation pieces as the inscription would lead us to believe. Nevertheless, there is some evidence that the Ewe did make hammocks from strip-woven cloth, and Heinrich Klose (1899, 2) noted at the end of the last century that they were very popular and even considered stronger than European versions (see Ross 1998).

In addition to the more conventionalized uses of kente mentioned above there are many more idiosyncratic functions that have been documented in different times and places. Although the large state umbrellas of the Akan and Ewe peoples would seem to be logical objects on which to showcase kente, it is only rarely employed in this context. Only one of the Asantehene's state umbrellas displayed at the 1991 Adae Kɛseɛ featured kente—an unusual version of the maroon, gold, and green cloth called Oyokoman, which lacked any weft designs.[6] Considered one of the oldest items of royal regalia, it is recognized as the umbrella of King Osei Tutu (r. ca. 1680–1717). Although the cloth is certainly a replacement, according to Boaten, it was made "to commemorate his establishment of the hegemony of the Oyoko clan as the royal clan of the Asante" (1993, 58).

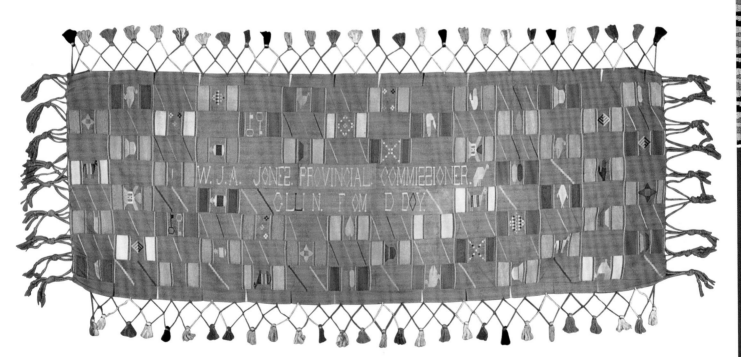

3.35

The state shields (*εkyεmfoɔ*) of Asante paramount chiefs are built on wicker frames, and the exteriors are covered with a variety of imported and locally produced fabrics (fig. 3.36). The Asantehene's five ceremonial shields are covered with a combination of colobus monkey skin and a strip-woven cloth with the warp pattern called Kyemee without any weft-faced designs (fig. 3.39). According to Ofori-Ansa, "The design was inspired by patterns in a particular imported silk cloth worn only by persons of high social status and was used during special ceremonies. The cloth was specifically designed in tribute to an Asante paramount Chief called Kyemee who was credited with bravery and strong leadership qualities" (1993, design no. 17). In what is probably a unique example, the guide to a *durbar* held in 1977 documents a state shield presumably made specifically for and given as a gift to His Royal Highness the Prince of Wales (anon. 1977, 26, 27). The inside of the shield is covered with strips of kente clearly woven with the Oyokoman warp pattern.[7]

There are several other perhaps unique uses of Kente. One of the royal fans of the queen mother of Mampon is also covered in an Oyokoman cloth (fig. 3.37). At the paramountcy of Kokofu one of the royal war drums has at least two Kente-covered amulets amidst other items promoting the power of the instrument (fig. 3.38). Outside of the Asante heartland in Aburi the massive pair of *fɔntɔmfrom* drums belonging to the chief are draped with old pieces of kente.[8]

3.38 ^
3.39 ˅

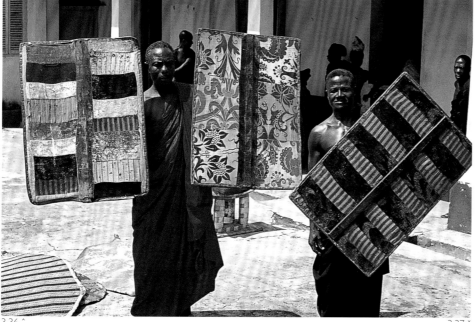
3.36 ^
3.37 ˅

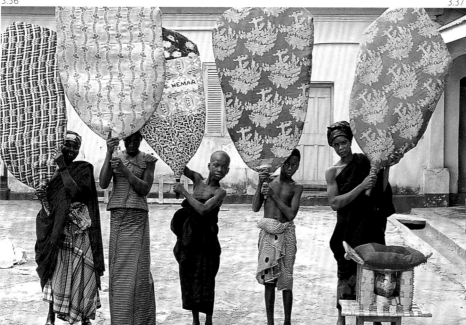

3.35 Presentation piece in the form of a hammock. Ewe peoples, eastern Ghana, circa 1930. Cotton. Length 259 cm. Collection of Lloyd Cotsen and the Neutrogena Corporation, Museum of International Folk Art, Santa Fe.

3.36 State shields from the treasury of the Mamponhene. Photograph by Doran H. Ross, Mampon, 1976.

3.37 Royal fan (far left) covered in Oyokoman kente belonging to the queen mother of Mampon. Photograph by Doran H. Ross, 1976.

3.38 State drum from the treasury of the Kokofuhene with Kente-covered amulets. Photograph by Doran H. Ross, Kokofu, 1976.

3.39 One of five state shields of the Asantehene covered with colobus monkey skin and kente called Kyemee. Photograph by Doran H. Ross, Kumase, 1980.

Kente may have had its origins as the exclusive prerogative of Asante or other Akan chiefs, but by the end of the nineteenth century it increasingly functioned in non-royal circumstances. At the end of the twentieth century it could be worn by anyone capable of affording it in almost any situation that merited prestige dress. For at least the past twenty years, key officers of the traditional warrior groups (*asafo*) of the Fante have occasionally worn kente in lieu of the more traditional *batakari*, or war shirt (figs. 3.40, 3.41). Women officers wear it more often than men (fig. 3.42), and some female subgroups of *asafo* companies dress entirely in kente (see fig. 3.1).

As Western practices and institutions have penetrated Ghanaian society, the number of contexts for wearing kente have increased proportionately. Traditional marriage ceremonies involved several ritual activities, but it is not clear how often, if ever, kente was worn. With the advent of Christian weddings, however, kente became appropriate attire for the bride and groom (fig. 3.43). The wearing of kente in college graduation ceremonies dates back to at least 1963 when W. E. B. Du Bois and members of the faculty of the University of Ghana were photographed at the presentation of an honorary degree to the American scholar. Today this practice extends through all educational levels in Ghana, and at the end of the school year Ghanaian newspapers are filled with graduation photographs featuring kente that range from day-care centers and nursery schools to the college level.

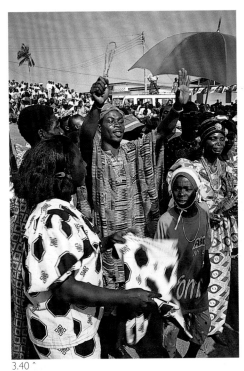

3.40 ^

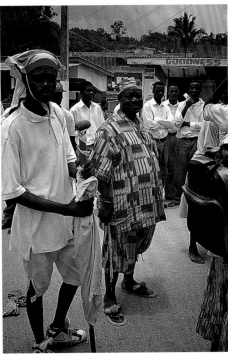

3.41 ^

3.42 ^

3.40 Captain (*asafohene*) of the "No. 5 Asafo Company" wearing a handwoven kente tunic at the annual Fetu Afahye. Doran H. Ross, Cape Coast, 1997.

3.41 Captain of the "No. 4 Asafo Company" wearing shirt, shorts, and hat made of machine-printed kente at the annual Fetu Afahye. Photograph by Doran H. Ross, Cape Coast, 1997.

3.42 Female leader of a Fante *asafo* group at the annual Fetu Afahye. Photograph by Doran H. Ross, Cape Coast, 1997.

3.43 Turn-of-the-century Basel Mission photograph of a Christian wedding with the groom wearing kente and bride in Western attire. Basel Mission Archive D-30.20.022.

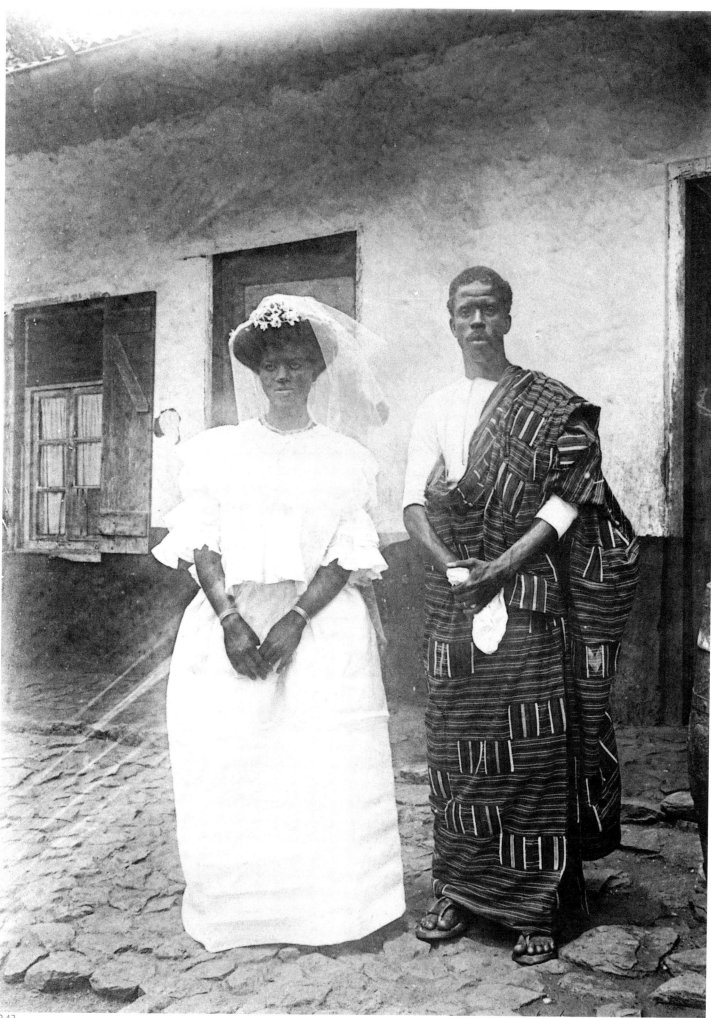

3.43

A survey of Ghanaian newspapers from August and September 1997 revealed an astonishing array of occasions where kente was worn. The *Ghanaian Times* reported on the launching of a commemorative stamp by the Ghana Postal Services honoring the Starlets, the World Soccer Champions in the category of girls under seventeen years of age; the Starlets are shown wearing kente (September 13, 1997, 12). The *Daily Graphic* covered a ceremony where kente was worn in Accra to honor forty Ghanaian civilian personnel hired to support United States forces during World War II (September 13, 1997, 11). The same paper also reported on the laying of a foundation stone for a new branch of the Apostolic Church in Sunyani, which proved another occasion for the wearing of kente (September 12, 1997, 16). The *Weekly Spectator* documented kente used by the Aflao Girls Brass Band in Cape Coast (September 6, 1997, 4) and at an induction service for Methodist Church officials (August 30, 1997, 9). A book-signing ceremony launching a two-volume work on the history of Western medicine in Ghana was also enlivened by the presence of kente (*The Daily Graphic,* September 13, 1997, 14). And the *Mirror* published a photograph of the first lady of Ghana, Nana Konadu Agyeman Rawlings wearing a splendid tailored kente to the opening of Parliament (January 17, 1998, 10).

The third Pan African Historical Theatre Festival (Panafest '97) held in Cape Coast and Elmina provided numerous and varied opportunities for the display or wearing of kente. (See the interleaf "Kente at Panafest".) The front page of the "Living" section of the *Sunday Herald* featured masks from the Chokwe (Angola), Dan (Liberia), and Pende (Democratic Republic of the Congo) peoples, along with a Kota reliquary figure (Gabon) juxtaposed with two photographs of kente and the headlines "Uniting the African Family" and " The Re-Emergence of African Civilization." The front page of the *Ghanaian Times* featured a courtesy call by the Suriname Panafest delegation to the Central Regional House of Chiefs (September 6, 1997), and the *Daily Graphic* published a photograph of a Jamaican couple, shown wearing kente, who had adopted ancestral names and held a "traditional wedding ceremony." At Panafest kente was systematically employed to further the themes of community, shared history, and creativity, among others.

The development of kente as a dress accessory is a logical extension of its function as a garment. Hats, ties, vests, cummerbunds, shoes, purses, bags, briefcases, backpacks, and jewelry have all been made from kente or adorned with it in Ghana for both local use and for export. As items of personal adornment, in the United States and elsewhere, these objects also serve in the construction of identity and in affirming ties to Africa. The creation of new uses for the cloth is part of a process of appropriation and commodification that has been pursued with equal zeal on both sides of the Atlantic. Although purists point accusing fingers at entrepreneurs in the United States, the exploitation of kente products is actually being led by West African initiatives. The baseball cap/backpack (see concluding chapter) is only one of the latest in a series of Ghanaian inventions targeting a United States market.

If kente is not the commodity itself, it is often used as a catalyst for sales through its association with another commodity or product. Hotel Georgia, "The Pride of Asante," in Kumase features on its brochure two exquisitely charming photographs of the granddaughter of the owner (figs. 3.44a,b). Here the images promote the idea of this hotel as a "luxurious" establishment for elite visitors seeking authentic experiences in the Asante heartland, the "original home of kente." The brochure spends as much space promoting the people, culture, and arts of the area as it does the hotel itself.

In 1997 kente was also used to advertise Spacefon, a mobile telephone company; a handwoven strip was shown draped on an Asante stool with a telephone leaning against it. Elsewhere in the advertisement a kente-adorned model was shown holding the phone. The intention seems to have been to equate Spacefon's introduction into Kumase with the cultural advancement of the region. Another ubiquitous advertisement occurring in the same year depicted two young boys in kente along with their "mother"; it promoted the MultiChoice decoder for use in restricting the young from "watching unsuitable programmes." Here it appears that the kente-clad children were intended to represent uncorrupted traditional values.

As should be evident from the above discussion, Kente is a multifunctional textile whose place in Ghanaian expressive culture extends well beyond the realm of personal adornment. This fact is not only crucial to understanding indigenous conceptions of the cloth but also to appreciating its varied roles in the Diaspora–topics that will be dealt with in chapters 12 and 13.

 ASHANTI - ORIGINAL HOME OF KENTE AND GOLD

3.44a,b Photographs of the granddaughter of the proprietor of the Hotel Georgia in Kumase figure prominently in a brochure used to promote the hotel.

Hotel Georgia

HEAD OFFICE

32 VOLTA·AVENUE
P. O. BOX 2240
KUMASI-ASHANTI
FAX 4299.
TEL: 3915 / 2434 / 4154 / 5733.

ACCRA OFFICE

HOTEL GEORGIA ANNEX
PATRICE LUMUMBA ROAD
AIRPORT RESIDENTIAL AREA
P. O. BOX 10323
TEL: 774390

3.44a,b

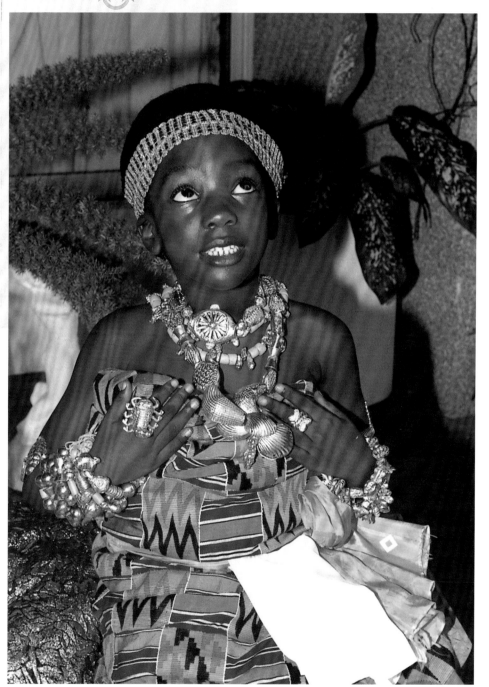

Interleaf A
In Place of Kente

Although kente is the most familiar of the textiles worn on special occasions in Ghana, a number of other locally produced cloths compete for attention. In addition to handwoven fabrics, the Asante and their Akan neighbors use a rich variety of stamped, appliquéd, embroidered, pieced, inscribed, silk-screened, and assembled garments. An impressive assortment of foreign brocades, damasks, and other materials also appears with considerable regularity at important events.

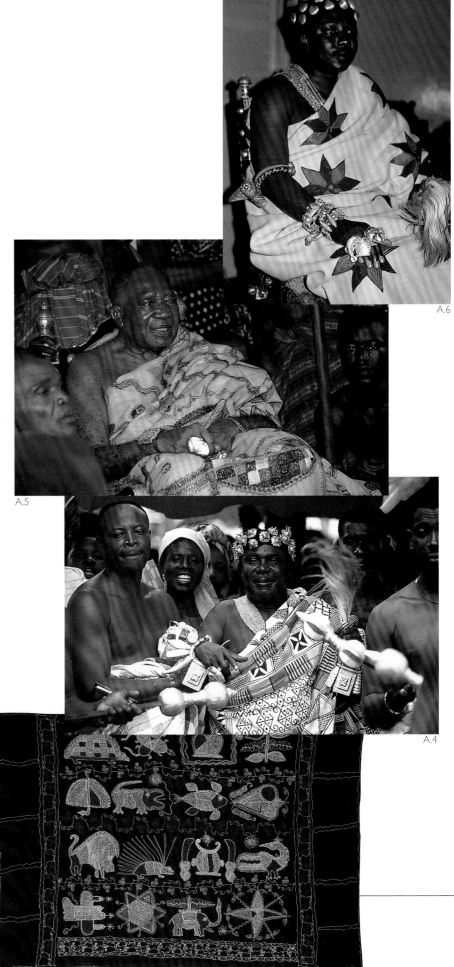

A.6

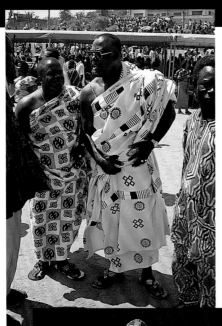

A.1

A.5

A.4

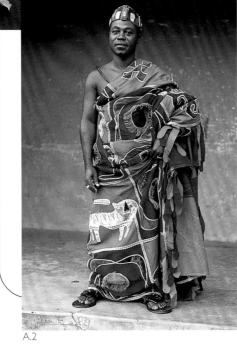

A.2

A.3

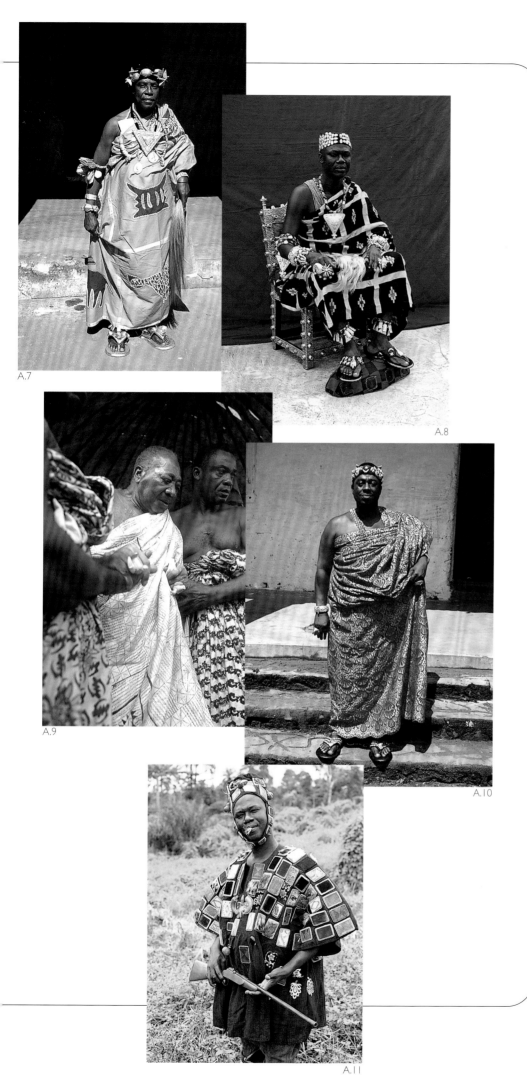

A.7

A.8

A.9

A.10

A.11

A.1 Unidentified individuals at Fetu Afahye wearing silk-screened (as opposed to stamped) Adinkra cloths. Photograph by Doran H. Ross, Cape Coast, 1997.

A.2 Nana Kwabu Ewusi VI, paramount chief of the Fante state of Abeadze Dominase, at the annual Yam festival. He wears an appliquéd cloth known as Akunitan, or "cloth of the great." Photograph by Doran H. Ross, Abeadze Dominase, 1976.

A.3 Akunitan (Cloth of the great). Machine embroidery on a British manufactured blanket. Rayon, wool. Length 310 cm. FMCH X82.736.

A.4 Unidentified chief wearing an Akwasiada (Sunday) Adinkra, a stamped cloth with embroidered bands, at the silver jubilee of the Asantehene. Photograph by Frank Fournier, Kumase, 1995.

A.5 Otumfuo Nana Opoku Ware II, Asantehene, at his silver jubilee wearing an embroidered cloth known as Nkrawɔ. Photograph by Frank Fournier, Kumase, 1995.

A.6 Nana Barima Asumadu Sakyii II, Kumawuhene, wearing an appliquéd and embroidered cloth on a European felt ground. The textile is known as Nkrawɔ. Photograph by Doran H. Ross, Kumawu, 1976.

A.7 Nana Adoku V, paramount chief of the Fante state of Mankesim, at the annual Yam festival. He wears an appliquéd Akunitan, or "cloth of the great." Photograph by Doran H. Ross, Mankesim, 1975.

A.8 Nana Oduro Numapau II, paramount chief of the Asante state of Essumeja. He wears a distinctive piece-work cloth composed of handwoven elements created on an Asante loom with a much wider warp than average. Photograph by Doran H. Ross, Essumeja, 1979.

A.9 Otumfuo Nana Opoku Ware II, Asantehene, at his silver jubilee. The Asantehene wears a cloth inscribed in Arabic. It is known as "Hyewo a enhye" (Burn but not burn; meaning "inflammable"). Photograph by Frank Fournier, Kumase, 1995.

A.10 Nana Boakye Yiadom II, Agonahene, wearing a European brocade. Photograph by Doran H. Ross, Agona, 1980.

A.11 Nana Oduro Numapau II, Essumejahene, wearing a batakari kɛseɛ, or "great war shirt." Photograph by Doran H. Ross, Essumeja, 1979.

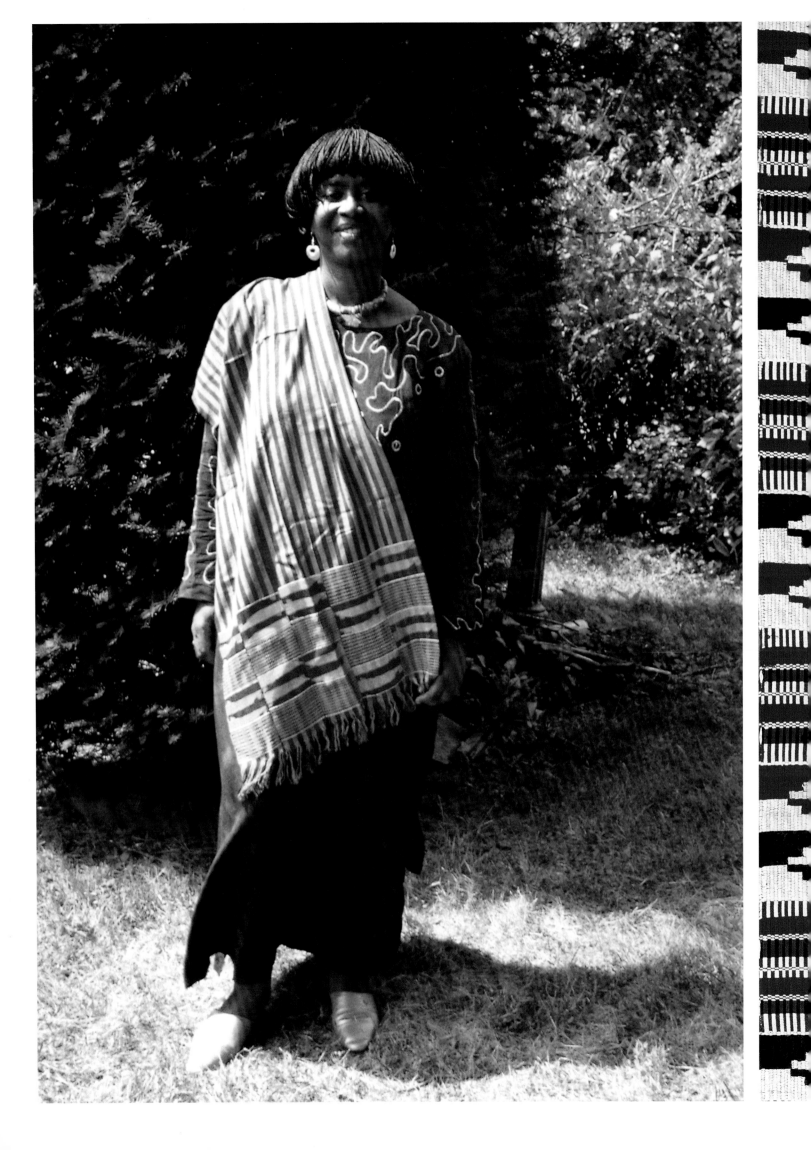

I have learned through my parents to admire kente and to appreciate that for most Ghanaians, kente cloths are heirlooms. They are precious treasures given on significant occasions and hopefully passed down from mother to daughter, uncle to nephew, father to son. They are chosen with care and given with great consideration to mark births, marriages, grand occasions. Attention is paid to the symbolism of the occasion and, where relevant, the meaning of the design itself. Mother owned, at one point, several full kente cloths; but very few have survived the vicissitudes of exiles, coups, thefts, and confiscations. My mother's cloths are grand affairs, and they have inspired a love of kente, the art and artistry, the symbolism, the style. I started my own collection with cloths that I refer to as shawls. I share the stories of three of these, interwoven with the stories of the first three kentes I remember—mother's oldest and most treasured, those that did survive the uncertainties of time.

The First Shawl, 1977

I have a picture in my mind of me being handed a gift in the house in England where I grew up. I'm with my mother in her bedroom, and we are standing on opposite sides of her bed; it is the summer after my graduation, and I am living at home again. We are planning what I should wear to a most important affair. I had entered the Vogue talent contest for new writers and artists that year and had been named a finalist. I've bought a new floral, navy cocktail dress, silky with full knife pleats and a boat neckline, elegant but so European. And I need a shawl or something to complete my outfit and make it mine. My mother takes me upstairs and pulls a beautiful new kente shawl out of her cupboard. Unlike the Sika Futoro cloth she has kept for me for my wedding day, this is a shawl that she has bought new, as a gift, because it was beautiful. It wasn't necessarily bought for *me*; mother has a wonderful habit of buying beautiful things when she can, for their *possibility*—every beautiful object will find its right person, its own occasion to be given as a gift. And this is one. I become the recipient, casually, incidentally, because this is an occasion where I would need such a shawl to wear. There is no ceremony; in fact she is a little distressed because it has a slight stain where some perfume given to her as a gift has spilled in her case on the journey. This is her second exile, and things brought from home are scarce. For me, it is the first kente I have ever *owned*. It is a simple plain weave of blue-and-gold silk stripes with a border in red and yellow, the design of fingers alternating with short stripes of what looks to me like the simplified sign of the snail (fig. 4.1). Over the years it has become soft with wear, as old kente silk does with time. One evening a decade later in the U.S., coming back from an Oxford University reunion party at the UN, we were deluged with a sudden shower of summer rain—unusually heavy—and the shawl, which I was wearing on my head as an elaborate scarf, was drenched. The soaking and later a dry cleaning removed the small traces of perfume stain that had been on it since I got it but made the gold uneven. It also made it so comfortable to wear. All its associations are joyful, and twenty years ago I won the talent competition it now commemorates.

The First Cloth, 1953/1968

The first time I ever *wore* kente cloth was in 1968 at my aunt's wedding, the second time I was in a wedding party as a bridesmaid. There is a picture of us all with me as *chief* bridesmaid (for the first of many such times) in a green kente cloth wrapper and a green silk blouse my mother sewed for the occasion. I have it to wear because it is one of the three she managed to bring with her into the first of our two exiles. She had bought it as a gift to herself in the 1950s, around the time I was born—the first piece she bought for herself. After the wedding she gave it away to her cousin whose wedding it was. So this kente has survived because mother gave it away as a wedding gift long ago. My aunt has it still.

The Second Shawl, Owia Repuɛ, 1988

It is Beijing, China, the Fourth World Congress on Women, 1995; I have now owned this shawl for seven years. I am standing in the lobby of the "UN" building, outside one of the conference rooms, when I spot the familiar kente pattern on a surprising person. The spectacular and unusual white sun rising in a red sky over a black earth is the symbol of my father's Progress Party—a party banned since 1972, which like all other political parties of that era has had to undergo various metamorphoses (figs. 4.2–4.4). But neither its name nor its symbol can be resurrected in the current political arena. The symbol was my mother's idea; she suggested it in those early heady days of the party's formation, after the ban on politics was lifted one year prior to the 1969 elections. A number of party stalwarts,

4.1 Abena Busia wearing her first kente, a gift from her mother. Photograph by Anne Spencer, New Brunswick, 1997.

4.2 Official portrait of Dr. K. A. Busia, Prime Minister of Ghana, 1969–1972. Dr. Busia is shown wearing a Sika Futoro kente.

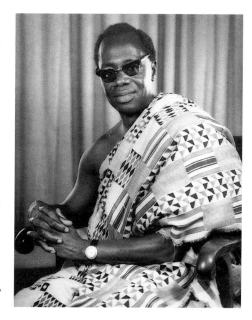

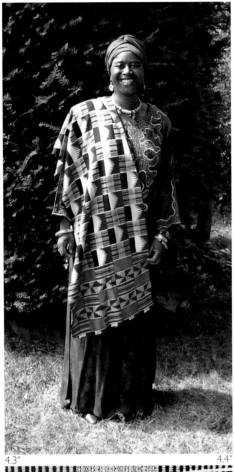

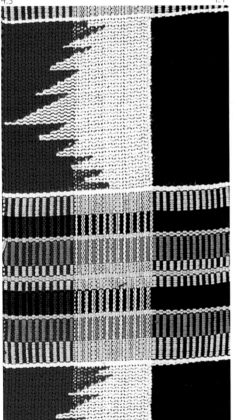

gathered at my parents' home, had been wrestling with the question of what our symbol should be, when my mother suggested the rising sun. That is how we felt, a sun coming up on a new dawn, and so it was. Together, they discussed and adopted it and chose the colors. A weaver turned it into a kente of striking beauty. The main body of the cloth alternates the striking rising sun (which people will say symbolizes divine power, progress, and enlightenment; though few will state that it was created as the symbol of the Progress Party) with the symbol—in yellow and green added to the red, black, and white—of the ceremonial shield, which stands for political and spiritual defense. The border alternates three motifs: the steps, symbolizing advancement and perseverance, the snail shell, symbolizing endurance and self-containment—both in red and yellow—and the plant symbol of healing and spiritual protection, which adds a blue stripe to the red. When after a decade and a half Nana Asante Frempong decided, despite injunctions, to weave it again, the first one off his loom he brought to the U.S. and gave to me. He, too, was once a member of the party. Yet time is a great leveler, and not all people read signs and symbols. Today, it is just a popular kente design. But here in Beijing, I am intrigued by the wearer, so I go and greet her. She is serving as a minister in the very government, which in an earlier incarnation had banned the Progress Party. I introduce myself and comment on the beauty of her kente; she clearly is quite proud of it. I have seen her photographed in it a number of times. It is much used and clearly treasured. I cannot resist expressing my surprise at seeing her wear it . . . she doesn't seem to understand. So, very gently, I tell her my name and remind her of the origins of the symbol. Suddenly she clutches at the shawl, surprise and discomfort registering in her eyes. I really don't think she knew . . . I have not seen any pictures of her wearing it recently. I continue to wear mine with pride. In a way, through the weaver, this is a gift from both my parents.

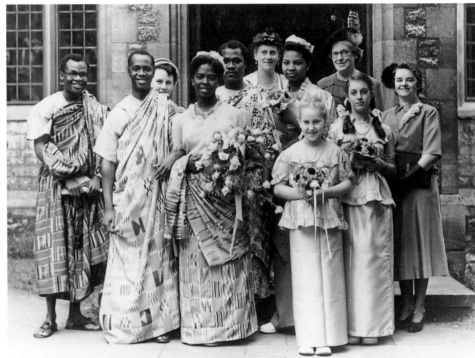

4.3 Abena Busia wearing a kente featuring the Owia Repuɛ motif, the symbol of her father's Progress Party. Photograph by Anne Spencer, New Brunswick, 1997.

4.4 Detail of kente strip with Owia Repuɛ motif. Private collection.

4.5 Dr. K. A. Busia and Naa-Morkor Busia, Abena's parents, at their wedding in 1950. Her mother wears an Adweneasa Sika Futoro kente.

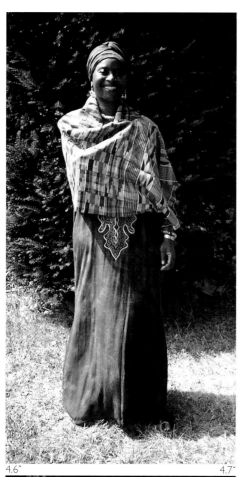

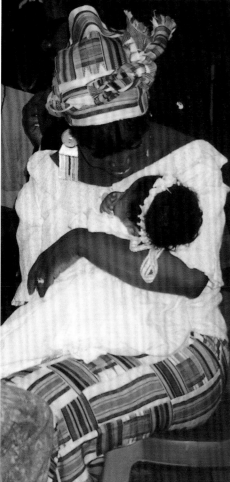

4.6ˆ 4.7ˆ

The Second Cloth, Sika Futuro, 1983/1950/1998

Fifteen years ago my mother gave me a sample of a kente cloth. It is not wearable, being far too small for a wrapper and too broad and short for a shawl. It was indeed woven as a sample of the weaver's craft. It is a sample piece of the classic gold Sika Futoro cloth she was married in; "gold dust," it is more treasured than the substance it was named after. The man who wove her wedding cloth gave her his sample as a gift, and she gave it to me so that I could use it as a wall hanging in my new flat when she visited me in the United States for the first time. This year, I inherit the real thing, the one she wore at her wedding. When she married in 1950, wearing kente was not considered either fashionable, or appropriate. Highly schooled people—my father and mother had an Oxford doctorate and nursing diploma respectively—were required to display the sophisticated ways of Europeans and set the standard with Western fashion. My mother should have been imitating Josephine Baker in designer costumes, hats, and gloves, especially as they were actually getting married in England, in Oxford too. But my parents, decades ahead of their day and proud of who they were and where they came from, wore the kente (fig. 4.5). It is curious today to think that they had to do this in defiance of friends and family, against the tide. Not only do fashions change, the politics of wearing kente change. I have now inherited this precious cloth, and this summer, almost half a century since it was made for my mother's wedding, I shall wear it at my own. No one will be surprised, and most people will be touched and pleased.

The Third Shawl, Adweneasa

The only kente I ever bought for myself, I also bought for my mother. I chose a shawl woven by the same weaver who gave me the Progress Party shawl, selecting a classic motif in yellow; the creation of this design is said to have exhausted the ingenuity of royal weavers (fig. 4.6). And my memory also is exhausted. Dates blur, some dates are specific and forever etched in memory because of the occasion—some blur, I remember the season but not the exact moment; I know the time before and the occasions since but not the exact day when. I have worn this shawl countless times but am uncertain when I bought it. I have had it more than a decade, and the only picture I have of me wearing it is a fairly recent one, taken two years ago at the baptism of my goddaughter. And on that occasion I'm wearing both mine and the one I gave to mother—one around my head and the other slung over my shoulder and wrapped around the child.

The Third Cloth, Toku Akra Ntoma, 1951/1997

I am looking at two photographs, one of my mother on my elder brother's wedding day and the other of my sister holding her only daughter in her arms at the child's christening. (fig. 4.7) They are wearing the same cloth. It is strikingly beautiful, predominantly white, in a design that symbolizes self-sacrificial leadership and veneration of the ancestors. Once mother's, she gave it to my sister. It is appropriate that my sister wears it on this day. Mother also received it as a gift, nearly fifty years ago when it was new. It was a gift to her from father to celebrate the birth and dedication of their son, our elder brother. For that reason, over thirty years later, mother wore it on his wedding day. Then, in the following decade, she gave it as a gift to my sister before her wedding. And my sister wore it for her daughter's dedication; two weddings: my mother at my brother's, my sister for her own; two dedications: my mother at my brother's, my sister at her daughter's; one celebration kente for three generations.

4.6 Abena Busia wearing an Adweneasa cloth, the only kente she ever purchased for herself. Photograph by Anne Spencer, New Brunswick, 1997.

4.7 The author's sister wearing a kente cloth in the pattern known as Toku Akra Ntoma. She holds her daughter at the child's christening. Photograph by Anne Spencer, New Brunswick, 1997.

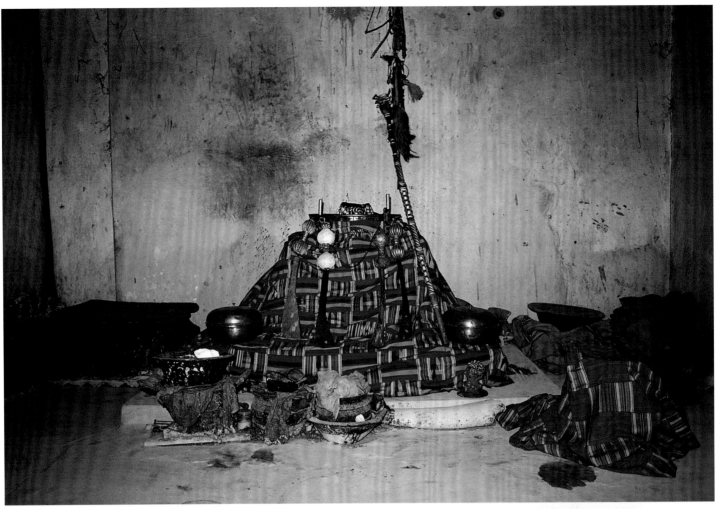

5.1 The shrine of Taa Kora, the "king" of the *atano* (Tano deities), at Tanoboase, "dressed" to receive visitors during the god's monthly Adae festival. The custodians of Taa Kora have draped the brass container that holds the material essence of the god with kente cloth. In addition, some of the god's regalia, symbols of his elevated status among the *atano*, have been carefully arranged around the shrine—a gold-studded headpiece and two ceremonial knives sit on top of the shrine, a spokesman's staff rests against the wall, and several state swords have been arranged in front of the shrine. Photograph by Raymond Silverman, April 23, 1980.

5.2 The ancient Tano deity Twumpuduo in his shrine room at Tuobodom. Like Taa Kora, this important god has been dressed in a kente cloth and presented with regalia that has either been given to the deity by grateful supplicants or purchased by the god's priest. In addition to a spokesman's staff and state swords, two elephant-tail fly whisks and a gold-studded headpiece have been placed in front of the shrine. The brass container that holds the material essence of Twumpuduo has been set on an *asipim* —a chair associated with chiefs—rather than the usual stool. In addition, a red fez and a gold "soul-washers" pendant have been placed on top of the shrine. The former demonstrates the manner in which traditions associated with other cultures, in this case Muslim, are often incorporated to enhance indigenous Akan institutions. Photograph by Raymond Silverman, May 4, 1980.

5.3 The most important Tano ɔbosom (god) in the town of Techiman, Taa Mensah, receiving a libation and a prayer from his priest, Kwabena Mensah, during the deity's Adae festival. This special day, devoted to venerating the god's powers and the former priests who have served him, is celebrated on Monokuo, a sacred day that occurs once during each forty-two-day Akan month. Taa Mensah is draped in white cloth, a symbol of spiritual purity. Photograph by Raymond Silverman, April 23, 1980.

5.2

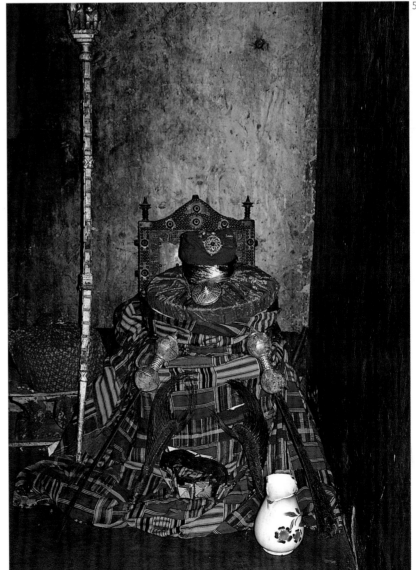

In the religious world of the Akan a large number of spiritual forces exist—forces that provide, protect, and maintain social order. Among the most prominent of these are the *abosom* (sing. *ɔbosom*), the gods. The bases for conceptualizing these spiritual forces are ideas of power and prestige found in the material world of the Akan. Thus kente cloth and other modes of visual expression are employed to dress the gods. The focus of interaction between *ɔbosom* and human is almost always a brass container that holds a mixture of substances and serves as the god's shrine (figs. 5.1, 5.2). The human characteristics of *abosom* are further elaborated by the use of regalia and the special rooms or compounds in which they are housed. It seems that this regalia and, in the past at least, the distinctive architecture associated with these shrines function as symbols of success and spiritual efficacy. They also act as indicators of status or rank relative to other deities and, in the Bono area, relative to chiefs as well. It is important to make this latter distinction for it helps to explain the manner in which material traditions generally regarded as secular are employed in various religious contexts.

In 1979–1980 I had the opportunity to study some of the traditions associated with the *abosom* found among the Bono (also known as Bron or Brong) in the traditional Akan states of Techiman, Nkoranza, and Asante. Most of my work was focused in and around the town of Techiman, a large commercial community strategically situated in the center of Ghana, which has served as the capital of the Akan state of the same name since the eighteenth century. The Techiman state was built in part on the ruins of the ancient state of Bono Manso. Established in the fifteenth century, Bono Manso is regarded as the first centralized Akan state. In 1723 it was conquered by the powerful Asante king, Opoku Ware I. Oral histories recorded in Techiman, Nkoranza, and Asante assert that the arts of kente weaving and goldwork originated in Bono Manso and that after its defeat, many Bono artisans were taken to the Asante capital, Kumase, where they played a key role in the production of the regalia that is a hallmark of Akan culture.[1] The territory that was once Bono Manso is now part of the states of Techiman and Nkoranza.

Central Ghana is the heartland of what is arguably one of the most revered religious traditions of the Akan, a tradition that involves the worship of the Tano River. The Tano is the longest river that runs through the Akan region, and its source is located near the village of Tanoboase, close to the site of the capital of the ancient state of Bono Manso. From this point, it flows south through the Akan states of Techiman, Ahafo, Sefwi, Anyi, Aowin, and Nzima, finally emptying into the Tano Lagoon on the Atlantic coast.

There are hundreds of shrines dedicated to the Tano in virtually every Akan state, even those located far from the river itself, and Tano worship is perhaps the most widespread of any Akan religious institution. Taa Kora is the original, or senior, Tano *ɔbosom* and is associated with the source of the river (see fig. 5.1). His shrine is maintained in Tanoboase. Not surprisingly the greatest concentration of Tano *abosom* is found in the Akan states of Techiman and Nkoranza, where the river originates. In Techiman alone there are at least 175 Tano shrines.[2] All ultimately derive from Taa Kora. Tano *abosom*, who may also be referred to as *atano*, are like all *abosom*, regarded as children of the supreme god, Onyame. In order to avoid any semantic confusion, it is necessary to define a few terms here that will be used throughout this essay. The deities that are the focus of this discussion are known as *abosom*: specifically, I deal with those associated with the Tano River, who may be referred to as *atano*, and witch-catching deities known as *abosommerafoɔ* (sing. *ɔbosombrafoɔ*). The names of the *atano* are often preceded by the word "Taa," a reference to their association with the Tano River. The material objects that represent the earthly abodes for these *abosom* are referred to as shrines, and the architectural structures in which these shrines are kept are known as shrine rooms or shrine houses.

There is limited but convincing evidence suggesting that worship of the *atano* is among the oldest religious institutions of the Akan.[3] They are regarded as *tete abosom* (ancient gods), and their presence probably predates the dramatic sociopolitical changes that occurred among the Akan roughly five hundred years ago, changes that transformed what historians believe were egalitarian village-based communities into the stratified societies and centralized states that we know today. This transformation appears to have begun in the northern Akan region among the Bono.[4] Oral tradition suggests that the original shrine of Taa Kora was located in a cave near the source of the river—where an altar made of stones and dedicated to the god is still maintained—and that it was moved to Tanoboase, two miles from the cave, in the seventeenth or eighteenth century, well after the establishment of the Bono state. Further evidence for the early worship of the Tano River is found in the oral traditions regarding other ancient *atano*, such as Twumpuduo, whose shrine is maintained in the village of Tuobodom (see fig. 5.2), and Techiman Taa Mensah (fig. 5.3).[5] These explain how the deities first revealed themselves to and were

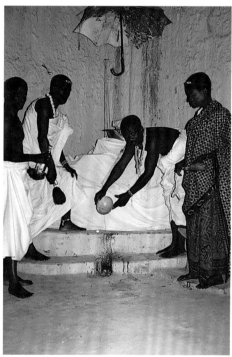

5.3

CHAPTER 5

The Gods Wear Kente

Raymond A. Silverman

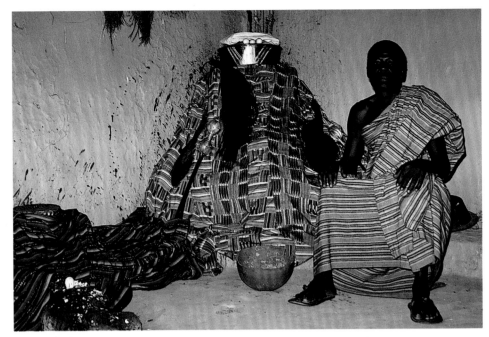

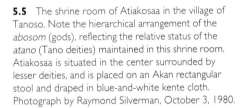

5.4 Kranka Taa Afua, a senior female Tano ɔbosom with her priest. Photograph by Raymond Silverman, Kranka, April 8, 1980.

5.5 The shrine room of Atiakosaa in the village of Tanoso. Note the hierarchical arrangement of the *abosom* (gods), reflecting the relative status of the *atano* (Tano deities) maintained in this shrine room. Atiakosaa is situated in the center surrounded by lesser deities, and is placed on an Akan rectangular stool and draped in blue-and-white kente cloth. Photograph by Raymond Silverman, October 3, 1980.

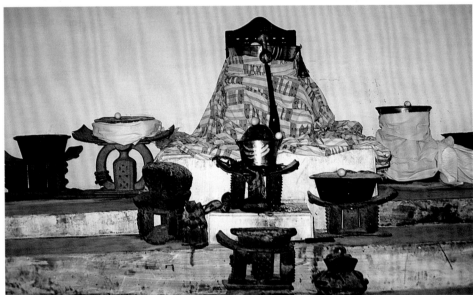

subsequently "domesticated" by hunters or people roaming in the forest. At present, we do not have enough information to reconstruct how the *atano* may have been represented or visualized five hundred years ago. It does, however, appear that the present mode of representing these deities was influenced by the rise of the Akan state.

As noted earlier, the visual imagery associated with the *atano* is in large part an expression of their efficacy, their success as spiritual forces. Though they are of another world, the *atano* are perceived as possessing certain human attributes. For instance, although most are male, they can be female as well, and gender is often reflected in their names (fig. 5.4); they maintain lineal relationships with other *atano*; and a few even profess to be Muslim.[6] They are "clothed" and fed by their priests or custodians, and their shrines, the brass containers that serve as their earthly abodes, are adorned with white chalk markings that delineate their faces. It is important to note, however, that the *atano* are never represented in sculpture or pictures. The sculptures found in some shrine rooms represent other spiritual forces who may assist the *atano* or his/her ɔbosomfoɔ (priest) in specific contexts.[7]

The most senior gods are perceived and treated as chiefs. In their shrine rooms one finds a profusion of shrines. No less than fifty *abosom* (not all of them *atano*) are maintained in the shrine rooms of the four oldest *atano*, Taa Kora, Twumpuduo, Techiman Taa Mensah, and Tanoso Atiakosaa. Twenty-one *abosom* are found in Techiman Taa Mensah's shrine room alone. Many of these deities are regarded as the offspring of the senior deity maintained in a given shrine room; they are lesser gods. The manner in which they are arranged in the shrine room reveals the hierarchy that exists among them, as among the chieftancy (fig. 5.5). The lesser gods are often said to represent the spiritual attendants or

court of the senior *ɔbosom.* Taa Kora is never carried or directly consulted. Like an Akan *ɔmanhene,* or paramount chief, he has an *ɔkyeame,* or spokesman, the Tano *ɔbosom* Atiakosaa, through whom he communicates with his human supplicants. There are specific days on which Taa Kora may be consulted. In figure 5.6 we see Atiakosaa being carried by his priest during the monthly Adae festival. The stool upon which Atiakosaa's shrine is placed in Taa Kora's shrine room is draped in kente on this important occasion (fig. 5.7).

The position of the major *atano* as chiefs among the *abosom* and as the spiritual counterparts of Bono chiefs is further reflected in the regalia they own. In Techiman, the major Tano *ɔbosom,* Taa Mensah, is actually regarded as the Techimanhene's equal—his spirit-world counterpart. The god is thus maintained in a palace that rivals that of the state's *ɔmanhene.* The regalia owned by Taa Mensah and other major *atano* includes state swords, spokesman's staffs, fly whisks, umbrellas, drums, ivory trumpets, kente cloth, gold-studded headgear, and gold jewelry.

The amount of regalia associated with Tano shrines ranges from virtually nothing to collections as rich as those owned by paramount chiefs. An *ɔbosom*'s regalia serves as a material indication of the deity's power and position relative to other gods. Thus Tano deities like Taa Kora, Twumpuduo, and Techiman Taa Mensah have large collections of regalia (see figs. 5.1, 5.2). There are many oral traditions that relate the practice, no longer prevalent today, of chiefs sending regalia in the form of stools, swords, umbrellas, etc., to *atano* who had assisted them in some way. At times, for instance, prior to going to war, a chief would seek the assistance of a particular *ɔbosom* promising it the enemy chief's political regalia if the campaign met with success. Today it is only very seldom that a chief gives regalia to a god. Instead the *ɔbosomfoɔ* will take the moneys given to the deity by supplicants and purchase regalia for the shrine. This shrine regalia is used in a manner similar to that in which a chief uses his regalia. On occasions when the deity "sits in state," the shrine is placed on a rectangular stool, headgear is positioned on top of the brass container, cloth (usually kente or a sumptuous imported cloth) is draped around the container and the stool, state swords and fly whisks are arranged around the base of the stool, and spokesman's staffs and umbrellas leaned against a nearby wall (see figs. 5.1, 5.2). During sacred periods, the god, like a chief, will don a white cloth reflecting a state of spiritual purity (see figs. 5.3, 5.8).

Much of the regalia is carried by the deity's attendants when the shrine is aired. In Techiman for instance, during important annual festivals, Taa Mensah emerges from his shrine room dressed in a decorative cloth and wearing a cowrie-studded red fez. Surrounded by his attendants and lesser *abosom,* the deity is carried by his *ɔbosomfoɔ* under one of his umbrellas preceded by his *abrafoɔ* (executioners) carrying swords, *akyeame* with spokesman staffs, and *ahoprafoɔ* (elephant-tail bearers) carrying fly whisks. The shrine's drums follow, sounding praises to the god. Structurally, such a procession is identical to that involving a chief and remains the ultimate display of the deity's status (fig. 5.9).

It is important to point out, however, that there are many *atano* who do not hold a prominent position in the hierarchy. The majority of *atano* shrines in Techiman were

5.6 Tanoboase Atiakosaa, Taa Kora's *ɔkyeame,* or spokesman, carried by his priest. Taa Kora, the paramount Tano god, is never carried or consulted directly by supplicants seeking the deity's assistance, but like a great chief, communicates through his *ɔkyeame,* Atiakosaa. Photograph by Raymond Silverman, April 23, 1980.

5.7 The stool for Tanoboase Atiakosaa draped in kente cloth, like Taa Kora, in celebration of the great deity's monthly Adae festival. The shrine itself, which usually sits on top of the stool, has been removed from the shrine room so that is may be consulted, as seen in figure 5.6. Photograph by Raymond Silverman, April 23, 1980.

5.8 Atiakosaa at Tanoboase, dressed in a white cloth on Fofie, another one of the Taa Kora's sacred days. Like Taa Mensah, illustrated in figure 5.3, Atiakosaa dons a white cloth signifying his spiritual purity. Photograph by Raymond Silverman, May 30, 1980.

5.7

5.8

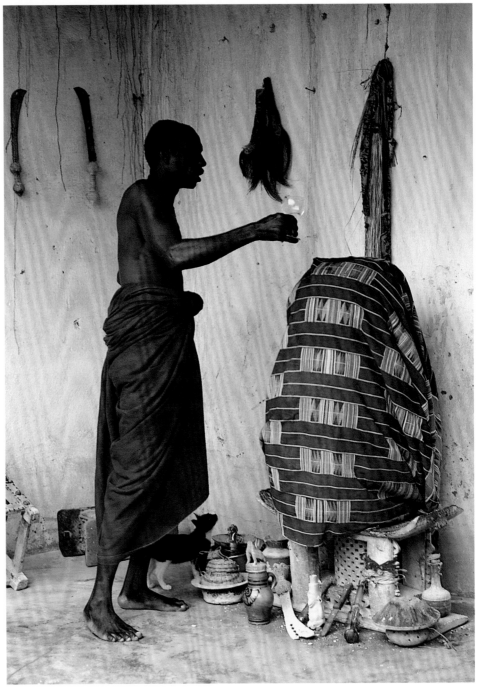

5.9 Procession of Techiman Taa Mensah and lesser *atano* (Tano gods) during the annual Techiman Apɔɔ festival. Like Akan chiefs, the deities are carried through the town followed by attendants who display the deities' regalia, symbols of their status and power. Photograph by Raymond Silverman, March 25, 1980.

5.10 Shrine of the Tano *ɔbosom* Taa Kwabena at Duase, near Kumase. Taa Kwabena's priest, Nana Kofi Opoku, pours a libation. Photograph by Raymond Silverman, October 5, 1980.

5.11 Kwaku Pong, the priest of the anti-witchcraft god, Kranka Brakune, sitting in state in the god's shrine compound. Since the god cannot be presented publicly, its efficacy is projected in the sumptuous kente cloth worn by Brakune's priest and the regalia carried by the deity's attendants. Photograph by René Bravmann, 1968.

established in the last 150 years, and many of these gods, despite their lack of prominence, possess large collections of regalia. The strictly observed rules governing the use of regalia in the political lives of humans do not seem to apply to the gods. An individual who is not a chief would not dream of owning and displaying the regalia reserved for chiefs, even if he could afford it. But the priests of *atano* who are especially efficacious and whose shrines attract many supplicants often purchase regalia for the deities they serve. These *atano* are quite literally dressed in a manner that expresses or reflects their success as spiritual forces whose powers can be used by state, village, family, or individual. The visual devices utilized in expressing this success are virtually the same as those used by chiefs and, in the religious realm, by the great *atano* (Taa Kora, Taa Mensah, etc.)

This use of regalia as an indicator or expression of success and spiritual efficacy is carried over into other religious domains, such as those involving the *abosommerafoɔ* . In contrast to the *atano*, whose roles have been described as prophetic, preventative, protective, providing, healing, and martial, the function of the *ɔbosombrafoɔ* is primarily politico-judicial: combating witchcraft, controlling those who use evil medicine, and executing implacable offenders. With the exception of one *atano* (Botwerewa) and a specific class of *abosommerafoɔ* known as Ntoa, most of the witch-catching deities appear to be newcomers to the Bono pantheon of gods. Botwerewa presents something of an anomaly for, unlike other *atano*, this deity has the ability to punish transgressors; other *atano* must seek the assistance of an *ɔbosombrafoɔ*.

Typically, the material essence of witch-catching deities is enclosed within a leather-bound wooden container. A good example of this form is a Ntoa shrine located at Sessiman near Nkoranza. Ntoa are unusual in that they and the aforementioned Botwerewa are the only witch-catching deities that may be regarded as *tete abosom*, ancient gods. The material traditions associated with the conceptualization or visualization of Sessiman Ntoa as a venerable and successful spirit are similar to those of the *atano*. Sessiman Ntoa owns a good deal of regalia.

As previously indicated, the great majority of shrines for witch-catching deities have appeared among the Bono much more recently than that of Sessiman Ntoa, and they present a very different picture. Several scholars (e.g., Debrunner 1961; Field 1970; McLeod 1975) have discussed these shrines among the Akan during the last hundred years. Without going into great detail, it seems that the increase may be explained as a response to certain social pressures occurring during the colonial and postcolonial eras. Specifically, they may be seen as a manifestation of the increased emphasis on individualism that has developed during the present century. It is significant that this sense of individualism is projected in the presentation of the anti-witchcraft shrines themselves, so that in contrast to the relatively conventional representation of the *atano*, the shrines of the *abosommerafoɔ* take a variety of forms. Indeed, in the highly competitive atmosphere in which *abosommerafoɔ*—or more accurately, the deities' priests—are vying for supplicants, innovation and uniqueness are often the key to success. The constraints associated with the *atano* are thus often cast aside. The wide range of images associated with the witch-catching deities in the Techiman area can be seen at a number of popular shrines.

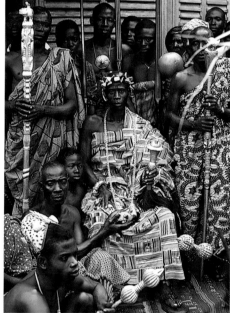

5.11

One example is the successful shrine of Brakune found in the village of Kranka located a short distance from Tanoboase. This shrine was established about eighty years ago, and its "parent" is located outside the Akan area, near Lawra, among the Dagarti in northern Ghana. Tradition requires that the deity remain sequestered, hidden from public view, but the ubiquitous symbols of power and success are still present. In this case Brakune's priest, Kwaku Pong, becomes the vehicle for display as he dons the accoutrements of an Akan chief (fig. 5.11).[8] This shrine has been so successful that its presence eclipses even that of the town's ancient Tano *ɔbosom*, Taa Afua. It is also interesting that both René Bravmann and Malcolm McLeod in the late 1960s photographed a recently carved mask associated with this shrine that supposedly represented Brakune. As far as I know, it is the easternmost example of a basic mask type associated with combating sorcery known as *gbain* that Bravmann (1974, 119–46) documented to the west, near the Ghana-Côte d'Ivoire border. It is a unique example of masking among the Bono and demonstrates the license given these priests in creating a material presence for the gods they serve.

In the context of this volume, I have emphasized the fact that kente and other symbols of wealth and power are used in specific contexts (fig. 5.10). It seems that the process of dressing both the *atano* and *abosommerafoɔ* draws upon the same set of symbols—including kente cloth and gold regalia—that serves as an expression of power and status in the political and social lives of the Bono and other Akan peoples. These symbols are used to celebrate and advertise success and to express spiritual efficacy.

70

B.4

Interleaf B
Scenes of Bonwire

Although there are forty or more villages and towns north of Kumase where weaving is a significant occupation of many inhabitants, Bonwire is the legendary and "official" home of Asante kente weaving. It is Bonwire that attracts tour buses and researchers alike. It has become the subject of songs (see "Singing about Kente," interleaf D), as well as the home of the first Asante kente festival (see "Bonwire Kente Festival," interleaf E). Weaving is said to have begun in Bonwire after two brothers observed Ananse the spider weaving his web. The photographs in figures B.1 and B.3 were taken by David Mayo, 1997; the remainder of the photographs are by Doran H. Ross, 1997.

B.1

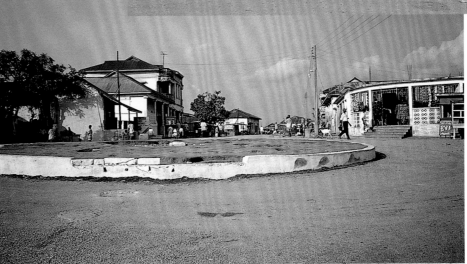

B.3

B.2

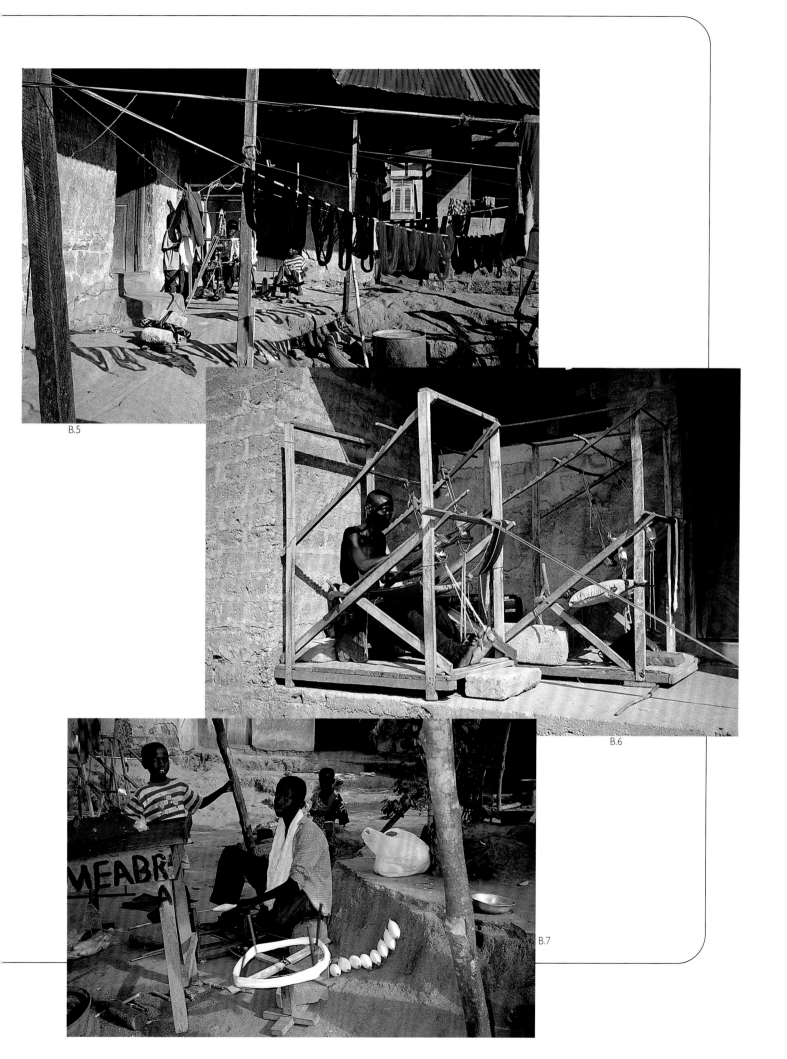

B.5

B.6

B.7

Interleaf C
Signs of Bonwire

In 1969 Bonwire had just one store selling ready-made kente. By 1997 at least twenty-five stores were marketing a variety of kente-adorned products—stores with names such as Abusua (Family) Kente Ventures and Brɛguo Yɛ Ya (To toil for nothing is painful). The sign on the bottom right (fig. C.6) is now in the Fowler Museum collections (wood, metal, and pigment; length 122 cm; FMCH X96.33.2). Local store owners had demanded that the sign's original owner remove it from the center of the roundabout in the middle of town, as it gave too much prominence to a single enterprise. All photographs are by Doran H. Ross; figure C.6 was photographed in 1996, and the remaining photographs were taken in 1997.

C.1

C.2

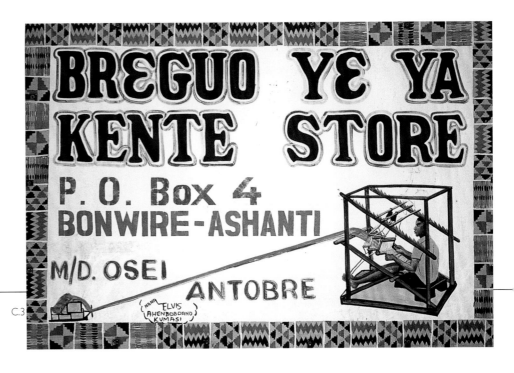

C.3

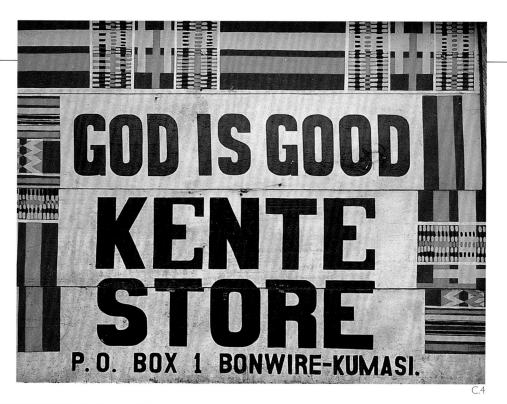

GOD IS GOOD KENTE STORE

P.O. BOX 1 BONWIRE-KUMASI.

C.4

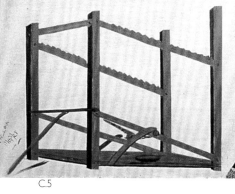

ABUSUA KENTE ➡ VENTURES

Box 16 Bonwire Ash.

C.5

KYERE BADU ADOM KENTE STORE

P.O. BOX 19 BONWIRE-ASHANTI

KING OF KINGS
NANA ELVIS
AHENBOBOANO
KUMASI

C.6

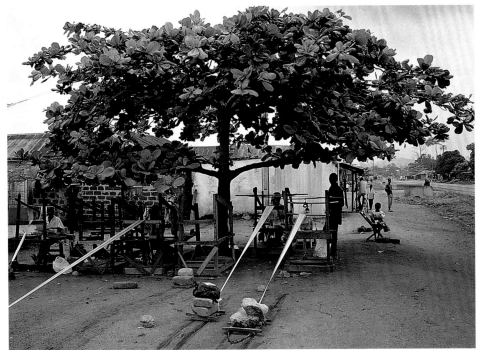

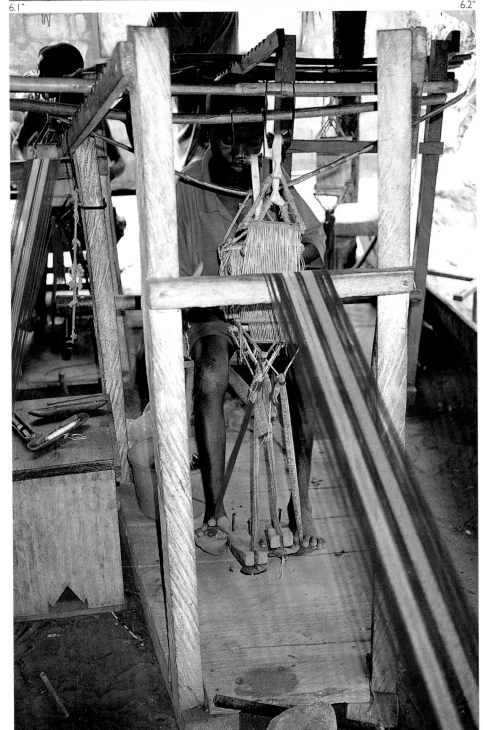

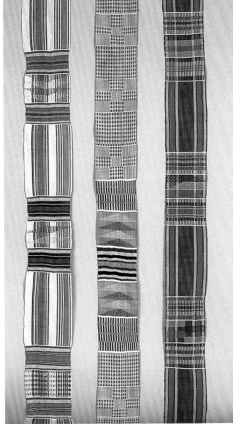

6.1 Asante weavers. Photograph by Doran H. Ross, Ntonso, 1997.

6.2 Ewe loom with Oyokoman warp. Photograph by Doran H. Ross, Agotime Akpokope, 1997.

6.3 Detail of three Asante kente strips. Cotton. Width of strip on left 8.7 cm. NM 84.291; NM 84.290; NM 84.298.

6.4 Textile fragment. Tellem culture. Eleventh to twelfth century. Cotton. National Museum of Mali. Photograph by Rachel Hoffman, 1989.

6.5 Textile fragment. Tellem culture. Eleventh to twelfth century. Cotton. National Museum of Mali. Photograph by Rachel Hoffman, 1989.

The History of the Loom in West Africa

Written descriptions of looms, weaving technologies, and their histories often prove difficult for both author and reader. Nevertheless, knowing how kente is produced is essential to understanding its design elements, their meanings, and the history of the cloth itself. It also provides a basic vocabulary for further discussion of these issues.

Both the Asante and Ewe weave on the horizontal narrow-band treadle (pedal) loom (figs. 6.1, 6.2). This is the basic loom type throughout most of West Africa, an area framed on the west and south by the Atlantic Ocean, on the north by the edges of the Sahara Desert, and on the east by the area around the present eastern border of Cameroon—a region of almost two million square miles (Lamb and Lamb 1980). Within this area there are a few exceptions to this loom type—most notably a ground loom with fixed heddle in northeastern Nigeria and northern Cameroon and a fixed vertical loom in southern Nigeria that is operated by women (for further discussion of loom types, see Lamb 1975 and Lamb and Lamb 1980). There are minor regional variations within the category of the horizontal narrow-band treadle loom (for example, a tripod loom is common in Sierra Leone). Up until the past twenty years, however, all of these minor variants could be subsumed under the rubric of horizontal treadle looms, and all were operated exclusively by males.

West African horizontal treadle looms produce narrow bands of cloth that may be less than 2.54 cm in width or as wide as 38 cm.[1] As a result they are often referred to as narrow-strip looms. Most Asante and Ewe weaves are between 7.5 and 11.5 cm wide (fig. 6.3). The woven strips, regardless of their width, must be cut at fixed intervals and sewn together selvage to selvage to create a larger piece of cloth. An Asante man's cloth typically requires twenty-four strips.

The significant similarity between most West African horizontal treadle looms suggests a shared history. Venice Lamb's (1975) survey of these looms and their potential sources remains one of the best reviews of key issues. Although the earliest known African weavings exist in the form of cloth made of flax found in ancient Egypt (Emery 1963, 222), excavations at Meroe, in present-day Sudan, provide the first evidence of woven cotton (including cloth fragments) in Africa; these finds date from 500 B.C.E. to 300 C.E. (Shinnie 1967, 159; Bergman 1975, 5–10). Lamb suggests the possibility that weaving technology might have entered West Africa from this source, perhaps along with the knowledge of iron smelting, and she singles out the two-thousand-year-old Nok culture in northern Nigeria as the beneficiary of this discovery (1975, 74). My own reading of the literature regarding Nok, however, does not reveal any evidence for weaving in the area. Fragments of plain weave were found at sites dating from the ninth to the eleventh century at Igbo Ukwu in southeast Nigeria, but they consist of grass, leaf, and bast fibers and not cotton (Shaw 1970, 1: 240–44).

As an alternative to the introduction of weaving technology from the east, Lamb suggests North African origins via the caravan trade. She posits that this could have been associated with the spread of Islam and its tenants concerning modesty in dress (1975, 74–84). The introduction of the camel to the trade between 200 and 400 C.E. and the reports of Arab geographers as early as the ninth century regarding the existence of gold in West Africa would perhaps have facilitated, if not fueled, such a transfer of information.

The earliest extant cotton textiles known today in West Africa date from the eleventh and twelfth centuries. They were recovered from the burial caves in the cliffs of the Bandiagara Escarpment above villages currently inhabited by the Dogon peoples in the modern state of Mali (figs. 6.4, 6.5). These textiles are attributed to a group called the Tellem who, according to biological research, are not direct ancestors of the Dogon. In one cave alone (Cave C), in addition to the remains of three thousand individuals, one hundred and fifty cotton textile fragments were recovered, including parts of twenty-one tunics (Bolland 1991, 108, 109). All were narrow-strip weaves varying between 18 and 26 cm (Bolland 1991, 73). Most of the fragments are plain weave or weft-faced plain weave with a restricted color range of natural cotton and blue derived from indigo dye. Many examples have subtle warp and weft stripes forming an overall checked pattern.

Textile historian Renée Boser-Sarivaxévanis gives preeminence to the Fulani (Peul) peoples and their caste of weavers (MaabuuBe) for the introduction of loom technology to West Africa stating that they "are known as the earliest and best weavers of the whole region" (1991, 39). The Fulani were originally nomadic pastoralists spread across much of the savannah from Senegal to Chad. She credits them with the introduction of the shaft loom for weaving wool as well as for the development of a loom for weaving cotton based on the former (1975; 1991, 38). She also goes so far as to assert that they "were certainly also the first cotton weavers of sub-Saharan Africa" (1975, 41). Boser-Sarivaxévanis is

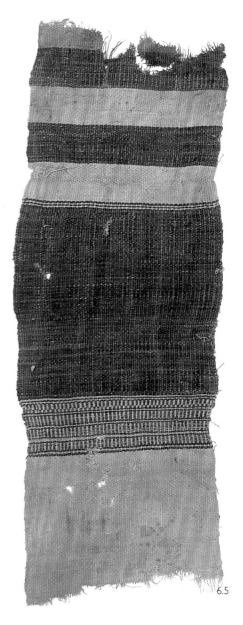

6.5

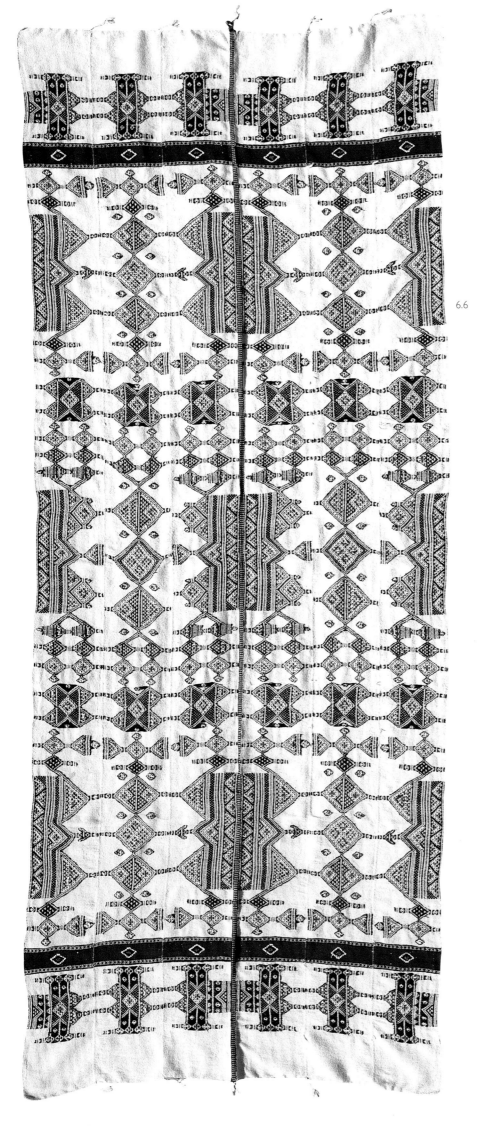

6.6

6.7

6.6 Contemporary Fulani young man's blanket (*kaasa landaka*). Natural dyes on handwoven narrow-band wool cloth. Length 369 cm. FMCH X87.501.

6.7 State drums covered with Fulani woven cloth called *nsa* by the Asante. Photograph by Doran H. Ross, Mampon, 1976.

6.8 Funeral of the Apagyahene of Abiriw, Nana Asifu Yao Okoamankran. The deceased has been laid in state on a brass bed covered with a European-made metallic cloth. The walls of the room are covered with Fulani-made *nsa* and kente. Documentation and photograph by Michelle Gilbert, Abiriw-Akuapem, 1992.

6.9 Counselor's staff (*ɔkyeame poma*) depicting Ananse the spider, who according to Asante folklore introduced weaving to the area. Photograph by Doran H. Ross, Akuropon, 1976.

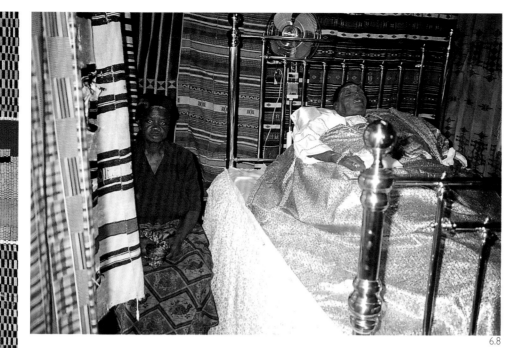

6.8

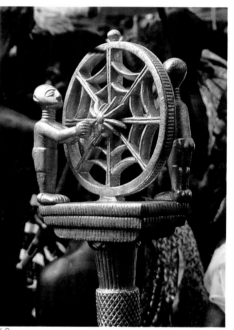

6.9

confident in her conclusions, and Rattray and Lamb lend some support to them.

Rattray also believed in a northern origin for Asante weaving, but he relied on a single oral tradition and the fact that cotton had to be imported from the north to support his position (1923, 220). Lamb's argument for northern origins is more detailed and specifies three different traditions as sources of influence: *kyekye* cloth from the Bondouku region of the Ivory Coast; Mossi weaving from Upper Volta; and *kassa* blankets from the Fulani of Mali (fig. 6.6; Lamb 1975, 104–10). Rattray was aware of the last of these traditions and noted the use of *nsa* cloth (the Asante name for *kassa*) in several sacred contexts including: a cover for the black stools at Bekwai (1923, 95); a cover for the Golden Stool (1923, 289 n. 3); the state umbrella for the Golden Stool (1927, 130); and as a "dress" for drums (fig. 6.7; Rattray 1927, 283–84). Lamb adds that Fulani blankets are also used as liners in the palanquins of Asante chiefs (1975, 89). In addition these cloths also serve in Asante funeral practices (Lamb 1975, 106, fig. 172). Among the Akuapem these Fulani blankets still line the interiors of the temporary funerary structures whose exteriors are covered with kente (figs. 6.8, 3.20, 3.21). As far south as the Fante on the coast, this author has observed Fulani blankets in use as *asafo* flags and as war shirts. The wide geographic spread of this textile type among the Akan and its use in highly charged ritual contexts suggest substantial historical depth for its presence and influence.

Although neither Lamb nor Rattray makes this point, it may be linguistically significant that the Asante name for the Fulani blanket (*nsa*) is also the name applied to the warp threads of the weave (Christaller 1933, 416), to the loom (*nsadua;* see Rattray 1927, 232), and to the finer silk weaves (*nsaduaso;* see Lamb 1975, 128). Whether these linguistic relationships reflect actual historical connections will require further research.

Historical reconstructions aside, the oral traditions known by virtually all weavers in Bonwire provide two accounts of the introduction of weaving to the Asante region. According to one account, during the time of Oti Akenten, in the mid-seventeenth century, two brothers named Nana Kuragu and Nana Ameyaw were in the forest hunting when they came across the spider Ananse weaving his web. After observing the spider for some time, they returned to their home village of Bonwire and introduced the weaving of raffia and subsequently cotton cloth. Significantly a spider plays the same role in Ewe accounts of the origin of weaving discussed by Adedze (chapter 9). Ananse, it should be noted, is credited with the creation or introduction of many phenomena in Akan folklore, including much of the folklore itself (fig. 6.9).

The second Asante account is also typically set in the time of Oti Akenten and tells of a man named Ota Kraban who visited Gyaman, in the area near present-day Bondouku in Côte d'Ivoire. He returned with a loom of the type currently in use and erected it in Bonwire on a Friday, hence the name of the loom Nsadua Kofi (*nsadua* "loom"; and "Kofi" being the day name for a male born on Friday). Ota Kraban is also credited with creating the cloth named after his own Oyoko clan, Oyokoman.[2]

There is undoubtedly some truth in the second account, as Asante weaving has many affinities with that of the Bondouku region, an area renowned for its cloth even before the founding of the Asante Empire. Towns such as Kong, Begho, and others northeast of Asante were situated on a well-traveled trade route that eventually connected the Asante heartland with trading centers such as Mopti and Jenne in the inland Niger Delta of present-day Mali (Lamb 1975, 81–88, 92). Significantly both of these centers are in an area known for Fulani weaving (see Gardi 1985).

6.10 Detail of Asante man's cloth with a weft-faced design called *bankuo*. Cotton. Width of warp strip 9.2 cm. FMCH X96.30.19.

The Evolution of Asante and Ewe Weaving

Regardless of source of influence, both Asante and Ewe weaving must have evolved following the same general series of steps. First was the introduction of the horizontal treadle loom and with it the weaving of cotton, which for the most part had to be imported into Asante from the north but was also grown locally in some Ewe regions. The first strips were undoubtedly plain weave with simple undyed-cotton and indigo-dyed warp stripes and simple weft designs; they would have been woven with a single pair of heddles. Despite the simplicity of this initial stage, a variety of stripe patterns could be produced. The fact that even today Asante kente in all its complexity takes its names from warp patterns is strong evidence that this is the beginning of the tradition. At some point, perhaps very early on, cotton dyed with a fairly restricted palette of additional colors was introduced into the process as were preliminary solid color weft-faced designs that are called *bankuo* by the Asante (fig. 6.10). These were probably initially limited to indigo with the gradual addition of other hues. It is impossible to confirm which of these innovations came first.

The next step was the unraveling of foreign silks, imported initially from the north and later the south, in order to increase the availability of thread colors (see chapter 10). These were first used selectively for single color weft-faced designs, and as they became more available, they were occasionally employed for the warp threads. As the color range expanded, so did the complexity of weft-faced patterns, eventually evolving into the mix of solid color bands of weft stripes known today as Babadua (fig. 6.11), a term that refers to a segmented cane similar to bamboo. The introduction of a second pair of heddles gathering warp threads in groups of six (and less commonly two, four, and eight) facilitated more complicated weft inlays called *adwen*. This term has been variously translated as "ideas" or "designs." Each block of *adwen* has its own name.

These stages of development are reflected in Asante patterns of nomenclature for weavings of different complexity. As mentioned in the introduction, kente is not the word the Asante use for their fine weaves, but rather *nsaduaso*. Within this umbrella term are four categories of weaving: Ahwepan, Topreko, Faprenu, and Asasia. Ahwepan is a plain-weave cloth either with or without simple weft stripes and thus requiring only a single pair of heddles (fig. 6.12a,b).[3] Topreko (passed once) typically features the characteristic kente composition of two blocks of weft-faced Babadua framing a block of weft-faced *adwen*, created with double or triple weft threads going over and under alternate groups of six warp threads manipulated by a second pair of heddles. This is followed by a ground thread. Weavers and cloth sellers refer to Topreko in English as "single weave" (fig. 6.13). The *adwen* block in Faprenu (thrown twice), also woven with two pairs of heddles, is created by two or three hand-picked supplementary weft threads or double or triple weft threads wound on a single bobbin with the threads passed back *and* forth (separated by a shift of the heddle) before the ground thread is inserted. It creates blocks of *adwen* so densely packed by the beater that none of the warp threads can be seen through the weft (fig. 6.14). This is referred to in English as "double weave" because it uses twice as many weft threads in relation to the ground thread as does the Topreko. It is not, however, the double weave known to textile specialists, which produces two fabrics one over the other in the same textile (see Seiler-Baldinger 1994, 98–99). Faprenu appears to be predominantly a twentieth-century phenomenon. I know of few examples before about 1920.

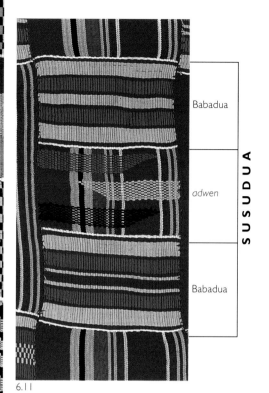

6.11

6.12a

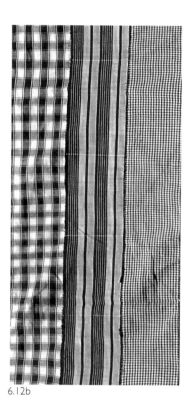

6.12b

6.11 Detail of characteristic Asante design unit named after the measuring stick called *susudua*. This unit includes a section of Babadua on each side of the design generically called *adwen*. Private collection.

6.12a,b Detail of Asante cloths with strips primarily of Ahwepan weave. Cotton. Width of warp strips (cloth on left) 10.3 cm. FMCH X96.30.62; FMCH X96.30.19.

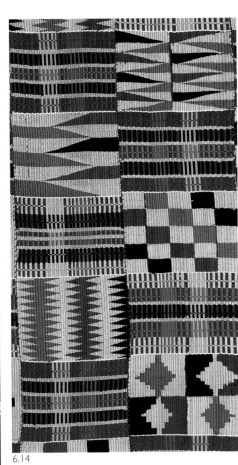

6.14

6.13

6.13 Detail of cloth type known as Topreko with "single weave" *adwen*. Cotton. Width of warp strips 8 cm. FMCH X87.506.

6.14 Detail of cloth type known as Faprenu with "double weave" *adwen*. Cotton. Width of warp strips 9 cm. FMCH X97.71.

Asasia is the rarest and most prestigious of the cloths. It is woven on three pairs of heddles; this produces a distinctive twill pattern in the diagonal alignment of the weft floats. The third pair of heddles allows for more intricate weft patterns (figs. 1.3, 6.15). Combined with the *asanan* heddles, this third pair of heddles is used to complete a twill effect in weft floats. Asasia cloths are the exclusive prerogative of the Asantehene and those he designates. They were traditionally woven by a single family of weavers in Bonwire. When Lamb was conducting her research from 1968 to 1972, she was told that there was only one weaver in the town who remembered the twill patterns and that he was no longer able to execute them (1975, 125–28). During my own research, as recently as 1997, I was told that there were actually several weavers still capable of producing Asasia and that only commissions from the Asantehene or other entitled chiefs were lacking. In any case it is obvious that these are the most labor intensive weavings. Lamb's observation that all the Asasia cloths she had seen were woven on Oyokoman backgrounds (1975, 127) is in accord with my own experience.

6.15 Detail of cloth type known as Asasia woven with a third pair of heddles and featuring a characteristic twill pattern. Silk. Length of full cloth 154 cm. National Museum of African Art, National Museum of Natural History. Purchased with funds provided by the Smithsonian Collections Acquisition Fund, 1983–85. EJ10579. Photograph by Venice and Alastair Lamb.

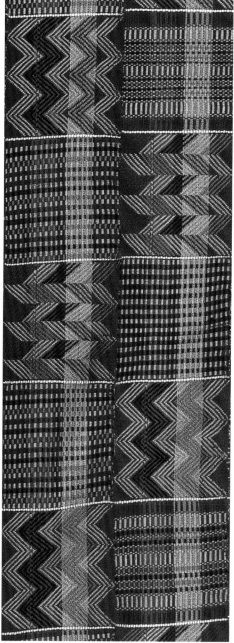

6.15

The Asante Loom

Today the Asante loom is typically built upon a wooden base, making it portable (fig. 6.16). Originally, however, it was firmly embedded in the ground. The loom consists of four vertical uprights, 158 cm high at the front. These are placed 133 cm apart on the side and 80 cm apart at the ends on the example in the Fowler Museum collection. The loom is often braced horizontally with two or four struts at the top and reinforced on each side with two additional pairs of parallel struts placed at a diagonal. The top strut of each of these diagonal pairs is notched to accommodate one or two movable crosspieces that serve as hangers for one or two heddle pulleys. The weaver sits on the descending end of the diagonal struts. Immediately in front of him is the breast beam upon which the warp threads are attached and the woven cloth wound. The warp extends out in front of the weaver through the reed in the beater, and also through the one, two, or three pairs of heddles before it passes over the warp beam and out up to twenty feet or more in front of the loom where the remainder of the warp is weighted on a sled to maintain tension on the loom (fig. 6.17).

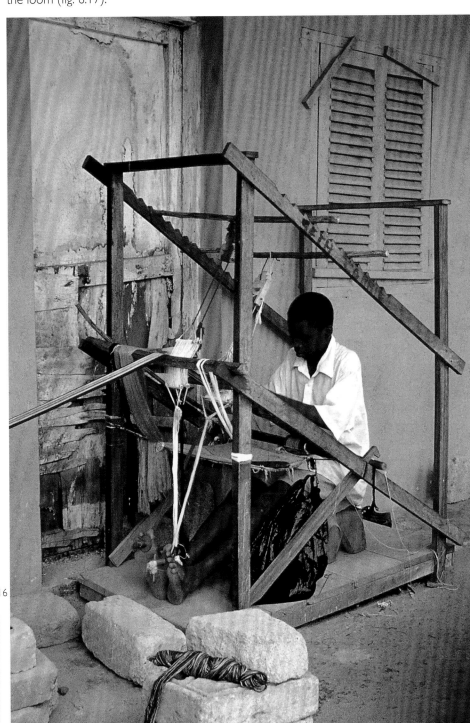

6.16 Seth Cophie working at Asante horizontal narrow-band treadle loom. Photograph by Doran H. Ross, Bonwire, 1997.

6.17 Heavily weighted sleds holding bundles of warp threads to maintain tension on the loom. Photograph by Doran H. Ross, Bonwire, 1997.

6.16

6.17

The Weaving Process

In the past the process of creating cloth began with the importation of raw or spun cotton from the savannah areas north of Asante. The Asante were still spinning some cotton at the time Rattray was conducting his research in the 1920s and 1930s, and the Ewe still spin and dye some cotton (fig. 6.18).[4] Today, however, the vast majority of weavers buy commercially produced thread in cotton, rayon, Lurex, or, more rarely today, silk (figs. 6.19–6.21).

As a first step in the weaving process, the weaver must wind the skeins of thread off of the skein winder (*fwiridie*) onto bobbins (*dodowa*) with the bobbin winder (*dadabena*; figs. 6.22, 6.23). This is often done by boys as young as five who are just learning to weave. The bobbins are then placed on the warp layer, or bobbin carrier, called by the Asante *menkomenam,* typically translated as "I walk alone" (fig. 6.24). Enough warp is then laid for up to as many as twenty-four strips in a man's cloth. Some individuals specialize in this process, which requires walking the warp threads around two poles set about 30 meters apart (fig. 6.25). At the starting point a third pole is set about 20 to 25 cm from the first,

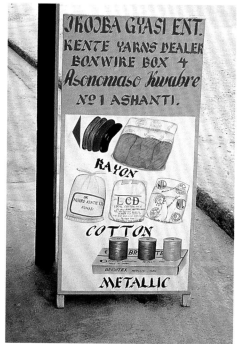

6.20^ 6.21˅

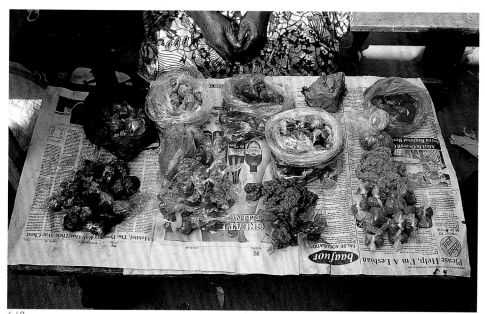

6.18

6.19

6.18 Assortment of dyes on sale at Ewe market. Photograph by Doran H. Ross, Agbozume, 1997.

6.19 Store selling weaving supplies, including Ewe heddle pulleys displayed on the counter. Photograph by Doran H. Ross, Kpetoe, 1997.

6.20 Sign in front of a thread seller's store. Photograph by Doran H. Ross, Bonwire, 1997.

6.21 Skeins of rayon yarn sufficient to weave a full man's cloth of the Oyokoman Adweneasa pattern. FMCH X97.36.41a-h.

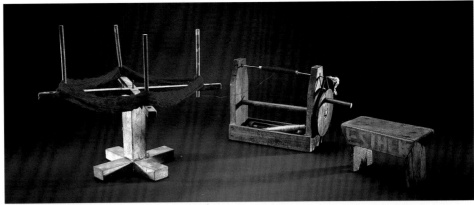

6.22ˆ

6.22a–c **(a)** Skein winder. Height 44.5 cm. Wood and nails. FMCH X95.52.3A-G. Anonymous Gift. **(b)** Bobbin winder. Height 27.5 cm. Wood, metal, rubber, and nails. FMCH X95.52.2.2A-C. Anonymous Gift. **(c)** Child's stool. Height 15 cm. Wood, pigment, and nails. FMCH X97.36.22. Museum Purchase.

6.23 Young boy winding two skeins of yarn onto a single bobbin for a double-thread weft. Photograph by Doran H. Ross, Bonwire, 1997.

6.24 Asante bobbin carrier with threads for Oyokoman warp. Height 27.8 cm. Palm rib, rayon threads, bamboo, metal. FMCH X96.30.45A-U. Museum Purchase.

6.25 Asante weaver laying the warp thread with the bobbin carrier. Photograph by Doran H. Ross, Bonwire, 1995.

6.26 The "weaver's cross," or laze, which allows the individual ordering of the warp threads. Photograph by Doran H. Ross, Bonwire, 1997.

6.27 Asante man retrieving the warp threads after they have been completely laid out. Photograph by Doran H. Ross, Bonwire, 1997.

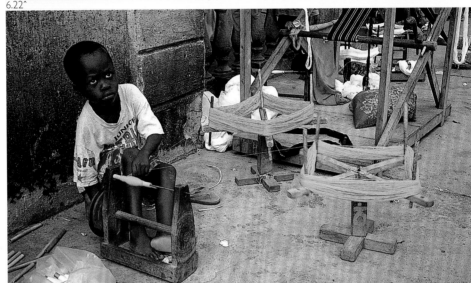

6.23ˆ

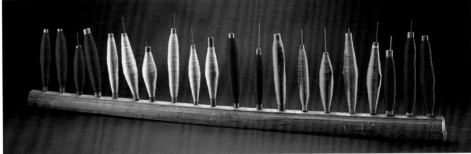

6.25ˇ　　6.24ˆ　　6.26ˇ　　6.27ˇ

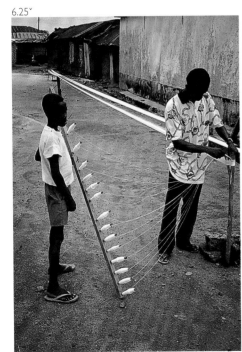

and in line with the other two. At the end of each lap around the second pole each individual thread is passed between the first and third poles, wrapped around the latter and crossed over itself before being taken back around the second pole, repeating the whole process again (fig. 6.26). This "weaver's cross," or laze, sets up the individual order of the threads, and each color is laid in order above the other to establish the desired warp-stripe pattern. Each group of threads of the same color is then tied together at the point of the crossover to maintain this order. Next the warp threads must be wound off of the poles onto a manageable armature in preparation for threading the heddles and reed (fig. 6.27).

Threading is a logical and extremely tedious process (fig. 6.28). The Asante and Ewe typically weave fine kente with two pairs of heddles (fig. 6.29). The first to be threaded is the *asanan* pair, the farthest from the weaver. The warp threads are gathered together in consecutive sets of six: every other group of six passes through a leash in the first heddle, and the remaining sets of six pass through a leash in the second heddle. These pattern heddles raise and lower alternate sets of six threads, creating a space (shed) through which the supplementary wefts pass to create weft-faced designs. When the shed is held open with the weaving sword, intricate hand-picked weft-faced designs can be created, which are based on these six-float units. Occasionally the *asanan* pair will be threaded in groupings of two, four, and/or eight threads in various combinations to facilitate greater variety in the weft patterns.

6.28 Threading the heddles. Photograph by Doran H. Ross, Bonwire, 1997.

6.29 *Asatia* (left) and *asanan* (right) heddles, purchased in Bonwire. Wood and rayon. Width of *asatia* heddle 15.5 cm. FMCH X96.30.71D, B.

6.30 Reed, or beater (*kyereye*), purchased in Bonwire. Wood, cordage, and palm rib. Height 14 cm. FMCH X96.30.71F.

6.31 Breast beam of loom showing attachment of warp threads. Photograph by Doran H. Ross, Bonwire, 1997.

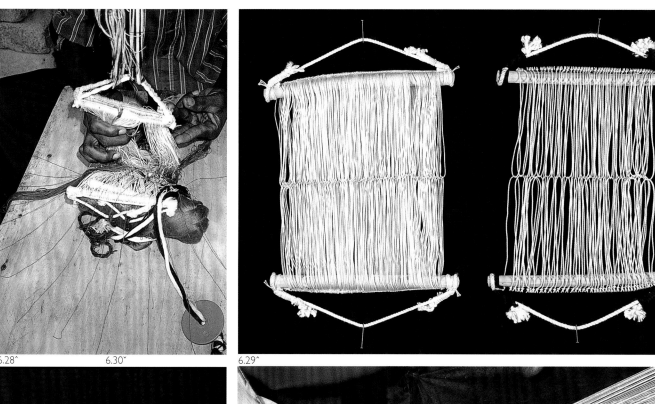

6.28^ 6.30˅ 6.29^ 6.31˅

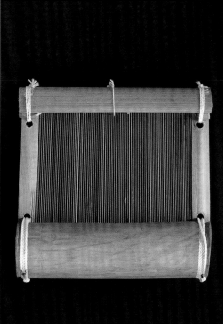

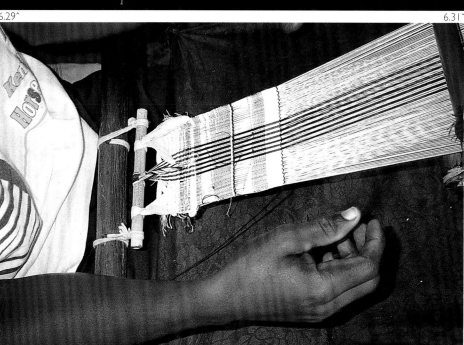

The second pair of heddles is called *asatia* and is responsible for the basic structure (ground) of the cloth. The groups of six threads emerging from the *asanan* are separated into individual threads. Every other thread passes through its own leash in the first of this pair of *asatia* heddles, and the remaining threads in order are passed through the leashes of the second *asatia* heddle. Careful to maintain the correct order, the reed (fig. 6.30) is then threaded with groups of four threads passing between each of its dividers. Finally the warp threads are secured onto the breast beam (fig. 6.31).

Each of the above pairs of heddles is connected to its mate by a cord that passes through a pulley. At the bottom of each heddle is a cord terminating in a toehold made of a calabash, coconut shell, or, more commonly today, parts of old rubber sandals. This counterbalanced arrangement when suspended from a loom permits the weaver to use his feet to raise and lower either pair of heddles depending on where he is in the weaving process. The complete warp rig consists of two pairs of heddles with pulleys, the reed, breast beam, and threaded and partially woven warp. It is entirely portable and may be taken off the loom frame and carried inside at the end of a day of weaving (fig. 6.32).

Before actual weaving can begin, additional bobbins must be wound with thread for use in the shuttles (fig. 6.33). Additional threads must also be cut in about 1-meter lengths to be used for hand-picked inlays; these are typically hung over the warp beam until needed (fig. 6.34). For plain-weave portions of the strip, the shuttle is thrown back and forth through the shed. The shed is created by the weaver who pumps his feet up and down in the toeholds that raise and lower each *asatia* heddle in an alternating sequence. After a number of back and forth passes of the shuttle, the weaver will sharply pull the reed toward him to evenly pack down the weft threads (figs. 6.35–6.37). Occasionally the weaver will wax the warp threads with the side of a candle to facilitate the up-and-down exchange of the two sets of warp threads and speed the movement of the shuttle. After weaving a fixed length of plain-weave cloth, as determined using the *susudua*, or measuring stick, the weaver then transfers his feet to the toeholds that manipulate the *asanan* heddles. Here he would usually begin weaving the design element called Babadua, multicolored bands of weft-faced plain weave also created using the shuttle but going between alternating groups of six threads.

6.32 Warp rig with partially woven cloth, two pairs of heddles with pulleys, reed, and unwoven warp threads. Length of warp rig 89 cm. Photograph by Doran H. Ross, Bonwire, 1997. FMCH X97.36.21F.

6.33 Shuttles with bobbins and rayon thread. Wood, metal, bamboo, and rayon. Length of longest shuttle 22.7 cm. FMCH X96.30.72a–d.

6.34 Asante weavers working under the shade of a tree. Photograph by Doran H. Ross, Ntonso, 1997.

6.35–6.37 Three views of the weaving process on different looms. Photographs by Doran H. Ross, Bonwire, 1997.

6.32

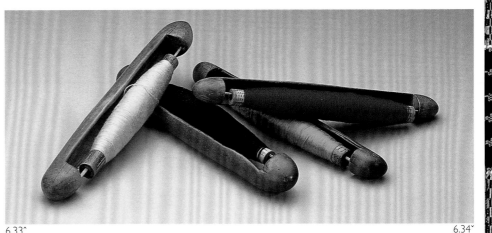
6.33^

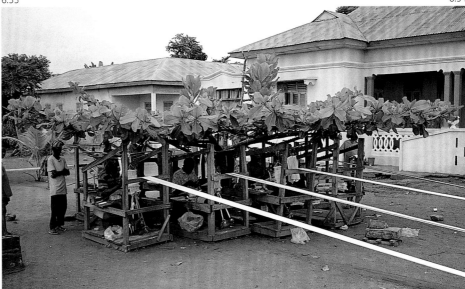
6.34˅

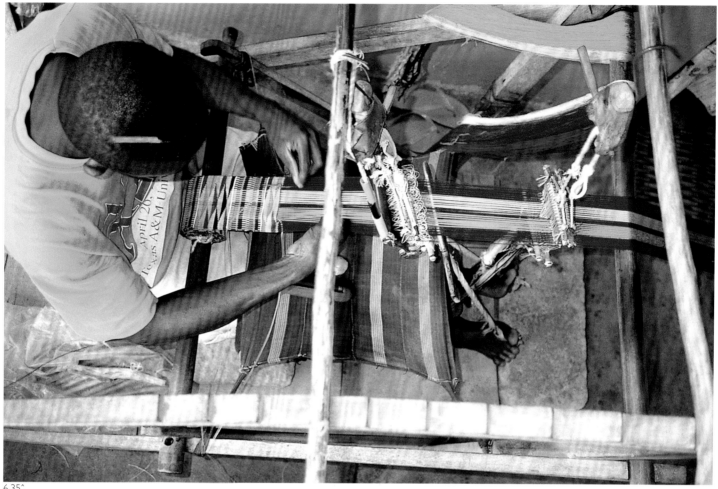

6.35^

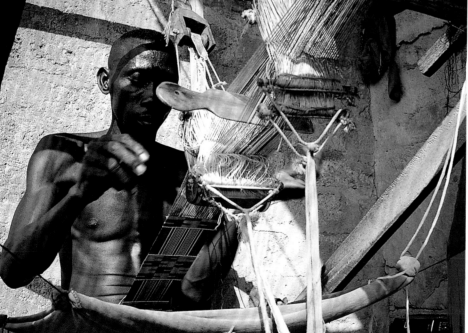

6.36^

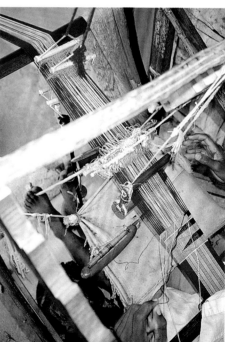

6.37^

After a measured length of Babadua, the weaver would typically shift to hand-picking the design for an *adwen* section. Ewe weavers would more likely use shuttles here. Regardless, the shuttle is still used at this stage to maintain the ground of the cloth but only after each line of supplementary weft has been inserted. This usually entails laying doubled weft threads between each ground thread in order to increase the predominance of the weft face. To avoid shifting his feet back and forth between the two pairs of toeholds for the two pairs of shuttles, the weaver usually pulls down one of the *asanan* heddles by hand and inserts the weaving sword into the open shed. When the measured unit of *adwen* is finished, another section of Babadua is woven before returning to the plain weave of the warp pattern.

If the cloth is intended to have borders (see cat. no. 11) on each of the long sides, the weaver must calculate where they fall. In order to obtain the checkerboard effect with the final sewing, the body of the alternate strips must begin with the Babadua/*adwen*/Babadua sequence and every other strip must begin with the plain-weave block. As the weaving progresses, portions of the woven strip are rolled onto the breast beam using the lever inserted into one of the holes at the end of the beam. This lever also prevents the beam from unrolling. If the roll of woven material on the breast beam becomes too bulky, the warp will be cut at the end of a complete strip and the warp threads reattached to the breast beam. Once the desired number of strips are woven they will be cut into individual strips and then sewn (fig. 6.38). Hand sewing is still considered the most desirable (fig. 6.39), but most cloths today are machine sewn (fig. 6.44).

6.38

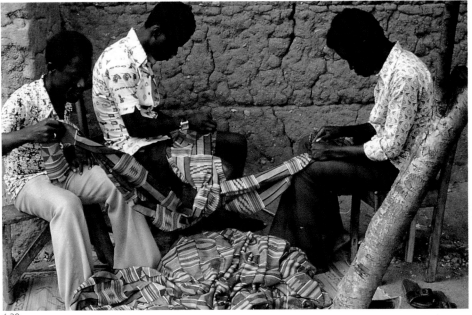
6.39

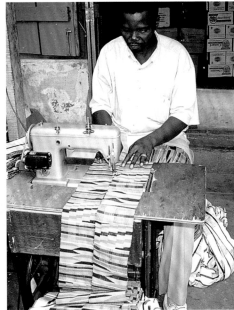
6.40

6.38 Woven strips ready for sewing purchased in the main Kumase market. Rayon. Width of strips between 12.2 and 14 cm. FMCH X96.36.40a–s.

6.39 Hand sewing of kente strips. Photograph by Herbert M. Cole, Bonwire, 1973.

6.40 Machine sewing of kente strips. Photograph by Doran H. Ross, Kumase, 1997.

6.41 Asante heddle pulleys. Wood and metal. Height of tallest 26.3 cm. FMCH X97.36.26A–C (hand); FMCH X96.30.74A–C (face); FMCH X66.911 (Akua'ba).

6.42 Ewe heddle pulley from Agbozume. Iron. FMCH X97.9.1.

6.43 Asante heddle pulley. Wood. Height 18.3 cm. National Museum of African Art and National Museum of Natural History, EJ10660. Photograph by Venice and Alastair Lamb.

Some parts of the weaving apparatus are occasionally given special aesthetic attention. The heddle pulley (figs. 6.41–6.43) may be carved in the shape of a human head or as the conventionally shaped Akua'ba (Akua's child), the Akan fertility figure (see Ross 1996). In fact, it has been suggested that the creation of a cloth and the conception of a child are related in that both benefit from some form of spiritual intervention (Cole and Ross 1977, 42). The disc-shaped Akua'ba or its regional variants also appear on the end of weaving swords along with other purely decorative forms (figs. 6.45-6.47). The sword (*tabon*) is responsible for holding open the shed between the two sets of warp threads to allow the hand-picking of weft designs. Like the pulley, it is one of the hardest working and most visible parts of the loom.

6.41

6.42

6.43

6.44ˆ 6.45˅ 6.46ˆ 6.47˅

6.44 Bono heddle pulley. Wood, string, and nails. Height 15 cm. National Museum of African Art, 96-13-1, Smithsonian Institution. Gift of Philip L. Ravenhill in memory of Sylvia H. Williams. Photograph by Franko Khoury.

6.45 Asante weaving sword. Wood. FMCH X97.36.25.

6.46 Asante weaving sword. Wood. Length 25.5 cm. National Museum of African Art EJ10659. Photograph by Venice and Alastair Lamb.

6.47 Asante weaving sword. Wood. Length 28.6 cm. NM 88.76.

6.48 Child's loom. Wood, metal, and cotton. Length 70.5 cm. FMCH X96.30.44a,b.

6.49 British-designed broad loom at National Cultural Centre. Photograph by Doran H. Ross, Kumase, 1997.

In addition to the horizontal narrow-band treadle loom, two other looms must be mentioned to complete the picture of Asante weaving technology. The first is a child's loom used in the past to teach the fundamentals of weaving (fig. 6.48). It has no heddles, and the wefts are inlaid by hand using a weaving sword, which also serves as a beater. This teaching tool was still in use during the 1920s (Rattray 1927, 233), but in recent years training has more typically begun with the full-sized loom.

The second loom is a British-made broad loom (fig. 6.49), which was introduced to Kumase sometime before 1957 when John Biggers observed looms of this type in use at the University of Science and Technology (1962, 9). In 1972 Lionel Idan began aggressively promoting the use of this loom at the University and at the National Cultural Centre and for most of the 1970s broadloom cloth in familiar kente patterns was popular among many Asante. Today, however, it has largely fallen out of favor, and many of these cloths are readily available on the market. Today broad looms are frequently used to produce weavings with representational imagery such as the wall hanging featuring a portrait of Kwame Nkrumah that is illustrated in chapter 10 (see fig. 10.34).

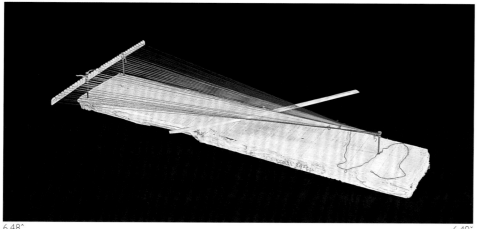

6.48^

6.49˅

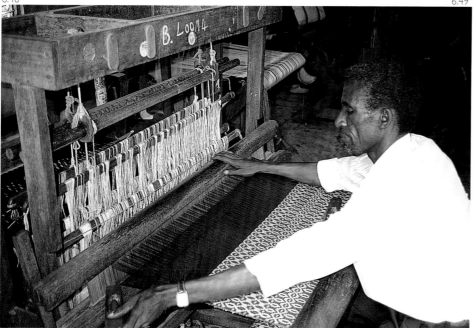

What's In a Cloth?

An entirely "double woven" Oyokoman Adweneasa similar to the cover image consists of the following rayon skeins (hanks) of thread (fig. 6.21):

warp:	14 red
	7 green
	7 gold
weft ground:	12 red
weft designs:	20 gold
	6 green
	6 black
	6 purple
	2 blue
	1 white

81 total skeins @ 1,800 Ghanaian *cedi* per skein = 145,800 *cedi*. At an exchange rate of 2,195 *cedi* to the dollar (as of September 1997), this would make the total cost of the thread for this cloth u.s. $66.42.

Each skein is about 1,340 yards long, so there are approximately 108,540 yards, or 61.67 miles, of thread in this cloth.

width of strips:	9-9.2 cm
length of cloth:	314 cm
width of cloth:	217 cm
weight of cloth:	7.4 lbs
warp threads per cm:	44 green
	42 yellow
	30 maroon
weft threads per cm:	20
warp threads per strip:	336
time to set up the loom:	4 days
time to weave:	4 months
selling price in the Accra market:	$310

Interleaf D
Singing about Kente

The popular song "Bonwire Kentenwene" was composed and recorded by Ephraim Amu in 1961 and became an instant hit in Ghana. The rhythmic sound of the heddles and shuttles is imitated in the refrain. The song is frequently recalled in Ghanaian discussions about the future of kente (see, for example, Dadson 1998, 17; Yankah 1990, 17). Yankah also refers to a "wonderful choral piece" called "Daa Daa Kente" composed by N. T. Essuman (1990, 17). Photographs by Doran H. Ross, Bonwire, 1997.

"Bonwire Kentenwene" (Twi Version)

1. Akyinkyin akyinkyin ama mahu nneɛma,
 Akyinkyin akyinkyin ama mate nsɛma,
 Asante Bonwire kentenwene menhuu bi da oo,
 Asante Bonwire Kentenwene mentee bi.
 Kwame Onimadeɛyɔ ne kentenwene na abɔ me gye,
 Ne nsa, ne nan, ne nsɛdua, sɛ wogyigye ni.

Refrain*
 Kro, kro, kro, kro, hi, hi, hi, hi, Krohikrohi krokrokro,
 hi, hi, krokrokro, hi, hi, krohikro,
 Krohikro n'ayɛ me dɛo, ayɛ me dɛo,
 Bonwire kentenwene na, ayɛ me dɛo, abɔ me gye.

2. Kentenwene dwom yi afa m'adwene dennen,
 Baabiara a mefa mereto no dennen,
 Na nnipa a wohuu me nyinaa hui sɛ asɛm da me so.
 Na me ho yɛɛ wɔn nwonwa ma wɔbɛkyeree me so,
 Eno Ohuonimmɔbɔ bɛfaa me kɔe kɔsoɛe ne fi
 N'ɔpataa, me ara bisaa me manantese.

3. Ohuonimmɔbɔ ante mase ara de,
 Nanso ɔbɔɔ mmɔden yɛɛ ho biara maa me,
 ɔmaa me nkatekwan pa bi di mee pa ara,
 Na ne dɛ maa me werɛ fii me dwom no kakra,
 ɔmaa me baabi pa dae ɔdasum pɛ m'abɔ dagye,
 Kentenwene dwom kro yi ara na mere to.

4. Mankyɛ Bonwire hɔ na mesan me baa fie,
 Me dwom no yɛ nnipa pii dɛ na wɔ pɛ atie,
 ɛmaa mani gye pii sɛ manya biribi pa rekɔ,
 Na meduu fie pɛ mekɔɔ ahemfie anantesebɔ,
 Mmerante ne mmabaa ne nkwankoraa mmerewa ne mmofra,
 Wɔbae, bɛboae, wɔn nyinara bɛkyeree me so.

* Refrain is repeated after every verse.

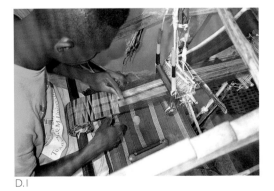

D.1

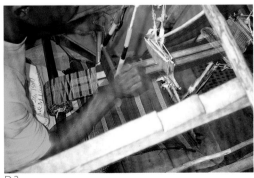

D.2

"Bonwire Kente Weaving" (English Version)

1. Roaming about has made me observe things,
 Roaming about has made me hear of stories,
 Asante Bonwire Kente weaving, I've never seen before,
 Asante Bonwire Kente weaving, I've never heard about before.
 The craftsmanship of Kwame, the expert Kente weaver, amazes me.
 His hands, his feet, the shuttle sound thus:

Refrain*
 Kro, kro, kro, kro, hi, hi, hi hi, Krohikrohi krokrokro,
 hi, hi, krokrokro, hi, hi, krohikro.
 I'm delighted at the sound krohikro,
 Bonwire kente weaving makes me go crazy.

2. My mind is filled with this kente weaving song.
 Wherever I go, I sing aloud.
 All who saw me realized that I had something on my mind.
 They were surprised and crowded around me.
 The merciful old lady took me to her home,
 Calmed me down, and asked why I was here.

3. The merciful old lady did not seem to understand me.
 But she did her best to help me.
 She gave me a bowl of delicious peanut soup, which I ate to my
 satisfaction.
 It was so delicious that I forgot about the song for a while.
 She prepared a place for me to sleep. When sleep came, I had dreams
 singing this same Kente weaving song.

4. I was not long in Bonwire and left for home. My song captivated many
 people and they wanted to listen.
 I felt happy that I had something worthy to take along.
 Soon on arrival at home I went straight to the chief's palace to
 proclaim my message.
 Young men, young women, old men, old women, and children,
 They came in their numbers and flocked around me.

*Refrain is repeated after every verse.

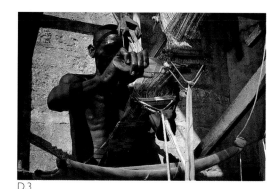

D.3

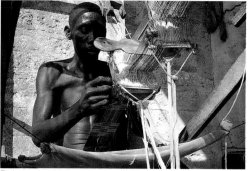

D.4

94

Interleaf E
Bonwire Kente Festival

The first Bonwire Kente festival—held January 5–11, 1998—celebrated "300 Years of Kente Evolution (1697–1997)." Presided over by Nana Nyarko Frimpomaa, the queen mother of Bonwire (fig. E.3), the festival included an exhibition, fashion show, weaving competition, *durbar*, dance, and sporting events. In attendance was Nana Konadu Agyeman-Rawlings, the wife of the President of Ghana (fig. E.8). The event was inaugurated to foster further economic development in the region and to reassert "the importance of Bonwire as the home and centre of the Kente weaving industry (Oteng 1998, 2)." Photographs by Cornelius Adedze, Bonwire, 1998.

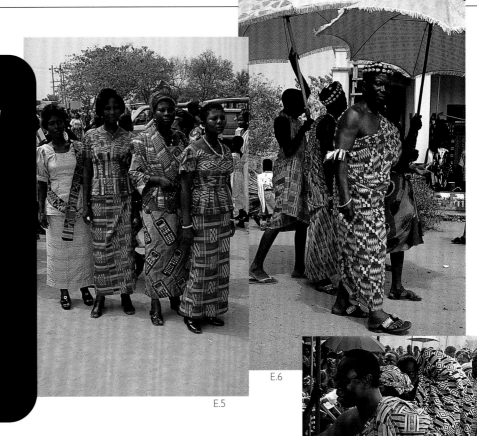

E.6

E.5

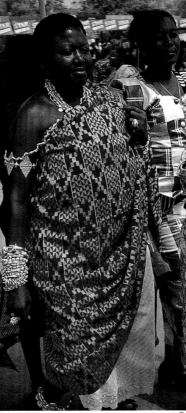

E.4

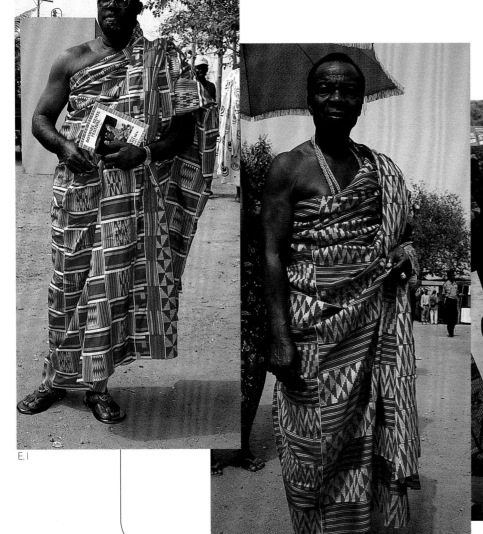

E.1

E.2

E.3

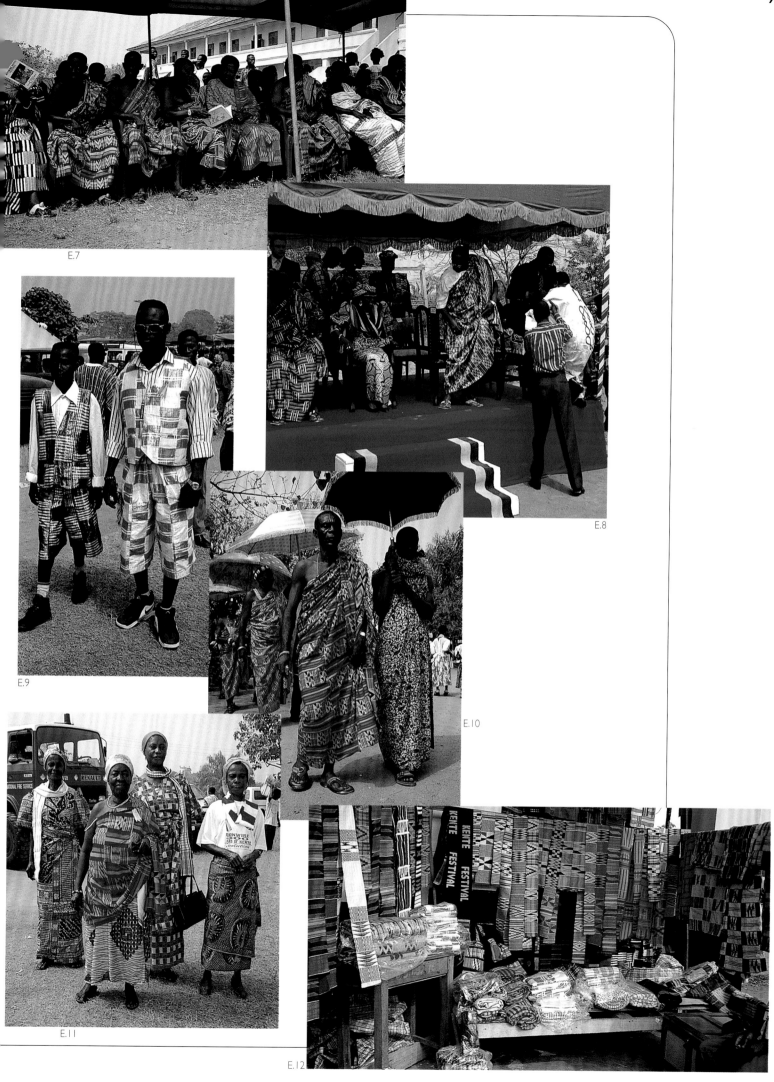

E.7

E.8

E.9

E.10

E.11

E.12

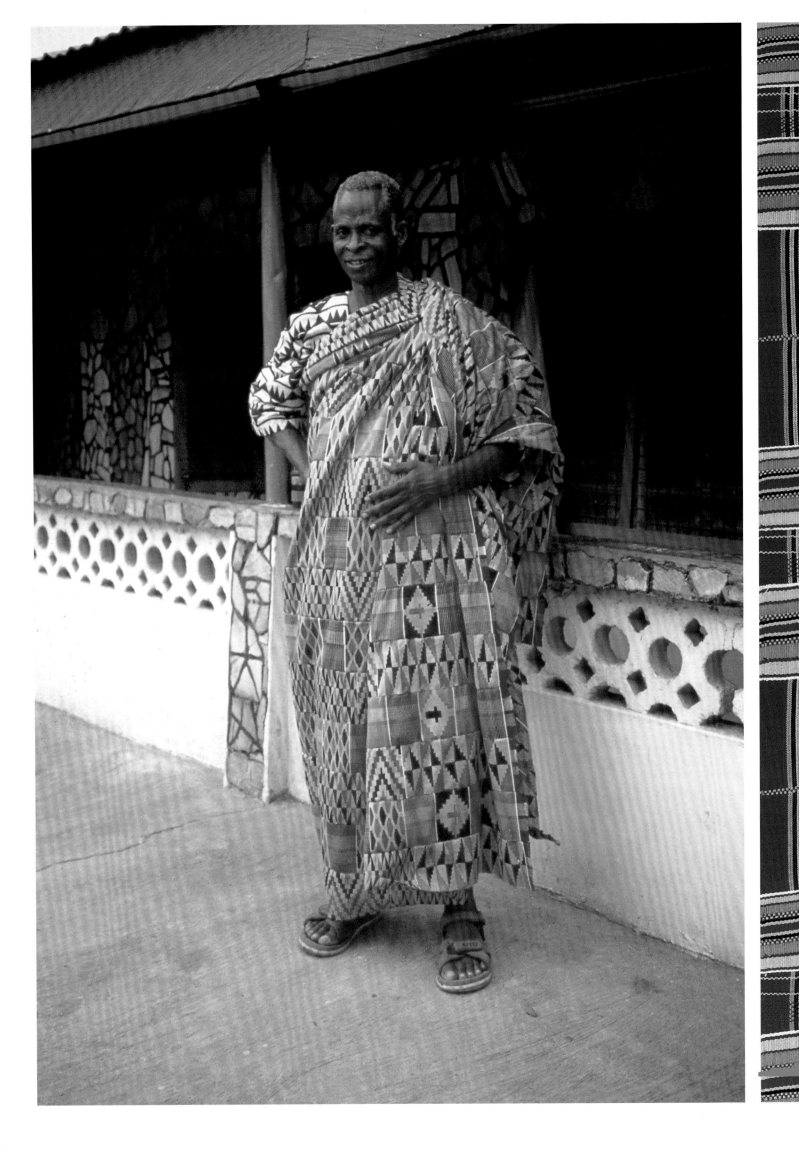

A Weaver's Story

Bonwire is the officially recognized center of Asante kente weaving.[1] Numerous small shops selling kente are clustered along its main street and bear names such as New Life Enterprise and God is Good Kente Store (see interleaf C, "Signs of Bonwire"). Nearby, a large, boldly lettered sign reads "Kente? Contact Samuel Cophie" and features an arrow pointing toward a shop located slightly away from the town center (figs. 7.2, 7.3).

One of eight children, Samuel Cophie[2] was born in 1939 in the Ewe town of Anyako in the southeast Volta Region of Ghana. Weaving is one of the main industries of Anyako, where it is referred to as "family work." Sons traditionally learn to weave from their fathers, and Cophie began to "sit at the loom" when he was six or seven. As is typical, he practiced on the last few yards of thread that remained on the loom after a project was completed. Of Cophie's seven brothers, five learned to weave.

Cophie left school at approximately sixteen, and after a brief stint as a police officer in the nearby town of Koforidua, he turned to weaving as a career. For five years he wove on contract for another weaver, Adjei Mensah, but by the end of the first year, he was also securing commissions on his own. Initially he specialized in the weaving of "Ewe kente," which often incorporates representational motifs, but later he began to explore Asante weaving in which the designs are more purely geometric.[3] He was aided in this by his ability to look at a pattern and then reproduce it; as he explains, "This is my talent."

Mensah encouraged Cophie to experiment and to combine Ewe and Asante designs. When Mensah died in 1960, Cophie decided to move to Bonwire, Mensah's hometown. He worked as a contract weaver in Bonwire for thirteen years. As an outsider, he was initially ignored, but gradually his weaving talents were recognized, and ultimately local weavers began to copy his weaving and even came to him for help.

In 1973 or 1974 Cophie produced and put on display two five-strip shawls on which he had woven state drums, swords, umbrellas, and stars. As luck would have it, on a single day five tourist buses arrived in town, and instead of the typical price of fifty to seventy *cedis* each, Cophie received more than double that amount for each shawl. With this capital, he was able to start his career as an independent weaver.

By the mid 1970s Cophie had become well-known, especially among the embassy community, and had received orders for his kente from the Yugoslavian, Canadian, and British high commissioners, as well as from the staff of the United Nations Development Program. His fame thus spread well beyond Bonwire. *Indutech*, an industrial-technical exhibition held in Ghana in 1986, brought foreigners flocking to Cophie's shop. Cophie credits his knowledge of English with helping his business, but his willingness to experiment has also been an important asset. A cloth he created for the Canadian High Commissioner, for example, incorporates a very unusual warp of blue, green, and black, as the commissioner did not want the dominant gold typical of Asante kente (fig. 7.4). The resulting cloth not only pleased the client, it continues to be made and to find admirers over twenty years later.

7.2

7.3

7.1 Samuel Cophie at home wearing a recently completed special order kente for an enstoolment. Photograph by Anne Spencer, Bonwire, Ghana, 1997.

7.2 Sign indicating the direction of Samuel Cophie's shop. Photograph by Doran H. Ross, Bonwire, Ghana, 1997.

7.3 A kente sign woven by Samuel Cophie in 1976, which formerly hung inside his shop. Rayon and Lurex. Length 63cm. FMCH X96.30.68. Museum purchase.

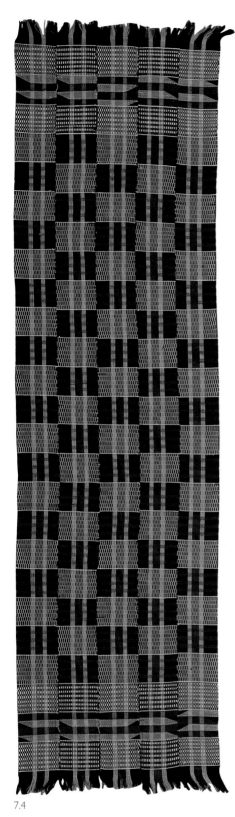

7.4

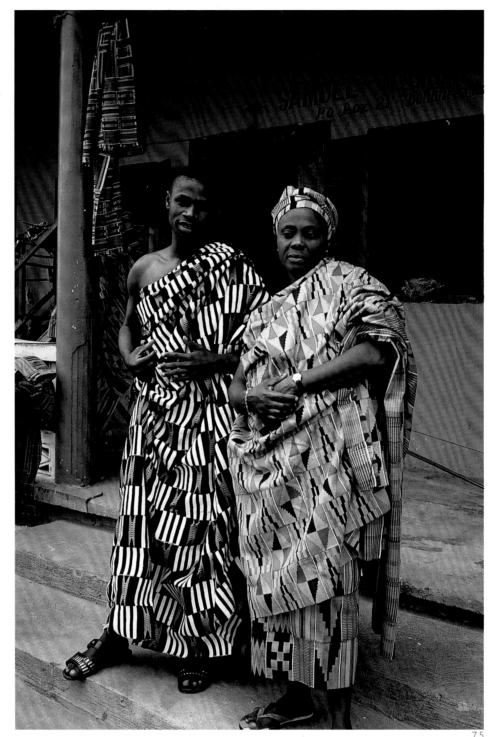

7.5

By Cophie's estimate, Bonwire contains eight hundred houses and approximately two thousand weavers—not all of whom reside there permanently.[4] Naturally, as his reputation spread, Cophie experienced some resentment in Bonwire on the part of local weavers who felt that an "outsider" was taking away their business. The support of Kwakudua, the chief of Bonwire, helped to temper this. At present, according to Cophie, resentment has subsided. A law, however, does state that visitors must park at a distance from his shop and walk there on foot, and there has been some controversy over the two signs he uses to direct clients to his shops (figs. 7.5–7.7). Cophie is the only weaver in Bonwire to have two shops; he opened the second, which is smaller, three years ago.

Cophie's house is a mile or so from town, and its courtyard is clearly the center of activity (fig. 7.1). Verandahs on two sides are typically occupied by weavers, who sit out of the sun's glare. Nearby are the granary and cooking area. Cophie's wife Dinah is an Ewe woman, and she helps him to run his shop. Of his six children, four are boys. Three of his sons are already weavers: Akwasi and Joshua weave at home, and Bempa runs Cophie's second shop. His fourth son, Seth, is presently learning to weave (fig. 7.8). In addition to running a successful weaving business, Cophie also engages in farming to provide for his many dependents. He grows maize to keep the large granary full, and he also raises yams, cassava, and vegetables. Farming is a seasonal activity, however, and weaving is a year-round business.

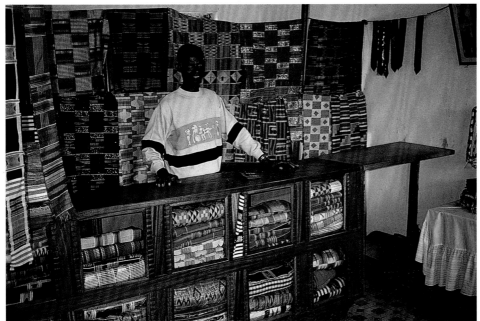

7.6

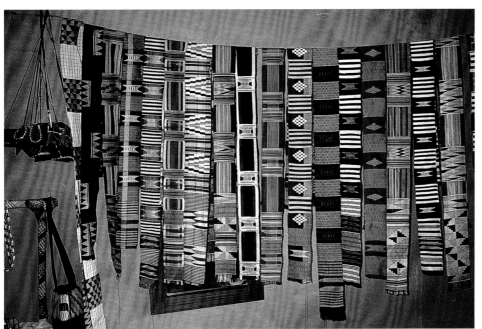

7.7

7.4 Shawl designed by Samuel Cophie. The original pattern was created for the high commissioner of Canada. Cotton and rayon. Length 180 cm. Private collection

7.5 Samuel Cophie's son Bempa and wife Dinah standing in front of his principal shop. Photograph by Doran H. Ross, Bonwire, Ghana, 1997.

7.6 Samuel Cophie behind the counter at his principal shop. Photograph by Doran H. Ross, Bonwire, Ghana, 1996.

7.7 Interior of Samuel Cophie's principal shop. Photograph by Doran H. Ross, Bonwire, Ghana, 1997.

Managing a Kente Business

Seventeen weavers presently work on contract for Cophie. This number varies depending on the current demand for kente. Numerous factors can influence this market. The impending election in 1996, for example, led to a decrease in foreign visitors with a concomitant reduction in sales.

Cophie provides the thread for twelve of his contract workers, and the other five supply their own. The five who supply their own thread are self-employed and may even have employees of their own. Cophie buys finished kente cloth from them. Since 1957, when Ghana gained independence, cotton and rayon threads, which were formerly imported, have been produced locally. Silk, which is used only occasionally, is, however, still imported and quite expensive. When he has an order for silk, Cophie goes to neighboring Togo to purchase the thread and buys extra to have in reserve. Since thread accounts for 70 percent of the price of a finished piece of cloth,[5] an adequate supply of thread represents a considerable capital investment. At present Cophie's contract weavers are using nine different warp patterns. Cophie either tells the weavers what he wants them to do or gives them a strip as a sample to follow. Five of his current contract weavers were formerly apprentices.

In addition to his son, Seth, Cophie now has four apprentices, ranging in age from fourteen to twenty-two (fig. 7.9).[6] They have been working for lengths of time varying from ten months to two years; the apprenticeship can last up to three years. In the past Cophie has trained as many as ten apprentices at once. When a boy becomes an apprentice, his parents enter into a relationship with the weaver, and this usually involves a payment of

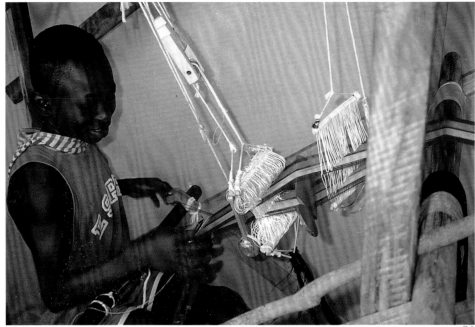

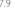
7.9

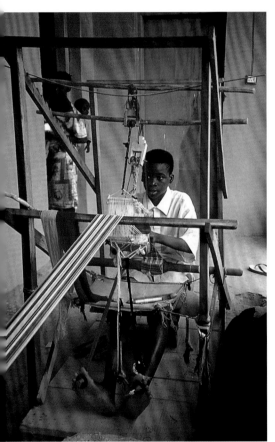

7.8 Seth Cophie executing a double weave kente design on the verandah of his father's shop. Photograph by Anne Spencer, Bonwire, Ghana, 1997.

7.9 Frank Abuo weaving at Samuel Cophie's principal shop. Photograph by Anne Spencer, Bonwire, Ghana, 1997.

6.10 Shawl designed by Samuel Cophie. The original design was produced for the family of the deceased wife of the Asantehene. NM 97.25.15. Photograph by Sarah Wells.

some sort. Cophie's primary concern is that the apprentice be obedient, and he makes it clear to parents that their children can be dropped from the apprenticeship if they prove difficult. Cophie provides the loom and the materials, and in turn, he owns the cloth that the apprentice produces. The apprentices wear their practice cloth, which is known as "household cloth." As their work improves, it can be sold in the market.

Although students may already know how to weave when they come to him, Cophie initially teaches them how to wind bobbins. Instruction in how to measure, or "lay" a warp follows. The apprentice is then ready to learn how to thread the heddles that will separate the threads during weaving. Learning how to arrange the threads in the proper order to create a desired pattern is the most difficult step in the course of instruction. Students learn by watching Cophie. At first he demonstrates using only two colors; gradually, he increases the number to four.

Once students start weaving, Cophie emphasizes developing a rhythm in plain weave. After mastering Ahwepan (plain cloth with simple warp stripes), students learn to throw two shuttles at a time. This enables them to weave Babadua, which is characterized by weft stripes of different colors, as well as Akyem and Wotɔa, both of which have rows of short vertical columns of alternating colors. By the end of six months, students should have progressed to the Babadua stage. From there, they can begin learning designs, starting with single weave. Only after mastering these techniques will they be ready—"their minds will be open," according to Cophie—to tackle double weave, the most time-consuming form of kente weaving in which the warp is completely covered by the weft designs.

Supervision is provided throughout the apprenticeship. Mistakes are left in the cloth, but the learner is given help so that he may avoid them in the future. The more experienced apprentices help to teach the beginners. At the end of a year, an adept apprentice can pick up new designs on his own. Cophie believes that if a student hasn't mastered the art of kente weaving in three years, he should be told to pursue another career. There is no formal "graduation ceremony" when instruction ends. Instead, the apprentice's parents typically bring Cophie a small gift, perhaps some limes. Cophie indicates that he is a Christian and tries to base his business on Christian values. For this reason, he will not accept a more expensive present, such as a ram, from the parents of an apprentice.

Clients

Cophie's analysis of his own clients and their buying habits is very revealing. Today approximately 40 percent of his clientele is made up of Ghanaians. Kente became fashionable again "in Ghana" about twenty years ago, following a period during which it had been considered old-fashioned. Although Cophie has sold his kente to chiefs, many more of his Ghanaian customers are women. Ghanaians are the most discriminating of his clients. They choose the best quality designs and favor the double weave. They seek out newly created patterns, and if they do not find what they are looking for, they commission a cloth. One of Cophie's clients, the Ɔmanhene of Juaben, the paramount chief of a nearby district, has ordered close to thirty kente cloths from him. This chief orders a new cloth for every special occasion, and, according to Cophie, weavers flock to see what he is wearing. Interestingly, the Ɔmanhene of Juaben has also brought Cophie old kente cloths to be copied.

According to Cophie, foreigners tend to buy less important patterns. More knowledgeable European clients look for original kente with traditional, "classic" designs. He notes that Japanese buyers know all about silk and are also well versed in weaving. The Europeans and Japanese account for about 10 percent of Cophie's sales. African American customers, on the other hand, are responsible for roughly 50 percent of his sales.

The Future of Kente

Samuel Cophie has been weaving in Bonwire for over thirty-seven years and has seen a number of changes in kente. While it has gone in and out of fashion among Ghanaians, they nonetheless continue to seek out the best quality and thus help to keep standards high. On the other hand, Cophie feels that there has been a decline in quality overall, partly as a result of increased demand. Although the number of weavers has increased, emphasis now is on fast, "shuttle-through patterns," as opposed to the labor-intensive work of the past, which involved designs requiring as many as six colors of thread at a time. Formerly, a single piece of cloth might take as long as six months to weave. Cophie has also observed the increasing use of Lurex in cheaper cloths—a trend that he does not believe will last.

Currently Cophie himself spends his time designing and managing[7] rather than weaving. He doesn't keep a systematic record of how many designs he has created, nor does he have a sample book. Instead, he relies on a photograph album with pictures of the kente he has produced. He prides himself on his original work and becomes furious when others copy his designs, especially when they execute them with inferior threads. He reports that this practice reduces his incentive to create new patterns. The only system for "patenting" a pattern, however, is not systematically enforced. It consists of showing a new pattern to a chief and paying money for the privilege of naming it. According to Cophie, this brings the weaver respect and is supposed to ensure that the pattern cannot be copied.

For those willing to pay, Cophie affirms, kente of the highest quality can still be had. A recently commissioned kente cloth for a man about to be enstooled in Accra took one weaver about four months to complete, roughly one strip per week (see fig. 7.1). It was executed entirely in double weave. Throughout his career, Samuel Cophie has continued to create and has resisted the temptation to do repetitive work or to take shortcuts in order to meet the increased demand for kente. He has responded to the stimulus of those who buy from him, whether they are Ghanaians or outsiders. Chiefs, especially, have provided inspiration, since they insist that each piece he designs for them must be more beautiful than the last. His willingness to experiment has often been tested with highly successful results. This was evidenced at the time of the funeral for the deceased wife of the Asantehene. The family asked Cophie to weave a cloth of black and white. The design he created is named in honor of the deceased, Akua Afriyie. Its border, invented by Cophie, is a combination of zigzag and a design known as Fa Hia Kɔtwere Agyeman (fig. 7.10).

Samuel Cophie's talents as a weaver have survived the test of time. At an early age he absorbed the Ewe weaving tradition and has spent much of his adult career in Bonwire, the center of Asante kente. His willingness to experiment and his creative gifts have help him to bridge these two traditions in his art[8]

7.10

Interleaf F
Women Weavers in Bonwire

In 1927 Robert Rattray recorded a number of prohibitions relating to women's interactions with looms and weavers (1927, 234). Despite the fact that there are a number of women weavers today who have bright, healthy children, the belief that weaving makes women infertile is still widely held by male weavers. Weaving instruction for women began as early as 1966 at Winneba Polytechnic, prompted by complaints from female students that their final exams—identical to those given to male students—included weaving, a subject in which they had been given no instruction (personal communication, Dr. Selina Akua Aholkkui, 1997). In the late 1980s a nascent women's weaving cooperative formed outside of Agbozume, but it was disbanded in the mid 1990s. Another initiative in Bonwire appears more successful. Sponsored by the Centre for the Development of People (CEDEP), the Anglican Diocesan Mothers Union, and Trinity Church in New York City, the Bonwire Anglican Women Kente Project claims to have trained twenty women weavers, eight of whom participated in the weaving competition during the Bonwire Kente Festival (*Daily Graphic*, January 15, 1998).

A few women began weaving in Bonwire prior to the founding of the cooperative. Yaa Yasmin Minkah (fig. F.3), the mother of four-year-old Eva and fourteen-month-old Emmanuel, has been weaving since she was fifteen. Born in Bonwire in 1971, she taught herself to weave using her uncle's loom. Her independent spirit may have been fostered by travels to Paris and Lagos to visit her aunt. It was in Nigeria that she observed women weaving. Despite taunts and warnings about infertility, she persisted. A meeting of chiefs was held to discuss her weaving, and she was allowed to continue.

Yasmin has been studying weaving with a relative, Tweneboa Kodua Albert, her older sister's husband, for three years. Although she is not charged for instruction, she must pay for her own for thread. Despite this major difficulty, she has mastered plain weave and simple designs and is now learning how to do double weave and lettering.

Unlike the traditional apprenticeship, this one obviously places competing demands on Yasmin's time and financial resources. Nevertheless, she seems determined to persevere. She has woven a woman's cloth and recently sold a single weave cloth. In the balancing act that must be mastered if she is to succeed as a weaver, she will first have to perfect the techniques she is still learning. Then she will need to build up capital through the sale of her work. With two young children, this task appears daunting, but the first step, the breaking of the sanction against women weavers, has already been taken.

—Anne Spencer

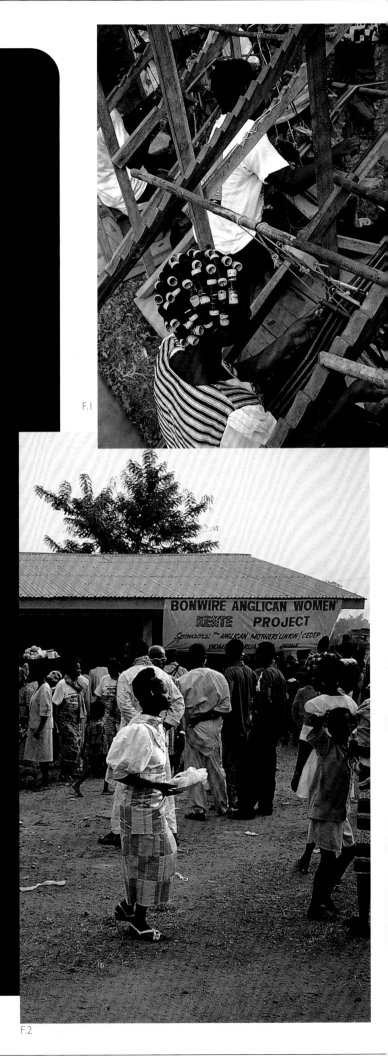

F.1

F.2

F.4

F.3

F.1 Unidentified woman weaver at the Bonwire Kente Festival. Photograph by Cornelius Adedze, Bonwire, 1998.

F.2 Unidentified individuals at the Bonwire Kente Festival. Photograph by Cornelius Adedze, Bonwire, 1998.

F.3 Yaa Yasmin Minkah at her friend's loom. Photograph by Doran H. Ross, 1997.

F.4 Unidentified woman weaver at the Bonwire Kente Festival. Photograph by Cornelius Adedze, Bonwire, 1998.

Interleaf G
Accra Textile Market

The Textile Market in Accra was established in 1988 next to the Art Centre on High Street. Under this covered shed are sixty-four stalls, each 6-feet wide and 9-feet deep. Most offer a few kente products, while at least twenty specialize in the marketing of both new and old cloths in addition to an assortment of strips, hats, bags, and other items. Quality and design vary tremendously, depending on the skill of the weaver, the size of the shop, and its location. The discerning buyer can purchase kente of the highest quality; the souvenir hunter, as well, will find something to suit his or her fancy. The market is both theater and commerce—aggressive selling, rigorous negotiating, and serious buying create a dynamic shopping experience. The photograph in figure G.1 was taken by David Mayo, 1997; the remainder of the photographs are by Doran H. Ross, 1997.

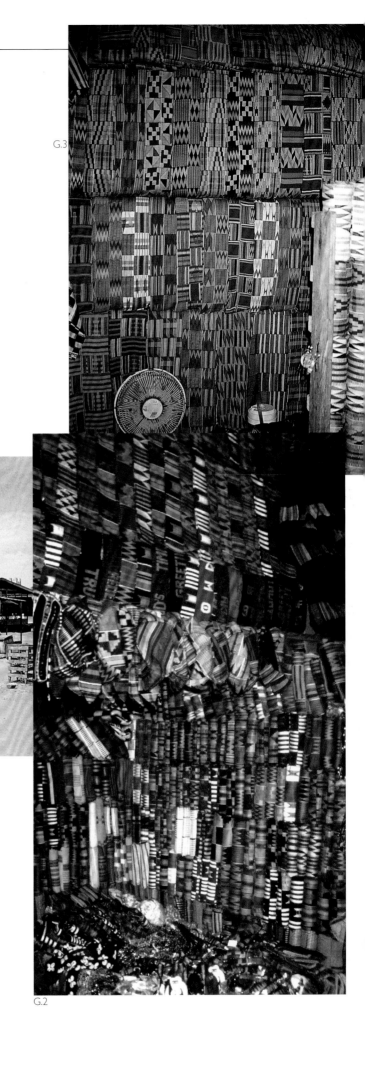

G.3

G.1

G.2

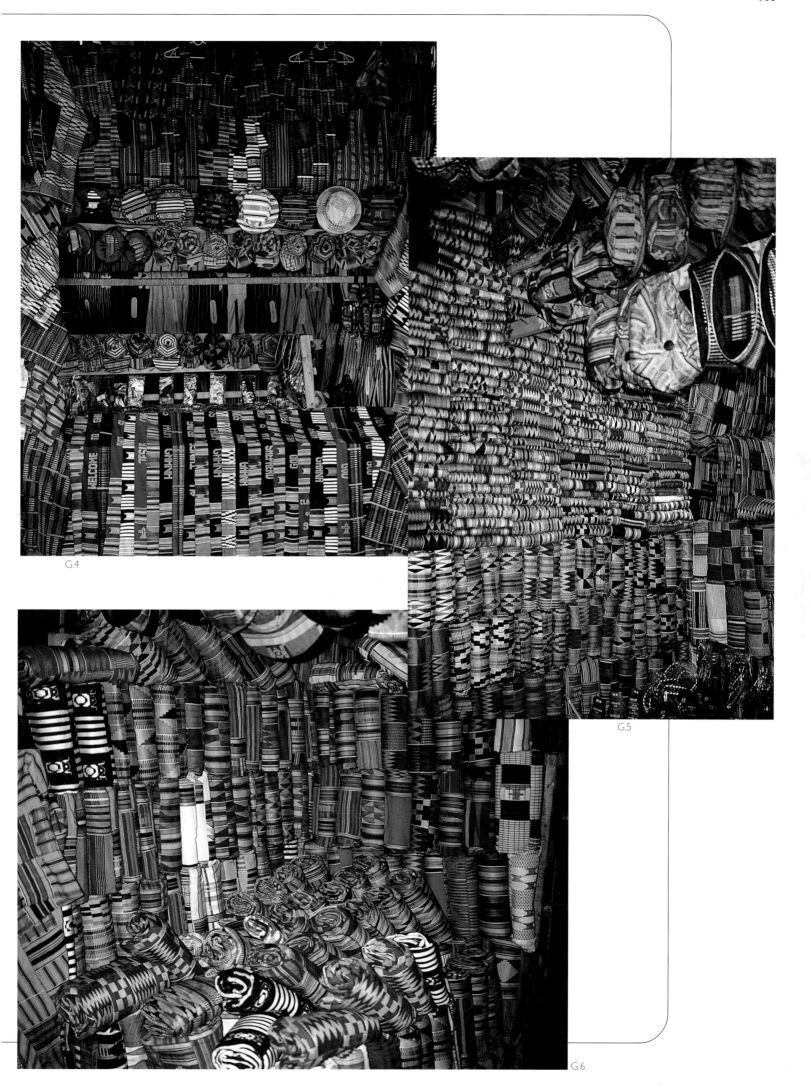

G.4

G.5

G.6

OVERVIEW

What is Kente?

KENTE IS MORE THAN A CLOTH
HISTORY AND SIGNIFICANCE OF GHANA'S KENTE CLOTH

Historical Background

Materials and Techniques

Aesthetics and Usages

Kente Symbolism

A Tradition in Transition

NAMES OF CLOTHS AND THEIR SYMBOLIC MEANINGS

NAMES OF MOTIFS AND THEIR SYMBOLIC MEANINGS

PARTS OF A CLOTH

USES OF KENTE

JUDGING THE QUALITY OF CLOTHS

SYMBOLIC MEANINGS OF COLORS

WEAVING MATERIALS

Parts of a Loom

The introduction to this volume outlines the contested terrain surrounding the name *kente* and discusses the appropriation of the term by both the Asante and Ewe at the end of the twentieth century. Chapters 6 and 9 consider the indigenous Asante and Ewe words for their respective cloths, pointing out that this nomenclature is also cloaked in considerable ambiguity, if not controversy. In this chapter we will examine Asante naming of both warp-faced and weft-faced patterns, briefly address issues of meaning or the lack thereof, and consider Asante notions concerning color symbolism as it relates to kente.

The principal sources for the names of Asante kente are Rattray (1927), Menzel (1972), Lamb (1975), and Ofori-Ansa (1993).[1] It is impossible at this remove to determine to what degree successive authors relied on their predecessors, and although there is a fair amount of consistency among names, significant variations also exist. It must also be emphasized that there is considerable fluidity in naming—a fluidity that was certainly even more pronounced before names were recorded in writing. Today it is not uncommon to ask a Bonwire weaver the name of an unfamiliar pattern only to have him consult Kwaku Ofori-Ansa's chart (fig. 8.1) or pull out a treasured and well-worn copy of one of the references listed above. There is no question that written studies have increased the codification of kente names and eliminated some of the wonderful nuances that once differentiated one weaver's verbal interpretation of a pattern from that of another—even if they agreed on an abbreviated name for the cloth.

The list of warp and weft patterns or names presented below is a selection of some of the more frequently encountered designs produced over the past fifty years. The total extant corpus of designs must be well over five hundred each for warp and weft. New designs, of course, continue to be created.

Warp Names

Most strips are identified by their warp-stripe pattern. Figures 8.4–8.29 illustrate a selection of some of the most common of these warp patterns. The majority of cloths consist of identical strips generally woven on a single long warp; thus, the cloth takes its name from the warp stripe of its strips. Less common, but not unusual, are cloths made up of two or more different warp patterns (fig. 1.1). These are typically called Mmaban, defined by Lamb as "mixed" or "there are many" (1975, 130). In this case the strips are usually ordered in a regular pattern (for example, a, b, c, a, b, c). Although, as noted, most cloths are named for their warp-stripe patterns, there are a number of exceptions to this practice. In all but one of these cases, the cloths are named for distinctive weft designs on a solid-color warp. The only cloth named for a solid-color warp itself is Sika Futuro (Gold dust), which is rarely, if ever, woven with a plain-weave ground (see fig. 8.23).

The names given to Asante kente are richly varied. Because they are primarily tied to stripe patterns, however, it is rare to find any correlation between name and pattern. Many cloths are named after important chiefs (see fig. 8.14) or queen mothers (see figs. 8.8, 8.9), and some of these are connected with important historical events. Others take their names from the plant or animal kingdom (see figs. 8.20, 8.22, 8.30h) or from other natural phenomena, for example, Sika Futuro (Gold dust; see fig. 8.23), Nyankontɔn (Rainbow; see fig. 8.24), and Owia Repuɛ (Rising sun; see fig. 8.25). The enormous corpus of proverbs that are used to explain the meaning of most Akan art forms also figure prominently in the naming of cloths (see figs. 8.16–8.19). This verbal-visual nexus is key to understanding and appreciating both the content and aesthetics of Akan art and material culture (see Cole and Ross 1977, 9–12; Ross 1982). This is especially true of the textile arts where it is well-documented that a cloth is frequently selected for its name as much as—if not more than—for its color or pattern (Cole and Ross 1977, 11; Bickford 1997).

In the absence of any comprehensive study of the popularity, frequency of use, or recognition of a particular cloth name (read warp-stripe pattern), there is still considerable evidence that Oyokoman with its wide gold and green warp stripes embedded in a maroon, red, or burgundy field occupies a distinct position in the history of Asante weavings (fig. 8.2). As mentioned earlier (see chapter 6), this pattern is credited in the frequently cited Asante oral tradition as being the first created by Ota Kraban upon his return to Bonwire from Gyaman. It takes its name from the Oyoko clan, which has produced every Asantehene since the descent of the Golden Stool in the late seventeenth century (see Wilks 1975, 364). Without question, it is also the most frequent warp pattern for Adweneasa (see below), one of the most labor intensive and creatively taxing of all Asante weavings. There are only a few other background warps that have had Adweneasa patterns woven into them, and Sika Futuro is probably the only other one to occur with any frequency (fig. 8.23). Oyokomon is also the only warp pattern for Asasia, the twill weave created with a third pair of heddles and the most labor intensive of all Asante

CHAPTER 8

Asante Cloth Names and Motifs

Doran H. Ross

8.1 "Kente Is More Than A Cloth," Kwaku Ofori-Ansa's chart of kente names and motifs (1993).

weaves. The Oyokoman pattern probably exists in more derivative variations than any other, a fact that in itself suggests considerable longevity (see figs. 8.4–8.7; see chapter 10).

The special place of the Oyokoman pattern in Asante weaving is further emphasized by the existence of Oyokoman cloths completely covered with weft-faced threads (double weave), obliterating any view of the warp threads except at the very end (fig. 8.3). The cloth given to President Bill Clinton in 1998 was of this type (see fig. 3.34). Even though there is no evidence of cloths completely covered in double weave before the second half of this century, the many examples of Oyokoman woven in this manner suggest that the pattern has certain properties beyond the visual. Perhaps it is simply a matter of historical allusion, but it may be that when woven in this manner, Oyokoman becomes a sort of amulet completely covered in another material—in this case the weft threads. This latter interpretation may be somewhat problematic, but no other warp pattern is given this treatment with any kind of consistency.

8.2

In addition to the Oyokoman interpretations in figures 8.4 through 8.7, Ofori-Ánsa gives the following explication for the conventional Oyokoman pattern in his popular chart:

> Oyokoman, Ogya da mu … literally means "There is fire (crisis) in the Oyoko nation." The cloth was designed in honor of the Royal Oyoko family from which Asante Kings and Queenmothers [are] selected. It also documents the civil crisis that occurred within the Oyoko family after the death of Osei Tutu in 1731 [more likely 1717 or 1720]. Green and yellow represent the two branches of the Oyoko family and the red between them, symbolizes "fire"— the civil crisis. In the past, only members of the Royal Family could wear this design. The various versions of the design symbolize ROYALTY, NOBILITY, HONOR , NEED FOR UNITY IN DIVERSITY, RECONCILIATION AND A REMINDER OF THE ADVERSE EFFECTS OF INTERNAL CONFLICTS. [1993, no. 21]

The emphasis in the last sentence of the above quotation is Ofori-Ansa's. My own research has been unable to confirm this symbolization (which Ofori-Ansa provides for each of the designs that he illustrates). Nevertheless, his chart has become increasingly influential in shaping both Ghanaian and American understandings of kente.

Evidence of the preference for the colors used in Oyokoman may be found among the earliest cloths in European collections (see fig. 10.9), and arguments for the importance of the cloth in Pan Africanist movements are convincing (see chapter 10). This red, green, and gold color combination has roots in Ethiopia, long recognized as a symbol of African independence. These colors were subsequently adopted as the national colors of Ghana. The selection was further reinforced by the infusion of Rastafarian music and art (also driven by Ethiopian history) into African popular culture. It is significant that while the majority of named Asante kente warp patterns exist independent of any connection to color (see below), Oyokoman variants always include red, green, and gold (figs. 10.47–10.51).[2] My own observations—albeit somewhat impressionistic—of the popularity of Oyokoman cloth suggest that it is worn by one out of ten individuals who choose fine (non-Ahwepan) weaves for wear in festival contexts. Oyokoman is also the most common "warp stripe" on broadloom kente and machine-produced, roller-printed kente made in four or five other West African countries. The obvious conclusion of the above is that Oyokoman has evolved with a considerably more important and complex history than most other Asante weaves and may very well be among the first and most elite of all royal cloths.

8.2 Detail of Oyokoman warp stripe with "single weave" weft designs. Rayon. FMCH X76.1843.

8.3 Detail of Oyokoman warp stripe (seen only on bottom edge) with "double weave" covering virtually the whole surface of the cloth, obliterating the warp-stripe pattern. Rayon. FMCH X96.31.9.

8.3

The historical malleability of the naming of Asante kente designs is perhaps best exemplified in one of the most familiar of all cloths, the name of which is derived from weft designs on a solid color field. Distinguished by an X pattern composed of nine squares (fig. 8.29a–c), it was identified before 1966 as Fathia Fata Nkrumah (Fathia befits Nkrumah) in honor of Kwame Nkrumah's Egyptian wife. When Nkrumah was deposed in 1966, its name was changed to "*Obaakofo mmu man*" (One man does not rule a nation), perhaps suggested by the eight squares radiating from the central one upon which the design is dependent. A kente cloth of this type was given to the United Nations in 1960 (see chapter 10).

This interpretation, however, ignores the fact that the design had a significant presence before Nkrumah's rise to power when it was identified as Afoakwa Mpua. This name is typically translated as "Afoakwa's nine tufts of hair," referring to a coiffure once associated with designated court officials, probably sword-bearers (fig. 8.29b). When this same design is aligned strip-to-strip to create an overall pattern across a solid color field, however, it is called Akyɛmpem (A thousand shields; fig. 8.29c).

Interestingly, these nine squares—regardless of the name applied to them—may be woven into a fabric of any solid color. Several warp stripe patterns may also be produced with different ground colors and still bear the same name. For example the cloth known as Mmɛɛda (Something that has not happened before) exists in green, blue, and black variants (fig. 8.15a-c). Kyemee, which takes its name from a famous Asante chief, has been documented in blue and red versions (fig. 8.14a-d). In other words in many cases the background color is actually not a determining factor in the warp pattern. Even cloths with color references in their names, such as Adwoa Kɔkɔɔ (A red- or copper-colored Monday-born woman), can occur in an assortment of colors. The Fowler Museum's example of the latter cloth does have red in the warp stripe, but examples published by Menzel contain only black and white warp stripes on a blue background and on a green background (1972, 1: 587, 603).

The issue of color symbolism as it applies to kente is one that merits considerably more research on both sides of the Atlantic. Venice Lamb devotes only one paragraph to the subject citing in an endnote "several informants in Bonwire" and referencing Kofi Antubam's *Ghana's Heritage of Culture* (1963):

> The use of certain dominant colors can reflect the moods and aspirations of the wearer. The use of gold, for instance, denotes warmth, long life, prosperity and so on. A Chief might wear gold while a Queen Mother or even a more humble woman, might wear silver, white or blue to signify purity, virtue or joy. White is usually worn by priestesses to symbolize deities or the spirits of the ancestors. Green may be worn by young girls to suggest newness, freshness and puberty. Black can stand for melancholy, loss, sadness, death or dissatisfaction. Sometimes red is worn at political meetings to indicate anger. [1975, 141]

Kofi Antubam was probably the first scholar and/or artist of Akan descent to discuss "Notions of Colour" (1963, 75–83). While he cites a number of contexts where items of a specific color are employed and interprets "meaning" (admittedly a problematic concept) in several instances, only a couple of examples are specific to kente and none of these in Asante situations.

My own research concerning this subject—conducted in Bonwire during twelve visits between 1976 and 1997—was decidedly unproductive until 1995, when several weavers and vendors in response to my queries either pointed at, referred to, or copied from Ofori-Ansa's chart "Kente Is More Than a Cloth" (1993). This chart associates some general values or qualities with eleven different colors. For example, regarding the color yellow Ofori-Ansa writes:

> Yellow in all its variations, is associated with the yoke of egg, ripe and edible fruits and vegetables and also with the mineral gold. In some spiritual purification rituals mashed yam is rendered yellow with oil palm and served with eggs. It symbolizes sanctity, preciousness, royalty, wealth, spiritual vitality, and fertility.

I am not convinced that these and other of Ofori-Ansa's interpretations of color have any significant history in the Asante tradition; however, as African art has developed as a discipline, we have consistently learned that every object of study is inevitably more complex and more sophisticated than initially imagined. Independent of the issue of a verifiable history of color symbolism, there seems to be an evolving understanding that colors have meaning in kente cloth. This is a consensus driven by both Ghanaians, such as

Ofori-Ansa, and African Americans. Interviews cited by Betsy Quick (see chapter 12) demonstrate that many African Americans have very specific ideas about red, gold, green, and black that they relate directly to kente. These colors have evolved from Pan Africanist ideologies that date back to Marcus Garvey's initiatives and are the colors of many African independence movements as well.

Debbi Chocolate's children's poem *Kente Colors* (1996) has also played an important role in the awareness of kente's color symbolism. Her book is frequently read at public events during Black History Month:

> Kente colors bright and bold:
> red, yellow, blue—
> black and gold.
> Emerald kente for harvest time.
> Indigo blue for African Skies.
> Yellow kente for pineapples sweet.
> Sunset kente red and deep.
> Mud pie kente rich and brown.
> Gold dust in a kente crown.
> Kente colors silver and black,
> swirling around dancers' backs.
> Ivory kente for dark young brides.
> Kente for a newborn child.
> Kente colors in bright silk robes—
> For generations young and old.

A few of Chocolate's lines, for example, the one alluding to "mud pie kente"—a reference to Bamana *bogolanfini* (mud cloth) from Mali—have nothing to do with the Asante strip-woven cloth. Nevertheless, her book has become instrumental in codifying the meaning of certain colors for a young audience and for their parents.

With any art form, the question may be raised as to whether the meaning of a work of art ends with the artist's (read weaver's) intentions or can be extended by the consumer, user, or viewer. If issues of meaning were left entirely to the artist, or even the indigenous patron or purchaser, however, incentives for connecting or identifying with a product intended for a larger audience would be severely diminished—as would sales.

As suggested earlier in this chapter, kente cloth has probably always been a dynamic, innovative, art form whose meanings have changed over time and from place to place. In some instances these changes have been external (dependent perhaps on the availability of silk, rayon, or certain dyes), and in others, they have been internal (see the discussion of the cloth known as Fathia Fata Nkrumah, above). Despite the rigidity suggested by royal patronage, even patterns as important as Oyokoman have been manipulated to produce new names and meanings.

The question remains as to what pattern names mean in the larger realm of kente-related behavior? Are they simply convenient "handles" that permit producers and consumers to differentiate cloths or are they replete with messages that extend beyond mere conventions of nomenclature? In chapter 10 of this volume I argue that Kwame Nkrumah's choice of cloths—especially for high-profile, historic occasions—seems to have been carefully calculated. In the absence of any empirical data, however, it is impossible to say how widespread such deliberate use of kente may be. Given that the average person would be fortunate to own a single kente cloth, such issues of choice are largely irrelevant. Still, for wealthy and important chiefs, whose treasuries contain many cloths, the potential exists to convey select messages to a "cloth-literate" audience by means of attire.

Weft Names

Unlike warp patterns, most weft designs are named after objects, for example, Sekan (Knife; fig. 8.34), Afa (Bellows; fig. 8.44), Afe (Comb; fig. 8.30e), or Ɛkye (Hat; fig. 8.36). Weft designs are rarely named after individuals or proverbs, although, if pressed, most weavers could quote an appropriate proverb for a given object or design. Also unlike most warp patterns, weft-faced designs tend to resemble their names. It is rarely clear, however, if they were named after the design was created based on some perceived similarity, or if the design was specifically intended to be representational. In addition, sometimes the relationship between name and design is not obvious. For example, Aprɛmo (Cannon; fig. 8.41) does not look at all like the piece of artillery, although the design does resemble the profile of the carriage that supports a typical European example. The pyramid-shaped Puduo or Kuduo (fig. 8.43a,b), which takes its name from a ritual cast-brass container, shares little in common with the actual shapes of these vessels; several early examples of these, however, do have small pyramids on their lids, and this might be the point of reference (see Silverman 1983).

Some Asante kente cloths feature a single weft motif (adwen) repeated throughout, but more commonly a cloth will incorporate a number of designs. The most extensive use of adwen occurs in a cloth identified as Adweneasa, in addition to its warp name (fig. 8.48, cover). This cloth is characterized by weft designs inserted into every available block of plain weave. Adweneasa is typically translated as "my skill is exhausted" or "my ideas are finished." This has led to the popular conception that every block of adwen in such cloths is different. This is not necessarily the case, and the word is intended only to designate a cloth in which the weaver has filled every possible area with some version of a weft design. When the weaver repeats a design in the best of these cloths, he attempts subtle variations to demonstrate his virtuosity and creativity.

Within the larger inventory of weft designs, three relatively conventionalized patterns stand out as building blocks and framing devices for the vast majority of other patterns. The most common of these is Babadua named after a segmented bamboo-like cane (fig. 8.31). This is also the most distinctive decorative device found on academic and liturgical stoles worn in the United States. It is primarily composed of continuous bands of plain weave that completely obliterate the warp threads from selvage to selvage.

The second pattern is called Wotɔa, a term whose meaning is not entirely clear. It is easily identified by its red and yellow color scheme alternating in bands of vertical stripes that completely cover the warp. In most cases, there are four bands, each separated by a delicate checkerboard pattern executed in the same colors (fig. 8.32). Ofori-Ansa calls the design "'Nwatoa' (snail shell), inspired by textures on the shell of a snail" (1993). Although there is widespread agreement that the Asante shuttle is called korokorowa (krokura, kurokurowa), Rattray in one place writes that "Nwatoa means shuttles, and this design [actually referring to the one below] is said to be woven with a shuttle in either hand" (1927, 240). This is an accurate description as the weaver alternates passes of one shuttle with red threads on the bobbin and another with yellow.

The third design, called Akyɛm (Shield) involves a greater palette of colors and allows the warp threads to show through in places (fig. 8.33). Generally only one of these three is used in the body of a single cloth where it will occur on either side of another weft design with these blocks separated by plain weave. It may also simply alternate with the same or different weft designs all the way down the warp.

Selected Cloth Names
(Primarily Warp Patterns)

8.4^

8.5^

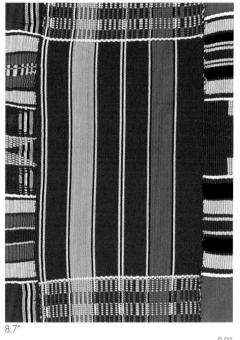

8.6^

8.7^

8.8˘

8.9˘

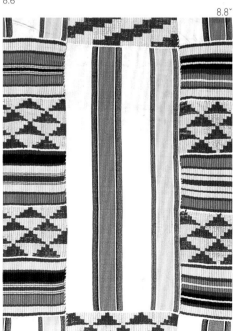

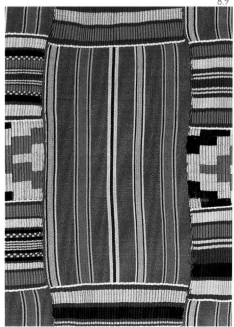

8.4 The Oyokoman pattern is named after the Oyoko, the clan of the Asantehene. It is one of the few kente patterns with a rigid color scheme, in this case red, green, and gold. While the name is almost always listed simply as "Oyokoman," Rattray (1927, 238) provides a more expansive interpretation and perhaps greater insight into its history: "'*Oyokoman ogya da mu*' ('there is fire between the two factions of the Oyoko clan'); referring to the civil war after the death of Osai Tutu between Opoka Ware and the Dako. This cloth was worn by the King of Ashanti at the Kwesi Adae (Sunday Adae ceremony)." FMCH X97.12.4.

8.5 Ammerɛ Oyokoman is a variation on the Oyokoman pattern (see fig. 8.4). It maintains the characteristic red, green, and gold color scheme. FMCH X96.30.15.

8.6 Oyoko nɛ Dako is a cloth named after the Oyoko and Dako clans. FMCH X96.31.6.

8.7 Mamponhemaa (Queen mother of Mampon). Rattray identifies this pattern as "Oyokoman Amponhema," which is suggestive of the Mampon connection to the Oyoko dynasty (1927, 240; see Wilks 1975, 333–38). FMCH X96.31.6.

8.8 Toku Akra Ntoma (Toku's soul cloth). Toku, a queen mother and warrior, was defeated in battle by Opoku Ware I (cr. 1720-1750). She was greatly admired for her courage. FMCH X96.31.8

8.9 This warp design takes its name from Frempomaa Bonwire Hemaa, an early queen mother of Bonwire. According to Ofori-Ansa, she was the grandmother of Ota Kraban, one of the men who introduced weaving to Bonwire (1993, 31; see also chapter 6 of this volume). NM 97.89.2.

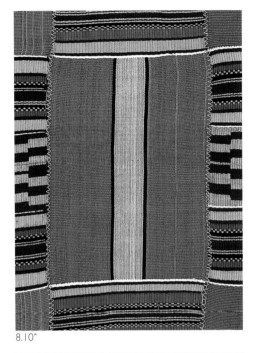

8.10^

8.11a^

8.11b^

8.12

8.12

8.13

8.10 Ɔhemaa aba Ghana (The Queen comes to Ghana). This pattern commemorates Queen Elizabeth's visit to Ghana in 1961. Private collection.

8.11a,b Adwoa Kɔkɔɔ (A red- or copper-colored Monday-born woman). This cloth was named after the wife of a Bonwire weaver. Although Rattray assigns this name to another pattern, it was recorded twice in association with each of these two textiles, and Menzel also recorded it twice (1972, 1: 587, 603). Rattray noted that, "The cloth was presented to King Kwaku Dua I, who then allowed only his wives to wear it" (1927, 243). FMCH X97.12.3; Private collection.

8.12 Known as Aberewa Ben, this pattern is named for a spiritually strong old woman of the Asensie clan. The cloth illustrated here was worn by the Adɔnten chief, one of the heads of the Asante army. Private collection.

8.13 Yaa Kete, the name of this design, is also the name of an honored female of the Oyoko royal family. FMCH X96.31.1.

8.14aˆ

8.14bˆ

8.14cˆ

8.14dˆ

8.14a–d The pattern known as Kyemee or Kyime is named for an important and powerful Asante chief known for his bravery. Rattray refers to the design as *"Kyime Kyerewere* or *Kyime Ahahamono* (Kyime who seizes and devours, or the green Kyime cloth). The loin-cloths of Kings and Queens of Ashanti were made in this pattern" (1927, 239). A-c: Private collection; d: NM 97.89.1.

8.15a–c Christaller translates Mmɛɛda—the name of this pattern—as "something unheard of, unprecedented, extraordinary" (1933; 303). This corresponds to the contemporary translation "something that has not happened before." Rattray identifies this same pattern as *"Asonawo mmada"* and explains its origins by noting that "the father of King Bonsu Panyin was Owusu Ansa, who belonged to the Asona clan the first of that clan ever to be father of an Ashanti king" (1927, 241). The three versions of this pattern illustrated here are all from the same cloth despite the fact that they are executed in different colors. FMCH X81.49.

8.15aˇ

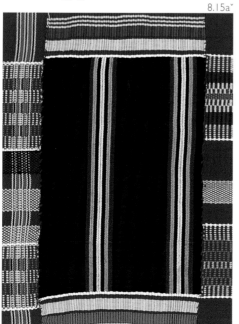

8.15bˇ

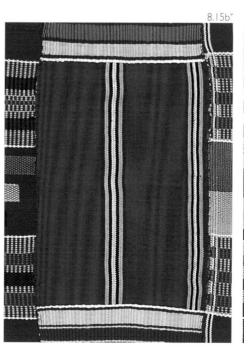

8.15cˇ

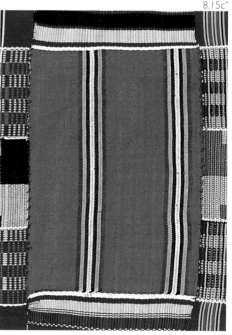

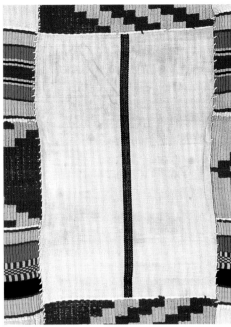

8.16^

8.17^

8.16 The proverb "*Woforo dua pa, na yepia wo*" (If you climb a good tree, you get a push) furnishes the name for this kente design. This pattern is commonly used as a finial on counselors' staffs. It was also a pattern popular with Kwame Nkrumah (see chapter 10). FMCH X96.30.15.

8.17 "*Anko nam*" may be translated as "I go alone" or "I walk alone." This name is particularly noteworthy when applied to kente because it is one of the few instances where there is a perceivable relationship between warp pattern and name. Private collection.

8.18 "*Sika frɛ mogya*" is another case of a pattern name derived from a proverb. In this instance the translation is literally "Money attracts blood," meaning that if you are wealthy, your relatives will flock to you. FMCH X97.11.20a.

8.19 This design takes its name from the proverb "*Papa nkɔ akyirl*" (Kindness does not travel far). The suggestion is that if you do good deeds, few people will hear about them; if you behave badly, however, everyone will learn about it. FMCH X98.17.1.

8.20a,b This cloth pattern is known as Agyenegyenesu, after a small insect that can walk on water. Implicit in this name is a warning about deceptive behavior. FMCH X96.30.15; Private collection.

8.18^

8.19^

8.20a˅

8.20b˅

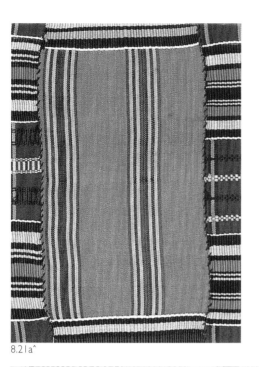
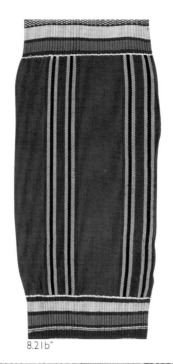
8.21aˆ 8.21bˆ

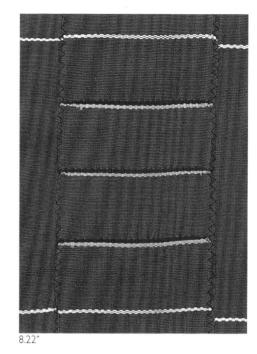
8.22ˆ

8.21a,b The proverb *"Fie buo yɛ buna"* supplies the name of this cloth. This saying may be translated as "Family management is not an easy task." The idea seems to be that the head of a family has a difficult job. FMCH X96.30.15; Private collection.

8.22 Makowa means "little peppers." This cloth is one of the few named for its weft design representing red and yellow peppers. It may be woven on any one of several solid color warps. The cloth has also been identified with the proverb *"Mako nyinaa mpetu mmre pɛ"* (All peppers do not ripen at the same time). FMCH X98.17.2.

8.23 The name of this cloth, Sika Futuro, literally means "gold dust." This is one of the very few named cloths with a solid color ground and a name that actually corresponds to its color. FMCH X86.1988.

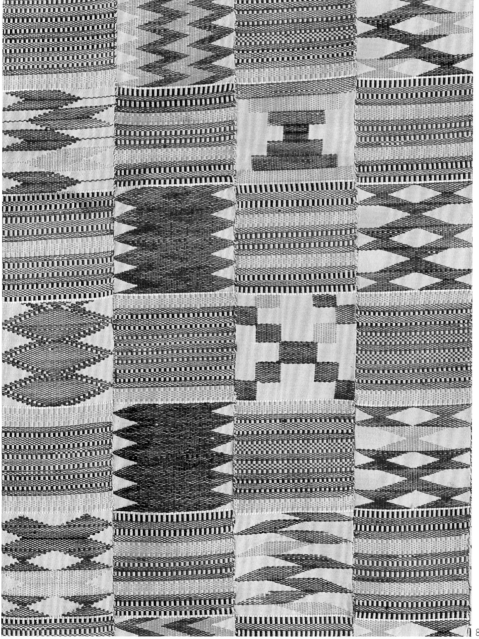
8.23

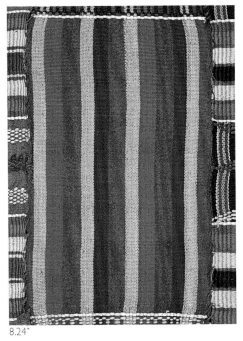

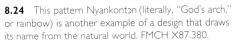
8.24^

8.25^

8.24 This pattern Nyankontɔn (literally, "God's arch," or rainbow) is another example of a design that draws its name from the natural world. FMCH X87.380.

8.25 This design, known as Owia Repuɛ (Rising sun), almost always appears with bands of black, gray, and red warps of equal width. The cloth, however, is apparently named for its weft design in the form of a half sun. This pattern was the emblem of the Progress Party (see chapter 4). Private collection.

8.26a,b The pattern known as Akosombo Nkanea (Akosombo lights) was named in honor of the Akosombo Hydroelectric Dam. Built during the 1960s, the dam crosses the Volta River and provides much of the electricity for Ghana as well as neighboring countries. This is probably an example of a cloth being renamed, since Rattray illustrated the red and green example referring to it as Dado or Ansaku. Dado was the name of the wife of the Bonwire weaver "Kuragu Yaa," another of the individuals credited with introducing weaving to the Asante heartland; Ansaku was a former king of Akwamu (1927, 241). Private collection.

8.26a^ 8.26b^

8.27ˆ

8.28ˆ

8.27 This cloth, known as New Ghana, is sometimes confused with Aberewa Ben (see figure 8.12). New Ghana, however, does not incorporate weft stripes in the plain weave. Private collection.

8.28 African Unity or African Freedom. This cloth is unusual in that it was named for its color combination rather than its warp-stripe pattern. It is characterized by black, red, and green stripes, often in an Oyokoman configuration, but it utilizes many other patterns as well. This design originated in the 1970s and was inspired by African Americans who wanted cloths featuring the colors associated with Marcus Garvey and his Pan Africanist movement (see chapter 10). FMCH X98.17.2.

8.29a–c This single pattern has had many names: **(a)** Fathia Fata Nkrumah (Fathia befits Nkrumah), which later became "*Obaakofo mmu man*" (One man does not rule a nation); **(b)** Afoakwa Mpua (Afoakwa's nine tufts of hair); **(c)** Akyɛmpem (A thousand shields). A: FMCH X95.45.8; b: Private collection; c: FMCH X81.12.96.

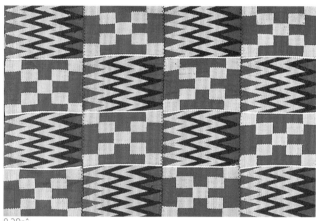

8.29aˆ

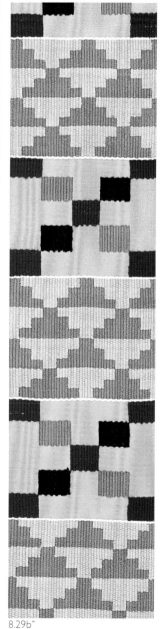

8.29bˆ

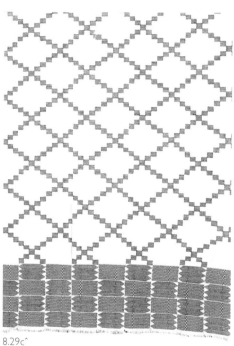

8.29cˆ

8.30

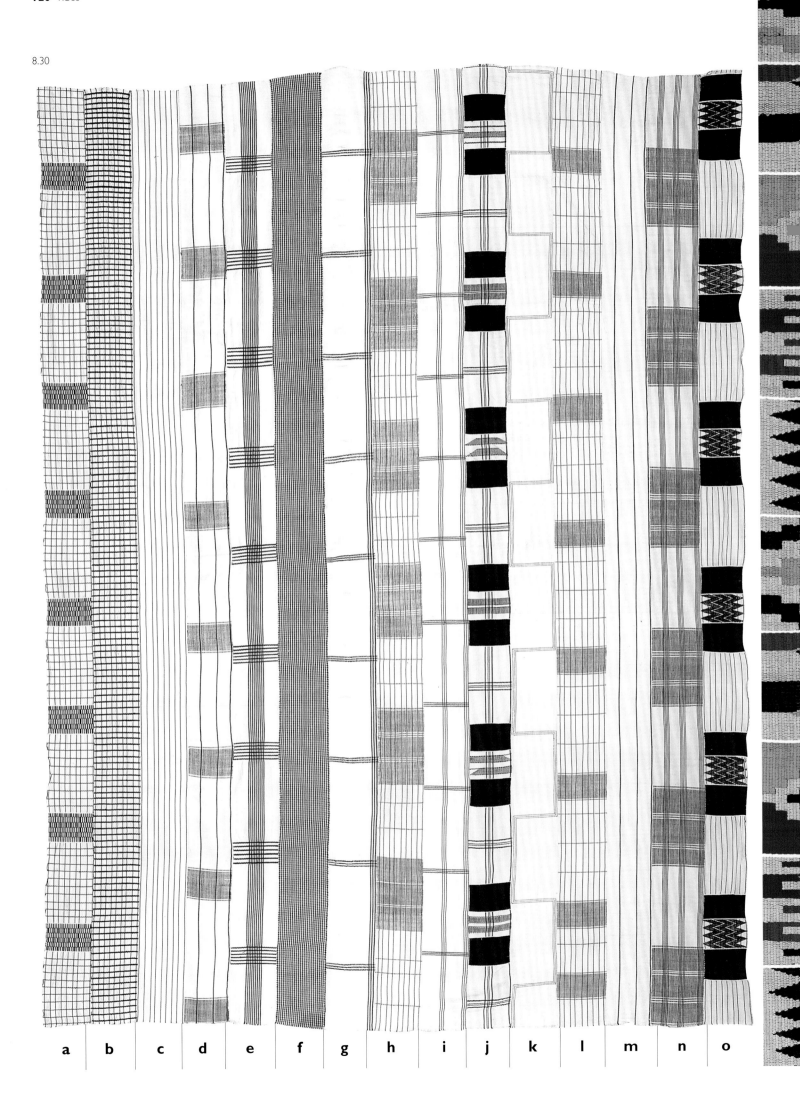

a b c d e f g h i j k l m n o

Weft Designs

8.30 In 1965 Labelle Prussin commissioned this cloth from Bonwire weavers to consolidate some of the basic indigo and white cotton weaves illustrated by Rattray. Nine of the fifteen strips closely match those in Rattray, and his interpretations are provided here.

a. "Nkatewasa ('the nkatewa seeds have come to an end')" (Rattray 1927, 246, fig. 134, no.15).

b. "*Ohene akamfo* (at the king's pleasure), also sometimes called *ohene nko nyon* or *ohene nko mfura*, 'the king only may weave', or 'the king may only wear'; said to have been personally designed by King Kwaku Dua I (A.D. 1838)" (Rattray 1927, 245, fig. 134, no. 5). Lamb calls this pattern Thenenkomfira, but the exact translation of this name is unclear (1975, 112, fig. 189). Komfira, however, refers to the dancing, twisting appearance of the weft stripes.

c. "*Nkruma 'Kwan* (the paths leading to the *okro* farm)." A woman's cloth, formerly worn only by Queen Mothers and princesses (Rattray 1927, 249, fig. 136, no. 49).

d. The name of this pattern is not documented. It is illustrated as number 410 in Menzel (1972, 1: n.p.), but she provides no name.

e. Afe (Comb). (Rattray 1927, 250, fig. 137, no. 71).

f. "*Kotwa* (the scar); also called *asambo* (the guinea fowl's breast, and *asam 'takra* (the guinea fowl's feather)" (Rattray 1927, 248, fig. 135, no. 39).

g. "*Aboadie* is perhaps synonymous with Bosomra, one of the *ntoro* patrilineal divisions; formerly worn by one of that division. This pattern is said to have been invented by Kwaku Dua I, for his children; at intervals are three white ribbed lines" (Rattray 1927, 249, fig. 146, no. 54).

h. "*Akroma* (the hawk)" (Rattray 1927, 247, fig. 134, no. 19).

i. "*Aduana* (a clan name for the Asante)" (Rattray 1927, 245, fig. 134, no. 2; see also Menzel 1972,1: 1411, 1412).

j. "Asebi Hene (the Asebi chief). He was in charge of the King of Ashanti's weavers; and it was worn by the chief of that stool, or by others with the king's permission" (Rattray 1927, 245, 250, fig. 134, no. 7, fig. 137, no. 69).

k. "*Nkontompo ntama* (the liar's cloth). The King of Ashanti is said to have worn this pattern when holding court, to confuse persons of doubtful veracity who came before him" (Rattray 1927, 244, fig. 130; see also Menzel 1972, 1: 711–17).

l. This pattern is the same as that in "h."

m. Name unknown. The warp pattern is the same as that in "d."

n. Name unknown.

o. "*Nyawoho (Nkyimkyim)* (he has become rich); *nkyimkyim* means bent, crooked, and refers to the design at intervals on the weft. It is stated that in olden times a man had to be worth £1,000 in gold dust, to wear this pattern, with the king's permission" (Rattray 1927, 246, fig. 134, no. 12, fig. 137, no. 72).

8.31^

8.32^

8.33^

8.31 Babadua is a well-known design that takes its name from a segmented bamboo-like cane. FMCH X97.12.5.

8.32 This design, known as Wotɔa, may refer to the shell of a snail. FMCH X96.31.8.

8.33 The Akyɛm design derives its name from a wickerwork shield that is covered with cloth and monkey skin (see fig. 3.39). FMCH X76.1843.

8.34^

8.35^

8.36^

8.37^

8.38^

8.39^

8.34 Sekan, the name of this motif, translates as "knife." FMCH X97.12.30.

8.35 The weft pattern known as Ntata is named after a two-edged sword. FMCH X76.1843.

8.36 Ɛkye, or hat, is the name of this weft pattern. FMCH X97.12.30.

8.37 This name of this cloth design, known as Achimota Mpoma, may be translated as "windows or shutters at Achimota," the site of an important colonial school. Private collection.

8.38 The name Ntabon refers to "weaving swords" (see figs. 6.46-6.47). FMCH X97.12.30.

8.39 This pattern name, Owia, may be translated as "sun" (see fig. 8.25). Private collection.

8.40aˆ

8.40bˆ

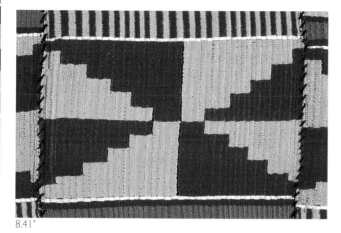

8.41ˆ

8.42ˆ

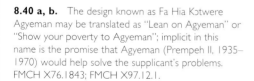

8.43aˆ

8.43bˆ

8.40 a, b. The design known as Fa Hia Kɔtwere Agyeman may be translated as "Lean on Agyeman" or "Show your poverty to Agyeman"; implicit in this name is the promise that Agyeman (Prempeh II, 1935–1970) would help solve the supplicant's problems. FMCH X76.1843; FMCH X97.12.1.

8.41 Aprɛmo may be translated as "cannon," and although this design does not look like that piece of artillery, it does bear a certain resemblance to the profile of the carriage that would support a typical European example. FMCH X98.17.1.

8.42 The name Nkyɛmfrɛ Nhyehyɛhoo may be translated as "a broken pot arranged together." It refers to a person who can handle difficult situations. FMCH X97.12.5.

8.43a,b The weft design known as Puduo or Kuduo takes its name from a ritual cast-brass vessel used in rites to sustain the family. Early examples of these vessels had small pyramids on their lids, and this may explain the pyramidal shape of the design. FMCH X76.1843; FMCH X97.12.5.

8.44^

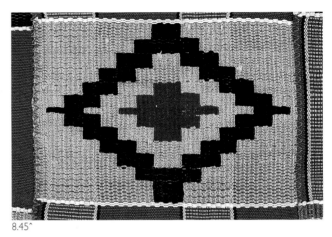

8.45^

8.46a^

8.46b^

8.47^

8.44 The motif known as Afa derives its name from a blacksmith's bellows. Private collection.

8.45 Akokɔ Baatan, or mother hen, is the name of this pattern. NM 97.89.1.

8.46a,b. The name of this cloth, Nkyimkyim, means "to turn or twist" or to "zigzag." This term is sometimes used to describe a person whose mind is not steady. FMCH X97.12.1; FMCH X76.1843.

8.47 The pattern name Kwadum Asa refers to an empty gunpowder keg. FMCH X97.12.3.

8.48 Opposite: Detail of Oyokoman Adweneasa (cover) with weft motifs identified in the spaces occupied by the repeated design called Akyɛm, or shield. FMCH X97.12.3.

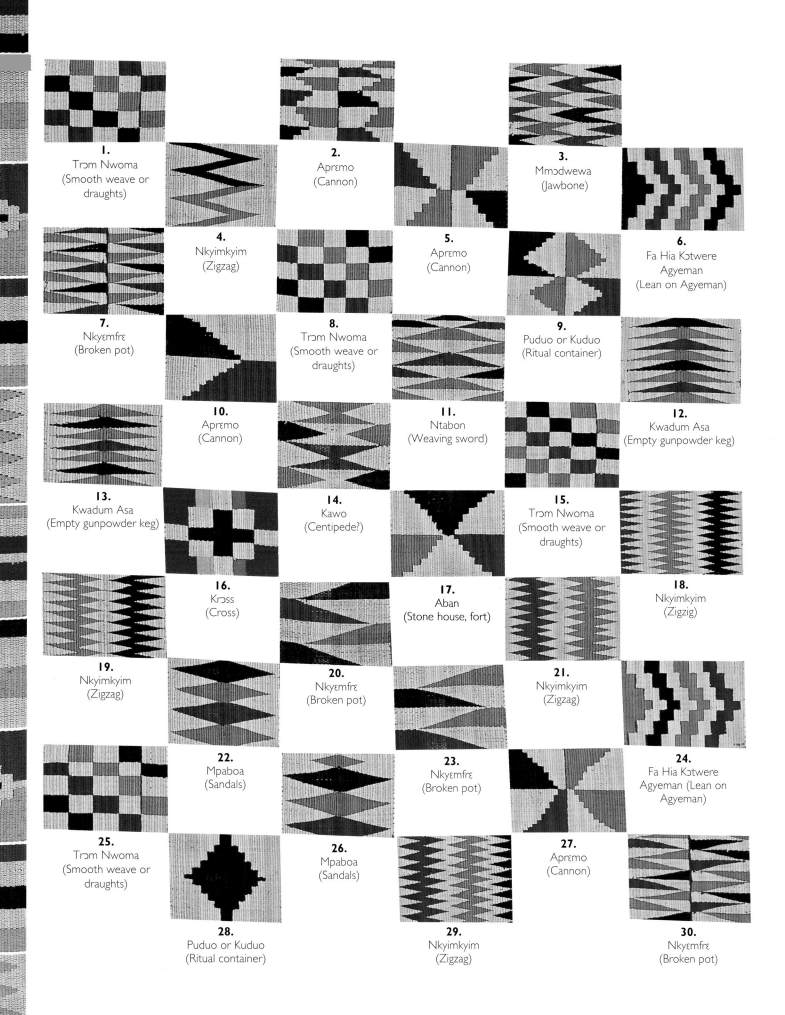

1.
Trɔm Nwoma
(Smooth weave or
draughts)

2.
Aprɛmo
(Cannon)

3.
Mmɔdwewa
(Jawbone)

4.
Nkyimkyim
(Zigzag)

5.
Aprɛmo
(Cannon)

6.
Fa Hia Kɔtwere
Agyeman
(Lean on Agyeman)

7.
Nkyɛmfrɛ
(Broken pot)

8.
Trɔm Nwoma
(Smooth weave or
draughts)

9.
Puduo or Kuduo
(Ritual container)

10.
Aprɛmo
(Cannon)

11.
Ntabon
(Weaving sword)

12.
Kwadum Asa
(Empty gunpowder keg)

13.
Kwadum Asa
(Empty gunpowder keg)

14.
Kawo
(Centipede?)

15.
Trɔm Nwoma
(Smooth weave or
draughts)

16.
Krɔss
(Cross)

17.
Aban
(Stone house, fort)

18.
Nkyimkyim
(Zigzig)

19.
Nkyimkyim
(Zigzag)

20.
Nkyɛmfrɛ
(Broken pot)

21.
Nkyimkyim
(Zigzag)

22.
Mpaboa
(Sandals)

23.
Nkyɛmfrɛ
(Broken pot)

24.
Fa Hia Kɔtwere
Agyeman (Lean on
Agyeman)

25.
Trɔm Nwoma
(Smooth weave or
draughts)

26.
Mpaboa
(Sandals)

27.
Aprɛmo
(Cannon)

28.
Puduo or Kuduo
(Ritual container)

29.
Nkyimkyim
(Zigzag)

30.
Nkyɛmfrɛ
(Broken pot)

9.1 Detail of Ewe man's cloth. Cotton. Collection of Peter Adler.

Nya la, ḍeti yibo wonye, megbea avɔa ḍeke me o.
(The word is like the black thread that is part of every cloth.)
—Ewe Proverb

There is a certain consensus that Ewe kente with its more richly varied palette and its frequent use of representational motifs—including lettering in French and English—is more dramatic than its Asante counterpart and that it is, in addition, more inventive in terms of overall composition (figs. 9.1–9.5). The Ewe people of West Africa live in the present-day republics of Ghana, Togo, and Benin. The Volta River and Lake Volta to the west separate the Ewe from their Akan, Ga-Adangbe, and Ga neighbors; and the Mono River to the east separates them from the Fon (who according to oral tradition were part of the original Ewe stock). The Atlantic Ocean constitutes a southern boundary. The region can be divided into the southern lowlands, central plains, and northern uplands.

Although I present this group as homogenous, various of its members speak distinct dialects, which are, nonetheless, mutually intelligible to a large degree. The origin of the Ewe people is known solely through oral tradition. Every Ewe child can recount this history going back at least to the last dispersion or migration from Notse (in present-day Togo) in the seventeenth century.

Ketu, or Amedzope, in the southeastern part of the Republic of Benin is believed to be the original homeland of the Ewe. Westerman (1939, 233–34) claimed that the Ewe were part of the Oyo Empire, but Parrinder (1956, 24) attributed the founding of Ketu to King Ede, whose descendant, the forty-seventh king, was installed in 1937. With the assumption that each king ruled for an average of twenty years, Asamoa calculated that the city was probably founded in the tenth century (1986, 3).

Although vestiges of ancient Ketu are still visible today (including complete wall systems and a huge midden), there has been no archaeological work or dating to substantiate the oral tradition. At Idahin and Ewe—towns in close proximity to Ketu— Parrinder reported having found ancient graves in laterite rock, burial mounds, cisterns, ruined fortifications, and potsherds about which the present Fon and Yoruba inhabitants of the region are oblivious (1956, 16). This observation prompted Asamoa to conclude that the Ewe were not part of the Oyo Empire or King Ede group but were instead a separate group that lived in the region before the expansion of Oyo. As a consequence of invasions by the Yoruba, they migrated from the region, one group moving to Tado, or Aja (in present-day Togo), and another to Notse, a large walled city of about 15.45 kilometers in circumference. The highest point of the Notse wall was between 3 and 4 meters. It was never completed (Aguigah 1985, 10–13) and was probably constructed for the sake of prestige like the other city walls of West Africa.

According to oral tradition, their forced participation in the construction of the Notse wall (Agbogbo), coupled with the tyrannical rule of King Agokoli, led to the final dispersal of the Ewe and ultimately to the establishment of several Ewe states (dukɔwo). Their experience with King Agokoli in Notse had made the various migrant Ewe groups determined never again to submit themselves to a single central authority. Other factors facilitated the formation of autonomous states: the migrants did not leave Notse in large groups nor did they leave at the same time. "Watsi" and "Peki," the names of two Ewe groups, mean "late arrivals," an indication that they were among the last to leave Notse. Internecine conflicts and incursions into Ewe territory by more centrally organized neighbors, such as the Akwamu, the Asante, and the Fon, perhaps also contributed to the fact that the Ewe never formed a single political union after leaving Notse (Amenumey 1986, 29–35). Despite this, the internal structure of the independent Ewe states remained very similar—a proof of cultural unity and identity.

It should be reiterated here that the colonial histories of the Ewe and Asante are quite different (see Ross, chapter 1). Unlike the Asante, who were colonized by the British in the nineteenth century, the majority of Ewe peoples lived under German domination in the late nineteenth and early twentieth centuries and later were divided under French and British rule.

9.2˄

9.3˅

9.2 Ewe man's cloth (Kpetoe). Cotton. Length 293 cm. Collection of Peter Adler.

9.3 Detail of Ewe kente collected before 1847 (see fig. 10.6). Danish National Museum, Copenhagen, Gc 192.

9.4 The chief of the district of Agou attending Agbogboza (the Ewe festival of the walls). His cloth features a woven inscription, "Chef de Canton d'Agou." Photograph by Agbenyega Adedze, Notse, Togo, September 10, 1989. Eliot Elisofon Photographic Archives, National Museum of African Art.

9.5 Ewe cloth. Silk. Length 195 cm. FMCH X98.16.2. Museum Purchase, Jerome L. Joss Fund.

9.4˅

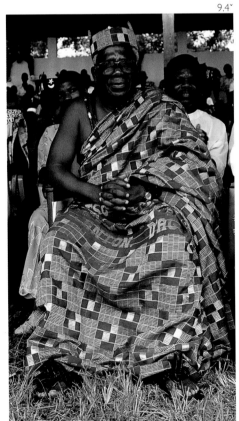

At the head of the Ewe polity are the political and religious leaders, namely the *dufia* and *anyigbafia*. The *dufia* (chief of the town) is concerned with administration, the judiciary, and tribute collection. A council composed of senior elders of the various lineages supports him in his functions. The *anyigbafia* (chief of the land) performs crucial ceremonies connected with drought, the sowing and harvesting of crops, and the mitigating of natural disasters and epidemics. Since the duties of the *anyigbafia* involve communication with the spiritual realm, he is considered almost sacred. In some places, such as Tado, he is never seen in public nor does he walk barefoot.

The diversity of resources available in Eweland (as the independent Ewe states are collectively known) favor the development of a mixed economy. Subsistence is based on peasant farming. Shifting cultivation, whereby a plot is cultivated and abandoned for a couple of years for refertilization, used to be the practice. This method, however, is now limited to villages where the demand for farming land is low. Although the average person might be involved in some farming, other occupations such as fishing and crafts are given considerable attention. The principal crafts are carving, weaving, ironwork, and pottery. Weaving includes the making of baskets, cloths, fans, purses, sacks, fences, trays, sieves, hats, nets, and traps.

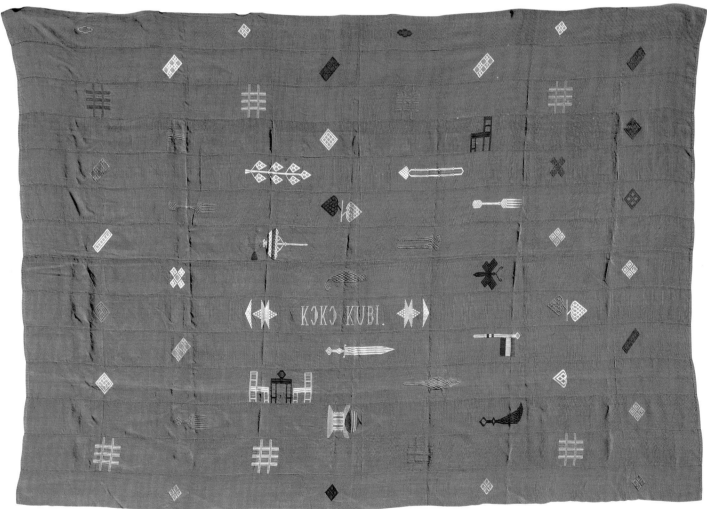

9.5

Agbogboza Festival

The festival known as Agbogboza (figs. 9.6–9.13) is held annually in Notse, Togo. The festival takes its name from the city walls (Agbogbo). Oral tradition states that before their final dispersal from Notse, the Ewe people suffered at the hands of the tyrannical king Agokoli. The king killed those Ewe elders who dared to oppose him and forced his subjects to build the Notse walls. Some accounts maintain that Agokoli had thorns and other sharp materials mixed into the clay to harm the workers. He is also reported to have demanded the builders to make rope out of clay. This ill treatment led the Ewe to leave Notse under various leaders. Ironically, the walls today have become a sacred monument. As one of the most visible vestiges of the ancient Ewe kingdom, they are considered a source of inspiration and a symbol of Ewe unity.

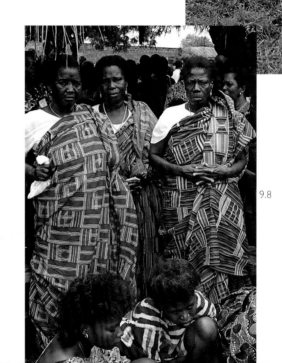

9.9

9.8

9.6

9.7

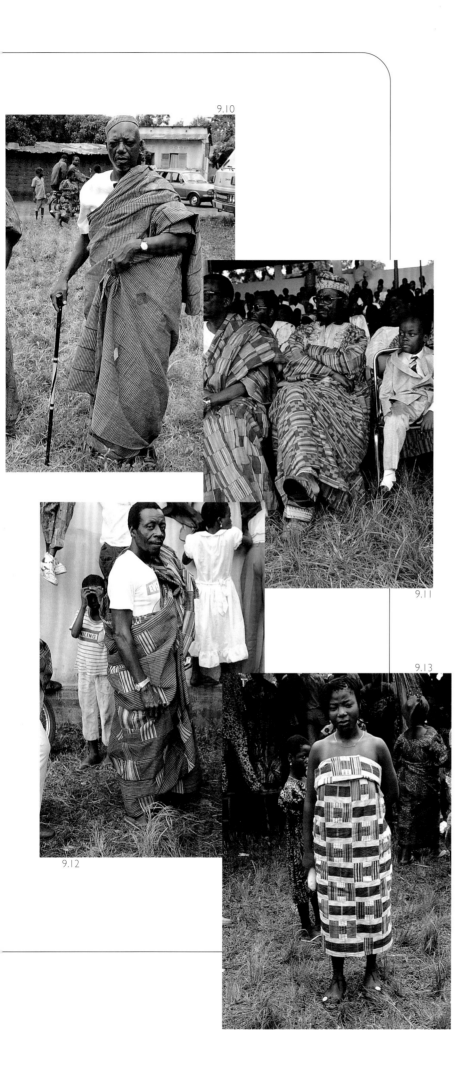

9.10

9.11

9.13

9.12

9.6 A "linguist" with his staff and a young girl at Agbogboza. Photograph by Agbenyega Adedze, Notse, Togo, 1989. Eliot Elisofon Photographic Archives, National Museum of African Art.

9.7 Young girls belonging to the same dance group clad in blue-and-white striped Notse cloth at Agbogboza. Photograph by Agbenyega Adedze, Notse, Togo, September 10, 1989. Eliot Elisofon Photographic Archives, National Museum of African Art.

9.8 A group of women at Agbogboza wearing their cloths as men customarily do. This tradition in the past was reserved for queen mothers in some areas, but it is now assumed by powerful women in southern Ghana and southern Togo. The woman on the left wears what is typically assumed to be an Asante cloth; the woman on the right, a typical Ewe cloth. Photograph by Agbenyega Adedze, Notse, Togo, September 10, 1989. Eliot Elisofon Photographic Archives, National Museum of African Art.

9.9 A subchief at Agbogboza wearing a cloth identified by the Asante as "*Sika fre mogya*" (Money attracts blood). This proverb is generally understood to mean that if you are wealthy, your family will demand favors of you. Photograph by Agbenyega Adedze, Notse, Togo, September 10, 1989. Eliot Elisofon Photographic Archives, National Museum of African Art.

9.10 A gentleman at Agbogboza wearing an Ewe cloth with closely spaced, uniform weft stripes running throughout; these stripes are occasionally interrupted by isolated blocks of weft-faced red and gold geometric designs. Photograph by Agbenyega Adedze, Notse, Togo, September 10, 1989. Eliot Elisofon Photographic Archives, National Museum of African Art.

9.11 The central figure is one of the dignitaries at Agbogboza. His cloth is sewn into a long gown in the style of a Hausa or northern Togolese dignitary. The textile is of the pattern known as Fathia Fata Nkrumah after the wife of Kwame Nkrumah. Photograph by Agbenyega Adedze, Notse, Togo, September 10, 1989. Eliot Elisofon Photographic Archives, National Museum of African Art.

9.12 Gentleman at Agbogboza wearing an Ewe cloth of the type woven in southeastern Ghana. Photograph by Agbenyega Adedze, Notse, Togo, September 10, 1989. Eliot Elisofon Photographic Archives, National Museum of African Art.

9.13 Young woman at Agbogboza wearing an Asante cloth with a warp pattern known as Aberewa Ben. Photograph by Agbenyega Adedze, Notse, Togo, September 10, 1989. Eliot Elisofon Photographic Archives, National Museum of African Art.

The Ewe Cloth-Weaving Tradition

The evidence of weaving in West Africa can be dated to the first millennium in the Sudanic centers, such as Jenne-Jeno and the Bandiagara Escarpment of Mali. In the forest regions and the coastal areas of West Africa, however, the wet climate and acidic soil have left hardly any evidence of weaving in the archaeological record. In Notse, the heartland of the Ewe, furthermore, many weaving tools and accessories were made of wood and other perishable materials (Posnansky 1992, 114). The oral traditions of the Ewe trace the origin of weaving to a hunter named Togbi Se, who after a futile day, sat under a tree to rest and observed a spider weaving its web. Togbi Se wondered why humans could not weave. He went home and tried imitating the spider by inventing a small triangular loom of a type now known as a child's loom (Hiamey 1981, 10–11).[1]

Although cotton cloth dominates the market today, the oral tradition supports the view that sisal, raffia, and bark cloth predated it. Raffia cloth is now used only during Ewe festivals such as Hogbetsotso.[2] Posnansky has argued that since Notse was the last center of Ewe dispersion, it could also have been the point of origin for the traditional cloth of the Ewe. In the 1980s, he documented a variety of striped narrow-strip loom-woven cloth in Notse that ranged in color from deep blues to white (figs. 9.14, 9.15).

> According to oral traditions and present local knowledge, the cloth industry became established because of the abundance of indigo trees and other dyeing substances in the Notse area and because of the excellent cotton that is still grown and ginned there. Notse cloths were known for the intensity and purity of their dyes. The antiquity of some of their patterns, the complex nomenclature, and the survival of the cloth in the face of strong market forces militating against it indicate the original strength of the textile industry. [Posnansky 1992, 116]

9.14

9.15

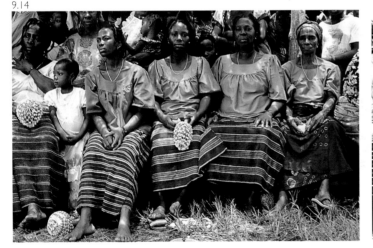
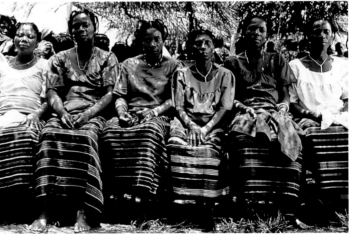

9.14, 9.15 Women belonging to the same dance group dressed in blue and white cloth at Agbogboza (the Ewe festival of the walls). Photograph by Agbenyega Adedze, Notse, Togo, September 10, 1989. Eliot Elisofon Photographic Archives, National Museum of African Art.

The dozen or so weavers left in Notse prefer locally grown cotton and hand-spun threads. This localized weaving industry is sustained by the demand for cloth to be used during funerals or as shrouds, as dowry, for mothers with newborn twins, or for certain festivals. The weaving tradition here is both age and gender based. Whereas all the weavers are male and aged between fifty-six and eighty, the spinners and dyers are all women between forty-five and eighty-five years of age. Cotton picking, ginning, spinning, and weaving are seasonal, usually occurring in the dry period between November and February and for a short time in August. When Posnansky (1992, 117) raised the question whether spinning would ever disappear from Notse, he was met with the response that it was a thing of the ancestors (*mama nu*) and that it would never die.

European visitors writing as early as the sixteenth century reported that the Ewe had a long-standing weaving tradition. In the early eighteenth century Phillip Eytzen, a Dutch merchant, reported:

> I found here in Quita [Keta] a large number of children and men constantly busy spinning cotton on little sticks of about a foot length. I wanted to buy some, as they said that they collected this cotton in order to maintain their children. They were prepared to sell, but they asked not less than three strings of cowries of one ball of cotton which does not weigh more than half a pound, which would mean paying about as much as at home. When I proposed to buy a big quantity of about hundred pounds for 20 Angels, they just laughed at me. . . . Saw also people making indigo in a hut. They first soak the leaves and then make balls of them about the size of a fist, which they put away. In this way, they seem to keep them in a good condition for more than a month. [Van Dantzig 1978, 206]

The same merchant noticed large quantities of cotton among the Fon, the immediate eastern neighbors of the Ewe. At a Fon market he observed that

> cotton can be found everywhere and a large quantity could be had if the Negroes did not use it themselves for the weaving of cloth of various qualities. . . . Some of the cotton was packed by the Negroes in little bales weighing 12 to 15 lbs.; they demand 6 ryksdaalers for them, but the seeds are not taken out. I saw more than 200 lbs. of it on the market, all of which was sold on the same day. It is used for lamps and for other purposes. Cotton yarn is exceptionally expensive. [Van Dantzig 1978, 208–9]

Somewhat later, Captain Paul Erdmann Isert (1755–1789), the son of a German master weaver and a member of the Danish trade mission in West Africa, provided one of the most detailed descriptions of cloth weaving among the Ewe at Little Popo (Aneho). In a letter dated December 29, 1783, Isert reported that

> the local Blacks also know how to weave cotton [cloth], which the Akras either do not know, or are too proud to do. Our factor took me to a Black who practices this profession, which I had not seen practiced in this land. When we arrived there we found absolutely no sign of any establishment. I wanted to turn back but the factor asked me to wait a moment because the loom could be set up very quickly. He called the weaver and in less than a quarter of an hour a loom was standing there, threaded with yarn, and the weaver was weaving. [Isert 1992 (1788), 91]

Isert went on to describe the loom and its parts. Interestingly, his description is, for the most part, applicable to the looms of the present (figs. 9.16–9.18):

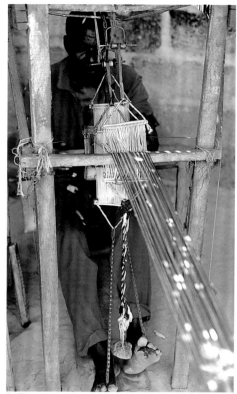

9.17ˆ

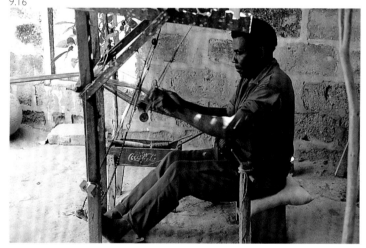

9.16

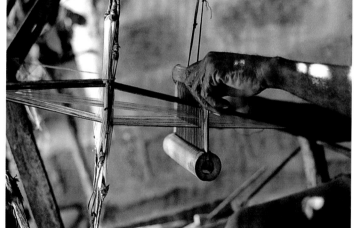

9.18˘

As much as this work merits the genuine admiration of the connoisseur, yet it is done very simply. Four posts of a good thumb's thickness are stuck into the earth, demarcating the area of the four posts of the loom. Against the two hindmost stand two two-foot long poles fixed at a slant so that they cross the latter, and in this cross another pole is laid horizontally, making the seat for the master. They have no warp-beam, but the warp is wound on a claw, which a helper far behind holds in his hand. Their [heddles are] similar to ours, only [they have] no eye, but [are] made up of two half-loops which are fastened together between which the thread lies. At the same time they tread with their feet on pedals made of a pair of thin sticks. The reed is just like ours but has two threads through each division; it hangs loosely without being fastened in the yarn. Their woven cloth is unusually narrow, seldom being over a quarter of an ell wide. The yarn is cotton, which they spin on a spindle. [Isert 1992 (1788), 91–92]

9.16–9.18 Weaver at his loom. Photographs by Agbenyega Adedze, Agbozume, Ghana, September 7, 1989. Eliot Elisofon Photographic Archives, National Museum of African Art.

Isert concluded his letter with a description of yarn dyeing that is particularly fascinating in view of the fact that it is nearly identical to the process Posnansky would document at Notse two hundred years later.

Above all they know how to dye fast, beautiful blue, which, if it does not actually surpass our indigo, is at least equal to it. They make it from the leaf of a kind of tree, and the root of another plant, over which they pour ash water made from palm nuts, thus causing it to ferment, although it is cold. This takes a few days. When the dye is ready they immerse the yarn in it, cold, several times, then dry and wash the yarn, and the procedure is finished. They also prepare all the other known colours, but these are less fast and less beautiful. And since they are lovers of the true red colour, they are forced to unravel European red cloth in order to weave the thread into their cloth. One such cloth (waist kirtle) of the finest sort, with red stripes, which is much esteemed everywhere, can cost upwards of 50 thalers. [Isert 1992 (1788), 92]

Even today, hand-spun, undyed thread can be purchased at the large textile market in Agbozume in addition to an assortment of dyes and dyed threads (figs. 9.19–9.21).

In the absence of extensive research on cloth among the Ewe, there has been considerable broad generalization. Several European visitors and scholars have compared Ewe and Asante weaving designs. This comparative bias seems to have led many scholars to derive their analysis of Ewe cloth traditions from their knowledge of cloth traditions among the Asante. To a large extent these comparative studies obscure the originality and creativity of both peoples and lead to questions of influence and borrowing that tend to fan ethnic chauvinism on both sides. The objective of this essay is to examine the cloth tradition among the Ewe peoples, determine its history, explain its functions, introduce its weavers, and describe its representation in Western literature.

9.19

9.20

9.19 Women selling machine-spun yarns at the market in Agbozume. Photograph by Agbenyega Adedze, Agbozume, Ghana, 1989. Eliot Elisofon Photographic Archives, National Museum of African Art.

9.20 Dyes and locally dyed yarn on display at the market in Agbozume. Photograph by Agbenyega Adedze, Agbozume, Ghana, 1989. Eliot Elisofon Photographic Archives, National Museum of African Art.

9.21 Locally dyed yarn and cloth on sale at the market in Agbozume. Photograph by Agbenyega Adedze, Agbozume, Ghana, August 26, 1989. Eliot Elisofon Photographic Archives, National Museum of African Art.

9.21

What's in a Name?

The Ewe have two generic names for cloth, *avɔ* and *ɖo*. *Ɖo* is in limited use within some central and northern Ewe areas, whereas *avɔ* is used by all the Ewe groups. A weaver is called *avɔbla* and not *ɖobla*. The Ewe do not call their handwoven cloth "Ewevɔ," which would be the literal translation of the so-called "Ewe cloth," the Western classification of cloth designs and patterns believed to be limited to the Ewe regions of West Africa (Kent 1971; Lamb 1975; Cole and Ross 1977; Gilfoy 1987; Adler and Barnard 1992; Coquet 1993). Another designation of similar origin is "Ewe kente." Perhaps the best linguistic explanation of the origin of the word *kente* lies in the Fante word *kenten*, which means "basket." Several scholars have speculated that because baskets and cloth are both woven, the cloth is called kente (Lamb 1975, 128). It should be noted, however, that while this label is attached to the cloth of the Asante, the Asante themselves use the term *nsaduaso*. As discussed in chapter 1, the name *kente*, however, is now used in the literature and in daily parlance to such an extent that some Ewe claim that the word *kente* is actually a corruption of the Ewe word *kete*, which is derived from *ke* (open) and *te* (close),[3] and is thus a perfect description of the weaving process.

A review of the "Ewe cloth" exhibited in the West reveals a tendency to impose certain generic names such as *adanudo* (Kent 1971; Lamb 1975; Gilfoy 1987; Adler and Barnard 1992; Coquet 1993). *Aɖanu* in Ewe could be translated as "skill" or "talent," and any weaver would have the right to claim the use of his talent or skill in designing a cloth. The source of this misnomer is, however, the uncritical adoption by Western scholars, especially Venice Lamb and Peter Adler and Nicholas Barnard[4] of the thesis of Edith H. Agbenaza, who named all "Ewe cloth" *adanudo*. She defined the latter as:

i) A piece of plain cloth designed only with colour without any motifs in it.
ii) A piece of cloth with an intricate pattern or
iii) A cloth with single motifs scattered all over it at regular intervals. [Agbenaza 1965, 61]

Hiamey, however, argues that:

> In Mrs. Agbenaza's work on the Ewe "Adanudo" which up to date has been unchallenged, she tries to create the erroneous impression of inferring that "Adanudo" in the whole of the Eweland means one thing that is "Kete" fabric whilst it is apparent in her work that she carried her research in the Agotime area alone where the people call their type of "Kete" which contain designs "Adanudo" so one can see the sort of dust thrown in the face of the innocent reader. [Hiamey 1981, iv]

It should be noted that the Anlo Ewe do sometimes call their cloth *adanuvor* if a design element is introduced in it (Hiamey 1981, 15). The Anlo Ewe, however, would never identify cloth as *ɖo*. Hence the designation "Anlo Adanudo cloth" is inappropriate (Lamb 1975, 163). Agbenaza (1965, 77), however, referred to *adanuvo* cloth, which she described as "a piece of cloth made from different strips of 'adanudo' woven from different warps . . . the weavers designing skill has been completely exhausted."

I will also say categorically that Venice Lamb's use of the term *susuvu* is also the result of some misapprehension (Lamb 1975, 194). *Susuvu* is not an Ewe word. Unfortunately, Gilfoy (1987) and Adler and Barnard (1992) perpetuated this misnomer. *Susuvu* is claimed to be the Ewe translation of the Twi word Adweneasa meaning "my skill is exhausted." I suspect that these scholars fell victim to one of the cardinal laws of ethnographic research, that is, if you keep asking the same question, you will eventually get the answer you want. Thus, insistence on a Ewe translation of "my skill is exhausted," or Adweneasa, produced the Ewe equivalent *susuvo*.[5]

Nonetheless, the Ewe, like most peoples of West Africa, do have complex names for each piece of cloth. It should be noted, however, that naming cloths is an ambiguous process among the Ewe. It is fluid and, unlike the names of objects or persons, follows no established rules. Cloth names can be philosophical, historical, related to a design element, or the result of the whims of the public (see the appendix at the end of this chapter). Interestingly some names have been used both for handwoven cloths and modern machine-woven and printed cloth (Ayina 1987; Domowitz 1992). Yet as cloth designs, motifs, and patterns are published in catalogs, they become rigidified and are used as points of reference with which any subsequent designs must be compared.

In the course of my research at Notse, I noticed that few weavers agreed on the same name for similar patterns. And women cloth traders seem to have the upper hand in designating these transient names. Even with the advantage of a controlled sample of weavers and cloth dealers at Notse, it was not easy to establish cloth names except for

some basic patterns.[6] This elasticity in naming cloths became more obvious to me in 1989 when I took color photocopies of various "Ewe cloths" from the collection of the Smithsonian Institution to Ghana and Togo with the intention of checking the accuracy of the names that had been assigned to them. Most of the weavers were visibly amused by these designations. Although they recognized the patterns and design elements, they could not agree on the names. One weaver plainly told me that naming cloth was not the business of men (weavers) but rather of the market women, whom he claimed invented the names. When I took the samples to the market women, I met with similar skepticism; completely different cloths in the stalls bore some of the names of the samples from the Smithsonian.

Posnansky acknowledged the discrepancies in naming cloths among weavers, dyers, and traders and was quite astonished when his favorite weaver could not even remember some of the patterns he had provided two years earlier (1992, 132). Lamb also confirmed this view when she admitted that "it must not be thought, however, that the act of naming produces too rigid a stereotyping of designs," only to turn around to do exactly that in her book (1975, 201). Exhibition catalogs and other publications that perpetuate the traditional museological concern with classification, authorship, and unique identity continue to impose definite names on "Ewe cloth."

Finally, some cloths come to acquire the name of the town in which they are purchased, for example, Agbozume cloth or Kpetoe cloth. Unfortunately these designations create the false paradigm of one location, one cloth. There were and continue to be itinerant weavers all over Eweland and the whole of Ghana. Samuel Cophie (see chapter 7), one of the weavers in the Asante weaving town of Bonwire, is, in fact, an Ewe from Anyako.[7] Should his patterns then be designated as Anlo-Ewe-Anyako-Bonwire kente? Or simply Bonwire kente or Asante kente? Or Bonwire school?

The literature on "Ewe cloth" is also replete with designations such as "copies or imitations of Asante." One weaver, Kodzotse Sabah, has contested the accepted view that all the so-called Asante kente originated with the Asante. He claims that some of these cloths were woven by Ewe weavers and appealed to the Asante, as a result the Ewe gave these cloths the name of their clients, the Asante.[8] Likewise, many Ewe weavers moved to the Asante region over the years to practice their trade. This is probably an indication of interaction between weavers of both ethnic groups in terms of designs and styles.

Some historical names of cloths, however, are indisputable. Weavers and traders alike know Takpekpe le Anloga due to its association with a historical event. Togbi Sri of the Anlo Ewe was said to invite other chiefs regularly for meetings, and at one of these gatherings, all those assembled decided to adorn themselves with Takpekpe le Anloga. Another popular historical cloth is Fathia, woven for and named after the wife of Dr. Kwame Nkrumah, the first president of Ghana. The current president Jerry Rawlings wore this cloth in his official state photograph.[9] Both the Asante and Ewe now weave this cloth.

9.22 Heddles on display at the market in Agbozume. Photograph by Agbenyega Adedze, Agbozume, Ghana, 1989. Eliot Elisofon Photographic Archives, National Museum of African Art.

9.23 Weaving tools (shuttles, reeds, spinning machine, etc.) for sale at the market in Agbozume. Photograph by Agbenyega Adedze, Agbozume, Ghana, 1989. Eliot Elisofon Photographic Archives, National Museum of African Art.

9.22

Looms and Taboos

One finds both mobile and permanent looms among the Ewe. In Notse, for example, apart from the beater, all loom parts are made by the weavers (Posnansky 1992, 122). Weavers who cannot make their own loom parts purchase them from the market (figs. 9.22, 9.23). Although looms can be easily made or purchased, once they are installed, the weaver must consecrate them by sacrificing a chicken and sprinkling its blood on the loom. The spirits of the ancestors are invoked to help the weaver to become prosperous. A consecrated loom possesses supernatural powers. No part of it may be used to hit anyone because a person so struck would swell and die. Women are not allowed to visit the weaver's shed, sit on his stool, or cook for him while they are menstruating. This would bring bad luck to the weaver, and any woman violating this rule would have to pay for the reconsecration of the loom. A weaver moving to another location must religiously bid farewell to his previous loom in order to secure success at his new location (Agbenaza 1965). In Notse, weavers offer special prayers daily before they start working, and they pour a libation while calling on their ancestors, especially those who were weavers, to intercede in the weaving process before they start a new cloth (Posnansky 1992, 122).

Lamb has found some differences between Ewe and Asante looms:

> In the Ewe loom the two back posts, supporting the back bar over which are stretched the warp threads on their way to the dragstone, are placed nearer to each other than is the case in Asante. The loom has something of the look of the prow of a boat. The Ewe tension device also differs a little from the Asante arrangement. The Ewe uses a short stick inserted into the warp from the bar which is held in position either by being tied with string or by being allowed to rest on the ground. In the Asante loom the tension is always held in position by one of the loom uprights. [Lamb 1975, 205]

Lamb also noticed that the Ewe heddle pulleys are usually carved in the shape of the head of a hen, cockerel, or human being. The Ewe also use pulleys made of iron in addition to those carved of wood (see fig. 9.17). The top and bowl of the Ewe reed, or beater, are made of a lighter wood, and the reed is tied along both sides giving it stronger teeth. Apart from these minor differences, Lamb agrees that the Ewe and Asante looms are quite similar (1975, 205–7).

9.23

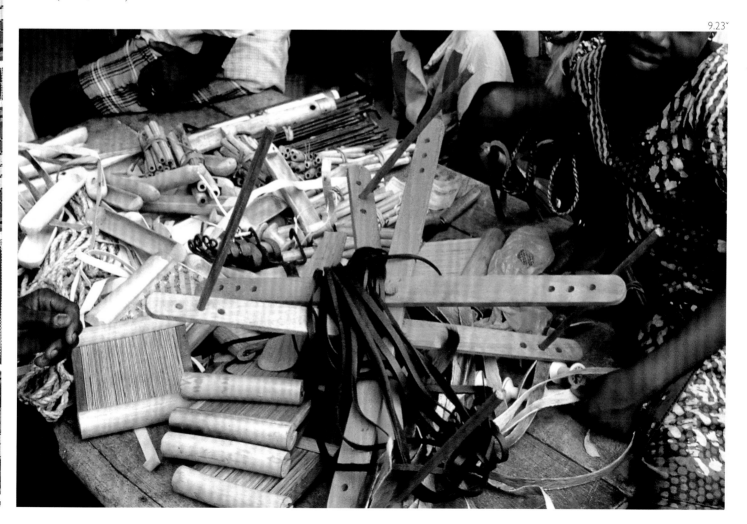

Cloth Types and Functions

With regard to "Ewe cloths," Lamb noticed four main characteristics: "first, the dye techniques used in Anlo cloth; second, the use of representational inlay designs; third, the blanket-type cloths of the Kpandu and Kpetoe regions; and fourth, the use of handspun cotton in and around Kpandu" (1975, 207). The repertoire of narrow-strip loom-woven cloth among the Ewe is quite vast. In addition to the so-called Asante kente patterns (see chapter 8), one is bound to see patterns or designs incorporating blue and white, greens, browns, reds, and muted earth and pastel colors, as well as inlay figurative motifs. Cloths are embellished with abstract geometric patterns and secondary colors and figurative motifs such as stools, pineapples, lizards, chameleons, parrots, keys, open hands, diamonds, birds, leaves, and inscriptions. Some of the motifs can also be seen on the linguist staffs belonging to the various chiefs; these staffs carry very important metaphorical messages.

A sample of representational motifs commonly used by Ewe weavers and the proverbs associated with each follows (fig. 9.24):

> Chameleon—The world is like a chameleon's skin, it changes (meaning no condition is permanent).
> Crocodile—The crocodile does not drown in a river (meaning I am invincible).
> Elephant—I am as big as the elephant (meaning I am invincible).
> Tortoise and snail—We do not point guns at each other (meaning we live in peace).
> Lion—I am the king.
> Key—When I lock it, no one can open it (meaning I am the ultimate authority).
> Hat—He who removes his hat can travel the whole world with ease (meaning the meek shall inherit the earth).
> Bird—A bird that grows feathers will always fly (meaning a child that survives infancy will always become somebody).
> Rooster—The rooster says to be afraid is to live (meaning live cautiously).
> Dagger—I have two sharp edges (meaning I am invincible).
> Pineapple—You cannot get to the pineapple without being pricked by its thorns (meaning no pain, no gain).
> Leaf—I will not survive if I am plucked from a tree (meaning I am one who depends on others).

Unfortunately cloths do not have a single dominant image and thus cannot be reduced to an unambiguous message.

Among the Ewe motif-laden cloths or specific patterns are not restricted by royal patronage, as is the case among the Asante. This is probably because the Ewe generally adhere to a non-hierarchical and democratic social structure (despite the existence of the institution of chieftaincy) that permits weavers to experiment with design patterns and clients to commission the cloths of their choice. It is important to note that the system of royal patronage among the Asante does not necessarily diminish the diversity or evolution of patterns and designs, but it does tend to micromanage weavers' talents. Thus, Picton's explanation of the dynamics of diversity and innovation in textile design is perhaps more appropriate to the case of Ewe weavers.

> If weavers are working within a tradition that enables and encourages experimentation in color and pattern, whether as a response to or a determination of fashion or for another reason, then, all other things being equal, that tradition has a capacity to develop, to evolve, that may be crucial to its survival, particularly during times of rapid change in culture and society. In a tradition that enables and encourages choice between options, innovation in pattern and design will be a matter of extending that range of options. [Picton 1992, 46]

Cloth serves many purposes in Ewe culture. Apart from protection from the elements, it is also a symbol, an adornment, and an object associated with rites of passage or rituals. Although the local cloth is very important, many Ewe today wear factory-printed clothes sewn in Western styles. The handwoven cloth has its place at puberty rites, marriage, ordinations of priests or priestesses, funerals, festivals, or rites for parents of twins. On such occasions, connoisseurs will be able to associate the cloth pattern and colors with the event.

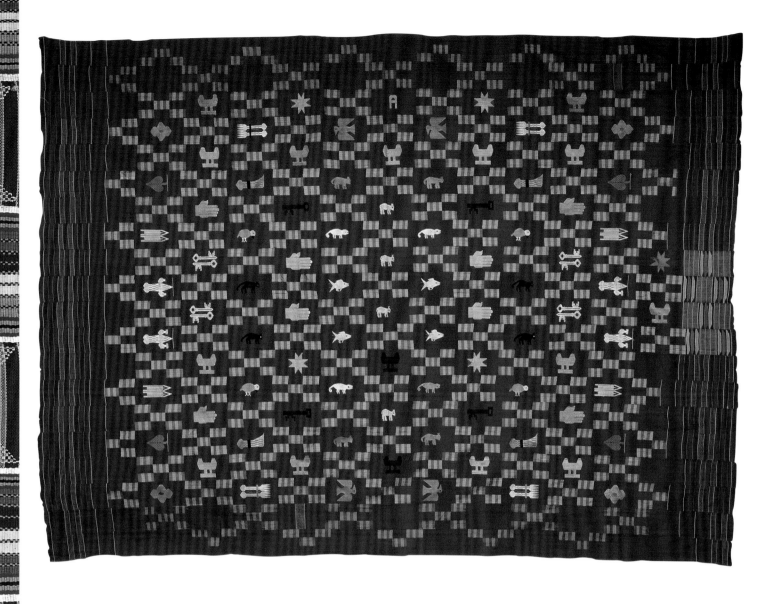

9.24 Ewe man's cloth incorporating a number of common motifs, including the chameleon, key, and bird. Cotton. Length 318 cm. Newark Museum purchase, Mrs. Parker O. Griffith Bequest Fund 97.25.6. Photograph by Sarah Wells.

The cloth for the ordination of a priest or priestess must be woven from locally grown cotton by a weaver who is pure at heart. If the weaver is not pure, he could die when the spirits are eventually invoked on the cloth. Because this particular cloth is sacred, it is woven in the outskirts of the town. After seven days of ritual and ceremonies held in seclusion, the priest or priestess is presented to the public for the first time in this cloth, which is later kept in the shrine. Anyone who is struck with the cloth could die. When the priest or priestess dies, he or she will be buried with the cloth. Locally grown cotton is also used to weave the cloth for the garments (*adewu*) of powerful hunters and warrior chiefs. Amulets made by the most renowned priests are attached to these garments to protect the wearers in battle.

Widowhood demands special rituals requiring the use of indigo blue cloths.[10] The bereaved spouse is kept indoors (six weeks for men and seven weeks for women) and may only use the indigo blue cloth that has been woven by a weaver in isolation who has not spoken to anyone during the weaving process. After the period of seclusion, the surviving spouse will usually wear the indigo blue cloth for a whole year (Agbenaza 1965). The time period varies by region. In Todome, one of the quarters of Notse, widows wear a cloth called Kleke, which has a pronounced white cleft, during the first ten months of mourning. It is also imperative for a son-in-law to offer handwoven cloth for the burial of a father-in-law or mother-in-law (Posnansky 1992, 131). Likewise, before a marriage is finalized, the groom must offer some cloth as part of the dowry. When a couple is blessed with twins, they go through certain rituals that confer on them some special powers. This occasion requires special cloths with green, red, and white predominating. In certain Ewe regions a girl's first menstrual period is considered the passage to womanhood, and this event is also celebrated with a particular cloth known as Agble. This cloth is typically offered by a prospective suitor who wishes to lay claim to the young woman (Agbenaza 1965, 102–3).

The Contemporary Weaver

There are three types of weavers among the Ewe today. The part-time weaver, the professional, or full-time weaver, and what I will call salaried weavers or mass producers. In the first category is the weaver who has another profession and practices weaving at leisure or during the off-season. Kofi Baeta of Notse exemplifies this type of weaver. He learned weaving from his father who also engaged in it on a part-time basis. A retired cocoa farmer, Baeta now weaves in his spare time in Notse. It must be noted that part-time weaving does not necessarily diminish ones skills. In fact, Kofi Baeta is an excellent weaver, one of the finest in Notse.

Kodzotse Sabah of Kpalime (Togo) is a seventy-nine-year-old full-time weaver (figs. 9.25, 9.26). Originally from Afiadenyigba (southern Volta Region, Ghana), he was born in 1928, and he learned his trade from his uncle as a young boy in Likpe (northern Volta Region, Ghana). Sabah's workshop in Kpalime is separated from his house, which is across the street. The workshop features a large billboard showing a full-length portrait of Sabah clad in kente. He has a large family and has trained several weavers who now have their own shops. In the 1980s, Sabah started training women to weave, thereby breaking the gender barrier in Ewe horizontal loom weaving. He is optimistic about the future of the weaving industry; since his childhood he has heard predictions that the local weaving industry would disappear as a result of the availability of imported cloth, but as this hasn't happened in his lifetime, he doubts it will happen after he dies.[11]

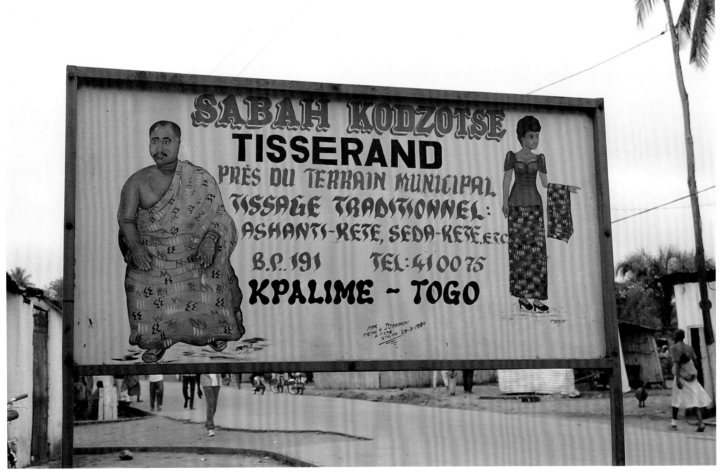

9.25 Billboard depicting Kodzotse Sabah, a professional weaver, and a woman dressed in kente. Photograph by Agbenyega Adedze, Kpalime, Togo, September 22, 1989. Eliot Elisofon Photographic Archives, National Museum of African Art.

9.26 Billboard depicting Kodzotse Sabah, a professional weaver, and a weaver at a loom. Photograph by Agbenyega Adedze, Kpalime, Togo, September 22, 1989. Eliot Elisofon Photographic Archives, National Museum of African Art.

Finally, salaried weavers are successful apprentices who for one reason or another could not set up their own workshops. They are joined by casual weavers who learned the trade intermittently from their fathers or who wove when they were young but never thought they would practice weaving as a trade until economic necessity compelled them to work for the new kente entrepreneurs. These entrepreneurs, recognizing the external demand for Ghanaian kente, have set up small factories or workshops where they supply everything from the loom to the thread. There are no limits on the design elements, and efficiency and speed at imitating designs appear to be the ideal goal. Such shops create the graduation and Greek letter strips that are now a common feature of the African American landscape. Although most local people complain about the quality of products from such workshops, they have, nonetheless, become part of the weaving tradition. Even some of the government handicraft centers have weaving workshops. One of the most important kente workshops is the Gobah Tengey Seddoh Kente Weaving Industry (GOBTENSEDDOH) at Dzelukope (southeastern Ghana). Although the children of the late Mr. Gobah learned how to weave from their father, they took to other professions until the 1970s and the rise of African-culture centered movements in the United States. In collaboration with some Americans, the young Gobahs set up their modern kente weaving industry, employed dozens of weavers, and exported their cloth to the United States. In recent times they have exhibited their products in South Africa with sponsorship from the Merchant Bank of Ghana. Thus, GOBTENSEDDOH is a kente weaving industry solely driven by outside demand and rarely catering to the Ghanaian market.

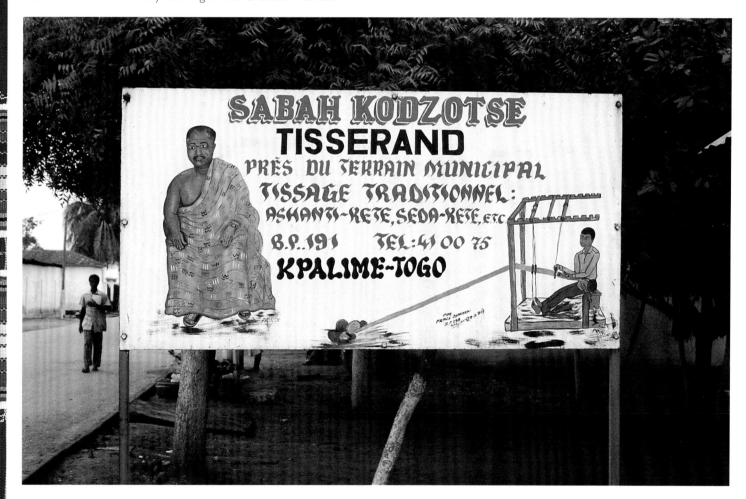

Agbozume, the Kente Market of the World

One of the most important handwoven cloth markets in Africa is in Agbozume, located on the highway from Accra, near the Togo border (figs. 9.27–9.30).[12] The market operates every fourth day. It is a place where you can find any material related to weaving: looms, tools, thread (local and imported), dyes, cloth, etc. The market gates open as early as 5:00 A.M. At the entrance, which is next to the highway, one is accosted by sellers of all kinds of kente products—napkins, shawls, full-length ladies' and men's wrappers, smocks, ties, etc. The aggressive manner in which these items are urged on prospective buyers is a sight to behold. In the market itself, one can see beautiful, colorful kente cloths—carefully folded and packed—on plastic and raffia mats spread on the ground.

By 8:00 A.M. the crowds and noisy atmosphere of the market scene have diminished. The weavers and the middlemen or middlewomen have finished their early morning transactions. Weavers who have made successful sales will return home and give money to their wives so that they can come to the market to buy their household necessities.[13] Students who earn a living by weaving must also leave the market to get ready for school. A few of the less fortunate weavers may linger because they have not been able to make sales, and they will mingle with the middlemen and middlewomen for the rest of the day. Any interested buyer who arrived after 8:00 A.M., however, would surely miss the best kente. These cloths would now be on trolleys being pushed toward buses heading for Benin, Côte d'Ivoire, Nigeria, Togo, and other parts of Ghana.

It is of interest that the Ewe distinguish between market cloth and commissioned cloth. One does not go to the market to buy a decent cloth; market cloth is meant for foreigners and non-connoisseurs. In most Ewe markets, women control the sale of cloth. These women traders go around the villages to purchase or commission cloths, which they later bring to the market.

9.27 The art of folding cloth as seen at the market in Agbozume. Photograph by Agbenyega Adedze, Agbozume, Ghana, September 7, 1989. Eliot Elisofon Photographic Archives, National Museum of African Art.

9.28 A woman and her son displaying cloth for sale at the market in Agbozume. Photograph by Agbenyega Adedze, Agbozume, Ghana, 1989. Eliot Elisofon Photographic Archives, National Museum of African Art.

9.29 Some weavers buy thread on credit and later find themselves unable to pay for it. This shopkeeper in Agbozume warns such weavers with a sign reading "NO CREDIT PLEASE." Photograph by Agbenyega Adedze, Agbozume, Ghana, August 26, 1989. Eliot Elisofon Photographic Archives, National Museum of African Art.

9.30 Three men from Niger selling a type of smock (batakari) made from Ewe strips at the market in Agbozume. Photograph by Agbenyega Adedze, Agbozume, Ghana, 1989. Eliot Elisofon Photographic Archives, National Museum of African Art.

9.27

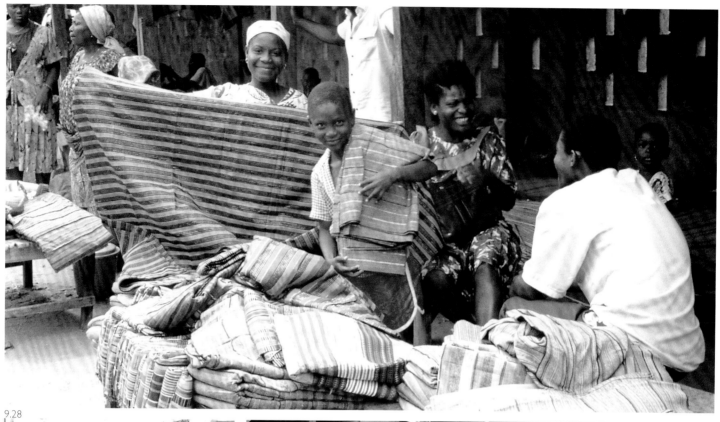

9.28

9.29

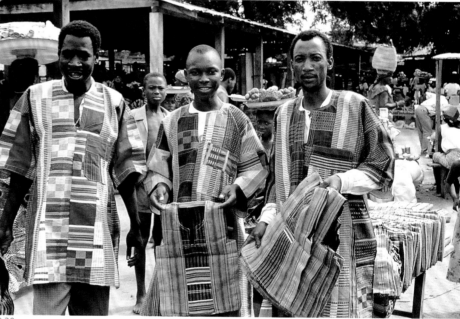

9.30

Conclusion

Due to the historical and social structure of Ewe society, there is hardly any dominant or royal cloth pattern, as can be seen among the Asante. In fact, the Ewe abhor the notion of kingship, hence the popular saying "*Ziga menye fiaga o*" (A big stool does not make one an important king). Anyone with the means can commission any pattern. With the exception of a few patterns, the names of cloths are subject to change, and any attempt to link Ewe cloth design or pattern to a particular name or town will probably not withstand the test of time.

Appendix: Ewe Cloth Names *

Abadzi	Bed
Afla	Bamboolike plant
Ahledome	Blue in the middle
Ahɔnɛ	Dove
Akpafiakɔme	Breast of the crow
Amekukuḑaka	Coffin
Amevaḑo	Somebody has arrived.
Amewuame	Man surpasses a man.
Atsusidomado	When my rival comes out, I will also come out.
Atsusikpɔdzedzome	The second wife saw it and jumped into the fire.
Babaḑu	Termites have eaten, or death is inevitable.
Deaƒeamekpɔ	Go to the house and see.
Domido	Get out and let us get out also.
Ðɔvɔ	The spider's web
Dzigbɔḑi	Patience
Dzinyegba	Heartbreak
Dziƒo kple Anyigba	Heaven and earth
Dzoxe	End of insults
Eḑuwodzi	You are [or he is] the winner.
Ehianega	It requires money.
Fiawoyome	A chief's retinue
Keḑedzi	Spread it on.
Kemagu	Rancor does not end.
Klogo	The shell of the tortoise
Kotokotoe	Round or circular
Kpevi	Double stones
Lokpo	The back of the crocodile
Matsimata	Let me weave this for myself.
Nyaxle	Open secret
Nyekɔnakpoe	Turn around and look at it.
Ŋusele ḑekawɔwɔme	There is strength in unity.
Tagomizɔ	Wear velvet and we shall move together.
Takpekpe le Anloga	Meeting at Anloga
Tremate	If you are not married, you cannot wear it.
Uuagba	Display of wealth

* Sources: Agbenaza 1965; Hiame 1981; and Posnansky 1992.

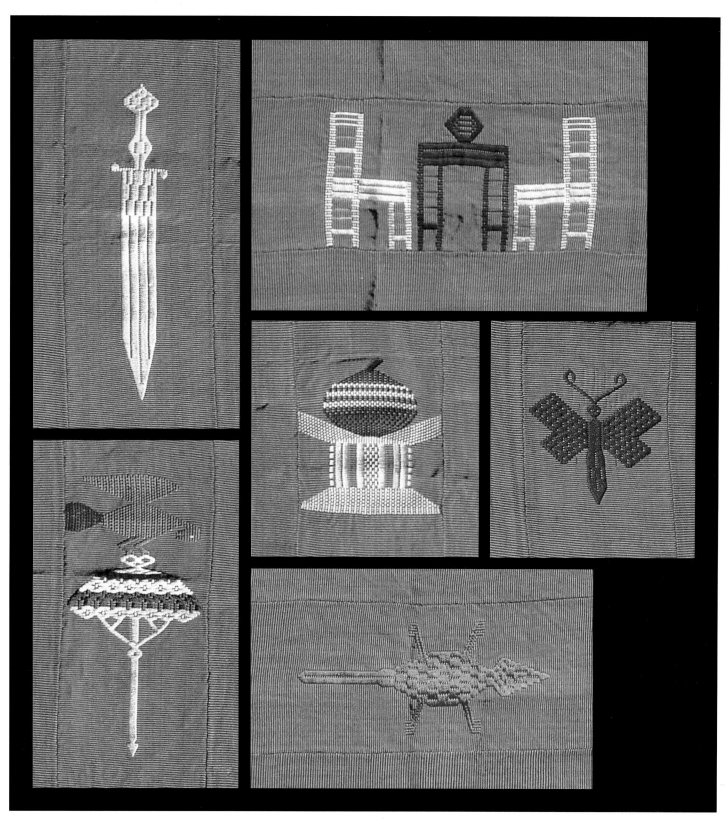

9.31 Details of motifs taken from the Ewe cloth
illustrated in figure 9.5

Interleaf H
Central Ewe and Agotime Weaving

The Ghana/Togo border area from Agbozume in the south to Apasa in the north has a complicated history. In the middle of this region in particular, there has been significant interaction with the Asante and the Adangbe (coastal peoples living roughly between Accra and Ada). The central Ewe—loosely defined here as living between Akpokope and Ho—produce weavings today that are virtually indistinguishable from those of the Asante. The Agotime Traditional Area with its "capital" of Kpetoe was the home of the first annual Agbamevoza (Kente Festival) in 1996. The festival of 1997 had as its theme "Peace and Unity for Development." The Ewe in this area still tend to use fixed looms embedded in the earth rather than the portable looms anchored on a wooden base that are standard for the Asante today. In figures H.6 and H.7, sixteen-year-old weaver Emanuel Fusese is shown at work at a fixed Ewe loom. Despite a fierce attachment to the preeminence of Ewe weaving, one of the most common patterns woven in this area is the classic Asante Oyokoman. The photographs in figures H.1, H.2, and H.9 were taken in Kpetoe, 1997 (H.1 and H.2 were taken by David Mayo); figures H.3–H.7 were taken in Dokpokope-Ho, 1997 (H.5 was taken by David Mayo); figures H.8 and H.10–H.12 were taken in Akpokope, 1997. Except as noted above, photographs are by Doran H. Ross.

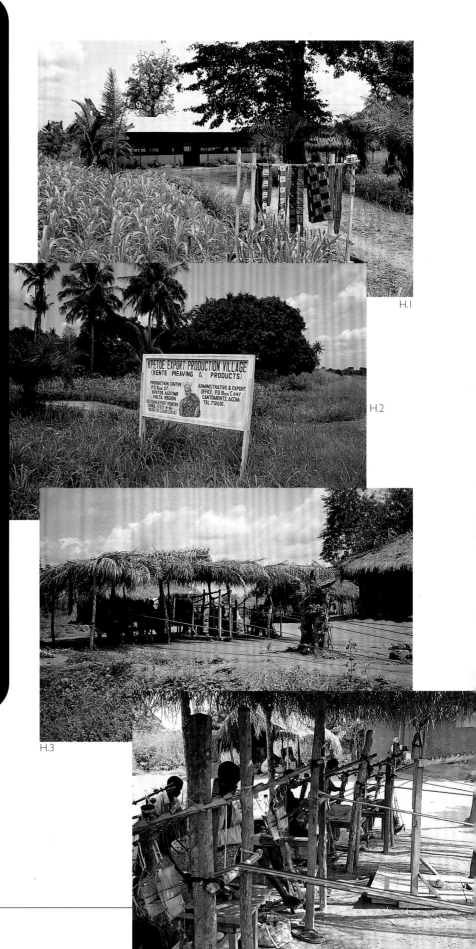

H.1

H.2

H.3

H.4

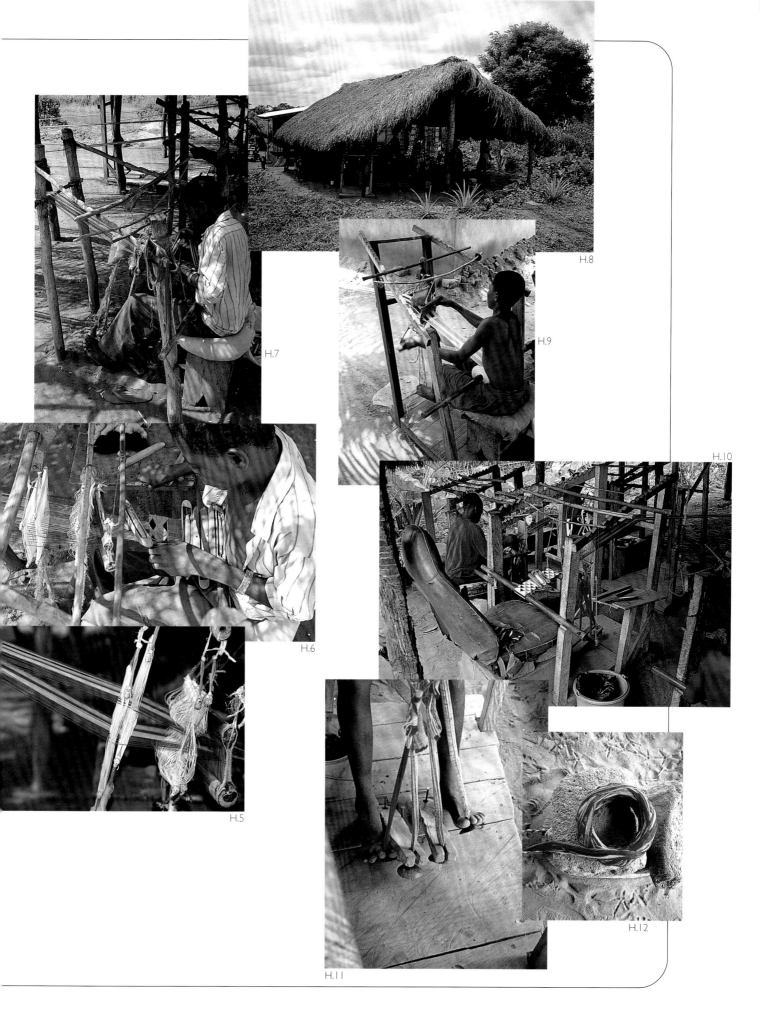

H.8

H.7

H.9

H.10

H.6

H.5

H.11

H.12

Interleaf 1
Muhammad Ali

In 1964 Muhammad Ali visited Ghana with his brother Rahaman Ali and was given at least three kente cloths on separate occasions. During most of his time spent in public Ali wore kente, especially one very fine Oyokoman. He met with Kwame Nkrumah, shopped in Makola Market, and while in Kumase tried to remove Ɔkomfo Anokye's famous sword from the ground. Wherever he went, he was surrounded by large enthusiastic crowds. All of the photographs reproduced here were taken by Howard Bingham, Ali's official photographer for the past thirty-five years. A selection of Bingham's remarkable photographs are published in *Muhammad Ali: A Thirty-Year Journey* (Simon & Schuster, 1993).

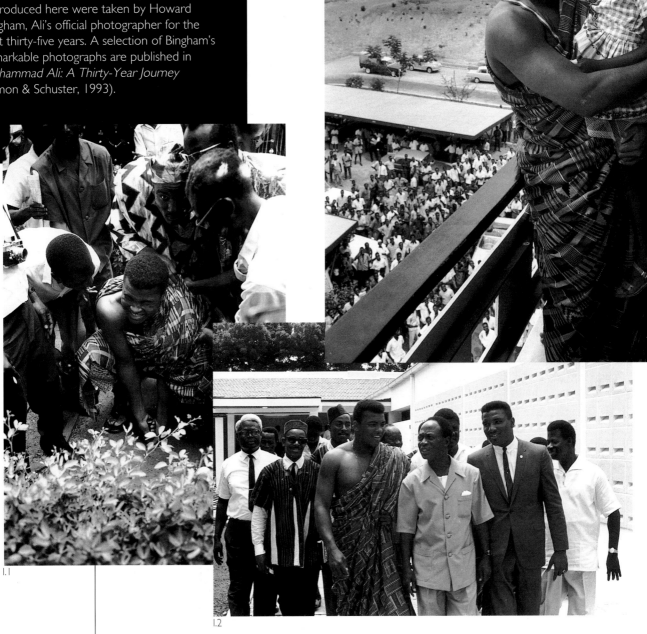

1.1

1.2

1.3

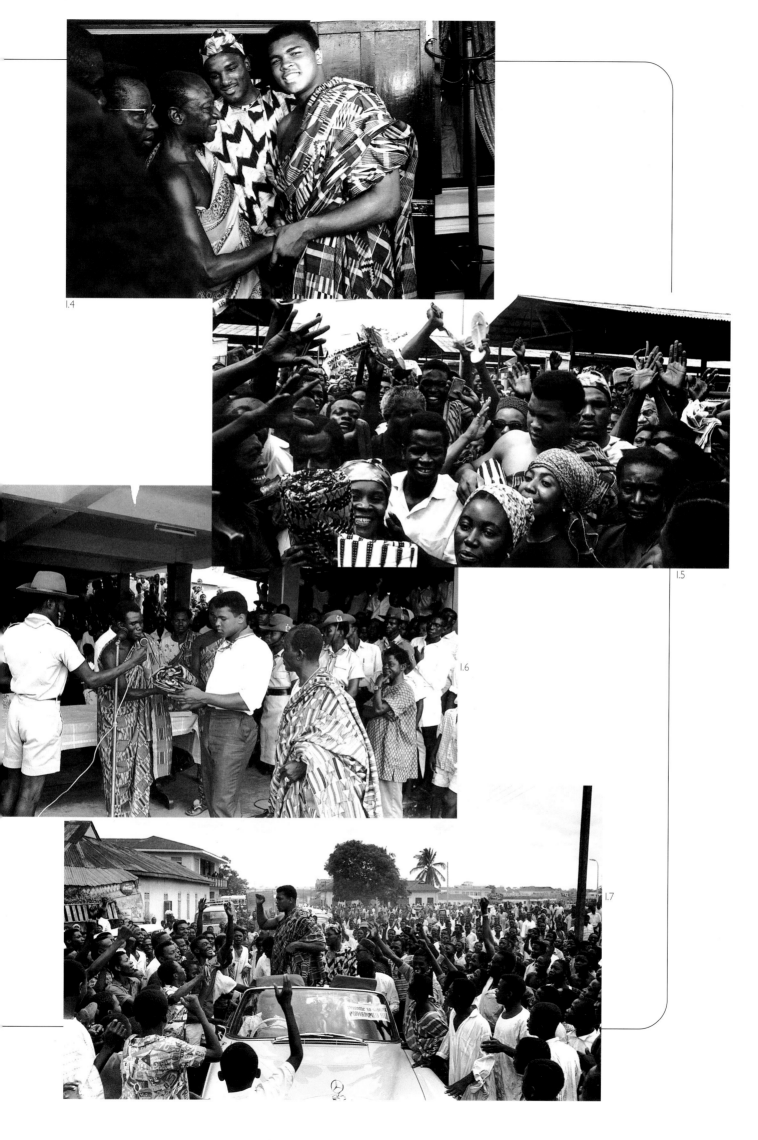

1.4

1.5

1.6

1.7

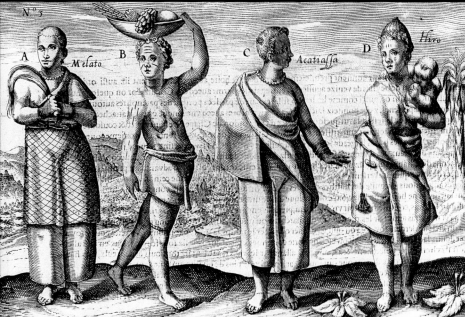

10.1 Artist's interpretation of early seventeenth-century men's dress along the Gold Coast based on written descriptions by Pieter de Marees (1602).

10.2 Artist's interpretation of early seventeenth-century women's dress along the Gold Coast based on written descriptions by Pieter de Marees (1602).

10.3 Market scene with cloth sellers in the center based on written descriptions by Pieter de Marees (1602).

Shortly after the beginning of Portuguese contact with what came to be called the Gold Coast of West Africa, visitors to the area began to record in writing the clothing and adornment practices of coastal peoples. These books were largely responsible for shaping initial European impressions of West Africans. One of the most significant and detailed of these was Pieter de Marees's *Description and Historical Account of the Gold Kingdom of Guinea* (1602), which includes the following observations on men's dress:

> [T]hey take two fathoms of Linen and put it between their legs and around their body, like a belt, letting it hang down below the knees, like Portuguese Trousers. When they go outside their houses they take another fathom of Linen, Silk or other cloth around their neck or over their shoulders and under their arms, as if it were a Mantle. [Van Dantzig and Jones 1987, 34]

The description of the loincloth in the first sentence closely approximates practices that continued into the twentieth century in some areas. As for the second cloth it is difficult to conceive how it could go "over their shoulders" and "under their arms" at the same time, although if the two body parts were referred to in the singular, this could correspond to current practice where the man's cloth passes under the right arm and over the left. As the translators note, a "fathom" of linen is only about three feet (van Dantzig and Jones 1987, 34 n. 2), which is considerably smaller than the familiar men's cloths of today. Still, we have an early indication of the practice of wearing a wrapped garment. The "Linen" referred to was probably a Dutch import and should not be confused with strip-woven cloth.

Although we know very little about de Marees, he appears to have had a fairly sophisticated knowledge of textiles and distinguishes cotton, silk, wool, and flax throughout his narrative, specifically referring to Holland linen, Leiden Say (a thin European textile popular in the sixteenth century), Spanish blankets, and Spanish serges (van Dantzig and Jones 1987, 34, 39, 44, 52, 54, 62, 85). His description of more elaborate women's dress is also of interest:

> [W]hen they go to Market…they wrap another piece of linen around their bodies, with another [cloth] belt under it, and hang one or two fathoms of Linen from below their breasts down to their feet, like a Frock. On top of that they take yet another cloth of "*Smallekens,*" Leiden Say or striped Linen, and hang it around their bodies, over their shoulders and under their arms like a little mantle. [Van Dantzig and Jones 1987, 39]

Of particular importance here is the translators' note on "*een ander cleet van Smallekens*": literally, "'another cloth [made] of little Narrow ones.' This probably refers to locally produced cotton cloth, made by sewing together the narrow strips woven on the traditional loom. Much of this cloth was imported from…what is now the Ivory Coast" (van Dantzig and Jones 1987, 39 n. 5). So here we most likely have a reference to strip-woven cloth even though it is probably neither Asante or Ewe.

De Marees included engravings in his book depicting both men's and women's dress with lengthy and detailed captions (figs. 10.1–10.3). Adam Jones has cautioned against relying on these images as accurate representations, since they were drawn from the author's written descriptions and not direct observation (Jones 1988, 13). Accurate or not, however, they did convey to de Marees's audience images of a people with a strong interest in textiles and with a variety of clothing types differentiated by social status.

Perhaps the earliest reference to Asante weaving is based on observations by a Danish envoy named Nog to the court of Opoku Ware I in the 1730s:

> Some of his subjects were able to spin cotton, and they wove bands of it, three fingers wide. When twelve strips long were sewn together it became a "Pantjes" or sash. One strip might be white, the other one blue or sometimes there were red ones among them. Opoku bought silk taffeta and materials of all colours. The artists unraveled them so that they obtained large quantities of woolen and silk threads which they mixed with their cotton and got many colours. [Rømer 1965 (1760), 36]

There are a number of interesting details in this description. First there is a suggestion of the width of the strip, "three fingers wide," which is less than the average width today but is consistent with many of the strips in nineteenth-century examples. There is also a reference to the number of strips (twelve) sewn together to make a whole cloth. Today women's cloths may have ten to fourteen strips compared to the conventional twenty-four for men, so either Nog is referring to a woman's cloth or men's cloths were much smaller in the first half of the eighteenth century and were worn more like a short cape or mantle.

10.4

10.5

10.4 Asante musician in Kumase wearing a warp-striped kente with weft-faced blocks of design. From a drawing by Thomas Bowdich (1819, drawing no. 5).

10.5 Asante loom in the courtyard of a Kumase house. From a drawing by Thomas Bowdich (1819, drawing no. 3).

10.6 Ewe kente collected before 1847. Danish National Museum, Copenhagen, Gc 192. Photograph by John Lee.

10.7 Asante (?) kente collected in 1850. Danish National Museum, Copenhagen, Gd 1. Photograph by John Lee.

The mixed strips of white, blue, and red are also of interest, a point that will be developed later in this chapter. Finally, there is the reference to unraveling European textiles, especially silk, to obtain threads with colors not available from local dyes.

British envoy Thomas Bowdich visited Kumase in 1817 and was clearly impressed by Asante weaving, remarking that "the fineness, variety, brilliance and size of their cloths would astonish" (1966 [1819], 310). He observed chiefs "in the general blaze of splendor and ostentation" who

> wore Ashantee cloths, of extravagant price from the costly foreign silks which had been unravelled to weave them in all the varieties of colour, as well as pattern; they were of an incredible size and weight, and thrown over the shoulder exactly like the Roman toga. [1966 (1819), 35]

Here again we have a reference to the unraveling of foreign silks to increase the range of colored threads available to Asante weavers. As discussed in chapter 6, these threads were more frequently employed to create weft-faced blocks of design than the warp. Bowdich illustrated his book with his own drawings, and one image of a harp-lute player has sufficient detail to reveal the man's blue-and-white striped cloth with intermittent weft-faced designs (fig. 10.4).

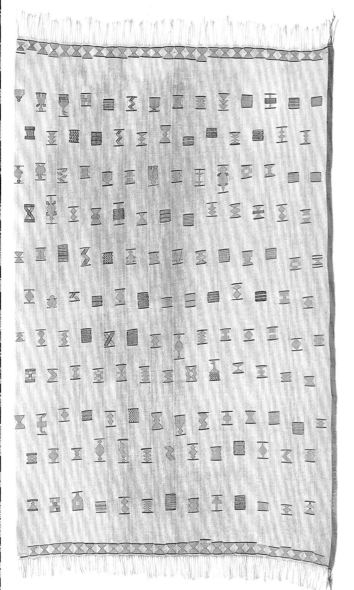

10.6

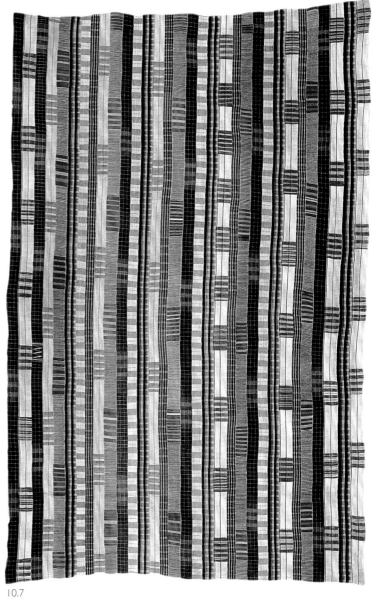

10.7

Another Bowdich illustration depicts a loom in the courtyard of an Asante house (fig. 10.5). Although it is unlikely that a weaver would work in the open without any protection from the sun, the representation of the loom is relatively accurate. Bowdich mentions collecting a loom and a textile "having precisely the same appearance on both sides" for the British Museum (Bowdich 1966 [1819], 310). Unfortunately neither has been positively identified in the museum (see McLeod 1981, 154).

The earliest extant cloths known to me in museums are those now in the Danish National Museum, Copenhagen, and the Museum of Culture, Basel. The eight cloths collected by Eduard Carstensen, governor of Danish possessions on the Gold Coast between 1844 and 1850 were all identified as "kintee."[1] One of the Copenhagen pieces (fig. 10.6) was accessioned in 1847. The cloth's twenty-seven strips contain an assortment of representational inlays, including a crocodile, frog, snake, and crab, along with such items of regalia as a stool, sword, umbrella, and combs (see fig. 9.3 for a detail of this cloth). This along with a report of the cloth coming from Popo confirms an Ewe attribution.

A second textile in the Danish National Museum was acquired in 1850 and has also been attributed to the Ewe (fig. 10.7). Nevertheless its thirty-two strips include a fairly consistent repetition of six different warp patterns, five of which are readily recognizable in Rattray's 1927 corpus of Asante indigo designs; the sixth has a plain white warp. Although it is possible that the Ewe used the same warp patterns at this time, I am more inclined to view this cloth as Asante. A third cloth dating from this same period alternates three different strips with simple warp stripes (fig. 10.8). After cloths consisting of a repetition of the same strip, cloths with two or three different strips were probably the most commonplace.

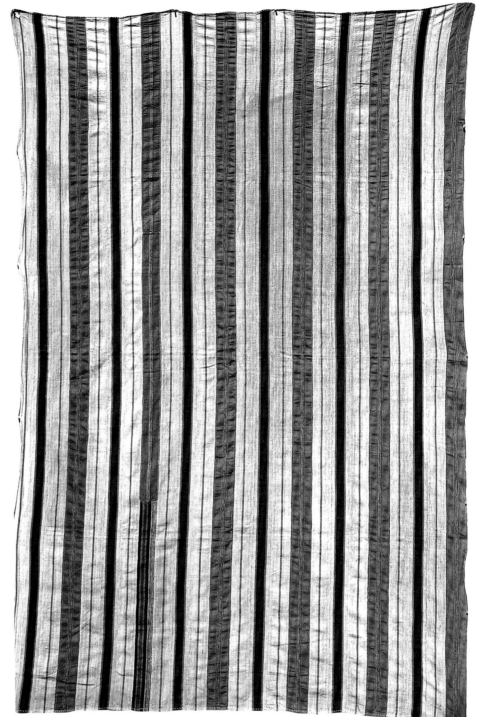

10.8 Strip-woven cloth of indeterminate origin collected on the Gold Coast circa 1850. Danish National Museum, Copenhagen, Gd 2.

10.9 Strip-woven cloth collected by Andreas Riis in 1840 from Akuropon. Basel Mission Collection in the Museum of Culture, Basel, 23.334.

10.8

The early cloths in Switzerland were acquired as part of Basel Mission activities during the nineteenth century. The earliest was collected by the missionary Andreas Riis in 1840 in Akuropon. What is most readily apparent in this cloth is the rigid geometry produced by lining up the weft-faced blocks of design on alternate strips to create a kind of elongated checkerboard (fig. 10.9). This textile could be either Ewe or Asante, and cloths from both areas were undoubtedly available to Akuropon, which is located between the two.

This work contrasts dramatically with another Basel Mission piece collected before 1888 from Kumase (fig. 10.10). Here again we have a repetition of the same warp-stripe pattern throughout the cloth, but the weft-faced designs are scattered randomly across the surface. In these weft blocks we can recognize the familiar Asante configuration of three units of Babadua separated by units of *adwen* (see chapter 6), but the weaver made no attempt to keep these units at a consistent length; they could not, therefore, have been sewn in a rigid grid even if this was desired.

A third Basel Mission textile was acquired from Abetifi by the missionary Gottlob Dilger in 1886 (fig. 10.11). Abetifi is considerably closer to the Asante than the Ewe, which would favor an Asante attribution. Again we have the repetition of the same warp stripe (twenty-eight times) with weft blocks lined up on alternate strips, although the corners of the blocks are not immediately adjacent as in figure 10.9.

The fourth Basel Mission cloth (fig. 10.12), collected sometime before 1914 by Adolf Kirchner at an unrecorded location on the Gold Coast, is also perhaps a nineteenth-century example. This remarkable weaving alternates two different warp-stripe patterns

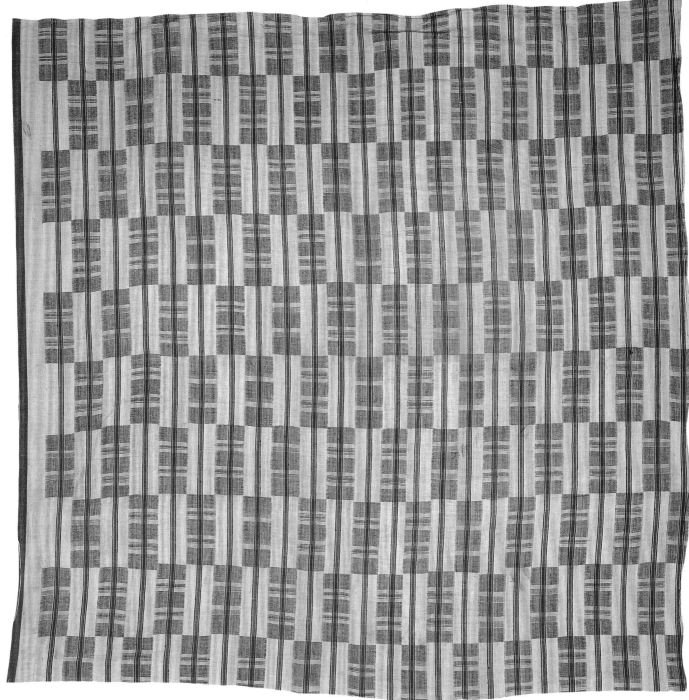

10.9

over twenty strips but is edged on the sides by two different strips (with no weft designs). These outside strips nevertheless maintain the dark/light alternation of the interior strips. The piece is most likely Ewe since the "tweedlike" effect in some of the weft-faced blocks is produced by twisting two different colored threads. Lamb considered this a recent innovation, but clearly it is of some duration (1975, 171).

These seven early cloths are of particular interest for two reasons. Only one of them has the "finished" or "bordered" ends (fig. 10.6) that are characteristic of most twentieth-century Asante kente. The "finish" where it does exist is also very simple and consists of a row of X-like designs and a fringe, not at all comparable to what can be seen in the first example in the "Catalog of Ewe Weaving," for example. A close examination of late nineteenth-century photographs (see below) provides little evidence of this finish, which leads to the conclusion that it only became common and conventionalized in the twentieth century.

The second point of interest rests with the dominant combination of faded red, green, and yellow weft blocks in figures 10.6 and 10.9 and an emphasis on this combination in figure 10.10. These examples can be multiplied several times in early twentieth-century kente and represent a distinct set of color preferences. As will be discussed in detail later, these colors will become very important in the Ghanaian independence movement, and for some of the same, as well as some different, reasons, they will also have considerable currency in various Black nationalist and Pan Africanist initiatives in the United States.

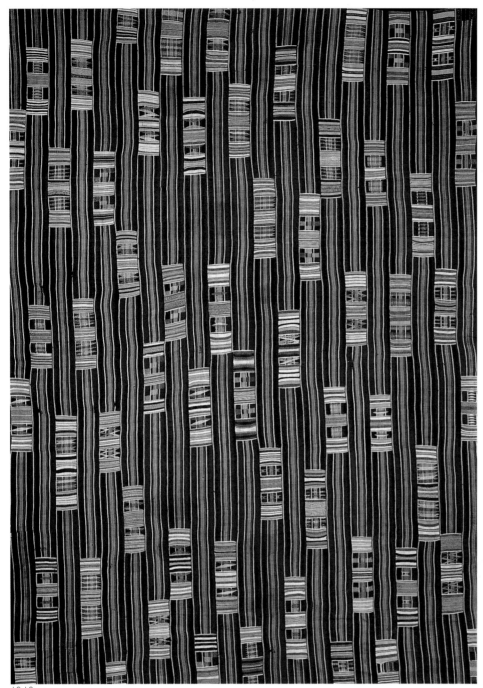

10.10

10.11

10.10 Asante kente collected in Kumase before 1888. Basel Mission Collection in the Museum of Culture, Basel, 23.336.

10.11 Asante (?) kente collected by Gottlob Dilger in 1886 from Abetifi. Basel Mission Collection in the Museum of Culture, Basel, 23.335.

10.12 Strip-woven cloth collected by Adolf Kirchner before 1914. Basel Mission Collection in the Museum of Culture, Basel, 23.333.

Perhaps more important than these early Basel Mission weavings is the impressive body of photography taken by missionaries or otherwise deposited at the Basel Mission Archive. Founded in 1815 the Mission has been active in Ghana since 1828, and the earliest photographs in its archive date from the 1860s. Of nearly five thousand photographs taken in the Gold Coast and now in the Basel Mission, about half of them focus on African peoples. A wonderful array of kente, both Asante and Ewe, is worn in the photographs, and many cloths can be "read" with remarkable clarity (figs. 10.13, 10.14.). Even a cursory survey of the images confirms that textiles framed by a distinct border are rare in early cloths, as are textiles woven and sewn to form a rigid grid. In the dress of chiefs, cloths that repeat the same pattern seem to be about as common as those that alternate two or more different strips (cf. figs. 10.15, 10.16 with the previous two photographs). The latter type is considerably less popular today.

In images that show a chief with his entourage, a hierarchy of dress is readily apparent. One of the earliest prints in the corpus is an image of "The king of Kumase's ambassador, sent to Cape Coast in 1872" (fig. 10.17). The ambassador is the only person clearly seated on a chair and wears a cloth with at least three different strips, two of which have weft inlays. The official to his right is probably his senior counselor and also wears a fine kente with weft-faced designs. The remainder of the handwoven textiles on view have simple warp stripes with no weft patterns.

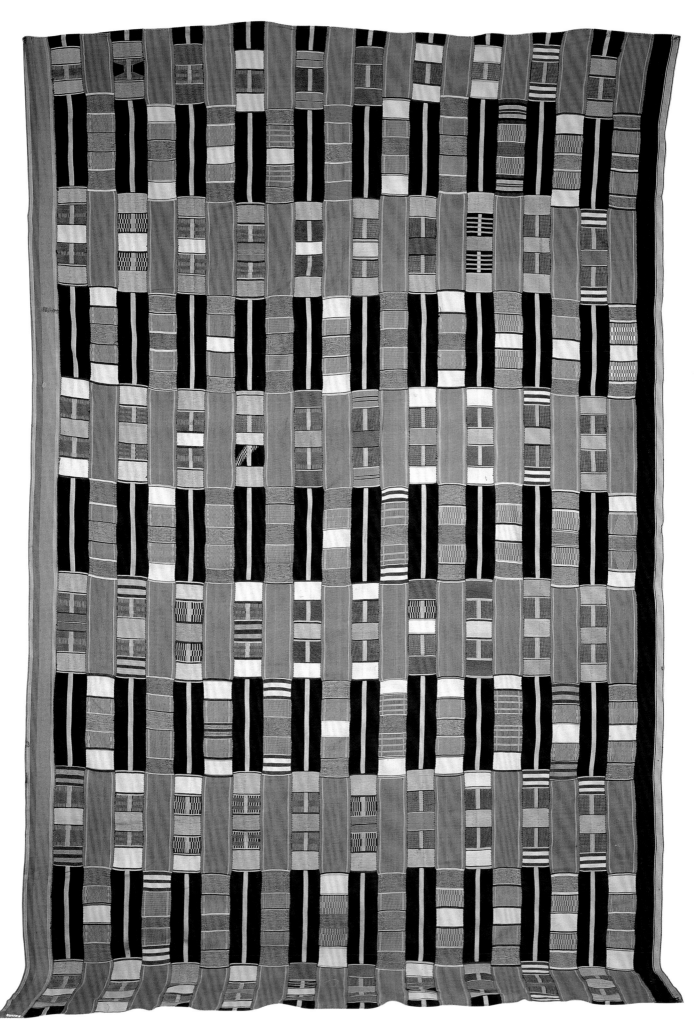

10.12

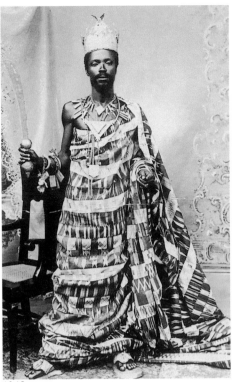

10.13

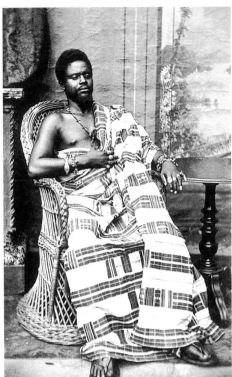

10.14

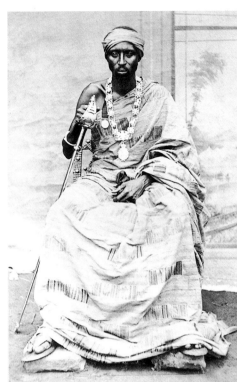

10.15

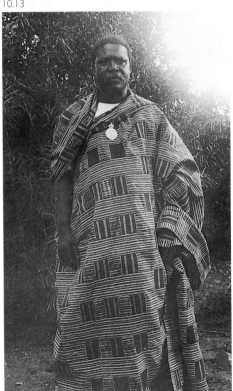

10.16

10.13 "King Akufo, Akropong" wearing large cloth with at least six different strips. Basel Mission Archive, D-30.11.041.

10.14 "King Atah of Kyebi" with kente composed of two alternating strips. Basel Mission Archive, D-30.13.050, 1902.

10.15 "King Sakite of Odumase" wearing a cloth repeating the same warp-stripe pattern. Basel Mission Archive, D-30.06.038, 1902.

10.16 "Chief Em. Mate Kole Odumase" wearing kente with a single strip sewn with the weft blocks aligned vertically. Basel Mission Archive, D-30.06.036. Photograph by Wilhelm Erhardt, 1899–1912.

A second chief photographed with his subjects wears a kente with at least seven varied warp-stripe patterns (fig. 10.18). To his right, again, is the next highest ranking person in the photograph, and he wears a cloth a cut below that of his chief. Only one other handwoven cloth is worn, and it is a plain warp-stripe kente on a man behind and slightly to the left of the chief. Among other prominent court officials, the chief sword-bearer occupies a position near the top. Distinguished by an eagle feather headdress, this official at Abetifi was photographed wearing a full man's cloth pulled off his shoulder and wrapped around his waist (fig. 10.19). The blocks of Babadua are clearly apparent as befitting the status of this individual.

Basel Mission photographs make it clear that women could also wear high-status textiles (figs. 10.20–10.23). The women lined up with chewing sticks in their mouths (fig. 10.20) are gathered for an undisclosed occasion, perhaps just for the photograph; most of them, including several young girls, wear fine cloths. The fourth woman from the right even has a cloth woven and sewn to form a tight grid, which requires considerably more attention to detail than do the other cloths on view.

A meticulous analysis of the Basel Mission photographs would likely shed considerable light on the development of Asante and Ewe weaving between about 1865 and 1915. As it is, the archive provides our most substantial view of clothing practices of the period and the encroaching influence of British colonialism and European missionary values. There are even images of the appropriation of strip-woven cloths for purposes other than apparel (fig. 10.24).

Before kente began making its way to the United States, it was moving out of the Gold Coast and into Nigeria at least as early as the 1930s. Around 1937 G. I. Jones collected a cloth obviously modeled on a Gold Coast kente that was woven by an Igbo woman from Akwete on a fixed vertical loom (fig. 10.25). Lisa Aronson documents the two-hundred-year-old trade in Ewe and other strip-woven cloths out of Popo, in present-day Togo, into the Ijo area of the Niger Delta (1982). In addition, she records an Ewe weaver who moved into Aba, a southern Igbo village, in the 1930s and an Ijo man who in 1939 apprenticed in the Ewe town of Keta before returning to Finima in the Delta. Both weavers passed on Ewe traditions and styles to local peoples. These examples suggest the dynamic complexity of trade and the exchange of weaving ideas along the West African Coast.

It has been argued that before any actual kente ever reached the United States, visual retentions of the cloth and related West African strip weaves appeared in African American pieced strip quilts (figs. 10.26–10.28). The idea of the strip quilt is said to have been a translation of West African handwoven strips. In *The Afro-American Tradition in Decorative Arts*, John Michael Vlach notes that its "wide distribution makes the strip quilt the most commonplace domestic example of black material culture in the United States. Why a single approach to the task of quilting should be so dominant among Afro-American quilt makers may be traced to the retention of design concepts found in African textiles" (1978,

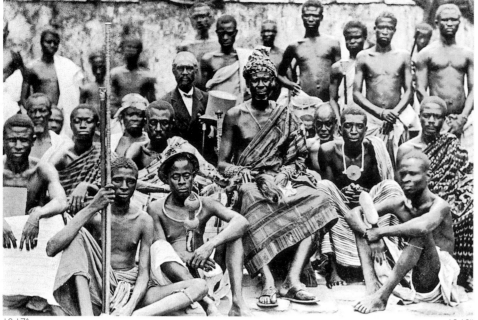

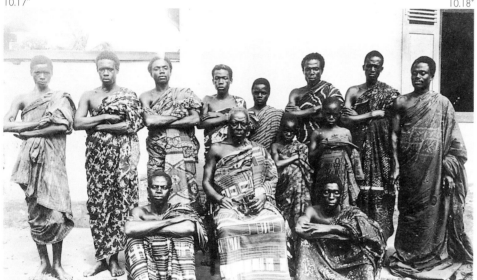

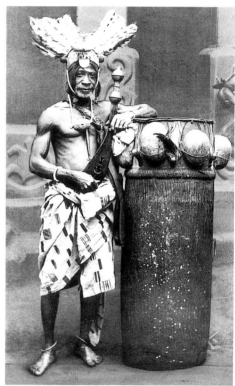

55). The former are often pieced together from the smallest possible rectangles of cloths, and the strips are then sewn together just as their African models (Wahlman 1993, 32). The quilts are also said to incorporate other ideas from the West African aesthetic tradition, including the use of "large shapes and strong contrasting colors" and "off-set matching of strips," as well as strips sewn together in "asymmetrical and unpredictable designs" (Wahlman 1993, 35). It is also argued that the varying of small squares and rectangles by size, arrangement, and color is an improvisational strategy that ultimately has its origins in West and Central Africa (Leon 1987). "Flexible patterning," for example, an A-B-C-A-B-C-A-C-B arrangement of design units or strips, again has its counterparts in West Africa and especially in kente (Leon 1987, 40, 41).

According to Maude Wahlman, the "unpredictable rhythms," "variations on a theme," and "improvisation" are traits also "found in other African-American arts such as blues, jazz, black English, and dance" (1993, 48). These arguments are somewhat controversial, but there are nevertheless a seemingly endless number of examples that can be compared favorably with the kente tradition. As opposed to "retentions," there are also deliberate African revivals in African American quilting and a relatively new tradition of actually incorporating handwoven or factory-made kente into contemporary textile arts (see below).

Related to arguments about African influence in the design of African American quilts are the piece-work cloaks (fig. 10.29) of the African American populations of Suriname especially those of the Saramaka peoples (Wahlman 1993, 25). Sally and Richard Price in their influential volume *Afro-American Arts of the Suriname Rain Forest* recognize the similarity of Maroon "narrow-strip sewing" to West African cloth, but they argue against any "direct inheritance" of the visual vocabulary based on the lack of evidence for the South American tradition anywhere before the twentieth century (1980, 72, 73). Arguing from silence is always somewhat problematic, but on one level it is irrelevant. Academic conclusions are often at odds with popular beliefs, and many do believe these are African retentions.

10.17 "The king of Kumase's ambassador, sent to Cape Coast in 1872," Basel Mission Archive, QD-30.020.0015, 1872.

10.18 "The town chief of Akropong Kwabena Agyemang Afae." Basel Mission Archive D-30.11.039. Photograph by Rudolf Fisch, 1885–1909.

10.19 Odow Kwame, chief sword-bearer of Abetifi. Basel Mission Archive, D-30.14.056. Photograph by Friedrich Ramseyer, 1864–1895.

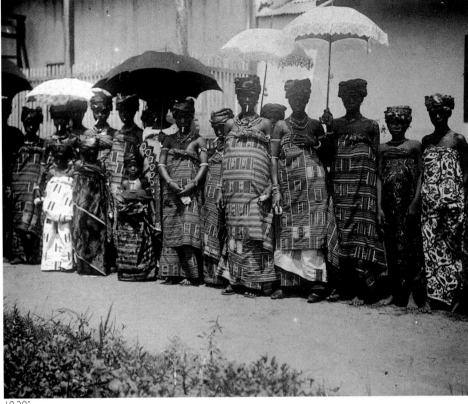

10.20^

10.21

10.20 "Women with European umbrellas and 'tooth sticks.'" Basel Mission Archive, QD-30.019.0005.

10.21 "The oldest Christian in Odumase." Basel Mission Archive, D-30.06.031. Photograph by Wilhelm Erhardt, 1899–1912.

10.22 "Ampofowa, Queen Mother from Akem." Basel Mission Archive, QD-30.024.0066.

10.23 Young Asante woman. Basel Mission Archive. D-30.62.009.

10.24 "Mission house in Kumase: Dining-room." Basel Mission Archive, D-30.16.048. Photograph by Friedrich Ramseyer, 1897–1906.

10.25 Akwete cloth, Igbo peoples, Nigeria. Woven on a fixed vertical loom by a woman in imitation of kente cloth. Collected by G. I. Jones circa 1937. Cotton. Length 183 cm. FMCH X84.1.

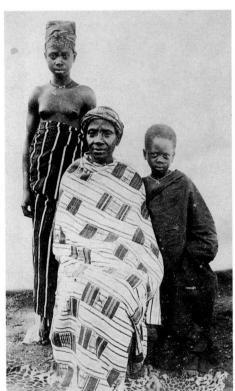

10.22

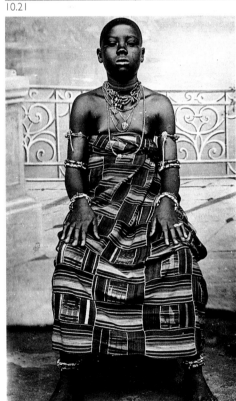

10.23

10.24^

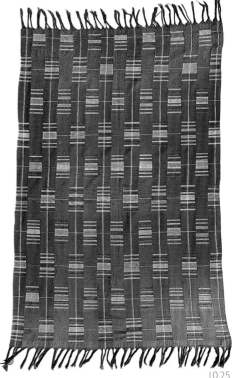

10.25

One provocative turn-of-the-century image from the Basel Mission Archive relates to both the African American strip quilts and the Suriname cloaks (fig. 10.31). It depicts a young woman wearing in Ghanaian style a cloth clearly composed of strips pieced together from a variety of industrially produced cloths. If this practice was widespread and of sufficient duration to have coincided with the slave trade, it could have influenced both traditions. There is, however, little evidence of this.

Written records, drawings, museum objects, and early photographs all helped to create an image of Asante and Ewe textiles for a very specialized audience in the second half of the nineteenth century and the first quarter of the twentieth. Yet few, if any, among this audience were interested in cultural studies. Most were pursuing religious, political, and economic agendas.

While the physical history of kente cloth in the United States does not really begin until the late 1950s, the ideological history that anticipated its arrival is probably best understood starting in the 1920s. The Harvard educated W. E. B. Du Bois (1868–1963), one of the founders of the NAACP, was instrumental in raising the political consciousness of African Americans from the early part of this century until the time of his death. Ronald W. Walters in his thoughtful book *Pan Africanism in the African Diaspora* credits Du Bois with "the task of conceptualizing both the African Diaspora and Pan Africanism" and playing a "pioneering role in conceptualizing the study of African and especially African American history" (1993, 38, 39). Du Bois emphasized the collective destiny of Black populations on both sides of the Atlantic and fought for the political and economic independence of colonized Africa. He promoted Black pride in many of his writings and in 1920 founded a children's magazine that ran for two years to "help foster a proper self-respect" (Wolseley 1971, 43). He participated in all six Pan African Congresses, organizing all but the first. Of note, for the last of these, held in 1945, Du Bois arranged the participation of Kwame Nkrumah (1909–1972) and George Padmore (1903–1959) as joint political secretaries. This marked the beginning of a relationship with Nkrumah that led Du Bois to move to Ghana in 1961 to become director of the *Encyclopaedia Africana* project (his lifelong dream). In 1963 Du Bois received an honorary doctorate from the University of Ghana wearing an academic robe lined with kente (fig. 10.33).

During the Harlem Renaissance, the forceful arguments of Alain Locke (1886–1954), who was also Harvard educated, persuaded African Americans to examine the ancestral heritage of Africa and especially its artistic legacy. Although Locke tended to treat "the spirit of African expression" in terms of narrow, and sometimes stereotypical, generalizations, he called on African Americans to return to their "original artistic temperament," in the hope that "the sensitive artistic mind of the American Negro, stimulated by a cultural pride and interest, will receive from African art a profound and galvanizing influence" (1925, 256).

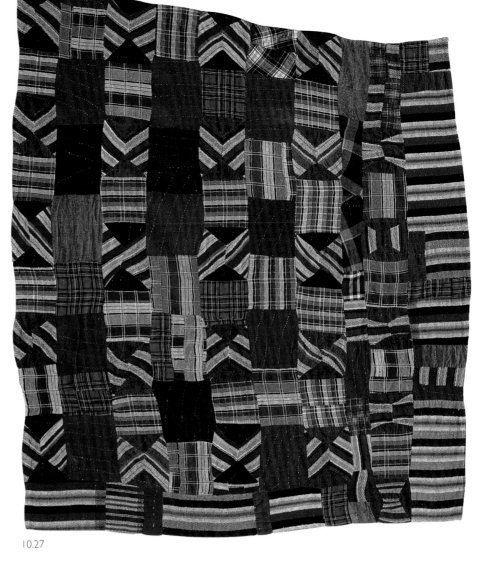

10.27

10.26

10.26 African American strip quilt (compound strip). Collection of Eli Leon. Photograph by Sharon Risedorph.

10.27 African American strip quilt. Collection of Eli Leon. Photograph by Sharon Risedorph.

10.28 African American strip quilt (improvisational strip). 213.4 cm X 218.4 cm. Collection of Eli Leon.

10.28

10.29

10.30

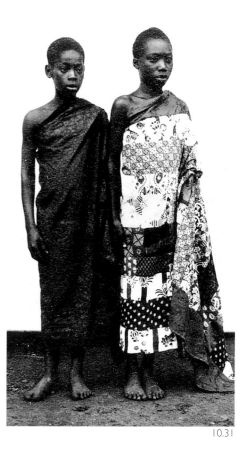

10.31

Locke valorized African art, in part, through examples of European artists borrowing African forms for their own use in the early part of this century. Nevertheless, he also clearly admired African art in its own right and emphasized the "almost limitless wealth of decorative and purely symbolic material" (1925, 267). He noted that "the African spirit…is at its best in abstract decorative forms" and singled out "the superb designs of the Bushongo" among others (1925, 267). Locke mounted several exhibitions of African art—many of which contained textiles—with the express purpose of educating young African American artists. Unfortunately, I have been unable to find any evidence that kente was included in these exhibitions.

Locke's familiarity with Bushongo textiles was probably a direct result of an exhibition held in 1923 at the Brooklyn Museum, *Primitive Negro Art Chiefly from the Belgian Congo*, which featured an installation of 1,454 objects including 149 raffia cloth embroideries and appliqués popularly known today as "Kuba cloth." Curator Stewart Culin wrote, "The entire collection, whatever may have been its original uses, is shown under the classification of art, as representing a creative impulse, and not for the purpose of illustrating the customs of the African peoples" (1923, 1). This was one of the earliest exhibitions of African art in the United States, and it still has the distinction of being one of the largest.

Of almost as much interest as the exhibition itself is the line of cotton dresses and frocks developed by Bonwit Teller & Co. based on close copies of "Bushongo" surface design (fig. 10.30). These fashions were shown in the store's Fifth Avenue window with a duplicate set on display at the Brooklyn Museum in conjunction with the exhibition of 1923. These dresses were clearly targeted at a White audience, and there is no evidence that any marketing was directed at the African American community. Although this

10.29 Men's cloaks, Saramaka peoples, Suriname. Cotton. Length of largest 101.5 cm. FMCH X80.1227.

10.30 Bonwit Teller advertisement for fashions inspired by Kuba raffia textile designs. "Women's Wear" section of the *New York Times*, April 14, 1923.

10.31 "Students from the Gold Coast." The girl on the right is wearing a cloth sewn together from strips of many different machine-woven cloths, some of which are pieced together. Basel Mission Archive, D-30.20.024.

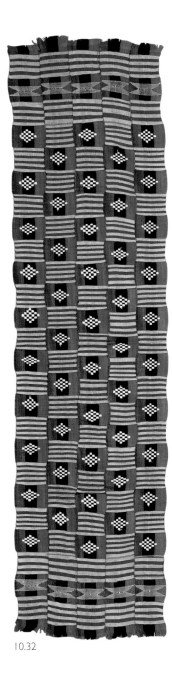

10.32

10.33

10.32 Shawl with red, green, and black warp stripes known as "African Freedom" or "African Unity." From the workshop of Samuel Cophie. Cotton. Length 167 cm. FMCH X96.30.48.

10.33 W. E. B. Du Bois at the graduation ceremony where he received an honorary doctorate from the University of Ghana, Legon, in 1963. Special Collections and Archives, W. E. B. Du Bois Library, University of Massachusetts, Amherst.

10.34 Broadloom weaving with hand-picked portrait of Kwame Nkrumah above the text of one of the Ghanaian leader's most famous public statements. Cotton. Height 141 cm. FMCH X97.36.29.

10.35 One of several "Official portraits" of Kwame Nkrumah. Ghana Information Services, 1957.

10.36 Commemorative cloth issued in honor of Kwame Nkrumah and Ghanaian independence. Cotton. Height 114 cm. FMCH X97.36.39.

initiative did not set any "trends," it represents one of the earliest instances of the appropriation of African textile design by the United States fashion industry.

Also important in setting the stage for the introduction of kente into African American communities from the 1960s on were some aspects of the ideology expressed by the charismatic Jamaican activist Marcus Garvey (1887–1940) and the Universal Negro Improvement Association (UNIA) he founded in 1911. Garvey's writings also influenced Kwame Nkrumah, the future leader of Ghana. As Nkrumah noted in his autobiography when recounting the ten years he spent studying in the United States:

> I think that of all the literature that I studied, the book that did more than any other to fire my enthusiasm was *Philosophy and Opinions of Marcus Garvey* published in 1923. Garvey, with his philosophy of "Africa for the Africans" and his "Back to Africa" movement did much to inspire the Negroes of America in the 1920's. [1957, 45]

Although Nkrumah was careful to distinguish that "Garvey's ideology was concerned with *black* nationalism as opposed to *African* nationalism" (1957, 53, 54), Garvey nevertheless remained an important force in focusing attention on a shared heritage on both sides of the Atlantic.

Garvey's somewhat obsessive interest in the trappings of leadership, including a strong interest in color symbolism, probably also influenced Nkrumah. On August 13, 1920, the convention of the UNIA adopted a "Declaration of Rights of the Negro Peoples of the World," which included as right number thirty-nine, "That the colors, Red, Black and Green be the colors of the Negro Race" (Thompson 1969, 324, 328). The interpretation given this color symbolism was "red for the blood of the race, nobly shed in the past and

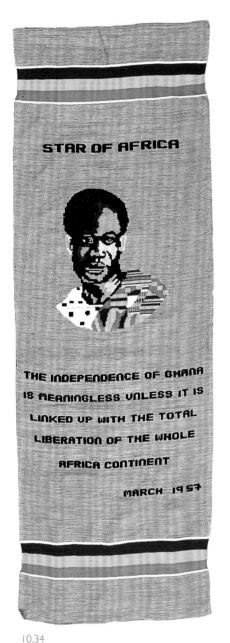

STAR OF AFRICA

THE INDEPENDENCE OF GHANA
IS MEANINGLESS UNLESS IT IS
LINKED UP WITH THE TOTAL
LIBERATION OF THE WHOLE
AFRICA CONTINENT

MARCH 1957

10.34

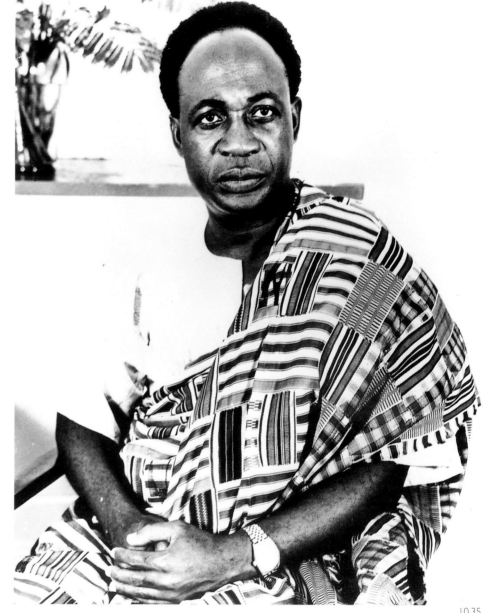

10.35

10.36

dedicated to the future; black to symbolize pride in the color of its skin; and green for the promise of a new and better life in Africa" (Cronon 1955, 67).[2] These colors were to become even more important from the 1960s onward, and in the past two decades they have been incorporated in a popular warp-stripe kente pattern called simply "African Freedom" or "African Unity" (fig. 10.32). The red and the green (along with white) became the colors of Nkrumah's Convention People's Party (CPP) and were used on the Ghanaian national flag (along with gold and black). The symbolism of the flag is officially explained in a handout from the Ghanaian embassy: "Red represents the blood of those who died in the country's struggle for independence; gold the mineral wealth; and green the rich forest. The black star symbolizes African freedom." Red, black, and green (along with white) are also the colors of the National Defence Council (NDC), the party of Jerry Rawlings, the current president of Ghana.

One reflection of African American interest in Kwame Nkrumah and the independence movement in Ghana was Richard Wright's *Black Power: A Record of Reactions in a Land of Pathos*. This is a somewhat cynical and occasionally condescending account of the author's journey to the Gold Coast in 1954. Nevertheless, it was a widely read book with a provocative and obviously influential title. If it was not universally well received, it still provided significant accounts of the history of slavery, the colonial exploitation of the Gold Coast by the British, and the rise of the Asante Empire in addition to Wright's own observations. Although Wright frequently referred to "colorful native togas," he did not distinguish between local handwoven cloth and machine-made imports. What is important here is Wright's clear-cut emphasis on the leadership of Ghana in the independence movements of Africa and his focus on Kwame Nkrumah as a catalyst for these movements (fig. 10.34). The book ends with a nine-page open letter to the Ghanaian leader.

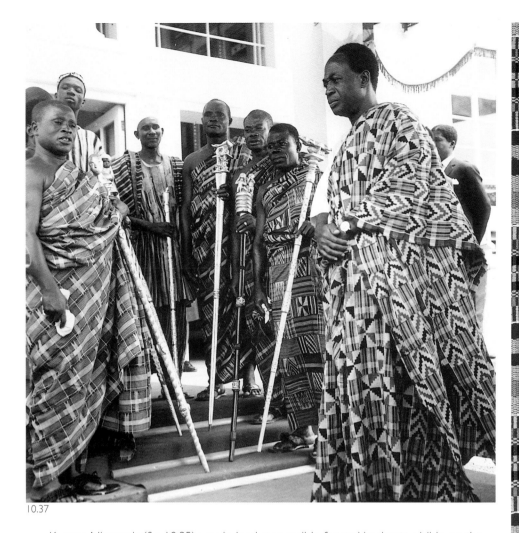

10.37

10.37 Kwame Nkrumah wearing Oyokoman Adweneasa kente and shown with group of linguists on Ghanaian Independence Day, March 6, 1957. Ghana Information Services.

10.38 Kwame Nkrumah and his cabinet just prior to Independence Day. *New York Times*, February 27, 1957.

Kwame Nkrumah (fig. 10.35) was indeed responsible for making kente visible on the world stage. He led the independence movement in Ghana as head of the Convention People's Party from 1949; as head of the majority party of the Legislative Assembly from 1951; as prime minister from 1952 through independence on March 6, 1957 (fig. 10.36); and as the first president of the Republic of Ghana from 1960 until he was overthrown in a military coup d'état in 1966.

The Ghanaian scholar G. P. Hagan is one of the few to have recognized Nkrumah's deliberate "leadership style" and his use of traditional dress on specific types of occasions: "Nkrumah carefully exploited…the Ghanaian love of the external symbols of collective and individual identification" (1991b, 187). Although Nkrumah, a member of the Akan subgroup called Nzima, was born along the coast near Côte d'Ivoire—far from either the Asante or Ewe weaving centers—he nevertheless wore Asante kente and northern Ghanaian smocks on key occasions after returning to Ghana in 1947 (fig. 10.37). Some members of the independence movement saw a return to traditional dress as part of the decolonization process. Nkrumah, however, clearly understood this issue in more sophisticated terms, as Hagan has thoughtfully summarized:

> The national good sense suggested that traditional clothing be reserved for use on formal occasions while European clothing be used for the non-regal realms of the farm, factory floor, and classroom. In the issue of clothing, the nationalist movement played out its cultural dilemmas in a medium the people could understand. The African was part of a world culture; thus while he had to find a way of expressing his distinct identity, he could not reject any aspect of world culture that was beneficial in terms of progress and development. Thus African dress had to live side by side with the European dress. This synthesis—seeing Ghanaian culture as part of world culture—made it also easier for Ghanaians to see their culture as a composite culture of diverse ethnic cultures. Ghanaian culture could be projected through the display of aspects of any of the ethnic cultures within the boundaries of Ghana. And Nkrumah showed how. [1991a, 15]

This understanding of the national (Ghanaian) situation as a microcosm of the international one had been readily apparent to Nkrumah. Hagan goes on to observe:

> Nkrumah made the *fugu* (smock) of the North national in appeal. The *fugu* was his battle dress, as it was for some leaders in the olden days. And he put on kente for formal ceremonies. In so doing, he used elements of cultural attire to show that customs from different ethnic cultures were merely different aspects or manifestations of one cultural identity, the Ghanaian identity. [1991a, 15]

THE NEW YORK TIMES, WEDNESDAY, FEBRUARY 27, 1957.

EBELS
T STEP

Approach
re Insist
he War

BRADY
rk Times.
Feb. 26—
nalists are
move in the
ed Nations
,
pted by the
n Feb. 15,
democratic
f the Alge-
ormity with
United Na-

s move, re-
has been
ve by both
nationalist
ional Liber-

be no ques-
ed rebellion
rrorism will
being. The
ionalists is,
a parallel
hould they
from the

s Held
olitical lead-
Mohammed
f the Na-
e Algerian
t in Madrid
"study" the
olicy. Since
n other re-
discussions
extremely

ion is that
been taken

Front guerrillas, and that a bi-
lateral cease-fire would necessi-
tate limitations of the French
Army and French police that
might interfere with the mainte-
nance of civil order

British Information Services

CABINET OF NEW AFRICAN NATION: Leaders of Ghana are, from left, seated: A. E. Inkumsah, Minister of Housing; Kojo Botsio, Minister of Trade and Labor; Dr. Kwame Nkrumah, Prime Minister; K. A. Gbdemah, Minister of Finance; A. Casely-Hayford, Minister of Communications. Standing, from left: A. E. A. Ofori-Atta, Minister of Local Government; N. A. Welbeck, Minister of Works; B. Yeboah-Afari, Minister of Agriculture; J. H. Allassani, Minister of Health; J. B. Erzuah, Minister of Education; L. R. Abavana, Minister Without Portfolio; Ako Adjei, Minister of the Interior, and Krobo Edusei, Minister Without Portfolio. Ghana, formed by union of the Gold Coast and British Togoland, will become a self-governing member of the British Commonwealth on March 6.

ists in Tunisia for the Algerian
rebellion.
 Prominent Tunisians say the
Tunisian people regard the Al-
gerian struggle as a prolonga-

who fled into Austria from the
Russians," they say.
 Indeed, the Tunisians feel
there is nothing unusual about
the support they are giving to

SAUD I!
ON ANT

Monarch's
Stand Ag;
Opposed

Special to
CAIRO, I
of Saudi Ar
today in his
the four-pov
to adopt a
against cc
Middle East
 The stron
reported to
President S
Syria, who
ing the Sov
Gamal Abd
was said to
Hussein of
ready denou
tation, was
 As a resu
over the w
communiqué
not end ton
evening ses
King Saud
uled flight I
 Saud Ha
 The Aral
tered the c
that he co
support in z
Communist
Middle East
suasively fo
President E
for econom
for the are
that the Un
demanded t
filiation of
was reconci
ism as long
was not be
 King Sau

7TH U. S. TURNCOAT
LEAVES RED CHINA

10.38

In *The Autobiography of Kwame Nkrumah* the Ghanaian leader only occasionally refers to his own attire in the text, and in thirty-six of the fifty black-and-white photographs in which he appears, he is wearing Western dress. Especially interesting, however, are the eleven photographs that show him wearing kente. The *Autobiography*, which had a publication date targeted at Ghanaian independence on March 6, 1957, was, of course, a major opportunity for Nkrumah to present himself to the world on his own terms. The first two photographs showing him in kente (see *Autobiography*, plates 13, 14) were taken on February 12, 1951, the day he was released from prison after over a year in confinement for a conviction on charges of sedition and a few days after his party had swept to victory in the elections of February 8. The cloth he is wearing is either a green or blue version of the now common warp-stripe pattern called Mmɛɛda (see fig. 8.15a–c), which is conventionally translated as "It has not happened before." More expansive interpretations of this pattern suggest that it is a "symbol of ingenuity, perfection, innovation, uniqueness and exceptional achievement" (Ofori-Ansa 1993). In either case it refers to something extraordinary.

The next place in the *Autobiography* where we see Nkrumah in kente is a rather casually posed photograph (plate 15, top) of "The Cabinet 1951–54." Here the prime minister is wearing an Oyokoman cloth named for the clan of the Asantehenes. Fresh from an election victory, Nkrumah has chosen this cloth deliberately. The Asante were always somewhat cool to Nkrumah's rise to power and tended to side with Dr. K. A. Busia in opposition to the CPP. It is not difficult to imagine Nkrumah choosing an Oyokoman cloth as a conciliatory gesture, one designed to embrace the Asante as part of his continuing effort to unite the country and move it toward independence.

We again see Nkrumah wearing a kente in plate 18 of the *Autobiography*, which is labeled "Delivering my Independence Motion in the Legislative Assembly, 10th July 1953." Unfortunately this image is blurred, and the cloth's pattern cannot be deciphered. It appears, however, to be the same cloth the Ghanaian leader is wearing in plate 19 (bottom) where he is shown formally greeting President William Tubman at the executive mansion in Monrovia, Liberia, on January 22, 1953. This is a cloth with a gold or yellow background that most closely approximates the warp pattern associated with the proverb *"Woforo dua pa, na yepia wo"* (If you climb a good tree, you get a push; see fig. 8.16). This maxim obviously argues for cooperative efforts and shared responsibilities, a message appropriate to both contexts in which this particular kente was worn and to Nkrumah's Pan Africanist aspirations.

The Mmɛɛda cloth discussed earlier reappears in plates 23 and 24 (top), following another important election for the CPP. These photographs are labeled "Arriving at

Christiansborg Castle to see the Governor after the 1954 election" and "About to take leave of the Governor after he had asked me to form a new government, 17 June 1954." These images are followed by a group photograph of the newly formed cabinet, which shows eight ministers wearing kente and two wearing northern smocks (plate 25, top). Nkrumah himself has returned to the same cloth he wore in plates 18 and 19; "If you climb a good tree, you get a push" is a near ideal choice of message to convey his zealous leadership of a history-making independence movement.

The final photograph in the *Autobiography* that shows Nkrumah in kente is plate 37, which bears the caption "Waving to the crowds . . . from the balcony of my office after the announcement of the date of independence." Here the exuberant leader is wearing one of the most celebrated and valued of all cloths, an Oyokoman Adweneasa. As discussed in chapter 8, Adweneasa is conventionally translated as "My ideas are finished" or "My skill is exhausted," but these interpretations have an element of finality that almost precludes the possibility of weaving another cloth. Samuel Cophie (see chapter 7) has chosen instead to translate the term as "I have done my best." All three variants convey Nkrumah's tremendous accomplishment at this historic moment.

As with Kente cloth, many other items of Akan regalia have meanings that may be conveyed by proverbs. Kwesi Yankah's discussion of the communicative dynamics of Akan counselors' staffs (*akyeame poma*), which are used to convey messages appropriate to given occasions (1995, 34), is equally applicable to the use of kente. Yankah considers that these proverbial messages communicated by a visual image "are often an iconic capsule of official policy respecting a given situation" (1995, 33). He continues by noting that "every Akan chief or king has two or more staffs. The higher a chief's status the wider the range of staffs, since an important chief deals with a greater variety of social and political situations and has to match various situations with relevant messages" (1995, 33). This also holds true if "head of state" is substituted for "chief or king," and "kente" for "staff." The fact that the kente is worn by the leader and the staff is carried by a follower makes the statement made by the cloth even more central and forceful.[3]

Nkrumah's rise to power and the steady progress of Ghana toward independence were systematically covered by the print media in the United States, especially the Black press. *Ebony* magazine was particularly attentive to this process, and kente cloth figured prominently in many of the photographs it published during this period. According to Roland Wolseley *Ebony* was founded by John H. Johnson in 1945 as "a black version of *Life* . . .born with the intention of emphasizing the bright side of black life and reporting success by black people in almost any endeavor" (1971, 63). The independence movement in Ghana was perhaps the ideal success story and one of considerable interest to African Americans. As Ronald Walters has described it, "the process of African independence stimulated by the independence of Ghana and by Nkrumah's activities as well. . .would have an impact on Africans of every description on the continent, but most importantly, it initiated an African revitalization movement in the Diaspora" (1993, 97).

Between its June 1952 issue, when *Ebony* announced Nkrumah as the new prime minister of Ghana, and its September 1966 issue, when it recorded the coup d'état that deposed him, *Ebony* published at least seventy-seven photos of people wearing kente (including twenty of Nkrumah) in thirty-four different issues. Benchmark articles included the one noted above introducing Nkrumah as Ghana's new prime minister. Here kente was called out in three photograph captions, including one that read, "Dressed in African gown made of kente cloth costing $150 and made by Native Gold Coast weavers" (June 1952, 97). Another significant article chronicled the historic meeting of Prime Minister Nkrumah and Liberia's President Tubman in Monrovia, giving Nkrumah most of the limelight and noting that "Nkrumah wore native robes during most of visit" (June 1953, 16). "Birth of an African Nation" (March 1957) with the official government portrait of Nkrumah in a kente was quickly followed by "Nixon Sees a New Africa" (June 1957). This piece documented the official United States contingent at Ghana's Independence Day ceremonies with four photographs of Nkrumah in kente, one in which he wears a northern *fugu*, and two of the Ghanaian leader in a suit and tie. Other photos featured the Reverend Martin Luther King Jr. and Coretta Scott King, Congressman Adam Clayton Powell, Congressman Charles Diggs Jr., Mrs. Louis Armstrong, Ralph J. Bunche, and the Duchess of Kent.

On March 4 and 6 the *New York Times* gave front-page coverage above the fold to the independence ceremonies featuring a photograph of Richard Nixon with kente-clad officials, although not Nkrumah, in each issue. A more impressive statement about kente was made several days earlier inside the paper with a photograph of the new Ghanaian cabinet (fig. 10.38) showing all thirteen members in kente (February 27, 1957).

Returning to coverage by *Ebony* during this period, perhaps as important for our

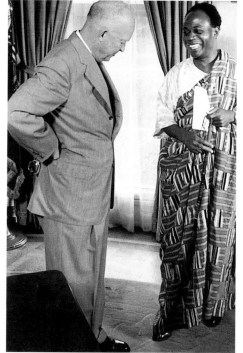

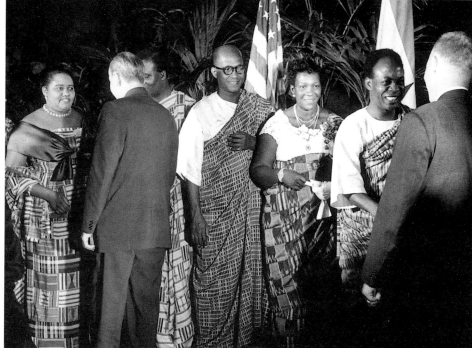

10.39 Prime Minister Kwame Nkrumah and President Dwight D. Eisenhower during Nkrumah's visit to the United States in 1958. Photograph by Ed Clark, *Life Magazine*. © Time-Life, Inc.

10.40 Prime Minister Kwame Nkrumah's entourage in receiving line during his visit to the United States in 1958. Photograph by Ed Clark, *Life Magazine*. © Time-Life, Inc.

purposes as the aforementioned articles were the seven photographs of the kente-rich wedding of Awule Mele Halm, daughter of the Ghanaian ambassador to the United States, to George Lantei Lamptey and two additional photographs of the wedding of Jemima Adusah and Peter P. A. Nuamah (November 1961, 63, 64). In the former ceremony both bride and groom are shown in matching silk kente with the maids of honor wearing kente strips around their waists. The wedding was conducted in Washington's National Cathedral by Dean Francis B. Sayre Jr., who wore a kente stole around his neck. In the Adusah-Nuamah ceremony, the entire wedding party, including flower girls, was enveloped in kente. Although the use of kente in African American weddings would not become popular until the 1970s and 1980s, photographs such as these helped to publicize the Ghanaian tradition (see also fig. 3.43).

In 1964 Muhammad Ali paid a highly publicized visit to Africa, and *Ebony* devoted nine photos to him in Ghana (September 1964). In the first of these we see Ali "decked out in kente cloth" riding in a convertible through the streets of Accra amidst an enormous crowd (p. 85). The second shows the "champ" walking next to his "personal hero" Nkrumah (p. 86). And in the last, he addresses a Kumase council meeting (p. 92). The article begins by reporting that "Ali loved Africa and Africa loved him" and also relates that he was given four plots of land "as an incentive to make Ghana his permanent home" (p. 85; see Interleaf I in this volume).

Making a big splash in the May 1965 issue of *Ebony* was the appointment of Alex Quaison-Sackey as the first Black president of the United Nations, a yearlong appointment that should not be confused with the position of secretary general, which at this time was held by U Thant of Burma. *Ebony* reproduced a full-page photograph of the two leaders with Quaison-Sackey wearing a fine Oyokoman kente.

Finally, in September 1966, *Ebony* ran "Kwame Nkrumah: The Fall of a Messiah," with a single image of the leader dating from his 1960 swearing-in ceremony. Although Nkrumah's reputation was destroyed for a time by the disclosure of massive corruption in his government, it has been restored to its rightful place in recent years.

Of all the events during this time, one stands out in terms of bringing kente, Nkrumah, and Ghanaian independence together for an American audience—Nkrumah's visit to the United States from July 23 to August 1, 1958. *Ebony* covered the visit in the article "The Return of Saturday's Child," illustrated with thirty-one photographs, thirteen of them showing Nkrumah in kente. The Ghanaian leader posed with a host of African American notables including: Congressman William Dawson of Illinois; Dr. Dorothy Ferebee, president emeritus of the National Council of Negro Women; Dr. Mordecai Johnson, president of Howard University; Congressman Adam Clayton Powell; and Roy Wilkins of the NAACP (October 1958, 17–24).

Nkrumah discussed this visit to America in his book *I Speak of Freedom* (1961) and specifically mentioned the following high-profile events:

- His welcome by Vice President Nixon with full military honors
- Appearing as a guest of honor at a White House luncheon hosted by President Eisenhower
- Meeting with the National Press Club
- Giving an address to the United States Senate

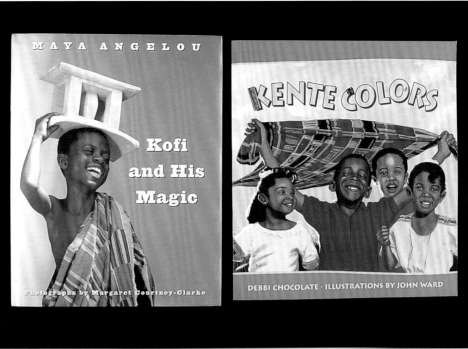

10.41

- Delivering a speech at the Council on Foreign Relations
- Attending a dinner hosted by Secretary of State and Mrs. Dulles
- Going to a luncheon given by the ambassador from New Zealand and attended by the ambassadors of other Commonwealth nations
- Receiving a tour of Hershey Chocolate factory, Harrisburg, Pennsylvania
- Attending a luncheon at his alma mater, Lincoln University
- Hearing Ralph J. Bunche at a reception in his honor given by the Harlem Lawyers' Association
- Speaking at the New York Cocoa Exchange
- Attending a meeting with the secretary general of the United Nations

One of the highlights of the visit was a trip by motorcade to the Harlem Armory where Nkrumah spoke to an audience estimated at seventy-five hundred. He wrote that "the spectacular and spontaneous welcome given me by the people of Harlem remains one of the happiest memories of the whole tour" (1961, 147). After New York Nkrumah went on to Chicago where he was greeted with similar fanfare and met with *Ebony* publisher John A. Johnson and toured the magazine's facilities. This United States tour was covered by all the major African American magazines and newspapers, including, of course, *Ebony*'s sister publication, *Jet*, and by most of the mainstream press. *Newsweek* ran a photograph of Nkrumah "clad in his colorful native kente" with President Eisenhower and gave a full page to the visit. Citing many of the events listed above, *Newsweek* wrote, "such a welcome…might have seemed unduly lavish, except for one thing: Nkrumah is emerging as a powerful voice in the rising tide of African nationalism. In wooing the 48-year-old Nkrumah, the U.S. bore in mind his stated objective: To make Ghana a base for liberating all Africa from colonial rule" (August 4, 1958, 33). *Time* gave the visit only half a page but featured a photograph of the prime minister in kente and noted in the text that before going out, he "draped on one of his $300 tribal robes of kente cloth" (August 4, 1958, 14). The *New York Times* covered the Nkrumah visit with at least three photographs of him: in one he wears kente and appears with Eisenhower; in a second he wears kente at the Harlem Armory and is shown with Ralph J. Bunche, under secretary of the United Nations; and in a third, he wears a light suit and appears on the floor of the New York Stock Exchange.

Perhaps the most visually arresting coverage in the mainstream press was *Life*'s double-page spread of the visit featuring Eisenhower admiring Nkrumah's kente (fig. 10.39) and Nkrumah and his entourage, all adorned in kente (fig. 10.40), in a receiving line, greeting more than fifteen hundred Washington notables over a two-hour period (August 4, 1958, 26, 27). In addition Nkrumah appears in kente in two other photographs where he is shown with the Nixons and the Dulleses. Ronald Walters cites Nkrumah's reception in New York and Chicago as "evidence that the independence of Ghana was an event of national significance that provided an opportunity for an outpouring of the Pan Africanism latent in the community" (1993, 99).

10.42 President Kwame Nkrumah speaking at the United Nations. Front page of the *New York Times*, September 24, 1960.

10.41 Two of the most popular children's books dealing with kente, Maya Angelou's *Kofi and His Magic* and Debbi Chocolate's *Kente Colors*, both published in 1996.

10.42 President Kwame Nkrumah speaking at the United Nations. Front page of the *New York Times*, September 24, 1960.

10.43 Kente cloth presented to the United Nations by President Kwame Nkrumah on September 26, 1960. The pattern is known as "One head cannot go into council." Silk. Length 602 cm. United Nations.

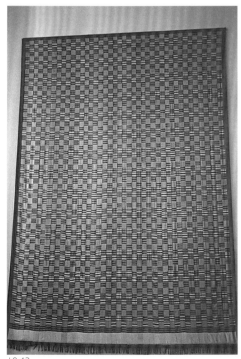

10.43

Images of Nkrumah and other Ghanaians wearing kente in West Africa and the United States were not the only means by which awareness of the fabric was increased among African Americans. In his visits to the United States Nkrumah repeatedly invited American Blacks to return home to visit or live in Ghana, encouraging professionals to help him build the country. At a dinner at Lincoln University Nkrumah said, "Back at home, we think of them still as brothers and we can assure them of a warm welcome whenever they choose to visit the land of their forefathers" ("Nkrumah Praises Ghana's Ties Here," *New York Times*, July 29, 1958, 10).

In addition to the African American luminaries mentioned above who attended the Ghanaian independence celebrations of March 6, 1957, a number of other prominent individuals made pilgrimages, including John Biggers, Thurgood Marshall, W. E. B. Du Bois, Maya Angelou, and Malcolm X. Biggers left an impressive record of his visit with his wife, Hazel, which began on July 3, 1957, in the volume *Ananse: The Web of Life in Africa* (1962). In addition to eighty-two drawings (not all of which were devoted to Ghana), there is a substantial text recounting his travels, and he even commented on the weaving process: "I loved to hear the singing treadles of the looms as brilliant threads of many colors were woven into the luxuriant designs of *kente* cloth" (1962, 29). There was sufficient interest in the volume to occasion its reprinting in 1979. Alvia J. Wardlaw wrote of the publication, "Arriving like a magnificent and unexpected gift, *Ananse* helped elevate the collective black consciousness to a new and higher level of self-awareness" (1995, 53).

Maya Angelou's affection for kente did not manifest itself in her writings until considerably after her 1962–1963 stay in Ghana. In her belated account of living in West Africa, *All God's Children Need Traveling Shoes* (1986), she writes of "a chief gloriously robed in rich hand-woven kente cloth" (1991, 60), and in another passage she expresses the hope that she will have enough money to "at last buy a small piece of kente cloth, red, gold and blue" (1991, 113). Angelou's children's book *Kofi and His Magic* (1996), which tells the story of a young boy weaver from Bonwire and features photographs by Margaret Courtney-Clarke, and Debbi Chocolate's *The Colors of Kente* (1996), illustrated by John Ward, have been instrumental in defining the tradition for both children and adults in the late 1990s (fig. 10.41; see chapter 12).

As for Malcolm X, kente cloth may not have caught his attention in his visits to Ghana of 1964 and 1965—as judged by his writings—but he was clear in the *Autobiography of Malcolm X* about his views of the country, "the very fountainhead of Pan-Africanism," and of Nkrumah, "In Ghana—or in all of black Africa—my highest single honor was an audience at the Castle with Osagyefo Dr. Kwame Nkrumah" (Haley and Malcolm X 1964, 352, 356). Given the massive popularity of his volume, Malcolm X's statements may have been among the most influential. Walters has said of this post-independence period, "because of Kwame Nkrumah's leadership, Ghana had become the hub of Pan African activity, and as such the country was a symbol of the aspirations of many peoples of African descent for the future viability of the continent. The country was regarded by many

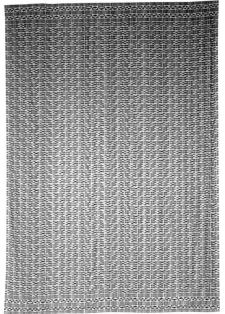

10.44

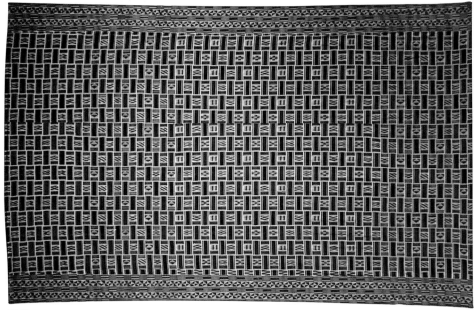

10.45

10.46

10.44 Kente cloth presented to the United nations by Lt. Colonel Kwame Baah, Ghana Commissioner of Foreign Affairs, in 1974. United Nations. Photograph by M. Tzouvaras.

10.45 Kente cloth presented to the United Nations in 1985. Silk. Length 602 cm. United Nations. Photograph by Lois Conner.

10.46 Kente cloth presented to the United Nations by President Jerry Rawlings on October 21, 1995. United Nations. Photograph by Evan Schneider.

10.47 Detail of Oyokoman man's cloth. Silk. Width of warp strips 9 cm. FMCH X97.12.4.

10.48 Detail of Oyokoman man's cloth. Rayon. Width of warp strips 9 cm. FMCH X97.36.2.

10.49 Display of Ghanaian national flags along High Street, Accra. Photograph by Doran H. Ross, 1976.

10.50 Detail of Oyokoman man's cloth with stripes arranged in order of national flag of Ghana. Rayon. Width of warp strips 8 cm. FMCH X97.36.3.

10.51 Kwame Nkrumah speaking in Parliament. Behind him is an Oyokoman kente, the stripes of which are arranged to correspond with the colors of the national flag of Ghana. Black stars are placed in the center of the gold stripes. Ghana Ministry of Information.

African peoples at that time as "the center of the Black World" (1993, 101).

Nkrumah made a second post-independence trip to New York City in 1960 to address the United Nations to argue in favor of an all-African force in the Congo and to denounce Mobutu Sese Seko in favor of Patrice Lumumba as the legitimate head of government. Appearing in kente (fig. 10.42), Nkrumah made the top of the front page of The New York Times ("Nkrumah Speaks," The New York Times September 24, 1960). Two days later Nkrumah presented a monumental kente to the United Nations to be used as a wall hanging in the east foyer of the Assembly Hall (fig. 10.43). James Teague covered the event for the Daily News Record, and his account merits extended quotation:

> A fragment [sic] of Ghana's handwoven "kente" cloth was sandwiched here Monday between bitter diatribes against the United States by Cuba's Fidel Castro and the Czech's President Antonin Novotny.
>
> It became the most broadly advertised bit of textiles, in its brief moment, perhaps any in history. Television cameras focused upon it, delegates of nearly 100 nations gazed at it, the UN press section was flooded with leaflets about it—and for a moment the General Assembly was silent.
>
> Dr. Kwame Nkrumah, president of the Republic of Ghana, swathed in folds of the native silk fabric, presented it formally as a gift of his people to the UN. The green, yellow and maroon piece measuring 19 feet 9 in. by 12 feet 7 in., was hung in its permanent place in the conference area outside the east delegates' entrance to the General Assembly Hall. With a sea-blue background, it proclaimed: "One Head Cannot Go Into Council" (two heads are better than one).
>
> The cloth took 10 weavers three and a half months to complete. [Teague 1960]

This was the first of four spectacular cloths presented to the United Nations by the "government and people of Ghana." After the first one faded, it was replaced in 1975 by an enormous fifty-eight strip work with the warp pattern Mmɛɛda, usually translated as "something that has never happened before" (fig. 10.44). It was succeeded in turn by a thirty-three strip Oyokoman in 1985 (fig. 10.45), and for the fiftieth anniversary of the United Nations in 1995, President Jerry Rawlings presented another Oyokoman with the emblem of the United Nations embroidered in the center of the cloth (fig. 10.46). These permanent installations at the United Nations have provided a consistent and highly visible presence for kente in this heavily visited location, which for many has become something of a pilgrimage site in New York City.

The popularity of Oyokoman kente in both Ghana and the United States is due in large part to either a wonderfully remarkable coincidence or an especially strategic decision. As mentioned earlier Oyokoman is the name of the clan to which all Asantehenes have belonged. The warp pattern of this cloth today appears to be distinguished by a maroon or red "background" with a green and a gold stripe, but it actually consists of stripes of maroon, green, maroon, gold, and maroon in sequence (figs. 10.47, 10.48). Red, gold, and green are of course the colors of the national flag of Ghana (fig. 10.49), which is said to have been based on the green, yellow, and red flag of Ethiopia, considered to be the oldest independent nation in Africa (Smith 1975, 234).[4] As Bernard Magubane makes clear in The Ties That Bind: African American Consciousness of Africa, Ethiopia rivals if not surpasses Ghana as a symbol of independence and freedom. The Italian-Ethiopian war of 1935–1936 spread "a new wave of African consciousness…through the black community" (Magubane 1987, 165). Ghana simply inverts the order of the Ethiopian

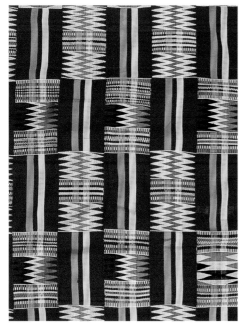

10.47

10.48

10.49

horizontal stripes and adds a black star, "the lodestar of African freedom" (Smith 1975, 234), to the central gold panel. Following Ghana's lead, these colors were subsequently adopted by twelve other newly independent African countries, including Mali, Senegal, Togo, and Cameroon, on their national flags.

Some kente identified as Oyokoman even adopt the flag's configuration of stripes (fig. 10.50). The conflation of Oyokoman kente and the Ghanaian national flag was made explicit in the kente that hung behind the speaker's platform at the independence celebration (fig.10.51). Here the stripes were reordered to match the flag, and a black star was inserted in the yellow band of every section of plain weave. The popularity of Oyokoman as the kente displaying the colors of African freedom and independence was further encouraged by the Rastafarian movement, which, of course, looked to Ethiopia for its origins. A portrait of Bob Marley shows the musician with kente rays emanating from his head and the Ghanaian flag draped to one side (fig. 10.52). In Ghana today those individuals who have chosen to wear kente often select an Oyokoman (fig.10.53), and textile vendors confirm that this is one of the two or three most popular kente among African American buyers.

As mentioned in chapter 3, even early in its history, kente was frequently used as a political gift. Nkrumah certainly used it as such. He presented William Tubman with a cloth in 1953, and this may have been the same one the Liberian president wore later in a *Time* magazine photograph (August 2, 1971). The boxers Floyd Patterson and Muhammad Ali were both honored with gifts of kente. W. E. B. Du Bois received a kente from Nkrumah in 1960 or before and was photographed with it draped around his body in Brooklyn before

10.50

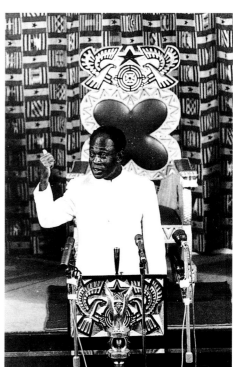

10.51

10.52^

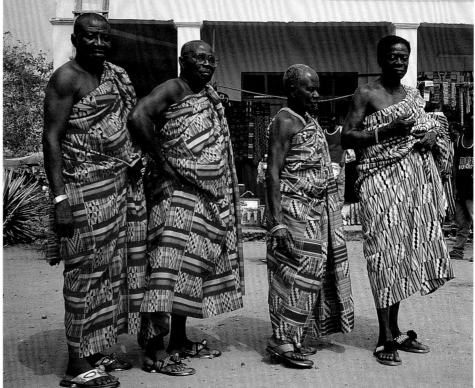

10.53^

10.54^

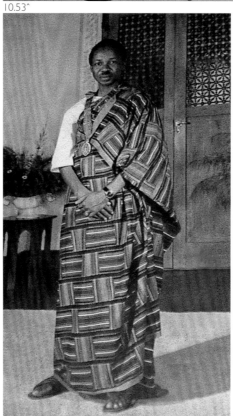

10.55^

10.56

10.52 Painting of Bob Marley with kente "rays" emanating from his head by I. Miller, 1995. Marley holds the national flag of Ghana. Height 69 cm. FMCH X96.33.3.

10.53 Celebrants at first annual Bonwire Kente Festival. The two men on the left are wearing Oyokoman cloth and the individual to the right of them has Oyokoman strips in his cloth of "mixed" patterns. Photograph by Cornelius Adedze, 1998.

10.54 Installation at the National Museum of Tanzania with a photograph of President Julius Nyerere wearing kente (the photograph was taken in 1962). Photograph by Jesper Kirknaes, 1971.

10.55 Portrait of President Julius Nyerere hanging in stairwell of National Museum of Tanzania. Photograph by Doran H. Ross, 1994.

10.56 Nelson Mandela wearing a kente stole. Photographed at Africa Square, 125th Street, Harlem. © 1990 Time Inc.

10.57 Asante dignitaries on Central Park West in front of the American Museum of Natural History, New York City. Photograph by Raymond Silverman, 1984.

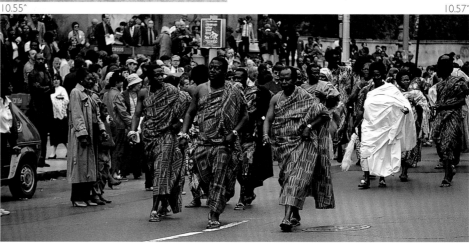

10.57˅

he moved to Ghana in 1961 (Du Bois 1978, 145). President Julius Nyerere of Tanzania, a man who shared Nkrumah's Pan Africanist ideology, received a kente sometime before 1962 when he was photographed wearing it in an official portrait (fig. 10.54). A second portrait (with Nyerere shown standing instead of sitting) featuring the same cloth was still on display at the top of the stairs in the National Museum of Tanzania in 1994 (fig. 10.55). It is particularly telling for an East African leader to forgo indigenous clothing in favor of a West African textile and style of dress.[5]

Although many people visited Ghana in the late 1950s and early 1960s and certainly returned either with strips of kente or with larger cloths, there is not much evidence of the wearing of kente by African Americans in the United States during the 1960s. One exception is the photograph taken in Brooklyn of W. E. B. Du Bois mentioned above. At this time kente was more commonly used as some form of interior decoration—a runner or cloth for a table, a wall hanging, a drape for furniture, or a bedspread.

While a knowledge of kente was steadily increasing among African Americans in the United States, the scholarly community was turning more and more attention to African textiles. The first article on kente in the UCLA journal *African Arts* appeared in 1970 (Hale). *Introducing West African Cloth* by Kate P. Kent, which was published in 1971 in conjunction with an exhibition in Denver, included a substantial section on kente. Roy Sieber's *African Textiles and Decorative Arts* appeared in 1972 and accompanied an exhibition that traveled from New York to Los Angeles, San Francisco, and Cleveland. Venice Lamb's *West African Weaving*, which focused on Asante and Ewe traditions, was at the time of its publication in 1975 the most substantial study ever written on a sub-Saharan textile.

A number of highly publicized events in the 1980s and 1990s reinforced earlier perceptions of the cloth as a complicated symbol of Ghanaian, Pan African, and African American identity. The traveling exhibition *Asante: Kingdom of Gold*, organized by the Museum of Mankind, London, in 1981, opened to much acclaim at the American Museum of Natural History, New York, in 1984. At the same time Central Park West was closed for a procession that included Asantehene Nana Opoku Ware II and his entourage of chiefs, court officials, musicians, and dancers; the procession was observed by several thousand admirers who came from Ghana, Canada, and the United States, especially New York City (fig. 10.57). The procession and the exhibition received considerable attention in the New York area and attracted a total attendance of approximately 350,000.

Yet another significant use of kente occurred during Nelson Mandela's triumphal tour of the United States in 1990. Mandela wore a kente strip on several occasions, and a photograph of him with the weaving even appeared on the cover of *Time* magazine (fig. 10.56; July 7, 1990). Mandela's desire to rally the whole of Africa, as well as the African American communities of the United States, against the ruling apartheid regime of South Africa was certainly part of the reason for his choice.

A ruling made in 1992 by Superior Court Judge Robert M. Scott of Washington, D.C., also helped to bring kente to center stage. As reported nationally, Judge Scott ruled that defense attorney John T. Harvey could not wear a kente cloth stole if he wanted a jury trial for his client. The suggestion by a White judge that he could be objective when viewing kente cloth and that Black jurors could not outraged many and led to numerous editorials similar to the one that appeared in the *Washington Post*, "Judging the Kente Cloth" (reprinted here).

Equally controversial, and also capturing the national spotlight, was the decision made in 1996 by school officials in Muskogee, Oklahoma, to withhold diplomas and transcripts from three graduating seniors for violating graduation dress code—two of the students had worn kente stoles and one had carried an eagle feather. The students were ordered to spend twenty-four days in the Muskogee Alternative Program as punishment before they could receive the withheld diplomas and transcripts. All three refused. The intervention of the American Civil Liberties Union (Brown 1996; Romano 1996) forced the school officials to capitulate.

A final example of kente achieving national, and indeed international prominence, occurred during President Bill Clinton's eleven-day trip to six African countries in March 1998. At his first stop in Accra he appeared with his wife and President and Mrs. Rawlings in Independence Square in front of a crowd of fifty thousand. Mr. and Mrs. Clinton were presented with and photographed wearing a full man's kente cloth and a kente shawl respectively (fig. 10.58). They were also photographed wearing individual stoles with their names woven into the strips as they were stepping onto the airplane to depart. *Newsweek* published a full-color image of the presentation, and both the *Los Angeles Times* and *New York Times* ran photographs of the Clintons wearing their gifts.

"Judging the Kente Cloth,"
The Washington Post, Saturday, June 13, 1992

The courtroom task of screening out those with views deeply rooted in nameless dreads or racial fears is difficult enough when it comes to juries. When these anxieties are found in a judge, then the wheels of justice themselves can grind to a halt. That now appears to be the case in D.C. Superior Court, where the trial of a man accused of robbery has been delayed while a judge and defense attorney engage in an outrageous showdown over a kente cloth. What's worse, this confrontation has been brought on by the judge.

A few weeks ago, Judge Robert M. Scott told defense attorney John T. Harvey that he had to remove the kente cloth he was wearing if he wanted a jury trial for his client. If Mr. Harvey chose not to remove the kente cloth, said the judge, Mr. Harvey either would be removed from the case or allowed to try the case, but without a jury. All this because Judge Scott reportedly fears a multicolored kente cloth might prejudice a presumably black jury in favor of Mr. Harvey and his client. It helps to note at this point that Judge Scott is white, while Mr. Harvey and his client are black.

Thursday, Mr. Harvey came to court with his client and his stole, but refused to enter a plea to Judge Scott. He instead insisted that the case be continued until the appellate court hears his motion on the judge's recusal from the case. Judge Scott responded by ordering Mr. Harvey off the case, not because of Mr. Harvey's apparel, he says, but because no plea was entered. Mr. Harvey has asked the D.C. Court of Appeals to vacate the order, that's where the matters stand.

The appeals court should swiftly remove the order—and Judge Scott—from the case. Judges have broad discretion when it comes to maintaining decorum and dignity in their courtrooms, but it is not unlimited. There is absolutely no reason in logic or law for Judge Scott to tell Mr. Harvey that he cannot wear a kente cloth before a jury—regardless of the jurors' race. The very suggestion is offensive to black jurors, that they somehow lose their judgment and objectivity at the sight of a kente cloth.

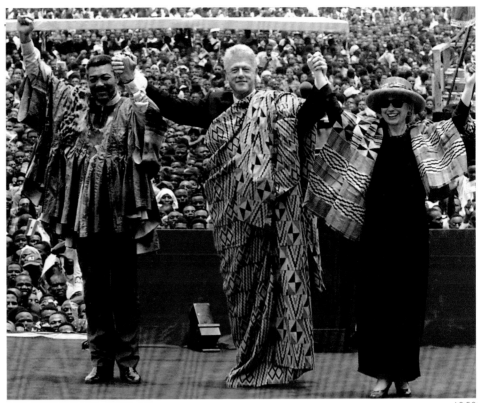

10.58

10.58 President Bill Clinton and First Lady Hillary Clinton wearing kente cloths presented to them by President Jerry Rawlings. Archive Photos 1998.

10.59 John Biggers, *Starry Crown*, 1987. Acrylic and mixed media on canvas. Dallas Museum of Art, Texas Art Fund, 1989.13.

10.60 Frank E. Smith. *River of Darkness*, 1986. Acrylic and ink on paper. Height 193 cm. Evans-Tibbs Collection.

10.61 James Phillips. *Spirits: "Juju" for Michael*, 1987–1989. Acrylic on hanging canvas. 183 cm × 91.5 cm. Collection of Michael D. Harris.

10.62 James Phillips. *Mojo*, 1987. Acrylic on canvas. 289 cm × 168 cm. Collection of the artist.

Just as kente has become increasingly a part of African American fashion—worn in multiple forms and contexts—so it has been gradually incorporated in fine and popular art created by Black Americans. John Biggers's trip to Ghana of 1957 led to a number of straightforward representations and impressions of individuals wearing kente. In his work of the 1980s and 1990s, these initial impressions evolved into complex compositions, the foregrounds and backgrounds of which repeat common geometric designs shared by quilting and kente traditions, as well as by other West African textiles. Designs such as checkerboards, gyronny motifs, equilateral triangles meeting at their tips, and elongated triangles projecting in from the side of long strips are found in both genres (fig. 10.59). Ghanaian connections are further emphasized by Biggers's use of readily recognizable, albeit faint, images of Akan combs, stools, umbrellas, etc., which appear to be emerging from the surface of many of his works (cf. Wardlaw 1995, 122, 152, 156). These designs recur, organized in strips, on the dresses of women depicted in his Shotgun House series, further emphasizing the connection with cloth designed to be worn.

Compositions unified by what appear to be African textile structures have been employed by a number of African American artists during the last twenty years. This is especially true of several artists from the AfriCobra group (African Commune of Bad Relevant Artists). Frank E. Smith's painting *River of Darkness* (1986) incorporates multiple kente riffs (10.60). Sharon Patton notes of this work that

> Smith is the inheritor of Alain Locke's idea that African textile patterns could be used as a structural base for painting. Irregular patches of color are combined with regularized motifs and asymmetrical compositions, common in African weavings and African-American quilts. Asymmetry of design and color creates a rhythmic syncopation analogous to music especially jazz. [1989, 104]

In a similar vein the surfaces of James Phillip's *Spirits: "Juju" for Michael* (1987–1989; fig. 10.61) and *Mojo* (1987; fig. 10.62) are organized in vertical strips of segmented zigzags, the latter separated in places by bars running perpendicular to the strip, closely echoing the Babadua design on kente. As with John Biggers's work from this period, "ghost" images of Adinkra stamps appear just below the surface of both paintings (Wardlaw 1989, 205, 213).

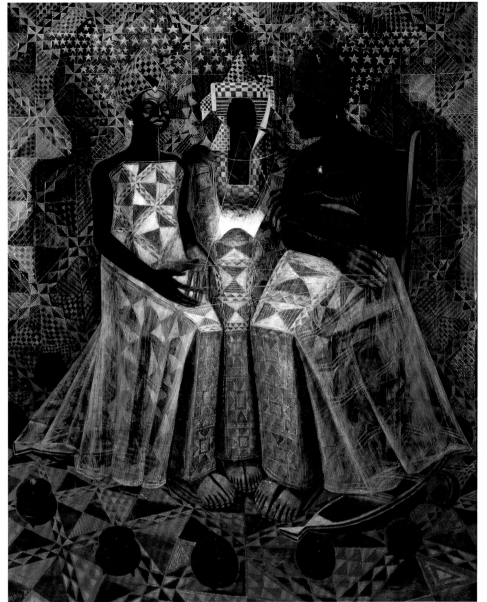

10.59

10.60

10.61

10.62

10.63 Larry Poncho Brown. *Kente Queen.* Offset lithography. 71 cm x 56 cm. Private collection.

10.64a,b Larry Poncho Brown. *Spirituality Totem I & II.* Offset lithography. 99 cm x 30.5 cm. Private collection.

10.65 Larry Poncho Brown. *Adorned #1.* Silk screen. 30.5 cm x 40.5 cm. Private collection.

10.66 Larry Poncho Brown. *Embrace.* Offset lithography. 68.5 cm x 68.5 cm. Private collection.

10.67 Adriene Cruz. *Prosperity Prayer,* 1995. Altar. 122 cm X 86.4 cm. Collection of artist. Photograph by John Klicker.

10.68 Adriene Cruz. *Ain't Missed a Beat,* 1992. 55.9 cm X 83.8 cm. Collection of artist.

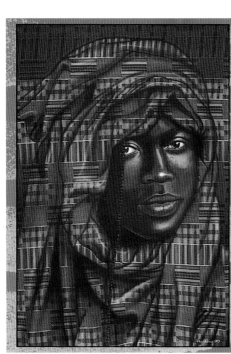

10.63

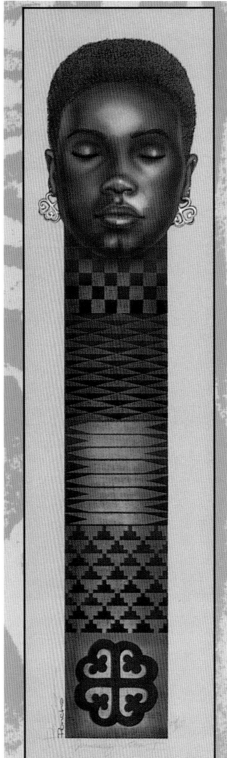

10.64a

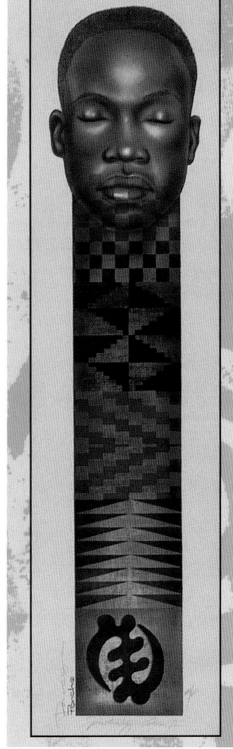

10.64b

Kente and Adinkra imagery often appear together in the work of Larry Poncho Brown, an artist who specializes in affordable prints produced by offset lithography in "open" or "limited" edition reproductions (fig. 10.64a,b). His company, Melanin Graphics, features work by a number of artists characterized by Brown as the "New Wave in African American Art." His own works often depict figures wearing roller-printed kente, which is actually applied to the surface of his painted originals. Several represent a man, woman, and child and feature titles such as *Circle of Love, Native Son,* and *Embrace* (fig. 10.66). The original of his first work using kente (1990) was actually painted on roller-printed cloth and titled *Kente Queen* (fig. 10.63). In an interview with Aphrodite Dielubanza, Poncho admitted that the piece was controversial and that it upset a number of African friends despite its popularity with most African Americans. *Adorned #1* (fig. 10.65) features a face emerging from two common kente weft designs, this time silk-screened on the canvas. Brown has also produced a series of four "Inspirational Art X-mas Cards," which depict the Madonna and Child, the three wise men, an angel, and the dove of peace; all of the cards incorporate kente. Brown's art consistently emphasizes positive imagery that is linked to an African past.

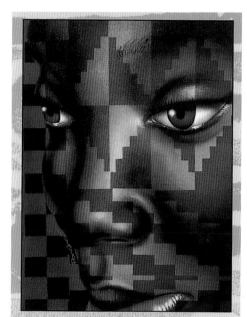

10.65

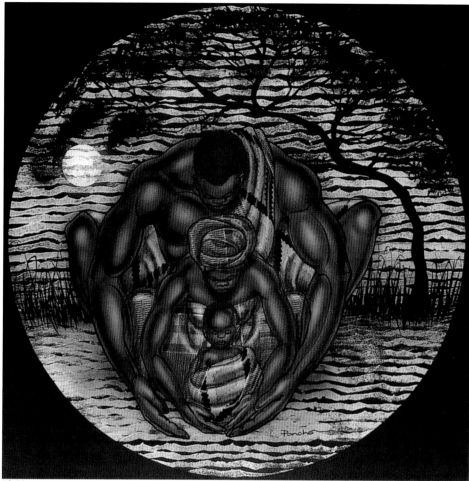

10.66

African American quilting continues to borrow from the visual vocabulary of kente and sometimes actually incorporates handwoven or roller-printed cloth. Adriene Cruz of Portland, Oregon, did not begin quilting until 1992, although she has worked as a textile artist for much of her life. Her works follow the African American strip quilt tradition (fig. 10.68), and her piece-work wall hangings incorporate sections of kente (fig. 10.67). Whether labeled a "revival," "renewal," or "reclamation" (in contrast to the "retentions" discussed earlier), this process appears to be accelerating in the 1990s with kente leading the way among the several fabrics used by African American textile artists to connect with African sources.

10.67

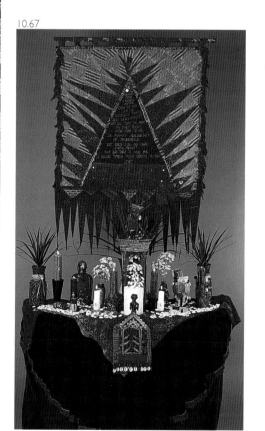

10.68

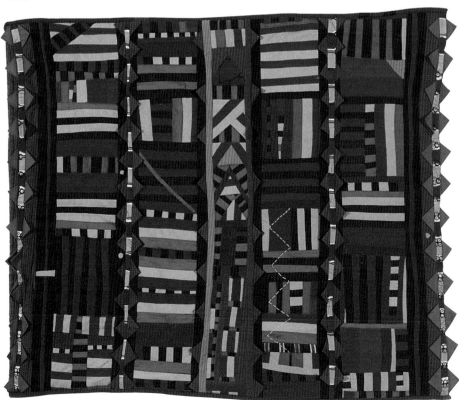

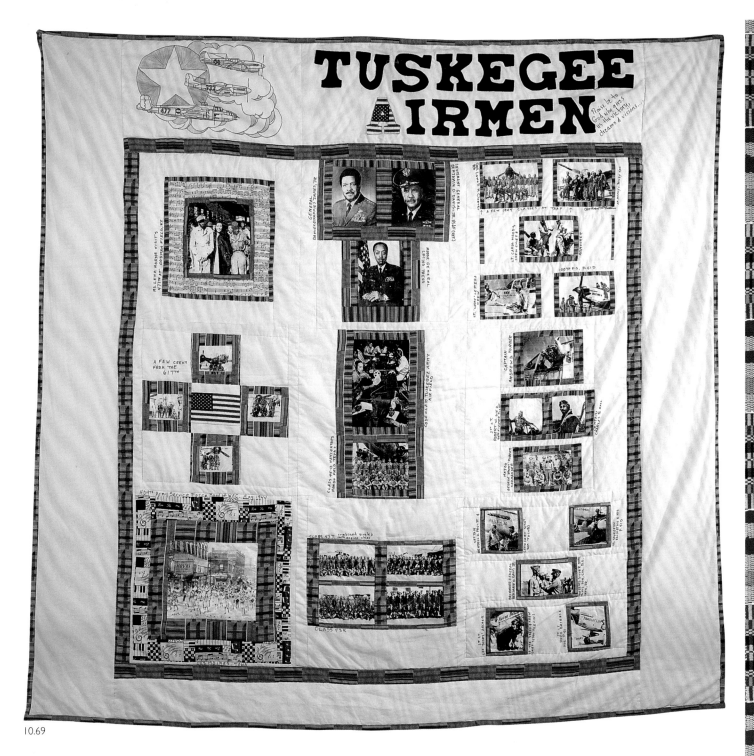

10.69

10.70

Dorothy Taylor, who moved to Los Angeles in 1969 from Arkansas, has been using kente in her textile creations for fifteen years. Her subjects are topical and contemporary or at least of significant contemporary interest. Taylor's quilt *Tuskegee Airmen* (1997), which incorporates photo transfer images taken from the book *The Lonely Eagles* (1976), attracts considerable attention whenever it is shown (fig. 10.69). Several people have recognized relatives in the quilt. Framing an image in kente, as Taylor has done in *Tuskegee Airmen*, is one of the most common applications of the cloth in contemporary art made on both sides of the Atlantic and will be dealt with below. Kente prints are also generously employed in Taylor's memorial quilt for AIDS victim Arthur Ashe (fig. 10.72) and in a commemorative jacket for the Million Man March. Another of Taylor's quilts is limited to the colors red, black, and green and includes six maps of Africa with kente piece-work in the same color scheme (fig. 10.70). Not all of her works incorporating kente deal with political or other contemporary events. A quilt made for her granddaughter Julia in 1993 features the numbers one through nine, two apples, two butterflies, a hand, a doll, a bird, and a map of Africa along with the child's name—all within a grid of printed kente strips (fig. 10.71). Images of remembrance, caring, solidarity, education, and play are mixed throughout Taylor's work and lend themselves to the almost always accessible and popular art of the quilt.

10.71

10.69 Dorothy Taylor. *Tuskegee Airmen*, 1997. Quilt. 182.9 cm X 172.7 cm.

10.70 Dorothy Taylor. Quilt with six maps of Africa, 1994. 157.5 cm X 111.8 cm.

10.71 Dorothy Taylor. "Julia" quilt, 1993. 99.1 cm X 99.1 cm.

10.72 Dorothy Taylor. *Arthur Ashe*, 1993. Quilt. 94 cm X 91.4 cm.

10.72

A number of artists who are experienced weavers have also been influenced by kente. Emma Amos had a long history of incorporating her own weavings in paintings before actually employing handwoven kente or kente prints. Both, however, are particularly prominent in her Falling Series of 1988–1992 (fig. 10.73). According to Thalia Gouma-Peterson,

> The anxiety generated by falling bodies also is a metaphor for Amos's response to the disasters occurring around her and an expression of her concern for what she sees as "the impending loss of history, place, and people." History is the basis for identity; without it one doesn't exist. In this context Amos's anxiety also reflects what bell hooks has described as "the pain of learning that we cannot control our image," a knowledge which "rips and tears at the seams" of the efforts of black people "to construct self and identity." [1993, 6]

In her earlier works Amos used her own weavings as apparel for figures within paintings or as borders for the paintings themselves. For most of the Falling Series she used Asante or Ewe kente, Mossi or related weavings from Burkina Faso, or strips of Swahili *kanga* from Kenya or Tanzania as a framing device. Some of these works, such as *Into the Dangerous World I Leapt* (1988), are autobiographical (fig. 10.76). In this case the upper and lower borders are constructed of textiles from Burkina Faso (Mossi?), and the left side of the work features a printed kente drape almost as if it were pulled aside to reveal the artist. *Will You Forget Me?* (fig. 10.74) and *Nothing but Blue Skies* (fig.10.75) are companion pieces painted in 1991 and framed on all four sides with Ewe kente. In the first of these Amos is falling through a cloudy sky hanging onto a photograph of her mother, India. In the second Amos's twenty-year-old daughter, who is also named India, grasps a photograph of her namesake taken at the same age. It has been suggested that the photographs serve as a kind of parachute or "braking device" to ensure a "safe landing" (Gouma-Peterson 1993, 12).

Although Gouma-Peterson mistakenly refers to these fabrics as "women's work," she nevertheless convincingly captures the role of African textiles in Amos's art:

> Most of her paintings are framed by sensuous strips of woven and printed cloth which frame and re-contextualize the narratives and securely keep them within the borders of the painting, even when the figures are hurtling through space. These borders are luxurious, colorful, and beautiful and provide a personal and cultured context of renewal and hope…. Their juxtaposition with the painted canvas forces the viewer to ask questions about the artificial division of art and craft in contemporary society, about the sources of civilization, and about the boundaries of culture. [1993, 6]

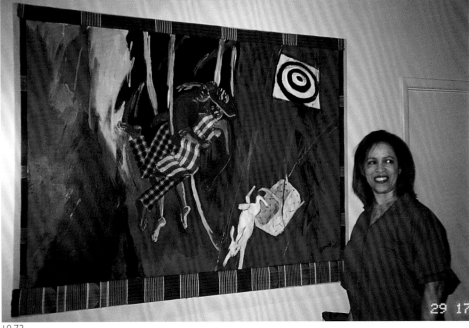

10.73

Gouma-Peterson also comments that the borders provide "stability" for the falling images (1993, 10) and that "the ever present frames of woven or printed African cloth add a tangible context, something for the figures to hold on to. They are the margins which remain firm, as the center collapses" (1993, 11). Amos, however, is careful to emphasize that falling is not necessarily a "horrible thing" and that she doesn't intend for her painted figures to "look scared" (hooks 1993, 23). As a weaver Amos clearly understands the structural properties of a handwoven textile and how the kente borders are effective symbols of control and containment that are rooted, in part, in the African past. Emphasizing this point, bell hooks notes, "Even this bordering is about your using art to construct that historical diasporic continuum. You don't come out with that kind of overt image that says we are connected to Africa; you use that fabric that says there is a link" (1993, 27).

Clearly kente involves a complex mix of associations in Amos's work prompting metaphors of "stability," "renewal," "hope," "connectedness," and "history." As revealed in Tracy Marcus's interview with the artist of 1997, utilizing kente is also a question of pride, "The pride in it is just so enormous…you have to be proud of what it is…just to wear it is to honor it."[6]

10.74

10.75

10.76

10.73 Emma Amos in her studio in front of her painting *Targets*. Photograph by Tracy Marcus, 1997.

10.74 Emma Amos. *Will You Forget Me?* 1991. Acrylic on linen canvas with Ewe kente borders. 163 cm x 112 cm. Collection of the artist.

10.75 Emma Amos. *Nothing But Blue Skies*, 1991. Acrylic on linen canvas with Ewe kente borders, laser transfer photography. 163 cm x 112 cm. Collection of the artist.

10.76 Emma Amos. *Into the Dangerous World I Leapt*, 1988. Acrylic and fabric on canvas. 84 cm x 165 cm. Collection of the artist.

Sonya Clark is another fiber artist and weaver who employs kente imagery in her weaving. She focuses her artistic energies on creating spectacular sculptural headdresses that make powerful statements about her African heritage and the ways in which that legacy fuels her creative efforts. Clark writes quite eloquently about her own work (see below) and emphasizes the communicative dimensions of her art, which frequently draws upon the messages embodied in traditional kente patterns. African headdresses have defined age, gender, vocation, and status in many African societies. In *Crowning Achievements: African Arts of Dressing the Head* (1995), Mary Jo Arnoldi and Christine Mullen Kreamer have emphasized the active role that headgear can play in the daily and ceremonial lives of diverse peoples and its central and focal role in adornment practices. Clark's kente-inspired symbolic headdresses continue this brilliant history.

Sonya Clark in Her Own Words

I seek to strengthen the tether to my African heritage, not to return to the past, but to better understand my place in the present

The Yoruba of Nigeria have a saying, "The head wrap is only good when it fits." I am in pursuit of making a head wrap that truly fits the collective head of the African Diaspora. I make symbolic headdresses that are fitting acknowledgments of the sanctity, power, and history of my African heritage. That which is carried on the head is often indicative of that which is carried within the head. The head is a sacred place, the center where cultural influences are absorbed, siphoned, and retained, and the site where we process the world through the senses. The sculptural headdresses I create are metaphorical funnels for the fluidity of cultural heritage and cultural melding.

Conceptually, my work is fed by my experiences as a first generation American woman of African-Caribbean descent, readings in psychology and anthropology, and travel experiences in Africa, Asia, Europe, and the Caribbean. I draw my source material from African Culture and its retention in the African Diaspora: images of women carrying loads on their heads, African hairstyles and headdresses, Caribbean carnival costumes, and traditional semiotics in motifs and materials.

As a medium, fiber permits me to claim my place in the African textile continuum that was brought to the Western Hemisphere during slavery and continually reembodies itself today in the African American quiltmaking tradition, African Caribbean carnivals, and the work of many contemporary artists. I use copper and fiber to create rich surfaces for my pieces that serve to reembody the strength of my African heritage and acknowledge the intellect, wisdom, and creativity of people of African descent.

10.77 *Sonya Clark. American African*
Shaped like a scale this piece questions, "Which part of the dual identity takes precedence?" History and racism have made the dual identity of being African and American a conflict. In reference to Du Bois's concept of double consciousness the piece employs the use of mirrors and reversals. One cap is made of printed kente cloth with a printed American flag as a lining. The word *American* is reverse appliquéd revealing the flag lining. The second cap is made with a printed flag on the outside and kente as a lining. The word *African* is stitched backward in reverse appliqué. If the viewer chooses the cap that looks more African (i.e., kente cloth), s/he will see a backward reflection of the word *American* in the mirror. If s/he chooses the more American looking cap, the reflection will read *African* in the mirror. Because the words are stitched around the head the person can not see either word, *African* or *American*, fully. The identity is broader than its reflection.

10.77a Detail of figure 10.77.

10.77b Detail of figure 10.77.

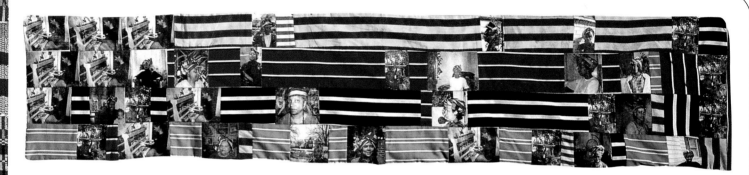

10.78a Detail of figure 10.78.

10.78 Sonya Clark. *Gele (head tie)*, 1995. Hand-dyed and handwoven silk and cotton, embroidery. 28" × 72". In this piece I mixed elements of African and American culture. I wove in the traditional West African weave structure but on a European loom. The pattern of the piece is a combination of American flag and kente cloth. I specifically selected kente patterns that stood for strength and endurance (*nwatoa*—from the pattern of a snail shell), advancement and achievement (*atwedie*—meaning steps), and prosperity and growth (*babadua*—meaning a strong bamboo-like cane).

The beauty of the *gele* is that it can be worn by women in many ways. Each woman's personality, individuality, and identity comes through in the ways she wraps her head. Yet, in the case of *Gele (head tie)*, the head tie remains constant. The message: within shared cultural identity, there is individuality. Each time an African American woman wears *Gele (head tie)*, the piece is empowered. I like to believe that some residue of the strength and wisdom of each woman stays with the cloth and empowers it. When the piece was completed it was taken to several African American women. I described how traditional kente is made and deciphered the patterns used in this piece. Each woman was asked to tie her head in the piece and be photographed in honor of her heritage of endurance, achievement, and growth.

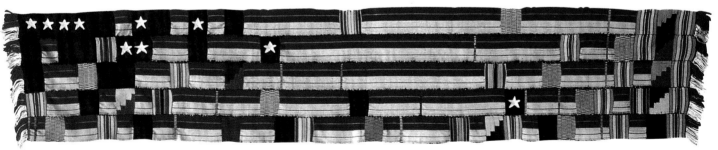

10.79 Sonya Clark. *Gele (Detroit)*, 1996. Pieced cotton and photo transfers. 28" × 72".
Just as many African American quilts are related formally and aesthetically to the strip-woven cloths of West Africa so is the piecing of *Gele (Detroit)* related to its strip-woven predecessor, *Gele (head tie)*. *Gele (Detroit)* documents where *Gele (head tie)* has been by using in situ photo transfers of African American women in Detroit wearing *Gele (head tie)*. The rhythm of the kente patterns (which stand for endurance, achievement, and prosperity) and stars (freedom) from the American flag are substituted and articulated in *Gele (Detroit)* through the photographs of women who embody these characteristics.

10.79a Detail of figure 10.79.

10.80 Students learning Egyptian hieroglyphics and Swahili at the Nyerere Education Institute, New Brunswick, New Jersey. Photograph © Chester Higgins, Jr. All rights reserved.

10.81 Installation ceremony making Dr. John Henrik Clarke an honorary chief of the Akan people, New York City, 1992. Photograph © Chester Higgins, Jr. All rights reserved.

10.82 Reception honoring President and Mrs. Jerry Rawlings on their visit to California. Left to right: Diane Watson, California State Senator; Nana Konadu Agyeman-Rawlings, First Lady of Ghana; Jerry Rawlings, President of Ghana; Richard J. Riordan, Mayor, City of Los Angeles; Marguerite Archie-Hudson, Member of the Los Angeles County Board of Education. Photograph by Howard Bingham, Los Angeles, 1995.

10.83 Anna Arnold Hedgman, the first woman to serve on the cabinet of a mayor of New York City (1954–1958). Photograph by Brian Lanker, 1987.

10.80

10.81

10.82ˆ

The art of photography and the work of contemporary African American photographers have also contributed to defining the image of kente at the end of the twentieth century. Chester Higgins (figs. 10.80, 10.81) and Howard Bingham (fig. 10.82, interleaf I) have taken photographs of people wearing kente in both Ghana and the United States. Bruce Caines, Brian Lanker (fig. 10.83), Lester Sloan (fig. 12.17), and many others have also intermittently participated in documenting the place of kente in the African American experience.

10.83

Paradoxically, perhaps one of the most telling statements about kente never depicts the celebrated fabric. The volume *KenteCloth* edited by Jas. Mardis, also bears the title *Southwest Voices of the African Diaspora: The Oral Tradition Comes to the Page*. This unillustrated anthology of stories and poems not only refrains from using a representation of the textile on the cover, it nowhere offers an explanation of what kente is. The reader is expected to understand the connection. Mardis in his compelling introduction summarizes his thoughts about the contributors to the volume.

> The writers of this body are invested in intentional acts of inclusion and remembrance. They are invested in the realistic cycle of a culture…In short they are challenged to griot. They are challenged to keep alive the stories of how we live instead of how we want the world to perceive our living. *KenteCloth* is the vehicle of getting it told on the page. [1997, xv, xvi]

Mardis concludes the introduction, "'Remember,' as if someday the culture, the Diaspora, would have to make remembering an intentional act. Welcome to *KenteCloth*, an intentional act" (1997, xvii).

At the end of the twentieth century, kente has become one of the most familiar of all African arts and perhaps one of the best known, if still misunderstood, of all African words. Its initial associations with royalty, wealth, and status were enlisted to help defeat notions of "primitive" African cultures as the source for slaves. As kente rose to prominence with Nkrumah's independence initiatives, it became allied with the Pan African and Black nationalist ideologies of the time and helped promote ideas of "Black power," "Black pride," and "Black is beautiful." As understanding of the cloth increased, it became a premier symbol of African heritage and a tangible link with the African continent and its history. In recent years the contexts in which it is used and its meanings on both sides of the Atlantic have diversified and become increasingly individualized as we will see in the next two chapters.

Interleaf J
Simple Sly

Ephraim Agawu (shown at left, fig. J.2), known as Simple Sly, was born in Adidome in the Volta Region in 1964. He began his career as a woodworker carving images of sugar cane, bananas, and pineapples for the tourist trade. He shifted to photography in 1991, but business was slow until he came up with the idea of dressing children as chiefs and queen mothers. He purchased an assortment of regalia and roller-printed kente cloths for his clients to wear, and they were responsible for providing the backdrop, usually a favorite textile. To build a clientele Agawu sent his assistant through local neighborhoods with a series of photographs mounted on a board advertising his work (fig. J.1; FMCH X97.36.20). The photograph of Simple Sly's studio (fig. J.2) was taken by David Mayo, 1997; the photograph of the advertising board (fig. J.1) was taken by Don Cole; all other photographs are by Simple Sly.

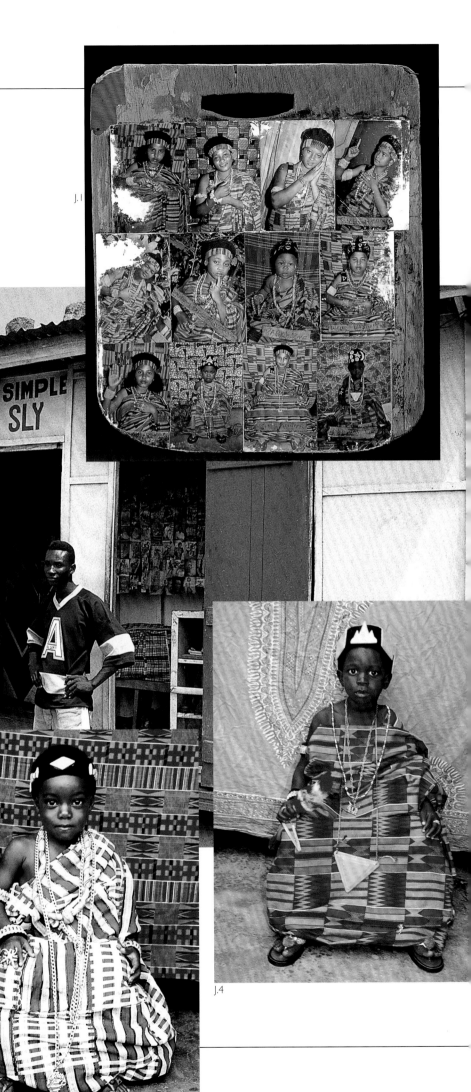

J.1

J.2

J.3

J.4

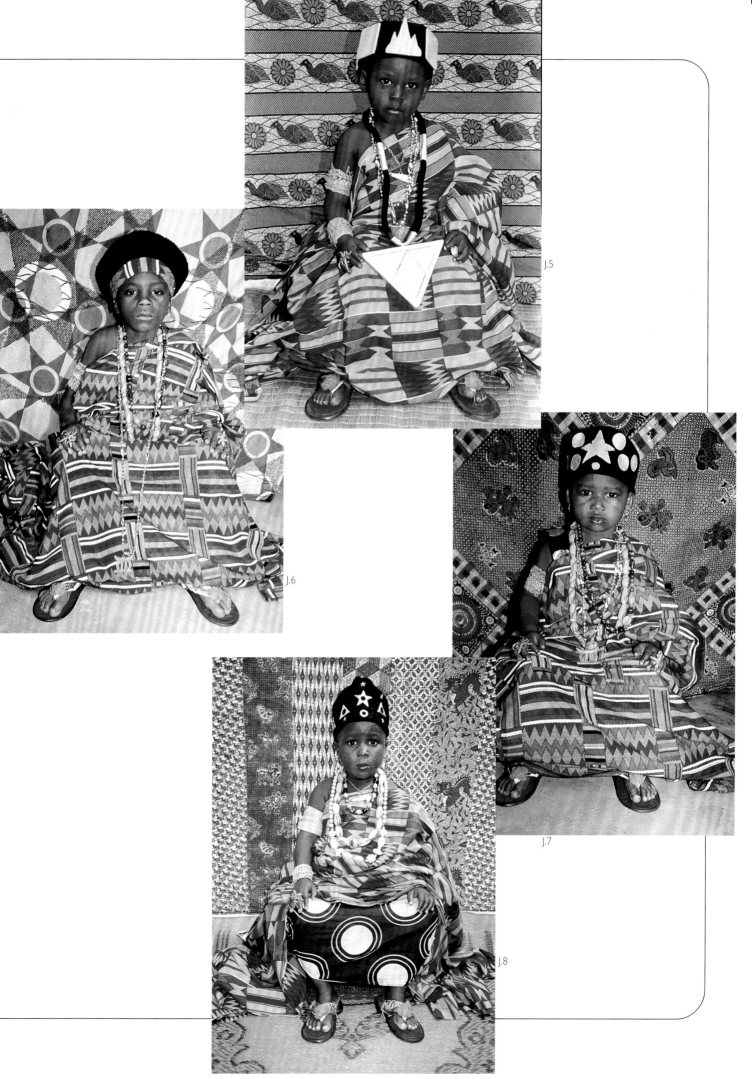

J.5

J.6

J.7

J.8

Interleaf K
Dolls

Dolls have long held a prominent position in discussions of Black identity. The first Black dolls produced outside of Africa were probably manufactured in Germany to serve as the servants or slaves of White dolls (Perkins 1995, 6–8). The National Negro Doll Company, one of the first Black-owned doll manufacturers, was founded by R. H. Boyd in the early 1900s (Perkins 1995, 22, 23). According to Cronan, "In 1919 the Harlem firm of Berry and Ross started the profitable production of dolls of a dusky hue designed to satisfy the most discriminating young mistress or parent. The Universal Negro Improvement Association encouraged this revolutionary toy development and [Marcus] Garvey's Negro World plugged the sale of black dolls" (1955, 175). Mattel created Christine in 1968 as a Black friend for Barbie but did not create a Black Barbie until 1980. This doll was basically poured into a White Barbie mold (Jones 1994, 149). In 1991 Mattel released Shani, "tomorrow's African American woman," along with Nichelle and Asha; these dolls had more realistic facial features, hair, and skin tones (Jones 1994, 151). Apart from this commercial framework, a number of African American artists have released their own interpretations of Black dolls. Ranging from the realistic to the abstract, many of these dolls have been dressed in kente prints to emphasize a connection with a vital African heritage. Another group of Black dolls is illustrated on pages 221–23 of the present volume.

K.4

K.3

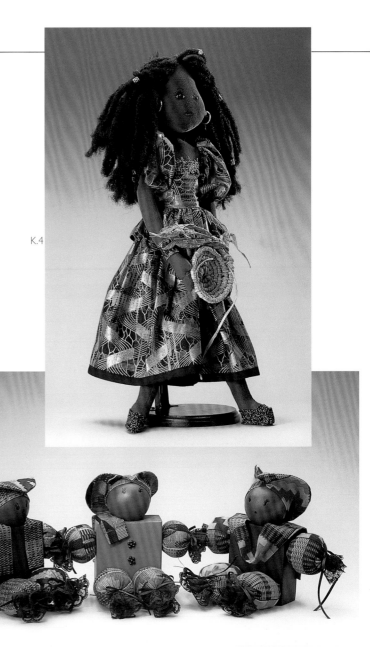

K.2

K.1

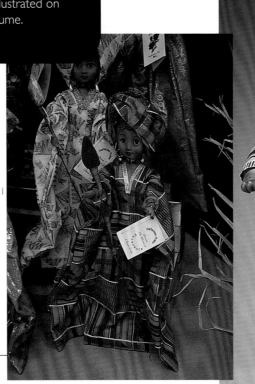

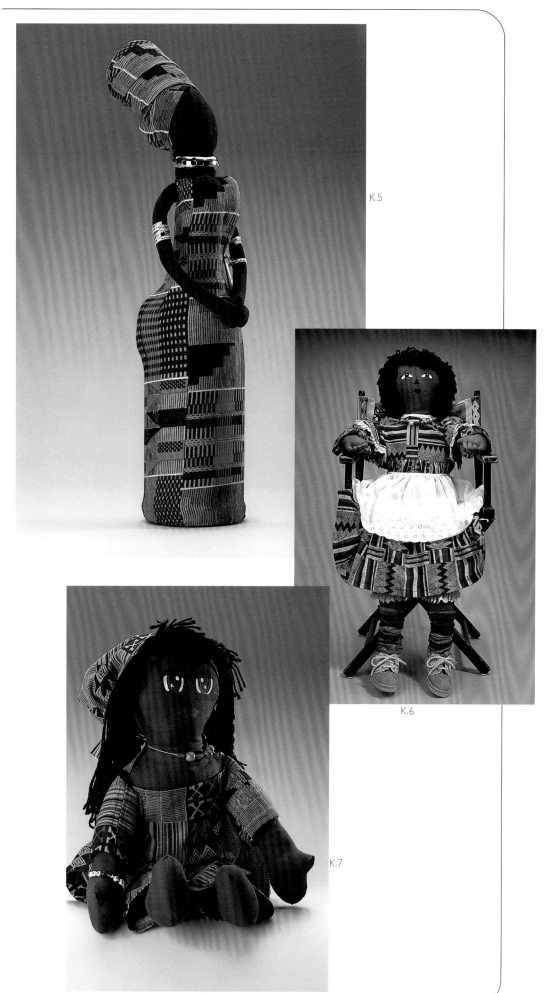

K.5

K.6

K.7

K.1 "Perfected Praise Presents the Woman of Excellence" at the Los Angeles Marketplace and Cultural Faire. Photograph by Danielle E. Smith and Aphrodite J. Dielubanza, Los Angeles, 1997.

K.2 Doll and chair. Synthetic fabric, plastic, beads, metal, plant fiber. Height of doll 58. cm. Private collection.

K.3 Dolls. Wood, cloth, stuffing, paint, lace, ribbons. Width of largest 23 cm. Private Collection.

K.4 Doll, California. Synthetic cloth, synthetic fiber, stuffing, raffia, wood, metal. The Tickles Collection. Private collection.

K.5 Doll, USA (?). Synthetic cloth, stuffing, metal, beads. Height 39.5 cm. Teiluj Dolls and Collectibles. Private collection.

K.6 Doll and chair. Cotton and synthetic cloth, stuffing, yarn, leather. Height of doll in chair 105 cm. The Tickles Collection. Private Collection.

K.7 Doll, USA. Synthetic cloth, stuffing, yarn, paint, beads. Height 58 cm. "Wibet" from Mona Love Collection. Private Collection.

Give the gift that celebrates style!

ONE YEAR (12) ISSUES $12 Only $1 an issue!
GIFT SUBSCRIPTIONS JUST
A gift announcement will be sent to each recipient

FIRST GIFT: Please Print

Name: Mr. Mrs. Ms.

Address

City

State Zip

SECOND GIFT:

Name

Address

City

State Zip

FROM:

Name

Address

City

State Zip

☐ Please enter my own subscription at these rates ☐ Payment enclosed. ☐ Bill me later.

11.1^

11.2^

11.1 A subscription form for *Ebony* magazine featuring a kente-patterned ribbon (November 1994). Reproduced with permission of Johnson Publishing Company.

11.2 Empak Publishing Company's *Black History Catalog* (1996) promoting educational materials. Reproduced with permission of Empak Publishing Company.

11.3 This page from the Spiegel Catalog features a variety of kente-adorned merchandise, including a woman's top, a handbag, and a child's stuffed toy. Reproduced with permission of Spiegel Corporation.

11.4, 11.5 Prime Heritage Collection makes a point of stressing the authenticity of the kente used in its graduation stoles and dress accessories. Reproduced with permission of Prime Heritage, Memphis.

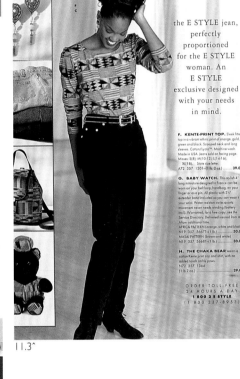

the E STYLE jean, perfectly proportioned for the E STYLE woman. An E STYLE exclusive designed with your needs in mind.

11.3^

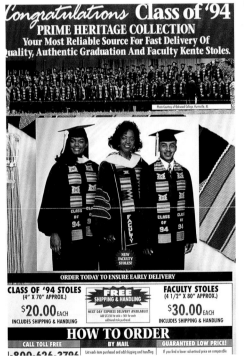

11.4^

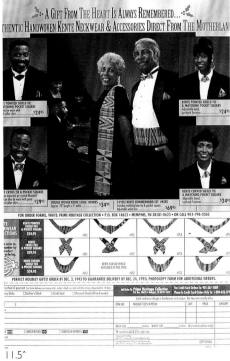

11.5^

Advertising has been the driving force of American consumerism for more than a century, but, as Raymond Williams perceptively comments, "in the last forty years and now at an increasing rate, it has passed the frontier of selling goods and services and has become involved in the teaching of social and personal values" (Williams 1992, 334). In addition, "homogenous messages," as William O'Barr notes, "are on the wane. More narrowly focused messages that are better fitted to our consuming profiles are on the rise. Behind this lies increasingly sophisticated market research on which messages may be based " (1994, 200).

The desire to target markets among, and to influence the taste and preferences of, certain racial minorities in the United States has led to the increased use of culturally specific symbols in advertising. Although it could be argued that in the course of building a broader and increasingly diversified customer base, businesses are forced to become more culturally attuned, this use of ethnic symbols raises a host of troubling questions: To what extent does a particular symbol accurately reflect a minority group's heritage and ideals? Is the use of the symbol meaningful or appropriate within the context of a specific ad? Does it communicate any subliminal messages? Who is privileged to choose a symbol to represent an entire group? What changes in meaning occur as a once relatively obscure object is elevated to the status of a cultural symbol? Are advertisers drawing upon existing norms and social identities or, in fact, inventing new ones? Is the construction of commercialized cultural profiles an inevitable consequence of the frenzied search for micro-markets?

With purchases totaling billions of dollars annually and growing, the buying power of African Americans can hardly be ignored. One notes an increasing Black presence in the media in response to corporate America's acknowledgment that African Americans constitute perhaps the most active and rapidly growing segment of the consuming public. Advertisers want both to understand the "Black psyche" and to find a visual imagery that will appeal to it. Blackness, which is itself constantly being redefined, is exploited through the selection and dissemination of these new symbols. Kente's rise to prominence within the context of modern advertising discourse is a case in point.

The Kente Phenomenon

In 1991 sales of African and African-style fabrics reached fourteen billion dollars in the United States, and kente was by far the hottest-selling item (Samuels 1992). Although other African textiles have been adapted for use in clothing, linen, and upholstery—including Kuba embroidered fabric from the Democratic Republic of the Congo (formerly Zaire) and Bamana mud cloth (bogolanfini) from Mali—none evokes the racial pride, identity, and solidarity associated with Akan kente.

Originally a royal cloth, kente is increasingly recognized as "African" by peoples of all colors, and it has come to symbolize African identity in the Diaspora. It is featured on greeting cards and is used to merchandise almost anything of interest to the African American community (figs. 11.1, 11.2). One encounters kente neckties, stoles (some boldly emblazoned with fraternity and sorority names), sashes, vests, caps, umbrellas, bags, backpacks, necklaces, earrings, and bracelets (fig. 11.3). Kente is worn on occasions ranging from religious events, to graduations, to political gatherings. This fashion statement is part of a recent attempt to promote cultural pride as part of which Blacks have endorsed and even invented African names and cultural forms.[1]

Much of the handwoven kente available in the United States comes from Ghana and neighboring West African locales. Within this context novel kente patterns are created daily to feed both the booming local tourist market and the demand for the textile in the United States. Côte d'Ivoire, a site not traditionally known for kente weaving, also exports the cloth, but examples from this source often contain meaningless, non-traditional patterns and feature shoddy workmanship. Authenticity has become a hotly contested issue as evidenced by the pains that AFEX International, Prime Heritage Collection, and other companies in the United States take to stress that their graduation stoles and dress accessories are "handwoven" and "direct from the motherland" (figs. 11.4, 11.5). Essence by Mail, "the original catalog for today's African-American woman," introduced a line of kente clothing in 1993. One of the catalog's advertisements describes a male kente ensemble—including a stole, bow tie, cummerbund, and handkerchief—as "hand-woven by Ashanti weavers from Ghana." Bearing the heading "Cultural Class," this ad also points to kente's role in defining and constructing a new sense of identity among African Americans.

Pride and Avarice: Kente and Advertising

Nii O. Quarcoopome

11.6^

11.6 American Family Insurance incorporates a modern kente pattern as a background in this advertisement. Reproduced with permission of American Family Insurance.

11.7 This HBO advertisement uses machine-made kente in a modern pattern for the company's logo. Reproduced with permission of Home Box Office.

11.8 "Truth in Advertising," a print advertisement for AT&T incorporates a border with a representation of kente. Reproduced with permission of AT&T.

The issue of the "authentic"—a term that Afrocentrist merchants and importers apply solely to handwoven kente (Hunter-Gadsden 1990, 80)—has suddenly become prominent and has in fact resulted in calls for a boycott of machine-made kente. Leslie Hunter-Gadsden in her article "Marketing the Motherland" (1990)—which stops short of urging a boycott of inauthentic kente—has advocated raising cultural awareness to the extent that African Americans will consistently make informed decisions about the authenticity and quality of the cloth they purchase. This reaction apparently stems from two sources: the first is cultural as Blacks seek to claim exclusive right to market their heritage; the second, economic, as those African and African American merchants in the business watch their profits cut substantially by the introduction of less expensive manufactured kente.[2] Sensitivity to this issue is growing, but much more needs to be done to reach the less-educated and less-savvy Black consumer. The issue of what constitutes authentic kente should not be limited to verifying the place of manufacture; quality also needs to be addressed.

The search for the "authentic" in African cultural works and practices is being foregrounded just when the desire among American Black consumers to acquire a piece of the Motherland is spreading. On the one hand, many shops specializing in African clothing, masks, and the like have made it part of their business practice to research the background of objects they buy and sell. For them, aggressive merchandising must be coupled with the transmission of knowledge, which often takes the form of book sales or even in-shop performances (Hunter-Gadsden 1990, 78ff.). On the other hand, as Timothy Jenkins points out in his essay "Misguided 'Authenticity'":

[African culture has often been appropriated by] middlemen who understand too well the lack of sophistication among their parvenu buyers. . . . Accordingly, as kente-related products have soared into a major market, those who kept their fingers on the pulses of the African-American consumers soon learned that they neither understood nor seemed to care much that the hats, wraps, handbags, and umbrellas ostensibly worn to boast African roots had labels reading "made in Taiwan." [Jenkins 1995]

Jenkins goes on to comment that the disparity between Black employment and Black entrepreneurial success may be attributed to the fact that "even the most intimate expressions of culture and social identity are so carelessly left to others to merchandise and capitalize."

Kente's popularity as a symbol bespeaks a monolithic view of African culture, not unlike the idea of Black communal identity. Kente and other cultural tokens have come to broadly symbolize Africa, the Motherland. When coupled with buzz words like *rich, cultural, heritage, roots,* and *pride,* kente becomes a potent expression of Afrocentrism. Such a presentation does little to demonstrate the diversity in ethnic groups, colors, languages, and cultures that exist on the continent today.

Similarly, if art historians today find it difficult and vexing to connect sub-Saharan African arts to those of Egypt, Afrocentrists see no problem conflating the two. To them, both emanate from a common source and together represent the totality of Black history, culture, and identity—a totality that must be reclaimed. Such "reclamation" of the African past in order to construct a modern African American self-image, however, raises the critical issue of selective memory. In this exercise kente often becomes a powerful device that is used to forge this questionable interrelationship while at the same time encapsulating the rich cultural heritage of Black Africa.

To some extent these distortions of African history stem from the ongoing search of African Americans for political empowerment. In the 1960s and 1970s Black Nationalists sought to construct a new African American identity and often exploited elements from their African heritage—including names, hair braiding, jewelry, and forms of dress—to validate diverse sociopolitical agendas. Many Blacks today want to revive this feeling of solidarity, unity, and pride and to incorporate it into the overall education and political consciousness of their children. They see kente as one possible means of creating identity and empowering a new generation. Some, such as actress Marla Gibbs, attach considerable sentimental value to the fabric. Gibbs maintains that it is her way to remain "spiritually connected to Africa" (Dunbar 1991, 5; Hunter-Gadsden 1990, 78). It would be erroneous, however, to assume that all Blacks view kente in this manner.

Knowledge of Africa has always been privileged, even among African Americans. Afrocentricity may be a trenchant criticism of the West, yet as one author asserts, "The truth is that although Afrocentricity provides African-Americans with the sense of self-

esteem and demystifies the Eurocentric American history we have been taught, it does very little to enhance our perspective of continental African reality" (*Essence*, July 1995, 116).

Kente in Advertising

Corporate America has not been slow to appreciate the growing popularity of kente. Consequently a number of print and television advertisements feature the distinctive cloth. They range from highly commercial and misinformed efforts to well-researched presentations with obvious relevance to the products being promoted. These products include photographic film, cameras, insurance, automobiles, toys, alcoholic and non-alcoholic beverages, cosmetics, and even cable television.

The highly geometric kente design may appear as a border decoration, as a background or backdrop, as a central object of attention or important element of dress or bodily ornamentation, or in a contemporary Black Afrocentric painting. In each case the kente cloth or pattern may fulfill one or more of the following functions. First, it may act as a code, expressing history, commonality of purpose, solidarity, social cohesion, and Black racial identity. In this instance, it is put to an essentially didactic use. Second, it may act as a vehicle to facilitate or assist in conveying a primary message; in this role it may serve as an inducement to persuade the reader or viewer to act in a particular fashion. Third, as a signifier, it may allude to a particular status or sense of well-being, promoting a certain lifestyle or habit and often suggesting intellectual sophistication.

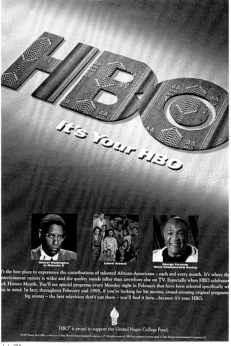

11.7^

Significantly, although kente has become increasingly familiar to the population at large, it rarely appears in mainstream magazines such as *Time* or *Newsweek*, whose readerships truly cut across the country's racial divides. It is often featured, however, in contemporary Black magazines, such as *Black Enterprise, Jet, Ebony, Vibes, Upscale, Image, Heart & Soul,* and *Essence.* Thus what might initially appear to be a growing corporate awareness of racial sensibilities may also be a form of race containment.

Although advertisers are more than willing to seize upon the symbolic potency of kente to manipulate the taste of the Black consumer, they often demonstrate very little concern about the authenticity of the cloth or the way in which it is presented. As a consequence corruptions of the kente design and its symbolism abound. Even Black-owned companies have participated in the misuse of kente. Several well-known ads for Black hair products, among them IC, African Natural, African Royal, and African Pride, incorporate kente. In the African Royal and African Pride ads, the conflation of Africanness and African American ownership assume a poignant militancy. Both are presented as essential components of a marketing strategy designed to lure an exclusively Black patronage. Such corporate appropriation commercializes handwoven "authentic" kente and distorts and oversimplifies Black culture and ancestry.

Print advertisements produced by American Family Insurance and the HBO cable network (figs. 11.6, 11.7) incorporate modern kente patterns designed for the tourist market. This preference for machine-made variants of the fabric suggests corporate indifference to, or ignorance of, the issue of authenticity. Ironically a print advertisement for AT&T that bears the title "Truth in Advertising" incorporates a border with a patently erroneous representation of kente (fig. 11.8). It features rounded motifs that are more reminiscent of Akan Adinkra cloth. These advertisers are presenting a piece of African culture to a mass audience that probably knows nothing about its significance beyond a fundamental association with Africa. In the effort to sell their wares, companies exploit the ignorance of African Americans and perpetuate misunderstanding of at least one aspect of African culture. The text of the HBO ad reads: "It's the best place to experience the contributions of talented African-Americans—each and every month. It's where the entertainment variety is wider and quality stands taller than anywhere else on TV. Especially when HBO celebrates Black History Month." The ad seems to want to conflate Black excellence in the entertainment industry with the exalted position accorded kente in the original Akan context. HBO obviously recognizes the wisdom of including shows that portray members of a racial minority in its programming, especially when that racial minority constitutes a substantial percentage of its viewing public. The combination of photographs of well-known African American celebrities, such as Denzel Washington and George Foreman, and the use of kente could have been much more profoundly compelling, however, if some reference to the cloth's cultural and historical meaning had been provided. Yet, in this and in many other cases, the primary intent is not to educate Blacks about Africa. Indeed, the selective and exploitative use of imagery, often coupled with an inappropriate context, precludes any educational function.

11.8^

Sketched facsimiles of kente cloth, such as those used on some African Royal and African Pride cosmetics bottles, do little justice to the extraordinarily fine geometric patterns of the textile. It is clear that the ultimate aim is not to convey kente's colored patterns in an accurate fashion. That approximations of this kind now pass for real suggests the extent of the degradation that kente has suffered. The idea, it seems, is to employ an image that instantaneously evokes Black cultural pride and thus serves as a powerful lure.

In another ad, Coca-Cola portrays its ubiquitous red-and-white emblem with a bottle superimposed on a colorful computer-generated kente backdrop (*Essence*, December 1994, 94). On a purely visual level, the curvilinear corporate logo and italicized slogan clash with the rectilinear kente design. The bright red of the Coke emblem also seems disjunctive when placed against the more somber yellow and green composition of the "textile." The visual conflicts, however, are only signs of deeper cultural clashes that occur when a fragment of African culture is taken out of context.

The boldly inscribed message, "Always," centrally positioned across the top of the corporate emblem, implies that there is some inherent connection between Coca-Cola and kente. What possible link, however, can exist between a carbonated drink and a royal cloth? How can African American cultural self-esteem be conflated with drinking Coke?

Although the advertiser in this case may be unaware of the traditional use of kente in Akan culture, it is certainly not unaware of the cloth's powerful symbolic associations within the African American community. Visual manipulation such as we see in this ad demonstrates corporate insensitivity to the whole issue of Black pride and self-esteem. When kente is reduced in this fashion, little is conveyed about its cultural significance, and nothing is done to enhance or advance the Black image. Presented as little more than wallpaper—a role that runs completely contrary to the textile's original use in Akan culture—the computer-generated kente image is a mockery. The ad makes explicit the primary commercial motive of Coca-Cola, which hopes to create a cultural association between kente and Coke in order to sell its product. In view of this, one might ask whether kente isn't becoming a menace instead of an asset to Black America.

Coca-Cola's controversial role in the politics and economy of South Africa during the final years of the apartheid era is still fresh in our minds. As one of the few large corporations that supported the racist power structure by continuing operations, it is ironic that Coca-Cola is now trying to identify its product with Black culture and history. Just as Coke found no problem in exploiting Black labor to promote racism and profit in South Africa, it now finds no problem in using kente to capitalize on Black racial pride. The appropriation of kente here is both meaningless and degrading, despite the fact that it is clearly a prudent business strategy.

There is no question that reduced to their essentials, "most commercials have somewhat faulty logic that encourages forming conclusions" on the basis of limited information (O'Barr 1994, 205). A Benson & Hedges advertisement showing an African American model in a kente dress holding a cigarette in her hand is a classic example. The advertiser is clearly attempting to refine its image by juxtaposing a positive cultural emblem, kente, with a product long considered to be harmful.

Chevrolet, on the other hand, may be trying to tap into the hunger of Black Americans for knowledge of African culture with its Kwanzaa ad featured in the popular Black magazine *Heart & Soul* (fig. 11.9). On the surface, it would appear that the advertiser sought to use the imagery didactically to outline and clarify the meaning and significance of Kwanzaa. The text is informative and seems primarily directed at the African American reader who may not be fully familiar with the symbolism of Kwanzaa, which is relatively new when compared to older American festivals. The use of an African narrative, probably adapted from a Swahili poem, to set forth the imagery sets up a dialogue between the Motherland and the Diaspora. The shrine or altar format with the carefully arranged paraphernalia seems consistent with similar sacred assemblages that have come to be identified with people of African descent in the Americas (Thompson 1995). The ritual arrangement, in fact, resembles that used by the modern Akan people in Ghana, particularly the kente cloth on the table.[3] The two opposed lions decorating the base of the candle holder recall the Egyptian sphinx, while the cracked but mended mug in the foreground may symbolize the reunification of African Americans with their Motherland. Whether consciously intended or not, the choice of the kente pattern in this case fits the context. It symbolizes the proverb, "*Woforo dua pa, na yepia wo*" (When you climb a tree worth climbing, you get the help you deserve). The implication is that the good efforts of the Black community will be supported by Chevrolet. Moreover, the inscription "*Harambee*" (Let us all work together), placed at the bottom center, suggests that the ulterior motive is to forge a semiotic connection with the Black community. This is true as

11.9

11.9 Chevrolet's Kwanzaa advertisement appeared in December of 1995. Reproduced with permission of Chevrolet.

11.10 Beefeater Dry Gin advertisement offering a poster reproduction of the painting *Maskamorphosis* by Calvin B. Jones. Reproduced with permission of Hiram Walker & Sons, Inc.

11.11 Beefeater Dry Gin advertisement offering a poster reproduction of the painting *Kwanzaa* by Calvin B. Jones. Reproduced with permission of Hiram Walker & Sons, Inc.

well of the closed book bearing the title *Africa*, which suggests the codification of Black history and serves to validate knowledge about African and Black cultural heritage.

Making the Kwanzaa celebration the chief focus of the ad to the point of virtually obscuring the sponsor could be interpreted as a demonstration of genuine interest on the part of Chevrolet, which after all boasts a substantial Black workforce. Such a demonstration of goodwill could reap considerable rewards for Chevrolet in the form of the Black community's enthusiasm and appreciation for the company's efforts. Yet there seems to be more to the ad than meets the eye.

The desire of corporate America to attract and retain Black patronage is evident in this effort to depict a Kwanzaa altar with its relevant sacred objects. Clearly, a picture of a car in the ad would have been an inappropriate intrusion in the otherwise solemn scene. But this act of omission is perhaps more a carefully calculated stratagem than an instance of corporate "selflessness." Psychologists studying the dynamics of advertising have demonstrated that when an object of desire is concealed from view, a strong subconscious longing for it can develop as a kind of subliminal persuasion.[4] The admonition "Buckle Up America," at the very bottom of the ad indirectly frames the subliminal message. This advertisement is not an act of charity. As Harold Burtt has pointed out, there is much to be gained from the "mere display of the trade name with no definite statement regarding purchase" (1938, 54). The proximity of the Chevrolet symbol and name with the Swahili term *harambee*, which as previously noted connotes "unity," has strong mnemonic implications. The important role of the text is clear given the centrality of Swahili in Afrocentric discourse, and especially in discourse pertaining to Kwanzaa (see chapter 12). Black heritage thus becomes conflated with the automobile manufacturer. The company also courts Black loyalty by identifying itself with the Black community's ideals: "Chevrolet respects the values and importance of Kwanzaa." The offer of a free color enlargement of the ad, obtainable by dialing an 800 number, provides Chevrolet with yet another means of establishing a permanent presence in Black homes. Chevrolet thus becomes an emotional substitute for the more transient Kwanzaa celebration.[5]

Similar manipulation of race consciousness is evidenced in a series of ostensibly informative ads for Beefeater Dry Gin. These ads offer poster reproductions of Afrocentric paintings by Black artist Calvin B. Jones, *Maskamorphosis* and *Kwanzaa* (figs. 11.10, 11.11). *Maskamorphosis* shows two African masks (probably originating from Côte d'Ivoire and Liberia) against a kente background, while *Kwanzaa* features a seated Black man in a kente toga flanked by another wearing a kente stole. In *Maskamorphosis* Jones combines kente with the mask forms to convey the power and resonance of African culture in Black American consciousness. His *Kwanzaa* painting goes a step further as kente receives greater prominence as the essential ceremonial attire. Here the sense of family and community typical of continental African cultures is reinforced through the critical relevance given the Black patriarch as an authority figure and ritual leader. The objective seems to be to capture the essence of Kwanzaa as a celebration of Africanness. The message that "The Beefeater Art of Good Taste series is an artistic celebration of African American culture," which appears in the copy accompanying *Maskamorphosis*, is there to communicate social consciousness on the part of Hiram Walker & Sons, Inc. This caring ethos is reinforced by the promise of grants from the net proceeds of poster sales to "community arts projects . . . minority scholarships in culinary sciences, hospitality and retail management."

A similar advertising format, emphasizing community service, is adopted for Pizza Hut's "Great Achievers" series, which salutes successful Black Americans. In one ad, Marla Gibbs, the popular star of *The Jeffersons*, poses with two African American children; all three are garbed in kente-decorated clothing. For Pizza Hut the combination of the popular Gibbs and kente is reducible to a well-recognized Black face and the ultimate symbol of Black history. The precise cultural meaning of kente is relatively unimportant in this context; it functions primarily as a signifier of African American ancestry. Pepsico, the owner of Pizza Hut, Pepsi, Frito Lay, Taco Bell, and KFC, however, sponsors another print advertisement with the heading "Serving the New Generation," which makes more explicit reference to kente. By means of a photograph of KFC employees wearing kente hats and kente-trimmed shirts, accompanied by an extended caption, Pepsico explains an ingenious business strategy whereby certain KFC outlets have been redesigned to appeal to their predominantly Black customers: "They added collard greens, red beans & rice, and sweet potato pie to their menu and swapped KFC's traditional uniforms for vests, ties and hats made of kente cloth." Combining this new image with a statement of commitment to the Black community in the form of increased employment and educational and business opportunities reflects a sensitivity that seems ideally designed to increase loyalty from a Black clientele.

11.10^

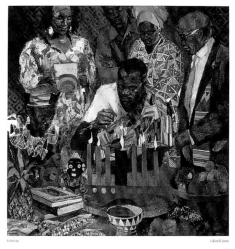

11.11^

Mattel's Kente Princess and other dolls specially manufactured for African Americans appeal to the Afrocentric obsession with reclaiming a proud heritage. The Kente Princess is a Black doll—resembling "Barbie" in many respects—adorned with headgear and clothing made of machine-printed kente fabric.[6] In an advertisement for the doll produced by Toys "R" Us, the copy reads: "You know that some dolls are more than just fun," articulating an ostensibly didactic purpose. A similar intent—developing Black pride and self-esteem among children—is professed in several other ads, notably those by Kodak Gold (fig. 11.12) and Playskool.

Playskool (a subsidiary of Hasbro Corp.) focuses on a doll dressed in kente as "a great way to carry pride & joy everywhere you go." Research has long recognized the potential emotional benefits of "ethnic dolls" to children of racial minorities. In her essay "Toys That Teach," Lisa Jones quotes child psychologist Darlene Powell Hopson: "It's important for us to be proactive in making sure that Black children embrace images that represent themselves and reinforce self-esteem and racial identity." Jones goes on to report Dr. Hopson's assertion that "toys and dolls are children's main way of communicating their feelings, thoughts and fantasies and they are natural tools to teach values" (Jones 1993, 6).

In one Kodak ad, a happy African American couple, arguably middle class, are shown focusing on their infant's kente bib, thus drawing the viewer's attention to its vivid colors. The facial expressions of the couple suggest not only a mood of celebration but also pride in their African ancestry, which is symbolized by the kente fabric. The ad text promises "a bright and colorful future encoded in the child and made possible through the agency of a Kodak film." For Kodak, the emphasis on the brilliant color captured by its film is paramount in the marketing strategy. The brightly colored kente helps to convey that message. At the same time an analogy is crafted wherein the enduring quality of Kodak pictures comes to resemble the resilience of kente and African American memory: "With Kodak Gold Film, it's easy to make those one-in-a-lifetime moments even more memorable."

As noted earlier, kente stoles, sashes, and shawls have been marketed for graduations and worn as expressions of political consciousness (see fig. 11.4). Because these accessories are usually sold and worn as single woven strips, they depart significantly from the traditional way in which kente was used by its Asante creators. It is true that the late nineteenth century witnessed a breakdown in strictures governing the acquisition and use of kente in Asante culture (Cole and Ross 1977, 42). Yet, even in contemporary Ghanaian society, it is only the well-to-do who are able to afford a full-size kente cloth. The popularization of the strip seems a clever way to circumvent high cost while retaining the status associated with the cloth. The acquisition of kente has been democratized making it possible for increasing numbers of Black Americans to procure a piece of their African heritage.

As might be expected, kente stoles and shawls are often featured in ads (see figs. 11.4, 11.5). In some instances, kente is made to serve more or less as an article of erotic charm, a practice that cuts to the very core of the issue of Black sexuality. One particularly egregious example is an ad for Imported Canadian Mist (marketed by Brown-Forman Beverage Company; *Ebony*, November 1993, 133–34), which bears the legend "Mist Behavin'," an attempt to reflect Black speech patterns. The ad reinforces stereotypes regarding Black male sexuality and Black female promiscuity that African Americans have long worked to discard. Significantly only the torsos of the male and female in the ad are illustrated. The message "a great first move," applauds the woman as she slips a card bearing her name and telephone number inside the man's cummerbund. The implication is that the Black male body when invested with the cultural pride that comes from wearing kente and warmed by sufficient quantities of Canadian Mist becomes irresistible, forcing women to succumb. Kente, like liquor, becomes a means of seduction.

Two ads by the cosmetics company Flori Roberts, however, give some indication of a positive use of Akan kente. The first ad for Ashanti perfume bears the tag line "the essence of beauty without boundaries . . . rich, regal, rare" (*Essence*, December 1993, 23). An original, richly colored woven kente sash is worn over the model's right shoulder. Royalty, wealth, power, and pride—all attributes deeply cherished by Afrocentrists—are here entertwined with the kente cloth. In the second ad, the "kente mystique," several makeup

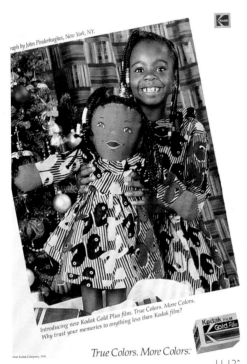

raph by John Pinderhughes, New York, NY.

Introducing new Kodak Gold Plus film. True Colors. More Colors. Why trust your memories to anything less than Kodak film?

Kodak Film Gold Plus

True Colors. More Colors.

11.12^

11.12 This Kodak film advertisement uses a kente backdrop. Reproduced with permission of John Pinderhughes and Eastman Kodak Company.

11.13 An advertisement from Parks Famous Flavor for its "delicious chitterlings" features Ray Haysbert Sr. wearing a kente stole. Reproduced with permission of Parks LLC dba Parks Sausages Company, Lydell Mitchell, president, Franco Harris, CEO and owner.

products are featured: Gold Coast and African Ruby lipstick, Melanin Cleanser, Gold Coast Enamel, and Ashanti Fragrance (*Essence*, April 1994, 23). A kente-decorated makeup box is prominently displayed. The copy reads "inspired by the rich jewel tones of the African kente cloth, and captivating exotic essence," clearly revealing that the advertiser intends not only to exploit the rich and vibrant colors of kente but to tap into the Afrocentric fervor of African Americans. In describing kente in terms of "mystique" and the "exotic," however, Flori Roberts presents a romanticized view of Africa, and specifically of Asante culture, wherein gold and precious minerals lie raw, abundant, and accessible. Hence, on the one hand, the "mystique" of the Asante recalls nineteenth-century Western constructions of "otherness" that preceded the colonization of Africa. On the other hand, the conjunction of race, history, and cultural pride may strongly project a positive image of modern Black womanhood. The copper-toned African American woman who graces both Flori Roberts ads, however, is hardly exemplary of Asante beauty. The Asante people generally view a dark complexion with pride.[7] Other difficulties arise in the details of dress and representation. The sash, for example, is traditionally worn on the left shoulder in Asante practice. Moreover, the female figure depicted on the perfume bottle is not a traditional Akan artistic form. Instead, it is a recent fabrication—the origin of which is unknown—developed for the tourist market in Ghana.

A Polaroid ad celebrating Black history features an antique map of Africa upon which a snapshot is pinned. The photograph, showing a masked figure and two Black children adorned in kente, is positioned in such a way as to reveal images of African wildlife on the map. The most prominent signifier of Africanness is the image of a seated monkey. Using an antique map perpetuates the notion of a continent that has been in a state of dormancy for centuries, ignoring the reality of modern Africa. While the ad is effective visually in making the connection between contemporary Black people and their African past, it also conjures up "darkest Africa," the popular precolonial portrait of the continent as the "primitive" antithesis of Western civilization updated for a contemporary audience.

A much more potent recovery of the long-abandoned "noble savage" concept of Africa is conveyed in a promotional package from Starbucks Coffee. Promising the "experience [of] a world of rare coffees and exotic tastes," the ad suggests a journey back to the old, not the new, Africa. African cultures and their economic products are still, to some in the West, objects of curiosity that must be sampled, novel tastes that must be acquired. The target market here consists of people of a distinct status and class—not necessarily Black—who share this narrow view of the non-Western world and cherish its underdevelopment. The visual relationship established in the image between the beauty of kente and the African Baule mask epitomizes the ambiguity contained in the notion of the noble savage, who is at once regal and horribly crude.

A corresponding ad by Parks Famous Flavor for their "delicious chitterlings" associates kente with Black economic success. Inviting us to enjoy the "Holiday Season with Friends, Chitterlings, & Champagne," the ad seems directed at a vast Black middle class, an image of which is neatly packaged and presented in the photograph (fig. 11.13). The man of the moment is clearly Parks's president, Ray Haysbert Sr., whose entrepreneurial success is underscored by his kente stole. As with other ads, the assumption exists that Black consumers will purchase products because they signify high status and knowledge of one's cultural heritage or that cultural awareness is a concomitant of consuming certain products.

It is possible for micro-markets to expand and transform themselves into macro or global markets. Highly localized market trends can eventually become diffuse phenomena. Thus the target audience for many ads incorporating kente seems to be expanding from middle-class and older Blacks with disposable income to include enlightened Whites (Hunter-Gadsden 1990, 80–82). This explains in part the phenomenal increase in kente-embellished products in the recent past. They may range from McDonald's plastic soda cups to more personal items such as bank checks. Popular American cultural icons have often appeared in conjunction with the use of kente. In an ad for the 1995 Miss Collegiate African American pageant at Disney World, Mickey and Minnie Mouse, draped in kente, are shown flanking the former pageant queen, whose appearance seems to strongly recall Nefertiti.

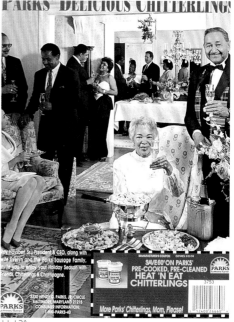

11.13

Conclusion

Although kente retains its esteemed role in Akan society, during the postcolonial era (1957 to the present), much has changed in the way the textile is used. Interestingly, for example, Ghana's first president, Kwame Nkrumah, preferred it as formal dress and went so far to install it behind the state throne in the Ghanaian Parliament (see figure 10.51). For this leader, kente symbolized African pride, and its artistry and vibrancy communicated his vision for the newly independent nation (see Ross, chapter 10).

In the United States kente has come to both symbolize and project a popular conception of African heritage. Through kente, Blackness has become homogenized; the large and economically diverse Black population is lumped together to construct a single neo-identity based on the consumption of particular products. This development unfortunately carries with it the potential to reinforce old racial stereotypes.

The cultural appropriation of kente in American advertising shows how integral multiculturalism has become to corporate commercial strategies. To think that the practitioners of this aesthetic of exploitation are limited to predominantly White-owned firms, however, would be at best shortsighted. Black-owned enterprises are very much players in this game. Indeed Black-owned advertising companies, such as Chicago-based Burrell Communications Group, which is known to specialize in serving this niche market, are very much at the center of this discourse. Being Black, they bring a particular slant to the reading of these ad images. Current strategies of diversification developed by corporate America not only place Black advertising companies at center stage but also make it incumbent on them to formulate ads based on their supposed knowledge of Africa.

The West it would seem has come full circle. From the destruction, looting, and expropriation of cultural properties from African palaces and religious shrines at the turn of the century, we see nearly one hundred years later another form of cultural appropriation, this time of significant African emblems. By using kente and other significant cultural forms to promote the sales of products, corporate America is chipping away at centuries of accrued symbolic meaning. Significantly, nowhere is kente represented in an approximation of its original use within the context of American advertising. This suggests a new ethos, one of display. As in its original African context, the cloth's distinctive design still reflects the ideals of strength, wealth, power, and superior social status. It is, however, becoming a catchall design for things ancestrally African. Kente is now the Motherland, reinvented, packaged, and made palatable for mass consumption. Viewing Africa in such a reductive fashion not only does a disservice to the enormous array of different cultural heritages on the continent, it also distorts the very notion of ancestry that for so long has sustained the African peoples of the Diaspora.

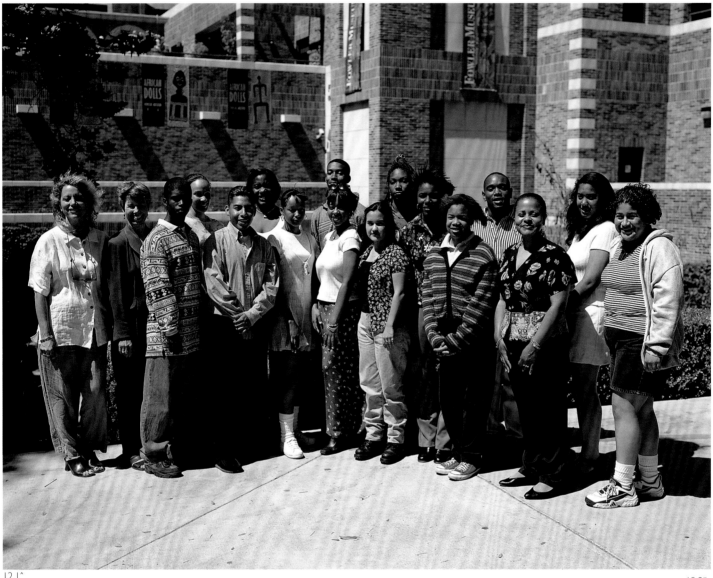

12.1^ 12.2ˇ

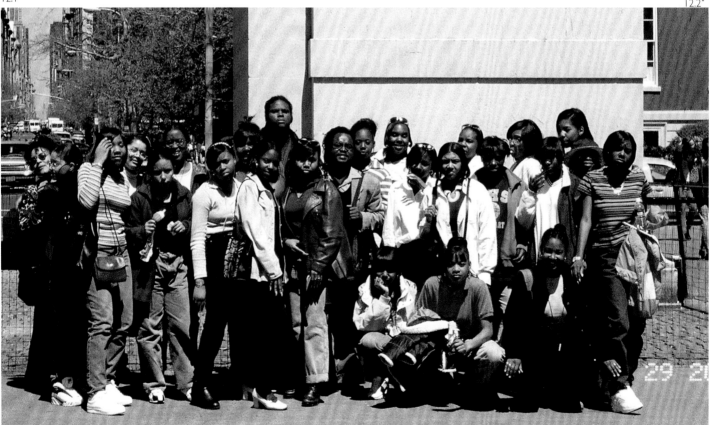

Wrapped in Pride: A Community Research Partnership

Art museum exhibitions often reflect the scholarly interests of the curator, the tastes of the connoisseur, or the passions of the collector. Seldom are they informed by the community, and rarely do museums engage high school students in the role of curator or community historian. This project, however, represents a step in that direction.

From September 1996 to June 1997 eighteen high school students in Los Angeles (fig. 12.1) and twenty-seven in Newark (fig. 12.2) immersed themselves in the study of kente, querying vendors, artists, community leaders, the clergy, and the public at large about its meaning and use. The students documented parades, family celebrations, and public gatherings in which kente was displayed or worn. Class assignments and readings led them to consider aspects of African art and history rarely included in conventional high school courses.

This was all part of an extraordinary collaboration that joined the Fowler Museum with students from two magnet programs at Crenshaw High School and paired the Newark Museum with students from Chad Science Academy and University High School. These unique partnerships engaged students as community researchers and exhibition planners and featured museum staff as mentors and teachers. The yearlong course of study focused on community research, emphasizing interviews and photographic techniques, and on an introduction to Ghanaian art history with special attention paid to kente and other West African textile traditions. Since both museums were committed to developing a major component of the *Wrapped in Pride* exhibition that would reflect the perspectives and interests of their respective African American communities, student research was seen as essential to the development of the exhibition and its accompanying publication.

Our expectations and hopes for the courses were high. Not only did we anticipate that students would develop greater appreciation for kente and an increased understanding of its significance for Ghanaians, we also hoped that they would reflect on the role of art in the life of a community and consider the importance of dress in the construction of identity. We wanted the project to go beyond the usual one-time-visit format for museum and school collaborations and to afford students firsthand experience as researchers. To effect this, the students would document and interpret the relevance of kente in their own communities as part of a tangible museum exhibition and a publication targeted for a broad and culturally diverse audience. Enrollees in the course were primarily African American, but one Latino student in Newark and four in Los Angeles enrolled as well. In both cities the students' research centered on traditions observable in their own communities.

Kente, Museums, and the Community: A Yearlong Course of Study

Working closely as teams, school and museum staffs in the two cities designed courses of study for the 1996–1997 school year, meeting to articulate student goals and expectations and to develop the course syllabus, select readings, and outline class and homework assignments. Evolving in response to staff concerns and critical feedback from students, the courses assumed a truly collaborative character. Beginning with introductory sessions on kente cloth and the exhibition project (fig. 12.3), as well as behind-the-scenes visits to the museums, the courses continued with classes introducing students to the basics of interviewing and photography so that the process of documenting the use of kente in their own communities could begin. Both institutions used selected lessons from Lisa Falk's *Cultural Reporter* (1995), developed for schools by the National Museum of American History, to prepare students to conduct community research. All class sessions commenced with a consideration of recent and upcoming opportunities for recording kente in the community, a critique of photographs and interviews, and a discussion of strategies for documenting future events.

Drawing upon assigned readings, films, and the vast holdings of the museums, students were introduced to the history and diverse cultures of West Africa. Students in both cities also had the opportunity to visit well-known African American artists in their studios—John Outterbridge in Los Angeles and Emma Amos in New York—and to meet other artists and discuss their work—Crenshaw students met with Fred Wilson and Newark students with Chester Higgins.

The museums were fortunate to be able to continue the student research over the summer of 1997 with the assistance of a special grant from the Getty Grant Program. Three of the Los Angeles students—Aphrodite J. Dielubanza, Taaji Madyun, and Danielle E. Smith—and four of the Newark students—Nadirah Keith, Janel Watts, Francina Radford, and Prunella Booker—were awarded paid internships to continue the research and preparation for the *Wrapped in Pride* exhibition. They worked with key museum staff to process

12.1 Some of the Crenshaw High School students who participated in *Wrapped in Pride: A Community Research Partnership*. Photograph by Don Cole, Los Angeles, June 1997.

12.2 Some of the Chad Science Academy and University High School students and teachers who participated in *Wrapped in Pride: A Community Research Partnership*. Photograph by Joy Robinson, New York, April 29, 1997.

collections, conduct additional interviews, and document summer "kente" events in both cities. In Los Angeles, two of the students, Aphrodite J. Dielubanza and Danielle E. Smith, continued working part-time on the project during the 1997–1998 school year to further document kente's many manifestations in the calendar of African American life. Over the summer of 1998 Aphrodite and Danielle also helped to assemble a family album of kente for the exhibition. In Newark all four of the students named above continued to work with curator Anne Spencer to document kente use on a part-time basis during the 1997–1998 academic year. It should be noted that although both courses shared a number of goals, the educational strategies employed to achieve them varied, as will be discussed below.

"Wrapped in Pride": The Museum Studies Course at Crenshaw High School

UCLA's partnership with Crenshaw High School drew juniors and seniors from the school's two magnet divisions, Crenshaw Gifted Magnet and Crenshaw Teacher Training Magnet. Seven boys and eleven girls enrolled in the class, which was offered as a special yearlong museum studies course within the Gifted Magnet Program. Crenshaw art teacher Susan Curren and computer science teacher Mary Covington collaborated as team teachers with Doran H. Ross, the director of the Fowler Museum, and the Museum's director of education, Betsy D. Quick.

Although the arts and traditions of the Asante peoples of Ghana were the focus of the class, in the course of the year students were also exposed to the traditions of the neighboring Ewe peoples and other West African cultures, especially that of the Yoruba of Nigeria. In subsequent lessons on the arts of African American communities—including a survey of artistic traditions in South America and the Caribbean—students developed a broad understanding of the cultural and artistic ties connecting Africans and their descendants in the Diaspora. Individual sessions ranged from the arts of Haitian Vodou to the Carnaval traditions of Bahia, Brazil, and the African American arts of Suriname.

In addition to the emphasis on community research and Ghanaian art history, the UCLA/Crenshaw course included an introduction to museum studies. Students were made aware of registrarial and conservation concerns, considered issues of education and design relating to exhibitions, and pondered the real-life dilemma of how to develop and fund a museum project. They had the opportunity to critique several exhibitions, as well as to evaluate the plans for the Museum's own *Wrapped in Pride*. With increasing confidence in and familiarity with the project, students carefully considered, argued over, and revised plans for the kente project. The students' perspectives were valued and came to inform the images and objects selected for the exhibition and accompanying publication.

This practical experience culminated with each student purchasing a kente-related object of his or her choice for the final, "Calendar of Cloth," section of the exhibition. In researching and selecting objects, the students were given the opportunity to work as curators, educators, and designers—experiences that added immeasurably to their overall involvement. The students followed their acquisitions by going through the standard museum accession procedures, preparing condition reports, developing educational materials and installation design, and planning for appropriate media coverage. Students thus had the opportunity to express the significance of kente in their own voices.

"The Kente Project" in Newark

In Newark the community research partnership, known as the "Kente Project," involved students from two local high schools, one public and one private. Fifteen ninth-grade students from University High School, a public magnet school for the humanities, and twelve eleventh-grade students from Chad Science Academy, an Afrocentric school with a focus on the sciences, joined with the Newark Museum in the partnership. The involvement of two such distinct educational institutions expanded the project's impact and acted as a catalyst within the African American community to ignite a dialogue concerning the use of Kente.

A project of this scale and with such high visibility naturally presents many challenges. Led by curator Anne Spencer, Lucy Brotman, the director of education, and the assistant director of education and manager of school programs, Eathon Hall, the Museum sought to forge a link between the "Kente Project" and the curricular objectives of the schools.

At University High School, the course was based in an art class composed of female students and taught by Gwendolyn Jackson. In addition, two male students from the Afro-Awareness club participated in the project. A specially created African American studies elective class, taught by Sister Gwen Samuels and composed of female students, provided the structure for the project at Chad Science Academy.

12.3 Crenshaw High School students Aisha Kennedy, Carroll E. Houston, and Maritza Mejia (from left to right) examine a piece of kente. Students had the opportunity for hands-on study of museum collections. Photograph by Susan Curren, Los Angeles, October 1996.

12.4 "African Boy" and "African Girl" costumes appeared among character ensembles in the Halloween displays at Shelly's Discount and Aerobic Dance Wear. Photograph by Betsy D. Quick, Los Angeles, October 1996.

12.3ʼ

Background information on the history of Ghana and the textile traditions of West Africa and a consideration of the relationship between dress and identity provided the students with a framework within which to consider kente in their community. At Chad, classes dealing with these topics were taught by Anne Spencer. Eathon Hall provided similar instruction for the students at University High School. However, the major emphasis was on enabling the students to become cultural reporters with a focus on conducting oral history interviews. For a variety of reasons, it was more expedient to have many of these interviews conducted at the schools.

In addition to the classroom instruction at Chad Science Academy, the students organized a Kwanzaa festival and an exhibition on kente and their community research. At University High School, students created an exhibition of kente-attired dolls, prepared food for a Ghanaian/African American Food Fair, and developed other kente-inspired art projects. During the summer of 1997 the student interns purchased representative kente objects in Newark for the section of the exhibition dealing with the local community.

For all the students involved in the project, participation broadened their exposure to a cross section of the Newark community—including Ghanaians, professionals, local politicians, and teachers—increasing their awareness of issues of cultural identity.

Students as Community Historians

Involving students as researchers and as interpreters of arts that are alive in their own communities was a unique feature of the *Wrapped in Pride* project. To a large extent, it allowed for a shift in emphasis away from academic debates about authenticity and connoisseurship and toward community definitions of identity and meaning.

Students conducted a total of ninety-six interviews in the two cities—an amazing feat when one considers the time and effort that such field studies can require. In addition to the challenge of juggling fieldwork on top of already busy academic schedules, students faced additional tensions associated with high-profile interviews. As they came to see their research as significant and to perceive themselves as competent interviewers, however, they began to feel more comfortable with the process. The best interviews reveal an understanding of the interview as a conversation—the student responding spontaneously and inquisitively to the subject's comments. The quality of the documentation they gathered quickly demonstrated to the students that assertiveness, attention to detail, and responsibility were skills that would serve them well in their academic careers and beyond.

The ninety-six individuals interviewed represent a fairly broad cross section of the African American communities in Los Angeles and Newark.[1] Fifty-one were men, forty-five women. A significant portion of the individuals interviewed in Newark were of Ghanaian descent (sixteen), while only three people in Los Angeles cited Ewe or Asante ancestry. In terms of occupation, twenty-four individuals were involved in business concerns, twenty-four were employed with educational institutions, eight were clergy members, seven were students or recent graduates, eight were community or political leaders, thirteen worked in the arts or in the museum field, and the remainder held professional positions in public health, philanthropy, urban studies, etc.

The students discovered that within their communities opinions about the meaning of kente were as rich and varied as the patterns of an exquisite Adweneasa cloth itself. Mixed with discussions of the contexts and patterns of kente use were heartfelt and often passionate expressions of the roles kente plays in private life, in business, and in the messages it conveys to audiences and congregations. Does one feel different when wearing kente? What are the responsibilities imposed by kente's Ghanaian origins? Will kente survive the vagaries of America's fickle marketplace? When woven together, the answers to these and other questions create a fascinating picture of how an art form and cultural tradition come to be defined and reconstructed in new and different cultural milieus.

12.4^

A Calendar of Cloth: Kente in the Cycle of Life

Most of my friends have kente for everyday use. They wear it every day—casual wear, ceremonies, and just everyday . . . just everyday clothing.
—Obinne, Owner of The African Cultural Exchange, interviewed by Maritza Mejia, Los Angeles, March 3, 1997

Kente is a sacred thing that does not have to be used every day of your life. It is only worn on holidays and during festivals.
—Nana Kyei Ababio II, Chief of Kagyase, interviewed by Shontae Scott and Francina Radford, Newark, 1996

Charged with identifying, interviewing, and photographing individuals who make, use, sell, or wear kente, the students engaged their communities in search of a diverse group of people to form the basis of their studies. With a preliminary list of events and individuals identified, the students commenced their research. The fall with its steady stream of celebrations—Halloween, Thanksgiving, Christmas, and Kwanzaa—was especially kente rich.

Kente and Halloween!

While the usual cast of Halloween characters—witches, ghosts, and goblins—predominated in costume stores in October, one could also choose to dress as an "African" in kente garb. Alongside princess gowns and skeleton suits, child-size "African Boy" and "African Girl" costumes were available for sale at Shelly's Discount and Aerobic Dance Wear in West Los Angeles. The store's owner, Shelly Shoi, recounted that these outfits, made of machine-printed kente, were sold throughout the year to students in African dance classes, but during October they were relocated to Halloween display areas within the store (fig. 12.4).[2] Kente in this instance was equated with Africa and constituted yet another possibility for dressing up. Those unfamiliar with American Halloween traditions need to be reminded that costuming is not all monsters and ghouls. Many people dress up as their favorite actor, politician, or other cultural hero. In this context kente can serve to reinforce positive images.

Kente and Thanksgiving

Following Halloween, the students had expected to see kente gracing Thanksgiving tables. When asked "When and how do you use kente in your personal life?" only one individual cited Thanksgiving as an opportunity to display the distinctive cloth, and then it was used to add texture to a table resplendent with the traditional Thanksgiving feast.[3] The apparent absence of kente surprised and puzzled the students. Thanksgiving is thought by some to be the "most accommodating" of American holidays (Alexander and Weaver 1986, C31)—embracing a multitude of immigrant traditions. Perhaps since Thanksgiving is often perceived as all-encompassing, the incorporation of kente is thought to be potentially less meaningful than in situations that clearly offer the opportunity to celebrate African descent. Further, families often express their diverse ancestries through distinct foodways rather than through forms of dress and adornment on this holiday. It should be noted that some individuals and communities reject Thanksgiving altogether, perceiving it as symbolic of European dominance over, and destruction of, Native American cultures with which many African Americans identify.

The absence of any strong gift-giving tradition at Thanksgiving also means that wrapping paper and cards—items on which kente is frequently depicted—are not required.

Kente and the Christmas Season

The day after Thanksgiving, the students observed that kente Christmas had arrived with a vengeance. With themed Christmas decorations all the rage, kente assumed a place of prominence. Kente Clauses (fig. 12.5), kente angels, kente wreaths, kente tree skirts (fig. 12.6), and kente Christmas cards, wrapping paper, and bags (fig. 12.8) were especially popular in malls catering to the African American community. Macy's Department Store in the Fox Hills Mall, Culver City, California, devoted significant space to kente tree ensembles and associated Christmas ornaments (fig. 12.7), and kente Kwanzaa decorations intended for the Christmas tree were interspersed among other Christmas fare, even though no avowed link exists between the two holidays save their proximity on the calendar. Smaller Afrocentric specialty shops in local malls were dressed in Christmas kente (figs. 12.9, 12.11) and prominently displayed a variety of Christmas articles and gifts featuring kente—stuffed animals (fig. 12.10), wreaths, holiday cards, special articles of dress, and kente Kwanzaa decorations (fig. 12.12)

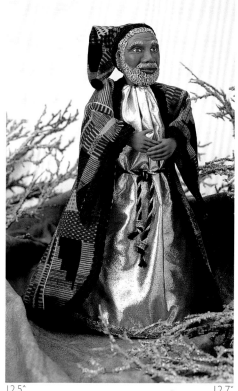

12.5^

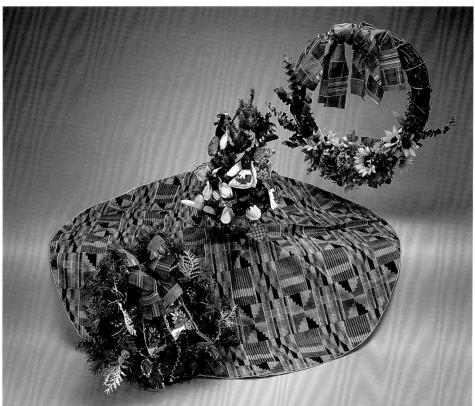

12.6^

12.7˘

12.5 "Kente Claus" by Stafford's Ethnic Collectibles. Plastic and fabric. Height 29.5 cm. Private collection. ©1966, Keith and Shereen Stafford.

12.6 Kente patterns adorned a range of products marketed at Christmas, including wreaths, angels, and tree skirts. Private collection.

12.7 Christmas decorations for sale at Macy's—including a "Kente Claus" and kente stocking. Photograph by Betsy D. Quick, Fox Hills Mall, Culver City, California, December 1996.

12.8 Christmas cards and bags ornamented with kente designs were readily available in stores during the Christmas holiday season. Paper and cloth. Private collection.

12.9 Many stores displayed Kente decorations on Christmas trees. Photograph by Betsy D. Quick, Fox Hills Mall, Culver City, California, December 1996.

12.10 Kente stuffed animals. Photograph by Betsy D. Quick, Fox Hills Mall, Culver City, California, December 1996.

Of note, Kente Claus was not restricted to store shelves. Keith Stafford, the designer of Kente Claus and founder of Stafford's Ethnic Collectibles, marched as Kente Claus in Macy's Thanksgiving Day Parade held in New York in 1996. Appearances of Kente Claus at department stores have drawn the attention of many shoppers (Mariott 1996, sec. 1, 33). Said to incorporate features drawn from Nelson Mandela, Muhammad Ali, Reverend Martin Luther King Jr., and Stafford himself (fig. 12.13), Kente Claus was created with crossover appeal to "unite African heritage and American tradition" (Mariott 1996, sec. 1, 33), while "inspiring Love, Peace and Family Unity for holiday seasons to come" (Stafford 1996–1997). Stafford reports that he created Kente Claus and the "Tribe of One" collection of Afrocentric angel dolls dressed in kente after one of his wife's foster children remarked, "I thought when we died we all went to heaven and turned into white angels" (McLaughlin 1996). Entrepreneurial initiatives such as Stafford's, which appropriate and embrace kente in non-traditional contexts (by Ghanaian standards), have led kente into new arenas of use and meaning.

12.11 Smaller Afrocentric specialty stores in shopping malls were frequently decorated in kente for the holiday season. Photograph by Betsy D. Quick, Fox Hills Mall, Culver City, California, December 1996.

12.12 Kente ornamented Kwanzaa wreath with candles. Photograph by Betsy D. Quick, Plaza Pasadena, Pasadena, December 1996.

12.13 Keith Stafford, owner of Stafford's Ethnic Collectibles, in his Kente Claus attire. Courtesy of Stafford Ethnic Collectibles, Keith and Shereen Stafford.

12.11^

12.12˘

12.13˘

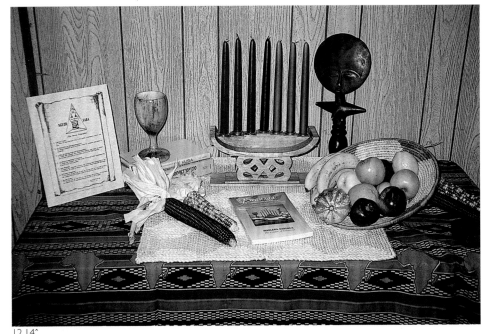

12.14^

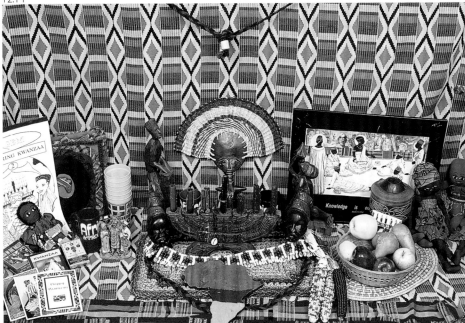

12.15^

12.14 Kwanzaa altar incorporating machine-printed kente cloth. Photograph by Byron Williams, Los Angeles, January 1997.

12.15 Kwanzaa altar at the home of Katungé Mimy. Photograph by Nadirah Keith, Newark, December 1997.

12.16 Katungé Mimy lighting Kwanzaa candles. Photograph by Nadirah Keith, Newark, December 1997.

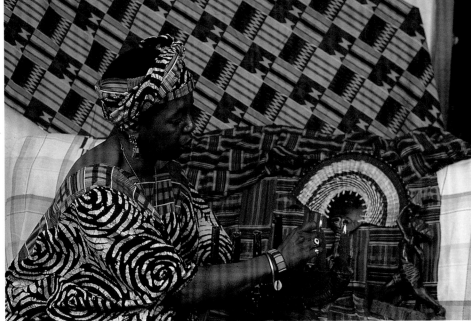

12.16^

Kente and Kwanzaa

Despite the commercial thrust given to kente at Christmas, few of those interviewed by the students spoke of using the cloth for this holiday, more often citing its use during Kwanzaa. The Kwanzaa celebration, created by Dr. Maulana Karenga in 1966, is now observed throughout the world by more than twenty million people of African descent (Ford 1996, B3). According to Karenga,

> Kwanzaa is an African American holiday celebrated from 26 December through 1 January. It is based on the agricultural celebrations of Africa called "the first-fruits" celebrations which were times of harvest, ingathering, reverence, commemoration, recommitment, and celebration. Therefore, Kwanzaa is a time for ingatherings of African Americans for celebration of their heritage and their achievements, reverence for the Creator and creation, commemoration of the past, recommitment to cultural ideals and celebration of the good. [Karenga 1997, 1]

Significantly these goals are remarkably similar to those articulated for traditional Ghanaian festivals (see Ross, chapter 3).

Kwanzaa takes its name from the Swahili *matunda ya kwanza*, meaning "firstfruits." Karenga chose Swahili terminology to reflect the commitment of African Americans to the whole of Africa and African culture (Karenga 1997, 8). He also sought to assert the significance of Swahili in the face of attempts by some to discredit it as a language of enslavement (Karenga 1997, 123). A seven-day cultural event, Kwanzaa is centered on seven principles: *umoja*, or "unity"; *kujichagulia*, or "self-determination"; *ujima*, or "collective work and responsibility"; *ujammaa*, or "cooperative economies"; *nia*, or "purpose"; *kuumba*, or "creativity"; and *imani*, or "faith." These principles are represented through specific symbols: crops, mat, candleholder, corn, seven candles, unity cup, gifts, and the flag representing African unity with its colors of red, black, and green. The straw mat, or *mkeka* (chosen by Karenga because it is a traditional African object), symbolizes the foundation of the holiday, the traditions of the African American community, and, by extension, history (Karenga 1997, 71). In recognition of the importance of history and tradition, Karenga specifies that all of the Kwanzaa symbols are to be placed on the *mkeka*, which serves as literal and metaphorical foundation for the celebration (Karenga 1997, 71).

Kente is increasingly associated with the Kwanzaa celebration and appears in several ways. It is often used to trim the *mkeka*, and departing from Karenga's guidelines, it is occasionally used in place of the straw mat or is often placed under it (figs. 12.14, 12.15). As one of the two gifts (*zawadi*) that are especially intended for children, kente is also given as symbol of heritage and is often worn at Kwanzaa rituals (fig. 12.16). Kente through its association with the *mkeka* and gift giving thus becomes a symbol of the history and traditions of the African American community. This use of kente is part of the evolution of Kwanzaa as it is observed by an ever-growing number of celebrants. Not all kente incorporates the red, black, and green of African unity, but the use of kente featuring these colors on Kwanzaa altars is hardly surprising and further locates the cloth at the center of Kwanzaa iconography and belief (see chapter 10).

While Karenga does not speak directly of the role of kente in Kwanzaa observances in either his 1977 or 1997 publications—nor, for that matter, in his interview with Crenshaw students—a number of official portraits show him attired in kente. He has chosen to wear kente for one portrait (fig. 12.17) in which he displays the Kwanzaa candles and fruit on a mat. Both his interview with the students and photographs in which he wears kente suggest the association of kente with the values and principles that lie at the heart of Kwanzaa and the Afrocentric movement.

> I wear [kente] as a symbol of culture rootedness. . . . What is important is that it is an act of culture self-presentation, culture self-determination, culture grounding. It shows people that not only am I representing myself in my culture, but I'm rooted in the culture. It also means a link of my past and with our heritage. . . . The kente, even though it comes from Ghana, to me is an African product. When I put it on, I'm reminding myself to always walk in dignity, to always present myself in a way that brings honor to my people, brings honor to my culture. It reflects my self-understanding as an African man, and it also brings forth the best of what it means to be African and human in the fullest sense.
> —Dr. Maulana Karenga, Chair, Black Studies Department, California State University, Long Beach, interviewed by LaRon Young, Los Angeles, January 5, 1997

Other individuals and institutions, however, place kente squarely within the Kwanzaa celebration. A significant number of books on Kwanzaa use kente designs on the cover or throughout the text. The cover on Jessica B. Harris's *A Kwanzaa Keepsake*, for example,

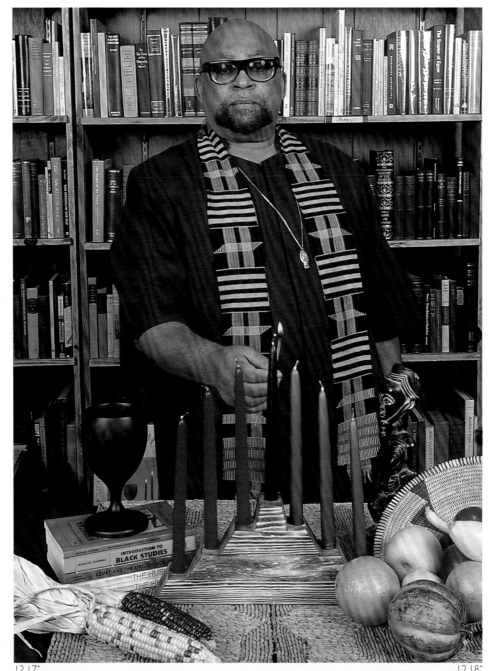

12.17 Dr. Maulana Karenga, creator of Kwanzaa, at his Kwanzaa altar. Photograph by Lester Sloan, Los Angeles, 1992/93.

12.18 A number of books on Kwanzaa use kente patterns as a framing device on their covers. Height of tallest 24 cm. Private colleciton.

12.17^

12.18^

12.20

12.21ˇ

12.19ˇ

12.19 Handmade kente Kwanzaa ornaments were readily available for sale at the Leimert Park Kwanzaa Fest held in Los Angeles. Private collection.

12.20 "Happy Kwanzaa" balloon by American Greetings Corporation available at the Leimert Park Kwanzaa Fest. Photograph by Ademunyia Akinloye, Los Angeles, December 1996.

12.21 Debra Ann Morris, "Ms. Clown," selling Kwanzaa balloons at the Leimert Park Kwanzaa Fest. Photograph by Doran H. Ross, Los Angeles, December 1996.

12.22^ 12.23^

12.22 Vendor at the Leimert Park Kwanzaa Fest. Photograph by Ademunyia Akinloye, Los Angeles, December 1996.

12.23 Even some of the youngest attendees at the Leimert Park Kwanzaa Fest were decked out in kente. Photograph by Taaji Madyun, Los Angeles, December 1996.

contains a medallion with a photograph of a family lighting Kwanzaa candles against a kente backdrop (fig. 12.18); this medallion, in turn, is superimposed on a detail of kente cloth. In the same publication Harris cites suggestions for making a mat: "Select a piece of fabric from the African Diaspora to serve as your placemat, but not just because it's pretty; know what it is, where it's from, and why you have chosen it. Ghana's kente has become a symbol of the Motherland for many of us, but there are other possibilities" (1995, 20).

In the Kwanzaa celebrations and parades that Crenshaw students observed, kente was used primarily to dress tables, frame bulletin boards, and attire participants and presenters (fig. 12.22).[4] At the Leimert Park Kwanzaa Fest and Parade in Los Angeles, student Danielle E. Smith noted many attendees wearing kente—babies in kente bonnets riding in kente-decorated strollers (fig. 12.23); young men wearing kente hats and baseball caps; and women sporting kente scarves and ensembles. Vendors offered kente products for sale (picture frames, backpacks, purses, jewelry, and Christmas and Kwanzaa ornaments; fig. 12.19), and they draped their display tables with kente.

One of the more flamboyant participants at the Leimert Park Parade was Debra Ann Morris, better known by her professional name, Ms. Clown. Attired in a kente-decorated clown costume, she established herself at the parade selling two different helium-filled Kwanzaa balloons ornamented with kente designs (fig. 12.21). One of these balloons (produced by American Greetings Corporation, Cleveland, Ohio; fig. 12.20) featured the words "Happy Kwanzaa" printed across kente patterns; the other (produced by C. Sayers & Sayers Enterprises) read "Celebrate Kwanzaa" and depicted a Kwanzaa candleholder on one side and a list of the seven principles of Kwanzaa on the other. At a later date Ms. Clown explained to the students why she chose kente for her own costume.

> I wanted to be different, I wanted to be an African clown, and to portray an African clown, I felt that I needed African patterns [like] kente. I wanted to get something that was more cultural because I've never seen any clown—especially female clowns—try to [be] an African clown. The more African I can become, the more I feel like I can stick out and make an image with a history.
> —Debra Ann Morris, "Ms. Clown," interviewed by Danielle E. Smith and Aphrodite J. Dielubanza, Los Angeles, July 1997

12.24^

12.25^

Ghanaian Patrick Adongo, a vendor at the Leimert Park event (fig. 12.24), remarked on the significance of kente during Kwanzaa and the positive role that the cloth assumes in building connections with Africa.

> Well, even though we don't celebrate Kwanzaa in Africa—I never even heard of Kwanzaa before I came here—I do identify with my brothers here. You know the celebration brings us together and also identifies our culture. So the kente plays a major role in this sense, that it takes us back to our roots, to Africa, how we were united, together.
> —Patrick Adongo, Vendor, interviewed by Danielle E. Smith, Los Angeles, December 29, 1996

Crenshaw student Havonnah Wills and her family used kente decorations on the mantelpiece and kente paper table linens for their Kwanzaa celebration of 1996. A number of guests, including several children, wore kente to the event (fig. 12.25). When given the opportunity to select a kente-related object for the exhibition, Havonnah selected a kente-decorated Kwanzaa mat.

> I chose the Kwanzaa mat and kente because my family celebrates Kwanzaa, and it relates to me and the African American community. It promotes positive change and personal growth of the individual as well as the community as a whole. I personally felt our exhibition, *Wrapped in Pride*, incorporated some of Kwanzaa's positive themes. Being that our exhibition is on kente and kente represents pride, I found Kwanzaa incorporated kente, pride, and positive themes.
> During interviews I've conducted I have found many people feel kente is a textile that represents African peoples in a positive way, and not only does Kwanzaa do that but it also is connected to kente. This to me seemed like a logical item to choose, and it also represents myself well and my belief system.
> —Havonnah Wills, Crenshaw High School Student, May 1996

Clearly, as Kwanzaa has become more mainstream, it has been promoted through products that capitalize on its symbols—Kwanzaa is unquestionably a profitable business. Despite its founder's admonitions against the commercialization of the holiday, today's celebrants can buy a wide array of Kwanzaa-related objects—paper goods, kits, cookbooks and guidebooks, special candleholders, balloons, centerpieces, and cards (fig. 12.26). With increasing numbers celebrating the holiday—in the home, through observances held in schools and churches, or at major community and citywide celebrations—countless Kwanzaa items are purchased by the African American community—many of them bearing kente-derived designs.

12.24 Patrick Adongo, vendor at the Leimert Park Kwanzaa Fest. Photograph by Danielle E. Smith, Los Angeles, December 1996.

12.25 Friends and family dressed in kente at the Kwanzaa celebration in the home of Crenshaw High School student Havonnah Wills. Photograph by Betsy D. Quick, Los Angeles, December 1996.

12.26 Kwanzaa cards are among those adorned with kente patterns. Private collection.

12.26^

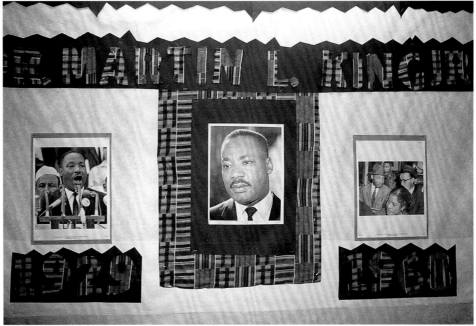

12.27^

January 15: Dr. Martin Luther King Jr.'s Birthday

Martin Luther King Jr. was assassinated in 1968 before the wearing of kente became popular, and to the best of our knowledge, he was never photographed wearing the cloth. Nevertheless, kente motifs often frame or embellish commemorative images of him (figs. 12.27, 12.28). The commemoration of Martin Luther King Jr.'s birthday typically includes activities ranging from gospel concerts, prayer breakfasts, poetry readings, school assemblies, and parades to the marketing of commemorative T-shirts, cards, and prints, all of which may incorporate kente.

Aisha Kennedy, a student at Crenshaw High School, attended the Fourth Annual Martin Luther King Jr. Memorial Concert at the University of Southern California's Bovard Auditorium. Organized by the Los Angeles chapters of Delta Sigma Theta and Alpha Kappa Alpha, the concert featured performances of gospel and contemporary music and an awards ceremony. Aisha noted that the sorority choirs wore kente stoles emblazoned with their respective Greek letters; the members of an all-male choir assembled from churches throughout the city also wore kente stoles. At another celebration held at John Adams Middle School in Santa Monica, Crenshaw High student Maureen Barrios reported that members of the Agape Choir wore kente stoles as did many other attendees. At the 1997 Martin Luther King Jr. Parade in the Crenshaw district of Los Angeles, students observed the use of kente on umbrellas, hats, and jackets (figs. 12.29, 12.30). Notably, a local Boy Scout troop marching in the parade wore kente neckerchiefs (fig. 12.31). Given the conservative nature of the Girl Scout and Boy Scout organizations, it is interesting that such a modification of the "official" uniform would be permitted. Was this the troop's usual neckerchief or a special Afrocentric addition worn specifically on the occasion of a national holiday commemorating an African American leader?

12.27 Kente letters are used to spell "Dr. Martin Luther King Jr." and to frame the Civil Rights leader's photograph at the Bethany Baptist Church. Photograph by Prunella Booker and Nadirah Keith, Newark, 1998.

12.28 Martin Luther King Jr. T-shirt worn over a kente shirt at the Martin Luther King Jr. Parade held in the Crenshaw district. Photograph by Havonnah Wills, Los Angeles, January 1997.

12.28ˇ

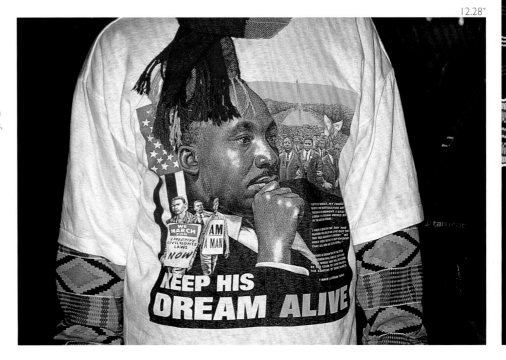

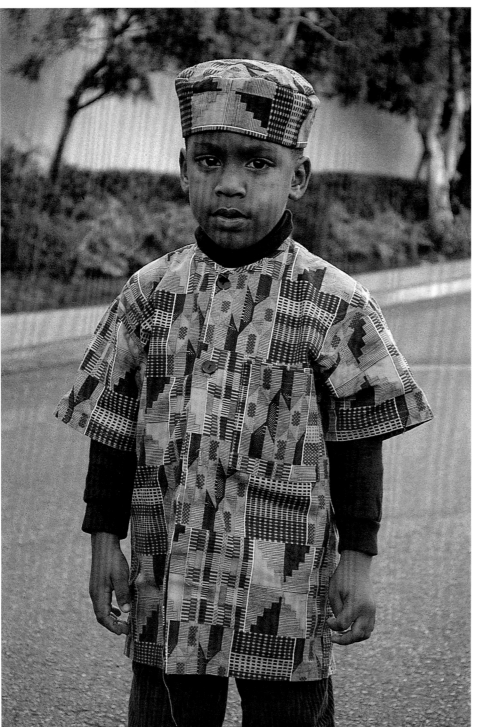

12.29⌃

12.29 Young boy attending the Martin Luther King Jr. Parade held in the Crenshaw district. Photograph by Aphrodite J. Dielubanza, Los Angeles, January 1998.

12.30 Attendee with kente umbrella at Martin Luther King Jr. Parade held in the Crenshaw district. Photograph by Havonnah Wills, Los Angeles, January 1997.

12.31 One Boy Scout troop marching in the Martin Luther King Jr. Parade held in the Crenshaw district wore kente neckerchiefs as part of their uniform. Photograph by Danielle E. Smith, Los Angeles, January 1997.

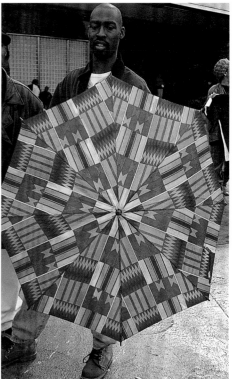

12.30⌃

12.31⌄

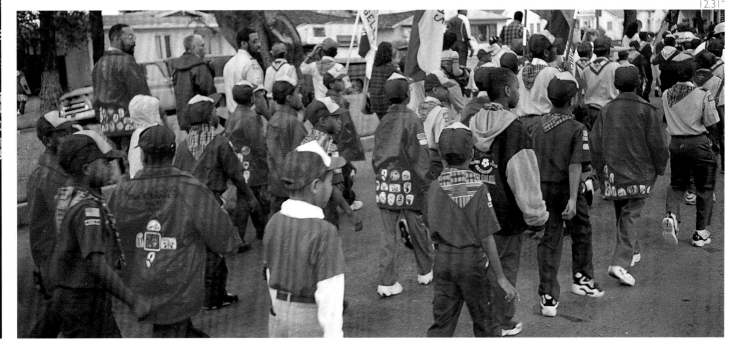

Kente in February: Celebrating Black History Month

What excites me about kente is its history and what it stands for. It reminds me of my roots and gives me a feeling of ethnic pride to be identified with the continent of Africa, our past, our rich history.
 —Sharpe James, Mayor of Newark, interviewed by Francina Radford and Janel Watts, Newark, 1997

I guess I feel differently when I dress in kente, more representative of my history—of part of my heritage—of the African ancestry of my culture. . . . I feel a stronger sense of pride. When we celebrate African American History month it kind of encourages everyone to wear some kente cloth if they possibly can.
 —Christopher Cottle, Assistant Dean of Student Life and Activities, Essex County College, interviewed by Prunella Booker, Newark, August 11, 1997

Black History Month isn't just African American, it's for Black people in general. The [kente] cloth plays an important role because it shows pride in our culture. I wish though that people didn't limit themselves to wearing African clothes only during February. I don't wear African clothes as much, but you wouldn't find me [wearing kente] only in February because it's a special month for Black people. Special is something that's only precious for a moment, and then poof, it's gone, so is their [African] attire. . . . I find it insulting in a way.
 —Terry Gullivan-Smith, Home Healthcare Nurse, interviewed by Aphrodite J. Dielubanza, Los Angeles, February 8, 1997

12.32

12.33^

12.32 Maxwell Juma, Staff Trainer, Newark Public Schools. Photograph by Erica Moore and Jasmine Hemingway, Newark, March 1977.

12.33 Willie Williams, Former Chief of Police, LAPD. Photograph by Danielle E. Smith, Los Angeles, January 1997.

12.34 Reverend Tom Choi of the Ascension/English Ministry of the Los Angeles Korean United Methodist Church wears kente during Black History Month to give "thanks for the diversity of people throughout the world." Photograph by Linda Lee, Los Angeles, February 1998.

12.35 Altar boys Aaron Fenderson and Gabriel Gomez at the First A.M.E. Church Family Day. Photograph by Clayton W. Everett, Los Angeles, June 21, 1998.

Among those interviewed by the students, the most frequently mentioned occasion for wearing kente was Black History Month. In fact, out of the ninety-six African Americans interviewed, thirty-nine cited the events of February as the primary occasions for their own use of kente. A look at the early history of the current monthlong celebration and the motifs that have come to symbolize it reveals an interesting dialogue concerning the appropriation of meaningful images in the reconstruction of history and identity.

In 1915 noted Black scholar and historian Carter G. Woodson founded the Association for the Study of Negro Life and History in Chicago. The Association advocated both scholarly and public efforts to advance awareness of the achievements of Black citizens. Eleven years later in 1926 Woodson initiated "Negro History Week" to further educate all Americans about African American culture and history and to instill a sense of pride among Black Americans. Lectures, musical performances, classroom lessons, and special exhibitions were cited as ideal means to correct White America's perceptions of Black Americans (Boateng 1995).

"Negro History Week" became "Black History Week" in 1972, and the weeklong celebration grew into Black History Month in 1976. The choice of the month of February was purposeful as it contained the birthdays of Frederick Douglass, W. E. B. Du Bois, Langston Hughes, and Abraham Lincoln, as well as the anniversaries of the founding of the NAACP and the first Pan African Congress.

The earliest Southern California observances in 1947 were sponsored by Our Authors Study Club, Inc., the Los Angeles branch of the Association for the Study of Negro Life and History (now known as the Association for the Study of Afro-American Life and History, Inc.),[5] which to this day continues to sponsor the citywide celebration. Early commemorations were marked by speeches and musical programs on the steps of City Hall,[6] and when in 1976 the city expanded the celebration to a month, the scale of the events grew accordingly.[7] Unfortunately, there is little documentation in city files of Black History Month events dating from the 1970s and 1980s. Likewise, there is no photographic record in the Bradley Archives at UCLA of Mayor Bradley wearing kente.[8]

Interestingly, while the city records fail to reveal the use of kente in association with early Black History Month celebrations, many of those interviewed by the students in Los Angeles pointed to the 1970s and 1980s as the time that they discovered kente. Quite often, these same individuals mentioned Black History Month in conjunction with their first observations of kente. Community leaders in both Los Angeles and Newark related to the students the important role that kente played in changing how African Americans thought about themselves and in instilling a sense of history, a sense of reclaimed pride and heritage—attitudinal shifts that lie at the heart of Black History Month celebrations. They associated kente with lost histories and with reconstructing an identity ripped apart by slavery and racism.

I think kente cloth did help in its own way in making African Americans come together as one group and identify themselves as a group unique in the society of so many ethnic groups.

> —Maxwell Juma, Staff Trainer, Newark Public Schools, interviewed by Janel Watts, Newark, August 6, 1997 (fig. 12.32).

For me, it's a linkage to a history that's not known and may never be known. . . . I am proud to wear and display something that identifies me by my ethnic origin and ties me to my past.

> —Willie Williams, Former Chief of Police, LAPD, interviewed by Danielle E. Smith, Los Angeles, January 10, 1997 (fig. 12.33)

I particularly wear it because it shows my Afrocentric history. It shows that our people were born in Africa originally and came here, and it makes me understand where I came from. . . . Wearing the kente cloth is really revealing a story of our history. When I wear the kente I'm establishing that pride of being African American, the pride of our heritage coming from Africa through slavery and establishing what we're establishing in America right now.

> —Captain Fateen Ziyad, Director, Community Relations, Newark Fire Department, interviewed by Tonya Johnson, Newark, 1997

Kente and Its Role in the Church during Black History Month

Regardless of their denomination, each of the eight members of the clergy interviewed by the students attested to the important role that kente plays in the church (fig. 12.35) during February. (Kente's place in the Black church will be discussed in greater detail below.) Each of the clergymen interviewed reported wearing kente during Black History Month, and several commented on the healing potential of kente and the positive messages that it conveyed to their congregations.

> I wear a robe that is dominated by kente. . . . I wear that every February. Also we decorate the church two to three times a year in kente. . . . It makes a connection with Africa, which we believe to be the Motherland. I feel that if I cannot go to Africa as often or as many times as I would like, at least I can identify with those in Africa, who I believe to be my brothers, through the apparel. I feel less European when wearing kente. I think kente cloth distinguishes me as a person who's aware that I am a young man of African descent now living in America.
> —The Reverend Richard Spaulding, Ark of Safety Faith Center, interviewed by Prunella Booker, Newark, 1997

Members of the clergy outside of the Black community also spoke of wearing kente as a gesture of support and in honor of diversity. Reverend Tom Choi (fig. 12.34) has commented:

> I wear a kente robe during Black History Month as a means of solidarity and giving thanks for the diversity of people throughout the world.
> —Reverend Tom Choi, Ascension/English Ministry of the Los Angeles Korean United Methodist Church, service of February 22, 1998

12.34ˆ 12.35ˇ

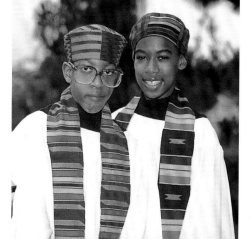

Kente's role in the church is not confined to Black History Month. It appears throughout the year on choir and ministerial robes and on the vestments of choir boys and church ushers; as drapes for the pulpit and altar; and as Bible covers.

Black History Month at the Shopping Mall

Increasingly malls feature community events—health expos, children's activities, museum satellite programs, and the like. Many of these shopping centers in Los Angeles, and many other cities as well, present Black History Month expositions. In 1997 the Plaza Pasadena's Fifteenth Annual Artists' Salute to Black History Month featured kente as the principal decorative motif on its promotional materials—canvas tote bags, baseball caps, and name badges. Dozens of booths at the event used printed kente to drape tables or as a backdrop to showcase merchandise; and they offered kente in myriad forms for sale. Backpacks, children's clothes, and men's and women's attire made of commercially printed kente are typically available at such events (figs. 12.36, 12.37). Kente graduation stoles (fig. 12.39), handwoven kente, and objects incorporating cut pieces of handwoven cloth also abounded (fig. 12.38).

Interestingly, a year after the students did their research, kente seemed to have been eclipsed by Bamana *bogolanfini* (mud cloth) at least at one Los Angeles mall. The weekend of February 13–15, 1998, in celebration of Black History Month, the Crenshaw Baldwin Hills Plaza in Los Angeles played host to the Pan African Film Festival and Artists' Expo. The event featured fashion shows, choral performances, and dozens of booths selling everything from handmade quilts to artists' prints to kente-covered shoes to home

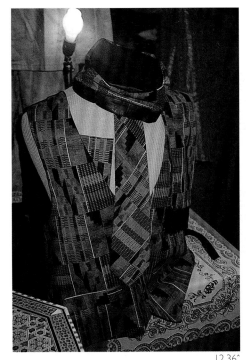
12.36ˆ

12.37ˆ

12.38ˆ 12.39ˇ

12.36 Machine-printed kente accessories for sale during the Fifteenth Annual Artists' Salute to Black History Month, Plaza Pasadena. Photograph by Maureen Barrios, Pasadena, February 1997.

12.37 Kente ties for sale at the Fox Hills Mall. Photograph by Barbara Belle Sloan, Culver City, California, February 1992.

12.38 Pieced kente robe by Obinne, The African Cultural Exchange, for sale at the Fifteenth Annual Artists' Salute to Black History Month, Plaza Pasadena. Photograph by Maritza Mejia, Pasadena, February 1997.

12.39 Motherland Imports sells kente stoles targeted for membership organizations, churches, and graduation at seasonal mall expos and commencement ceremonies, as well as through mail-order catalogs. Photograph by Doran H. Ross, Crenshaw Baldwin Hills Plaza, Los Angeles, February 1998.

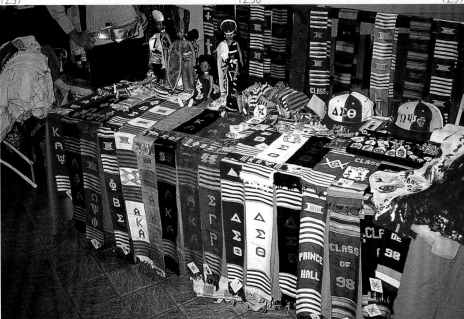

accessories and furnishings (figs. 12.40, 12.41). The most au courant textile, however, was clearly *bogolanfini*, which could be found adorning infants' rompers, men's and women's clothing, and many other items. Kente was absent from the fashion show, which featured Western- and African-style fashions in mud cloth and an exquisite variety of African printed cottons. In previous years kente had played a far more prominent role in this event.

Dolls dressed in kente, however, remained very popular both in toy stores and special doll booths, despite the apparent gains of mud cloth. Commercially made dolls with printed kente clothes and the word *kente* incorporated in their names—Color Me Kente Kenya by Tyco Industries, Inc. (fig. 12.42), Ghanian [*sic*] Barbie by Mattel (fig. 12.44), Asha Doll by Mattel (fig. 12.45), and stuffed animals, such as Akan, The Royal Bear (fig. 12.43)—were widely available in toy stores. Ghanian Barbie is but one of Barbie's many "ethnic" guises, created to broaden the doll's appeal to an increasingly diverse population. With so many girls interested in dolls wearing the latest fashions, kente in this instance represents an interesting meshing of the traditional and the modern. Color Me Kente Kenya invites the child to color his or her own kente design (the choice of the name "Kenya" is, to say the least, unusual, given kente's West African origins, and it probably represents a deliberate appropriation aimed at broadening the African connection).

12.40^ 12.43^

12.41^

12.42^

12.44^

12.45^

12.40 Upholstered chair in woven kente at African Marketplace Store, Crenshaw Baldwin Hills Plaza. On consignment from The African Cultural Exchange. Photograph by Doran H. Ross, Los Angeles, February 1998.

12.41 Children's chair upholstered in machine-printed kente for sale at Crenshaw Baldwin Hills Plaza during Black History Month. Photograph by Sadikifu Shabazz, Los Angeles, February 1997.

12.42 "Color Me Kente Kenya, Growing Up Proud" is a trademark owned by Mattel, Inc. Plastic and fabric (marking pens included). Height 38.5 cm. Private collection. ©1998 Mattel, Inc. All rights reserved. Used with permission.

12.43 "Akan, The Royal Bear" and companion book prominently feature kente. Bear: cloth and stuffing; book: paper. Height of bear 51 cm. Private collection. Book written by Deborah Easton, illustrated by Vince Gilliam. ©1994 Identity Toys, Inc.

12.44 "Ghanian [*sic*] Barbie" is a trademark owned by Mattel, Inc. Plastic and fabric. Height 34.5 cm. Private collection. ©1998 Mattel, Inc. All rights reserved. Used with permission.

12.45 "Asha" doll is a trademark owned by Mattel, Inc. This doll wears a kente-inspired dress. Plastic and fabric. Height 33 cm. Private collection. ©1998 Mattel, Inc. All rights reserved. Used with permission.

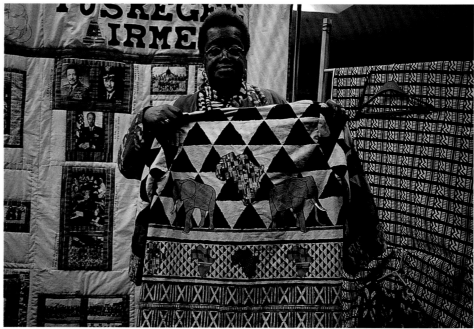

12.46^

12.46 Handmade doll and quilt by Dorothy Taylor. Both incorporate machine-printed kente. Displayed at the Fifteenth Annual Artists' Salute to Black History Month, Plaza Pasadena. Photograph by Carroll E. Houston, Pasadena, February 1997. Cloth and stuffing. Height 53.5 cm. Private collection.

12.47 Dorothy Taylor shown in front of her quilt honoring the Tuskegee Airmen at the Fifteenth Annual Artists' Salute to Black History Month held at Plaza Pasadena. Taylor frequently uses machine-printed kente on her quilts. Photograph by Byron Williams, Pasadena, February 1997. Private collection.

12.48 Artist and dollmaker Mari Morris shown with her dolls at the Pan African Film Festival and Artists' Expo held at the Crenshaw Baldwin Hills Plaza to celebrate Black History Month. Photograph by Doran H. Ross, Los Angeles, February 1998.

12.47^

During the course of their research the students had discovered that a selection of the handmade dolls offered at fairs and vendor expos in February wore kente dresses (fig. 12.46) and could be put to sleep on kente quilts. Los Angeles quiltmaker Dorothy Taylor told Crenshaw High students Aphrodite J. Dielubanza, Danielle E. Smith, and Taaji Madyun that she uses commercially printed kente in her quilts (fig. 12.47) and on her dolls (see fig. 12.46) because of its "bright celebratory colors" (July 1997). Aphrodite also spoke with Los Angeles doll maker Mari Morris, whose Tickles Collection regularly features dolls wearing kente (fig. 12.48):

> I use [kente] as part of their dress. . . . I might put it on their hats, I might use it as a scarf. . . . I don't use it on every doll, just now and then. Mostly adults buy my dolls . . . and there seems to be an automatic attraction to [those with kente].
> —Mari Morris, Doll Maker, interviewed by Aphrodite J. Dielubanza, Los Angeles, March 30, 1998, and by Carroll E. Houston, Los Angeles, January 4, 1997

Morris's first introduction to kente came in 1972, as a student of textiles at the University of California at Berkeley. Intrigued with its color and patterning, she continued to study the cloth and later, in 1985, traveled to Kumase to study kente weaving for three months. Morris's interest in the patterning potential of kente led her to weave kente and to incorporate it in her work as a fiber artist. In her interview with Aphrodite J. Dielubanza, she described a pair of shoes she created for a New York exhibition, "I wove a kente fabric and made it into a handwoven pair of shoes. After I put them together, I handcobbled really tiny nails around the shoes and called them 'wear apart' shoes."

Today Morris wears touches of kente in her own dress, embellishes her home with full cloths, and uses kente-patterned cloth selectively on her dolls. Now focusing primarily on doll making, she employs exquisite combinations of texture and color to evoke a certain expressiveness and distinct personality in each of her characters.

When invited to select a kente-related object for the exhibition, three Crenshaw students chose dolls dressed in kente to represent what the cloth meant to them:

> Since childhood, I have always loved to play with and display dolls. My favorites were Barbie dolls. I had White, African American, Asian, and Hawaiian Barbies. I have never had an African doll, so I thought that the kente dolls would be a perfect addition to my collection. Each doll that I own has a special meaning. The kente doll represents the strength and wisdom of the African culture.
> —Monique Lane, Crenshaw High School Student, Los Angeles (fig. 12.49)

> I chose these life-size Raggedy Ann and Andy kente dolls to represent that everyone is a kid at heart . . . the perfect item to represent everyone's identity and pride.
> —Cesar Bravo, Crenshaw High School Student, Los Angeles (fig. 12.51)

> Dolls are used to capture the characteristics of individuals and groups. The dolls in my own collection represent various areas, different ethnic backgrounds, and sizes. The African American dolls I owned were often dressed in Americanized apparel but were infrequently dressed in cultural apparel that represented who I am. This purchase will close the gap between who I am and how I am perceived by others by representing my culture.
> —Aisha Kennedy, Crenshaw High School Student, Los Angeles (fig. 12.50)

12.48ˇ

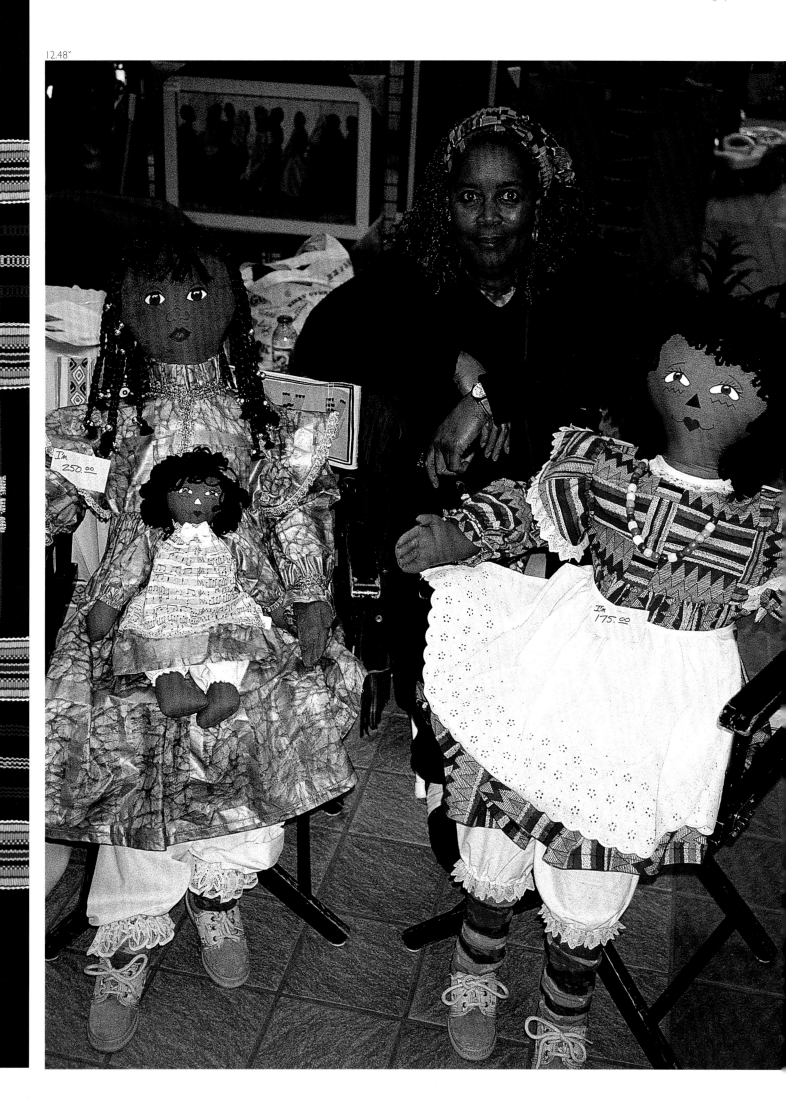

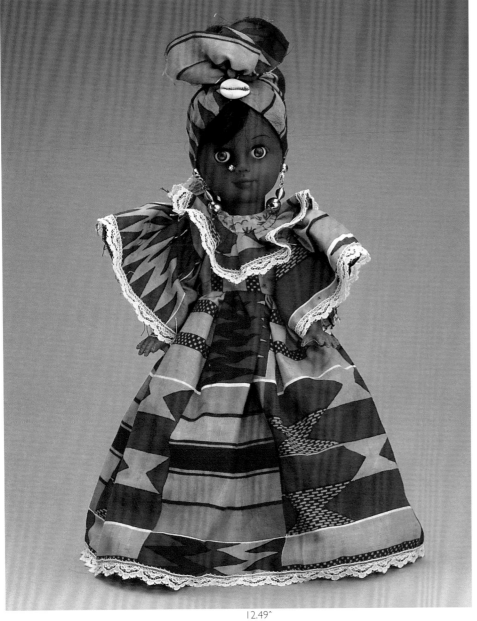

12.49ˆ

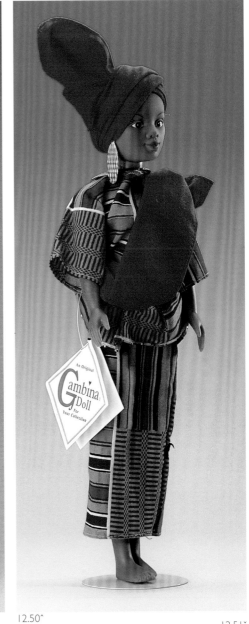

12.50ˆ

12.51ˇ

12.49 Crenshaw High School student Monique Lane purchased a doll dressed in kente for the *Wrapped in Pride* exhibition. Plastic and fabric. Height 36 cm. Private collection.

12.50 Crenshaw High School student Aisha Kennedy purchased a "Gambina Doll," dressed in commercially printed kente fabric for the *Wrapped in Pride* exhibition. Synthetic cloth and other materials. Height 37 cm. Private collection.

12.51 Crenshaw High School student Cesar Bravo purchased near life-size Raggedy Ann and Andy dolls for the *Wrapped in Pride* exhibition. The dolls were purchased from a street vendor named Walter on Central Avenue in Los Angeles. Printed kente cloth and stuffing. Height 115 cm. Private collection.

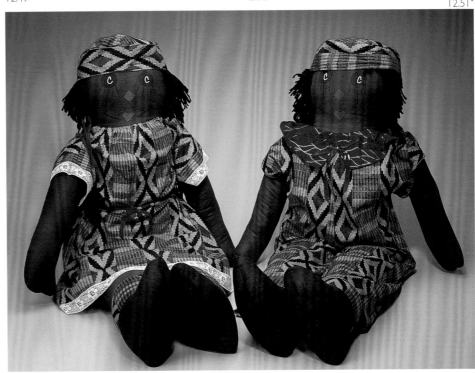

Kente as a Valentine

Valentine's Day, February 14th, obviously falls in the middle of Black History Month. In 1998 the Crenshaw Baldwin Hills Plaza Artists' Expo coincided with Valentine's Day. We wondered if kente, or mud cloth for that matter, would appear on valentine cards or be used in some way to convey messages of love. Might it be possible to wrap your sweetheart in kente? As might be expected, floating on high in Michael's Cards and Gifts store were bunches of helium-filled, heart-shaped valentine balloons featuring kente patterns (fig. 12.52). "The Language of Love Beats in Africa: Happy Valentine's Day" was written on one side of the balloon, and emblazoned on the other were phrases of love in six African languages—Swahili, Zulu, Xhosa, Sotho, Yoruba, and Twi. Spanning the continent, these expressions of love were set against a backdrop of brilliant kente designs (seemingly an interpretation of the printed versions of the Oyokoman design).

Produced by Pioneer Balloon, the Heritage Collection valentine balloons, described above, were the only mass-produced kente valentine items spotted for sale at the Crenshaw mall.[9] The card shop selling the balloons also offered an Afrocentric line of valentine cards, but none of them featured kente or any other African textile. A boutique line of Afrocentric cards and prints by Pamela Robinson was available for sale in that artist's booth. Among her general greeting, graduation, and Kwanzaa cards, one valentine portrayed a couple simply silhouetted in kente-inspired patterns (photographed roller-printed versions of the Oyokoman pattern; fig. 12.53).

Of note, Pioneer Balloon makes ten Afrocentric balloons in its Heritage Collection. The designs on five of these appear to be drawn quite directly from kente patterns,[10] while four have more generic "African" patterns.[11] In the former, a band of kente typically encircles the appropriate phrase; on some, however, individuals are depicted with patterned strips around their necks, perhaps a reference to kente stoles. One unusual valentine balloon in the collection seems to incorporate the relatively somber coloration of mud cloth patterns in a palette of pinks or purples.[12] The traditional mud cloth tones of black and brown were clearly deemed ill suited to America's traditionally pink-and-red celebration. The promotional copy for this line of products asserts that "the dramatic designs use authentic artwork to celebrate life's special occasions in an exciting new way. Created for the African American marketplace, with 32 million consumers, the collection's unique look has multicultural appeal."[13] African designs, and here particularly kente, not only have cachet for the African American market but are also promoted as having potential to cut across color lines with "multicultural appeal."

12.52 Kente patterns and messages of love in several African languages adorned Valentine's Day balloons for sale at Michael's Cards and Gifts, Crenshaw Baldwin Hills Plaza, during Black History Month. Photograph by Doran H. Ross, Los Angeles, February 14, 1998.

12.53 A Valentine's Day card by artist Pamela Robinson featuring a couple in kente attire. The design was produced by photographing cut pieces of roller-printed kente. The card was available for sale at the Pan African Film Festival and Artists' Expo held at the Crenshaw Baldwin Hills Plaza to celebrate Black History Month, 1998. Paper. Height 21.6 cm. Private collection.

12.52ˆ

12.53ˆ

Kente Goes to School

Kente Colors Bright and Bold:
Red, Yellow, Blue—
Black and Gold.
Emerald Kente for Harvest Time.
Indigo Blue for African Skies.
Yellow Kente for Pineapple Sweet.
—Debbi Chocolate, *Kente Colors* (1996)

Any discussion of the role of kente during Black History Month must include school celebrations. In Los Angeles "Negro History Week" was first instituted formally by the Los Angeles Board of Education in 1951,[14] and in 1981 it was expanded to a month.[15] Accompanying the Board's actions were recommendations to teachers on appropriate and educationally sound activities for use in celebrating Black History Month.[16] None of these specifically mention kente cloth; they do require, however, that lessons be taught concerning the artistic traditions of the peoples of Africa, as well as folklore, Black life and history, African politics and geography, and contemporary issues.

Today the Los Angeles Unified School District requires instruction for Black History Month. Kente is often incorporated as an important symbolic or decorative motif—if not as a topic of study—in teachers' curricula for February. In fact, kente patterns surface everywhere—in school assemblies, dramatic performances, art activities, and classroom decorations. Young singers wear kente, students perform African dances costumed in the distinctive cloth (fig. 12.54), and teachers trim Black History Month bulletin boards with printed (fig. 12.55) and hand-painted kente strips (fig. 12.56). Kente motifs adorn invitations, Web sites related to Black History Month feature kente designs and lessons on kente, and units of study and literature illustrated with kente are frequently at the center of classroom discussions (fig. 12.57). Many schools, especially those with significant African American populations, also schedule "African Heritage Days" when students and faculty are encouraged to wear African dress. During Black History Month of 1998, some teachers and students chose to wear kente at 92nd Street School, an elementary school in South Central Los Angeles (fig. 12.58), and at Crenshaw High School.

Today, the student population at the 92nd Street School is 80% Latino and 20% African American, almost the reverse of what it was twenty years ago. The Black History Month assembly held in 1998 at the 92nd Street School was, nonetheless, ablaze with kente. The performance space was covered with student art depicting kente, and five out of six classes incorporated the cloth in their presentations. Whether performing Igbo dances or singing "This Little Light of Mine," students appeared in machine-printed or paper kente—sashes, headbands, and ties could all be observed. In Gwendalyn Newman's kindergarten class students wore kente headbands as they performed Debbi Chocolate's poem *Kente Colors* (figs. 12.59–12.61). Chocolate's highly acclaimed children's book (published in 1996) has been instrumental in shaping the perception of kente's color symbolism. While a literal reading of the poem might lead to some misunderstanding of kente's uses in Ghana, its beauty lies in its affective treatment of color and contextual imagery. Fanciful interpretations aside (see Ross, chapter 8), this poem lends itself to oral recitations. As Gwendalyn Newman has pointed out:

One of the skills that we work on in kindergarten is learning about the colors. . . . In Debbi Chocolate's book, kente helps you see the world around you . . . purple sky or it might be pink, or gray. . . . The story opened up the students' awareness of their environment . . . and there was a kind of magic that the students saw in kente and in the colors of their world. Because all of my students—African American and Latino— discovered the book together and began to do some comparisons across cultures, they started to feel like a family in the classroom. The colors of kente helped the students become more sensitive to one another, they started paying closer attention to each other and noticing the colors they were wearing . . . then they started holding hands. . . . We can go back and trace the history of kente and know that it's been a part of our heritage for centuries. . . . Each piece of kente has a story—a tale to tell—and that's the secret I wanted my students to discover. As we learned more about kente's symbolism, the students came to understand the stories the cloths were telling and the magic that surrounds the tradition. A magical story.

—Gwendalyn V. Newman, Kindergarten Teacher, 92nd Street School, interviewed by
Aphrodite J. Dielubanza, Los Angeles, May 8, 1998

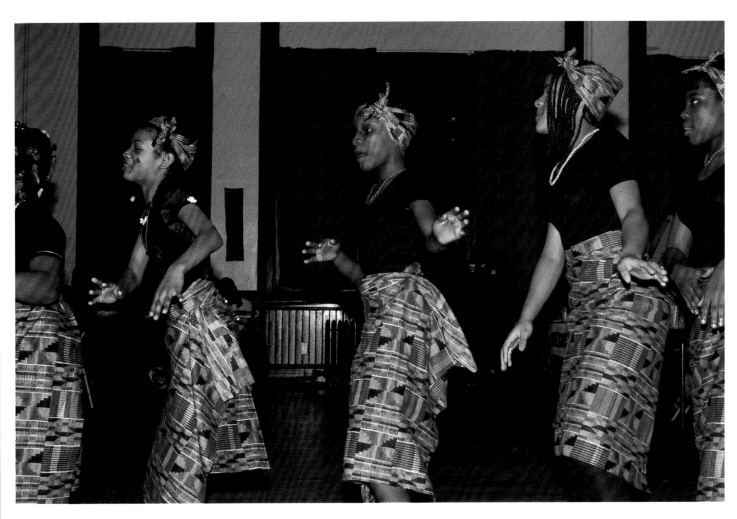

During the assembly many children could be seen poring over Chocolate's book and reading it aloud between the various class performances (fig. 12.62).

Children in other classrooms and the After School Program helped to make the murals and kente-inspired works displayed in the auditorium and school offices (fig. 12.63). A border of kente patterns framed the backdrop displayed on the stage, which read: "*Africa's Gifts to the World: Art, Music, Dance and Fashion*"(see fig. 12.60), created by students in the After School Program led by art teacher John Estrada. Estrada introduced student artists in a number of grades to African textiles, especially kente cloth, and then invited them to create a design block based on kente aesthetics. Each student was to choose a limited color palette that was personally significant, to create a design using these colors, and to paint it on paper. Estrada had hoped that as a next step the students would be able to produce color photocopies of their images and use the reproductions to form a multiple-strip kente cloth. The students' initial efforts were stunningly beautiful (fig. 12.64a–j), and their comments take the viewer into the dreams and imaginations of five- through ten-year-olds. Iris Resendez, a second grader, created a design with "amarillo por el oro" (yellow for gold), "rojo por el amor" (red for love), and "cafe por el todo" (brown for everything). "Chb," a first grader, used "red for fire, blue for sky, black for birds, yellow for sun, and white for clouds." Luis Resendez, a kindergartner, selected "rojo por felisido [*sic*]" (red for happiness), "verde por el pasto" (green for pasture), and "azul por el mar" (blue for the ocean). Cesar Garcia, a second grader, chose "negro por la noche" (black for the night), "amarillo por el sol y oro" (yellow for the sun and gold), and "azul por el cielo" (blue for the sky). Charmaine Jackson, a first grader, saw color in this way: "green is money and yellow stands for the flowers and sun." Frank Chavez, a fifth grader, did not define his colors, and Lucille Thomas, a fifth grader, imagined "red for flowers, black for mystery and night, and orange for the [black]board monitor" (a much-coveted position).

Speaking to the assembled guests at the performance, Estrada referred to kente as a metaphor for strength and solidarity, repeating the adage that kente is "a cloth that cannot tear easily" (see Ross, chapter 1). He urged students to stand strong, like the cloth, which would not tear in the face of adversity. For the many Latino students at 92nd Street School the use of kente served primarily as an introduction to the study of Africa, whereas for African American students, some of whom were already familiar with the cloth, its incorporation into the celebration signaled an affirmation of their history and culture.

92nd Street School Celebrates Black History Month

Black History Month is celebrated in schools throughout the nation during the month of February. Classroom studies are devoted to the accomplishments of important African Americans, and a variety of Afrocentric performing arts events are presented in schoolwide assemblies. Kente cloth figures prominently in much of the curriculum and in many of the celebrations. This was certainly the case at the 92nd Street Elementary School in South Central Los Angeles in 1998. Student performers danced wearing kente sashes and headbands; student artists created kente designs in individual works and class murals; teachers framed bulletin boards with kente borders; and precocious kindergartners recited Debbi Chocolate's poem celebrating the colors of kente. For many of the predominantly Latino students and families at the school, kente clearly became an icon for Africa.

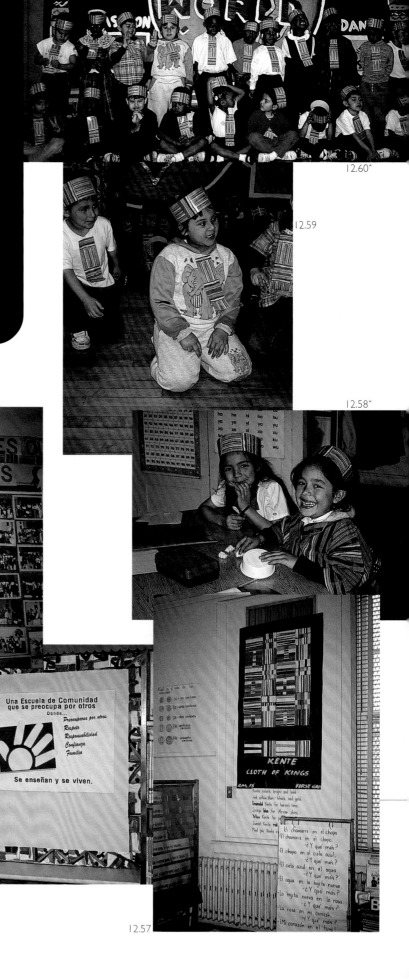

12.60^

12.59

12.58^

12.55^

12.56^

12.57

12.61^

12.62^

12.63^

12.55 A border of paper kente frames a bulletin board decorated with pictures of students in the main office of 92nd Street School during Black History Month. Photograph by Doran H. Ross, Los Angeles, February 1998.

12.56 Hand-painted kente borders created by student artists frame a Spanish-language bulletin board in the library of 92nd Street School. Photograph by Betsy D. Quick, Los Angeles, February 1998.

12.57 First-grade students at 92nd Street School collaborated to paint *Kente, Cloth of Kings* in conjunction with their reading of Debbi Chocolate's *Kente Colors*. Photograph by Betsy D. Quick, Los Angeles, February 1998.

12.58 First-grade students Sonia Martinez and Martha Perez in Claudia Hernandez's class at 92nd Street School wore paper headbands decorated with kente patterns and kente attire on the day of the Black History Month assembly. Photograph by Betsy D. Quick, Los Angeles, February 1998.

12.59 Students Francisco Salas (left), Ruben Tovar (back center), and Katherine Figueroa (right) rehearsing their choral reading of Debbi Chocolate's *Kente Colors* for 92nd Street School's Black History Month Assembly. Photograph by Doran H. Ross, Los Angeles, February 1998.

12.60 Students participating in the After School Program at 92nd Street School created the mural *Africa's Gifts to the World* under the direction of art teacher John Estrada. The mural framed the stage at the Black History Month assembly. Gwendalyn V. Newman's kindergarten class, wearing paper kente headbands and ties, is shown performing in front of the mural. Photograph by Doran H. Ross, Los Angeles, February 1998.

12.61 Left to right: Students Breana Thomas, Alisha Clinton, Shahday Brown, Jason Leiva, and Charnell Pogues in Gwendalyn V. Newman's kindergarten class at 92nd Street School wore paper kente headbands and ties for their recitation of Debbi Chocolate's *Kente Colors*. Photograph by Gwendalyn V. Newman, Los Angeles, February 1998.

12.62 The students in Gwendalyn V. Newman's kindergarten class crowded around the book *Kente Colors* during breaks between performances at 92nd Street School's Black History Month assembly. From lower left to right: Wilbert Martin, Adolfo Gonzalez, Alisha Clinton, and Shahday Brown. Photograph by Betsy D. Quick, Los Angeles, February 1998.

12.63 One of several bulletin boards in 92nd Street School's main office using kente patterns and excerpts from Debbi Chocolate's *Kente Colors* to celebrate Black History Month. Photograph by Doran H. Ross, Los Angeles, February 1998.

12.64a

Kente Interpretations

Student artists participating in the After School Program at 92nd Street School painted kente patterns on paper during Black History Month in 1998. This project was organized by art teacher John Estrada who had hoped to produce color photocopies of the paintings and to join them together to create a kente "cloth." Photographs by Don Cole.

12.64b

12.64c

12.64d

12.64e

12.64f

12.64g

12.64h

12.64i

12.64j

A number of recent editorials have railed against Black History Month celebrations asserting that they serve no purpose and actually harm efforts to mainstream serious discussions and curricular offerings relating to Black history throughout the year. Viewed in this way, the use of kente observed at school celebrations (aside from graduation) might be called into question. It is important to remember, however, that Carter Woodson had sought to integrate African American history seamlessly into the general curriculum and that he had hoped that eventually a special time would not be needed to make the public more aware of Africa's history and the contributions of African Americans to society (Peace 1996, A21). Until such a time, programs such as the one observed at 92nd Street School (and many other schools), combined with units of study in the classroom, directly address students' lack of knowledge in a comprehensive and systematic manner. A focus on kente broadens the sometimes predictable discussions of Black History to include the expressive arts of African cultures. Using kente as headbands and sashes, albeit made of paper, to proclaim a celebration and to adorn participants is, in fact, in keeping with the spirit of the Ghanaian tradition. It cannot be disputed that kente has become ubiquitous; its connections with Africa, instantaneous; and its absorption into the African American landscape, lasting.

12.65 Crenshaw High School students Taaji Madyun (left), LaRon Young (center), and Monesha Lacy (right) wore kente stoles at their graduation ceremony. Photograph by Havonnah Wills, Los Angeles, June 1997.

12.66 Students and administrators alike wore kente stoles to the commencement ceremonies held at Chad Science Academy. Left to right: Brother Baldwin Cappell, Brother Leon Moore, and Lakeya Shipley. Photograph by Larry Johnson, Newark, 1997.

12.67 Students and administrators wear kente at the Chad School graduation. Left to right: Sister Gwen Samuels, Atiya Puryear, Amelia Herbert, and Brother Leon Moore. Photograph by Larry Johnson, Newark, 1997.

12.68 The entire graduating class at Horace Mann High School, Gary, Indiana, wore matching kente stoles ordered from Motherland Imports. Photograph by Panoramic Photography, Inc., 1997.

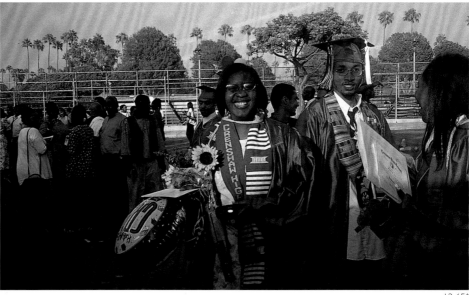

12.65^

12.66^

Graduation: Kente, Pomp, and Circumstance

One important formal occasion when kente is increasingly worn by African American students is commencement (figs. 12.65–12.67). As Ross has already established (see chapter 10), the use of kente to mark the achievement of graduation is a long-standing tradition in Ghana. During the 1970s the use of kente stoles at ceremonies awarding honorary doctorates to African American leaders in both Ghana and the United States made a particularly powerful political statement. W. E. B. Du Bois, Adam Clayton Powell, Thurgood Marshall, and Maya Angelou all declared their African roots by wearing kente at academic ceremonies.

The comments of both Ghanaians and Americans demonstrate the potency of kente as a symbol of achievement at graduation ceremonies. As Edmund Phillips, originally from Accra, Ghana, explained to students in Newark:

> In Ghana when we finish middle school at our graduation party, we all put on kente. Some . . . parents will . . . rent it, and some will buy it for you so you can own one. I was lucky [my parents] bought me one. . . . I don't have my kente here because it's precious to me so I have to keep it back home. You don't have functions here that ask us to wear the kente. But back home we have functions that we have kente for. I'm keeping it for my sons. I will pass it to my sons.
> —Edmund Phillips, Staff Member, The Newark Museum, interviewed by Francina Radford and Georgina McLeod, Newark, 1997

In Newark, Christopher Cottle, Linwood Oglesby, and Teresa Smith shared their reflections on graduation with students Prunella Booker, Tracy Shakur, and Janel Watts.

12.67˘

Every year we identify all our graduating students, and any student who is graduating can purchase [a stole]. We chose kente because of the fact that it's from Ghana; it was formal attire, and it also represents royalty. Therefore we felt it would be appropriate for our students to have something of that nature, particularly for their special day of graduation, because they are at that point in time very special people, and our royalty, and those whom we are commemorating for their major accomplishment. We thought kente would reflect that purpose and that feeling.

 —Christopher Cottle, Assistant Dean of Student Life and Activities, Essex County College, interviewed by Prunella Booker, Newark, August 11, 1997

Recently we had a graduation ceremony for the residents of Harmony House. We ordered gowns that had kente cloth around the collar as well as the cap. We chose that kind of sacred cloth because we felt it was culturally significant and had additional meaning to the residents. That was the first time we have worn kente. It was so beautiful that we would do it again. They seemed to sense a certain pride in wearing the cloth. The reason it was chosen was to signify the connection between Africa and our people here in this country.

 —Linwood Oglesby, Administrator, Harmony House, New Community Corporation, interviewed by Tracy Shakur, Newark, 1997

I first saw kente at another graduation that I attended, and I thought it was very beautiful to see everyone wearing it. I saw other ethnic groups wearing it also, and I said, "Oh that's pretty nice that they didn't mind wearing it." Some people might think, "No I'm not wearing that because I'm not African American. I'm not African." But they didn't seem to feel that way. They went ahead and put it on, and I thought that was pretty nice. Actually it's a compliment that they would want to wear that, to be associated with it.

 —Teresa Smith, Administrator, Essex County College, interviewed by Janel Watts, Newark, July 17, 1997

12.68˘

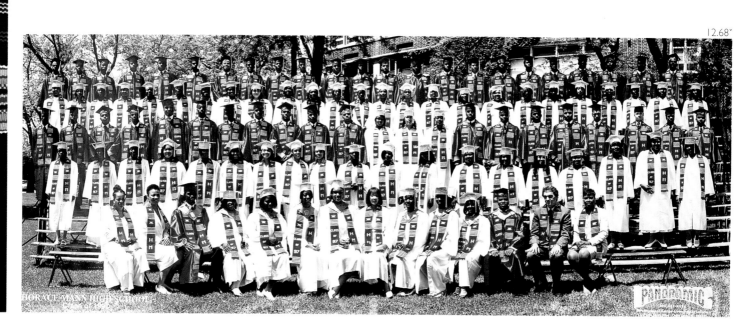

In Los Angeles Twyla Lang-Gordon, whose company, Motherland Imports, supplies kente stoles to high schools and universities throughout the United States (fig. 12.68), also spoke of how important the wearing of kente is to African American students:

> I think that now a lot of students look forward to wearing their kente at graduation. A lot of the stores that order from me say "These students, they feel that they cannot graduate without kente. They just cannot walk across the stage without a piece of kente on them."
> —Twyla Lang-Gordon, Owner of Motherland Imports, interviewed by Aphrodite J. Dielubanza, Danielle E. Smith, and Taaji Madyun, Los Angeles, July 1997

Kente stoles have become more and more commonplace at university graduations since the late 1970s. While initially worn only by African American graduates, over the last ten years they have been included in more diverse commencement ceremonies, as well as in other contexts: younger and younger students (even kindergartners) are wearing kente stoles at graduations as are students of diverse ethnicities (fig. 12.69). Private organizations, such as Panhellenic groups and professional academic organizations, also use kente to signify membership. The styling of kente stoles worn by graduates and by members of organizations today, however, is significantly different from the traditional kente colors and patterns worn in the 1970s. Current styles incorporate the symbols, colors, and names of schools or groups—a popular tradition that stands in marked contrast to the graduation stoles of the 1970s, which lacked the individuation preferred today. Such expanded use and interpretation of kente signal its increased acceptance by mainstream society and at the same time reflect notions of individualism so pervasive in the United States.

Speaking with Crenshaw students Aphrodite J. Dielubenza, Danielle E. Smith, and Taaji Madyun in July of 1997, Twyla Lang-Gordon indicated that her marketing of kente stoles is broad based—including elementary schools, middle schools, and high schools, as well as universities (see figs. 12.71–12.77). Her expected sales for 1998 are seven thousand stoles. She has also diversified her market to include sales to private organizations and non-African American student bodies. Groups may purchase strips with their graduation dates, organization names, and unique colors and symbols (fig. 12.70). Lang-Gordon says that in 1988 her business became the first in the United States to market kente to sororities, fraternities, and other private organizations:

> I market right now to the nine predominantly Black sororities and fraternities, to both the college student and alumni. I also do them for the NAACP, churches, Jack and Jill of America, NSEE, National Medical Society, National Bar Association, and Masonic groups. I think kente gives [these groups] a means of wearing something that's of their heritage and culture. At the same time it's a form of unity. For instance, the sorority will wear them on special days like founder's day, or they'll wear them to initiation or if there's a sorority choir, they'll wear it. It's like a form of identifying with your heritage and yet identifying with the sorority or the fraternity at the same time or with whatever group that you're in. It's kind of like a unifier, so everybody is not walking around with exactly the same thing, but you have something on that's the same, like a badge I guess.
> —Twyla Lang-Gordon, Owner of Motherland Imports, interviewed by Aphrodite J. Dielubanza, Danielle E. Smith, and Taaji Madyun, Los Angeles, July 1997

Lang-Gordon's clientele has diversified to the extent that she now offers a line of kente in Spanish, *Clase de 1998*, featuring the colors of various Latin American nations (fig. 12.71). She also cites a request from a university in Vermont for kente incorporating Chinese characters. She ventures this explanation for kente's increasing popularity:

> We're now getting a lot of requests from other Greek organizations and organizations that are not a part of the nine [predominantly Black sororities and fraternities] to make scarves [stoles] for them. We're getting people saying "Why aren't you doing it for us or how can we get one?" There's a small demand in the non-Black community also. A lot of Hispanics are starting to ask if they can get their colors put on kente. . . . I don't think it has any specific cultural meaning to them, but they do like their flag color depending on what country they're from. We've gotten requests for Native American kente scarves with their colors and designs on them. Mexican people wanted maybe a pyramid on it, and many of the Asians at West L.A. College are getting the traditional African kente.
> —Twyla Lang-Gordon, Owner of Motherland Imports, interviewed by Aphrodite J. Dielubanza, Danielle E. Smith, and Taaji Madyun, July 1997

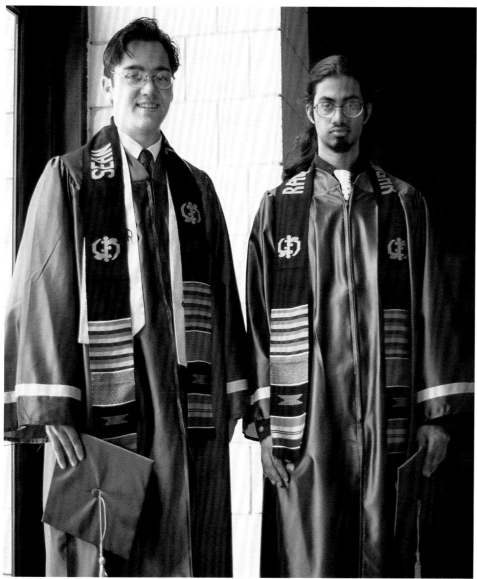

12.69^

12.69 Sean Campbell and Rakesh Changur, graduates of Essex County College. Photograph by Jeffrey Lee, Newark, 1997.

12.70 Kente stoles marketed by Motherland Imports are available for sale at vendor fairs and marketplaces throughout the year. Photograph by Danielle E. Smith, 1997.

12.70˘

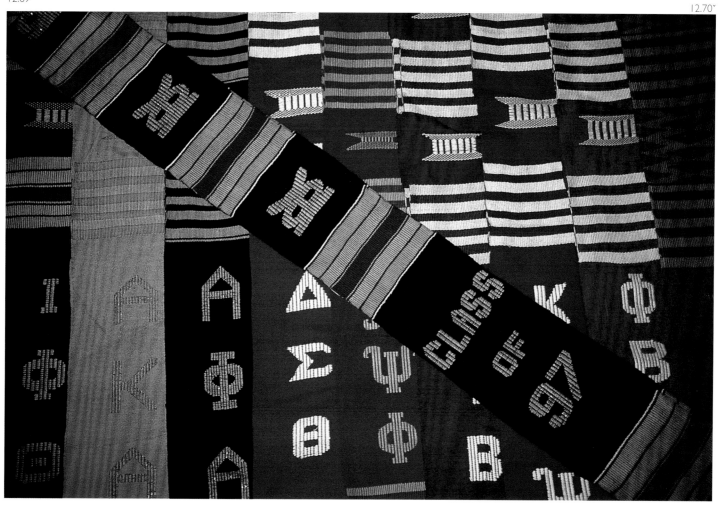

Twyla Lang-Gordon: Marketing Kente for Graduation

Today kente stoles adorn graduates of diverse ethnicities at all educational levels. African American, Asian, Caucasian, and Latino students from kindergarten to graduate school choose to wear the cloth at their commencements. Twyla Lang-Gordon, owner of Motherland Imports, has captured a significant segment of that market with her line of Ghanaian kente stoles, custom designed to meet demands of the 1990s. Gordon reports that her company, which recorded sales of over seven thousand stoles in 1997, was the first to market kente to African American sororities, fraternities, and other organizations. So successful is Gordon's venture that it has been adopted as a case study for McDougal Littell's *Algebra 2: Explorations and Applications* textbook (1997). In this context students are asked to analyze and solve algebraic problems—using sales charts, growth predictions, and spreadsheets—based on Gordon's business.

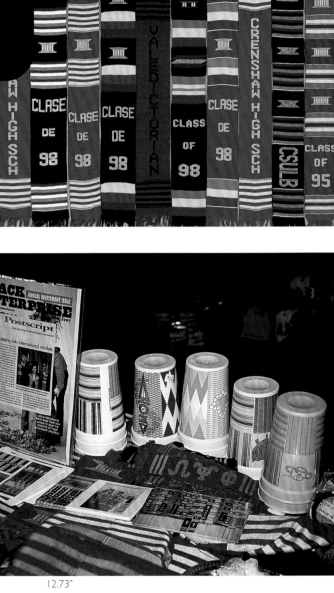

12.71˅

12.72˅

12.73ˆ

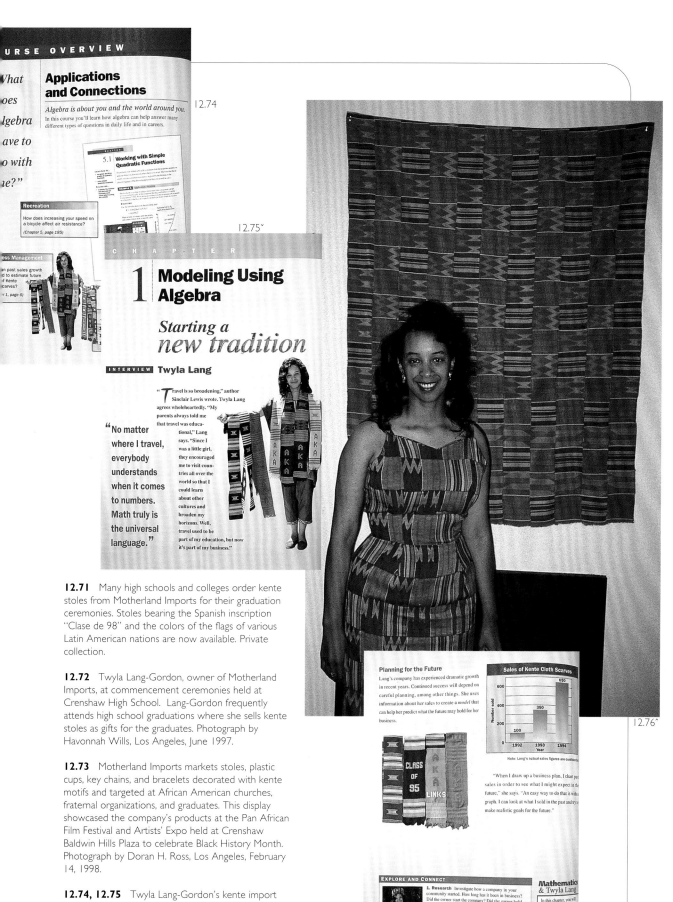

12.74

12.75˘

12.76˘

12.77

COURSE OVERVIEW

Applications and Connections

Algebra is about you and the world around you.
In this course you'll learn how algebra can help answer many different types of questions in daily life and in careers.

5.1 Working with Simple Quadratic Functions

Recreation
How does increasing your speed on a bicycle affect air resistance?
(Chapter 5, page 185)

Business Management
... past sales growth ... to estimate future ... Kente scarves?
(Chapter 1, page 6)

CHAPTER 1

Modeling Using Algebra

Starting a *new tradition*

INTERVIEW Twyla Lang

"Travel is so broadening," author Sinclair Lewis wrote. Twyla Lang agrees wholeheartedly. "My parents always told me that travel was educational," Lang says. "Since I was a little girl, they encouraged me to visit countries all over the world so that I could learn about other cultures and broaden my horizons. Well, travel used to be part of my education, but now it's part of my business."

"No matter where I travel, everybody understands when it comes to numbers. Math truly is the universal language."

Planning for the Future

Lang's company has experienced dramatic growth in recent years. Continued success will depend on careful planning, among other things. She uses information about her sales to create a *model* that can help her predict what the future may hold for her business.

Sales of Kente Cloth Scarves

"When I draw up a business plan, I chart past sales in order to see what I might expect in the future," she says. "An easy way to do that is with a graph. I can look at what I sold in the past and try to make realistic goals for the future."

Note: Lang's actual sales figures are confidential.

EXPLORE AND CONNECT

1. Research Investigate how a company in your community started. How long has it been in business? Did the owner start the company? Did the owner hold other positions in the company? Write a profile of the company based on your research.

2. Writing Based on the graph shown above, what prediction would you make for 1995 sales? Explain.

3. Project Lang was able to adapt the traditional use of Kente cloth in a way that made it meaningful for American students. Learn more about a tradition from another culture. Think of a way that this tradition can be adapted to be meaningful in American life.

Twyla Lang displays some of her Kente cloth products.

Mathematics & Twyla Lang
In this chapter, you will learn more about how mathematics is used to make decisions in business.
Related Exercises
Section 1.1
• Exercises 2 and 3
Section 1.4
• Exercises 14 and 15

2 Chapter 1 *Modeling Using Algebra*

12.71 Many high schools and colleges order kente stoles from Motherland Imports for their graduation ceremonies. Stoles bearing the Spanish inscription "Clase de 98" and the colors of the flags of various Latin American nations are now available. Private collection.

12.72 Twyla Lang-Gordon, owner of Motherland Imports, at commencement ceremonies held at Crenshaw High School. Lang-Gordon frequently attends high school graduations where she sells kente stoles as gifts for the graduates. Photograph by Havonnah Wills, Los Angeles, June 1997.

12.73 Motherland Imports markets stoles, plastic cups, key chains, and bracelets decorated with kente motifs and targeted at African American churches, fraternal organizations, and graduates. This display showcased the company's products at the Pan African Film Festival and Artists' Expo held at Crenshaw Baldwin Hills Plaza to celebrate Black History Month. Photograph by Doran H. Ross, Los Angeles, February 14, 1998.

12.74, 12.75 Twyla Lang-Gordon's kente import business is featured as a case study in McDougal Littell's *Algebra 2: Explorations and Applications* (1997) by Miriam A. Levia and Richard G. Brown. Photograph by Benn Mitchell/The Image Bank Houghton Mifflin Company.

12.76 Twyla Lang-Gordon, owner of Motherland Imports. Photograph by Danielle E. Smith, Los Angeles, 1997.

12.77 Twyla Lang-Gordon's kente import business is featured as a case study in McDougal Littell's *Algebra 2: Explorations and Applications* (1997) by Miriam A. Levia and Richard G. Brown. Photograph by Benn Mitchell/The Image Bank Houghton Mifflin Company.

In recent years events such as Columbia University's multicultural baccalaureate ceremony of 1991 (which included prayers in Arabic; songs in Hebrew and Latin, as well as Southern Baptist hymns; and the wearing of culturally specific symbols such as kente stoles and Muslim women's headcovers, or *hijabs*) have captured media attention (Foderaro 1991, B6, L). Many members of the clergy, administrators, and student leaders have heralded such changes as a positive move toward inclusion and a simultaneous celebration of individual achievement and cultural diversity.

This shift in the traditionally conservative commencement has not, however, been praised by all (Gose 1995, A31). At Duke University's 1994 graduation, roughly one hundred Black graduates wore stoles "without incident" (Gose 1995, A31). But the following year they were asked to forgo the tradition and only a few wore the cloth. Typically university officials cite a number of reasons for their concerns: at formal commencements, the personal is frowned upon, and permitting the use of kente would increase the use of other such forms of self-expression; historically commencement has been seen as a solemn event, not a celebration; and the multicolored kente stoles detract from the distinctiveness of faculty hoods and gowns, which indicate fields of study and alma maters, as well as from the specially colored tassels and mortarboards that distinguish individual graduates for their academic achievements (Gose 1995, A31). Many people of color, however, see such restrictions as culturally insensitive and wonder why messages such as "Hire Me! I Need A Job," which have appeared on mortarboards in recent years, are not perceived as even more detrimental to the tenor of graduation events (Gose 1995, A31).

So contentious and charged are these questions that in May of 1996 three students at Oklahoma's Muskogee High School were denied diplomas for wearing cultural symbols to their graduations (see Ross, chapter 10 for a full discussion of this event). According to a spokesman for the Muskogee Schools, Derryl Venters, "The whole thing came up because the school district felt previous graduation services were a bit on the rowdy side. We wanted to bring back some level of dignity. Our way of thinking is that this policy is similar to other policies in this area relating to graduation" (Romano 1996, A3). Many observers see it differently—and interpret the school district's actions as a denial of pluralism and as an infringement of students' civil liberties.

Again, in 1998, two Black students from Arvada High School, near Denver, were denied permission by their principal, Ken Robke, to wear kente stoles over their graduation gowns at commencement (UPI, 1998). The cloths that seniors Aisha Price and Enockina Ocansey had hoped to wear were specially ordered by Ocansey's father in his Ghanaian homeland and were intended to be symbols of the graduates' heritage. In response to a suit filed by the ACLU, which charged that the school policy violated the students' constitutional right to free expression, United States District Judge Richard Matsch "ruled that the school must be allowed to enforce its policy, which is designed to keep the annual graduation exercise dignified and without distraction" (UPI, 1998). Wearing symbols of one's identity—even when they are intended to stand for such positive values as unity and achievement—is not always viewed as positive, even in 1998.

Interestingly, while African American students are being denied diplomas for wearing kente at commencements, the president of Lincoln University, Niara Sudarkasa (fig. 12.78), regularly wears a blue and yellow kente stole on her royal blue academic robe at formal university events. The cloth she wears was originally given to her now-deceased mother on a visit to Ghana in 1968 (Yankeh 1990). Sudarkasa comments, "Something told me to use the kente in the robe. I saw it as a way of having my mother always with me. I also reflected on the connection with Ghana and with Kwame Nkrumah" (Yankeh 1990).

12.78 Niara Sudarkasa, President, Lincoln University, wearing kente-trimmed academic robes. Photograph by Brian Lanker from *I Dream a World: Portraits of Black Women Who Changed America.* ©1989.

Juneteenth

Juneteenth, the oldest known event intended to commemorate the ending of slavery, originated in the Southwest. Today, however, it is observed in an estimated 140 cities throughout the United States and Canada (Stewart 1997, B1). Juneteenth marks the date of June 19, 1865, when Union soldiers, led by Major General Gordon Granger, arrived in Galveston, Texas, to enforce the Emancipation Proclamation, which had become official two years earlier on January 1, 1863. (Juneteenth is celebrated on a range of dates around June 19th throughout the Southwest.) Several explanations as to why freedom had been withheld for two years in Texas have come down through the years; they range from accounts of the murder of the official messenger to allegations that slave holders deliberately withheld information. Early Juneteenth celebrations in Texas involved rodeos, community gatherings, prayer services, and special attire. Seen today as a holiday that

12.79 Storyteller Leslie Perry wears a kente vest while performing at a Juneteenth celebration held at the Autry Museum of Western Heritage. Photograph by Alan J. Diugnan for the *Los Angeles Times*, June 19, 1997.

celebrates African American freedom, Juneteenth also encourages personal development and respect for all cultures.

As with Black History Month celebrations, Juneteenth has become an occasion to wear kente. Special events at community centers, schools, and museums often include performers who wear kente. At the Juneteenth celebration of 1997 held at the Autry Museum of Western Heritage, Los Angeles, African American storyteller Leslie Perry wore a kente vest while telling the story of freedom (fig. 12.79). It is a day now widely celebrated by many who do not have roots in the Southwest but who have need for the meaning the day offers (Stewart 1997, B1). Sociologist and poet Derrick Gilbert comments that "the notion of tradition is a powerful one. What so many black folks yearn for is a notion of history, a notion of lineage and not one that's contrived in political arenas" (Stewart 1997, B1). While kente has no direct connection with the emancipation of slaves, it is a recognizable symbol of African ancestry.

Kente in the Los Angeles African Marketplace and Cultural Faire

In urban centers, kente—in all its manifestations—is frequently marketed at special expos featuring African and Afrocentric products. In Southern California, the largest and best publicized of these is the Los Angeles African Marketplace and Cultural Faire (figs. 12.80–12.94), held under the auspices of the city's Department of Cultural Affairs on three weekends near the end of summer. First initiated in 1986, the African Marketplace celebrates the cultural influence of the peoples of the African Diaspora through live performing arts events, cuisine, sports, children's activities, a business expo, and merchant displays (fig. 12.81). It is a popular and well-attended event that plays host to over one hundred thousand visitors during its three-week run (fig. 12.82).

The amazing array of products available and the services offered are clear indications of the success of Black-owned businesses and reflect the tastes and trends of the Afrocentric marketing of the 1990s. At the Twelfth Annual African Marketplace, held in 1997, over 350 merchants offered goods for sale. In recent years, the kente offerings have been dazzling, both in terms of their range and their presentation—merchants have displayed kente-patterned beach balls, infants' clothing (fig. 12.83), potholders (fig. 12.84), garment bags, holiday wreaths, and adult attire; they have dressed their display tables with commercially printed kente cloth (figs. 12.85, 12.86); and they have advertised payment options in kente-wrapped frames (fig. 12.87). Woven and printed kente have not only been available for purchase (figs. 12.88–12.92), they have historically been the dress of choice for countless sellers and attendees (figs. 12.93, 12.94). As with more recent Black History Month artists' expos, however, the public's preference for mud cloth over kente was observable throughout vendor stalls at the African Marketplace of 1997. Fewer kente-adorned articles of clothing were observed for sale than those utilizing mud cloth. Kente, however, continued to be used to frame and otherwise define objects celebrating African American identity, such as posters featuring the principles of Kwanzaa, Bible covers, and heritage quilts.

Kente at the Los Angeles African Marketplace

In many urban centers throughout the United States, Afrocentric markets offer a wide variety of goods and services evocative of Africa. In Los Angeles such markets are scheduled throughout the year but occur most frequently at Kwanzaa, during Black History Month, and near the end of summer. Leimert Park hosts an artists' expo over the seven days of Kwanzaa, various malls feature a changing Afrocentric marketplace, and the Los Angeles African Marketplace plays host to over three hundred vendors selling everything from books to handmade or imported clothing and furniture. Each market features artists' booths, performing arts events, and education services and programs aimed at the general public. Kente in all its manifestations is a regular feature of these events.

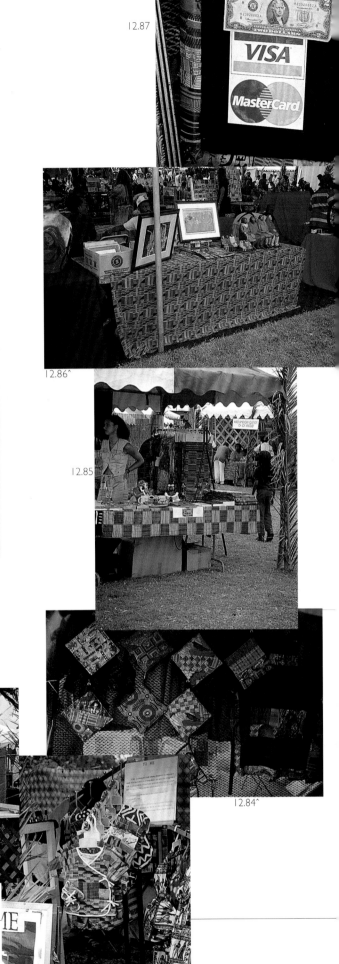

12.87

12.86^

12.85

12.80^

12.81^

12.82^

12.83

12.84^

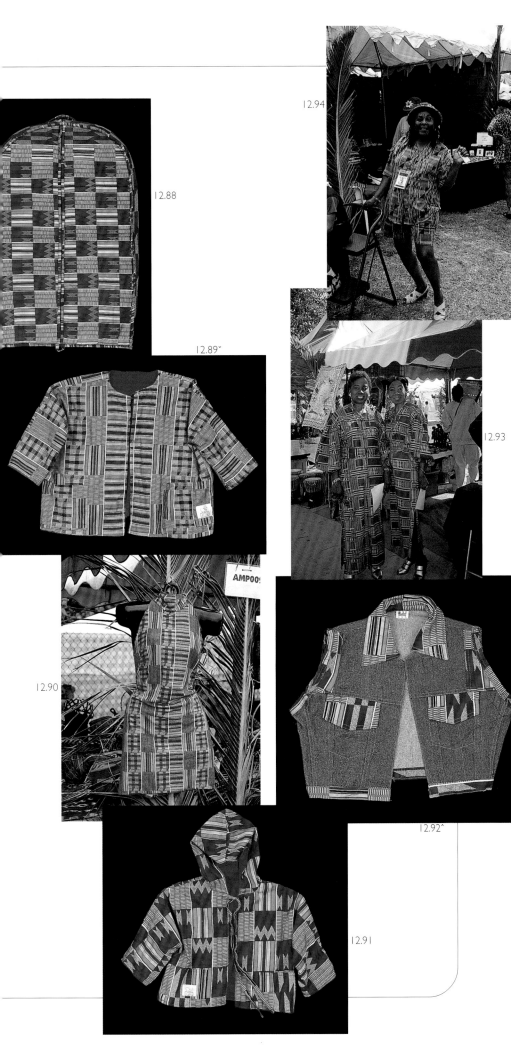

12.94

12.88

12.89˘

12.90

12.91

12.92ˆ

12.93

12.80 Kente attire for sale at the Los Angeles African Marketplace. Photograph by Betsy D. Quick, Los Angeles, August 1997.

12.81 Kente vests for sale at the Los Angeles African Marketplace. Photograph by Aphrodite J. Dielubanza, Los Angeles, August 1997.

12.82 A young attendee wears a kente baseball cap at the Los Angeles African Marketplace. Photograph by Aphrodite J. Dielubanza, Los Angeles, August 1997.

12.83 Infants' and children's clothing made of commercially printed kente could be purchased from many vendors at the Los Angeles African Marketplace. Photograph by Danielle E. Smith, Los Angeles, August 1997.

12.84 Kente adorned all manner of objects, including potholders and oven mitts, at the Los Angeles African Marketplace. Photograph by Aphrodite J. Dielubanza, Los Angeles, August 1997.

12.85 Kente adorned vendors' stalls as well as objects available for sale at the Los Angeles African Marketplace. Photograph by Danielle E. Smith and Aphrodite J. Dielubanza, Los Angeles, August 1997.

12.86 Kente was frequently used as a table cover at vendors' stalls at the Los Angeles African Marketplace. Photograph by Danielle E. Smith, Los Angeles, August 1997.

12.87 Payment options framed in kente appeared at one vendor's stand at the Los Angeles African Marketplace. Photograph by Aphrodite J. Dielubanza, Los Angeles, August 1997.

12.88 Commercially printed kente garment bag. Purchased at the Los Angeles African Marketplace, August 1997. Cloth, foam (?), and zipper. Height 98 cm. Private collection. Photograph by Don Cole.

12.89 Woman's or child's shirt in commercially printed kente. Purchased at the Los Angeles African Marketplace, August 1997. Cloth, buttons. Width 90 cm. Private collection. Photograph by Don Cole.

12.90 This halter dress was one of many clothing items made of commercially printed kente available at the Los Angeles African Marketplace. Photograph by Danielle E. Smith, August 1997.

12.91 Child's shirt made of commercially printed kente. Purchased at the Los Angeles African Marketplace, August 1997. Height 59.5 cm. Private collection. Photograph by Don Cole.

12.92 Child's sleeveless denim vest trimmed in commercially printed kente. Purchased at the Los Angeles African Marketplace, August 1997. Width 55 cm. Private collection. Photograph by Don Cole.

12.93 Visitors to the Los Angeles African Marketplace wearing kente. Photograph by Aphrodite J. Dielubanza and Danielle E. Smith, Los Angeles, August 1997.

12.94 Commercially printed kente in the Oyokoman pattern is widely used for clothing as observed here at the Los Angeles African Marketplace. Photograph by Aphrodite J. Dielubanza, Los Angeles, August 1997.

12.95^

12.96^

And Anytime Throughout the Year

> Kente cloth can be worn everyday, or you can wear it on special occasions. There are so many ways you can use the kente cloth, and I try to use it that way. And I think other people do the same.
> —Linda Farrell, Director, New Community Corporation Fashion Institute, interviewed by Tracy Marcus, Newark, March 10, 1997

To assume that kente is used or worn solely on set occasions would be a mistake. Although it has been suggested by many that in Ghana kente is reserved for special events, its usage in an African American context is determined to a large extent by the lifestyle and preferences of the individual. Comments gathered by the students show the extent to which kente has come to permeate the normal flow of events in daily life.

Kente and the State of Grace

> I was first introduced to kente cloth perhaps twenty years ago when Afrocentrism and African materials became available on the market. People who wanted to identify with their roots, with their origins, with their Motherland, began to wear African apparel. Then in the religious bookstores African American robes became a product, and so preachers began to wear them also. It was a statement that we are proud of where we have come from and we are going to conduct ourselves with pride to make where we come from proud of us.
> —Reverend Cecil L. Murray, First A.M.E. Church, interviewed by Maritza Mejia, Los Angeles, January 1997 (fig. 12.95)

African-style vestments and dress have been adopted by many faiths over a twenty-year span (figs. 12.96–12.98). Along with the world of academia, the world of religion is said to be one of the "two most graceful in Black America, in which kente plays a role" (Yankeh 1990). Yankeh cites Barbara Harris as exemplary of that state of grace. The first female to hold the position of Episcopal bishop in the Anglican church, Harris is perhaps one of the better known and highest ranking clerics in the United States to don kente at official functions. At her own insistence, she wore kente-trimmed vestments over her priestly robes at her 1989 consecration in Boston, which took place before a multidenominational crowd of eight thousand (Yankeh 1990). Reverend Antonio Nelson of Trinity and St. Philip's Episcopal Cathedral in Newark explained the wearing of a kente stole in the Anglican Church:

12.95 Reverend Cecil L. Murray of the First A.M.E. Church has worn kente during services for two decades. At least half of his clerical robes incorporate kente in some way. Photograph by Don Cole, Los Angeles, July 1998.

12.96 Father James McConnell of the Queen of Angels Church standing in front of kente panels. Photograph by Cristina Vega, Newark, 1997.

12.97 Pauline Blount and John Bennett at Bethany Baptist Church. Photograph by Prunella Booker and Nadirah Keith, Newark, 1998.

12.98 Reverend Antonio Nelson (left), Reverend Petero Sabune (center), and Angela Ifill (right) wear kente robes at Trinity and St. Philip's Episcopal Cathedral. Photograph by Nzinga Green, Newark, 1997.

12.97^

12.98

12.99^

12.99 Members of the Metropolitian Baptist Church choir wearing kente stoles. Photograph by Janel Watts and Nadirah Keith, Newark, 1998.

12.100, 12.101 Reverend J. L. Armstrong of the First A.M.E. Church wearing kente-trimmed robes. Photographs by Don Cole, Los Angeles, July 1998.

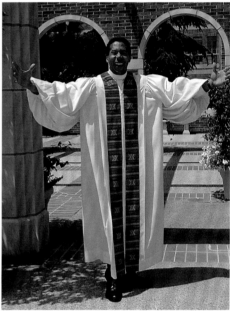

12.100^

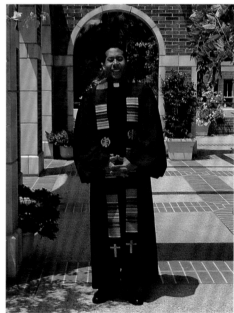

12.101^

> We put on a kente stole because it means we are carrying the burden of the congregation here; so this symbolizes the yoke of Christ. Back in Ghana, when I wear this kente stole, it talks about God, God, God, God . . . that before the White man brought us God we knew God already.
> —Reverend Antonio Nelson, Trinity and St. Philip's Episcopal Cathedral, interviewed by Janel Watts, Newark, February 2, 1997 (see fig. 12.98)

Members of the clergy may elect to incorporate kente in their robes, and these are sometimes coordinated with the robes worn by their choirs (fig. 12.99 and see below). It is both difficult and expensive to incorporate handwoven kente in the structure of traditional liturgical garments. For this reason, machine-woven kente is often used. Whether factory-made or handwoven, kente on the pulpit produces a profound effect.

At the First A.M.E. Church in Los Angeles, kente-adorned vestments and choir robes are used throughout the year and especially during Black History Month. As Reverend Cecil L. Murray related to Crenshaw student Maritza Mejia, "kente is used in worship, dramatic plays, decoration, and social events . . . essentially all the time" (January 9, 1997). Reverend Armstrong, also of the First A.M.E. Church, commented that Easter services, particularly those held on Good Friday, represent an occasion for ministers to wear their best kente robes (figs. 12.100, 12.101),[17] an opinion echoed by Father Paul Schetelick of Blessed Sacrament Church in Newark:

> Kente is part of whatever season is being celebrated. . . . It helps me celebrate the seasonal part of who we are—some kente is very rich, woven with gold thread and different colors; some is very plain with two colors, sometimes blue and white or black and white [for regular services]; and for big celebrations such as Easter, we use more ornate kente.
> —Father Paul Schetelick, Blessed Sacrament Church, interviewed by Brehita Taborn, Newark, April 2, 1997

Typically, according to Reverend Quanetha Hunt, the minister of youth and membership at First A.M.E. Church, members of the church's Brookinaires Choir wear blue robes with kente stoles on the third Sunday of each month as does Reverend Murray.[18] During Black History Month the various choirs are encouraged to wear African dress of their own choosing. At a service on February 15, 1998, Crenshaw student Aphrodite J. Dielubanza and staff of the Fowler Museum observed that five of the forty-five choir members wore kente-inspired dress, and six of the thirteen ministers (out of a total of thirty-five on staff) and two altar boys attending the congregation that day wore robes or garments with kente details. Four ministers wore machine-woven kente sewn into the body of their robes, and two wore vestments that included handwoven kente stoles.

Reverend Cecil L. Murray spoke eloquently about his own use of kente and about what kente can teach us:

> Kente plays an extremely important role first of all with the Black church. That's the place where Black people congregate more than any other place—so you have access to Black people. Secondly, you have access to the minds of Black people. Images can liberate the mind . . . if you have images that are relevant to Black people [which they see] ninety minutes [in church], once a week, for fifty-two weeks a year, for ten years [the images] begin to say something to the mind. So the people will feel better about themselves, and thus they act better and live better.
> Kente reminds us that the world is larger than where you are. The world is larger than what you have suffered, what you have experienced. The world is large enough to step across the Atlantic, the Pacific, and to join people as people. So the significance to me

12.103^

12.104^

![Still on the Journey album cover]

12.102^

12.102 Cover for the compact disc *Still on the Journey*, the twentieth-anniversary album of Sweet Honey in the Rock. Produced by Toshi Reagon and Bernice Johnson Reagon. Photograph © Joe Grant. Cover design ©1993 EarthBeat Records.

12.103 Members of the gospel group Sweet Honey in the Rock are known for their individualized kente apparel. Photograph by Richard Green, 1992.

12.104 Members of the Boys Choir of Harlem wearing kente stoles over their choir robes. Photograph courtesy of the Boys Choir of Harlem.

12.105 The bride and groom often select kente attire if they plan an Afrocentric wedding ceremony. From *Jumping the Broom: The African-American Wedding Planner* by Harriet Cole. Photograph © 1993 by George Chinsee. Reprinted by permission of Henry Holt and Company.

12.106 Wedding ring pillows made by artist Barbara Stephenson-Addy, owner of Afro-Centric Designs, may incorporate kente. These pillows were displayed at Jimmy's Bakery in Leimert Park. Photograph by Aphrodite J. Dielubanza, Los Angeles, 1997.

12.107 Broom trimmed in kente made by Barbara Stephenson-Addy, owner of Afro-Centric Designs.

12.108 Kente wedding cake made by Jimmy's Bakery, Leimert Park, Los Angeles, California. Photograph by Danielle E. Smith, Los Angeles, 1997.

12.109 Kente place setting by Avon, including French-made dishes, stemware, and table linens. Longest dimension 45 cm. Private collection.

is that it's a bridge joining worlds together. Kente cloth means dignity, freedom, liberation, joining hands, love.
—Reverend Cecil L. Murray, First A.M.E. Church, interviewed by Maritza Mejia, Los Angeles, January 9, 1997

Reverend Milton Biggham of the Mount Vernon Baptist Church of Newark discussed the cloth as healing the wounds of racism and hatred.

Kente brings together two worlds, a world that we come from and a world that we now live in, in terms of a people. When wearing kente, I think there's a sense of pride, there's a sense of belonging, which is important for Black Americans, Black people, people of color. Because of the divisions that exist among us, anything that we can use to bring us together should be used. If it is a piece of cloth, let it be so.
—Reverend Milton Biggham, The Mount Vernon Baptist Church of Newark, interviewed by Janel Watts, Newark, August 13, 1997

As an extension of the church, professional gospel groups often adopt kente as a form of colorful but respectful dress. Sweet Honey in the Rock (figs. 12.102, 12.103), a female group, is especially well known for the individualized kente apparel of its members. Other groups such as the Boys Choir of Harlem (fig. 12.104) and the Bronx Mass Choir often wear kente when performing.

Weddings offer another opportunity to wear and use kente both within the church and outside of it. Some African American couples choose to create a wedding ceremony based on African models, and others meld African traditions with Western conventions (fig. 12.105). Cultural links are established by the foods that are served, the choice of dress, and the rituals performed at the ceremony (Cole 1993, 21). Handwoven kente may be worn traditionally by the bride and groom, or it may be made into sashes, cummerbunds, and bowties. From the planning stages to the final dance, kente may play a part—embellishing the invitations, adorning the participants, covering the pillow used to hold the rings (fig. 12.106), wrapping the broom for the "jumping the broom" ceremony (fig. 12.107), dressing the wedding table, and trimming the wedding cake (fig. 12.108). In addition, wedding gifts of cloth, table linens, dishes, and stemware in kente patterns have become increasingly more popular (fig. 12.109). Kente is as ubiquitous or as minimal as preference and taste dictate.

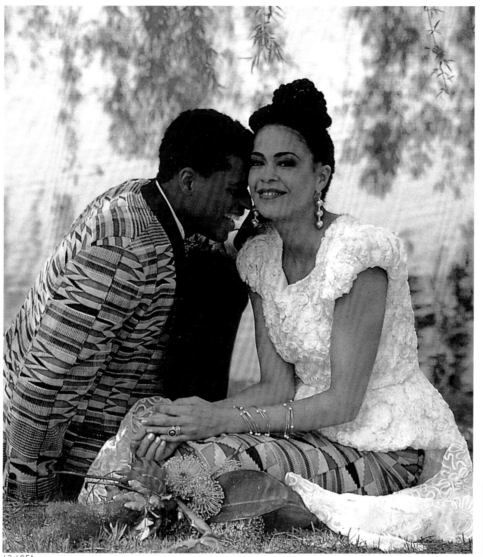

12.105^

12.106^

12.107^

12.108^

12.109^

Jimmy Davis, owner of Jimmy's Bakery in the Leimert Park area of Los Angeles, creates wedding cakes with kente decoration (see fig. 12.108) and uses the same trim on cakes intended for baby and wedding showers:

> [Kente] would be worn at wedding sessions. I said "hmmm," you know, why not incorporate it in the cake. Some wedding cakes have a thin line of ribbon. Why not use the kente cloth, and the response was like "Wow, wow! That's great!" The people really thought it was something unique and fabulous. Since then we've gone from not only putting it on the side of the cake, but we'll get custom ornaments made of the cloth as well, and we'll go on and put it on the wedding pillows. The people wanted to incorporate the cloth into the Afrocentric traditional wedding—not so much that they wanted to abandon the whole European wedding theme but have some sort of ethnic flavor to it. So it's done on the cake, it's done in the cloth, and it's done in the accessories. That's how it started four years ago. We make cakes with kente borders at least once a week—actually sometimes more, but we do it all the time.
> —Jimmy Davis, Owner of Jimmy's Bakery, interviewed by Carroll Houston, Danielle E. Smith, Aphrodite J. Dielubanza, and Taaji Madyun, Los Angeles, July 9, 1997

This business venture is closely related to another. Barbara Stephenson-Addy receives numerous requests for wedding and shower cake decorations using kente (fig. 12.110), as well as handmade brooms tied with kente (see fig. 12.107) to be used in the African American "jumping the broom" ritual. Stephenson-Addy purchases Black male and female dolls about 11 inches high, discards their clothes, and makes them new outfits in printed kente. Even when the wedding is not completely Afrocentric, Stephenson-Addy reports that couples will often select either wedding cakes trimmed in kente and topped with figures dressed in kente or straw brooms tied with kente.

> I usually make kente cake tops about twice a month, and between February and September, maybe three a month and also brooms. People seem to really like them because they represent Black people, and kente cloth is so popular now, you know, everybody wants to wear it. Most often even if the color of the wedding or the print of the wedding is different from kente, they'll still choose the original kente. They most often choose the cloth with the orange background.
> —Barbara Stephenson-Addy, Owner of Afro-Centric Designs, interviewed by Danielle E. Smith, Aphrodite J. Dielubanza, and Taaji Madyun, August 1997 (fig. 12.111)

Community Voices: Portraits of Kente

> When kente came to this country, no one had any idea that it was going to become this thing that you would gravitate to, but we've been a hungry people for a long time, and it was like feeding [the] starving.
> —Carolyn Whitley, Coordinator of Student Activities, Newark Public Schools, interviewed by Aja Davis and Danielle Scarborough, Newark, August 8, 1997

> Every chance I get, I talk to people, I tell the stories. Kente cloth represents one's culture, one's history, one's pride, one's artistic opinions. This is something you would wear at a family gathering, and people make statements, and you walk around—walking statements.
> —Arnold Adjepong, Owner of Kente Concepts, interviewed by Ugochuku Nwachukwu, Newark, April 14, 1997

12.110 Kente wedding cake decoration by Barbara Stephenson-Addy, owner of Afro-Centric Designs. The cake decoration was displayed at Jimmy's Bakery, Leimert Park. Photograph by Aphrodite J. Dielubanza, Los Angeles, 1997.

12.111 Artist Barbara Stephenson-Addy creates wedding cake decorations, brooms, pillows, and other special items decorated with kente for weddings, baby showers, and other events. Photograph by Taaji Madyun, Los Angeles, 1997.

Kwanzaa, Christmas, Black History Month, and graduations were the times of the year when those interviewed most commonly spoke of wearing kente. Entwined in their discourse, however, were stories rich in detail concerning the meaning of kente and its relevance to their own lives and the lives of people they know, love, and respect. These stories are replete with memories of their earliest encounters with the cloth, thoughts about its color symbolism, and the emotional responses evoked by it. Individuals described how kente played a part in their businesses; public figures remarked on the messages kente conveyed to audiences; clergymen spoke of its power to heal. Conflicting concerns about commercialization and ownership were passionately expressed. Such comments were often heated and irreconcilably opposed, suggesting the tenor of the dialogue on appropriation and control of cultural imagery. The following are stories that emerged from the student interviews—with their competing patterns and contrasting tones, they form a narrative rich in meaning and insight.

"A Sign of the Movement": Kente and Politics

Major people in the Afrocentric movement, social leaders, poets, artists, [wore kente]. Kente became very popular in the 1980s and most African people wore it. Church leaders wore it, politicians wore it, intellectuals wore it, activists wore it. . . . It became a sign of the movement.
> —Dr. Maulana Karenga, Chair, Black Studies Department, California State University, Long Beach, interviewed by LaRon Young, January 1997

For many, kente is associated with the politics of the 1970s and 1980s and the search of African Americans for their roots—the reclaiming of their histories. Those who were active at this time often mention kente as a symbol of the era and speak of it nostalgically. Their remarks suggest that in kente they discovered the wealth and complexity of their African heritage.

> When you think about it, it was through kente cloth that African Americans first began to show their Africanness. It made us feel real good and real connected with the Motherland. I attribute [to] kente . . . the origin of our consciousness raising.
> —Mildred Crump, Councilwoman, interviewed by Janel Watts and Francina Radford, Newark, November 6, 1996

> I've been wearing kente approximately fifteen years. I've known about kente since the late 1960s when a lot of African Americans were trying to find their roots. And now that it's the 1990s, we're trying again. In the 1960s what we were doing in the Civil Rights movement was trying to identify with our African heritage. And one of the things that we discovered was the materials—the rich heritage of cloth and textures brought from Africa.
> —Captain Fateen Ziyad, Director, Community Relations, Newark Fire Department, interviewed by Tonya Johnson, Newark, March 3, 1997

Some individuals mentioned specific incidents that they associate with their introduction to kente. Willie Williams mentioned Dr. Maulana Karenga's creation of Kwanzaa when he spoke of his personal discovery of the cloth.

> When the television series *Roots* came out, there was discussion about the kente cloth . . . worn by special people in Africa, by the chiefs, and . . . that was really the first introduction to me and many African Americans in this country. And then years later, when Dr. Maulana Karenga worked with developing what we now call our Kwanzaa celebration, which starts December 26, the kente cloth was introduced to some and reintroduced to others.
> —Willie Williams, Former Chief of Police, LAPD, interviewed by Danielle E. Smith, Los Angeles, January 10, 1997 (fig. 12.113)

> I saw kente for the first time maybe a decade ago when I attended the Black Issues Convention. I think on that occasion I wanted to become an African American. I wanted to stand out. I wanted to deny my European habits and traditions. I was drawn by the color and subsequently by the history—so it was love at first sight.
> —Sharpe James, Mayor of Newark, interviewed by Francina Radford and Janel Watts, Newark, 1997 (fig. 12.112)

Over the past four or five years kente seems to have reasserted its former status as a potent political symbol. Some government and community leaders pointed out to the students the importance of kente in a political context and also remarked on the rewards to be reaped from wearing it on certain occasions:

> Because I'm the mayor of the city and I go to various events, I try to be appropriately dressed—I don't go to every event wearing [kente]. I think I pick and choose those events where ethnicity matters, when I want to state a cultural difference, a cultural fact, or identify with my race. Some people say you [can wear ethnic dress anytime], but I think at times you have to be just neutral in order to best represent the city. When I wear kente, I feel good; it makes me stand out; it makes me a king. I feel I have more power.
> —Sharpe James, Mayor of Newark, interviewed by Francina Radford and Janel Watts, Newark, 1997 (see fig. 12.112)

12.112^

12.113^ 12.114^

12.112 Sharpe James, Mayor of Newark, wears kente at selected civic events. Photograph by Janel Watts, Newark, 1997.

12.113 Willie Williams, Former Chief of Police, LAPD, at a "Community Appreciation Breakfast" held in his honor. Photograph by Bobby Washington, Los Angeles, December 1996.

12.114 Governor Christine Todd Whitman at her pre-inaugural reception held at the Newark Museum. Photograph by Shelley Kusnetz, Newark, 1993.

Willie Williams recalled wearing a kente stole in 1991 at his swearing in as president of the National Association of Black Law Enforcement Executives . As he told students:

> I can't say that I've intentionally worn it because I have access to the visual media. When I think about wearing it, I think it'll look good with what I have on, or there's a specific occasion where I want to make sure that I wear it. . . . I always try to let people know that I may be the chief of police and a police officer for a short time in my life, but I was born African American and I'm going to die African American. So I guess maybe I have worn it specifically because I know that being the chief they'll see and report it.
> —Willie Williams, Former Chief of Police, LAPD, interviewed by Danielle E. Smith, January 10, 1997

The wearing of kente by elected leaders certainly does not go overlooked. Barbara King commented on the wearing of kente by New Jersey governor, Christine Todd Whitman (fig. 12.114; Whitman also wore kente to her gubernatorial inauguration):

> And of course you'll find the governor of New Jersey when she comes to certain events like the New Jersey Black Issues Convention . . . she'll have her kente cloth on.
> —Barbara King, Vice President, Africa Newark Cultural Organization, interviewed by Nadirah Keith, Newark, 1997

"I Sell Something Every Week Made with Kente": The Business of Kente

Kente's cachet and popularity have given rise to a host of new businesses. It has also been important in terms of professional demeanor and dress. Artists, clothing designers, pastry chefs, boutique operators, lawyers, teachers, morticians, quilt makers, and entertainers all comment on kente in the context of their endeavors.

> I display kente in my store and in my house. I use it daily. I use it for whatever purpose, especially as drapery. My friends use kente most of the time as decoration in their cars. . . . I have no special feelings for the cloth, I just use it.
> —Stewart Clemons, Entrepreneur, Vidussian Store, interviewed by Rolando A. Cordoba, Los Angeles, March 1, 1997

The use of kente is central to the success of Debra Ann Morris's "Ms. Clown" business:

> I use kente in my tablecloth, on my clown cart, the face painting. My whole setup. Sometimes when I'm painting children's faces, I'll apply kente cloth patterns. Basically warrior patterns or princess patterns. There's also a pattern for marriage.
> Some of the other clowns I've seen have said to me, "You should be wearing red, white, and blue." That's just not me. . . . I know in this American culture to be accepted I have to wear a White face and be all-American, so I wear a mask, but my own color shows. My costume shows where I'm really at, but I'll put on that red, white, and blue face just to try to make it in the world.
> —Debra Ann Morris, "Ms. Clown," interviewed by Danielle E. Smith and Aphrodite J. Dielubanza, Los Angeles, July 1997

Morris spoke to the students of her diverse clientele and of the impact her kente costume has had in bridging cultural gaps. Her remarks suggest her readiness to incorporate kente into every aspect of her business, as well as the popularity she is gaining in the African community in Los Angeles.

> Some [of my clients] specifically ask for an African American clown, so . . . they're asking for the whole package. I went to a Chinese party for a little boy . . . they came in their traditional costume, and I had on my traditional costume. That was very unique, and it made us closer. Our differences made us closer.
> Prior to me having the kente cloth, I hadn't had one African ask me to do a show, but once I started wearing the kente, that changed. . . . Now I have a Barney costume. I would like to put some kente cloth on Barney. My daughter acts as my assistant, and she wears a kente cloth vest. If there's a place that I can put [kente] on display or advertise who I am, I'll do that.
> —Debra Ann Morris, "Ms. Clown," interviewed by Danielle E. Smith and Aphrodite Dielubanza, Los Angeles, July 1997

12.115 Offices of Designers Network International, Leimert Park. Photograph by Taaji Madyun, Los Angeles, 1997.

Ahneva Ahneva, designer/producer of Designers Network International, is a Los Angeles clothing designer who often incorporates kente or creates fashions inspired by kente. She first discovered the cloth in high school. As with many others interviewed by the students, she discovered her own African identity in part through dress and then incorporated her culture into her life—a quest that she sees today as part of her personal mission:

> Well, I actually became aware of kente cloth in Chicago, my hometown. I was a young student at [Chicago's] Inglewood High School. I was president of the Black Students Union and responsible for coordinating activities for our organization. At that time I used to have to find African clothing for us to wear, because part of what we did was to connect with our culture by dressing in our heritage, so we would wear African fabric.
> —Ahneva Ahneva, Designer/producer of Designers Network International, interviewed by Danielle E. Smith, Aphrodite J. Dielubanza, and Taaji Madyun, July 1997

Today kente is an essential component of Ahneva Ahneva's clothing design business (fig. 12.115). Her clientele includes actresses Veronica Foster and Alfre Woodard, Congresswoman Maxine Waters, and Mrs. Jerry Rawlings, First Lady of Ghana (fig. 12.116), to name a few. Unlike many entrepreneurs who use inexpensive, machine-printed kente in ready-to-wear clothing lines, Ahneva's one-of-a-kind dress designs often incorporate handwoven kente and consequently sell in the one thousand dollar price range (see figs. 12.117–12.121):

> I wear kente every day, every way, every how. I try to work it into my everyday lifestyle, because what I really am doing is a part of my ministry—which my clothing has become for me—to show men and women how . . . youth can incorporate their culture into their everyday lifestyle. I sell something every week [made with] kente. So I use a lot of kente, and I wear it a lot. I wear it in suits, I wear it in dresses, I wear it in my crowns, I wear it in jackets, and so we do a lot with kente cloth.
> —Ahneva Ahneva, Designer/producer of Designers Network International, interviewed by Danielle Smith, Aphrodite J. Dielubanza, and Taaji Madyun, Los Angeles, July 1997 (fig. 12.117)

12.116 Ahneva Ahneva with President Jerry Rawlings of Ghana and First Lady Nana Konadu Agyeman-Rawlings. Photograph by Howard Bingham, Los Angeles, 1995.

Designers Network International: Kente and Haute Couture

Handwoven kente cloth is used extensively in the creations of Los Angeles fashion designer Ahneva Ahneva. Founded in 1974, Designers Network International offers striking one-of-a-kind items featuring kente, mud cloth, and other African textiles. The cloths are incorporated in a broad range of styles and used to create distinctive wedding gowns, tuxedo jackets, dresses, suits, and headgear. Ahneva's clientele includes entertainment industry figures, government officials, and community leaders. Ahneva Ahneva often wears kente herself and speaks of its importance in her design work as a means of communicating a sense of Africa's proud heritage.

12.117

12.118˅

12.119

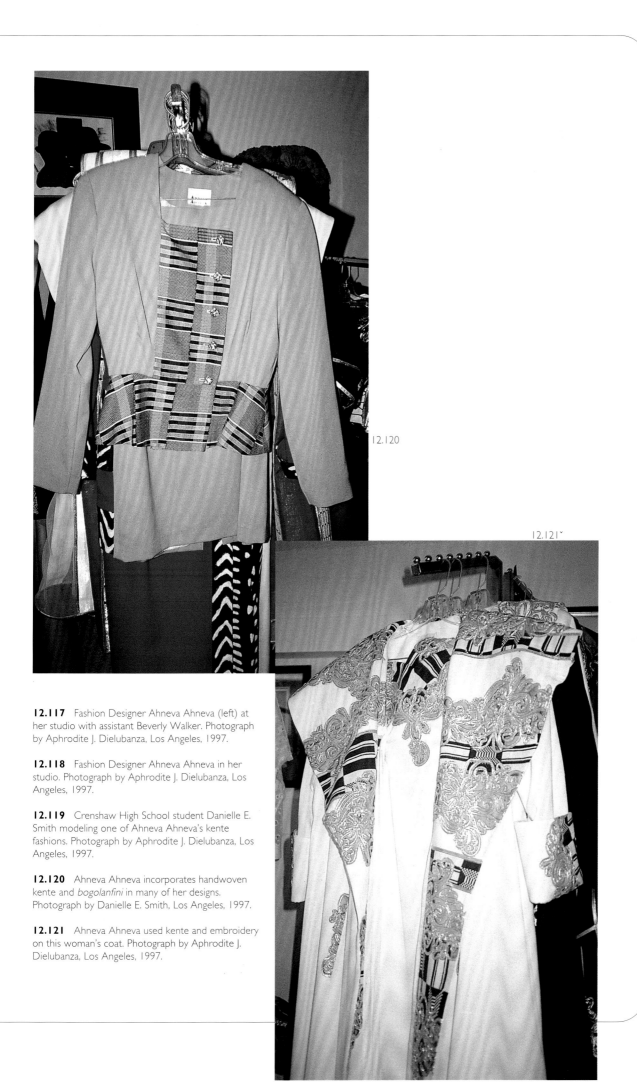

12.120

12.121

12.117 Fashion Designer Ahneva Ahneva (left) at her studio with assistant Beverly Walker. Photograph by Aphrodite J. Dielubanza, Los Angeles, 1997.

12.118 Fashion Designer Ahneva Ahneva in her studio. Photograph by Aphrodite J. Dielubanza, Los Angeles, 1997.

12.119 Crenshaw High School student Danielle E. Smith modeling one of Ahneva Ahneva's kente fashions. Photograph by Aphrodite J. Dielubanza, Los Angeles, 1997.

12.120 Ahneva Ahneva incorporates handwoven kente and *bogolanfini* in many of her designs. Photograph by Danielle E. Smith, Los Angeles, 1997.

12.121 Ahneva Ahneva used kente and embroidery on this woman's coat. Photograph by Aphrodite J. Dielubanza, Los Angeles, 1997.

Interestingly, however, some business owners reported that they have noted a decrease in the popularity of kente. As a result their interest in it and reliance upon it in their businesses has diminished. Tiplah Mulbah, owner of Tiplah's Village in Newark, comments:

> I would say less than a third of my orders are made with kente, because people are not buying as much kente as they used to. You know for the past two years the popularity of the kente, whether the woven or the prints, has been dropping down. Kente is just one side of the whole story [it's] African prints that people are looking for now.
> Tiplah Mulbah, Owner of Tiplah's Village, interviewed by Janel Watts, Newark, August 1997

Patsy Johnson, owner of PJ's Choir Robes, pointed out some interesting technical problems that arise when handwoven kente is incorporated in robes. Cutting and sewing the handwoven cloth is inherently difficult, and the variations that occur in weaving interfere with the ability to fulfill orders over a period of time when uniformity is desired. Other choir-robe makers echoed these concerns (fig. 12.122).[19] Larger companies, such as Collegiate and Cokesbury, Inc., do not even offer handwoven kente stoles or robes in their catalogs, presumably for the same reasons. Johnson's hesitations aside, she was clear about the importance of kente in dress:

> [I was inspired by kente's] popularity, I guess, by the fabric and feeling that I needed it for the month of February. I needed it to do something for that time . . . just the inspiration of needing it in my line someplace.
> I find that [printed kente] is better than using the [handwoven] kente because I don't know how the woven is going to react. . . . It may give, and it may create a problem, so I don't use too much of that unless it's the whole garment that's made from the woven goods. I don't use too much kente because I run into a lot of patterns being . . . discontinued. . . . Individual [orders for clergy] I don't mind working with at all, but when it comes to a group, sometimes it creates a problem.
> —Patsy Johnson, Owner of PJ's Choir Robes, interviewed by Danielle E. Smith, Aphrodite J. Dielubanza, and Taaji Madyun, Los Angeles, July 21, 1997

The students discovered intriguing explanations for kente's diminishing popularity among consumers. Some of those interviewed cited the fixation in America with changing fashion trends; others pointed to the flooding of the market with machine-printed kente; and still others saw the current availability of a variety of African textiles as a factor.

"You Shouldn't Make Sneakers Out of It": The Debate on the Commercialization of Kente

> Kente is a dead statement unless people are wearing real kente. The real kente is good, but when they started making imitations, it just killed it.
> —Ben Caldwell, Professor, California Institute of the Arts, interviewed by Havonnah Wills, Los Angeles, March 5, 1997

> Those who are using kente [as book bags] don't know the meaning of kente. . . . They see it more as a fashion than as a cultural and artistic preserve. It is not looked at as an artistic masterpiece. Imitations are all over. It will get to the point where kente will lose traditional and cultural character. People who are using a kente book bag will not respect it anymore ten years from now.
> —Dr. Charles Boateng, Kente Weaver and Professor of Political Science, Kean College, interviewed by Francina Radford, Newark, 1997 (fig.12.123)

A highly charged and emotional debate rages concerning recent appropriations of kente for everything from beach balls to backpacks (figs. 12.124–12.126). The students found that there was, in effect, a line drawn in the sand; either kente was viewed as sacred, as special, or it was viewed as anything you want it to be. Often Ghanaians took the former stance; African Americans, the latter. Many voices condemned a use of kente that they saw to be disrespectful.

> Kente is not [to] be worn on the basketball court or made into a pair of boxers.
> —Bernard Jackson, Owner of Renaissance Gallery, interviewed by Francina Radford, Newark, 1997

12.122ˆ 12.123ˆ

12.122 Student Aphrodite J. Dielubanza models a choir robe with kente trim made by Patsy Johnson at PJ's Choir Robes in Leimert Park. Photograph by Danielle E. Smith, Los Angeles, August 1997.

12.123 Kente backpacks for sale at the Los Angeles African Marketplace. Photograph by Doran H. Ross, Los Angeles, August 1997.

12.124 Kente is used to frame photographs of African American male models, actors, and athletes on this wall calendar. Height 33.2 cm. LaMont Communications © 1996. Alayé Fit to Be King Calendar. Private collection.

12.125 Commercially printed kente is used on items ranging from oven mitts to baby bibs. Printed cloth, batting, and plastic. Tallest dimension 50 cm. Private collection.

12.126 Handwoven kente embellishes hair clips and a variety of jewelry items. Purchased in Ghana. Length of necklace 21 cm. Headband FMCH X96.30.35A; earrings FMCH X95.51.38A-B, FMCH 96.30.33A-B; necklace X95.51.38A; bracelets FMCH X96.30.36A-B; hair clip FMCH 96.30.34.

12.127 Among the many kente-inspired articles of clothing available for sale by Obinne of The African Cultural Exchange are men's shoes. Photograph by Maritza Mejia, Los Angeles, 1997.

A lot of people are using imitation kente as throws on their couches, or to sleep in, or as handkerchiefs or book bags. We think these are not appropriate uses for kente because kente is sacred. Kente is spiritual. Kente is traditional. Kente actually projects our past, our history, and it also projects the artistic talents of the African peoples. On the other hand, the fake ones have helped generate more attention and publicity for the kente industry. I think that people, especially of African descent, should know that kente is a secret masterpiece, it's not just germane to Africans, it's germane to humanity.

— Dr. Charles Boateng, Kente Weaver and Professor of Political Science, Kean College, interviewed by Francina Radford, Newark, 1997

12.124˘

I would hate to see kente become a cloth of fashion [fig. 12.126] and then something trendy and then be abandoned, because it's something which has enjoyed the passage of time and is living. Kente is like the rich fabric of Ghanaian life—everything is brought together in kente.

— Dr. Merrick Posnansky, Professor Emeritus of African History, UCLA, interviewed by Aphrodite J. Dielubanza, Los Angeles, February 6, 1998

Edmund Phillips and George Asamoah-Duodu, both formerly of Ghana, had the following comments:

Something you value so much, you shouldn't make sneakers out of it. That makes me upset. They're disgracing the value of it.

— Edmund Phillips, Staff Member, The Newark Museum, interviewed by Francina Radford and Georgina McLeod, Newark, 1997 (fig. 12.127)

I believe the cloth is kind of gold. Our belief in Ghana is that we came from gold. When you see somebody wearing the kente it kind of makes you feel power, big—how precious to have such a thing. Here in the United States, it's a fashion thing. To me they don't have similar views to us, and they act like it's an ordinary cloth. It makes you a little upset.

— George Asamoah-Duodu, Staff Member, The Newark Museum, interviewed by Prunella Booker, Newark, 1997

12.127˘ 12.125˘

12.126˘

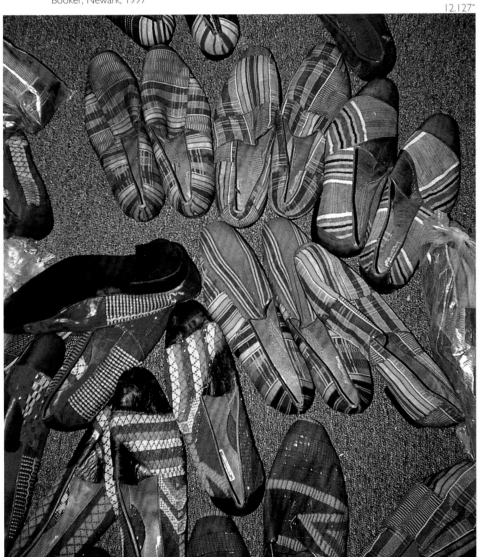

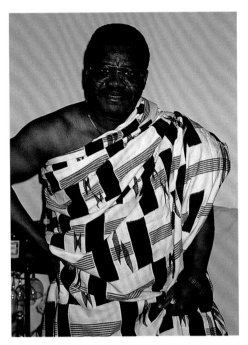

12.128 Augustine Nnuro, Engineer and Chief Linguist, Asante Cultural Society, in one of his many kente cloths. Photograph by Kristen Quine, Los Angeles, February 1998.

On the other side of the debate, the students gathered the following comments:

Until I came here I didn't know there was a high demand for kente among African Americans. And if [they] have this demand, I don't think the level of production in Ghana could meet their demand. So it's fine if somebody was smart enough to find a way to produce it to meet the demand. It's fine, it's fine. Otherwise, it would've been very prohibitive to buy kente if it continued to be made by hand as we do back home. I'm telling you it takes about two months to make one, so how long would it take to market it to about thirty million African Americans. . . . I think if I had the foresight, I would've done the same thing to become rich overnight.
— Augustine Nnuro, Engineer and Chief Linguist, Asante Cultural Society, interviewed by ` Aphrodite J. Dielubanza, Los Angeles, February 11, 1998 (fig. 12.128)

I feel that we have paid in blood, sweat, and tears to have this connection back to our homeland. . . . We are redefining what [we can do] and what not, because we have to establish our African presence in America. . . . So that might mean that if we are inspired to use the cloth in such a way that has never been used in the homeland, that it does not mean we're disrespecting the cloth. . . . We have created our own legacy, which is our birthright, to use the cloth to adorn ourselves, to beautify it, and to use in our rituals and other things. So I think we all need to relax a little bit about it, because it's all good. It's all good.
— Ahneva Ahneva, Designer/producer of Designers Network International, interviewed by Danielle E. Smith, Aphrodite J. Dielubanza, and Taaji Madyun, Los Angeles, July 1997

I wear kente on a lot of different occasions. I have a cummerbund for weddings. If I'm going out on business trips, I have a tie and a handkerchief, and I also wear an apron in the kitchen everyday. I also have sneakers if I'm going to a picnic. So all kinds of occasions. I also have a kente cloth bag that I use during the day. What especially appeals to me about kente is the colors, the different combinations and mix, and the fact that it's a connection to roots, the ethnicity of it.
— Captain Fateen Ziyad, Director, Community Relations, Newark Fire Department, interviewed by Tonya Johnson, Newark, March 3, 1997

I read an article indicating that some of the Ghanaians here are offended when they see cotton print that is not even kente cloth worn, maybe across somebody's behind or on a pair of jeans or something like that, because kente is a very special kind of cloth. But at the same time they're honored because at least there is some consciousness of the cloth here in the States. I guess it's a two-edged sword, so to speak.
— Vanessa Freeland Thomas, Home Economics Teacher, Irvington High School, interviewed by Janel Watts, Newark, 1997

A few of those the students spoke with demanded that the African American community take responsibility for learning to identify and appreciate genuine kente. This sentiment was often expressed in concert with the sentiment that Black-owned businesses should import quality merchandise and, in turn, receive the support of Black Americans.

It's really important that our people understand the idea of being loyal to our own products and understand what they are. If we don't understand that we have to buy things made by African people, we'll buy these other things because they're cheaper and our people won't have jobs. They won't be able to feed their own people because there's no business. So this is what has happened with kente cloth—it got knocked off by the Koreans, and the cheaper, less significant kinds of kente cloth came through, and people would buy that.
— Gloria Imani Jackson, Owner of Ile Olukun African Department Store, interviewed by Janel Watts, Newark, March 3, 1997

"We Can't Seem to Have Anything That's Uniquely Ours": The Conflict Concerning Ownership

I find it annoying when Caucasians wear kente. There are certain things, like kente or wearing your hair in braids, natural hairstyles, that I consider uniquely African American. I think that they relate back to our heritage, about who we are and what we are, whether we recognize our history that far back or not. It's very obvious that it's the root for us. I'm not always comfortable that others might have the reverence that we do, but I can't speak for everybody. I also find it a little annoying that we can't seem to have anything that's uniquely ours.
— Mary Puryear, Program Officer, Community Resources Department, The Prudential Foundation, interviewed by Janel Watts, Newark, August 6, 1997

If I see European Americans or Italians wearing kente, it shows that at least they are involved in something outside their culture. I think that's good. And most of the time it's surprising [to find] they understand more [about] the culture, why they're wearing it and where it came from, than a lot of African Americans do. . . . So I don't have a problem with people other than African Americans wearing kente.
> —Captain Fateen Ziyad, Director, Community Relations, Newark Fire Department, interviewed by Tonya Johnson, March 3, 1997

The students discovered that one of the most heated topics that arose in their interviews was that of cultural ownership. Following their interviews, the students often shared with each other and with teachers and museum staff the degree of emotionality that this issue called forth. Some interviews were full of anger about the "theft" of kente by individuals of non-African heritage. Others reflected a sense that kente as a unique badge of African identity had been lost. Still others saw the use of kente by a more general populace as a good thing—a sign that African traditions are no longer being marginalized.

> White people always impose themselves into everything, and I resent it. It's this whole issue that we can never have anything by ourselves. It's personal, it's your culture, your clothes—they denote who you are.
> —Margie Shaheed, Administrative Assistant, New Community Corporation, interviewed by Janel Watts, Newark, April 14, 1997

> I have no problem with White Americans wearing kente because we wear other people's clothing, and it's really flattering to see someone else love our culture enough to wear it.
> —Barbara King, Vice President, Africa Newark Cultural Organization, interviewed by Nadirah Keith, Newark, 1997

> I don't feel you [should] wear another culture's ceremonial cloth . . . and Whites are very much like us . . . they don't know that it's ceremonial either. They just think it's the latest thing. But personally I have a problem with it, and I know that many people who do it don't do it out of disrespect . . . they just think it's the newest thing to do. But it does bother me. It bothers me because for so many years, hundreds of years, we have had nothing to identify with that was either beautiful, or had dignity, or belonged to us that any of us could say was African.
> —Carolyn Whitley, Coordinator of Student Activities, Newark Public Schools, interviewed by Aja Davis and Danielle Scarborough, Newark 1997 (fig. 12.129)

12.129 Carolyn Whitley, Coordinator of Student Activities, Newark Public Schools. Photograph by Aja Davis and Danielle Scarborough, Newark, 1997.

"We Come from Kings and Queens": Kente, a Royal Cloth

When I wear kente, I feel very royal. I feel like I am very special.
—Gloria Imani Jackson, Owner of Ile Olukun African Department Store,
interviewed by Janel Watts, Newark, March 3, 1997

People should realize when wearing kente cloth that since it is a royal fabric, they should act like royal people, people who are dignified, people who have respect for each other. Unfortunately, sometimes people just wear [something] because it is popular.
—Sharon vann Williams, Missionary and Youth Group Worker, St. John's Unified
Free Will Baptist Church, interviewed by Najah Dupree, Newark, February 21, 1997

The students found that discussions of kente frequently mentioned its association with royalty. More often than not, this connection evoked an emotional response and was felt to impose certain responsibilities on the wearer. Many individuals insisted that wearing kente required a change of demeanor and that putting the cloth on made you feel "different." Many felt, in fact, that kente metaphorically transported them to Africa, to a place of pride and royal heritage.

Sometimes if I think I have to deal with certain people, and I need strength . . . I'll wear kente.
—Mary Puryear, Program Officer, The Prudential Foundation, interviewed by Janel Watts,
Newark, August 6, 1997

When I wear kente cloth it says I'm from Africa. I'm royalty. We come from kings and queens, not the slavery bit we've all come to know. So kente makes me feel a part of Africa.
Marita McEntyre, Graduate, Essex County College, interviewed by Nadirah Keith, Newark, 1997

When I wear kente I tend to act differently, I tend to walk around more proudly. I think I stand more erect. My shoulders are straight, my chest is out. I am somebody.
—Sharpe James, Mayor of Newark, interviewed by Francina Radford and Janel Watts, Newark, 1997

I just feel when I'm wearing kente I'm an African woman in her royal garments. I feel as though I'm an African woman all the time, but when wearing the clothing, it just transforms you. It's like you just have on your royal garments that day.
—Ellen Ugdah-Gningue, Facilities Manager, Essex County College, interviewed by Janel Watts,
Newark, July 31, 1997

Most of the Ghanaians interviewed approached the wearing of kente with great seriousness. Kente's connections with one's heritage and identity were so central that acclaimed Ghanaian poet Abena Busia (see chapter 4), now an English professor at Rutgers University, commented to students:

I always used to go to conferences and wear power suits. It was when I was asked to give a poetry reading, and I was trying to figure out what to wear, that I realized I just couldn't wear a power suit or even a nice cocktail dress. You see my poetry is very special—I feel it comes from inside me—I realized I didn't want to do a poetry reading wearing what I considered European dress. Since then I've always given poetry readings and lectures wearing Ghanaian dress and often carrying kente cloth.
—Abena Busia, Poet and English Professor, Rutgers University, interviewed by Erica
Moore and Prunella Booker, May 28, 1997

I normally dress traditionally when I'm going to ceremonies like weddings, "out-doorings," and to meet friends who are from Africa. If there is a ceremony I put kente on just to identify myself as to where I come from or who I am. It's something we cherish, part of our culture. It's part of you, it identifies who you are, and that's why we cherish it and want to put it on. It's different from jeans or a school uniform because kente signifies and tells who you are, so you feel differently.
—Walter Amoah, Medical Student, Montclair University, interviewed by Prunella
Booker, New Jersey, July 22, 1997

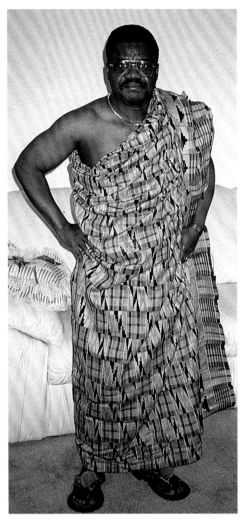

12.130 Augustine Nnuro, Engineer and Chief Linguist, Asante Cultural Society, in one of his many kente cloths. Photograph by Kristen Quine, Los Angeles, February 1998.

12.131 Nana Kofi Enin and his wife on the occasion of his installment as Southern California Asante chief. Photographer unknown, Los Angeles, April 1995. Courtesy of Shades of L.A. Archives/Los Angeles Public Library.

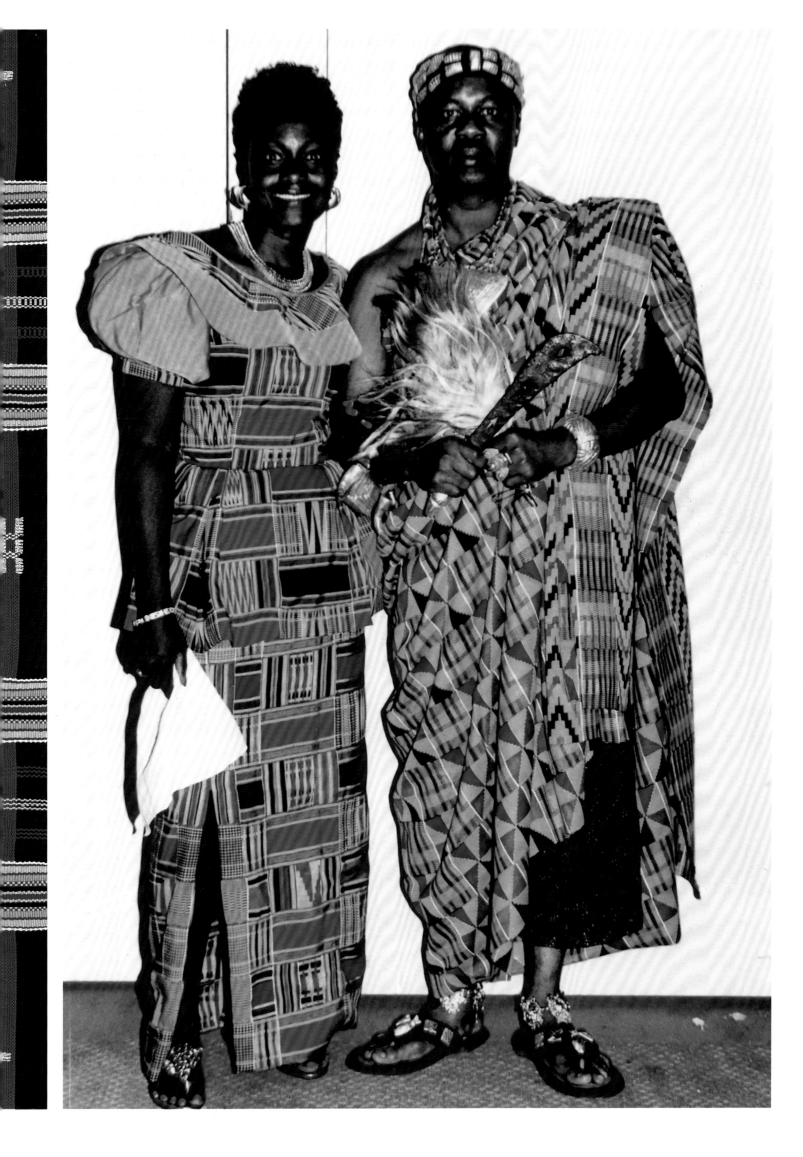

12.132ˆ

"Kente Carries Both Color and Philosophy": The Colors of Kente

In conversations about kente's appeal as a royal cloth, people also spoke at length about its color (fig. 12.132). Comments ranged from simple exclamations concerning the beauty and complexity of kente's coloration to explanations of its color symbolism. Those interviewed frequently described kente's rich and vibrant palette and remarked that the brilliant colors represented joy and celebration for them. The initial attraction to color often led to research and a discovery of the cloth's origin and meaning:

> Kente appeals to me because of the bright colors—you can mix and match it with your clothes, also the colors all symbolize something. Each color has a different meaning.
> —Mary Cudjoe, Director, New Jersey Martin Luther King Commission, Newark, interviewed by Prunella Booker, Newark, August 12, 1997

> What really appeals to me about kente is the colors, the designs, and the fact that it belongs to this one people. It's their thing and they're so proud of it. When I went to Ghana, I was blinded. It's amazing. It's not just the material, it's the people. It's like their heart is in this.
> —Stephanie Hughley, Program Director, New Jersey Performing Arts Center, Newark, interviewed by Francina Radford, Newark, 1997 (fig. 12.133)

> It's really beautiful when you see a lot of Ghanaians in kente. In the holiest celebration in Rome all the Ghanaians put on kente cloth. At Saint Peter's as soon as they appeared there was an uproar and everybody clapped because it was colorful, it was beautiful. The Pope even commented, "This is beautiful. Clap for Ghanaians."
> —Father John Oppong Baah, Queen of Angels Roman Catholic Church, interviewed by Janel Watts, Newark, August 3, 1997

> When I saw [kente] for the first time about thirty years ago, I just immediately had an affinity for it even before I knew what it was or where it came from. The color, the design . . . I don't know if that's because of my background as an artist, but something about the fabric, the patterns, and the colors spoke to me.
> —Carolyn Whitley, Coordinator of Student Activities, Newark Public Schools, Newark, interviewed by Aja Davis and Danielle Scarborough, Newark, August 8, 1997

Statements about the color symbolism of kente varied markedly. They included very personal explanations and often involved discussions of the red, black, and green that have come to symbolize African unity (largely as the result of the efforts of Marcus Garvey, see Ross, chapter 10). Reverend Cecil L. Murray, from First A.M.E. Church in Los Angeles, remarked:

> The colors mean different things of course. Red, the . . . very vital force of the earth, the bloodline. Blue is the color of the sky. Black the color of the night and the color of storm. Yellow is the opening, the dawning. Purple, the symbol of the soul that can be lifted thus as kings—you can go from a stable boy to a king or queen. So the colors have great significance. Red, black, and green are my favorites because those have come to be accepted in America as the freedom colors. . . . With kente you not only can have [style] but you can also have a philosophy, a deep underlying truth about freedom, about dignity, about culture, and about where our slave people have come from. So kente carries both color and philosophy.
> —Reverend Cecil L. Murray, First A.M.E. Church, interviewed by Maritza Mejia, Los Angeles, January 9, 1997

> The gold is for the gold they stole, the black is for the people, and the green is for the land. The red is my favorite because it stands for the blood my ancestors shed.
> —Sharon Givens, American Barber College Instructor, interviewed by Monique Lane, Los Angeles, 1997

> Well for my knowledge, red means blood shed, yellow is the gold that has been stolen. Green is like the land, black is people, meaning the whole human race.
> —Abdul Mhuzi, Kilimanjaro International, interviewed by Aisha Kennedy, Los Angeles, December 27, 1996

> I know the gold is for, you know, the prosperity of Ghana and sometimes you have the red. The red symbolized the blood that people shed in order to gain independence from the British, and sometimes you have the black strips there too. That indicates our race and our pride of our race.
> —Patrick Adongo, Businessman, interviewed by Danielle E. Smith, Los Angeles, December 29, 1996

12.133ˇ

12.136ˇ

12.137ˇ

12.134ˇ 12.135ˇ

12.132 Detail of Babadua motif sections and warp-stripe pattern in the colors of African unity. Asante cloth. Length of cloth 328 cm. FMCH X97.36.2.

12.133 Stephanie Hughley, Program Director, New Jersey Performing Arts Center (right), and Francina Radford. Photograph by Nadirah Keith, Newark, 1997.

12.134 Detail of Babadua motif in the colors of African unity. Asante cloth. Rayon. Length of cloth 183 cm. Private collection.

12.135 Detail of Asante cloth. Rayon. Length of cloth 163.5 cm. FMCH X95.51.18. Anonymous gift.

12.136 Detail of Asante cloth. Rayon. Length 183 cm. Private collection.

12.137 Detail of Asante cloth. Rayon. Length 196.5 cm. Private collection.

12.138^

"It's like History to Be Passed On": The Meanings of Kente

Kente fabric has a very long and deep history, and I've always admired the patterns. Kente tells a story, and it has a meaning. So it's like history to be passed on. It brings more Black pride into the community. It's something that everyone can relate to.
 —Marate Kristos, Newark Festival of People, interviewed by Francina Radford, Newark, June 1997

Beauty, connectedness to the Motherland, communal wisdom, sense of family and identity, pride, struggle, and survival: thoughts about the meaning of kente are as diverse as kente cloths themselves. When students posed the question "What does kente mean to you?" they received responses that reflected a multiplicity of experiences and associations with the cloth. Ghanaians spoke passionately about kente and their national identity, about its connection with the pride and dignity of Ghana, and about its meaning as a cloth for very special events. African Americans spoke of kente's role in shaping one's identity and tracing one's roots. A sampling of the replies the students documented appear below.

Kente Means Fashion and Style

It means that I am connected to a very rich and glorious legacy that Africa gave to the world. So it's a wonderful, wonderful experience to know that I'm connected to the origin of fashion, to the origin of technique in fashion. . . . It represents who we are, and when you wear your culture, you certainly wear your crown. When you walk into the room, you are a queen by birthright, and people are bowing, they're kissing your hand, they're stepping out of the way, then you walk through.
 —Ahneva Ahneva, Designer/producer of Designers Network International, Los Angeles, interviewed by Danielle E. Smith, Aphrodite J. Dielubanza, and Taaji Madyun, July 1997

Kente cloth represents royalty, wealth, and richness so when you wear a piece of kente cloth, it's a statement, a fashion statement. I have some associates who wear just a strip across their shoulder, as a wrap on their head with their regular clothing. It's just the kente cloth that stands out. Kente is a very alluring product. You can't wear kente without it drawing attention.
 —Muneerah Naazier, Owner of Muneerah Cultural Shock Boutique, as interviewed by Aphrodite J. Dielubanza, Los Angeles, January 7, 1997

Kente Means Dignity

Kente cloth means dignity, freedom, liberation, joining hands, love. The significance of kente cloth is the significance of dignity . . . grass doesn't just spring up, grass has roots. This is especially important for African Americans because we were told that we just sprang up—that we're just here in America with no ties to any other nation. And if we do have ties, it's a heathen culture. We know now, of course, that all civilizations, all culture, all people sprang from Africa. African Americans then are among the oldest stock in the world so the kente cloth says essentially you belong somewhere.
 —Reverend Cecil L. Murray, First A.M.E. Church, interviewed by Maritza Mejia, Los Angeles, January 9, 1997

12.138 First Lady Nana Konadu Agyeman-Rawlings and her husband President Jerry Rawlings of Ghana receiving a special recognition award presented by entertainer Michael Jackson. Photograph by Howard Bingham, Los Angeles, 1995.

12.139 Kabu Okai-Davies, Founder and Director, African Globe Studio Theatre. Photograph by Francina Radford, Newark, 1998.

Kente Means Struggle and History

I don't know too much about the cloth, but I have seen important individuals wear it. I think it gives Blacks a sense of definition. It's something to remind us of the Motherland. Kente cloth itself represents the struggle of an entire race of peoples. I believe that kente serves as no threat to White people who respect African Americans. I do believe, however, that kente is a major threat to Whites who are fearful of Black unity and the rise of success of the Black race.

 —Edward McGowan, Retired Salesman, interviewed by Monique Lane, Los Angeles, 1997

Kente Means Survival

As an African, there's more to kente than just a social significance. You know, it's the history, it's the value. The history of kente cloth is the history of the Asante people. But the important thing is, in spite of all the Western commercialization and industrialization and commodity-based products, kente was still able to maintain its originality. Kente was still able to remain African, and, therefore, the process of creating kente was linked to the spiritual and cultural fabric of life itself. Kente cloth was so deeply rooted in the cultural and royal life of the Asante people that unless the tradition is totally destroyed, kente will always survive. African Americans can always go back to kente as a point of reference, as a point of future attachment to Africa. I think we as people of African origin must grab on to it in a very spiritual way. That is what is going to maintain its value both as a material and as a cultural symbol.

 —Kabu Okai-Davies, Founder and Director, African Globe Studio Theatre, interviewed by Francina Radford, Newark, 1997 (fig. 12.139)

Kente Means Family

I'm a native of Ghana. My dad had some kente, my mom had some kente; it was important because it wasn't something they wore everyday. Even if you were going to church, it had to be Christmas or Easter, you wouldn't wear it every Sunday going to church. When somebody puts his or her kente outfit on you know it's a special occasion. I have a picture of my sister in hers, and it's her graduation, so it's a very special occasion.

 —Arnold Adjepong, Owner of Kente Concepts, interviewed by Ugochuku Nwachukwu, Newark, April 14, 1997

Kente is a symbol of pride and confidence. It shows very much in my culture, and I think if you remove kente, the symbol is gone, my pride is gone as an Asante. It is very symbolic to me. It identifies me as an Asante, so it is very special to me.

 —Augustine Nnuro, Engineer and Chief Linguist, Asante Cultural Society, Los Angeles, interviewed by Aphrodite J. Dielubanza

12.139^

"I Stand Up a Little Taller When I Wear Kente": Kente and Pride

If one were to search the students' interviews for a single phrase that would give a sense of the cloth and its importance, that phrase would clearly indicate the feeling of pride that kente engenders. Pride in wearing kente, pride in its connections with Africa, pride in one's African heritage, pride in the cloth's beauty. A significant number of people (in fact, roughly half of the individuals) interviewed spoke of kente making them feel proud or being filled with pride when they used it, wore it, or even thought about it in connection with their African roots.

> I think perhaps I stand up a little taller when I wear kente. There is a sense of pride that one feels when wearing something from the Motherland. Having been there and actually watched the weaving and having had the opportunity to purchase pieces in Ghana gives me a special feeling, and I think I do feel a little different.
> —Karen Smith-Phillips, Lawyer, interviewed by Wendy Jean-Louis, Newark, April 7, 1997

> Kente, of course, means pride. When I see an African American wearing kente, I know they're proud of themselves and our culture. Kente stands out more than other African cloths because of its color and unique patterns. When something stands out so strong, it has to make a statement. If I could, I would buy an umbrella, a pair of socks, a pillow, another hat. I would buy a kente jacket, and a purse. If there's kente lingerie out there, I would buy that too.
> —Terry Gullivan-Smith, Home Healthcare Nurse, interviewed by Aphrodite J. Dielubanza, Los Angeles, February 8, 1997

> One of my beliefs is that whatever you wear, you need to feel comfortable in it, and I believe that if you are proud . . . you should be proud wearing something that came from your people, and kente cloth comes from our people. So when we wear it, we must wear it with pride and wear it well.
> —Patsy Johnson, Owner of PJ's Choir Robes, interviewed by Danielle E. Smith, Aphrodite J. Dielubanza, and Taaji Madyun, Los Angeles, July 21, 1997

> Well to me, when I look at a piece of kente cloth, it's a part of our heritage, part of our culture as African people, and it just gives me great pride, knowing that one of our people wove this fabric, and I have a little understanding of the process.
> —Laura Beth Hendrix, Entrepreneur, interviewed by Danielle E. Smith, Los Angeles, January 2, 1997

> I wear kente dresses, hats, and scarves on different occasions—some formal, some informal. I feel kente cloth is more than a fashion statement, it's a cultural statement, or a cultural artifact—if you will. Kente symbolizes Africa to me, and it stands for the sacrifices made for me to enjoy the privileges that I have to enjoy. I feel closer to my people, closer to my heritage. It's a proud feeling when I'm wearing African fabric.
> —Mary Cudjoe, Director, New Jersey Martin Luther King Commission, interviewed by Prunella Booker, Newark, August 12, 1997

> I have several [kente], and I am proud of them. When I wear kente in the United States, I use them for special occasions such as dinners for a head of state or when I have to give speeches. Since I live in the United States, the cultural message that I'm sending when I wear kente is how proud I am about my Ghanaian and African roots.
> —Nii Akuetteh, Consultant and Professor, Georgetown University, interviewed by Tracy Marcus, Newark, 1997

Kente Is Not About Pride; "It's About Dignity"

In the course of the interviews the words *pride* and *dignity* were frequently employed to describe kente's significance for the individual as well as for the African American community. Is one term better than the other? Webster's Dictionary defines *pride* as "the quality or state of being proud, a reasonable or justifiable self-respect"; *dignity* is defined as "the quality or state of being worthy, honored or esteemed." Beyond these definitions, what are the politics of pride and the politics of dignity and how might these inform an understanding of kente in America. Should the title of our exhibition, *Wrapped in Pride*, actually have been *Wrapped in Dignity*?

The choice of an exhibition title is not taken lightly in planning a project of this scale. It was, in fact, a topic of serious debate among the students enrolled in the course and among members of the museum staffs. Our discussions considered subtle shadings of meaning, the associations of particular words and phrases within the African American community, and the vocabulary most often used by interviewees to describe kente. In the end the comments collected in interviews indicated to us that the word *pride* seemed to resonate most strongly for the students, museum staffs, and the communities in Los Angeles and Newark. It also best captured kente's close association with the Black Pride movement of the last twenty years.

Dr. Maulana Karenga, however, had a different perspective, and he shared his thoughts on the meanings of *pride* and *dignity* during a student interview.

Kente should be projected [in the exhibition] not as a source of pride but as a source of dignity. That's because the kente represents not only the culture of rootedness in a general sense but it represents a certain assumption of dignity by embracing your culture and walking with the self-respect and self-understanding that reflects the best of African dignity. Usually kente cloth is thought of in wrong terms, but our argument is that it's not too much royalty in the [sense of] kingship and queenship [but rather] royalty in rightness and in dignity. You carry yourself in such a way, in such dignity that you represent royalty in dignity. Pride is like a diminutive kind of way of referring to Black people, as if they always need therapy, [as if] they need to feel good about themselves. That's not good. What is important is dignity, self-respect based on grandness, culture rootedness, and understanding that you use your culture as a resource rather than a reference. Soon as I wrap myself in the dignity of the cloth, it is a reminder of the history and culture from which I come and my obligation to always bring forth the best to what it means to be African and human in the fullest sense. When I drape, when I'm stepping forward, I'm stepping in dignity. It's not anything about pride, it's in dignity. I'm bearing the burden and glory of the most ancient history in the world.

It's about dignity, a reminder of our dignity and to walk in dignity and to insist on equal respect and mutual respect and equal regard from the rest of the world. If one doesn't root himself and bring out the best in his culture, then what is the culture for? I don't want the opinions of European Americans to always reduce what we are doing to pride. The art is pride, the cloth is pride, the song is pride, the holiday is pride . . . is there anything we can talk about that they don't call pride? We have to insist on another word.
—Dr. Maulana Karenga, Chair, Black Studies Department, California State University, Long Beach, interviewed by LaRon Young, Los Angeles, January 5, 1997

12.140 Commercially printed kente upholsters the seat and knee rest of this computer chair, which was purchased by Crenshaw High School student Danielle E. Smith for the *Wrapped in Pride* exhibition. Length 80.5 cm. Private collection.

"I Never Knew Where It Came From":
Student Perspectives on the Meanings of Kente

To return to the Los Angeles students' reflections on the cloth that they had devoted so much time to studying is perhaps the appropriate way to end our "Stories of Kente." Many of the students entered the course with little knowledge of the textiles, a modest understanding of African history, and only vague ideas about the workings of museums and the nature of exhibitions. Some of the students could place kente in Ghana, others could vaguely describe its appearance, and a few had never heard of it.

Unlike many of those with whom they would later speak, the students' embrace of kente was rarely political. They told us quite frankly that they themselves would rarely wear kente. As teenagers, they preferred jeans and a sweatshirt. Several of them felt, however, that there were occasions when wearing kente was absolutely appropriate for their generation: graduation, "African Heritage Days" held at school, church events, or awards ceremonies. They might own a piece of kente or a kente-style object—stationery, a stuffed animal, an umbrella, or a pillow—but it was not an integral part of their public presentation.

The comments that follow reveal some of the insights the students gained from talking to community members. They suggest, as well, how the students' perceptions of kente, of their own histories and identities, and of Africa were transformed over the course of the year. In the process of their research and in choosing objects for the exhibition, they had come to consider and give clear voice to what kente meant to them.

> It's been very enlightening for me. I've always wondered about the meaning and symbolism of kente cloth. I've worn it and knew it was part of my heritage, but I never knew where it came from or how it originated. This class has taught me things I can take home, and be proud to share with my family.
> —Danielle E. Smith, Crenshaw High School Student

> Kente is us.
> Kente is you.
> Kente is beauty and pride
> that overflows from you.
> Remember our African heritage.
> It is me.
> It is you.
> —Taaji Madyun, Crenshaw High School Student

> From bookmarks to bandages, kente designs are on everything whether we realize it or not. It's amazing how kente started in Africa and has become one of the most popular and well-recognized cloths in the United States as well as abroad.
> —Sadikifu Shabazz, Crenshaw High School Student

> To me, kente . . . used to be just a piece of cloth. Getting involved in the museum studies class, however, changed my way of thinking. I was able to learn about the significance of this cloth, which seems to be appealing to so many people, including myself. I also became appreciative of this cloth once I learned about the hardship and cultural value behind it. The class has inspired and encouraged me to learn more about something that once had little importance and meaning to me. Kente to me, now, makes a strong cultural statement.
> —Aphrodite J. Dielubanza, Crenshaw High School Student

One of the things that I thought was very interesting was the fact that very few people knew much about kente. A lot of the responses I got when I asked different people what kente cloth was that it was a cloth that meant Black pride.
　　—Sadikifu Shabazz, Crenshaw High School Student

My outlook on African cultures has grown more positive as a result of studying kente. . . . I have found a real connection with Africa beyond just wearing African colors, etc. Now I can walk with pride as I wear my kente hat, shirt, or jacket.
　　—Byron G. Williams, Crenshaw High School Student

I chose this matching kente sash and crown [to purchase for the exhibition] because the person who wears kente wears it to show pride in their heritage and ethnicity. A person who wears kente is not embarrassed of their roots and in wearing it is sending that message to other people. This set identifies the type of person you are, and it sends a very powerful fashion statement to the whole world.
　　—Maureen Barrios, Crenshaw High School Student

With this man's kente outfit [purchased for the exhibition] I feel that the person who would wear it will wear it with dignity. Their statement would be pride of culture, heritage, and roots.
　　—Maritza Mejia, Crenshaw High School Student

I chose this kente-covered computer chair [for the exhibition; fig. 12.140] because of what it represented to me. When I first saw this object, the fact that it was covered with kente cloth spoke to me in a very unique manner. Being that it is a chair—and there to literally support the weight of those who sit on it and figuratively to be the support base for not just individuals but entire groups of people—materialized in my mind's eye. I no longer beheld the chair as just a chair, but a symbol, an Americanized Asante stool so to speak, that had a utilitarian as well as symbolic purpose.
　　—Danielle E. Smith, Crenshaw High School Student

"Kente Is More Than Just a Cloth"

Kente is more than just a cloth, it is more than a symbol of African pride, it is a cultural icon. It is difficult to determine exactly what it means, because it means so many things to so many people.
　　—Amy Tariq, Crenshaw High School Student

As Amy Tariq has so aptly remarked, kente is "many things to so many people." For many, it is the visual icon of the Black political and social movements of the 1970s and 1980s. This association brings with it notions of pride, dignity, and heritage. Others regard kente as a sacred cloth that should not undergo change. Can kente be at once the heart of Ghanaian identity and a hot-selling commodity in the global market of the 1990s? Can it exist both as a baseball cap/backpack and as a cloth for the Asantehene? In its many manifestations, it is as complex as the communities that use and esteem it. Ghanaians relate that the use of kente in their homeland is changing as a result of the American experience. They do not necessarily speak of such changes in negative terms but often express interest at this transformation. Scholars and purists may debate such issues, but in the end kente continues to evolve and to speak to new generations, while remaining rich with meanings from the past. Kente may have begun as a royal cloth, as a cloth of status, as a cloth for Ghana, but in its ever-changing life, it has gained new meanings and will doubtless acquire even more for future generations.

Interleaf L
Stoles for All Occasions

Without question the most important handwoven kente commodity is the "stole," a single strip that may be woven in conventional patterns or may incorporate words, colors, and designs that reflect new audiences. Whether worn around the neck; sewn on the lapels, sleeves, or body of a garment; or incorporated into another product, the strip is a versatile and striking visual statement with substantial meaning for its users.

Organizations as diverse as the Masons, NAACP, African American churches, college fraternities and sororities, 100 Black Men, Isis, and the Soroptomists have commissioned stoles for their use. Hispanic groups have also commissioned stoles that bear inscriptions in Spanish (e.g., "*Classe de 1998*") and the colors of the home country (e.g., blue and white for Guatemala) incorporated into the weft-faced bands known as Babadua. (See Appendix 4 for a list of accession numbers.)

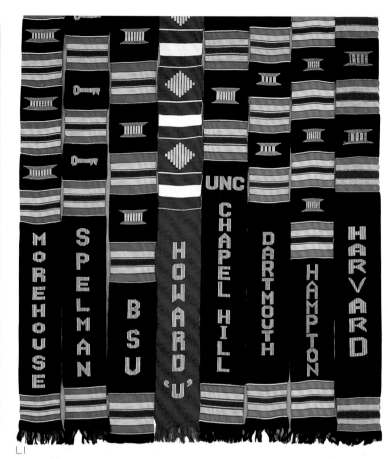

L.1

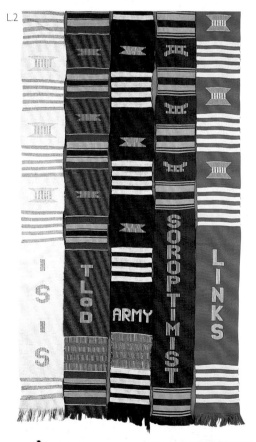

L.2

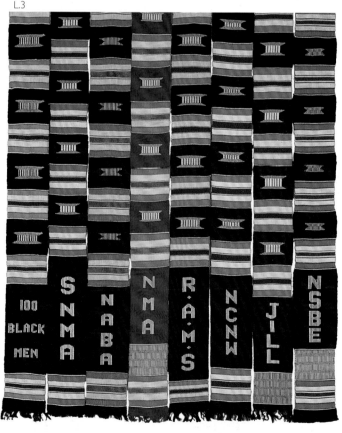

L.3

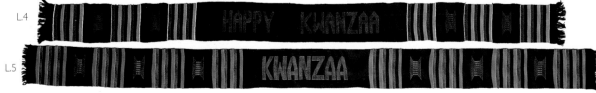

L.4

L.5

L.6

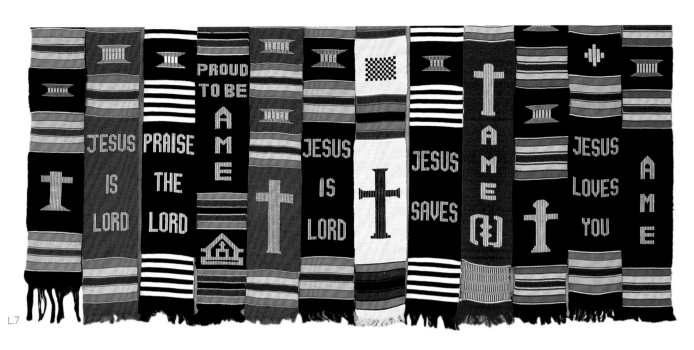

L.7

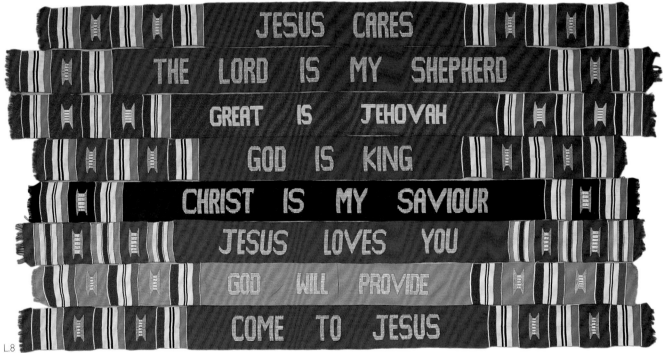

L.8

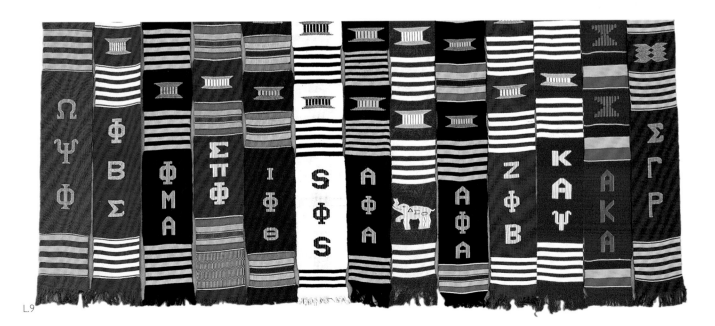

L.9

268

Interleaf M
"Still I Rise"

On Sunday, June 21, 1998, in UCLA's Drake Stadium, more than two hundred graduates, adorned in kente stoles, received their diplomas during "Still I Rise: The Nineteenth Annual UCLA All African Peoples' Graduation Celebration." The singing of the "Negro National Anthem," pouring of libations to ancestors, a reading of Maya Angelou's poem "Still I Rise," the delivery of inspirational speeches, and the presentation of dance performances set the stage for the conferring of degrees. Many of the graduates wore black, red, green, and gold stoles bearing the woven phrase "UCLA Class of 98." Members of sororities and fraternities wore kente strips bearing their organizations' letters and colors. Some of the students participating had also attended one of the sixteen official ceremonies held for graduate and undergraduate students and organized by field of study.

In contrast to many other universities, UCLA has historically been open to students wearing kente at commencement; but this year, in the wake of the reversal of the university's affirmative action policy, some university regents questioned the source of funding for and purpose of "separate" graduations—ceremonies that are distinguished by ethnically specific stoles, sashes, and other insignia. Photographs by Betsy D. Quick, 1998.

—Betsy D. Quick

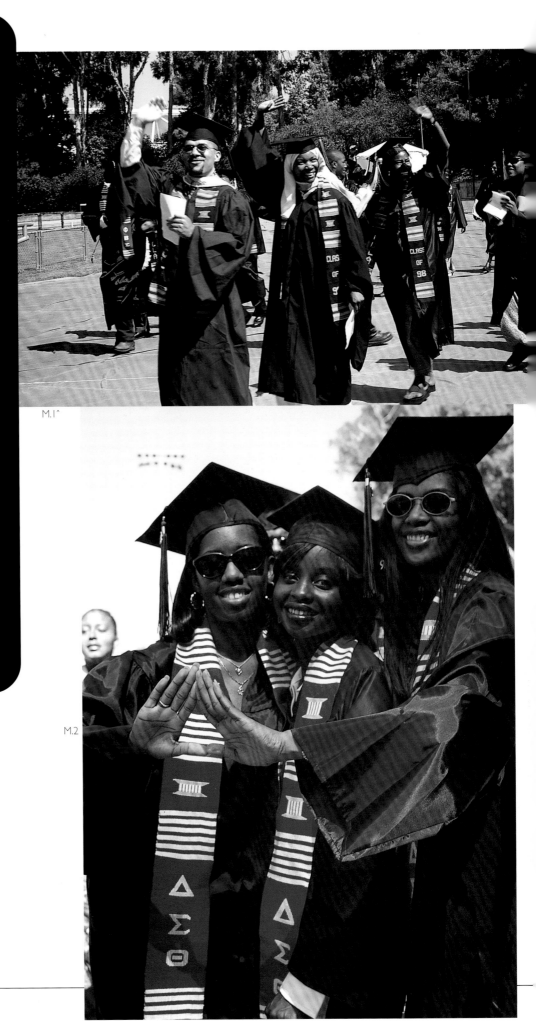

M.1

M.2

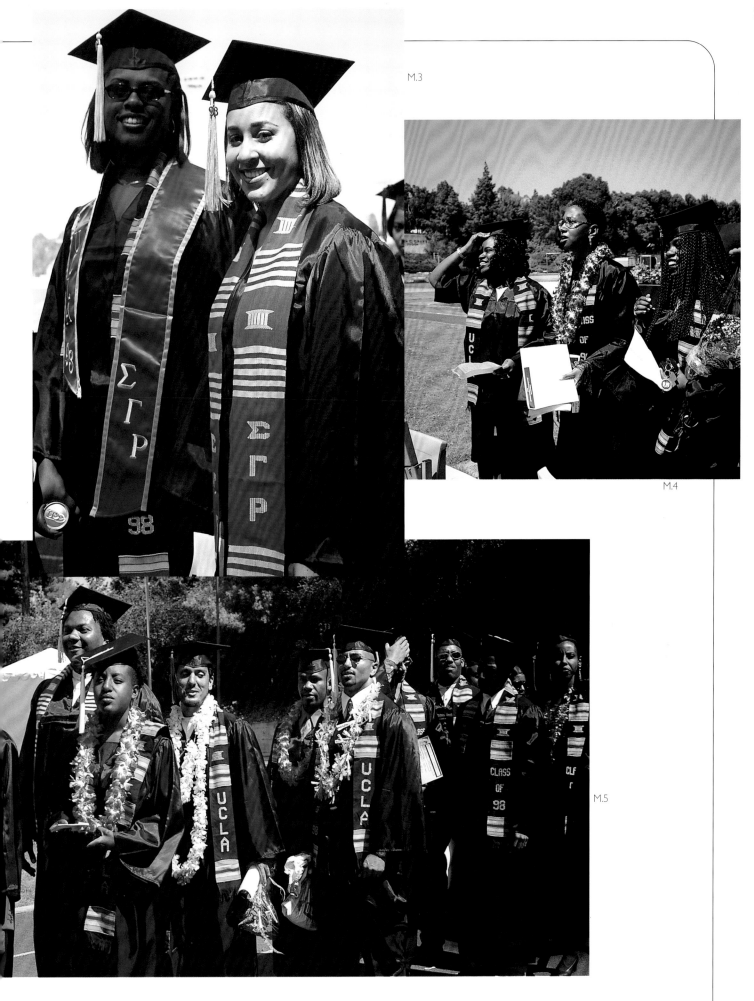

M.3

M.4

M.5

Interleaf N
Panafest '97

The Third Pan-African Historical Theatre Festival, popularly known as Panafest '97, was held in Cape Coast and Elmina from August 29 to September 7, 1997. It celebrated two themes: "The Re-Emergence of African Civilisation" and "Uniting the African Family for Development." Festival events included a memorial and remembrance day, visual arts exhibitions, a canoe regatta, *asafo* and fancy dress displays, a five-day Pan African Colloquium, and a large bazaar. An ambitious weaving demonstration featured at least fifteen looms and weavers from Bonwire. Accompanying the demonstration was a "Kente Revolution" fashion show. The marketplace featured a dramatic selection of handwoven cloths and kente adorned items. Photographs by Doran H. Ross, 1997.

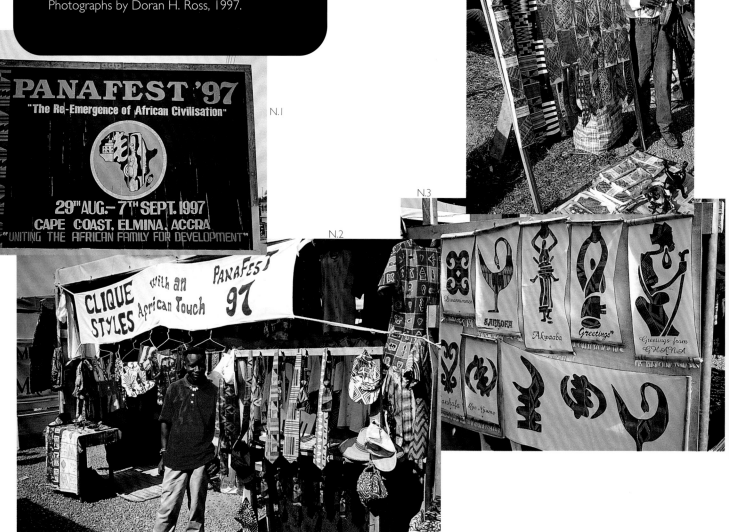

N.5

N.4

N.1

N.3

N.2

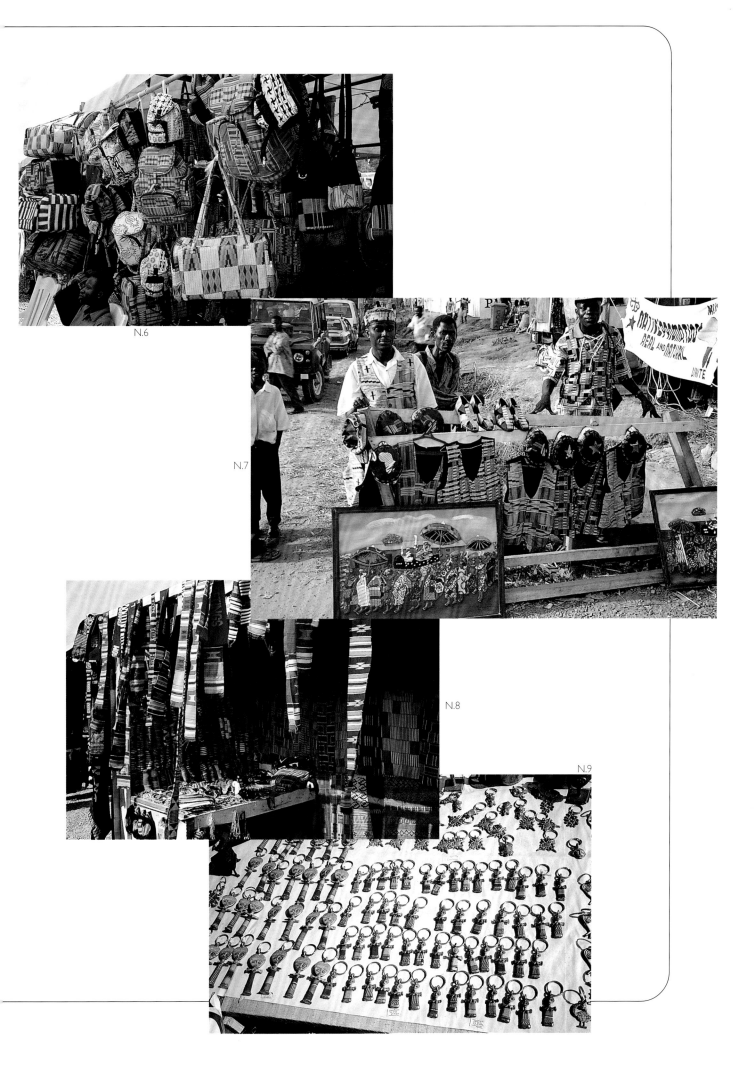

N.6

N.7

N.8

N.9

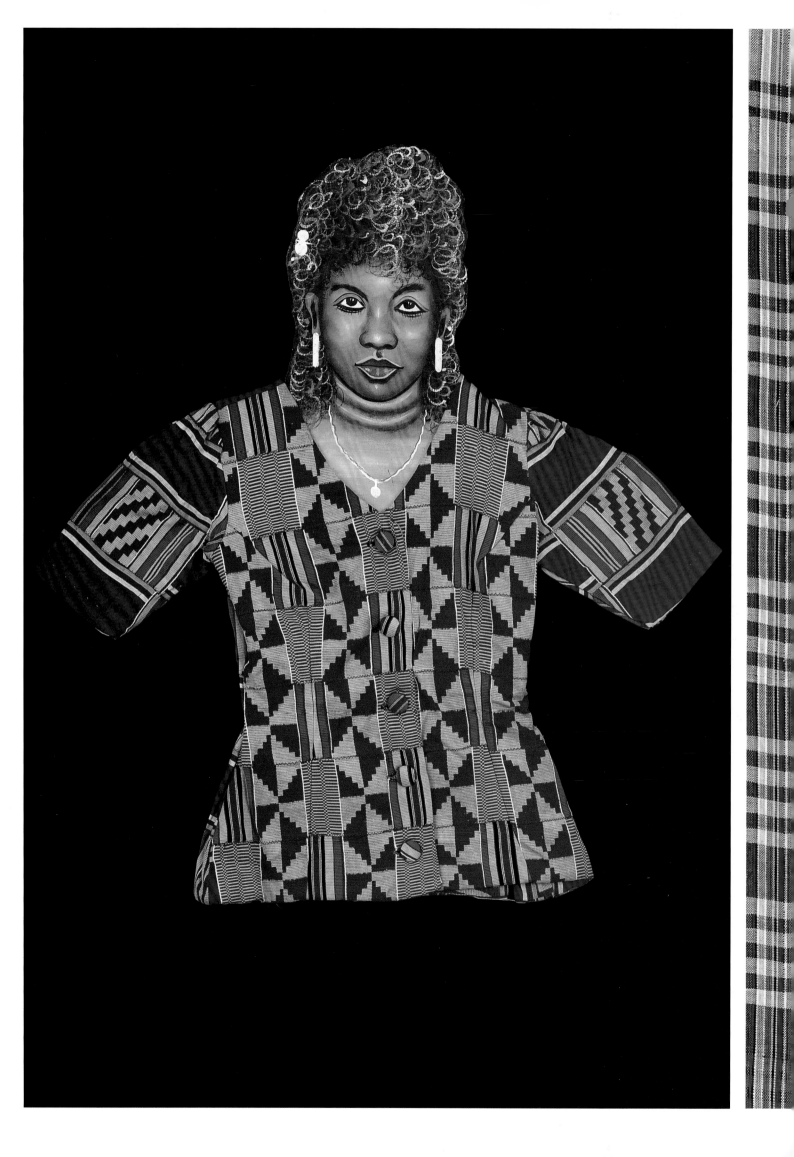

CHAPTER 13

Fashioned Heritage

Doran H. Ross

Is it any wonder we've embraced Ghana's beautiful kente cloth as our own? It appeals to our aesthetics and historic sense. It's fine with a catsuit or any other kind of suit. Kente has no borders.
—Washington 1991, 80

The history of kente is intricately tied to such problematic concepts as ethnicity, tradition, appropriation, commodification, identity, authenticity, simulacra, popular culture, and the souvenir, among others. Thus the previous chapters would seem to lend themselves to a postmodern analysis dealing with contemporary thinking about expressive culture. While I will touch upon some of the above-listed areas in this chapter, I will leave it to others to take the analysis into the realm where metanarratives joust with distortions of space and time in contests that conclude that there is no absolute knowledge. For those who make, sell, use, design with, or otherwise think about kente, these issues are intensely relevant, and they demand to be addressed further in a language that is as engaging and approachable as the textile itself.

While we have used the word *traditional* somewhat selectively throughout this volume, it is perhaps one of the most problematic of all the terms applied to the narrow-strip weaving practices of the Asante, Ewe, and related groups. The word itself suggests a certain unchanging continuity that is at odds with what we know of the history of these practices: the technology was in all probability introduced from the north; many of the materials and dyes were foreign in origin; cloths produced in distant places were unraveled so the threads could be reused; and when rayon and Lurex became available, they were rapidly embraced. Furthermore, when European-inspired, tailored styles became fashionable at the expense of wrapped and draped garments, kente was cut and sewn to follow the trend (fig. 13.1). When the written word gained currency, it became the woven word—first among the Ewe, then among the Asante (fig. 13.2). When single strips or stoles were sought by visitors to Ghana, either as affordable souvenirs in themselves or to be incorporated into a larger garment back home, weavers added extra lengths on their warps to produce a few additional strips.

Once a single strip was no longer destined for a larger cloth, it was available to be cut into something smaller. This led to the use of kente in the late 1960s in the hats, vests, purses, jewelry, and shoes already described (figs. 13.3–13.6). If we can speak of a "tradition" of kente, then these items must be included as part of that tradition. There are few, if any, textile "traditions" on the planet that have such a dynamic history. Certainly, there are few textile "traditions" wherein a square centimeter of cloth covers the surface of a single bead to become an earring.

13.1 Clothes hanger. Ghana. Plywood, paint. Height 47.3 cm. FMCH X96.30.41. Asante woman's blouse sewn from handwoven cloth. Width 89 cm. FMCH X97.36.15.

13.2 Ewe kente strips. Cotton, silk (?), rayon(?). Length of top strip 159.5 cm. Collection of Michelle Gilbert.

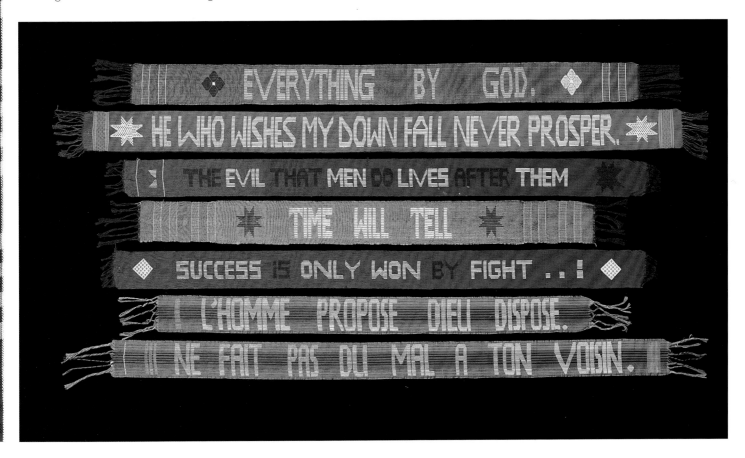

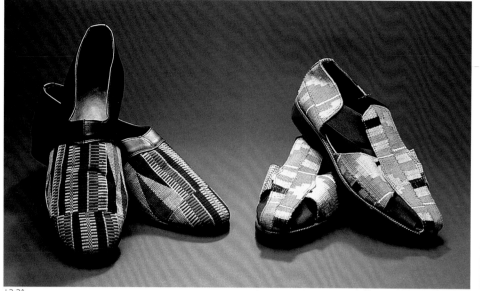

13.3ˆ

13.4ˆ

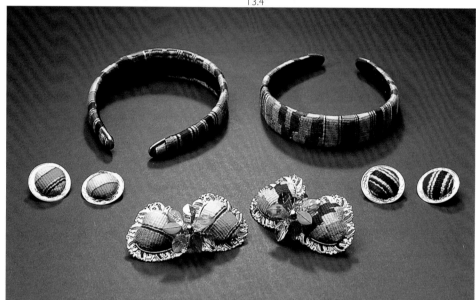

13.5ˆ

13.6ˇ

13.3 Shoes. Leather, rayon. Length of examples at left 32.2 cm. FMCH X98.24.1A-B; FMCH X97.36.13A-B.

13.4 Hair ornaments made from Asante strip-woven cloth. Rayon. Height 34 cm. Private collection.

13.5 Headband, barrettes, and earrings covered with Asante strip-woven cloth. Rayon, metal. Length of headband at left 14 cm. Private collection.

13.6 Barrettes covered with Asante strip-woven cloth. Rayon, metal. Length of example at top 13.5 cm. Private collection.

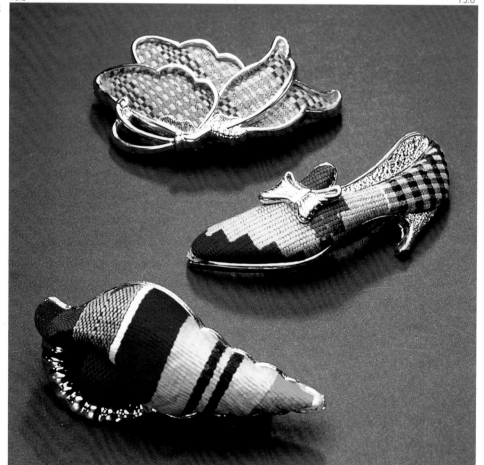

One of the main ambitions of this volume has been to bring the history of Ghanaian kente cloth up to date by describing recent developments on both sides of the Atlantic. To a large extent the history of kente in the United States revolves around events, art, and popular culture that can be encapsulated within a span of less than fifty years. Some of the principal contexts for the display of kente are connected with even more recent history. Black History Month, initiated in 1926, has only been widely embraced nationwide since the 1970s. Kwanzaa was created by Maulana Karenga in 1966. Martin Luther King Jr. Day was officially recognized in 1986. In movies as far apart in their sensibilities as Stephen Spielberg's *The Color Purple* (1985) and the Eddie Murphy vehicle *Coming to America* (1988), kente cloth has played a calculated role. Kente has figured prominently in the instances cited above and in others as a purposeful demonstration of Black consciousness, especially as it celebrates and identifies with Africa.

Although the cloth has both humble and regal associations, much of its considerably longer history in Ghana is about the increasing democratization of elite styles, designs, and materials. Concurrent with this is the accelerating commodification of a "traditional" art for outside audiences, many with backgrounds and tastes dramatically different from the Asante and Ewe. Some forty years after kente caught the attention of Americans on Kwame Nkrumah's historic visits to Washington, D.C., in 1958 and 1960, and during the subsequent pilgrimages of many African American leaders and others to Ghana, the textile is more widely embraced than ever as a bridge between Africa and the Americas. Fundamentally, this volume is about an African textile that has simultaneously found many homes in many countries, many forms within those homes, and many meanings within those forms.

Issues of identity have been a fashionable topic in the social sciences for many years. It is beyond the scope of this volume to even begin to address the many ongoing debates that surround such concepts as identity, personhood, and the self, although it is hoped that the essays included will provide an additional basis for further discussion of these issues. For our present purposes, however, we will embrace Joan W. Scott's definition, "[I]dentity is a fixed set of customs, practices, and meanings, an enduring heritage, a readily identifiable sociological category, a set of shared traits and/or experiences" (1992, 14).

Dress or self-adornment is, of course, only a small part of this definition—and some would argue, a superficial part at that. Yet responses to questions concerning the meaning of kente suggest otherwise. Below, we have listed words and phrases used to describe the textile. These personal associations have been excerpted from the writings of scholars, the responses of interviewees, and the reflections of students and others—almost all African American. Most of the words and phrases can be found within the pages of this volume. We have chosen in this instance not to identify their speakers or writers so as to avoid privileging any one voice. Likewise we have simply alphabetized the responses, so as to avoid favoring any one idea.

Kente is…

accomplishment achievement advancement Africanness Afrocentric artistic opinions beautiful beauty belief system belonging birthright blood, sweat, and tears bridge celebration ceremonial cherished colorful community compliment confidence connectedness consciousness raising cool a cultural difference cultural fabric a cultural root culture grounding dignity diversity endurance family fashion statement feeding the starving flattering formal frame freedom fun glorious good graceful growth a guest hardship healing heritage history honor hope hot identification individuality inspiration joining joining hands legacy liberation lineage linkage love love at first sight luxurious mix in different Motherland original ornate part of my ministry part of you personal power precious pride prosperity relevant reminder renewal representative reverent rich rightness rootedness royal sacred sacrifice sanctity seasonal self-determination self-presentation self-respect self-understanding sense of definition sign of the movement solidarity something we cherish special a special occasion spiritual stability stories strength structure struggle style survival symbolic togetherness transformation unity value walking statement warm wisdom

Although it is obviously not intended as any kind of empirical study, this list presents an amazingly rich series of associations. As should be clear, many of these words are synonymous or closely related. There are some tellingly consistent themes. Ideas related to "history," for example, *heritage, legacy, rootedness, birthright, Motherland, connectedness,* and *bridge,* are among some of the most common associations with kente. The word *pride* was used most frequently, perhaps recalling the "Black Pride" movement of the late 1960s and 1970s. Allied with pride are such qualities as *dignity, achievement, accomplishment, advancement.* Other words are drawn from the realm of religion such as *sacred, reverent, spiritual, healing,* and *sanctity.* Aesthetic dimensions are also preeminent in the choice of words such as *beautiful, colorful, glorious, graceful, ornate.* Befitting its history as a royal cloth, there are also a number of associations dealing with the wealthy and elite, for example, *precious, luxurious, rich, prosperity.* Even a cursory examination of the listed terms reveals an apparent and overwhelming emphasis on life-sustaining values: *strength, confidence, sacrifice, endurance, growth, struggle, power, renewal, survival.* It would be difficult to find another instance where such positive and passionate qualities are assigned to a textile by people who do not reside in its country of origin. But for many African Americans kente is from their "place" of origin in the largest sense. It is not as important that kente comes from Ghana as it is that it comes from Africa. The details are less significant than the bigger picture.

In the United States the attributes cited above are rarely attached to a specific named kente pattern or design. In fact at times, they are not even associated with the Asante people, or for that matter with Ghana, but rather with some generalized notion of Africa as the Motherland and as an enormous source of creativity. Nevertheless, these clusters of values and qualities do collectively align quite remarkably with those itemized by Ofori-Ansa in his chart of 1993 (fig. 8.1). And while Ofori-Ansa's work is slowly penetrating African American communities, it probably had little influence on the writers and interviewees who furnished the material from which we compiled the above list. Although we have no way to assess the situation prior to about 1950, it would appear that the construction of meaning in the kente genre is escalating with its expanding audience.

This expansion of meaning and the concomitant expansion of kente products have contributed to another hotly contested issue: What constitutes the appropriate use of kente? A significant number of Ghanaians feel that kente developed and should remain solely in the realm of festive dress. According to these individuals, any other uses are improper, disrespectful, or in bad taste. Ekow Quarcoo documented one such controversy:

> In 1992 there was a heated media battle in Ghana over whether or not it was proper to use Kente for any other purposes beside its traditional use as a dressing cloth. The debate was sparked off when a full-length Kente cloth was used as a tablecloth at a televised public function. The conservatives, or the conservationists, thought that the dignity of Kente had been vandalized while the revolutionaries argued in favour of the vast commercial potential of Kente and the dire need for diversification of its use. [1996, 26]

Ghanaian scholar and social critic Kwesi Yankah clearly takes sides in this debate:

> Today two out of three tourists visiting Ghana are eager to return home with a kente souvenir, bought directly from the village craftsmen, or other distribution outlets in Accra and Kumasi. Back home in Europe and America, to what use does the tourist put the kente? A few proudly wear them as blouses, shirts or skirts. Mainly, however, the kente is used by tourists as home decoration. In American and European homes, kente cloths are used as room drapings, and sometimes as table and bed-spreads—extended misapplications which Ghanaians would normally consider as culturally subversive. Kente was woven to be worn. [1990, 15]

Yankah seriously underestimates how frequently kente is actually worn outside of Ghana in its myriad forms, but he does recognize that "Among the uses to which the kente has been put in Black America, the two most graceful are in the worlds of religion and academia" (1990, 16). He singles out Bishop Barbara Harris (fig. 1.12) and Dr. Niara Sudarkasa (fig. 12.78) as exemplary.

Yankah's insistence on kente as a garment and his opposition to its use in the home are misguided on two points. First as should be clear from chapter 3, kente has a relatively long and substantial history of serving in a variety of capacities within Ghana. These include surface coverings for palanquins, umbrellas, shields, amulets, walls and beds during funerals, photographic backdrops, and probably other situations of which I am unaware. To this might be added the hanging of kente on walls with labels in the "Kente Exhibition" held

during the Bonwire Kente Festival of 1998. As mentioned in chapter 1, the presentation of kente as a museum object in Ghana dates to at least March 6, 1957, with the opening of the National Museum of Ghana in Accra. To restrict the use of kente to apparel is to deny the history and ultimately the versatility of the cloth itself. It also contradicts the ongoing democratization of the cloth over at least the past one hundred years.

A second misunderstanding relates to the use of kente as a runner, tablecloth, wall hanging, or bedspread (figs. 13.7, 13.8). In the United States among people of widely varied ethnic and cultural backgrounds, the above contexts are often reserved for valued family heirlooms. True, grandmother's intricately crocheted tablecloth would not be used on a daily basis, but like an admired kente, it might adorn the table on special occasions. Similarly, a quilt pieced together from grandmother's dress fabrics might no longer serve as a bed covering but might instead be transformed into a wall hanging. These are places of honor—contexts that may recall both recent and distant history, whether a visit to Ghana or a family legacy. Indeed, a large variety of kente products are being produced in Ghana today to be hung on the wall or otherwise prominently displayed in the house with considerable respect (figs. 13.9, 13.10).

13.7ˆ

13.8ˆ

13.9ˆ

13.10ˆ

13.7, 13.8 Furniture adorned with kente in the home of Annie E. Calomee, collected in Bonwire in 1974. Photograph by Taaji Madyun, Los Angeles, 1997.

13.9 Wall hangings featuring Asante handwoven strips. Rayon, iron. Height of example at left 114.5 cm. FMCH X98.24.2-5.

13.10 Wall hangings with machine-woven (left) and roller-printed (right) cloth. Ghana. Cotton, wood, metal. Height of example at left 91 cm. FMCH X95.51.39; FMCH X95.51.40.

Another especially important arena for the use or representation of kente is in contexts associated with education. Its presence in graduation ceremonies from nursery school through the highest levels of university achievement in both Ghana and the United States has already been documented. But kente and education embrace each other in numerous other circumstances. Most kente backpacks are actually book bags to be worn to and from school (fig. 13.11). A *Ghana Schools Exercise Book* produced in Ghana for local use has a cover framed in kente (fig. 13.12). Numerous book covers printed in the United States enlist kente designs to foster themes of African American history and cultural achievement. These include: Venice Johnson's *Heart Full of Grace: A Thousand Years of Black Wisdom* (1995); Benjamin Faulkner's *What to Name Your African-American Baby: Names of Significance and Dignity to Reflect Your Child's Heritage* (1994); and the Time-Life publication *African Americans: Voices of Triumph* (1993; figs. 13.13, 13.14). A popular silk-screened T-shirt sold widely in Los Angeles features two kente-adorned individuals framed by the words "Learn from the Past / Create the Future" (fig. 13.15). Even the *1999 African American Student's Guide to College* has portions of a ten-strip cloth on its cover.

13.11^

13.12^

13.13^

13.14^

13.15^

13.11 Backpacks made from roller-printed cloth. Ghana. Cotton. Private collection.

13.12 *Ghana School Exercise Book*. Paper. Height 24.7 cm. FMCH X98.24.6.

13.13 Benjamin Faulkner, *What to Name Your African-American Baby* (St. Martin's Press, 1994). Height 21 cm. Private collection. Venice Johnson, ed., *Heart Full of Grace* (Fireside, 1995). Height 17.7 cm. Private collection.

13.14 *African Americans: Voices of Triumph* (Time-Life Books, 1993). Height 28 cm. Private collection.

13.15 Detail of silk-screened T-shirt. Cotton. Width 98 cm. FMCH X98.24.7.

In a related vein, kente is often associated with major figures in African American history. The United States National Park Service has printed two posters honoring Frederick Douglass and Mary McLeod Bethune, each with a portrait, quotation, and a band of kente running top to bottom (figs. 13.16, 13.17). Similarly a display honoring Jackie Robinson at the National Museum of American History used several roller-printed kente accents to highlight the installation (fig. 13.18). Also seen around Washington, D.C., is a roller-printed kente jacket with a silk-screened image of Malcolm X on the back (fig. 13.19). While it is unlikely that Douglass, Bethune, Robinson, or Malcolm X had any direct connection to kente, the textile is nevertheless appropriated to emphasize their ultimate roots in Africa and perhaps to suggest that these four individuals have become a kind of "royalty," among many other potential associations.

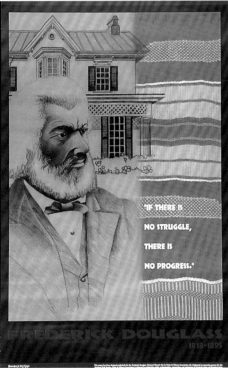

13.16^

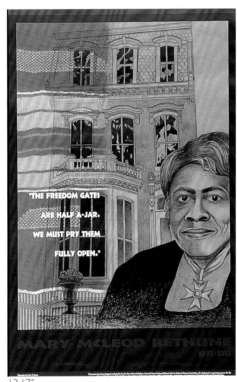

13.17^

13.18^

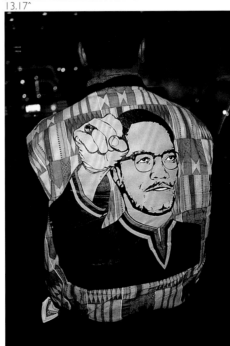

13.19^

13.16 *Frederick Douglass (1818–1895).* Poster with illustration by Erik B. Jones; design by Karen M. Heil. Parks and History Association (800) 990-PARK.

13.17 *Mary McLeod Bethune (1875–1955).* Poster with illustration by Erik B. Jones; design by Karen M. Heil. Parks and History Association (800) 990-PARK.

13.18 Installation honoring Jackie Robinson at the National Museum of American History, Smithsonian Institution, Washington, D.C. Photograph by Doran H. Ross, 1997.

13.19 Roller-printed kente jacket with silk-screened image of Malcolm X worn by a Washington, D.C., taxi driver. Photograph by Doran H. Ross, 1997.

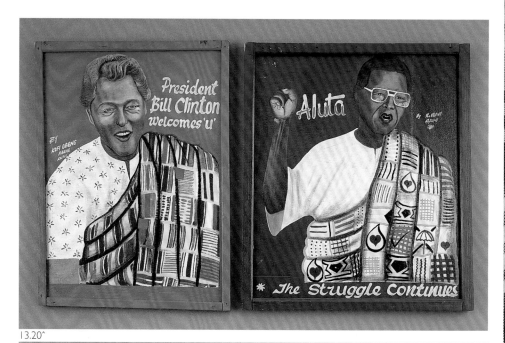

13.20^

13.20 "President Bill Clinton Welcomes 'U'" and "Aluta, The Struggle Continues" (Nelson Mandela) by Kofi Obeng Abene Kwahu. Ghana, 1995. Wood, enamel. Height of example at left 69.5 cm. Collection of Diane and Ernie Wolfe III.

13.21 "Long Live" by Isaac Azey. Kumase, Ghana, 1994. Wood, paint. Height 83.5 cm. Collection of Diane and Ernie Wolfe III.

13.22 Mickey Mouse, Minnie Mouse, and Rosalyn White, "Miss Collegiate African American" in 1993. Magic Kingdom, Walt Disney World Resort, Florida. © Disney Enterprises, Inc. Photograph by Lee McKee.

13.23 Detail of roller-printed shirt with silk-screened image of an Egyptian. USA. Cotton. Width 98 cm. FMCH X98.24.8.

13.24 Window with poster titled *The Theft of African Civilization* and framed by an Asante kente strip. Photograph by Danielle E. Smith, Los Angeles, 1996.

13.25 Erykah Badu with Baby Bear, Elmo, Zoe, and Rosita of "Sesame Street". Zoe, Elmo's best friend, and Rosita, the bilingual Muppet, wear head ties like their popular singing buddy. Courtesy Children's Television Workshop, " 1997. Photograph by Richard Termine.

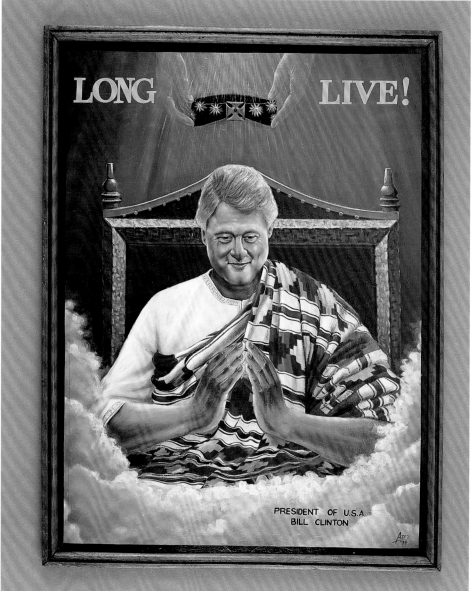

13.21^

Reversing the appropriation of kente to celebrate African American culture heroes, Ghanaian artists frequently dress international leaders, such as Bill Clinton and Nelson Mandela, in kente as if to make them Ghanaian (figs. 13.20, 13.21). Significantly both images of Clinton were painted before his widely publicized trip of 1998, during which he actually was adorned in a strip-woven cloth.

Conflating three to four thousand years of African history, a remarkably frequent and varied series of juxtapositions pairs images of ancient Egypt with Asante kente (figs. 13.23, 13.24). Although some scholars have argued for a historical connection between the two areas (e.g., Meyerowitz 1960; Segy 1963), significant distances in time and space would seem to argue otherwise. Nevertheless ancient Egypt is widely embraced as part of the experience of the Black Diaspora, and its pairing with kente, even if mystical in origin, helps remind us that Egypt is indeed part of Africa. Moving more fully into the realm of fantasy, roller-printed kente is being embraced in such fictional geographies as Disneyland and Sesame Street, presumably in an attempt to diversify public images. Both Mickey and Minnie Mouse have been photographed wearing kente (fig. 13.22), and the Muppet Rosita, La Monstrua de las Cuevas, wears a kente head tie in a recent photograph with Erykah Badu (fig. 13.25).

13.23^

13.22ˇ

13.24^

13.25^

The commodification of southern Ghanaian and Togolese strip weaves is not a recent phenomenon. It undoubtedly had its beginnings shortly after the introduction of weaving, but it was probably initially restricted to ready-made plain weaves, most often solid, undyed cotton or indigo-dyed warp stripes. Most cloths with complicated weft designs were reserved for royalty and other wealthy members of the elite and were most likely produced exclusively on commission well into the twentieth century. There is some evidence for the development of an "arts and crafts" market targeted at an expatriate population during the 1920s (Rattray 1923, 306; Johnson 1937), but the aggressive commercialization of kente and other familiar Akan genres had to await the 1950s, Ghanaian independence, and a nascent tourist industry. Kate P. Kent recorded a weaver's cooperative in Bonwire established under Nkrumah with a small store selling ready-made items that was still in existence in 1969 (1971, 32). This may be the same store run by James Antobreh's uncle in 1972, which was also part of a cooperative (Lamb 1975, 157). By 1997, however, the number of Bonwire shops had increased to at least twenty-five.

The development of markets for the sale of ready-made kente paralleled the development of novel kente products. By 1970 Hale recorded that Ghanaian entrepreneurs were producing "place mats, table runners, stoles, skirts, blouses, cummerbunds, cushion covers, bell pulls with tassel, trim for curtains, covers for stationery folders, sandal decoration covered with Plastic, and just plain decorative wall pieces" (1970, 29). By 1997, if not much earlier, purses, backpacks, briefcases, vests, hats, assorted jewelry, and hair ornaments were also adorned with kente (figs. 13.26, 13.27). As Quarcoo has stated, "Today, just a little patch of kente on virtually anything adds to its value either in terms of money or cultural importance" (1996, 26). It is significant that most of these items still exist in the realm of personal adornment including what the Western fashion establishment would call "accessories."

13.26ˆ

13.27ˆ 13.28ˇ

13.26 Briefcase covered with machine-printed kente. USA. Synthetic cloth, vinyl, nylon. Width 37.2 cm. FMCH X98.24.13.

13.27 Pyramid-shaped purses. Asante, Ghana. Handwoven rayon. Private collection.

13.28 Selection of roller-printed fabrics for sale in a Dakar market including several kente patterns produced by Sobit in Dakar, Senegal. Photograph by Doran H. Ross, 1997.

Coinciding with the creation of new applications for strip-woven kente was the mass production of mill-woven kente patterns. The history of the production of machine-made kente remains to be sorted out. The first factory-printed cloths from West African mills did not appear until the 1960s (Bickford 1997, 9), and it is not clear whether kente patterns were among them. The British manufactured factory-printed Adinkra for sale in Ghana near the end of the nineteenth century, but there is no evidence of kente patterns coming out of Britain until the 1970s. One of the earliest examples of machine-woven kente, which can be dated to 1960 is a 65% Dacron, 35% cotton, double woven cloth produced by the American firm Galey & Lord and unveiled with an actual swatch in the trade magazine *American Fabrics* (51 [fall–winter 1960]). After reprinting the Teague piece from the *Daily News Record* describing Nkrumah's presentation of a cloth to the United Nations (quoted above, p. 172), the magazine boasted:

> The American Market's first development of the new Ghana trend is presented in the actual swatch alongside. It is a stunning example of creative fashion alertness to the current world scene, *and* to the needs of a market which welcomes the stimulus of new and different design approaches. Through the cooperation of Galey & Lord, we are privileged to present this swatch from one of the first pieces to come off the looms…*a whole new fashion trend may be in the making*.

This quotation accompanied the official portrait of Nkrumah in kente over the headline "Ghana: An Untapped Source of Design Inspiration."

The commodification of kente has followed several paths. As we have seen it began with the production of ready-made textiles as opposed to commissioned cloths. This was followed by the creation of new products using strip-woven cloth. Factory-produced fabrics based on kente designs developed about the same time (fig. 13.28). Another direction took the kente design vocabulary and exploited it in the form of packaging and advertising, as well as extending forms of kente adornment into television and film. These initiatives evolved more or less evenly on both sides of the Atlantic until the 1990s when designing with kente accelerated in the United States.

It is tempting to analyze machine-produced or roller-printed kente in terms of contemporary discussions of simulacra—the fake, faux, imitation, reproduction, replica. Although it is in the nature of a simulacrum that the user does not generally identify it as such, it should still be emphasized that many consumers in the United States either do not recognize the difference or do not care to admit a bias; this is a position I personally endorse. There is a certain elitism that accompanies most discussions of the simulacrum—a tendency to denigrate any context wherein it is embraced and to use the term itself pejoratively.

The discussion in chapter 10 of the conflation of the Ghanaian flag and Oyokoman kente is perhaps useful here. When one speaks of a national flag, one does not ask if it is authentic or not. It is the image that counts—sometimes the colors or proportions are slightly off, and sometimes the image is printed on fabric rather than pieced together. Sometimes it is rendered in silk and sometimes in plastic. The fact remains that the flag is the signifier that represents a multitude of ideas whether reduced to an Olympic pin, hanging from the ceiling of the Smithsonian Institution's National Museum of American History, or draped on the wall behind the podium of the Ghanaian Parliament.

I think the flag metaphor conforms to the view many people hold of kente. And as with frequent discussions of Old Glory in the United States, what constitutes the desecration of kente is still open for debate. Still, there is a certain consensus that most forms of adornment including hats, vests, cummerbunds, and ties remain in the realm of respectability.

Whether object or image, the ever-increasing commodification of kente for expanding markets seems to be proceeding without any constraints. As Arjun Appadurai notes, however, "the diversion of commodities from their customary paths always carries a risky and morally ambiguous aura" (1986, 27). That kente carries such an enormous cultural load, as suggested by the responses listed at the beginning of this chapter, makes its seemingly unrestrained commodification even more problematic. The fact that there is such variety within this cultural load, however, probably encourages further contexts of appropriation. This is particularly true in the United States, which according to Appadurai "is eminently suited to be a sort of cultural laboratory and a free trade zone for the generation, circulation, importation, and testing of the material for a world organized around diasporic diversity" (1993, 425).

13.29ˆ

13.34ˆ

13.30ˆ

13.32ˆ

13.35ˆ

13.36ˆ

13.31ˆ

13.33ˆ

13.37ˆ

Some kente-adorned objects follow traditional Ghanaian contexts, such as the umbrellas manufactured by a number of different companies (figs. 13.29, 13.30). Other uses of kente have produced some surprising results. A large backpack constructed of fine strip weaves is too majestic to invite use (fig. 13.31). Both handwoven and machine-woven kente baseball caps have become commonplace, but more unusual is the backpack with strip weaves assembled in the shape of a baseball cap (fig. 13.32). The Ghanaian appropriation of this American form has a parallel in the Ghanaian appropriation of the *jimbe* drum from the Mande speakers of Mali, Côte d'Ivoire, and Senegal. The *jimbe* is more popular among African Americans than any indigenous Ghanaian percussion instrument so local carvers are now producing these "foreign" drums for export. They cover them in kente, however, to enhance salability and to establish the Ghanaian connection (fig. 13.33). In the United States, artificial flowers with blooms made from roller-printed kente have also become popular (fig. 13.34).

The appropriation of kente in the above contexts has not been the target of much, if any, criticism. Most of the examples cited exist within positive and even noble circumstances. But what of more ambiguous uses of kente designs? Are adhesive bandages called "Kente Strips" (in an Oyokoman pattern) an appropriate use of this imagery (fig. 13.35)? What about kente beach balls (fig. 13.36) or Wine Butler's kente jackets for wine bottles? Is the African doll clad in roller-printed kente purchased at the Accra airport and designed to hold a roll of toilet paper an example of appropriation going too far (fig. 13.37)? One could argue that health care, recreation, conviviality, and good hygiene are as life affirming as education. Is it possible that we tend to overemphasize the serious side of kente? When we examine the names of cloths, we tend to focus on the historical and proverbial, perhaps losing track of the wit and playfulness that is inherent in some of these names. For example, one cloth, "*Sika fre mogya*," is typically translated as "Money attracts blood." The "blood" here stands for family, but the phrase can be interpreted in conflicting ways. Some say that the wealthy in the family are naturally obligated to support those relatives who are less fortunate, while others say that the less fortunate are always making demands on their wealthy kin. The irony is not lost on the weavers who seem to delight in the perhaps intentional ambiguity of the name. The potential role of humor in kente nomenclature certainly merits further research especially in terms of contemporary genres.

Many of the kente objects and products discussed above are perhaps best understood in terms of contemporary discussions of "popular culture." Johannes Fabian explains this phrase as follows:

(A) it suggests contemporary cultural expressions carried by the masses in contrast to both modern elitist and traditional "tribal" culture; (b) it evokes historical conditions characterized by mass communication, mass production, and mass participation; (c) it implies, in my understanding, a challenge to accepted beliefs in the superiority of "pure" or "high" culture, but also to the notion of folklore, a categorization we have come to suspect as being equally elitist and tied to certain conditions in Western society; (d) it signifies, potentially at least, processes occurring behind the back of established powers and accepted interpretations and thus, offers a better conceptual approach to decolonization of which it is undoubtedly an important element. [1997, 18]

To the extent that we can speak of kente-involved agendas or kente-involved initiatives, many of the contemporary items in this volume fit quite comfortably into Fabian's understanding of popular culture.

That kente has been appropriated by many outside of Ghana is obvious. Unfortunately issues of appropriation in contemporary scholarship are often couched in pejorative terms; but appropriation is not by definition negative. As bell hooks reminds us, "acts of appropriation are part of the process by which we make ourselves. Appropriating—taking something for one's own use—need not be synonymous with exploitation. This is especially true of cultural appropriation. The 'use' one makes of what is appropriated is the crucial factor" (1995, 11). Even when the "use" is considered appropriate, however, there can be repercussions. Robert Nelson clarifies the two-sided nature of these transactions, "in every cultural appropriation there are those who act and those who are acted upon, and for those whose memories and cultural identities are manipulated by aesthetic, academic, economic or political appropriations, the consequences can be disquieting or painful" (1996, 127). Most problematic to Ghanaian weavers is the appropriation of production. Obviously, the availability of cheaper commercial prints can affect purchases of handwoven cloth. Yet it is likely that the factory prints have helped popularize the prototype and may have ultimately increased demand for the original. Without a

13.29 Umbrellas with roller-printed cloth produced in Abidjan, Côte d'Ivoire. Cotton, plastic, metal. Length 87 cm. Homeland Authentics. Right: FMCH X98.24.9; other examples: Private collection.

13.30 Umbrella-hat made from roller-printed kente with *Bamana* mud cloth edging. Los Angeles. Cotton, metal, elastic, plastic. Diameter 19 cm. FMCH X96.32.1.

13.31 Backpack constructed of handwoven Asante strips. Ghana. Rayon, cotton, synthetic fabric, padding, zipper, plastic, metal. Height 56 cm. FMCH X96.30.13.

13.32 Backpack in shape of a baseball cap with handwoven Asante strips. Rayon, foam, zipper. Height 50 cm. FMCH X97.36.18.

13.33 *Jimbe* drum with cover, carved by Joseph Armah Niiattoh, 1997. Cotton, foam, zipper, wood, animal hide, cordage. Height 54 cm. FMCH X98.24.10A-B. *Jimbe* drum carved by Joseph Armah Niiattoh, 1997. Wood, cotton, animal hide, pelt, cord. Height 69.5 cm. Private collection.

13.34 Vase with roller-printed kente "flowers." Ceramic, wire, cloth. Height 71.5 cm. Private collection

13.35 Shades adhesive bandages. USA. Promethean Products. Height 12 cm. FMCH X98.24.11. Gift of Edward Lifschitz.

13.36 "Globals" inflatable African sphere. Taiwan. Plastic. Diameter when inflated 51 cm. On The Wall Productions. Private collection.

13.37 Toilet paper dispenser purchased at Kotoka International Airport, Accra, 1998. Cloth. Height 48 cm. FMCH X98.24.12.

systematic market study—virtually impossible in such an informal sector—this would be difficult to prove.

By the end of 1997 factory-made kente was being produced by mills in Senegal (figs. 1.22, 13.28), Côte d'Ivoire, Togo, and Benin (and other mills outside of Africa), and many of the products mentioned earlier incorporating strip-woven material were being made in factory-produced versions. But as Paul Wood has noted, "the principal commodity of late capitalism [is] no longer products in the traditional sense, but images" (1996, 262). In making distinctions between handwoven and machine-woven "kente," one can argue that the latter is in fact the image of kente. The same can be said of kente as applied design. In the United States kente has entered the mainstream as an image of Africa. As Takiyiwaa Manuh has observed

> The commodification of *kente* has been taken to new heights by the firm J. C. Penney, which now produces a catalogue for black customers. The catalogue displays crockery and glassware edged with *kente*, as well as bedspreads and curtains in *kente* designs. Kaftans and *boubous* made with factory-produced cloth from Ghana bear the names by which they are marketed there. The sell here is the "authentic" article, which is meant to reassure the buyers that however far they may be from their roots, they can take these symbols home with them and drink and eat from them, or even sleep on them.
>
> Essentially, this cloth has become the major means for uniting the diaspora with the motherland.

The competition between handwoven and mill-woven kente is less an issue for the middle persons who take either cloth and turn it into another product. Vendors, even those in Bonwire, also seem to defer to the marketplace and tend to offer items made from both indigenous and industrial production. Distinctions between the two tend to fall within the ongoing process of democratization that has characterized kente history for much of the life of the genre. Implicit in the process of democratization is the process of increasing affordability, which manifests itself in several ways. High and low quality handwoven kente represent opposite ends of the affordability spectrum. "Double weave," "single weave," and "plain weave" represent significant differences in labor and material costs. Choices of thread—silk, rayon, Lurex, or cotton—affect price. Method of manufacture— handwoven strip weave, handwoven broadloom, machine woven, and roller-printed—also represent a range from most to least expensive.

All of these variables are especially relevant to the fashion industries of Ghana and the United States. Other kente products aside, it is still in the realm of apparel that kente maintains its highest profile, even if it is more of a decorative and symbolic accent rather than a complete garment. Still, handwoven kente by its very nature can never become part of the mass-produced ready-to-wear side of the industry. The fact that the traditional Ghanaian modes of wearing kente were never embraced by African American men or women in the United States has also inhibited the use of strip-woven material. Fashions tailored from the latter still remain the exception (fig. 13.1, 13.38). There are many reasons for this in addition to the greater expense. The heavier handwoven cloth with its inevitable, if slight, irregularities is more difficult to cut and sew. It also does not drape as well when tailored. Despite recent improvements in thread quality, some of the dyes remain fugitive and run when wet thus requiring the added expense of dry cleaning.

Nevertheless, the popularity of tailored kente apparel has been given a big boost by Nana Konadu Agyeman-Rawlings, the first lady of Ghana, who favors clothing made from strip-woven cloth when appearing in public (see fig. 3.34). Some of Mrs. Rawlings's fashions have been made by Los Angeles designer Ahneva Ahneva (see pp. 250–51), who restricts her use of kente to the handwoven.

More typical are the Ghanaian designers Nora Bannerman of Sleek Fashions and Eddie and Charity Agbenyeke of Treasure Leisure who employ either handwoven or machine-produced kente depending on their clients' tastes and pocketbooks. According to Adda and Chapman, "Nora sees the printed kente as a further step in helping the ordinary man. Though she as a designer prefers the use of woven kente in designing for her clients, she sometimes has to use the printed fabric for those…who desire something with a kente touch and yet cannot afford the woven one" (1990, 20).

Ghanaian textile and fashion designer Francis Selorm Seshie, who has lived in Denmark since 1992, has created his own kente-inspired fabrics in velvet, silk, cotton, and polyester and used them in everything from dresses to T-shirts and sweatshirts (fig. 13.39, 13.40). At Panafest '97 he presented a "dance-drama and fashion show" titled "The Kente Revolution" (*The Mirror*, August 30, 1997).

13.38 Alfre Woodard wearing a dress by Ahneva Ahneva. Los Angeles, 1995.

13.39 Front-page photograph, *The Mirror*, August 30, 1997. "Sleek Mabel Kernn, a model of Ghanaian-Danish parentage, showing her true colours in this silk kente fabric designed into a dress by Francis Selorm Seshie, a Ghanaian textile and fashion designer who lives in Denmark."

13.40 Sweatshirt and pants in kente-inspired print designed by Francis Selorm Seshie. Denmark. Cotton, elastic, zipper. Length of pants 112 cm. Gye Nyame, CCI-Ketus, Kente Design. FMCH X97.36.19a,b.

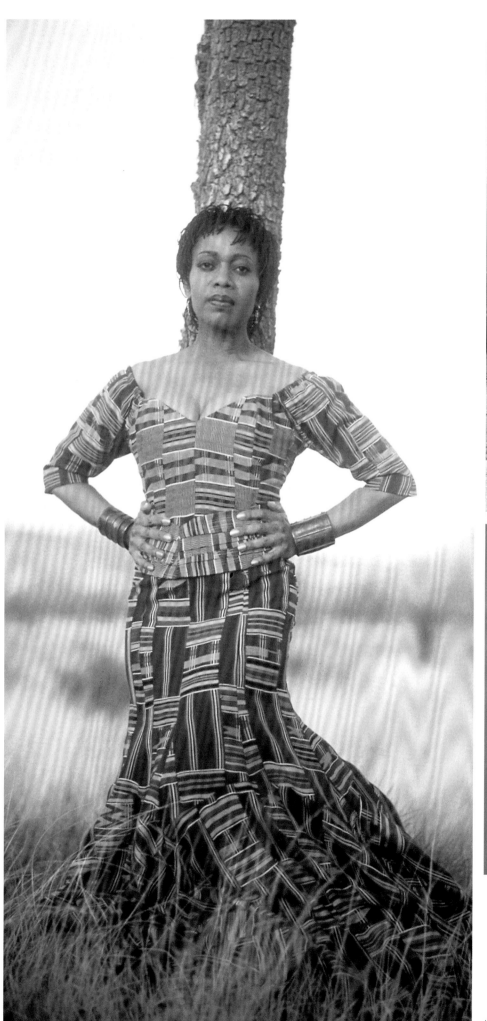

13.39^

13.40^

13.38

Constance White in her recent book *Style Noir* (1998), "The first how-to guide to fashion written with Black women in mind," recommends the use of both handwoven and industrially produced kente in a wide variety of forms and contexts, although she cautions against cheap cotton prints. Assorted kente fabrics also repeatedly appear in Harriette Cole's *Jumping the Broom: The African American Wedding Planner* (1995). These publications and others suggest that kente fashions are still current near the end of the twentieth century.

The fashion industry, however, is probably not where the future of kente resides. Constance White documents a "renaissance" in Afrocentric fashions in the 1970s and considers the late 1990s the next such occurrence. It would not be surprising for kente material to periodically reappear on the fashion horizon, much like Egyptian revival themes and styles insert themselves in the American consciousness every twenty or thirty years. Fashion by its very nature is transitory and largely propelled by the requirements of self-conscious change. Nevertheless, a fashionable and increasingly well-entrenched tradition for kente display has developed in both the church and the academy—serious and historically conservative institutions that may be slow to change but typically make long-term commitments to good ideas.

In addition to religious and educational contexts, it seems likely that the future of kente will rest with the rich assortment of kente-adorned products and kente-inspired designs that have characterized a number of meaningful contemporary events. Perhaps leading the way is Kwaanza (see pp. 211–15), which is being observed by more African Americans and others each year. Whether employed as an item of dress, adorning the Kwaanza table, or given as a culturally significant gift, kente seems to have found a permanent and increasingly important home. That photographs of kente or kente designs are found on the covers of most books dealing with Kwaanza further reinforces this association. Black History Month also provides numerous opportunities for the use and display of kente in many forms, as do celebrations of Martin Luther King Jr. Day and Juneteenth. Kente, more than any other item of material culture, is a symbol for a wide array of sophisticated ideas about the heritage of Africa. And more than its patterns and colors, it will be the ideas of kente that will ensure its honored role in African American communities in the United States and elsewhere. Kente nomenclature embraces history, honors cultural heroes, and offers a wealth of proverbial wisdom making it appropriate and adaptable to many objects and situations. The strength of kente is not so much in the fabric of the cloth as in the ideas that bind it to African American life and tie it to the Motherland.

13.42˄

13.41 Clothes hanger with roller-printed dress. Ghana. Wood, paint, cotton. Height 152.2 cm. FMCH X95.45.11a-c.

13.42 Mannequin with roller-printed dress. Wood, paint. Height 99 cm. FMCH X97.36.17A. Dress. Cotton. Length 64 cm. FMCH X97.36.17B.

13.43 Two-fold screen with roller-printed kente and plywood heads painted by Isaac Azey in Aid to Artists Gallery, Accra. Photograph by Doran H. Ross, 1996.

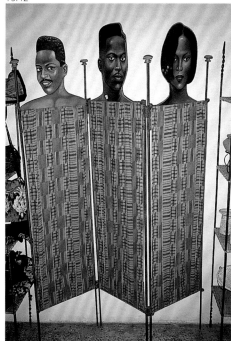

13.43˄

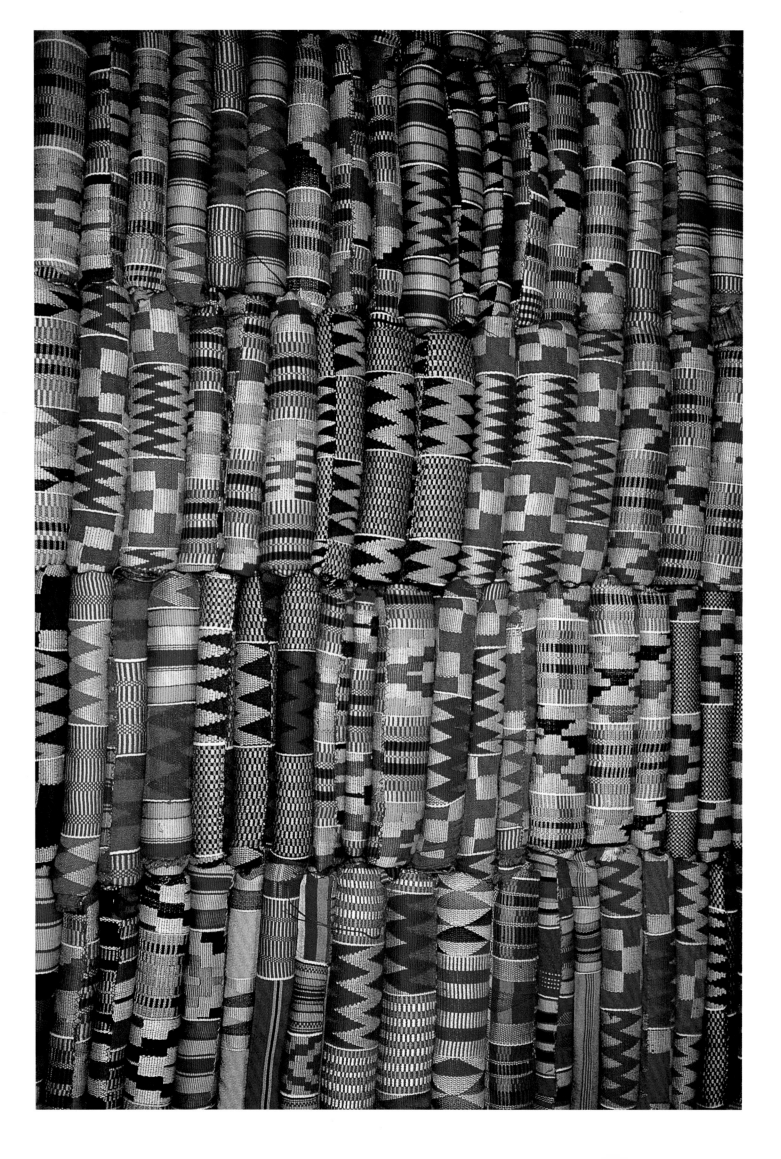

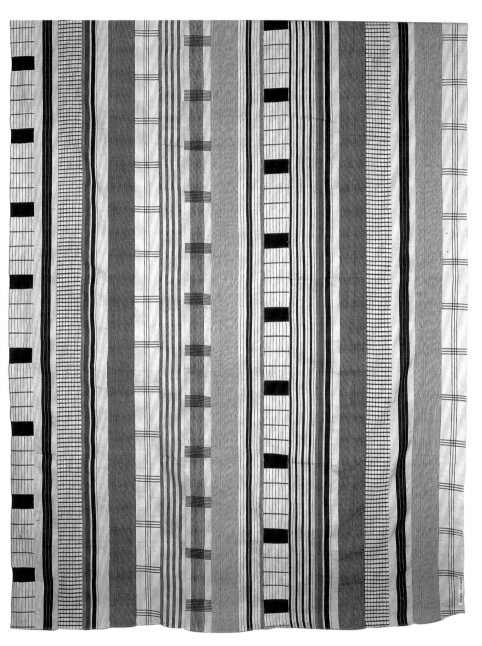

CATALOG

Asante and Ewe Weavings

Doran H. Ross

1. Asante wrapper. Cotton. Length 182.8 cm. National Museum of African Art, National Museum of Natural History, purchased with funds provided by the Smithsonian Collections Acquisition Program, EJ10567. Photograph by Franko Khoury. This cloth is referred to as Mmaban (mixed). It has eighteen strips featuring twelve different warp stripes.

Opposite page: Women's cloths stacked for sale at the Accra Textile Market. Photograph by Doran H. Ross, 1997.

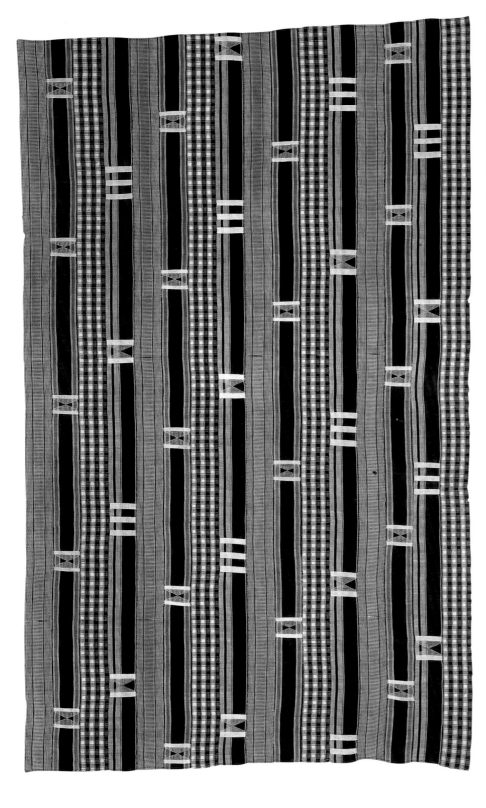

2. Asante wrapper. Cotton. Length 214.6 cm.
National Museum of African Art, National Museum of
Natural History, purchased with funds provided by the
Smithsonian Collections Acquisition Program, EJ10565.
Photograph by Franko Khoury. This cloth is referred to
as Mmaban (mixed). It has sixteen strips featuring four
different warp stripes. See Gilfoy (1987, 73) for
technical information.

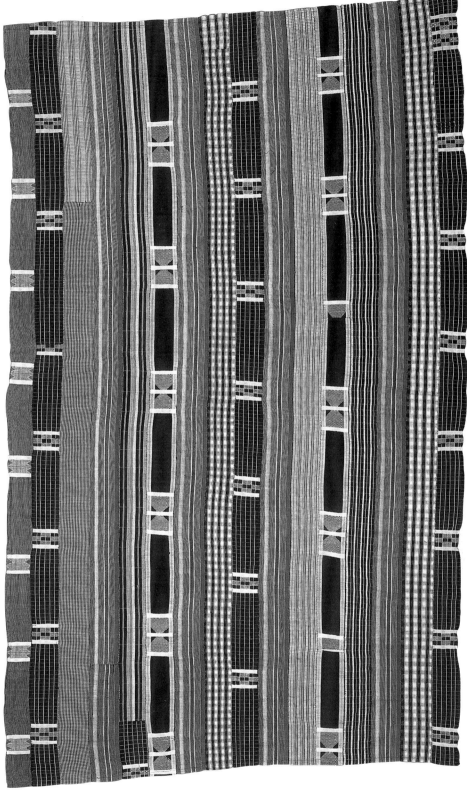

3. Asante wrapper. Cotton, silk. Length 223.5 cm. National Museum of African Art, National Museum of Natural History, purchased with funds provided by the Smithsonian Collections Acquisition Program, EJ10574. Photograph by Franko Khoury. This cloth is referred to as Mmaban (mixed). It has sixteen strips featuring ten different warp stripes. See Gilfoy (1987, 72) for technical information.







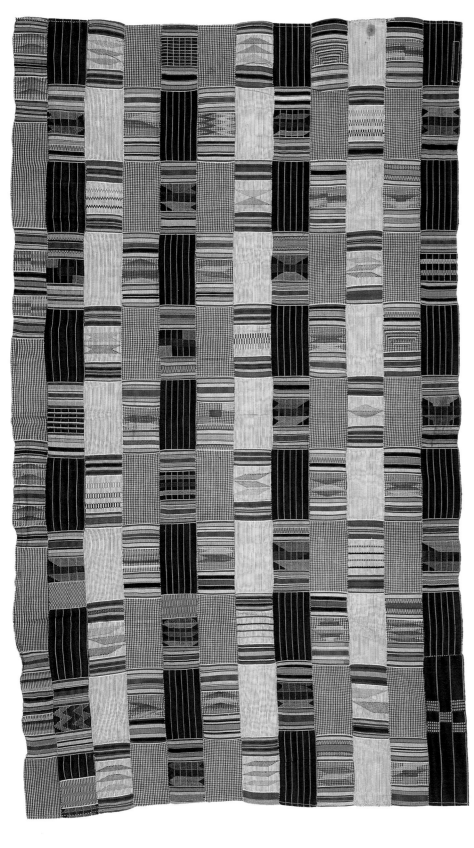

294

4. Asante wrapper. Cotton, silk. Length 162.9 cm. National Museum of African Art, National Museum of Natural History, purchased with funds provided by the Smithsonian Collections Acquisition Program, EJ101551. Photograph by Franko Khoury. This cloth is referred to as Mmaban (mixed). It has twelve strips featuring four different warp stripes. The right-hand strip was not part of the original cloth. See Gilfoy (1987, 76) for technical information.

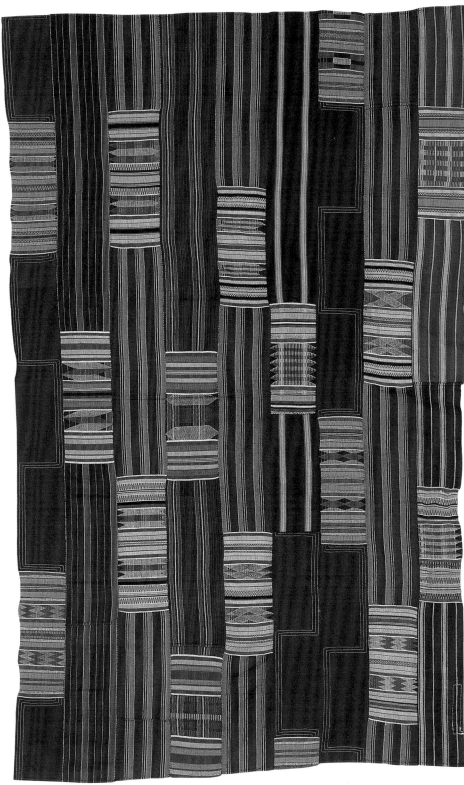

5. Asante wrapper. Cotton, silk. Length 131.1 cm. National Museum of African Art, National Museum of Natural History, purchased with funds provided by the Smithsonian Collections Acquisition Program, EJ10553. Photograph by Franko Khoury. This cloth is referred to as Mmaban (mixed). It has nine strips featuring six different warp stripes. See Gilfoy (1987, 77) for technical information.

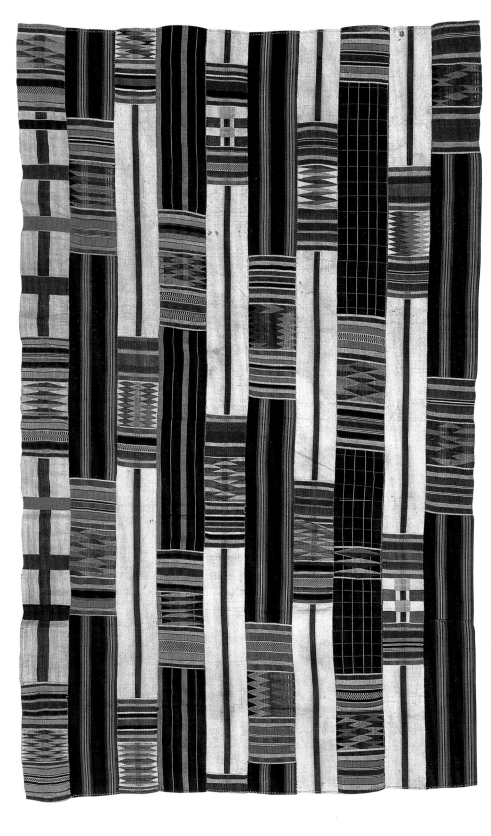

6. Asante wrapper. Cotton, silk. Length 139.1 cm. National Museum of African Art, National Museum of Natural History, purchased with funds provided by the Smithsonian Collections Acquisition Program, EJ10597. Photograph by Franko Khoury. This cloth is referred to as Mmaban (mixed). It has ten strips featuring five different warp stripes. See Gilfoy (1987, 79) for technical information.

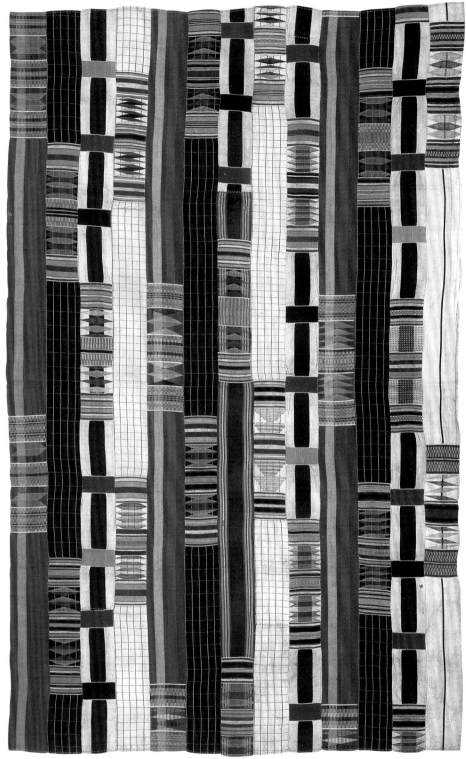

7. Asante wrapper. Cotton, silk. Length 159.1 cm. National Museum of African Art, National Museum of Natural History, purchased with funds provided by the Smithsonian Collections Acquisition Program, EJ10598. Photograph by Franko Khoury. This cloth is referred to as Mmaban (mixed). It has thirteen strips featuring six different warp stripes. See Gilfoy (1987, 83) for technical information.

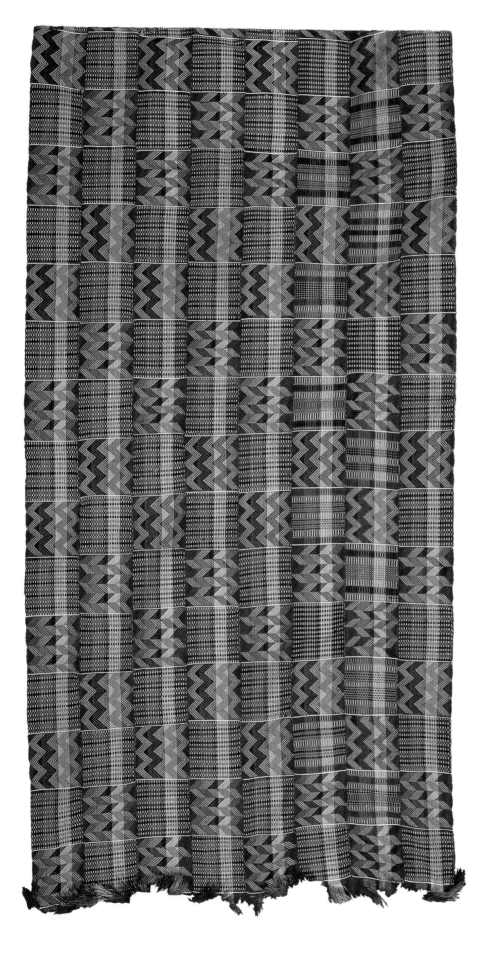

8. Asante wrapper. Silk. Length 154 cm. National Museum of African Art, National Museum of Natural History. Purchased with funds provided by the Smithsonian Collections Acquisition Fund, 1983-85, EJ10579. Photograph by Venice and Alastair Lamb. This is an Asasia Oyokoman Adweneasa cloth.

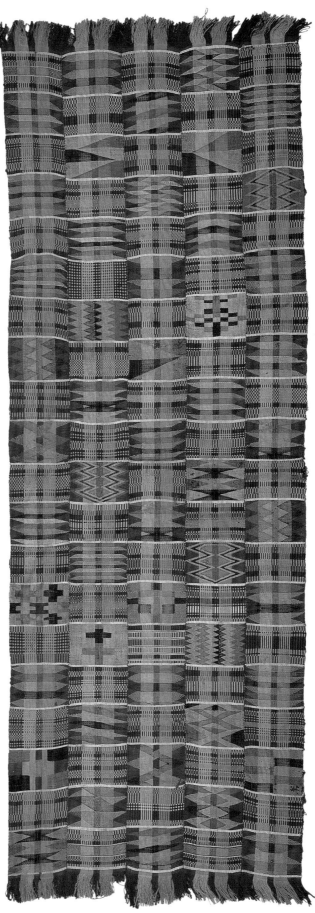

9. Asante shawl. Cotton, silk. Length 117.2 cm.
National Museum of African Art, National Museum of
Natural History, purchased with funds provided by the
Smithsonian Collections Acquisition Program, EJ10577.
Photograph by Franko Khoury. This is a five-strip
Oyokoman Adweneasa cloth. See Gilfoy (1987, 89) for
technical information; although contrary to Gilfoy, this is
not an Asasia.

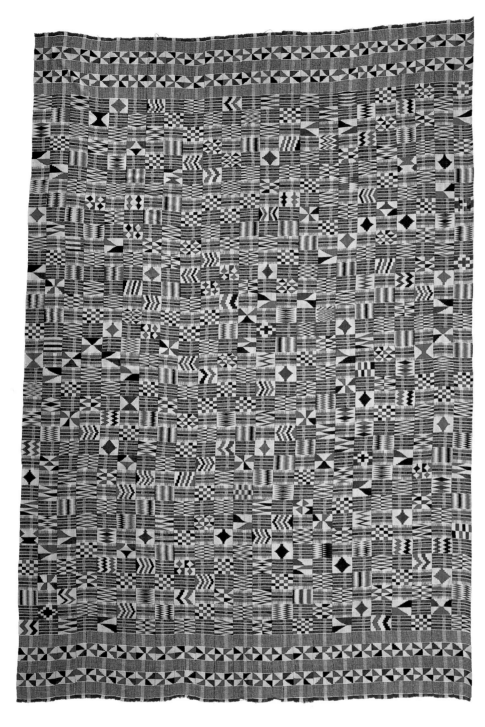

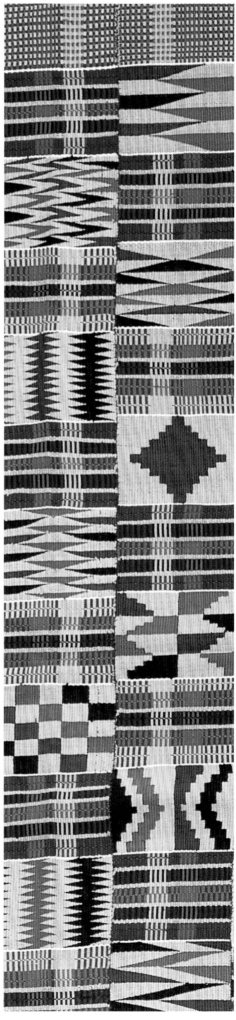

10. Asante man's cloth. Rayon. Length 314 cm.
FMCH X97.7.1. Anonymous gift. This Oyokoman
Adweneasa cloth conforms to the oft-stated rule that
the nineteen, twenty, or twenty-one blocks of *adwen*
in a standard Adweneasa strip should not be repeated
within that strip but may be repeated elsewhere on
the cloth. See Appendix 1 for technical information.
See also cover and page 125.

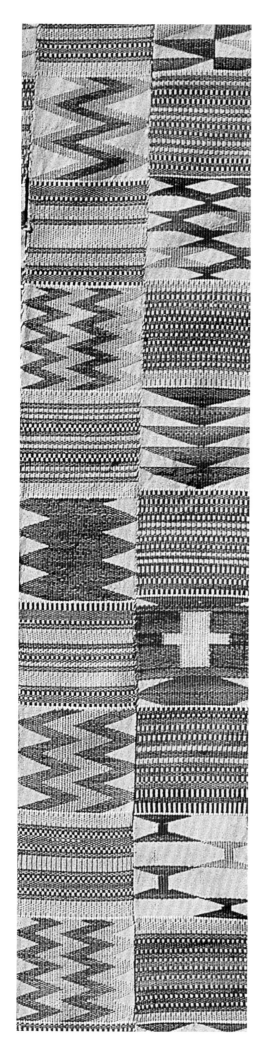

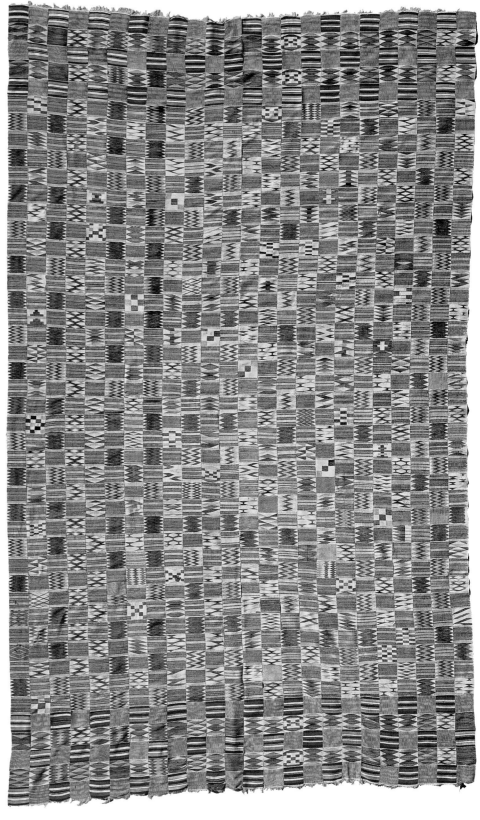

11. Asante man's cloth. Rayon. Length 296 cm. FMCH X86.1988. Anonymous gift. This Sika Futuro Adweneasa cloth is characterized by its solid gold-colored warp. See Appendix 1 for technical information.

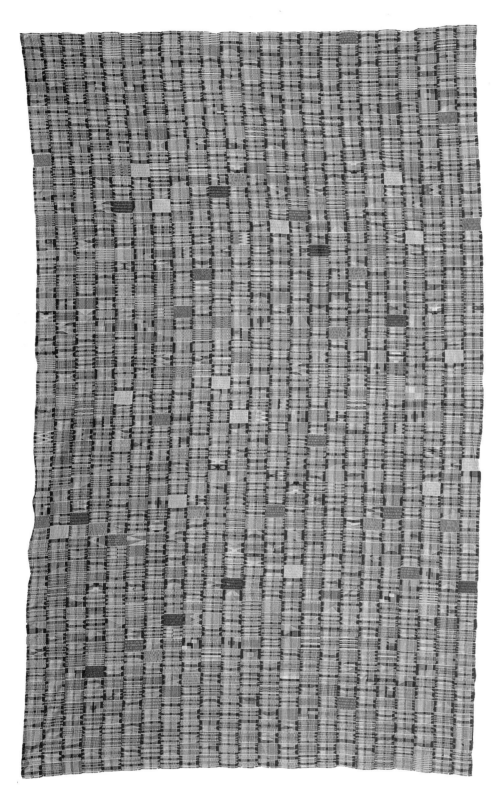

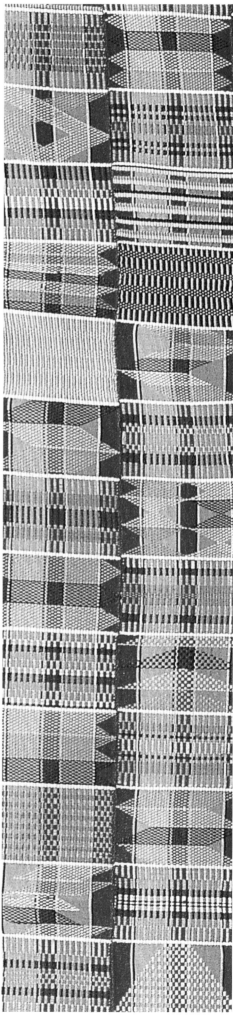

12. Asante cloth. Cotton. Length 318 cm. FMCH X96.31.7. Anonymous gift. This Oyokoman Adweneasa cloth is notable for its lack of decorative borders, which might support a northern Ewe, rather than an Asante, origin.

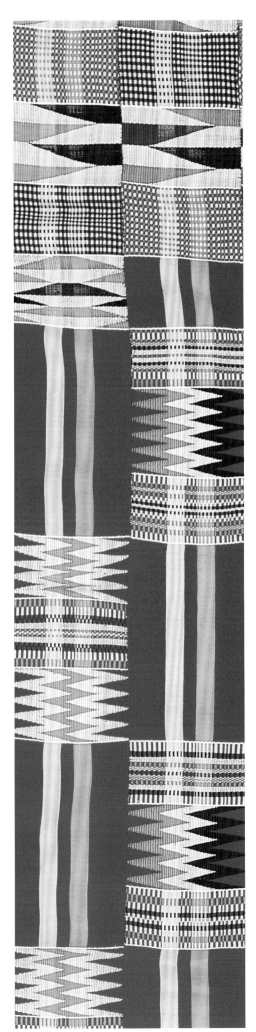

13. Asante cloth. Silk. Length 226 cm. FMCH X97.12.4. Gift to the Museum. Every other strip on this Oyokoman cloth features the typical configuration of Akyɛm/*adwen*/Akyɛm. Alternating strips reverse this pattern with design blocks of *adwen*/Akyɛm/*adwen*. See Appendix 1 for technical information.

14. Asante man's cloth. Rayon. Length 318 cm. FMCH X97.12.1. Anonymous gift. The design units on this Mmɛɛda cloth feature three blocks of Babadua with an *adwen* block between each. See Appendix 1 for technical information.

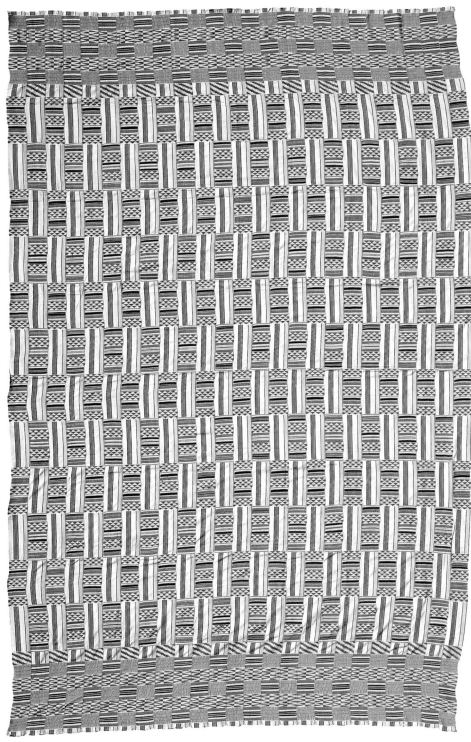

15. Asante man's cloth. Cotton, rayon. Length 355 cm. FMCH X96.31.8. Anonymous gift. This cloth is known as Toku Akra Ntoma. On every other strip three blocks of Babadua are separated with two double weave *adwen* sections. Alternate strips feature design units with three double weave *adwen* sections separated by two Babadua sections. See Appendix 1 for technical information.

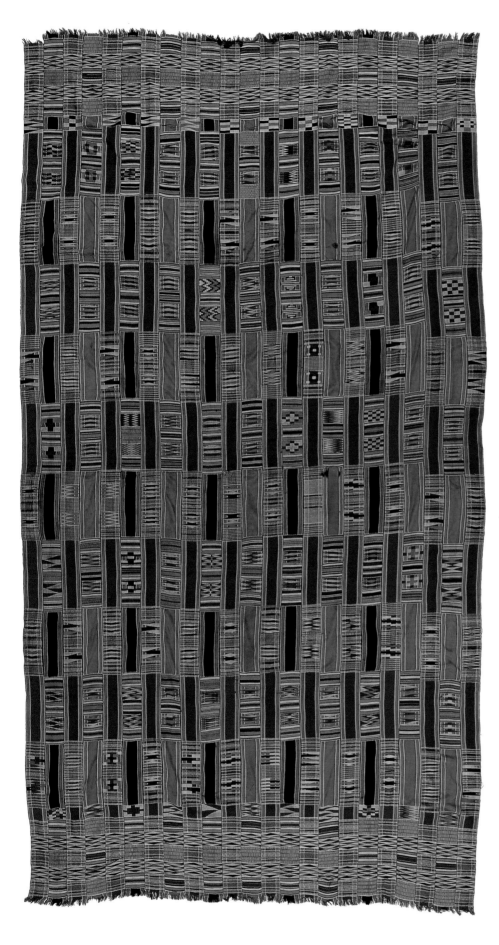

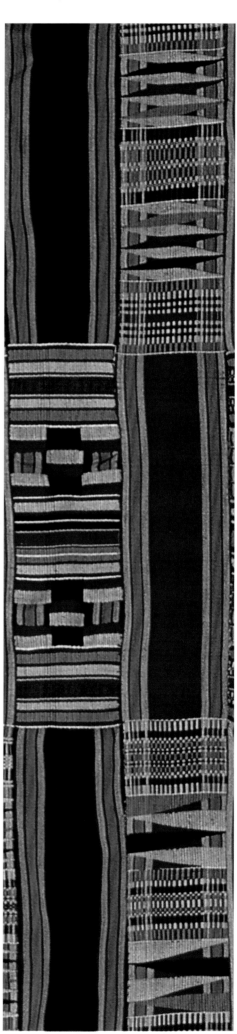

16. Asante man's cloth. Silk. Length 320 cm.
Collection of Peter Adler. Adler, AM#13. This cloth is
referred to as Mmaban (mixed). It has twenty-three
strips featuring three different warp stripes. Tripled
Babadua designs alternate with tripled Akyɛm designs.

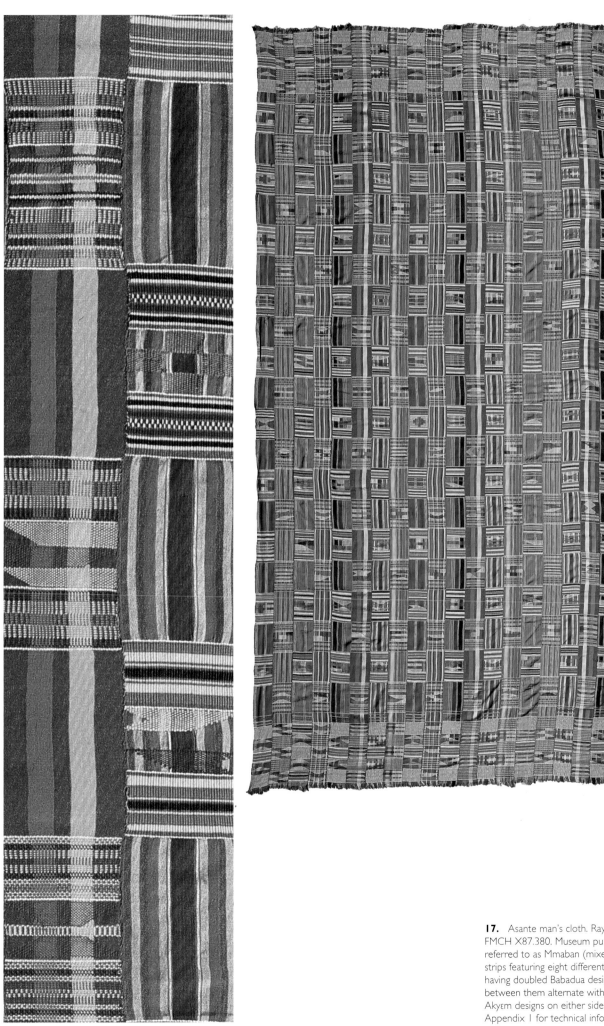

17. Asante man's cloth. Rayon. Length 364 cm. FMCH X87.380. Museum purchase. This cloth is referred to as Mmaban (mixed). It has twenty-four strips featuring eight different warp stripes. Strips having doubled Babadua designs with an *adwen* design between them alternate with strips featuring doubled Akyɛm designs on either side of an *adwen* design. See Appendix 1 for technical information.

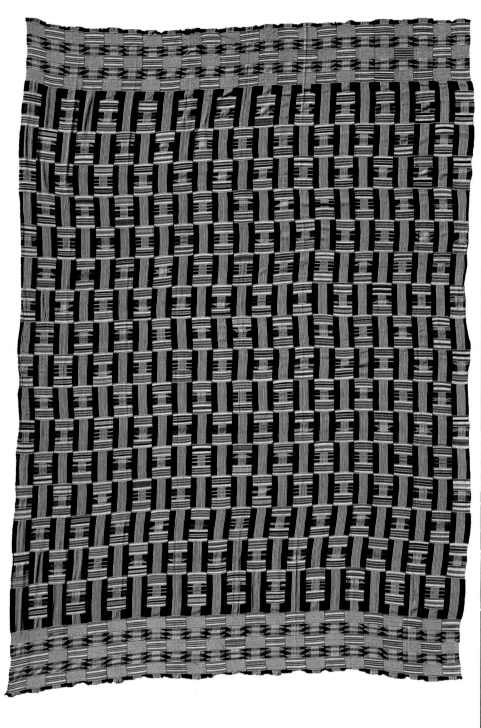

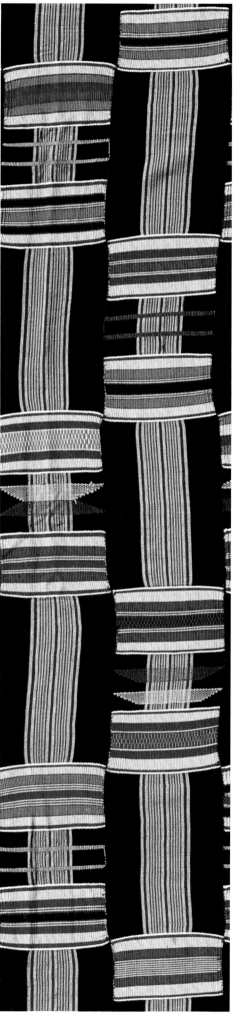

18. Asante man's cloth. Rayon. Length 310 cm.
FMCH X97.12.3. Anonymous gift. Each design block of
this Adwoa Kɔkɔɔ cloth features a Babadua design on
either side of an *adwen* design. See Appendix 1 for
technical information.

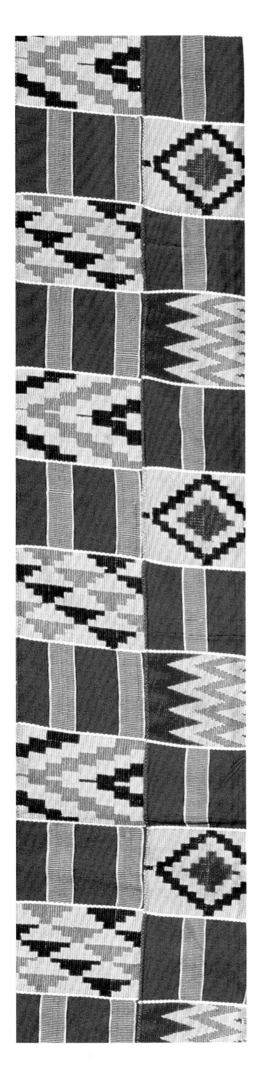

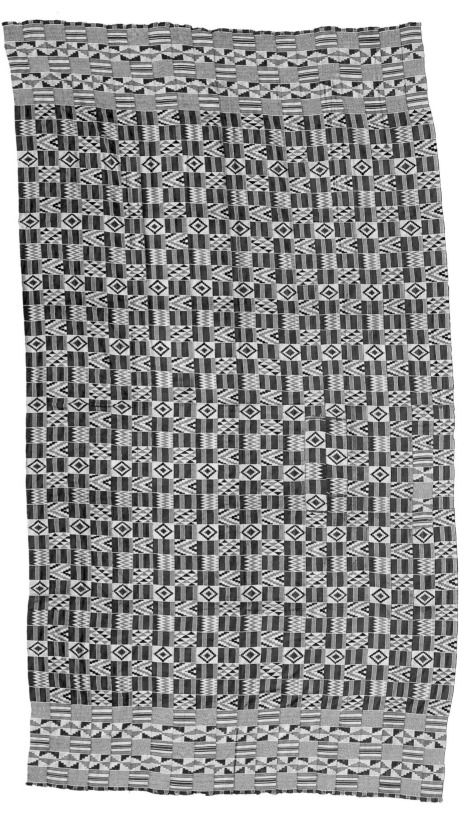

19. Asante man's cloth. Rayon. Length 342 cm. NM 97.89.1. Purchase 1997 The Members' Fund. In this cloth, referred to as Kyemee or Kyime, *adwen* designs alternate with sections of plain weave with no supplementary weft float designs. The second strip from the right has a patch with a border section in the middle. See Appendix 1 for technical information.

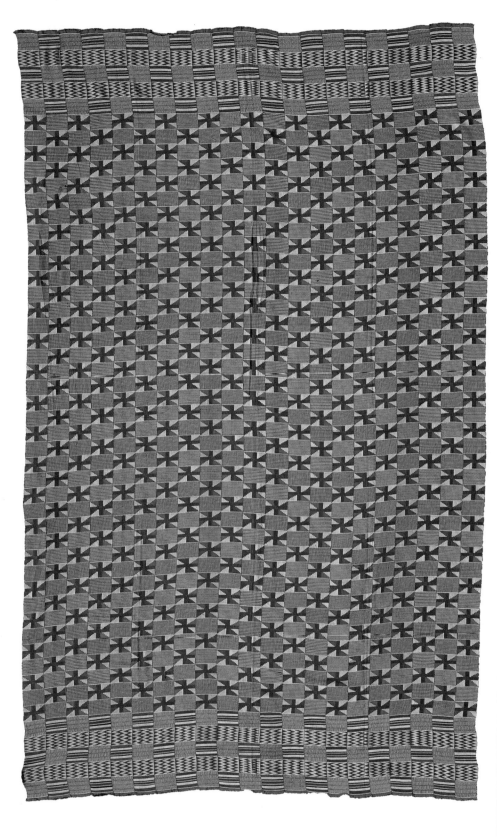

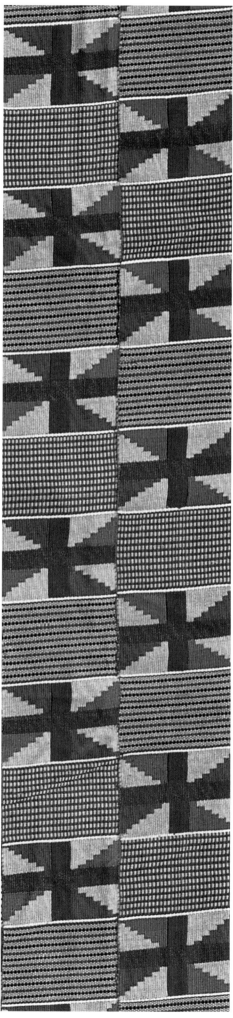

20. Asante man's cloth. Rayon. Length 328 cm.
FMCH X97.12.2. Anonymous gift. This cloth is named
Aprɛmo after its weft pattern. It is covered completely
with double weave *adwen* designs.

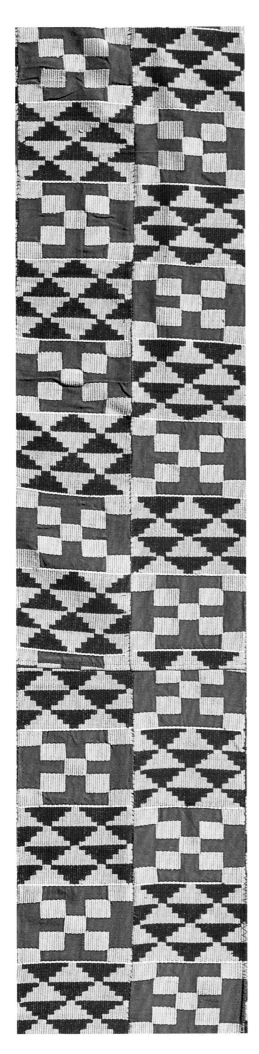

21. Asante cloth. Cotton, rayon. Length 251 cm. FMCH X97.12.5. Anonymous gift. This cloth is named after Fathia Fata Nkrumah. It is a queen mother's cloth cut down from a man's cloth and is completely covered by double weave *adwen* designs. Woven by the Samuel Cophie workshop.

Cat. no. 22^

Cat. no. 24^

Cat. no. 23

Cat. no. 25

22. Asante woman's broadloom cloth (Kumase). Rayon. Length 210 cm. FMCH X96.31.2. Anonymous gift. This broadloom kente is laid out in the Oyokoman pattern.

23. Asante woman's broadloom cloth. Cotton. Length 217 cm. FMCH X97.36.9A. Museum purchase. This broadloom kente is laid out in the Sika Futuro pattern.

24. Asante woman's broadloom cloth. Rayon, cotton. Length 195 cm. FMCH X97.11.15. Museum purchase. This broadloom kente has been designed to simulate four different warp-stripe patterns. The lower-right section has been patched without attention to matching the stripes.

25. Asante woman's broadloom shawl. Cotton, rayon (?). Length 192 cm. FMCH X97.36.10. Museum purchase. The words *Jolly Rose* have been woven into the simulated strip patterns of this broadloom kente.

Cat. no. 26

Cat. no. 28

26. Asante woman's broadloom shawl. Cotton, rayon. Length 164 cm. FMCH X96.30.49. Museum purchase. An enlarged rendering of the Nkyimkyim design embellishes the center of this shawl.

27. Asante woman's broadloom shawl. Cotton, rayon. Length 144.5 cm. NM 97.25.13. Purchase 1997 Mrs. Parker O. Griffith Bequest Fund. An enlarged Nkyimkyim design predominates on the body of the cloth.

28. Detail of an Asante man's cloth. Rayon. Length 320.3 cm. FMCH X97.36.31. Museum purchase.

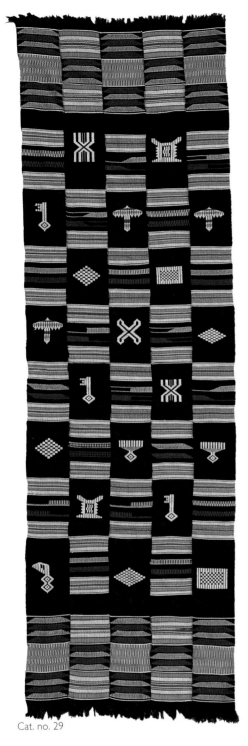

Cat. no. 29

Cat. no. 30

Cat. no. 31

Cat. no. 32

29. Asante woman's shawl. Cotton, rayon. Length 164.5 cm. FMCH X96.30.46. Museum purchase. This five-strip shawl with figurative images was woven by the Samuel Cophie workshop.

30. Asante woman's head tie; part of woman's wrapper set. Rayon. Length 184 cm. NM 97.25.12A. Purchase 1997 Mrs. Parker O. Griffith Bequest Fund. The design known as Fa Hia Kɔtwere Agyeman alternates with Akyɛm designs in the main body of this seven-strip Oyokoman cloth. The Nkyɛmfrɛ design embellishes its borders.

31. Asante woman's shawl. Cotton. Length 161.5 cm. N.M. 97.25.14. Purchase 1997 Mrs. Parker O. Griffith Bequest Fund. This cloth is composed of four strips.

32. Detail of Asante woman's cloth. Cotton, Lurex. Length 207 cm. Private collection. See also cat. no. 36.

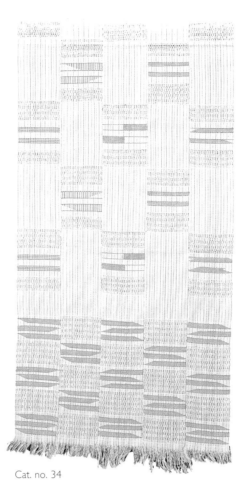

Cat. no. 33

Cat. no. 34

Cat. no. 35

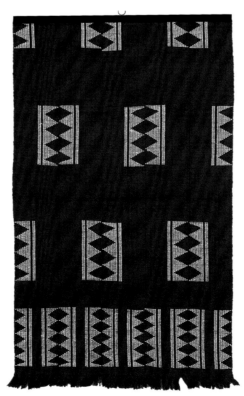

Cat. no. 36

33. Detail of Asante woman's shawl. Cotton, rayon, Lurex. Length 176.5 cm. FMCH X96.30.50. Museum purchase. Lurex is used in both the warp and weft of this five-strip shawl.

34. Detail of Asante shawl. Cotton, Lurex, rayon. Length 185 cm. FMCH X96.30.47. Museum purchase. Lurex is used in both the warp and weft of this five-strip shawl.

35. Detail of Asante man's cloth. Cotton, Lurex. Length 348 cm. FMCH X96.30.63. Museum purchase. Lurex is used in the warp of this multi-strip cloth.

36. Asante woman's shawl. Cotton, Lurex. Length 207 cm. Private collection. Lurex is used in the weft of this five-strip shawl.

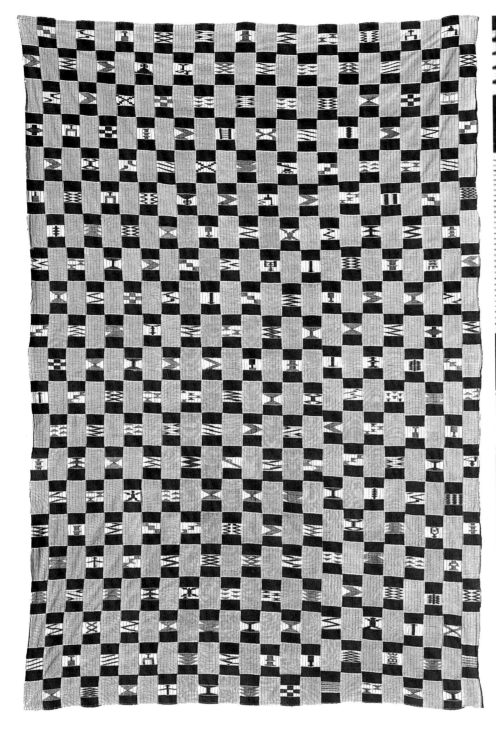

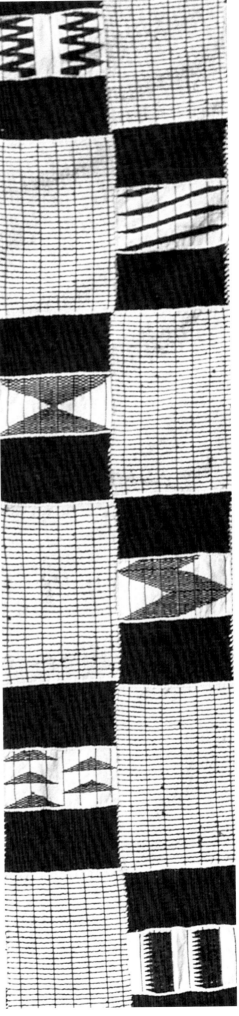

37. Ewe man's cloth. Cotton. Length 273.5 cm.
Collection of T. A. Baldwin. Figurative images embellish
this multi-strip cloth.

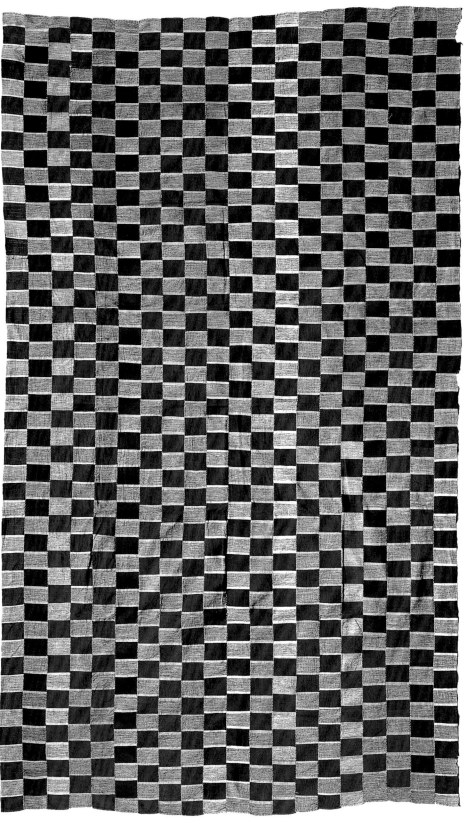

38. Ewe man's cloth. Cotton. Length 276.2 cm. FMCH X97.11.13. Museum purchase.

318

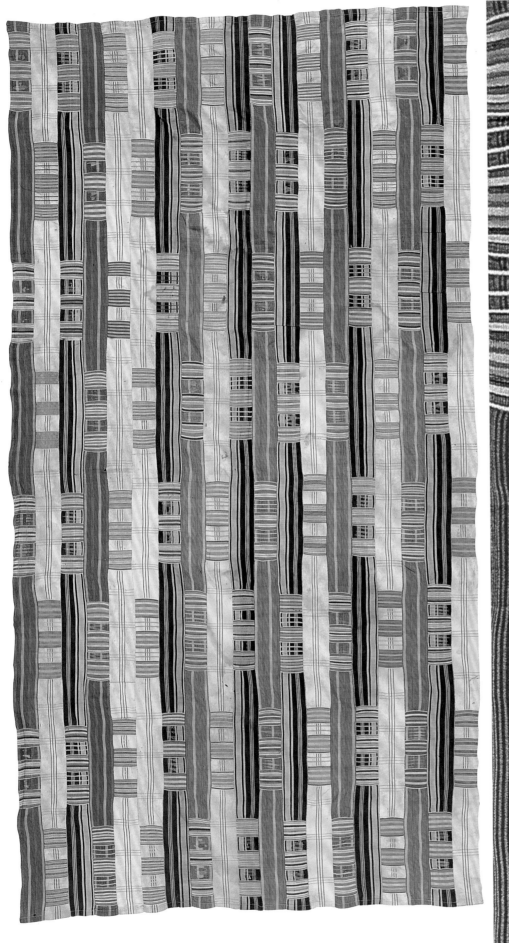

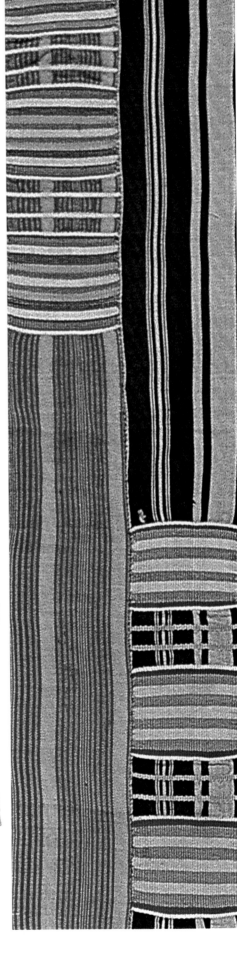

39. Ewe man's cloth. Cotton. Length 252 cm.
Collection of Peter Adler. (YE 189A). Adler, AM
#109. This cloth has nineteen strips featuring three
different warp stripes.

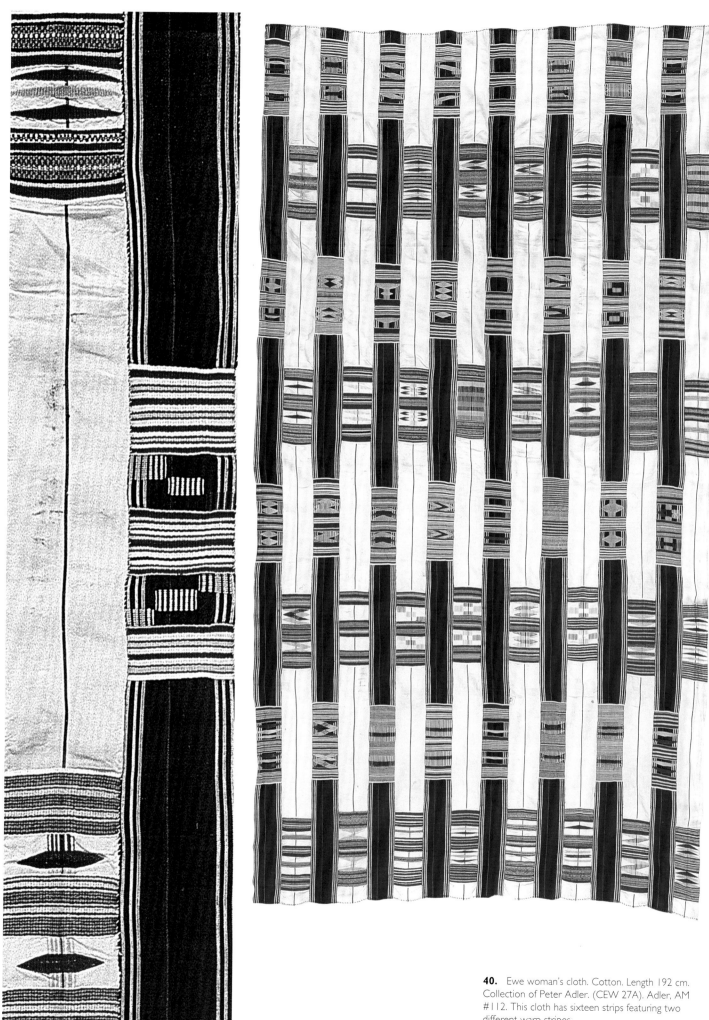

40. Ewe woman's cloth. Cotton. Length 192 cm. Collection of Peter Adler. (CEW 27A). Adler, AM #112. This cloth has sixteen strips featuring two different warp stripes.

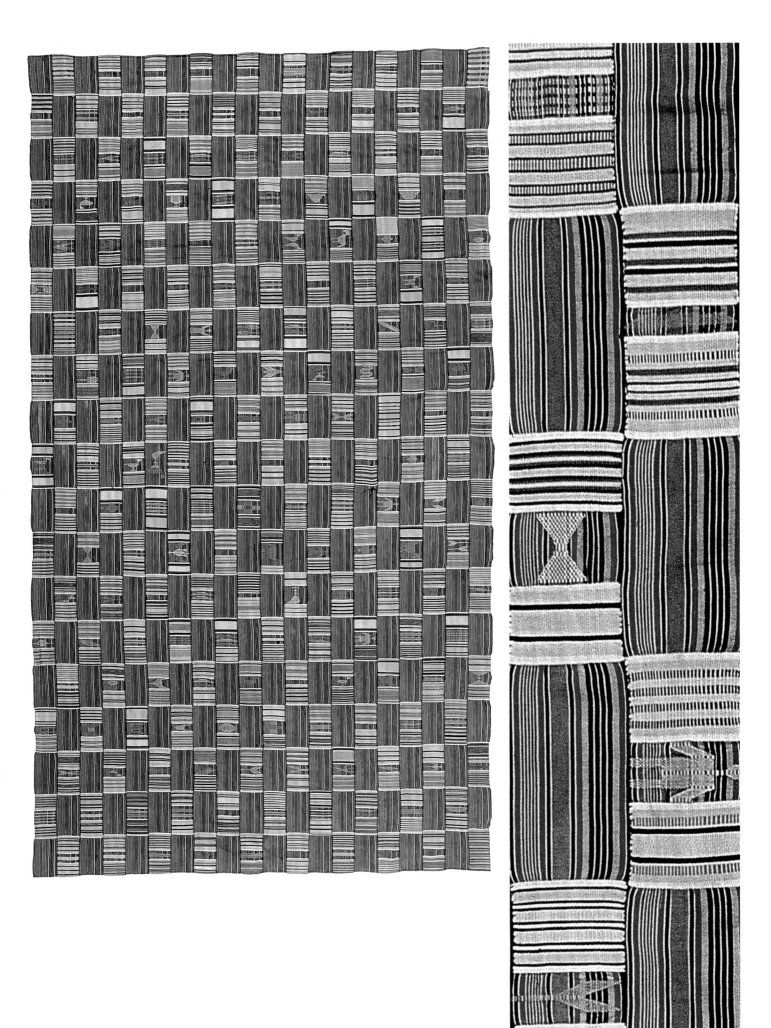

41. Ewe cloth. Cotton. Collection of Peter Adler.
CEM 26b. Figurative weft designs embellish this cloth.

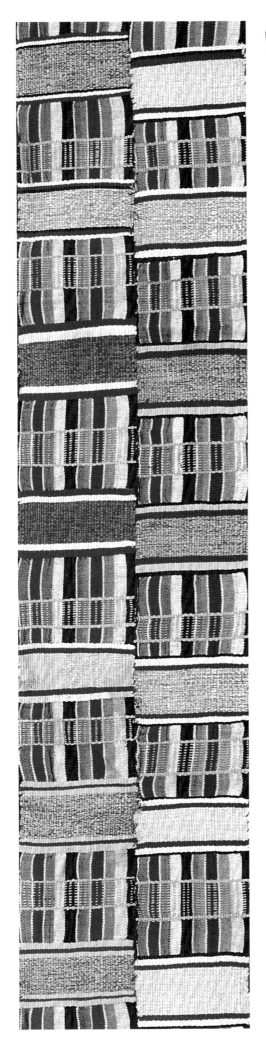

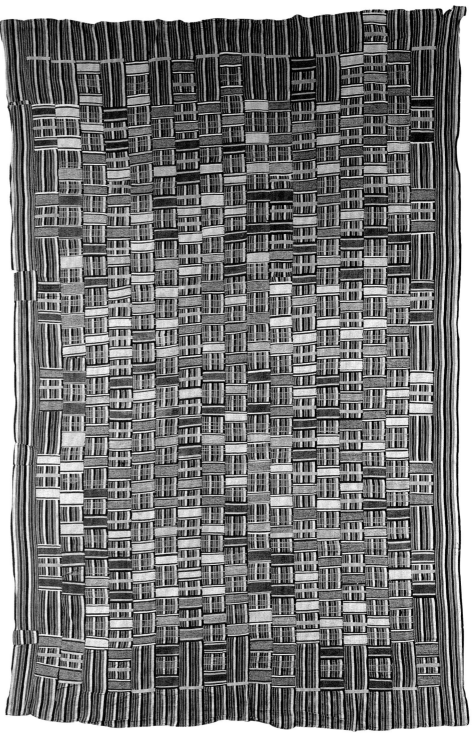

42. Ewe man's cloth. Cotton. Length 260 cm. NM 97.25.10. Purchase 1997 Mrs. Parker O. Griffith Bequest Fund. Two-color wefts produce the variegated color blocks on this cloth.

Cat. no. 43a

Cat. no. 43b

Cat. no. 43c

Cat. no. 43d

43a–d. Details of Ewe man's cloth. Cotton.
Collection of Peter Adler. (CEM 25). Adler, AM #44-
47. Figurative weft designs embellish this cloth.

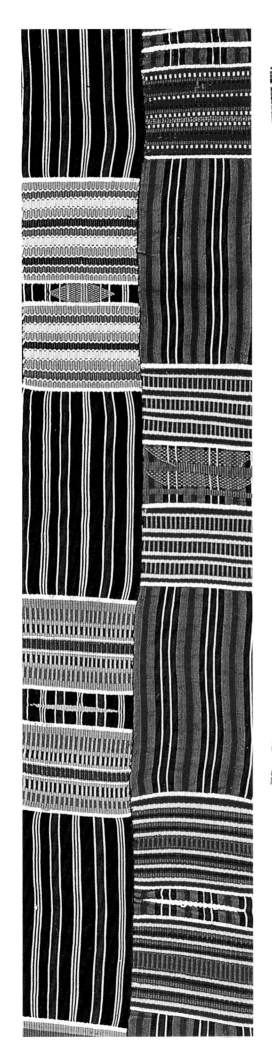

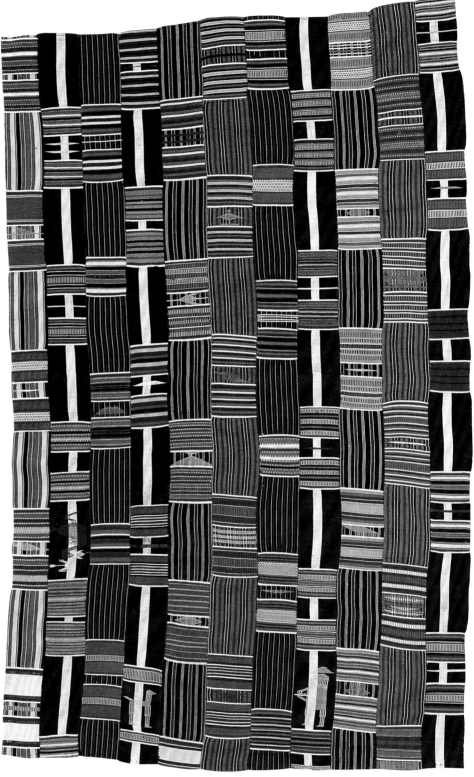

44. Ewe woman's cloth. Cotton. Length 149 cm. Collection of Peter Adler. (CEW 21A). Adler, AM #104. This cloth has eleven strips featuring six different warp stripes. Figurative weft designs embellish the cloth.

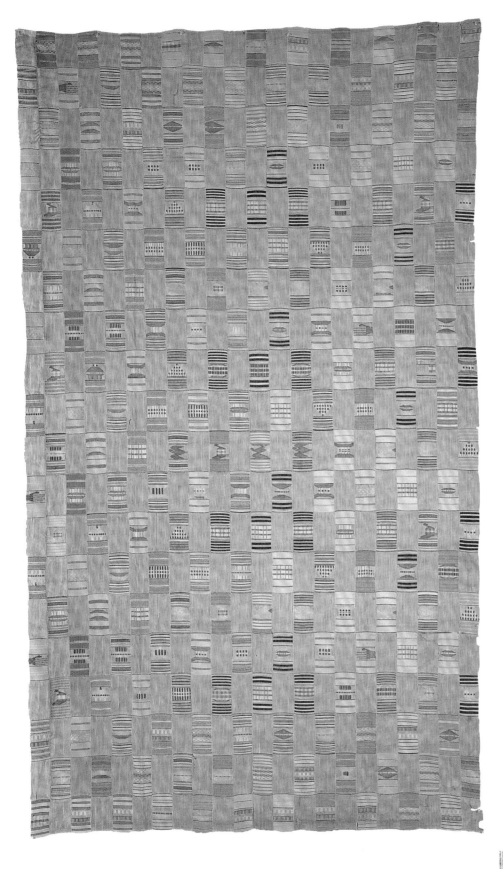

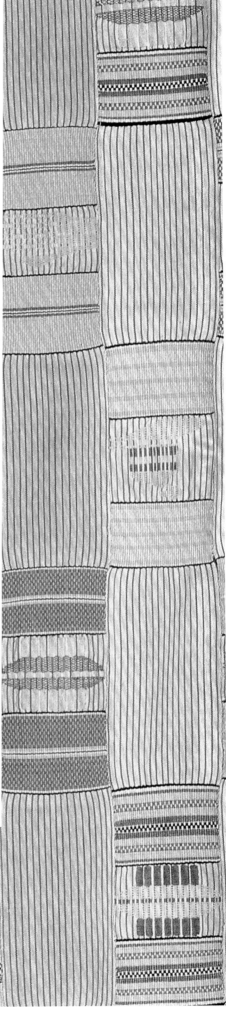

45. Ewe man's cloth. Cotton. Length 296 cm. Collection of Peter Adler. Adler, AM #36. Figurative weft designs embellish this cloth.

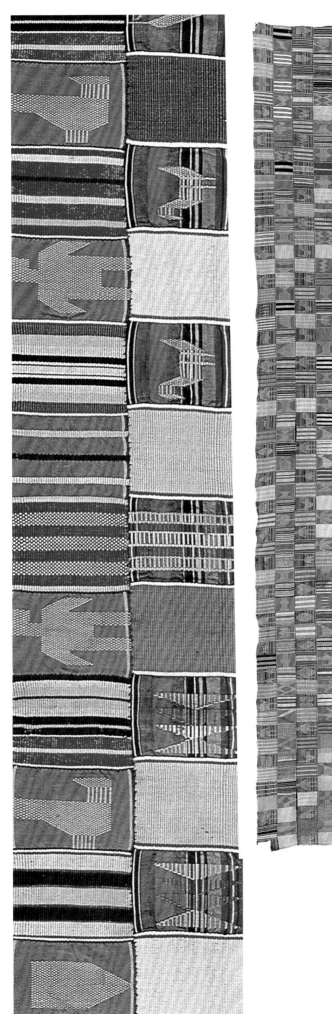

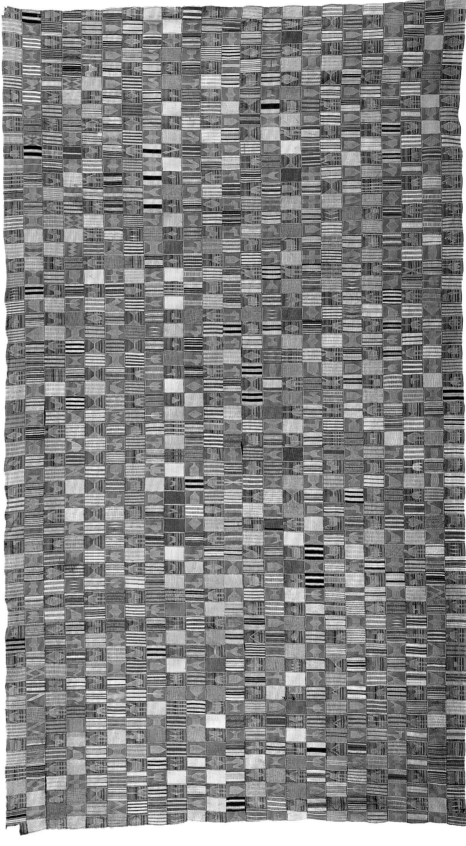

46. Ewe cloth. Cotton. Length 306.1 cm.. Collection of T. A. Baldwin. This cloth has twenty-three strips featuring two (?) different warp stripes. Figurative weft designs embellish the cloth.

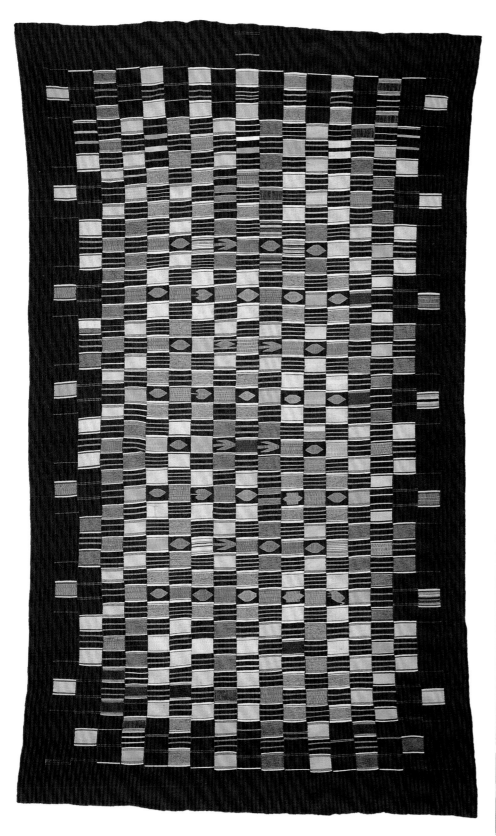

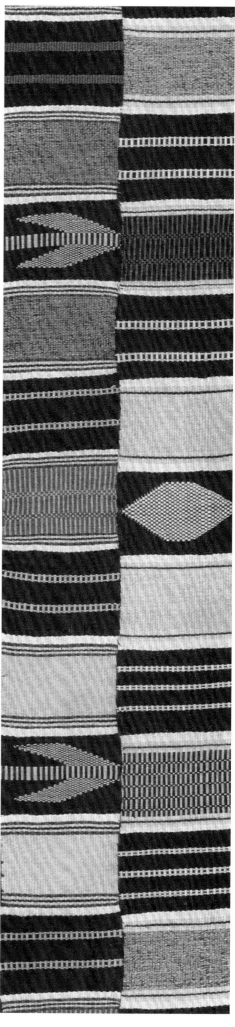

47. Ewe man's cloth. Cotton. Length 276 cm. NM 74.103. Gift of Mrs. Harrison F. Durand, 1974. From the collection of her father, Murray Gibson. Figurative weft designs embellish this cloth.

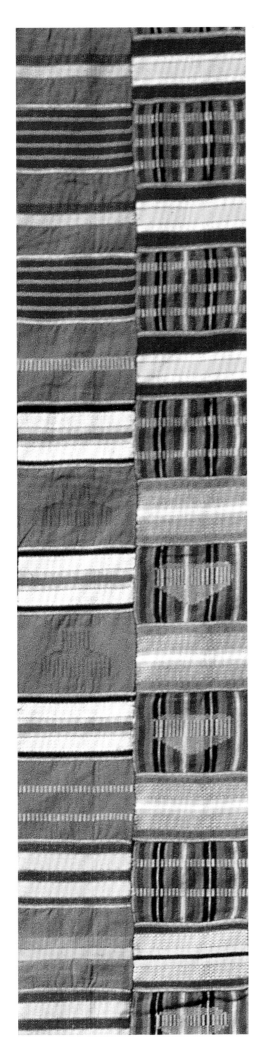

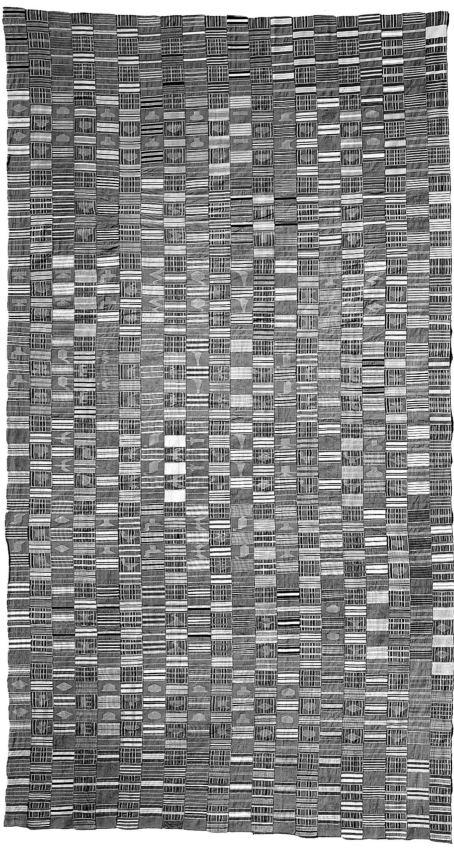

48. Ewe man's cloth. Cotton. Length 348.3 cm. FMCH X98.16.1. Museum purchase, Jerome L. Joss Fund. This cloth has twenty strips featuring three different warp stripes. Figurative weft designs embellish the cloth.

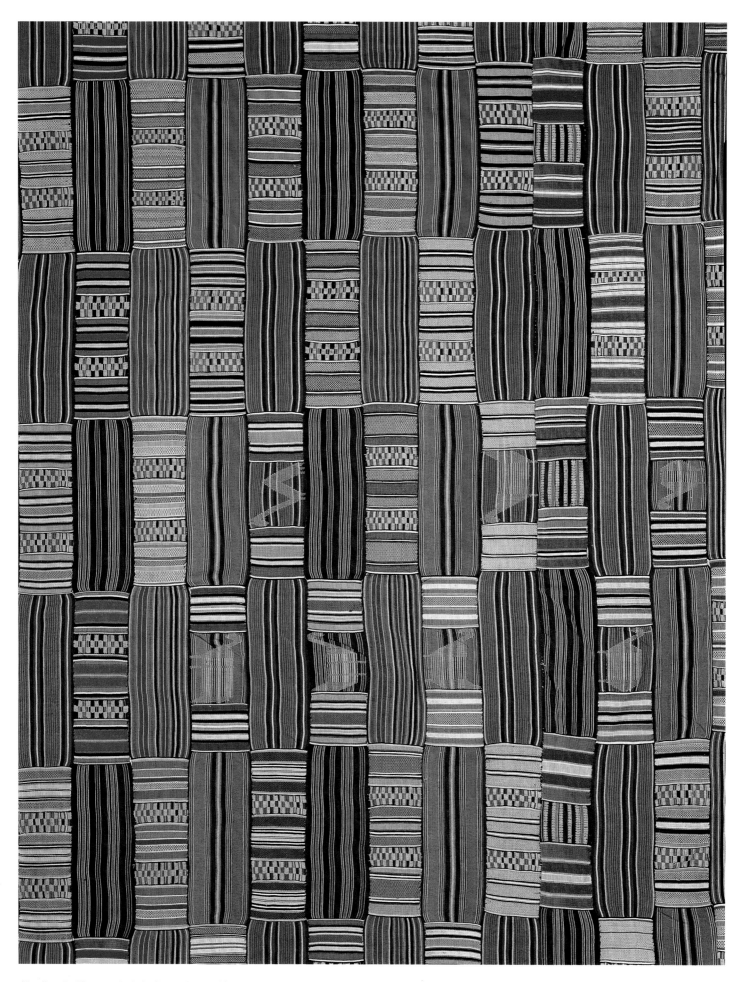

49. Detail of Ewe man's cloth. Cotton. Length 331 cm. FMCH X96.30.54. Museum purchase. This multi-strip cloth features four different warp stripes. Figurative weft designs embellish the cloth.

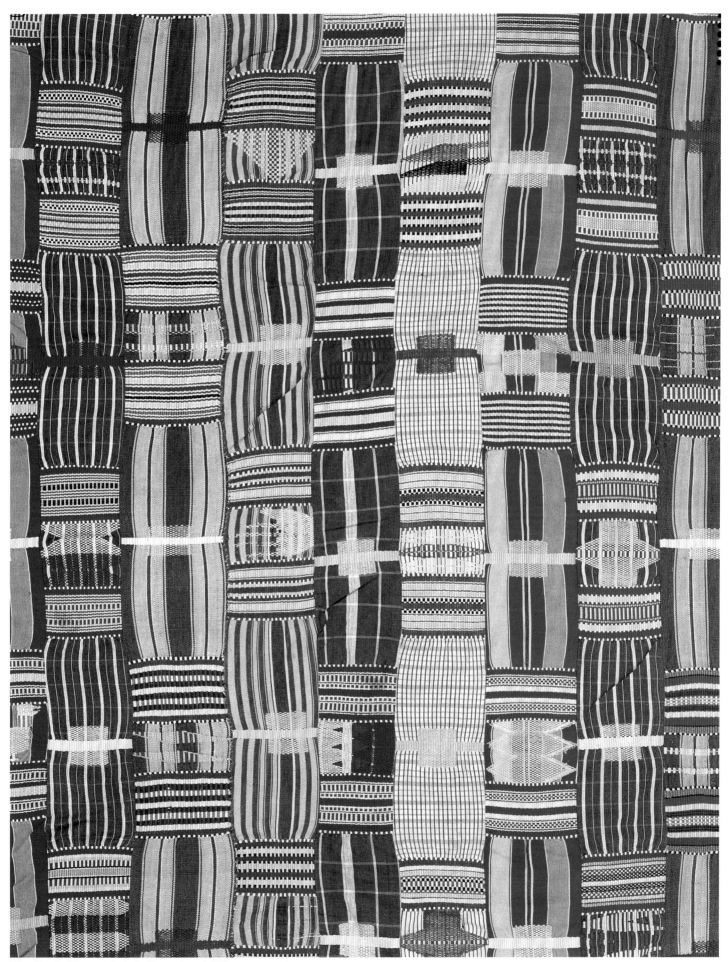

50. Detail of Ewe man's cloth. Cotton. Length 290 cm. FMCH X96.31.5. Anonymous gift. This multi-strip cloth features seven different warp stripes. Figurative weft designs embellish the cloth. See Appendix I for technical information.

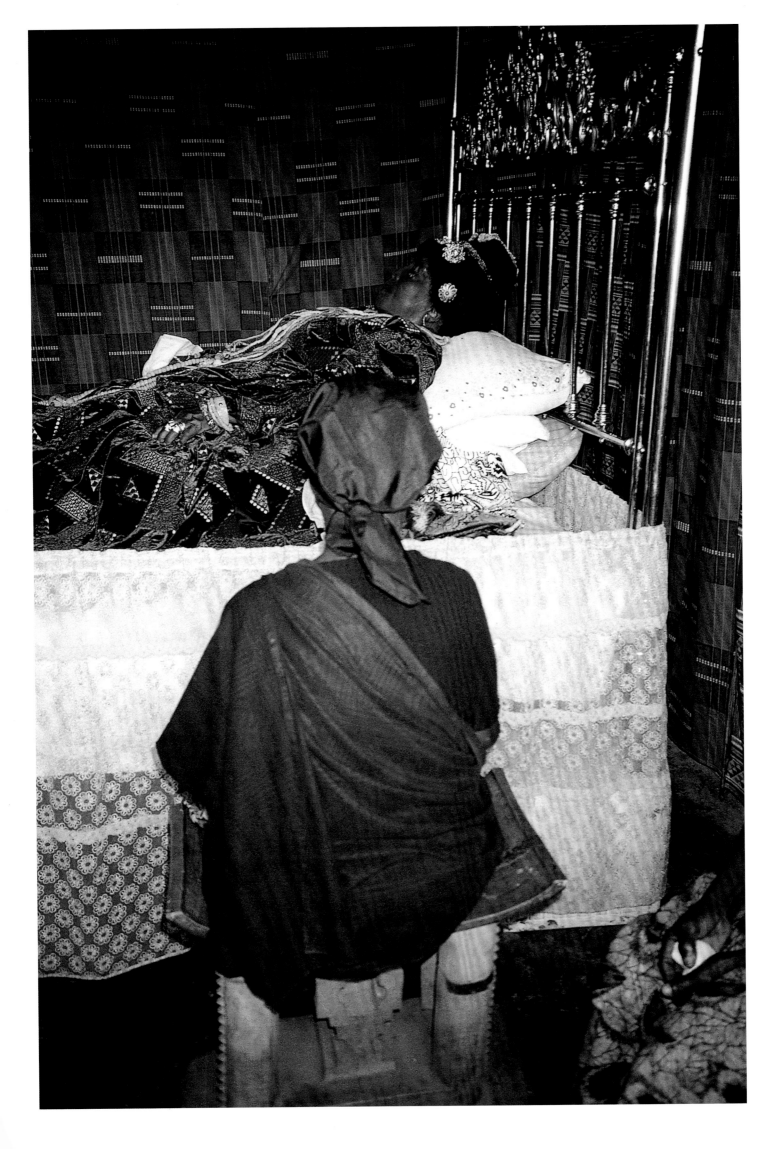

Appendix 1:
Technical Analysis of Selected Cloths by Mary Jane Leland

1. Man's Cloth

Accession number: NM 97.89.1

Asante

342 cm long (warp), 194.5 cm wide

20 strips: 8.9–10.2 cm wide selvage-to-selvage

Materials:
Ground warp:
Rayon machine-spun 2-ply S-twist, blue, black, white, red, yellow

Ground weft:
Rayon machine-spun 2-ply S-twist, blue, red, yellow, black, white, green, pink

Supplementary weft:
Rayon machine-spun 2-ply S-twist, maroon, yellow, green, pink, black

Techniques:
Warp-faced and weft-faced plain weaves with 3-strand discontinuous supplementary wefts reciprocally aligned over and under 8 warps to create very dense solid color double-faced weft surface areas referred to as Faprenu, or "double-cloth," by the Asante

Warp to weft proportions:
1/1 warp-faced plain weave ground (Ahwepan)
8/2 weft-faced plain weave (36 pairs=72 wefts per cm) (Badadua, Wotɔa)
8/3 supplementary wefts (Faprenu)

Ground thread count:
30–35 warps per cm, 16–18 wefts per cm

Finish:
Top and bottom warps cut, untreated; strips joined on selvages by zigzag machine stitch except for one hand-sewn side strip

2. Man's Cloth

Accession number: NM 97.89.2

Asante

269 cm long (warp), 145 cm wide

16 strips: 8.4–10.2 cm wide selvage-to-selvage

Materials:
Ground warp:
Rayon machine-spun 2-ply S-twist, green, yellow, white, black, and 2-ply Z-twist, pink

Ground weft:
Rayon machine-spun 2-ply S-twist, maroon, yellow, white, green, black, and 2-ply Z-twist, pink

Supplementary weft:
Rayon machine-spun 2-ply S-twist, yellow, green, black

Techniques:
Warp-faced and weft-faced plain weaves with 3-strand discontinuous supplementary wefts reciprocally aligned to create very dense solid color double-faced weft-surfaced color areas

Warp to weft proportions:
1/1 warp-faced plain weave ground (Ahwepan)
4, 6, 8/1 weft-faced ground (76 wefts per cm) (Badadua, Wotɔa)
4, 6, 8/2 supplementary weft adwen (64 per cm, Faprenu)

Ground thread count:
36–38 warps per cm, 17–18 wefts per cm

Finish:
Cut warps, untreated; strips joined at selvages in hand-sewn 3-strand pink overcast stitch and brown zigzag machine repairs

3. Woman's Cloth

Accession number: FMCH X66.924

Asante, Bonwire

183 cm long (warp), 140 cm wide

15 strips: 8.2–10.5 cm wide selvage-to-selvage; 10 different warps, 2 repeat and 1 appears 4 times

Materials:
Ground warp:
Cotton machine-spun 2-ply S-twist, white, blue

Ground weft:
Cotton machine-spun 2-ply S-twist, white, blue

Supplementary weft:
Cotton machine-spun 2-ply S-twist, blue

Inserted warp/weft:
Cotton machine-spun 2-ply S-twist, blue (1 strip)

Techniques:
Balanced, warp-faced and weft-faced plain weaves with 3-strand discontinuous supplementary weft in reciprocal and non-reciprocal alignment; strip 5 contains 3 sets of 2 blue warps each "inserted" into the warp plain weave (separated by 8 white warps), which turn at intervals of approximately 26 cm to become wefts across the strip (separated by 4 white wefts each set), called Nkontompo Ntama, or "liar's" pattern (Gilfoy 1987, 64)

Warp to weft proportions:
1/1 and 1/2 plain weave ground (Ahwepan) 4, 6, 8/1
2/1 selected combinations
1–3/4, 6, 8 found in various of 15 strips

Ground thread count:
28–34 warps per cm, 15–28 wefts per cm

Finish:
Cut warps, untreated; selvage joins hand-sewn tight overcast stitch with paired white strands.

Comments:
Ingenuity is displayed in the use of only blue and white, various warp striping, plain balanced weave checks, texture from "bundling" warps and wefts in groups of up to 8 strands, spacing blue-white color assignments.

4. Man's Cloth

Accession number: FMCH X86.1988

Asante

296 cm long (warp), 180 cm wide

24 strips: 7–7.5 cm wide selvage-to-selvage

Materials:
Ground warp:
Silk machine-spun 2-ply Z-twist, yellow

Ground weft:
Silk machine-spun 2-ply Z-twist, yellow
Silk machine-spun 2-ply Z-twist, white
Silk machine-spun 2-ply Z-twist, light green, maroon, black, bright blue

Supplementary weft:
Silk machine-spun 2-ply Z-twist, maroon, black, bright blue

Techniques:
Warp-faced (slight) and weft-faced plain weave with paired discontinuous supplementary wefts in reciprocal aligned floats over and under sets of 4 warps creating double-faced weft surface color areas

Warp to weft proportions:
1/1 plain weave ground (Ahwepan)
4/1 weft-faced plain weave (64 wefts per cm, Babadua, Wotɔa)
4/2 supplementary wefts (57–65 wefts per cm, adwen, Faprenu)

Ground thread count:
27 warps per cm, 21 wefts per cm (202 warp ends per strip)

Finish:
Cut warps, untreated (frayed from use); selvages joined by loose hand-sewn overcast stitch in 3-strand yellow.

5. Man's Cloth

Accession number: FMCH X87.380

Asante

364 cm long (warp), 218 cm wide

24 strips: 8.3–10.2 cm wide selvage-to-selvage; 8 different warp stripe patterns, 5–54 color stripes per strip

Materials:
Ground warp:
Rayon machine-spun 2-ply S-twist, white
Rayon machine-spun 2-ply Z-twist, blue, green, maroon, yellow, black

Ground weft:
Rayon machine-spun 2-ply S-twist, white
Rayon machine-spun 2-ply Z-twist, maroon, yellow, green, blue, black

Supplementary weft:
Rayon machine-spun 2-ply Z-twist, maroon, yellow, black, green, blue

Techniques:
Warp-faced and weft-faced plain weaves with 3-strand discontinuous and continuous supplementary weft in reciprocal aligned floats over and under sets of 4, 6, 8 warps

Warp to weft proportions:
1/1 warp-faced ground (Ahwepan)
4, 6, 8/1 weft-faced plain weave (Babadua, Wotɔa)
4, 6, 8/3 supplementary wefts (30–42 wefts per cm, adwen, Akyɛm)

Ground thread count:
20–42 warps per cm, 15–18 wefts per cm (267–330 warp ends per strip)

Finish:
Cut warps, untreated; selvage joined by hand-sewn overcast stitch in 3 strands of red or green

6. Man's Cloth

Accession number FMCH X96.30.16

Asante

345.5 cm long (warp), 238.5 cm wide

23 strips: 20–21.5 cm wide selvage-to-selvage

Materials:
Ground warp:
Cotton machine-spun 2-ply S-twist, black (2 tones)

Ground weft:
Cotton machine-spun 2-ply S-twist, black (2 tones), red

Techniques:
Balanced plain weave of paired warps and wefts with blocks of "bubbled" wefts that create rough texture, red cross band in plain weave "bubbled" entry (see Menzel 1972, 1: nos. 752–57)

Warp to weft proportions:
2/2 balanced plain weave, often termed basket weave

Ground thread count:
28 warps per cm, 24 wefts per cm (320 warp ends per strip)

Finish:
2.5 cm machine-stitched hems each end; cut warps, selvage joined by hand-sewn overcast stitch

Field collected 1996

Comments:
This is a man's cloth for mourning.

7. Man's Cloth

Accession number: FMCH X96.31.5

Ewe, Kwamlafa

290 cm long (warp), 144 cm wide

23 (of original 24) strips: 6.5–8.5 cm wide selvage-to-selvage; 7 different warp patterns, one distressed strip "sewn out" in resewing of strips

Materials:
Ground warp:
Cotton machine-spun 2-ply S- and Z-twist, red, blue, white, natural unbleached, pale blue, pale yellow

Ground weft:
Cotton and rayon machine-spun 2-ply S- and Z-twist, blue, red, white, black

Supplementary weft:
Cotton and rayon machine-spun 2-ply S- and Z-twist, pale yellow, golden yellow, white, red, black, blue, rose, maroon, pale gray, bright green

Techniques:
Warp-faced and weft-faced plain weaves with 1-, 2-, 3-, and 4-strand discontinuous supplementary weft in floats over and under sets of 8 single warps and 5 warp pairs (10 warp ends)

Warp to weft proportions:
1/1 plain weave ground
2/1 warp-faced ground (paired warp)
10/1 weft-faced plain weave (Babadua, Wotɔa)
10/2,3,4 supplementary wefts (adwen, Faprenu)

Ground thread count:
48–60 warps per cm, 13–25 wefts per cm (412–480 warp ends per strip)

Finish:
1.5–2 cm hem each end with frayed edges; selvages originally joined by hand-sewn, 3-strand, blue overcast stitch, hand-sewn mending in various colors, finally machine over-stitched, reducing strip width by .5–1 cm

8. Man's Cloth

Accession number: FMCH X96.31.8

Asante

335 cm long (warp), 224 cm wide

25 strips: 8.8–10 cm wide selvage-to-selvage

Materials:
Ground warp:
Silk machine-spun 2-ply Z-twist, white
Silk machine-spun 2-ply S-twist, maroon, yellow, black, green

Ground weft:
Silk machine-spun 2-ply Z-twist, white
Silk machine-spun 2-ply S-twist, maroon, yellow, black, green, blue

Supplementary weft:
Silk machine-spun 2-ply S-twist, maroon, yellow

Techniques:
Warp-faced and weft-faced plain weaves with paired discontinuous supplementary wefts in floats over and under 6 and 8 warps in double-faced reciprocal alignment

Warp to weft proportions:
1/1 warp-faced ground (Ahwepan)
6, 8/1 weft-faced plain weave (64 wefts per cm, Babadua, Wotɔa)
6, 8/2 supplementary weft (56 wefts per cm, Faprenu)

Ground thread count:
32–46 warps per cm, 18–19 wefts per cm (388 warp ends per cm)

Finish:
Cut warp ends, untreated; selvages joined with hand-sewn 2-strand overcast stitch

9. Man's Cloth

Accession number FMCH X97.7.1

Asante

314 long (warp), 217 cm wide

23 strips: 9–9.2 cm wide selvage-to-selvage

Materials:
Ground warp:
Rayon machine-spun 2-ply S-twist, maroon, green, yellow

Ground weft:
Rayon machine-spun 2-ply Z-twist, maroon, white

Supplementary weft:
Rayon machine-spun 2-ply S-twist, yellow, green, black, blue

Techniques:
Warp-faced and weft-faced plain weaves with 3-strand discontinuous and continuous supplementary weft reciprocally aligned over and under sets of 6–8 warps producing double-faced solid color weft-faced design blocks

Warp to weft proportions:
1/1 warp-faced plain weave ground (Ahwepan)
6–8/1 weft-faced ground (Babadua, Wotɔa)
6–8/3 supplementary discontinuous wefts (90 wefts per cm, Faprenu)
6–8/3 supplementary continuous wefts (60 wefts per cm, Akyɛm)

Ground thread count:
30–44 warps per cm, 20 wefts per cm (336 warp ends per cm)

Finish:
Cut warp ends, untreated; selvages joined by 3-strand maroon hand-sewn overcast stitch

10. Man's Mourning Cloth

Accession number: FMCH X97.11.1

Asante

359 long (warp), 212 cm wide

21 strips: 10.5–10.8 cm wide selvage-to-selvage; 5 strips only: 10 cm wide (darker and narrower red warp stripe)

Materials:
Ground warp:
Cotton machine-spun 2-ply S-twist, black (two tones), red (two tones)

Ground weft:
Cotton machine-spun 2-ply S-twist, black, red

Techniques:
Warp-faced plain weave

Warp to weft proportions:
1/1 plain weave ground
1/2 red paired weft plain weave ground

Ground thread count:
31–34 warps per cm, 10–24 wefts per cm; the 16 wider strips have 336 total warp ends including 97 red ends. The five narrower strips contain only 58 red warp ends each.

Finish:
Zigzag machine-stitched 2.5 cm wide hem each end; selvages joined by machine zigzag stitching

Comments:
Two separate warps were prepared for this cloth, which is notable for the change in the widths of strips and width of red stripes, the different red tones, and the different tones of blacks. Also of note are the subtle warp stripes in the two tones of black visible in the flat weave.

11. Woman's Cloth

Accession number: FMCH X97.11.20A

Asante

194.5 cm long (warp), 116.5 cm wide

12 strips: 9.4–10.4 cm wide selvage-to-selvage

Materials:
Ground warp:
Rayon machine-spun 2-ply S-twist, yellow, maroon, green, blue, black, white

Ground weft:
Rayon machine-spun 2-ply S-twist, yellow, maroon, green, black, white

Supplementary weft:
Rayon machine-spun 2-ply S-twist, yellow, green, black, maroon

Techniques:
Warp-faced and weft-faced plain weaves with 3-strand discontinuous supplementary wefts in reciprocal aligned floats over 8 warps producing double-faced weft-surfaced solid color areas

Warp to weft proportions:
1/1 warp-faced ground (Ahwepan)
8/1 weft-faced plain weave (64 wefts per cm, Babadua, Wotɔa)
8/3 supplementary wefts (78 weft strands per cm, Faprenu)

Ground thread count:
32–46 warps per cm, 18–19 wefts per cm (390 warp ends per strip)

Finish:
Cut warp ends, untreated; selvages joined by 3-strand hand-sewn overcast stitch

Comments:
There are 27 stripes per strip.

12. Woman's cloth

Accession number: FMCH X97.11.20B

Asante

194 cm long (warp), 104 cm wide

11 strips: 9.4–10.4 cm wide selvage-to-selvage

Materials:
Ground warp:
Rayon machine-spun 2-ply S-twist, blue, yellow, maroon, green, black, white

Ground weft:
Rayon machine-spun 2-ply S-twist, yellow, maroon, green, black, white

Supplementary weft:
Rayon machine-spun 2-ply S-twist, yellow, maroon, green, black

Techniques:
Warp-faced and weft-faced plain weaves with 3-strand discontinuous supplementary wefts in reciprocal aligned floats over and under 8 warps producing double-faced weft-surfaced solid color shapes

Warp to weft proportions:
1/1 warp-faced plain weave ground (Ahwepan)
8/1 weft-faced ground (64 wefts per cm, Babadua, Wotɔa)
8/3 supplementary weft (78 weft strands per cm, Faprenu)

Ground thread count:
32–46 warps per cm, 18–19 wefts per cm (390 warp ends per strip)

Finish:
Cut warp ends, untreated; selvages joined with 3-strand yellow hand-sewn overcast stitch

Comments:
The warp thread count is yellow 32 per cm, blue and green 46 per cm.

Appendix I

13. Man's Cloth

Accession number: FMCH X97.12.1

Asante

318 cm long (warp), 208 cm wide

22 strips: 9–9.8 cm wide selvage-to-selvage

Materials:
Ground warp:
Rayon machine-spun 2-ply S-twist, blue, yellow, maroon, black, white

Ground weft:
Rayon machine-spun 2-ply S-twist, yellow, maroon, green, blue, black, white

Supplementary weft:
Rayon machine-spun 2-ply S-twist, yellow, maroon

Techniques:
Warp-faced and weft-faced plain weaves with paired supplementary discontinuous wefts in reciprocal aligned floats over and under sets of 6–8 warps

Warp to weft proportions:
1/1 warp-faced plain weave ground (Ahwepan)
6–8/1 weft-faced plain weave (64–70 wefts per cm, Babadua, Wotɔa)
6–8/2 supplementary wefts (48–52 weft per cm, Faprenu)

Ground thread count:
32–44 warps per cm, 382 warp ends per strip, 17 stripes per warp strip

Finish:
Cut warp ends, untreated; selvages joined by hand-sewn overcast stitch in black thread

14. Man's Cloth

Accession number: FMCH X97.12.3

Asante

310 cm long (warp), 215 cm wide

23 strips: 9–10.5 cm wide selvage-to-selvage

Materials:
Ground warp:
Rayon machine-spun 2-ply S-twist, black, yellow, maroon, green

Ground weft:
Rayon machine-spun 2-ply S-twist, black, yellow, maroon, green, blue, white

Supplementary weft:
Rayon machine-spun 2-ply S-twist, yellow, maroon

Techniques:
Warp-faced and weft-faced plain weaves with paired strands of discontinuous supplementary wefts on reciprocal aligned floats over and under sets of 4 warps

Warp to weft proportions:
1/1 warp-faced plain weave ground
4/1 weft-faced plain weave (70 wefts per cm, Babadua, Wotɔa)
4/2 supplementary weft (14 pairs per cm, adwen)

Ground thread count:
30–34 warps per cm, 17 wefts per cm (334 warp ends per strip)

Finish:
Cut warp ends, untreated; selvages joined by hand-sewn overcast stitch in black thread

Comments:
Each strip contains 29 stripes in warp.

15. Cloth

Accession number: FMCH X97.12.4

Asante

226 cm long (warp), 151 cm wide

16 strips: 9.3–10 cm wide selvage-to-selvage

Materials:
Ground warp:
Rayon machine-spun 2-ply Z-twist, maroon, yellow, green

Ground weft:
Rayon machine-spun 2-ply Z-twist, red, white

Supplementary weft:
Rayon machine-spun 2-ply Z-twist, yellow, green, blue, black

Techniques:
Warp-faced and weft-faced plain weaves with paired continuous and discontinuous supplementary wefts interlacing over and under sets of 6–8 warps in reciprocally aligned floats

Warp to weft proportions:
1/1 warp-faced plain weave ground
6–8/1 weft-faced plain weave (Babadua)
6–8/2 continuous supplementary weft (15–26 pairs of wefts per cm, Akyɛm)
6–8/2 discontinuous supplementary weft (24–32 weft pairs per cm, Faprenu, adwen)

Ground thread count:
30–48 warps per cm, 18–20 wefts per cm (363 warp ends per strip)

Finish:
Cut warp ends, untreated; selvages joined with hand-sewn overcast stitch in paired maroon strands

16. Man's Cloth

Accession number: FMCH X97.36.2

Asante

328 cm long (warp), 225 cm wide

23 strips: 9.7–10.4 cm wide selvage-to-selvage

Materials:
Ground warp:
Rayon machine-spun 2-ply S-twist, maroon, yellow, green

Ground weft:
Rayon machine-spun 2-ply S-twist, maroon, white

Supplementary weft:
Rayon machine-spun 2-ply S-twist, yellow, green, black

Techniques:
Warp-faced and weft-faced plain weaves with 3-strand continuous and discontinuous supplementary wefts working over and under sets of 6 warps in reciprocally aligned floats

Warp to weft proportions:
1/1 warp-faced plain weave ground (Ahwepan)
6/2 weft-faced plain weave (white weft)
6/3 supplementary weft (42 per cm, continuous, Akyɛm); 54–57 per cm, discontinuous, Faprenu)

Ground thread count:
34–36 warps per cm, 14–17 wefts per cm (354 warp ends per strip)

Finish:
Cut warp ends, untreated; selvages joined by 3-strand maroon hand-sewn overcast stitch

17. Man's Cloth

Accession number: FMCH X97.36.3

Asante

304 cm long (warp), 201 cm wide

24 strips: 5 strips 9–10 cm wide selvage-to-selvage; 19 strips 7.2–9 cm wide selvage-to-selvage

Materials:
Ground warp:
Rayon machine-spun 2-ply S-twist, green, yellow, maroon

Ground weft:
Rayon machine-spun 2-ply S-twist, green, yellow, white, maroon, black, blue

Supplementary weft:
Rayon machine-spun 2-ply S-twist, yellow, green, black

Techniques:
Warp-faced and weft-faced plain weaves with 3-strand discontinuous supplementary wefts in reciprocal aligned floats over and under sets of 6 warps

Warp to weft proportions:
1/1 warp-faced plain weave ground (Ahwepan)
6/1 weft-faced plain weave (Babadua, Wotɔa)
6/3 supplementary wefts (30–32/cm, continuous, Akyɛm; 64/cm, discontinuous, adwen)

Ground thread count:
Wide-strip warp 34 per cm, weft 17 per cm
Narrow-strip warp 39 per cm, weft 17 per cm

Finish:
Cut warp ends, selvages joined by 3-strand maroon hand-sewn overcast stitch

Comments:
The wide strip contains 112 maroon ends of the 340 total warp ends. The narrow strip shows 116 maroon ends of the 336 total warp ends (two separate warp windings with closer "denting" in the reed for the narrower strip).

Abenasehene—An Asante official designated with the maintenance of the Asantehene's cloths.

Abosom—An Akan term for gods.

Abusua—An Akan term for clan or family.

Adae Kɛseɛ—An annual festival of the Asante peoples, which often coincides with other significant anniversary events. The festival typically includes a public procession by the Asantehene, purification and ancestral rites, a *durbar*, prayers and almsgiving, and visits to the royal mausoleums where the remains of past Asantehenes are maintained.

Adinkra—A dyed cloth with stamped designs made by the Akan peoples. When used for mourning, Adinkra cloths are typically dyed dark brown, brick red, or black. Designs are stamped on them with a bark and iron slag mixture that imparts a highly valued glossy surface.

Adwen—A complex design block used in weaving kente cloth. It is created by the addition of supplementary weft float threads. The introduction of a second pair of heddles, gathering warp threads in groups of six (and less commonly two, four, and eight), facilitates such weft designs. This term has been variously translated as "ideas" or "designs." (See figs. 6.11, 6.14.)

Adweneasa—A particular category of Asante kente characterized by weft designs woven into every available block of plain weave. The word "Adweneasa" is often translated as "my skill is exhausted" or "my ideas are finished." This has led to the popular misconception that every block of *adwen* in such cloths is unique. Rather, in an Adweneasa cloth the weaver has filled every possible area with some version of a weft design. (See fig. 8.48, cover.)

Adwoa Kɔkɔɔ—An Asante warp design. The name refers to "a red- or copper-colored Monday-born woman." The design is thought to take its name from the wife of a Bonwire weaver. (See figs. 8.11a, b.)

Agyapadie—Heirloom regalia of the Asante (owned by the state), including kente and other royal textiles, stools, swords, jewelry, and counselors' staffs. Rattray (1929, 331) explains the etymology of the word as "adie-pe-agya, as something sought after (by the ancestors) and then put aside (for safekeeping)."

Ahwepan—The simplest of Asante weaves; a plain weave cloth either with or without simple weft stripes and thus requiring only a single pair of heddles. (See figs. 6.12a, b.)

Akan peoples—Twi speakers who include the Asante, as well as the Akwamu, Fante, Akuapem, Denkyira, Akyem, Nzima, and Bono peoples.

Akyɛm—One of three Asante weft designs used as a building block for the majority of other patterns. Either the Akyɛm (shield), Babadua, or Wotɔa design usually frames another weft design with these blocks separated by plain weave. (See fig. 8.33.)

Aman, sing. ɔman—States of the Asante Kingdom, each headed by a paramount chief.

Ananse—The wise spider character who figures importantly in Akan oral literature and is credited with the creation or introduction of many forms of Akan folklore. Ananse is also associated with stories concerning the origin of weaving.

Appliqué—A term used to describe a decorative cloth technique in which small pieces of cut cloth are applied or sewn on the surface of the ground cloth to form designs.

Asafo—Traditional warrior groups of the Fante peoples.

Asanan—The pair of heddles on an Asante loom that are farthest from the weaver. They are usually threaded with alternating groups of six warp threads. Occasionally *asanan* heddles will be threaded in groupings of two, four, or eight threads in various combinations to facilitate greater variety of the weft patterns.

Appendix 2

Asante peoples—One of the most populous and best known of the Akan (Twi) speaking peoples living primarily in south central Ghana. Today the Asante are organized into a loose confederacy of states.

Asantehene—Supreme chief of the Asante peoples of Ghana.

Asantehene Osei Tutu—First Asantehene of the Oyoko Dynasty (r. ca. 1680–1717). Osei Tutu consolidated the Asante Empire.

Asasia—The rarest and most elite of the royal cloths, Asasia are characterized by their elaborate twill weaves. They are woven on a narrow-band loom that utilizes three pairs of heddles. (See fig. 6.15.)

Asatia—The pair of heddles on an Asante loom that are closest to the weaver. They are threaded with alternating single warp threads that have emerged from the groups of six threads in the *asanan* heddles to produce the basic plain weave ground structure of kente cloth.

Atano—Gods of the Tano River revered by the Asante peoples of Ghana. On occasions when one of these deities "sits in state," its shrine (a brass container) is placed on a stool, and cloth (usually kente) is draped around both. Atano are treated as chiefs in their possession of royal regalia. (See figs 5.4, 5.5.)

Babadua—Solid color bands of weft stripes often observed on Asante kente. This design is named after a segmented cane similar to bamboo. Along with Akyεm and Wotɔa, it is one of the most common Asante weft designs and is used as a building block for the majority of other patterns. (See fig. 8.31.)

Bankuo—Solid color weft-faced designs appearing on Asante kente cloths. (See fig. 6.10.)

Batakari—Akan term for an amulet-laden war shirt. (See fig. 3.25.)

Beater or reed—See *kyereye*.

Bobbin—See *dodowa*.

Bobbin carrier—See *menkomenam*.

Bobbin winder—See *dadabena*.

Cotton—A soft fibrous substance composed of the hairs surrounding the seeds of various tropical plants of the mallow family. Used in making textiles.

Dadabena—Asante term for bobbin winder; a device used to facilitate the winding of thread from skeins to bobbins. (See fig. 6.22b.)

Ɖo—Ewe term for fine strip-woven cloth.

Dodowa—A small spool (or bobbin) onto which thread is wound for laying the warp or for insertion as a weft. (See fig. 6.33.)

Durbar—Term used throughout Ghana to mean a "turning out" of chiefs and their court officials in honor of an important occasion or visiting dignitary. It signifies a public audience at the court of a local ruler.

Dwa—Akan term for stool.

Ɛkyɛmfoɔ—State shields of Asante paramount chiefs that are built on wicker frames and covered with fabric. The Asantehene's ceremonial shields are covered with colobus monkey skin and kente. (See fig. 3.36, 3.39.)

Ewe peoples—Kwa-speaking peoples who live in the present-day republics of Ghana, Togo, and Benin.

Fante peoples—One of several culturally and linguistically related groups known as the Akan. In terms of population, the Fante rank second among the Akan, and the Asante rank first.

Faprenu—One of the more complex of the three types of Asante fine weaves (known collectively by the Asante as *nsaduaso*). Faprenu can be translated as "thrown twice," referring to the two or three hand-picked supplementary weft threads or double or tripled weft threads wound on a single bobbin with the threads passed back *and* forth (separated by a shift of the heddle before the ground thread is inserted). This technique creates blocks of *adwen* so densely packed by the beater that none of the warp threads can be seen through the weft. It is referred to as "double weave" because it uses twice as many weft threads in relation to the ground thread as Topreko. (See fig. 6.14.)

Fugu—A smock characteristic of the northern peoples of Ghana. It is constructed of handwoven strip cloth shaped and sewn into a man's shirt.

Fwiridie—An Asante term for a skein winder, a device used in conjunction with the bobbin winder to load skeins of thread onto a bobbin. (See fig. 6.22a.)

Hand—A term used to describe the tactile qualities of a textile—the feel of a textile.

Heddle—The specific part of a loom that raises and lowers the warp threads during weaving. Sometimes called a harness or leash. (See fig. 6.29.)

Heddle pulley—The device used to raise and lower the heddles during weaving. Among the Asante and Ewe, these pulleys are often carved, sometimes elaborately. (See figs. 6.41–6.43.)

Hemaa—A female member of the chief's court who represents his matrilineage. She could be the mother of the chief, or she might be his mother's sister, her daughter, or even his own sister.

Hogbetsotso—The only Ewe festival today in which raffia cloth is used.

Horizontal narrow-band treadle loom—See *nsadua*.

Kassa—Strip-woven cloths made by the Fulani of Mali. These cloths may have been a northern influence on early Asante weaving. According to Lamb (1975), *kassa* cloths (called *nsa* by the Asante) are sometimes used as liners in the palanquins of Asante chiefs, and they are used in Asante funeral practices. (See fig. 6.6.)

Kente—Strip-woven cloth produced by the Asante peoples of Ghana and the Ewe peoples of Ghana and Togo, distinguished by its complex patterns and often, brilliant colors. Primarily handwoven by men, kente is made of cotton, rayon, Lurex, and sometimes silk. It is "traditionally" worn by men as a kind of toga and by women as upper and lower wrappers. Today the cloth and its designs have been transformed into an array of objects including clothing, accessories, and furniture.

Kenten—Fante word for basket.

Korokorowa—Asante term for shuttle; a tool used by the weaver to pass the weft through the shed opening in the warp. (See fig. 6.33.)

Kwanzaa—According to Dr. Maulana Karenga who created the holiday in 1966: "Kwanzaa is an African American holiday celebrated from 26 December through 1 January. It is based on the agricultural celebrations of Africa called 'the first-fruits' celebrations which were times of harvest, ingathering, reverence, commemoration, recommitment, and celebration. . . . It is a time for ingatherings of African Americans for celebration of their heritage and their achievements, reverence for the Creator and creation, commemoration of the past, recommitment to cultural ideals and celebration of the good" (1977, 1).

Kyereye—Asante term for a beater or reed; the comblike instrument through which the warp ends are passed to keep them evenly spaced and aligned. The reed also serves to beat in the weft. (See fig. 6.30.)

Leash—The eye or heddle of a loom through which individual warp threads are threaded. The leashes carry the warp threads as they are raised and lowered during weaving. See also *heddle*.

Loom—A frame or machine used to interlace two or more sets of threads or yarns at more or less right angles in order to form a cloth.

Menkomenam—Warp layer or bobbin carrier. The name of this device is typically translated by the Asante as "I walk alone." The *menkomenam* holds the bobbins from which the threads are laid out to set the pattern and length of the warp. (See fig. 6.24.)

Mmaban—An Asante cloth composed of several differently patterned strips. "Mmaban" may be translated as "there are many." (See fig. 1.1.)

Mprakyire—The two young girls who form part of the entourage of the Asantehene. They often hold horsetail fly whisks and are carried on the shoulders of attendants. (See fig. 3.13.)

Nsa—Asante term for Fulani strip-woven *kassa* cloths or blankets.

Nsadua—Asante term for horizontal narrow-band treadle loom typically used by men for the weaving of kente. (See fig. 6.16.)

Nsaduaso—Term used by the Asante for finer strip-woven cloths, including Topreko, Faprenu, and Asasia. (See figs. 6.13–6.15.)

Ntama or ntoma—Generic term applied to Asante strip-woven cloth.

Ɔkomfo—Term for priest among the Akan peoples of Ghana.

Ɔkomfo Anokye—Powerful priest who, according to Asante tradition, delivered a solid gold stool from the heavens to land gently on the knees of King Osei Tutu in the late seventeenth century.

Ɔkyeame—Akan term for wise counselor (or linguist) to the Asante chief. This official acts as chief advisor, judicial advocate, military attaché, foreign minister, and spokesman. He is identified by a carved wooden staff decorated with gold leaf and topped with a finial representing a proverb or saying.

Ɔmanhene—Paramount chief of an Asante state (oman) whose position and authority are further enhanced by state regalia, including the finest kente.

Oyokoman—Asante warp-stripe pattern typically identified by its wide gold and green warp stripes embedded in a maroon, red, or burgundy field. This pattern has evolved with a considerably more important and complex history than most other Asante weaves and may very well be among the first and most elite of all cloths. It is credited in Asante oral tradition as being the first pattern created by Ota Kraban upon his return to Bonwire from Gyaman. It takes its name from the Oyoko clan and is the most frequent warp pattern for Adweneasa. Today it is arguably the most popular cloth among African and African American buyers, perhaps because its colors are the same as the colors used to symbolize African unity and freedom. (See fig. 8.2)

Queen mother—See *hemaa*.

Rayon—Any of a group of smooth textile fibers made in filament and staple form from cellulosic material by extrusion through minute holes.

Reed—See *kyereye*.

Shed—The opening in the warp (when the heddles are raised or lowered), through which weft threads are passed in the weaving process.

Shuttle—See *korokorowa*.

Sika Dwa Kofi—Asante name for the "Golden Stool born on Friday." The Golden Stool is the most sacred symbol of the Asante Kingdom and is thought to contain its *sunsum*, or spirit.

Silk—A fine continuous fiber produced by various insect larvae—especially silkworms—usually for cocoons. It is used for textiles.

Skein—A quantity of yarn stretched round and round some type of a winding device.

Skein winder—See *fwiridie*.

Strip-woven cloth—Individually woven strips sewn together to form a larger cloth. In West Africa, narrow-strip cloth is primarily woven by men on horizontal narrow-band treadle looms (known by the Asante as *nsadua*).

Sunsum—Soul or spirit of the Asante nation that is said to be housed within the Golden Stool.

Susudua—Measuring stick used by the Asante to measure the lengths of completed weft-faced pattern blocks.

Tabon—Asante term for weaving sword; a tool used to maintain the open shed through which wefts are passed. (See figs. 6.45–6.47.)

Textile—A woven fabric.

Topreko—The simplest of the three categories of Asante fine weaves (known collectively as *nsaduaso*). Weavers and cloth sellers refer to it as "single weave," thereby suggesting the literal translation of Topreko, "passed once." Topreko is recognized by its composition of two blocks of weft-faced Babadua framing a block of weft-faced *adwen*, created with double- or triple-weft threads going over and under alternate groups of six warp threads manipulated by a second pair of heddles and followed by a ground thread. (See fig. 6.13.)

Warp—The lengthwise threads of a woven cloth that run parallel to its selvages (or finished edges).

Weave—To form a cloth by interlacing strands of yarn, fiber, and so forth, or to make cloth on a loom by interlacing warp and weft threads, crossed at more or less right angles.

Weaving sword—See *tabon*.

Weft—The crosswise threads of a woven cloth that run perpendicular to the warp threads and selvages (or finished edges).

Wotɔa—An Asante weft-faced design easily identified by its red and yellow color scheme and characterized by bands of vertical stripes that completely cover the warp. The name of the design may refer to the shell of a snail. (See fig. 8.32)

Zawadi—The gifts given to children at Kwanzaa. These are "symbolic of the seeds sown by the children (i.e., commitments made and kept) and of the fruits of the labor of the parents" (Karenga 1977, 35).

Appendix 3: Accession Numbers

Notes to the Text

The following is a key to the accession numbers and relevant collection information for the kente stoles pictured in interleaf L, "Stoles for All Occasions."

Row L1 (left to right): Private collection; private collection, private collection; FMCH X95.51.25; private collection, private collection; private collection; private collection.

Row L2: All private collection.

Row L3: All private collection.

Row L4: FMCH X95.51.18.

Row L5: Private collection.

Row L6: FMCH X98.7.1.

Row L7 (left to right): FMCH X95.51.8; FMCH X95.51.3; FMCH X95.51.5; FMCH X95.51.1; FMCH X 95.51.7; FMCH X95.51.2; FMCH X96.30.26; FMCH X95.51.6; private collection; FMCH X95.51.9; FMCH X95.51.4; private collection.

Row L8 (top to bottom): FMCH X95.51.13; FMCH X95.51.14; FMCH X95.51.12; FMCH X95.51.16; FMCH X95.51.15; FMCH X95.51.17; FMCH X95.51.10; FMCH X95.51.11.

Row L9 (left to right): Private collection; private collection; private collection; private collection; private collection; FMCH X95.51.19; FMCH X95.51.21; FMCH X95.51.20; FMCH X95.51.23; FMCH X95.51.22; FMCH X95.51.24; private collection.

Chapter 1

1. For a discussion of Asante craft organizations see Marion Johnson (1979). Overnight tours to Kumase out of Accra typically include stops at the Asante carving village of Ahwiaa and the weaving center of Bonwire. Tour buses are almost a daily occurrence in Bonwire, and plans are underway to improve social amenities and to develop a craft center.

2. *West Africa: The Rough Guide* by Jim Hudgens and Richard Trillo provides a one hundred twenty-six word entry for Bonwire and no listings at all for the Ewe weaving centers of Agbozume and Kpetoe (1995, 814, 815). Alex Newton and David Else's *West Africa: A Lonely Planet Travel Survival Kit* provides an eighty-six word entry for Bonwire and a forty-five word listing for Kpetoe (1995, 427, 418). Nevertheless, these two guides remain the most reliable tourist introductions to Ghana and neighboring countries.

Chapter 2

1. Asante history and culture is complex and filled with conflicting oral traditions. The best introduction to the Asante is Malcolm McLeod's *The Asante* (1981). Robert S. Rattray's *Ashanti* (1923) and *Religion and Art in Ashanti* (1927) are still indispensable. For Asante history, see John Kofi Fynn's *Asante and Its Neighbors 1700–1807* (1971) and Ivor Wilks's *Asante in the Nineteenth Century* (1975).

2. On occasions of great consequence or upon the enstoolment of the Asantehene, it is said that the king would be lifted by other chiefs and his buttocks touched three times upon the Golden Stool to invoke its power (Rattray 1923, 290; Kyerematen n.d., 27).

3. The exact makeup of the early kingdom is not entirely clear. Over time other states were incorporated into the kingdom and rose or fell in favor depending on historical events. As of 1976 there were fourteen officially recognized Asante paramountcies: Kumase, Mampon, Kokofu, Dwaben (Juaben), Nsuta, Bekwai, Offinso, Kumawu, Edweaso (Ejisu), Agona, Asokore, Denyase, Asumegya (Essumeja), and Adanse Fomena, although the status of each varied within the kingdom itself.

Chapter 3

1. A. A. Opoku's *Festivals of Ghana* (1970) remains one of the most accessible guides to some of the more important festivals throughout the country.

2. The Adae Kɛsɛɛ has apparently subsumed the public events of the grand Odwira festivals documented and discussed by Bowdich (1819, 274–82), Rattray (1927, 122–43), and Wilks (1975, 75–79), although the purification rituals of Odwira still take place annually.

3. Albert Mawere Opoku in his analysis of Asante dance describes the chief's performance in the palanquin: "The chief's head moves to the challenging rhythmic throb of the *fontomfrom atopretia* dance. He holds a musket in his left hand and a state sword in the other. He crosses the sword over the gun, swaying from side to side, like a king cobra, searching for an imaginary foe. He leans to his left, then to his right; he leans forward and points his sword forward. With a studied smile on his lips, he flings himself back onto the cushions behind him. He may twirl the gun with his left hand while making attacking, hacking feints with the sword; all the while, he is being rocked and tossed up and down to the rhythm of the *fontomfrom* sounds, in a re-enactment of a historic routing of a powerful adversary" (1987, 196–97).

4. Although Thierry Secretan's *Going into Darkness: Fantasy Coffins from Africa* (1995) is primarily about highly sculptural coffins, he photographically documents a number of Ga funerals that are interesting visual essays on cloth behavior in those contexts. They include several instances of Asante and Ewe strip-woven cloth.

5. Another photograph shows Kwame Nkrumah at the opening of Parliament standing in front of a dark blue version of the Akyɛmpem, or "thousand shields," pattern (Kyerematen 1964, 111).

6. One of the state umbrellas of the paramount chief of Akuapem has an Oyokoman covering, and two others appear to have kente tops (Kyerematen 1964, 90).

7. The two photographs of the shield published in the program *Durbar of Asante Chiefs in Honour of His Royal Highness The Prince of Wales* (1977) show both sides of the shield. The caption for the reverse mistakenly identifies the cloth on that side as Kyemee, which is actually the pattern on the front of the shield.

Chapter 5

This essay is based on field research carried out in Ghana in 1979–1980 that was supported by fellowships granted by the U.S. Department of Education, the Social Science Research Council, and the American Council of Learned Societies. I wish to thank the priests (*abosomfoɔ*) of the shrines I visited for generously sharing their knowledge and insights with me about the history and significance of the gods they serve. This essay is a revision of a paper delivered in November 1986 at the Twenty-Ninth Annual Meeting of the African Studies Association in Madison, Wisconsin.

1. A former Techimanhene, Akumfi Ameyaw, claimed that many elements of Asante culture originated in Techiman. "Kente weaving came from Techiman. Even the ancestors of the present Bonwire Chief came from Techiman. When the Asante conquered Techiman, they picked some of the people who knew handiwork and took them to Asante. They selected goldsmiths and men who knew other crafts" (Warren and Brempong 1971, 71). Warren (1975, 3) recalls a tradition that the "ancestors of the inhabitants of Bonwire, the kente-weaving capital of Asante, are suppose to have come from Techiman." There are, of course, alternative histories dealing with the origins of kente. These are dealt with elsewhere in this volume.

2. This figure is derived from a survey of 394 shrines (of which 175 were Tano *abosom*) in the Techiman area conducted by Dennis Michael Warren in 1970–1971. See Warren 1974 and 1976 for a summary of the results of this survey.

3. This evidence is presented in Silverman 1987.

4. Anquandah (1982, 87) suggests that the "Akan cradle, if there was one, is likely to have straddled the geographical area between Brong, Adanse, and Assin, especially since the Brong dialect is known to exhibit the most archaic traits of the Akan language."

5. The names of the *atano* are often preceded by the name of the community in which they are located. Thus one refers to "Techiman" Taa Mensah or "Tanoboase" Atiakosaa.

6. Sometimes the name of the deity reflects gender. Thus Nsoko Taa Kofi (Kofi is the day name for a male born on Friday) is a male god who resides in the village of Nsoko. Kranka Taa Afua (Afua is the day name for a female born on a Friday) is female and resides in the village of Kranka. It is interesting that a few Tano *abosom* have identified themselves as adhering to non-indigenous faiths, like Islam. Tanoboase Taa Kwasi, for instance, is Muslim.

7. It is perhaps significant to mention that in 1980 there was very little in the way of representational visual imagery associated with any aspect of Tano worship as practiced among the Bono. Today, the Tano shrine rooms in the Bono area are for the most part devoid of any wooden figurative sculpture. This perhaps reflects the belief that Tano *abosom* do not need the assistance of other spiritual forces; or perhaps it is simply a testimony to the thriving African art market. In Asante one can still find the well-known *akua'mma* figurative sculptures, though many seem to be fairly recent carvings. There are also other types of figurative sculptures found in Asante shrine rooms that may represent spirits who assist the shrine priest in his healing practices.

8. In 1980 when I interviewed Kwaku Pong, he was roughly seventy years old. Therefore, in this photograph, taken by René Bravmann in 1968, the priest is roughly fifty-eight years old.

Chapter 6

1. Venice Lamb unnecessarily defines narrow-strip weaving as "not narrower than one inch" (1975, 28). Handwoven strips ornamenting an Asante sword-bearer's eagle-feather headdress (*ntakrakye*) in the Houston Museum of Fine Arts are less than a half an inch wide and were clearly woven on a horizontal treadle loom.

2. The official brochure for the first Bonwire Kente Festival outlines these accounts in the greatest detail to date but is clearly presenting an Asante perspective to counter recent Ewe claims to originating kente (Safo-Kantanka and Awere 1998, 8–11).

3. Venice Lamb mistakenly defines Ahwepan as "plain cloth with no patterns" (1975, 129), but Ahwepan may have weft and/or warp stripes, so plaid patterns are even possible. The basic definition of Ahwepan is a cloth produced only on the *asatia* heddles so that the single weft thread passes over one warp, under the next, over the third, and so on. This basic weave is also called *tabby*.

4. The Asante also imported spun cotton from the north (Posnansky 1987).

Chapter 7

1. This essay is based on interviews conducted in Bonwire on 23 and 24 April and 2 and 4 May 1997.

2. Cophie, or Kofi, is an Asante name, and not the name of Samuel Cophie's grandfather. Cophie explains that he didn't like the Asante translation of his family name, Tsidi (which was roughly "something that is forbidden"), and therefore he dropped it.

3. By Cophie's definition, a cloth must have a design in it in order to be considered kente. Within the context of "Ewe kente," the mark of a good weaver is his ability to create recognizable images.

4. When I asked another weaver how many weavers there are in Bonwire, his answer was "plenty."

5. This is according to the only woman weaver in Bonwire, Yaa Yasmin Minkah.

6. They are Kwaku Appiah, Cudjoe, Kofi O.J., and Yaw Seth.

7. During the course of one interview session, Cophie was interrupted to give several of his weavers more thread and to negotiate a price for finished strips with another.

8. This interaction between Ewe and Asante kente weaving is not unique to Samuel Cophie. According to Venice Lamb, there was considerable mingling of designs in the 1970s, at the time Cophie was experimenting. She noted that this trend was not new, but that it was on the increase (Lamb 1975, 159–60).

Chapter 8

1. Rattray's (1927, 236–50) and Lamb's (1975, 118–23) distinction between the names of cotton and silk cloths is somewhat confusing and is based more on distinctions of color and complexity of weft patterns than on actual material. Stereotypically the blue (indigo) and white (natural cotton) cloths are called "cotton," and those with many colors and conforming to what we conventionally identify as Asante kente are called silk. In fact what are identified as silk cloths by both authors have been woven in both cotton and rayon in addition to silk for at least the past seventy-five years.

2. Menzel's catalog (1972, nos. 502–710) is a bit confusing on this point since she tends to group the warp stripes in terms of predominant color, so cloths with the same names are widely separated. It would be very instructive to rearrange her photo layouts by cloth names.

Chapter 9

I am deeply grateful to Doran Ross for inviting me to contribute this chapter and for offering suggestions for its improvement. I would also like to thank Professor Merrick Posnansky for introducing me to textile research as well as for his comments on this essay. Editorial suggestions made by Lynne Kostman are also appreciated.

1. Christopher Ehret argues that the presence of an original vocabulary for weaving among many West African peoples is an indication that their weaving technology was locally developed (personal communication, October 1997).

2. Hogbetsotso is the annual festival of the Anlo Ewe of southeastern Ghana and commemorates their exodus from Notse, the last ancestral home of the Ewe.

3. J. S. Kundra, cited by B. Gadagbui on <Okyeame@Africaonline.com>, February 22, 1996. The words *kente/kete* and their origin continue to be a source of lively discussion in both the Ghanaian press and the Ghana on-line network, Okyeame. See also Bishopp 1977; *Daily Graphic*, August 28 and October 2, 1996, and August 27, 1997.

4. Adler and Barnard added the suffix *adanudo* to all the cloth they found among the Ewe in their catalog.

5. For further discussion on the controversy surrounding the meaning of "Adweneasa," see Picton 1992, 40–41.

6. There were about a dozen weavers at Notse, and I was able to do a complete study of cloth production in all its aspects.

7. Doran Ross, personal communication, September 1996.

8. Kodzotse Sabah is a seventy-nine-year-old professional (full-time) weaver living in Kpalime, Togo (personal communication, June 1997).

9. Kodzotse Sabah's son, Gladstone, informed me that people bring Rawlings's photograph to his father to commission the same cloth.

10. It is worthwhile noting that a widow is called *ahosi*, a word derived from *aho*, meaning "indigo blue" in Ewe.

11. Kodzotse Sabah, personal communication, June 1997.

12. This section is largely taken from an unpublished report on the Agbozume market by Cornelius Adedze, October 17, 1997.

13. Contrary to the view held by Lamb, weavers' wives do not control the sale of cloth. Cloth trade among the Ewe involves a significant financial investment that is not accessible to the large majority of the weavers and their wives. It is rather women cloth sellers at the markets who control the sales.

Chapter 10

1. A ninth piece sent to Denmark at this time, a checkerboard-style cloth, which is related to cloths from present-day Mali or Burkina Faso, is perhaps an Ewe version of this cloth (see Lamb 1975, 183).

2. Interestingly on August 18, 1921, Garvey explained to Charles Mowbray White that "red showed sympathy with the 'Reds' of the world, and the Green their sympathy for the Irish in their fight for freedom, and the Black—the negro" (Hill 1984, 603). At what time this interpretation was replaced by one more directly relevant to African Americans is not clear.

3. In previous publications (e.g., Cole and Ross 1977, 162 and Ross 1982), I tended to downplay the communicative dynamics of Akan staffs, but I am now convinced by Yankah's persuasive arguments.

4. It is possible that the prevalence of red, white, and blue colors in many nineteenth- and early twentieth-century kente cloths was influenced by the same color schemes on the British and Dutch flags and the display of bunting in European political displays. The actual wearing of European flags has in fact been documented among the Akan. In 1817 Bowdich presented several Union Jacks to the Asantehene, who had them sewn together in much the same fashion as a kente cloth (1819, 124). There is much more evidence to be revealed on this subject, and it I will present it in a future paper.

5. Lamb illustrates an undated photograph of President Kenneth Kaunda of Zambia wearing a roller-printed version of kente (1975, 22); this is the same cloth Kaunda wore during a visit to the United States in 1966 (*Jet* 1966, 38).

6. From a transcription of an interview with Emma Amos by Tracey Marcus conducted in the former's New York City studio, April 29, 1997.

Chapter 11

1. Kente, like other appropriated African artworks, mediates the interaction between advertiser and consumer. Research has shown that a product or an object may be employed as a vehicle in fashioning "an idealized image of a particular social category," here, Black America (O' Barr 1994, 3).

Notes to the Text

2. Hunter-Gadsden notes that merchants are beginning to compare the trend in the appropriation of kente with what happened to Black music. They also regard the reproduction of kente and Bamana *bogolanfini* for bedspreads and other uses by such companies as Martex and Hallmark as demeaning and a form of cultural piracy (1990, 80).

3. In traditional circles, kente's ceremonial significance as a funeral shroud prevails, albeit rarely. Even in Ghana, however, the fabric has also appeared in mundane and sometimes less dignified contexts. It has seen use as a table cloth and served as fabric for tunics and even underwear (Quarcoopome 1983, 94, fig. 115). The uses to which the cloth is currently being put in an African American context thus seem to represent a continuum.

4. The efficacy of indirect suggestion has long been recognized by psychologists, although it functions in ways that are culturally specific. Early in the century Harold Burtt noted that Americans generally resent blunt commands in an advertising context. According to Burtt "one of the subtlest kinds of indirect suggestion is the creation of an appropriate atmosphere for the commodity. In many situations we are responsive not merely to the main object of our attention but to the background of stimulation which goes along with it" (Burtt 1938, 56). Recent scholarship offers a stronger theoretical articulation of the same concept. Charles Forceville's study of "pictorial simile"—wherein a subject is absent but unambiguously suggested by the pictorial context—is a case in point. He notes that even if there is no obvious similarity between image and hidden product, the former's qualities are projected on the latter (Forceville 1996, 136–45). An equally convincing argument resides in the theory of "content-free advertising," the situation in which because content is irrelevant and sometimes even unintelligible, name recognition becomes the primary goal (Padgett and Brock 1988, 186).

5. See Burtt (1938, 355). Presenting an attractive, emotionally charged, and culturally relevant picture in an advertisement and then offering the viewer a free copy of that picture, suitable for framing, is also a powerful mnemonic device.

6. It should be noted that while slimness is neither foreign to nor considered offensive by African peoples, few African societies would consider "Barbie" and ideal figure type. Kente clothing adorning what is essentially a Black "Barbie" doll thus represents a significant step on the cloth's journey within the context of American popular culture.

7. Use of African American models to illustrate the "exotic" African in an advertising context is nothing unusual. Black Americans now serve to mediate American relations with the African "other" (see O'Barr 1994, 90–93).

Chapter 12

1. While this study shows a good balance in the gender, occupation, age, and economic standing of the interviewees, it should not be seen to represent a scientific sampling of the African American populations of the two cities. Students interviewed people whom they had independently contacted, as well as others who had been recommended to them by teachers, museum staff, and earlier interviewees. All but one of the individuals interviewed were of African descent. In addition, while most of the individuals approached for interviews consented, a small number refused to participate for political or personal reasons.

2. Personal communication from Shelly Shoi to Betsy D. Quick, October 1996.

3. The *Washington Post* (Graham 1983) reports an African harvest ritual celebrated in lieu of Thanksgiving by members of an African temple in the Washington area, but such events are not necessarily commonplace in the African American community.

4. Personal communication from Crenshaw High School students to Betsy D. Quick, January 1997.

5. Los Angeles City Council File #31794.

6. Los Angeles City Council File #77874.

7. Los Angeles City Council File # 72-4298.

8. The students in Los Angeles had hoped to be able to interview former Mayor Tom Bradley. Bradley was the first African American to be elected mayor of Los Angeles, and he also held that office longer than anyone else in the city's history. The former mayor's poor health, however, precluded interviews. Anton Caleia, Bradley's administrative assistant remarked in telephone conversations with Betsy D. Quick that none of Bradley's colleagues remember him wearing kente in public life. A search of the Bradley Archives at UCLA failed to produce any documentation of the former mayor wearing kente. During the tumultous 1970s when Bradley held office, many prominent African American leaders did wear kente, thus making its absence in the Bradley Archives noteworthy. Colleagues of the former mayor have informally suggested that his support was so broad based that culturally specific symbols such as kente would have been somehow out of place during his term of office.

9. This was documented by Doran H. Ross and Betsy D. Quick, February 14, 1998.

10. The five Heritage Collection mylar balloons that take their patterns more directly from kente are: Birthday #32278 and #32282, Celebrate Your Heritage #31522, Heritage-Hope Your Day Blooms with Sunshine #32368, and Happy Kwanzaa #31479.

11. The four Heritage Collection balloons drawn from generic African patterns are: Heritage—A Baby is a Precious Gift #32326, Heritage—True Love Lights the Way Down a River of Dreams #32280, Heritage—Peace #31481, and Heritage—Your Timeless Beauty is Celebrated with Love This Mother's Day #31930.

12. The Heritage Collection balloon that seems to draw its inspiration from mud cloth designs is Our Hearts Beat Together #31525.

13. Pioneer Balloon Company flyer #DLO9MR96.

14. Document #0257, LAUSD Board Secretariat, dated 1/29/51.

15. Document #262, LAUSD Board Secretariat, dated 2/2/81.

16. LAUSD Reference List No. 18: Observance of Black History Month, February 1981.

17. Personal communication from Reverend J. L. Armstrong to Betsy D. Quick, March 1998.

18. Personal communication from Reverend Quanetha Hunt to Betsy D. Quick, February 1998.

19. Phone inquiries made by Betsy D. Quick to the owners of Praise Robes, Los Angeles, and Robes of Faith, Atlanta, revealed similar concerns about using handwoven kente in the body of the robe. Both of these companies are Black-owned and serve African American communities throught the United States.

References Cited

The Adae Kese Durbar
　　1995　Festival program, Kumase Sports Stadium (13 August). Otumfuo Opoku Ware II Asantehene. Kumase, Ghana.

Adda, Rebecca, and Kodzo Chapman
　　1990　"Kente in Modern Fashion," *Uhuru* 2 (5): 19–21.

Adler, Peter, and Nicholas Barnard
　　1992　*African Majesty: The Textile Art of the Ashanti and Ewe.* London: Thames and Hudson.

"Africa's Quiet Revolution: Gold Coast's First Native Prime Minister is Symbol of Awakening from One Thousand-Year Slumber"
　　1952　*Ebony* (June): 94–100.

Agbenaza, Edith H.
　　1965　"The Ewe Adanudo: A Piece of Creative Cloth Woven Locally by Ewes." Bachelor's thesis, University of Science and Technology, Kumase, Ghana.

Agotime Traditional Area. Agbamevoza (Kente Festival) 1997, Celebrations
　　1997　Festival program (25 August and 31 August). Under the auspices of Nene Nuer Keteku III. Theme: Peace and Unity for Development.

Aguigah, Dola
　　1985　"Premiers résultats des fouilles archéologiques à Notse (Togo) de mars à juin 1984." In *Actes du séminaire UCLA-UB sur les sciences sociales*, vol. 1. Lome, Togo: Ministère de l'Education Nationale et de Recherche Scientifique.

"Alex Quaison-Sackey: U.N.'s First Black President"
　　1965　*Ebony* (May): 198–206.

Alexander, Daryl Royster, and William Woys Weaver
　　1986　"For Thanksgiving, Two Feasts. Two Traditions," *New York Times* (19 November): C31.

Alexander, Lois K.
　　1982　*Blacks in the History of Fashion.* New York: Harlem Institute of Fashion.

Amenumey, D. E. K.
　　1986　*The Ewe in Pre-Colonial Times: A Political History with Special Emphasis on the Anlo, Ge, and the Krepi.* Accra: Sedco.

Angelou, Maya
　　1986　*All God's Children Need Traveling Shoes.* New York: Vintage Books.
　　1996　*Kofi and His Magic.* New York: Clarkson Potter.

Anquandah, James
　　1982　*Rediscovering Ghana's Past.* London: Longman.

Antubam, Kofi
　　1961　*Ghana Arts and Crafts.* Ghana: Ghana National Trading Corporation.
　　1963　*Ghana's Heritage of Culture.* Leipzig: Koehler & Amelang.

Apaa, Kwaku
　　1997　"Another Story About Kente," *Daily Graphic* (27 August): 9.

Appadurai, Arjun
　　1993　"Patriotism and Its Futures," *Public Culture* (5): 411–29.

Arhin, Kwame
　　1987　"Savanna Contributions to the Asante Politcal Economy." In *The Golden Stool: Studies of the Asante Center and Periphery.* New York: American Museum of Natural History.

Arhin, Kwame, ed.
　　1991　*The Life and Work of Kwame Nkrumah.* Ghana: Sedco Publishing.

Arnoldi, Mary Jo, and Christine Mullen Kreamer
　　1995　*Crowning Achievements: African Arts of Dressing the Head.* Los Angeles: UCLA Fowler Museum of Cultural History.

Aronson, Lisa
　　1982　"Popo Weaving: The Dynamics of Trade in Southwest Nigeria," *African Arts* 15, 3 (May): 43–47.

Asamoa, Ansa
　　1986　*The Ewe of Ghana and Togo on the Eve of Colonialism: A Contribution to the Marxist Debate on Pre-Captialist Socio-Economic Formation.* Tema: Ghana Publishing Co.

Asihene, Emmanuel V.
　　1978　*Understanding the Traditional Art of Ghana.* New Jersey: Fairleigh Dickinson University Press.

Awere, J. Oti
　　1998　"Ghana's Primary Cultural Destination." In *Bonwire Kente Festival: 300 Years of Kente Evolution, 1697–1997.* Festival program (5–11 January).

Ayina, E.
　　1987　"Pagnes et Politique," *Politique Africaine* 27 (September–October): 47–54.

Beckwith, Carol, and Angela Fisher
　　1996　"Royal Gold of the Asante Empire," *National Geographic* 190, 4 (October): 36–47.

Bergman, Ingrid
　　1975　*Late Nubian Textiles.* Stockholm: Esselte Stadium.

Bickford, Kathleen E.
　　1997　*Everyday Patterns: Factory-Printed Cloth of Africa.* Kansas City: University of Missouri—Kansas City Gallery of Art.

Biggers, John
　　1962　*Ananse: The Web of Life in Africa.* Austin: University of Texas Press.

"Birth of an African Nation: Independence Comes to Gold Coast, Renamed Ghana after Ancient Black Empire"
　　1957　*Ebony* (March): 17–24.

Bishopp, G.
　　1977　"A Comparison of the Social and Aesthetic Role of Asante and Anlo Ewe Narrow Strip Weaving." Master's thesis, University of California, Santa Barbara.

Boaten I, Barfuo Akwasi Abayie
　　1993　*Akwasidae Kɛsɛɛ, A Festival of the Asante: People with a Culture.* Accra: National Commission on Culture.

Boateng, Akuamoah
　　1990　"Genesis of Kente: The Bonwire Story," *Uhuru* 2 (5): 24–26.
　　1995　"February is Black History Month," *Ghana Review* 1 (6). Available online at <*www.dal.cal"acswww/grfibhm.html*>.

Bolland, Rita
　　1991　*Tellem Textiles: Archaeological Finds from Burial Caves in Mali's Bandiagara Cliff.* Amsterdam: Royal Tropical Institute.

Bonwire Kente Festival: 300 Years of Kente Evolution, 1697–1997
　　1998　Festival program (5–11 January).

References Cited

"Bonwire Kente Festival"
 1998 *The Mirror* (17 January): 10–11.

Boser-Sarivaxévanis, Renée
 1972 *Les Tissues de l'Afrique Occidentale*. Basel.
 1991 "An Introduction to Weavers and Dyers in West Africa." In *Tellem Textiles: Archaeological Finds from Burial Caves in Mali's Bandiagara Cliff*. Amsterdam: Royal Tropical Institute.

Bowdich, T. Edward
 1819 *Mission from Cape Coast Castle to Ashantee*. 1st ed. London: John Murray. 3rd ed. London: Frank Cass & Co., 1966.

Brady, Thomas F.
 1957 "Negro Nation is Born in Africa: Gold Coast Becomes Ninth Member of Commonwealth," *New York Times* (6 March): 1.
 1957 "Nixon is in Accra for Ghana Fetes: Seventy Nations to Attend Gold Coast's Rebirth as Independent Country," *New York Times* (4 March): 1.

Braffi, Emmanuel Kingsley
 1995 *Silver Jubilee of Otumfuo Opoku Ware II Asantehene and Some Aspects of Asante History*. Kumase: University Press.

Bravmann, René A.
 1974 *Islam and Tribal Art in West Africa*. Cambridge: Cambridge University Press.

Brown, B. J.
 1996 "Disciplined Grads to Get Transcripts," *Muskogee Daily Phoenix* (31 May): 1A, 5A.
 1996 "Disciplined Grads, ACLU to Meet," *Muskogee Daily Phoenix*. (18 June): 3A.
 1996 "College to Pay Grads' Way: Two Who Battled MHS Dress Code Accept Minn. Offer," *Muskogee Daily Phoenix* (26 July): 1A, 4A.

Burnham, Dorothy K.
 1980 *Warp and Weft: A Textile Terminology*. Toronto: Royal Ontario Museum.

Burtt, Harold
 1938 *Psychology of Advertising*. Boston: Mifflin Company.

"Busia Foundation Established"
 1997 *Online Independent* 5, 32 (16–23 July): 22.

"Champ's African 'Love Affair': Cassius Wins Continent in Whirlwind Courtship"
 1964 *Ebony* (September): 85–92.

"Chiefs Asked to Exhibit Honest Life Style."
 1997 *Ghanaian Times* (6 September): 7.

Chocolate, Debbi
 1996 *Kente Colors*. New York: Walker and Company.

Christaller, Johann Gottlieb
 1874 *A Dictionary, English, Tshi (Ashante), Akra*. Basel: Basel Evangelical Missionary Society.
 1933 *Dictionary of the Asante and Fante Language Called Tshi (Twi)*. 2d ed. Basel: Basel Evangelical Missionary Society.

"Church Lays Foundation Stone"
 1977 *Daily Graphic* (12 September): 16.

"Clergymen Inducted"
 1997 *Weekly Spectator* (30 August): 9.

Cole, Harriette
 1993 *Jumping the Broom: The African-American Wedding Planner*. New York: Henry Holt and Company.

Cole, Herbert M., and Doran H. Ross
 1977 *The Arts of Ghana*. Los Angeles: Regents of the University of California.

Coquet, Michele
 1993 *Textiles Africains*. Paris: Adam Biro.

Corrigan, Peter
 1994 "Interpreted, Circulating, Interpreting: The Three Dimensions of the Clothing Object." In *The Socialness of Things: Essays on the Socio-Semiotics of Objects*. New York: Mouton de Gruyter.

Cronon, Edmund David
 1955 *Black Moses: The Story of Marcus Garvey and the Universal Negro Improvement Association*. Madison: University of Wisconsin Press.

Culin, Stewart
 1923 Notes to *Primitive Negro Art: Chiefly from the Belgian Congo*. New York: Brooklyn Museum.

Dadson, Nanabanyin
 1998 "Bonwire kro-hin-ko," *The Mirror* (10 January): 17.

Dery, Severious Kale
 1997 "U.S. Honors Forty Ghanaians," *Daily Graphic* (13 September): 11.

Dantzig, A. van
 1978 *The Dutch and the Guinea Coast, 1674–1742: A Collection of Documents from the General Archive at the Hague*. Accra: GAAS.

De Maree, Pieter
 1987 *Description and Historical Account of the Gold Kingdom of Guinea (1602)*. Translated and edited by Albert Van Dantzig and Adam Jones. New York: Oxford University Press.

Debrunner, Hans
 1961 *Witchcraft in Ghana: A Study of the Belief in Destructive Witches and Its Effect on the Akan Tribes*. 2d ed. Accra: Waterville Publishing House.

Domowitz, S.
 1992 "Wearing Proverbs: Anyi Names for Printed Factory Cloth," *African Arts* 25 (July): 82–87.

Douglas, Linda Brown
 1992 "Kente Cloth in the Fabric of Campus Life," *Black Issues in Higher Education* 9 (9): 1, 12.

Douglas, Robert L.
 1996 *Wadsworth Jarrell: The Artist as Revolutionary*. San Francisco: Pomegranate Artbooks.

Du Bois, Shirley Graham
 1978 *Du Bois: A Pictorial Biography*. Illinois: Johnson Publishing.

Dunbar, Donnette
 1991 "Everybody Wants a Piece of Africa Now," *Los Angeles Times* (27 October): E5.

"Durbar in Honor of His Royal Highness the Prince of Wales"
 1977 Dwaberem, Manhyia, Kumasi. Festival program (21 March).

Emery, Walter Bryan
1961 *Archaic Egypt.* Harmondsworth: Penguin; reprint 1963.

Eshun-Baidoo, Francis
1997 "Minister Launches Medical Books," *Daily Graphic* (13 September): 14.

Essuman, N. T.
1990 "Daa Daa Kente." Choral composition.

Fabian, Johannes
1997 "Popular Culture in Africa: Findings and Conjectures." In *Readings in African Popular Culture*, edited by Karen Barber. London: International African Institute, 18–28.

Falk, Lisa
1995 *Cultural Reporter.* Smithsonian Institution: National Museum of American History.

Field, Margaret J.
1960 *Search for Security: An Ethno-Psychiatric Study of Rural Ghana.* Reprinted. New York: W. W. Norton & Co., 1970.

Foderaro, Lisa W.
1991 "At Columbia Rite, a Sum of Diverse Cutlures," *New York Times* (13 May): B6.

Forceville, Charles
1996 *Pictorial Metaphor in Advertising.* London: Routledge.

Ford, Andrea
1996 "Thirty Years Later, Kwanzaa Still Growing," *Los Angeles Times* (30 December): B3.

"Foreign Relations: Pride of Africa"
1958 *Time* (4 August): 14.

Frimpong, K. Ohene
1997 "Stamps in Honour of Starlets" (13 September): 12.

Fynn, John Kofi
1971 *Asante and Its Neighbours, 1700–1807.* Evanston: Northwestern University Press.

Gardi, Bernard
1985 *Ein Markt wie Moptie: Handwerkerkasten und traditionelle Techniken in Mali.* Basel: Wepf & Co.

"Ghana: An Untapped Source of Design Inspiration; The Textiles of Ghana"
1960 *American Fabrics* 51 (fall–winter): 53–61.

Gilfoy, Peggy Stoltz
1987 *Patterns of Life: West African Strip-Weaving Traditions.* Washington, D.C.: Smithsonian Institution Press.

Gose, Ben
1995 "Kente at Commencement," *The Chronicle of Higher Education* (26 May): A31.

Gouma-Peterson, Thalia
1993 *Emma Amos: Paintings and Prints, 1982–92.* Wooster, Ohio: College of Wooster Art Museum.

Graham, Barbara
1983 "Celebration Combines Thanksgiving with an Old West African Ceremony," *The Washington Post* (23 November): 68.

Hagan, George P.
1991 "Nkrumah's Cultural Policy." In *The Life and Work of Kwame Nkrumah*, edited by Kwame Arhin. Ghana: Sedco Publishing Limited.

Hale, Sjarief
1970 "Kente Cloth of Ghana," *African Arts* 3 (3): 26–29.

Haley, Alex, and Malcolm X.
1964 *The Autobiography of Malcolm X.* New York: Ballantine Books.

Harley, Sharon
1995 *The Timetables of African-American History: A Chronology of the Most Important People and Events in African-American History.* New York: Simon & Schuster.

Harris, Jessica B.
1995 *A Kwanzaa Keepsake.* New York: Simon and Schuster.

Harris, Michael D.
1994 "From Double Consciousness to Double Vision: The Africentric Artist," *African Arts* 27, 2 (April): 44–53.

Hiamey, T. B.
1981 "The Origin and Development of the Weaving Industry in Anlo-Some Area of Ghana (Agbozume & Ano-Afiadenyigba Weaving Industry: A Case Study)." Bachelor's thesis, University of Science and Technology, Kumase, Ghana.

Hill, Robert A., ed.
1984 *The Marcus Garvey and Universal Negro Improvement Association Papers. Vol 3., September 1920–August 1921.* Berkeley: University of California Press.

hooks, bell
1995 *Art on My Mind: Visual Politics.* New York: The New Press.

Hudgens, Jim, and Richard Trillo
1995 *West Africa: The Rough Guide.* 2nd ed. New York: Penguin Books.

Hunter-Gadsden, Leslie
1990 "Marketing the Motherland," *Black Enterprise* (December) 21: 76–82.

Idiens, Dale, and K. G. Ponting, eds.
1980 *Textiles of Africa.* Bath: The Pasold Research Fund.

Isert, Paul Erdmann
1992 *Letters on West Africa and the Slave Trade: Paul Erdmann Isert's Journey to Guinea and the Caribbean Islands in Columbia (1788),* translated by Selena Axelrod Winsnes. Union Académique Internationale, Fontes Historiae Africanae, serie varia 7. Oxford: Oxford University Press.

Jacques-Garvey, Amy, ed.
1992 *Philosophy and Opinions of Marcus Garvey.* New York: Macmillan Publishing Co.

Jenkins, Timothy
1995 "Misguided Authenticity," *American Visions* 10, 4 (May): 4.

Johnson, Marion
1937 "Wood-Carving by the Wood Carver to the Asantehene," *The Teacher's Journal* 10 (3): 269–71.
1979 "Ashanti Craft Organization." *African Arts* 13, 1 (November): 61–63, 78–82, 97.

References Cited

Jones, Adam
 1988 "Drink Deep, Or Taste Not: Thoughts on the Use of Early European Records in the Study of African Material Culture." *Workshop on Resources and Documentation in the Study of African Material Culture*, Bellagio (25–27 May).

Jones, Lisa C.
 1992 "Black Toys: Gifts for Play and Pride," *Ebony* (November): 243–46.
 1993 "Toys That Teach," *Ebony* (November): 56–66.
 1994 *Bulletproof Diva: Tales of Race, Sex, and Hair*. New York: Doubleday.

Jones, Patricia
 1989 "Kente Cloth: Back to the Future," *Essence* (January): 42.

Karenga, Dr. Maulana
 1997 *Kwanzaa: A Celebration of Family, Community and Culture*. Los Angeles: University of Sankore Press.

Karikari-Mensah, Alberta
 Short Notes and Questions on Textiles. Accra: Christ the King International School.

Kent, Kate Peck
 1971 *West African Cloth*. Denver: Denver Museum of Natural History.

Klose, Heinrich
 1899 *Togo Unter Deutscher Flagge; Reisebilder und Betrachtungen von Heinrich Klose*. Berlin: D. Reimer.

Kraamer, Malika
 1996 "Kleurrijke Veranderingen: De Dynamiek van de Kentekunstwereld in Ghana." Ph.D. diss., Erasmus Universiteit Rotterdam.

Kuklick, Henrika
 1979 *The Imperial Bureaucrat: The Colonial Administrative Service in the Gold Coast, 1920–1939*. California: Hoover Institution Press.

"Kwanzaa—Our Culture is Sacred: Kwanzaa Position Statement."
 International Black Buyers & Manufacturers Expo & Conference. Available online at <http://www.IBBMEC.com/kwanzaa.html>.

Kyerematen, A. A. Y.
 1961 *Regalia for an Ashanti Durbar*. Ghana: Kwame Nkrumah University of Science and Technology.
 1964 *Panoply of Ghana: Ornamental Art in Ghanaian Tradition and Culture*. New York: Praeger.
 1969 *Kingship and Ceremony in Ashanti: Dedicated to the Memory of Otumfuo Sir Osei Agyeman Prempeh II, Asantehene*. Kumase: UST Press.

Lamb, Venice
 1975 *West African Weaving*. London: Duckworth.

Lamb, Venice, and Alastair Lamb
 1980 "The Classification and Distribution of Horizontal Treadle Looms in Sub-Saharan Africa." In *Textiles of Africa*, edited by D. Idiens and K. B. Ponting. Bath: Pasold Research Fund.

Lange, Karen
 1992 "Ghanaian Cloth Raises U.S. Constitutional Questions," *Africa News* (3–16 August): 4.

Leiva, Miriam A., and Richard G. Brown
 1997 *Algebra 2: Explorations and Applications*. Illinois: McDougal Littel.

Leon, Eli
 1987 *Who'd a Thought It: Improvisation in African-American Quiltmaking*. San Francisco: San Francisco Craft & Folk Art Museum.
 1992 *Models in the Mind: African Prototypes in American Patchwork*. North Carolina: The Diggs Gallery and Winston-Salem State University.

Locke, Alain, ed.
 1925 *The New Negro: Voices of the Harlem Renaissance*. New York: Atheneum.

Mackin, Doris Mary Ann
 1978 "Contemporary Interpretations of the Ashanti Kente Cloth." Masters thesis, San Jose State University.

Magubane, Bernard Makhosezwe
 1987 *The Ties That Bind: African-American Consciousness of Africa*. New Jersey: Africa World Press.

Manuh, Takyiwaa
 1998 "Diasporas, Unities, and the Marketplace: Tracing Changes in Ghanaian Fashion." *Journal of African Studies* 16, 1 (winter): 13–19.

Mardis, Jas., ed.
 1997 *KenteCloth: Southwest Voices of the African Diaspora, The Oral Tradition Comes to the Page*. Denton: University of North Texas Press.

Marriott, Michael
 1996 "New Symbol of the Holiday Has a Mission, Not a Belly," *New York Times* (29 December): 33.

"Matsch Turns Down Kente Cloth Request."
 1998 *UPI Top Stories Online* (19 May). Available online @ <www.upi.com>.

McLaughlin, Ken
 1996 "African and Holiday Traditions United in Kente Claus," *The Philadelphia Inquirer, Daily Magazine* (20 December).

McLeod, Malcolm D.
 1975 "On the Spread of Anti-Witchcraft Cults in Modern Asante." In *Changing Social Structure in Ghana: Essays in the Comparative Sociology of a New State and an Old Tradition*, edited by Jack Goody. London: International African Institute.
 1981 *The Asante*. London: British Museum Publications.
 1987 "Gifts and Attitudes." In *The Golden Stool: Studies of the Asante Center and Periphery*. New York: American Museum of Natural History.

Menzel, Brigitte
 1972 *Textilien Aus Westafrika*, 3 vols. Berlin: Museum Für Völkerkunde.

Meyerowitz, Eva Lewin-Richter
 1960 *The Divine Kingship in Ghana and Ancient Egypt*. London: Faber and Faber.

Nelson, Robert S.
 1996 "Appropriation." In *Critical Terms for Art History*. Chicago: University of Chicago Press, 116–28.

Nelson, Robert S., and Richard Shiff, eds.
 1966 *Critical Terms for Art History*. Chicago: University of Chicago Press.

Newton, Alex, and David Else
 1995 *West Africa: A Lonely Planet Travel Survival Kit*. 3rd ed. Australia: Lonely Planet.

"Nixon Sees New Africa: Vice President Visits Eight Countries on Good Will Tour"
1957 *Ebony* (June): 32–38.

Nkrumah, Kwame
1957 *The Autobiography of Kwame Nkrumah.* New York: Thomas Nelson and Sons.

O'Barr, William M.
1994 *Culture and the Ad: Exploring Otherness in the World of Advertising.* Boulder: Westview Press.

Ofori-Ansa, Kwaku
1993 *Kente is More Than a Cloth: History and Significance of Ghana's Kente Cloth.* Maryland: Sankofa Publications.

Ofosu-Appiah, L. H., ed.
1977 *Dictionary of African Biography (The Encyclopaedia Africana).* Volume 1, *Ethiopia—Ghana.* New York: Reference Publications.

Opoku, A. A.
1970 *Festivals of Ghana.* Accra: Ghana Publishing Corporation.

Opoku, Albert Mawere
1987 "Asante Dance Art and the Court." In *The Golden Stool: Studies of the Asante Center and Periphery.* New York: American Museum of Natural History.

Oteng, Rose
1998 Foreword to *Bonwire Kente Festival: 300 Years of Kente Evolution, 1697–1997.* Festival program (5–11 January).

Owusu-Baah, Nana
1998 "Asante or Bonwire Kente: Which is Which? *Graphic Showbiz* (2–8 April): 13.

Padgett, Vernon, and Timothy C. Brock
1988 "Do Advertising Messages Require Intelligible Content? A Cognitive Response Analysis of Unintelligible Persuasive Messages." In *Non-Verbal Communication in Advertising,* edited by Sidney Hecker and David W. Stewart. Toronto: Lexington Books, 185–204.

"Panafest Kente Splash."
1997 *The Mirror* (30 August): 1, 17.

Parrinder, Edward Geoffrey
1956 *The Story of Ketu.* Ibadan: Ibadan University Press.

Patrick, Alice
1991 *Women Get Weary but They Don't Give Up.* Mural, National Council of Negro Women, Los Angeles, 1991.

Patton, Sharon F.
1984 "The Asante Umbrella," *African Arts* 17, 4 (August): 64–73.

Peace, J. Leon Jr.
1996 "And For as Long as It Takes," *The Washington Post* (March 27): A21.

Perkins, Myla
1993 *Black Dolls: An Identification and Value Guide, 1820–1991.* Kentucky: Collector Books.

Picton, John, and John Mack
1989 *African Textiles.* London: British Museum Publications.
1992 "Tradition, Technology, and Lurex: Some Comments on Textile History and Design in West Africa." In *History, Design, and Craft in West African Strip-Woven Cloth.* Washington, D.C.: National Museum of African Art, Smithsonian Institution.

Pinkney, Alphonso
1976 *Red, Black, and Green: Black Nationalism in the United States.* New York: Cambridge University Press.

Posnansky, Merrick
1987 "Prelude to Akan Civilization." In *The Golden Stool: Studies of the Asante Center and Periphery.* New York: American Museum of Natural History.
1992 "Traditional Cloth from the Ewe Heartland." In *History, Design, and Craft in West African Strip-Woven f Cloth.* Washington, D.C.: National Museum of African Art, Smithsonian Institution.

Price, Sally, and Richard Price
1980 *Afro-American Arts of the Suriname Rain Forest.* Los Angeles: University of California Press.

Quarcoo, Ekow
1996 "Kente: An Endangered Species?" *Akwaaba: The Inflight Magazine for Ghana Airways* 1 (July–September): 26–28.

Quarcoopome, Nii
1983 "Three Unconventional Objects from Ghana." In *Akan Transformations: Problems in Ghanaian Art History,* edited by Doran H. Ross and Timothy F. Garrard. UCLA Museum of Cultural History Monograph Series, no. 21. Los Angeles: Museum of Cultural History UCLA, 92–96.

Ramseyer, Friedrich August, and Kühne Ramseyer
1875 *Four Years in Ashantee.* New York: Robert Carter and Brothers.

Rattray, Robert S.
1923 *Ashanti.* Oxford: Claredon Press.
1927 *Religion and Art in Ashanti.* Oxford: Claredon Press.

"The Return of Saturday's Child: Prime Minister Nkrumah Once Scrubbed Pots in U.S.A., Comes Back as Voice of New Africa"
1958 *Ebony* (October): 17–24.

Riggins, Stephen Harold, ed.
1994 *The Socialness of Things: Essays on the Socio-Semiotics of Objects.* New York: Mouton de Gruyter.

Romano, Lois
1996 "Diplomas Denied Three Students Who Wore Cultural Symbols," *The Washington Post* (24 May): A3.

Rømer, L. F.
1965 *The Coast of Guinea.* Translated by K. Bertelsen. Legon: Institute of African Studies.

Rose, Robert
1976 *The Lonely Eagles: The Story of America's Black Air Force in World War II.* Los Angeles: Tuskegee Airmen, Western Region.

Ross, Doran H.
1977 "The Iconography of Asante Sword Ornaments," *African Arts* 11 (1): 16–25, 90–91.
1984 "The Art of Osei Bonsu," *African Arts* 17 (2): 36–51.
1996 "Akua's Child and Other Relatives: New Stories for Old Dolls." In *Isn't S/He a Doll? Play and Ritual in African Sculpture,* edited by Elisabeth Cameron. Los Angeles: UCLA Fowler Museum of Cultural History, 42–57.
1996 "Asante." In *The Dictionary of Art,* Edited by Jane Turner. New York: Macmillan Publishers Ltd.
1998 "Hammock?" In *The Extraordinary in the Ordinary: Textiles and Objects from Lloyd Cotsen and the Neutrogena Corporation,* edited by Mary Hunt Kahlenberg. New Mexico: Neutrogena Corporation.

References Cited

Ross, Doran H., and Timothy F. Garrard, eds.
1983 *Akan Transformations: Problems in Ghanaian Art History*. Monograph Series, no. 21. Los Angeles: Regents of the University of California.

Safo-Kantanka, O.-B., and J. Oti Awere
1998 "Facts About the Origin, Discovery, and Evolution of Kente." In *Bonwire Kente Festival: 300 Years of Kente Evolution, 1697–1997*. Festival program (5–11 January).

Sampson, Ekow (architect)
"Proposed Museum & Craft (Kente) Production Centre Schematic Design: Wonoo-Ashanti, Ghana," Ghana Tourist Board, Ashanti Regional Office.

Samuels, A.
1992 "Making the Transition from Cultural Statement to Macy's," *New York Times* (26 July).

Sanders, Charles L.
1966 "Kwame Nkrumah: The Fall of a Messiah," *Ebony* (September): 138–46.

Sarpong, Peter
1971 *The Sacred Stools of the Akan*. Accra-Tema: Ghana Publishing Corporation.
1974 *Ghana in Retrospect: Some Aspects of Ghanaian Culture*. Tema: Ghana Publishing Corporation.

"'Saturday's Child'—Via Harlem to African Power"
1958 *Newsweek* (4 August): 33.

Schildkrout, Enid, ed.
1987 *The Golden Stool: Studies of the Asante Center and Periphery*, Anthropological Papers of the American Museum of Natural History, vol. 65, part 1. New York: American Museum of Natural History.

Schildkrout, Enid, and Frank Fournier (photographer)
1996 "Kingdom of Gold," *Natural History* 105, 2 (February): 36–47.

Secretan, Theirry
1995 Going into Darkness: Fantastic Coffins from Africa. London: Thames and Hudson, Ltd.

Segy, Ladislaus
1963 "The Ashanti *Akua'ba* Statues as Archetypes and the Egyptian Ankh: A Theory of Morphological Assumption." *Anthropos* (58): 839–67.

Seiler-Baldinger, Annemarie
1994 *Textiles: A Classification of Techniques*. Washington, D.C.: Smithsonian Institution Press.

Shaw, Thurston
1970 *Igbo Ukwu: An Account of Archaeological Discoveries in Eastern Nigeria*. Evanston: Northwestern University Press.
1977 *Unearthing Igbo-Ukwu: Archaeological Discoveries in Eastern Nigeria*. Ibadan, Nigeria: Oxford University Press.
1978 *Nigeria: Its Archaeology and Early History*. London: Thames and Hudson.

Shinnie, Peter Lewis
1967 Meroe: A Civilization of the Sudan. New York: Praeger.

Silverman, Raymond
1982–1983 "Fourteenth–Fifteenth Century Syrio-Egyptian Brassware in Ghana," *Nyame Akuma* 20: 13–16.
1986 "Dress for Success: Adorning the Gods of the Akan." Paper delivered at the Twenty-Ninth Annual African Studies Association Meeting, Madison, Wisconsin.
1987 "Historical Dimensions of Tano Worship among the Asante and Bono." In *The Golden Stool: Studies of the Asante Center and Periphery*, edited by E. Schildkrout. Anthropological Papers of the American Museum of Natural History, vol. 65, part 1. New York: American Museum of Natural History.

Smith, Shea Clark
1975 "Kente Cloth Motifs," *African Arts* 9, 1: 36–39.

Smith, Whitney
1975 *Flags through the Ages and across the World*. New York: McGraw-Hill.

"Splendid Opening"
1997 *Weekly Spectator* (6 September): 4.

Stafford, Keith
1996–1997 "Kente Claus is Coming this Holiday Season." Press Release for Stafford's Ethnic Collectibles.

Starke, Barbara M., Lillian O. Holloman, and Barbara K. Nordquist
1990 *African American Dress and Adornment: A Cultural Perspective*. Dubuque: Kendall/Hunt Publishing.
1997 "Stretching the National Fabric: Scotland and Vivienne Westwood, Watch Out: Tartan is Not the Only National Fabric to Travel Worldwide as a Fashion Vehicle," *Economist* 8 (1997): 93–94.

Stewart, Jocelyn Y.
1997 "A Tradition Revived," *Los Angeles Times* (19 June): B5.

Swithenbank, Michael
1969 *Ashanti Fetish Houses*. Accra: Ghana Universities Press.

Teague, James
1960 "'Kente' Fabric of Ghana Halts U.N. Action . . . Briefly," *Daily News Record* (27 September).

Thompson, Jon, and Cary Wolinsky (photographer)
1994 "Cotton, King of Fibers," *National Geographic* 185, 6 (June): 60–87.

Thompson, Robert Farris
1995 *Face of the Gods: Art and Altars of Africa and the African Americas*. New York: Museum for African Art.

Thompson, Vincent Bakpetu
1969 *Africa and Unity: The Evolution of Pan-Africanism*. Great Britain: Humanities Press.

Van Dantzig, Albert, and Adam Jones, trans. and eds.
1978 *The Dutch and the Guinea Coast 1674–1742: A Collection of Documents from the General Archive at the Hague*. Accra: GAAS.
1987 *Description and Historical Account of the Gold Kingdom of Guinea (1602)*, by Pieter de Maree. New York: Oxford University Press.

Vlach, John Michael
1978 *The Afro-American Tradition in Decorative Arts*. Ohio: Cleveland Museum of Art.

Wahlman, Maude Southwell
> 1993 *Signs and Symbols: African Images in African-American Quilts.* New York: Penguin Books and Museum of American Folk Art.

Walters, Ronald W.
> 1993 *Pan Africanism in the African Diaspora: An Analysis of Modern Afrocentric Political Movements.* Detroit: Wayne State University Press.

Wardlaw, Alvia J.
> 1989 "A Spiritual Libation: Promoting An African Heritage in the Black College." In *Black Art—Ancestral Legacy: The African Impulse in African-American Art.* Dallas Museum of Art. New York: Harry N. Abrams.
> 1995 *The Art of John Biggers: View from the Upper Room.* Houston: Museum of Fine Arts and Harry N. Abrams.

Warren, Dennis Michael, and K. O. Brempong
> 1971 *Techiman Traditional State: Part I, Stool and Town Histories.* Legon: Institute of African Studies, University of Ghana.

Warren, Dennis Michael
> 1971 *Akan Vocabularies Dealing with the Arts, Religion, Sciences.* Ghana: Techiman.
> 1974 "Disease, Medicine, and Religion Among the Techiman-Bono of Ghana: A Study in Culture Change." Ph.D. diss., Indiana University.
> 1975 *The Techiman-Bono of Ghana.* Dubuque: Kendall/Hunt Publishing.
> 1976 "Bono Shrine Art," *African Arts* 9 (2): 28–34.

Washington, Elsie B.
> 1991 "Splash! Fall Colors," *Essence* (September): 73–85.

"Weddings Around the World: Diplomats, Ranking Officials and Brides in Brilliantly-Colored Gowns Highlight Imaginative Ceremonies in America, Africa."
> 1961 *Ebony* (November): 63–68.

Werbeloff, Arnold
> 1987 *Textiles in Africa: A Trade and Investment Guide.* London: Arnold Werbeloff.

Westerman, Diedrich
> 1939 *The African Today and Tomorrow.* London: Oxford University Press.

White, Constance C. R.
> 1998 *Style Noir: The First How-To Guide to Fashion Written with Black Women in Mind.* New York: Penguin Putnam.

Wilks, Ivor
> 1975 *Asante in the Nineteenth Century: The Structure and Evolution of a Political Order.* London: Cambridge University Press.
> 1976 "A Photograph of the Asantehene Kwaku Dua II," *Asante Seminar '76: The Asante Collective Biography Project Bulletin,* 4 (February): 39–40.
> 1993 *Forests of Gold: Essays on the Akan and the Kingdom of Asante.* Athens: Ohio University Press.

Williams, Raymond
> 1992 "Advertising: The Magic System." In *The Cultural Studies Reader,* edited by Simon During. New York: Routledge, 320–36.

Wolseley, Roland E.
> 1971 *The Black Press, U.S.A.* Ames: Iowa State University Press.

"Women Enter Kente Industry . . . As Prejudices Are Removed"
> 1998 *Daily Graphic* (15 January).

Wood, Paul
> 1996 "Commodity." In *Critical Terms for Art History.* Chicago: University of Chicago Press, 257–80.

"World's Top Negro Statesmen Meet: Parley of Gold Coast's Nkrumah and Liberia's Tubman Symbolizes Africa's Coming of Age"
> 1953 *Ebony* (June): 15–24.

Wright, Richard
> 1954 *Black Power: A Record of Reactions in a Land of Pathos.* New York: Harper.

Yankah, Kwesi
> 1990 "Around the World in Kente Cloth," *Uhuru* 2 (5): 15–17.
> 1995 *Speaking for the Chief: Okyeame and the Politics of Akan Royal Oratory.* Bloomington: Indiana University Press.

Zulu, I. M.
> 1992 "The Kente Tradition: A Story in Every Cloth," *Uhuru Na Umoja* (15 May): 7.